Smart Cameras

Ahmed Nabil Belbachir
Editor

Smart Cameras

 Springer

Editor
Ahmed Nabil Belbachir
AIT Austrian Institute of Technology
Donau-City-Str. 1
1220 Wien
Tech Gate Tower, 5. OG
Austria
nabil.belbachir@ait.ac.at

ISBN 978-1-4419-0952-7 e-ISBN 978-1-4419-0953-4
DOI 10.1007/978-1-4419-0953-4
Springer New York Dordrecht Heidelberg London

Library of Congress Control Number: 2009937051

Printed on acid-free paper

Springer is part of Springer Science+Business Media (www.springer.com)

Preface

Smart cameras are vision systems that do not only take images but also understand them. The primary idea behind this book was to create a pioneering reference to the topic of *smart cameras* by providing a collection of works in one volume. The resulting book reconciles several disparate scientific, technological, and commercial aspects related to smart cameras: detectors, pixels, signal processing, image sensor architectures, embedded systems, computer vision, sensor network, applications of smart cameras, and market trends. While excellent textbooks exist in many of those fields, there was a need to have a single publication that adopts the perspective of linking the specific mechanisms in the context of smart cameras.

The concept of the smart camera has existed for more than three decades. Tremendous progress has been made in the smart camera technologies and approaches both at academic level and at industrial level. Cameras are getting increasingly intelligent and more and more attractive for a wide range of applications: in surveillance and monitoring, in industrial applications, in robotics, in transportation, and in many other fields. This edited book aims to provide background information, fundamentals, an overview of the historical evolution, applications, and the latest trends in smart cameras concepts to professionals, practitioners, and students.

It integrates contributions from different authors with outstanding competence and experience in the fields of hardware electronics, signal processing, embedded computing, computer vision, sensors networks, and smart cameras applications in surveillance, machine vision, and the automotive industry. Furthermore, this publication includes a concrete analysis on smart camera market evolution through interviews with market leaders and exhibiting companies at the *Vision Expo*[1] in Stuttgart, Germany.

The invention of the camera can be traced back to the 10th century when the Arab scientist Al-Hasan Ibn al-Haytham alias *Alhacen* provided the first clear description and correct analysis of the (human) *vision process*. Although the effects of single light passing through the pinhole have already been described by the Chinese Mozi (Lat. Micius) (5th century BC), the Greek Aristotle (4th century BC), and the Arab

[1] Web site of the annual *Vision Expo* at http://cms.messe-stuttgart.de/

Al Kindi (9th century), none of them suggested that what is being projected onto the screen is an image of everything on the other side of the aperture. The Greeks described the vision process in two ways. Aristotle and his followers supported the *intromission theory* such that vision occurs when physical forms enter the eye from an object. The second theory is the *emission theory*, and Euclid (3rd century BC) and Ptolemy (2nd century) believed that visual perception occurs when the eye emits rays of light. Ibn al-Haytham argued that seeing occurs neither by physical forms entering the eyes nor by rays emitted from it. He described *vision* as a process which takes place in the brain rather than the eyes. He proved in experiments that rays of light travel in straight lines from each point of an object on the outside to project its image on the inside. He designed the first camera obscura to be the first to shift physics from a philosophical to an experimental basis. One hundred and fifty years later, Averroes pioneered neuroscience by attributing the photoreceptor properties to the retina and describing the organ of sight. The Latin term *camera obscura* was first used by the German scientist Johannes Kepler in 1604. Since the 10th century, models of the camera obscura were large darkened rooms. The first portable model was initiated by Robert Boyle and Robert Hooke in the late 17th century. In 1839, the first produced photographs[2] were announced using cameras developed by the French Louis Daguerre *(Daguerreotype)* and the English William Fox Talbot *(Calotype)*. These inventions ushered in a new era of technologies, e.g., the Morse's telegraph (communications), photographic cameras (visual arts and cinematography), and later digital photography by the pioneer American scientist Eugene F. Lally in 1961.

The above-listed inventions and contributions helped to further the understanding of vision and inspired the development of technologies to realize this process in a so-called camera. But when did the camera get intelligence to be a *smart camera*?

The invention of the digital computer in 1937 by George Stibitz can be considered as the starting point for intelligent cameras. The smart camera concept was born in the context of military and/or space applications at *National Aeronautics and Space Administration* (NASA)'s Jet Propulsion Laboratory motivated by having a stand-alone vision system for scene interpretation onboard space shuttles. In 1961, at the annual convention of the American Rocket Society Eugene F.Lally intruduced the idea of having an integrated imaging device and a processing unit. He proposed manned Mars missions with cameras employing mosaic arrays of photodetectors with their output being processed in the digital domain to provide on-board guidance and navigation. Hans Moravec reported in his PhD thesis about a cart built in the early 1960s for navigation and obstacle avoidance. This cart was an electric vehicle, remote controlled by a computer, and equipped with a TV camera through which the computer was able to see in order to run simple but realistic obstacle courses.

[2] The first permanent photograph was taken by the French Joseph Nicéphore Niépce. This earlier photographic process required hours for successful exposure. In 1839, results were published from the first commercially viable photographic process to permanently record and fix an image in shorter exposure time compatible with portrait photography.

The name *smart camera* was published for the first time by Ron Schneidermann in 1975 who described techniques used by camera manufacturers to achieve automatic exposure control toward developing systems for controlling the shutter.

The breakthrough of the smart camera was the invention of the optical mouse by Richard Lyon in 1981. It was the first realized smart camera combining an imaging device and an embedded processing unit in a compact system. The mouse used a 16-pixel visible-light image sensor with integrated motion detection on the same chip and tracked the motion of light dots in a dark field of a printed paper or similar mouse pad. This mouse was successfully commercialized and sold for Xerox systems in the 1980s. Agilent (a spin-off company of HP) developed a high-speed and high-resolution mouse camera in 1999, with 18×18 pixels and 1500 images per second, using a built-in DSP to allow real-time detection and tracking of changes in the images. The Agilent optical mouse was very successful as it was commercialized for the home-use market and is recorded to be the most widely sold *smart camera*. Lyon's optical mouse ushered in an era of novel sensor technology and concepts called *vision chips*, which are reviewed in detail in Alireza Moini's book published in 1997. Vision chips, or smart visual sensors, are sensors with integrated image acquisition and parallel processing, often at the pixel level, using analog and digital circuits. In the late 1980s, Carver Mead introduced the neuromorphic concept to describe VLSI systems containing analog and asynchronous digital electronic circuits that mimic neural architectures present in biological nervous systems. This concept revolutionized the frontier of computing and neurobiology to such an extent that a new engineering discipline emerged, with the aim to design and build artificial neural systems, such as vision systems, auditory processors, or autonomous roving robots. Besides the optical mouse, machine vision can be regarded as the driving field for emerging smart cameras because of the lucrative market. Many companies have emerged since the early 1980s with a focus on building inexpensive machine vision systems for industrial applications. Many of these companies also exhibit at the annual *Vision Expo* in Germany.

The book comprises 20 chapters organized into 8 parts.

Part I comprises three chapters which provide a detailed introduction to smart cameras. Chapter 1 narrates the historical evolution of smart cameras from the early beginnings until the most recent achievements. A technical definition of smart cameras is given in Chapter 2, along with a classification based on their fundamental system architecture. Chapter 3 describes typical smart camera technologies, design requirements, and applications.

Part II provides in two chapters important background information on imaging technologies. Chapter 4 describes the detectors, pixels, and signal processing of image sensors. The sensor architecture, geometry, and read-out techniques are featured in Chapter 5.

Part III presents three chapters which investigate embedded vision aspects. Chapter 6 highlights design and application challenges of embedded computer vision in smart cameras. Chapter 7 describes high-performance embedded computing for smart cameras in machine vision applications. Embedded vision design and applications for smart stereo cameras are presented in Chapter 8.

Part IV provides examples of three computer vision methods for smart cameras. Chapter 9 outlines self-calibration aspects for smart video cameras. Chapter 10 shows techniques for object segmentation and change detection for smart camera applications. Object tracking on embedded hardware is described in Chapter 11.

Part V comprises four chapters that deal with distributed smart cameras. Chapter 12 presents the design, architecture, and application of a high-performance wireless smart camera. Chapter 13 tackles the aspects of geo-registration and inter-sensor calibration in large sensor networks. The management methodologies of large-scale smart camera networks are described in Chapter 14. Chapter 15 shows methods for applying stereo vision in a cooperative camera network.

Part VI features three selected applications of smart cameras. Chapter 16 presents with smart cameras for machine vision. Chapter 17 features visual surveillance applications. Camera-based automotive systems are presented in Chapter 18.

Part VII comprises Chapter 19, which highlights the market evolution of smart cameras. Interviews conducted at the "Vision Expo 2008" in Germany provide facts and figures to illustrate the current market situation and requirements for smart cameras.

Part VIII comprises Chapter 20, which provides future perspectives and directions of smart cameras by considering the scientific interest, application needs, and the market evolution.

The following authors, sorted by chapter, have contributed to this book.

1. Ahmed Nabil Belbachir[3], Peter Michael Göbel[4]
2. Yu Shi[5], Fábio Dias Real[6]
3. Fábio Dias Real[6], François Berry[6]
4. Christoph Posch[3]
5. Alireza Moini[7]
6. Oliver Sidla[8], Norbert Brändle[9], Wanda Benesova[10], Marcin Rosner[10], Yuriy Lypetskyy[10]
7. Johannes Fürtler[3], Ernst Bodenstorfer[3], Michael Rubik[3], Konrad J. Mayer[3], Jörg Brodersen[3], Christian Eckel[3]
8. Kristian Ambrosch[3], Martin Humenberger[3], Sven Olufs[4], Stephan Schraml[3]
9. Roman Pflugfelder[3], Branislav Mičušík[3]
10. Andrea Cavallaro[11]
11. Gustavo Fernández Domínguez[3], Csaba Beleznai[3], Martin Litzenberger[3], Tobi Delbrück[12]

[3] AIT Austrian Institute of Technology, Austria

[4] Vienna University of Technology, Austria

[5] National ICT, Australia

[6] LASMEA CNRS, France

[7] Silverbrook Research Pty. Ltd, Australia

[8] SLR Engineering, Austria

[9] Dynamic Transportation Systems, arsenal research, Austria

[10] Joanneum Research, Austria

[11] Queen Mary University of London, UK

[12] Institute for Neuroinfomatics, ETH Zürich, Switzerland

12. Richard Kleihorst[13]
13. Khurram Shafique[14], Feng Guo[14], Gaurav Aggarwal[14], Zeeshan Rasheed[14], Xiaochun Cao[14], Niels Haering[14]
14. Wolfgang Beer[15], Werner Kurschl[16], Florian Matusek[17], Bernhard Moser[15], Stefan Mitsch[16], Stephan Sutor[17]
15. Sanjeev Kumar[18], Christian Micheloni[18], Gian Luca Foresti[18]
16. Yu Shi[5]
17. Khurram Shafique[14], Omar Javed[14]
18. Massimo Bertozzi[19], Luca Bombini[19], Alberto Broggi[19], Paolo Grisleri[19], Pier Paolo Porta[19]
19. Bernhard Kohn[3], Raffael Binder[20]
20. Ahmed Nabil Belbachir[3]

I would like to thank all authors for their valuable contributions making the realization of this publication possible. It was an honor for me to integrate knowledge and contributions from authors with such distinct expertise in the fields of electronics, computer vision, computational neuroscience, and physics.

I also want to thank all 67 reviewers of the individual chapters for helping to improve the quality of the contributions. Moreover, I would like to express my gratitude to several individuals who supported the realization of this book including Yu Shi, Roman Pflugfelder, Norbert Brändle, Gustavo Fernández Domínguez, Peter Michael Göbel.

Special thanks to Richard Lyon, Steve Kirsch, Hans Moravec, Don Braggins, Eric R. Fossum, Hongdong Li, and Peter Sturm for their inspiration and advice. I also thank Andrea Lyman for proofreading the manuscript and improving its quality and I thank Alireza Moini for permitting the use of his image for the book cover. Last but not least, I also wish to thank for the support, guidance, and assistance provided by my editor Charles B. Glaser and his assistants from Springer. Please inform me if anyone has not been included in the acknowledgments or if an important topic has not been dealt with in this publication, and I will rectify this in future editions. Readers' comments and suggestions are most welcome.

Vienna, Austria Ahmed Nabil Balbachir

[13] NXP Semiconductor Research Laboratories, The Netherlands

[14] ObjectVideo Inc, Reston, VA, USA

[15] Software Competence Center Hagenberg GmbH, Austria

[16] Upper Austria University of Applied Sciences, School of Informatics, Communications & Media, Austria

[17] KiwiSecurity Software GmbH, Austria

[18] University of Udine, Italy

[19] VisLab, Italy

[20] AIS Advanced Information Systems GmbH & Co, Austria

Contents

Part I Introduction to Smart Cameras

1 Smart Cameras: A Historical Evolution 3
Ahmed Nabil Belbachir and Peter Michael Göbel

2 Smart Cameras: Fundamentals and Classification 19
Yu Shi and Fábio Dias Real

3 Smart Cameras: Technologies and Applications 35
Fábio Dias Real and François Berry

Part II Imaging Technologies and Architecture of Smart Cameras

4 Detectors, Pixels, and Signal Processing 53
Christoph Posch

5 Image Sensor Architectures 81
Alireza Moini

Part III Embedded Vision

6 Embedded Vision Challenges 99
Oliver Sidla, Norbert Brändle, Wanda Benesova, Marcin Rosner,
and Yuriy Lypetskyy

7 High-Performance Smart Cameras 119
Johannes Fürtler, Ernst Bodenstorfer, Michael Rubik, Konrad J. Mayer,
Jörg Brodersen, and Christian Eckel

8 **Embedded Stereo Vision** . 137
 Kristian Ambrosch, Martin Humenberger, Sven Olufs,
 and Stephan Schraml

Part IV Computer Vision for Smart Cameras

9 **Self-Calibrating Cameras in Video Surveillance** 161
 Roman Pflugfelder and Branislav Mičušík

10 **Change Detection for Object Segmentation** . 181
 Andrea Cavallaro

11 **Object Tracking on Embedded Hardware** . 199
 Gustavo Fernández Domínguez, Csaba Beleznai, Martin Lizenberger,
 and Tobi Delbrück

Part V Distributed Smart Cameras

12 **Designing a Wireless Smart Camera with a High-Performance
 Vision System** . 227
 Richard Kleihorst

13 **Automatic Geo-registration and Inter-sensor Calibration in Large
 Sensor Networks** . 245
 Khurram Shafique, Feng Guo, Gaurav Aggarwal, Zeeshan Rasheed,
 Xiaochun Cao, and Niels Haering

14 **Application Development and Management of Smart Camera
 Networks** . 259
 Wolfgang Beer, Werner Kurschl, Florian Matusek, Bernhard Moser,
 Stefan Mitsch, and Stephan Sutor

15 **Stereo Vision in a Network of Co-operative Cameras** 267
 Sanjeev Kumar, Christian Micheloni, and Gian Luca Foresti

Part VI Selected Applications of Smart Cameras

16 **Smart Cameras for Machine Vision** . 283
 Yu Shi

17 Smart Cameras for Visual Surveillance . 305
 Khurram Shafique and Omar Javed

18 Camera-Based Automotive Systems . 319
 Massimo Bertozzi, Luca Bombini, Alberto Broggi, Paolo Grisleri,
 and Pier Paolo Porta

Part VII Smart Camera Markets

19 Market Demands and Analysis . 341
 Bernhard Kohn and Raffael Binder

Part VIII The Future of Smart Cameras

20 Future Directions of Smart Cameras . 359
 Ahmed Nabil Belbachir

References . 365

Index . 397

Contributors

Gaurav Aggarwal ObjectVideo Inc, Reston, VA, USA

Kristian Ambrosch Safe and Autonomous Systems, Safety & Security Department, AIT Austrian Institute of Technology, Vienna, Austria, kristian.ambrosch@ait.ac.at

Wolfgang Beer Software Competence Center Hagenberg GmbH, Austria

Ahmed Nabil Belbachir Neuroinformatics, Safety & Security Department, AIT Austrian Institute of Technology, Vienna, Austria, nabil.belbachir@ait.ac.at

Csaba Beleznai Video and Security Technology, Safety & Security Department, AIT Austrian Institute of Technology, Vienna, Austria, csaba.beleznai@ait.ac.at

Wanda Benesova Joanneum Research, Austria

François Berry LASMEA CNRS, Clermont-Ferrand, France, francois.berry@lasmea.univ-bpclermont.fr

Massimo Bertozzi VisLab, Italy

Raffael Binder AIS Advanced Information Systems GmbH & Co, Austria, raffael.binder@gmx.at

Ernst Bodenstorfer AIT Austrian Institute of Technology GmbH, Donau-City-Straße 11220 Wien, Austria, http://www.ait.ac.at

Luca Bombini VisLab, Italy

Norbert Brändle Dynamic Transportation Systems arsenal research, Austria

Jörg Brodersen AIT Austrian Institute of Technology GmbH, Donau-City-Straße 11220 Wien, Austria, http://www.ait.ac.at

Alberto Broggi VisLab, Via G.P. Usberti 181/A, 43100 Parma, Italy broggi@CE.UniPR.IT

Xiaochun Cao ObjectVideo Inc, Reston, VA, USA

Andrea Cavallaro Queen Mary University of London, UK, andrea.cavallaro@elec.qmul.ac.uk

Tobi Delbrück ETH Zürich, Zürich, Switzerland, tobi@ini.phys.ethz.ch

Christian Eckel Oregano Systems - Design & Consulting GmbH, Mohsgasse 1A-1030 Wien, Austria, http://www.oregano.at/

Gustavo Fernández Domínguez Video and Security Technology, Safety & Security Department, AIT Austrian Institute of Technology, Vienna, Austria, gustavo.fernandez@ait.ac.at

Gian Luca Foresti Department of Mathematics and Computer Science (DIMI), University of Udine, Via delle Scienze 206, 33100 Udine, Italy

Johannes Fürtler AIT Austrian Institute of Technology GmbH, Donau - City - Straße 11220 Wien, Austria, http:// www.ait.ac.at, johannes.fuertler@ait.ac.at

Peter Michael Göbel Vienna University of Technology, Vienna, Austria, goe@chello.at

Paolo Grisler VisLab, Italy

Feng Guo ObjectVideo Inc, Reston, VA, USA

Niels Haering ObjectVideo Inc, Reston, VA, USA

Martin Humenberger Safe and Autonomous Systems, Safety & Security Department, AIT Austrian Institute of Technology, Vienna, Austria, martin.humenberger@ait.ac.at

Omar Javed ObjectVideo Inc, Reston, VA, USA

Richard Kleihorst VITO NV and Ghent University, Boeretang 200, 2400 Mol, Belgium, richard@kleihorst.com

Bernhard Kohn AIT Austrian Institute of Technology, Austria, bernhard.kohn@ait.ac.at

Sanjeev Kumar Department of Mathematics and Computer Science (DIMI), University of Udine, Via delle Scienze 206, 33100 Udine, Italy

Werner Kurschl Upper Austria University of Applied Sciences, School of Informatics, Communications and Media, Austria

Martin Litzenberger Neuroinformatics, Safety & Security Department, AIT Austrian Institute of Technology, Vienna, Austria, martin.litzenberger@ait.ac.at

Yuriy Lypetskyy Joanneum Research, Austria

Florian Matusek KiwiSecurity Software GmbH, Vienna, Austria, matusek@kiwi-security.com

Konrad J. Mayer AIT Austrian Institute of Technology GmbH, Donau - City - Straße 11220 Wien, Austria, http://www.ait.ac.at

Christian Micheloni Department of Mathematics and Computer Science (DIMI), University of Udine, Via delle Scienze 206, 33100 Udine, Italy, christian.micheloni@dimi.uniud.it

Branislav Micusik Video and Security Technology Unit, Safety and Security Department, AIT Austrian Institute of Technology, Vienna, Austria, branislav.micusik@ait.ac.at

Stefan Mitsch Upper Austria University of Applied Sciences, School of Informatics, Communications and Media, Austria

Alireza Moini Silverbrook Research Pty. Ltd, Australia, alireza.moini@silverbrookresearch.com

Bernhard Moser Software Competence Center Hagenberg GmbH, Austria, bernhard.moser@scch.at

Sven Olufs Automation and Control Institute, Vienna University of Technology, Vienna, Austria, olufs@acin.tuwien.ac.at

Roman Pflugfelder Video and Security Technology Unit, Safety and Security Department, AIT Austrian Institute of Technology, Vienna, Austria, roman.pflugfelder@ait.ac.at

Pier Paolo Porta VisLab, Italy

Christoph Posch AIT Austrian Institute of Technology, Austria

Zeeshan Rasheed ObjectVideo Inc, Reston, VA, USA

Fábio Dias Real LASMEA CNRS, Clermont-Ferrand, France, fabioliveir@yahoo.com.br

Marcin Rosner Joanneum Research, Austria

Michael Rubik AIT Austrian Institute of Technology GmbH, Donau - City - Straße 11220 Wien, Austria, http://www.ait.ac.at

Stephan Schraml Neuroinformatics, Safety & Security Department, AIT Austrian Institute of Technology, Vienna, Austria, stephan.schraml@ait.ac.at

Khurram Shafique ObjectVideo Inc, Reston, VA, USA, kshafique@objectvideo.com

Yu Shi National ICT Australia, Sydney, Australia, yu.david.shi@gmail.com

Oliver Sidla SLR Engineering, Austria, os@slr-engineering.at

Stephan Sutor KiwiSecurity Software GmbH, Vienna, Austria, sutor@kiwi-security.com

Acronyms

ADC	*Analog-to-digital converter*
AE	*Address Event*
AER	*Address-event representation*
AIA	*Automated imaging association*
AIS	*Automated identification system*
ANPR	*Automatic number plate recognition*
AOV	*Angle of view*
ASC	*Aspect-scale-context information*
ASIC	*Application-specific integrated circuit*
ASIP	*Application-specific information processing*
CCD	*Charge-coupled device*
CMOS	*Complementary metal oxide semiconductor*
CoC	*Circle of confusion*
CPU	*Central processing unit*
DAC	*Digital-to-analog converter*
DoF	*Depth of field*
DSP	*digital signal processor*
DVS	*Dynamic Vision Sensor*
EMVA	*European machine vision association*
FIFO	*First-in first-out*
FIO	*Falsely identified object*
FIT	*Falsely identified tracker*
FOV	*Field of view*
FPGA	*Field programmable gate array*
HDR	*High dynamic range*
HPSC	*High-performance smart camera*
IAC	*Image of the absolute conic*
IBM	*International Business Machines Corp.*
JPDAF	*Joint probabilistic data association Filter*
ITS	*Intelligent transportation systems*
KLT	*Kanade Lucas Tomasi point tracking algorithm*
LAPP	*Linear array picture processor*
MDA	*Model-driven architecture*

MHT	*Multiple hypothesis tracker*
MO	*Multiple object*
MT	*Multiple tracker*
MV	*Machine vision*
MX	*Multiple exposure*
NASA	*National Aeronautics and Space Administration*
NMOS	*n-type metal oxide semiconductor*
NSAD	*Normalized sum of absolute differences*
OpenCV	*Open computer vision library*
PASIC	*Processor ADC and sensor integrated circuit*
PCA	*Principal component analysis*
PDF	*Probability density function*
PMOS	*p-type metal oxide semiconductor*
PTZ	*Pan-tilt-zoom*
RCA	*Radio Corporation of America*
SDK	*Software Development Kit*
SIMD	*Single instruction multiple data*
SVM	*Support vector machines*
TDI	*Time delayed integration*
TI	*Texas Instruments*
TVS	*Transient vision sensor*
VACE	*Video and analysis content extraction*
VC	*Vision components GmbH*
VCA	*Video content analysis*
VLSI	*Very large scale integration*
WiCa	*Wireless camera*
WSN	*Wireless sensor network*

Part I
Introduction to Smart Cameras

Chapter 1
Smart Cameras: A Historical Evolution

Ahmed Nabil Belbachir and Peter Michael Göbel

Abstract This chapter provides a survey on the evolution of smart cameras from the first concepts to recent emerging technologies. Following initial definitions of smart cameras, the chapter is organized chronologically in order to introduce concepts and technologies which emerged before smart cameras were developed. In addition to highlighting the origins of smart cameras, their historical evolution is presented over the past decades from scientific concepts to breakthrough technologies.

1.1 Introduction and Initial Definitions

Traditionally, a camera is a hollow dark chamber which has an opening at the front – at least a small-diameter hole (pinhole) or more commonly a lens system – and either a mirror or focus plane at the back. In the focus plane, there can be a diffusing screen, a photographic film, or a digital sensor device for receiving the projection image from the scene in front of the camera. The name "Camera" goes back to Latin and means "room," or "chamber," whereas the adjective "smart" can be tracked back to Middle English and means something like "a sharp and quick thought," or simply being "intelligent." Thus, the phrase "smart camera" means "intelligent camera," basically a camera that does a little more than simply taking pictures.

Given the lack of a precise and unique definition within the community, many definitions have been proposed by developers and manufacturers. One, in our opinion, practical definition was developed by the *Automated imaging association* (AIA) that defines three essential common features for cameras as being *smart*:

(i) *Integration* of some key functions into the device (e.g., optics, illumination, imaging capture, and image processing).
(ii) *Utilizing a processor and software* in order to achieve computational intelligence at some level.
(iii) *The ability* to perform multiple applications without requiring manual actions.

A.N. Belbachir (✉)
Neuroinformatics, Safety & Security Department, AIT Austrian Institute of Technology, Vienna, Austria
e-mail: nabil.belbachir@ait.ac.at

A.N. Belbachir (ed.), *Smart Cameras*, DOI 10.1007/978-1-4419-0953-4_1,
© Springer Science+Business Media, LLC 2010

Furthermore, the AIA categorizes vision systems, according to the grade of integration, in three product categories:

(i) *The smart camera*, as a complete or nearly complete vision system, contained in the camera body itself. Illumination and optics may or may not be integrated, but image processing and software programs must be within this camera body.
(ii) *The vision sensor*, which is primarily a lower end smart camera that too may approach the same performance of a high-end smart camera category type.
(iii) *The embedded vision processor*, where a camera is tied to an external computing system.

However, although the classification schemes given in this section make practical sense, other categories of smart cameras are presented in detail in Chapter 2. This chapter uses a more general view regarding the historical evolution, as we believe that gleaning context information from related fields is as important as focusing on smart cameras only. Therefore, this chapter starts with reviewing the ancient beginnings of camera technology in Section 1.2. Subsequently, early smart camera concepts are presented in Section 1.3, which is followed by Section 1.4 that is illustrating the breakthrough of these concepts. We finally conclude the chapter with Section 1.5 on emerging smart cameras and their application.

1.2 History: From the Early Beginning of Smart Concepts

At a first glance, camera technology seems to be an achievement of the twentieth century. However, its roots can be traced back (see also Fig. 1.1) to the fifth century BC. Thus, the study of the nature of light by the ancient Greek may be credited as the early beginning of camera theory [160]. It was the philosopher Empedocles of Acragas (492–432 BC), who believed that "the goddess Aphrodite basically made the human eye out of the four elements" and postulated a theory that "the fire within the eye shines out of the eyes and these rays should interact with rays from the sun which makes seeing possible."

Micius (470–391 BC) reported the reversion of projected light when it passes through a pinhole; Aristotle (384–322 BC) described projective effects through natural slits or holes and noticed that the smaller the hole, the sharper the projection; and finally Euclid (323–283 BC) demonstrated that light travels in straight lines.

In conclusion, all the aforementioned work can be subsumed as an early description of the pinhole principle: Fig. 1.2 (a) shows a theoretical and ideal pinhole setup, whereas Fig. 1.2 (b) shows that an image gets blurred when one uses a finite aperture $d > 0$ for the hole diameter. Thus, the smaller the hole, the sharper the image. However, this is only true up to a certain point, where diffraction of the light causes blurring again. After Josef Petzval (1807–1891), Lord Rayleigh (1842–1919) formulated the relationship for the optimal diameter $d = 1.9\sqrt{f \times \lambda}$, where d is the pinhole diameter, f the focal length, and λ the wavelength (550 nm). The

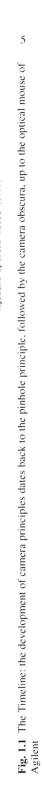

Timeline (1550 – 1950)

Pinhole principle
(Micius, ~400BC)
(Aristotle, ~350BC)

- Camera obscura
 (J. Kepler, 1604)
 (Alhacen, ~1000)
 (S. Kuo, 1088)
 (L. da Vinci, 1490)
 (R. Gemma-Frisius, 1544)
 (G. Battista Della Porta, 1558)
 (R. Boyle/R.Hooke, ~1690)

- Camera lucida •
 (W.H. Wollaston, 1807)

- First permanent photo paper •
 (J.N. Niepce, 1826)

- Lens theory • • Collodion process • 35mm film cameras
 (C.F. Gauss, 1841) (F.S. Anker, 1851) (1913)

- Motion picture camera
 (T.A. Edison, 1891)

- Daguerrotype/Calotype • • Flash bulb
 (Daguerre/Talbot, 1839) (GE, 1927)

- Silver bromide process
 (R.L. Maddox, 1871)

- Photography mass use
 (G.E. Kodak, 1892)

- Digital computer
 (George Stibitz, 1937)

Timeline (1950 – 2000)

- Polaroid camera
 (E. Land, 1948)

- Video tape recorder
 (B. Crosby Labs, 1951)

- Vidicon (TV bulb)
 (RCA, 1950)

- Underwater camera
 (J.Y. Cousteau, 1957)

- MOS sensor
 (Noble & Chamberlain, 1962)

- NASA changed from using analog to digital
 (1960 ff.)
 (E.F. Lally, 1961.)

- CCD chip
 (W.S.Boyle & G.E. Smith, 1969)

- Name Smart Camera
 (Ron Schneidermann, 1975)

- Texas Instruments patented filmless camera (1972)

- Optical mouse "R.Lyon" Xerox (1981)

- Line scan camera
 (Fairchild, 1985)

- Kodak introduces 1.4 megapixel sensor (1986)

- Kodak + MS starts partnership •
 picture transfer protocol (PTP)

- CMOS chip
 (Jet Prop Lab, 1995)

- Kodak introduces photo CD standard (1990)

- Pixar starts digital image processing (1985)

- Several consumer digital cameras launched (1994)

- Engel presents smart camera (1986)

imputer introduced (1995) •
Agilent optical mouse (1999) •

Fig. 1.1 The Timeline: the development of camera principles dates back to the pinhole principle, followed by the camera obscura, up to the optical mouse of Agilent

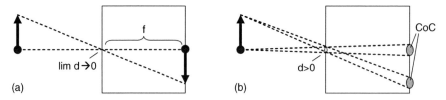

Fig. 1.2 The pinhole principle of the *camera obscura* explained by a theoretical setup (**a**) and a practical setup (**b**) with a finite small diameter of the pinhole. Due to the finite diameter of the pinhole, the image gets blurred, which is illustrated by the *gray CoC blur circle discs* in (**b**)

F-number $F = f/d$ of a pinhole camera achieves very high values, e.g., $F = 222$ for $f = 100$ mm and $d = 0.45$ mm, compared with the range $F = [2.8 \ldots 22]$ of regular lens objectives. Therefore, the *Depth of field* (DoF), which is the range of distance within a subject, appears acceptably sharp, calculate by the diameter from the allowed *Circle of confusion* (CoC) (also known as the largest blur circle that will still be perceived by the human eye as a point when viewed at a distance of 25 cm, yielding nominally a resolution of five lines per mm (see Fig. 1.2 (b)). Thus, as a particular rule of thumb, the CoC diameter limit may be given by the "Zeiss formula" CoC $= a/1730$, with a being the diagonal of the camera view. Another base for CoC is the inter-pixel spacing at digital sensors, typically in the 5–10 μm range. However, the pinhole camera principle is still used at present for landscape photography and nuclear (medical) imaging (Pinhole-SPECT).

The Arab scientist, Ibn al-Haytham alias Alhacen (965–1038) [160], was the first to provide in his "*Book of Optics*" the first clear description and correct analysis of the (human) *vision process* and how an image is formed by the eye. He then applied analogously the same principle, thus inventing the *camera obscura*, but he stated "we did not invent this" (i.e., "Et nos non invenimus ita," in the later given Latin translation of his book). He was the first to describe *vision* as a process which takes place in the brain rather than the eyes. Ibn al-Haytham argued that seeing occurs neither by physical forms entering the eyes nor by rays emitted from it, as claimed by the Greek philosophers. He proved in experiments that rays of light travel in straight lines from each point of an object on the outside to project its image on the inside. He designed the first camera obscura to be the first to shift physics from a philosophical to an experimental basis. After 150 years, Averroes pioneered neuroscience by attributing the photoreceptor properties to the retina and describing the organ of sight. Shen K'uo (1031–1095) is credited for giving the first description of the camera obscura in China. Leonardo da Vinci (1452–1519) reported his impressions on projections of illuminated objects through a small hole into a dark room and concluded that sharpness and illumination strength depend on the aperture width. Gemma Frisius (1508–1555) observed in 1544 a solar eclipse through a camera obscura. In 1558, Giovani Battista della Porta (1535–1615) perfected the camera obscura by giving a detailed description of how to add a convex lens and trace accurate projections of images from nature, and he suggested the use of the camera obscura by the painters. The Latin term *camera obscura* was first used

by the German scientist Johannes Kepler in 1604. Since the tenth century, models of the camera obscura were large darkened rooms. The first portable model was initiated by Robert Boyle and Robert Hooke in the late seventeenth century.

Later, William Hyde Wollaston (1766–1882) patented in 1807 the "Camera Lucida" which was actually a reinvention of the latest camera obscura. Figure 1.4 shows a camera lucida, made by Bausch & Lomb Optical Co., Rochester, NY. The main difference to the camera obscura is that it no longer uses a dark chamber (thus, camera lucida means "light room"). The problem with Wollaston's camera was that it was complicated to operate and so Giovanni Battista Amici (1786–1863) introduced in 1818 an improved version of the camera lucida, shown in Fig. 1.3.

Fig. 1.3 The pinhole principle of the *camera lucida* explained by a theoretical setup (**a**) and a practical setup (**b**) with a finite small diameter of the pinhole. Due to the finite diameter of the pinhole, the image gets blurred, which is illustrated by the *gray discs* in (**b**)

Carl Friedrich Gauss (1777–1855) published in 1841 his *Theory of Lenses* and Joseph Nicephore Niepce (1765–1833) invented in 1826 the first permanent photo paper and is therefore credited as the inventor of photography. Louis Daguerre (1787–1851) joined forces with Niepce and sped up the photo development process in 1839 by proposing the *Daguerreotype process* in the same period as Talbot's *Calotype process*. Frederick Scott Archer (1813–1857) invented the *Collodion process* in 1851, followed by Richard Leach Maddox' (1816–1902) development of the *Silver bromide process* in 1871. George Eastman (1854–1932) initiated the mass use of photography in 1888 by founding the Eastman Kodak Company.

In 1891, Thomas Alva Edison (1847–1931) invented the motion picture camera, and in 1913, Oskar Barnack (1879–1936) developed the prototype 35 mm film camera, the UR-Leica. Vladimir Kosma Zworykin (1889–1982) invented the first usable camera tube, the kinescope, in 1923, followed by the iconoscope in 1934. Edwin Herbert Land (1909–1991) invented the polaroid process in 1948 using a polarizer filter which he had invented in 1932 during his studies. In 1950, the *Radio*

Fig. 1.4 A camera lucida, made by Bausch & Lomb Optical Co., Rochester, NY

Corporation of America (RCA) developed the Vidicon, a mono-chromatic camera tube which is lightweight, smaller, and consumes less power than other models such as the iconoscope. The Bing Crosby (1903–1977) Enterprises labs demonstrated in 1951 the first magnetic video tape recording which was developed by John T. Jack Mullin (1913–1999); in 1955 the lab demonstrated a model for color video recording.

In 1960, NASA ushered in the age of digital communication by switching from using analog to digital technology. The concept of digitizing images on scanners and the concept of digitizing video signals predate the concept of making still pictures by digitizing signals from an array of discrete sensor elements. Eugene F. Lally of the Jet Propulsion Laboratory published the first description of how to produce still photos in a digital domain using a mosaic photosensor [307]. The purpose was to provide onboard navigation information to astronauts on missions to planets. The mosaic array periodically recorded still photos of star and planet locations during transit and when approaching a planet provided additional stadiametric information for orbiting and landing guidance. The concept included camera design elements foreshadowing the first digital camera. Solid state imaging started in the 1960s, when numerous groups were working on NMOS, PMOS, and bipolar processes with varying degree of success [187]: Morrison [387] reported in 1963 a structure that allowed the determination of the spatial position of a light spot; IBM [239] presented

in 1964 the Scanistor which used an array of n–p–n junctions. The noun pixel has been introduced around 1964 [343]. Westinghouse unveiled in 1966 a monolithic 50×50 pixel array of phototransistors [474].

However, all of these sensors operated without integration, and therefore, their sensitivity was very low. Weimer et al. [561] at RCA introduced in 1967 a 180×180 pixel sensor using CdS/CdSe thin-film transistors. At Fairchild, Weckler suggested in the same year to operate p–n junctions in a photon flux integration mode by using a reverse-biased p–n junction capacitance; in 1968 a 100×100 element sensor was introduced, he called the device *reticon* and thus established Reticon Inc. [154].

Noble [403] described at Plessey company LTD in 1968 several configurations of self-scanning silicon image detector arrays, and also documented the issue of fixed pattern noise in 1970 [193]. The first *charge-coupled device* (CCD) chip was proposed by Boyle and Smith in 1969. Texas Instruments engineer Willis Adcock designed a filmless camera and applied for a patent in 1972, but it is not known whether it was ever built. The first recorded attempt at building a digital camera was in 1975 by Steven Sasson, an engineer at Eastman Kodak [562]. It used the then-new solid state CCD image sensor chips developed by Fairchild Semiconductor in 1973 [419]. The camera weighed 8 lbs (3.6 kg), recorded black and white images to a cassette tape, had a resolution of 0.01 megapixels (10,000 pixels), and took 23 s to capture its first image in December 1975. The prototype camera was a technical exercise, not intended for production. Sony launched in 1981 their Mavica electronic still camera. In 1985, Fairchild introduced the first line scan camera, using a sensor array with pixels in one row only; and Pixar labs started with digital image processing. Kodak introduced their first megapixel sensor in 1986.

1.3 Early Smart Camera Concepts

It is not fully clear from the literature when the concept of smart cameras was introduced for the first time. The notion probably goes back to military and/or space applications motivated by having a stand-alone system for scene interpretation on board space shuttles. Thus, the idea of having an imaging device and a processing unit capable of performing real-time scene interpretation can be traced back to the 1960s. One paper [307] introduced by E.F. Lally in 1961 while at the Jet Propulsion Laboratory for NASA was titled, "Mosaic Guidance for Interplanetary Travel." It was presented at the annual convention of the American Rocket Society and proposed manned Mars missions including the design of cameras employing mosaic arrays of photodetectors with their output processed in the digital domain to provide onboard guidance and navigation. This was the first presentation of a digital photography concept and an early concept of a smart camera.

Hans Moravec [386] reported about a cart built in the early 1960s for navigation and obstacle avoidance. This cart was an electric vehicle, remote controlled by a computer and equipped with a TV camera through which the computer was able to

see in order to run simple but realistic obstacle courses. Figure 1.5 shows a picture of the first model of such a cart in 1963. The cart holding a TV camera can be seen in Fig. 1.6. The main limitation of having a compact smart system was the size of the computers and converters at that time. The images were transmitted from the TV camera to an ADC converter (size of a refrigerator) and then routed to a room full of computer equipments to process and interpret the information.

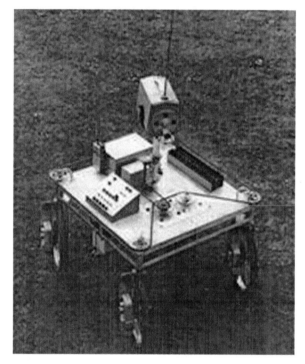

Fig. 1.5 Picture of the Stanford cart built in 1963

In 1966, Runge et al. implemented an electronic model of a pigeon's retina, shown in Fig. 1.7 by using discrete components [461]; and Fukushima et al. designed another retina model with 700 photoreceptors in a discrete analog network [200]. Using networks of analog circuits for processing of images may be regarded as the beginning of (smart) VLSI vision processing.

Herbert Simon already predicted in the mid-1950s [498] that "Machines will be capable, within twenty years, of doing any work that a man can do." An approximation to this utterance occurred indeed in less than 20 years in robotics: Shakey, in Fig. 1.8, was the first mobile robot to reason about its own actions; it was developed at the Stanford Research Institute, Artificial Intelligence Center, from 1966 to 1972 [455]. Endowed with a limited ability to perceive and model its environment, Shakey was designed to perform tasks that required planning, route finding, and the rearranging of simple objects. In an issue of the *Life Science Magazine* in the late

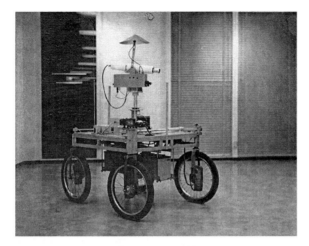

Fig. 1.6 Picture of the cart, holding the TV camera in 1975

Fig. 1.7 The Avian Retina model by Runge et al. with a view of the sensor array. The model used a discrete analog network [461], cadmium sulfide photosensors with a viewing angle of $\approx 40^\circ$

1960s, Shakey was quoted as "the first electronic person – who – could travel around the moon for months at a time without receiving a single beep of direction from the earth."

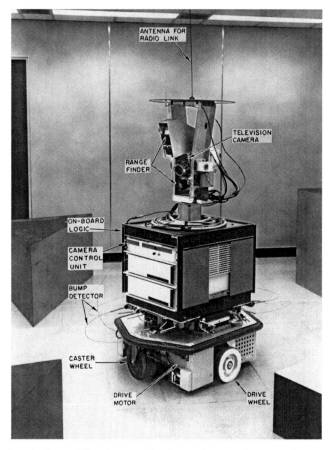

Fig. 1.8 Shakey, the first mobile robot, capable of reasoning about its own actions

A paper by Brodin in 1980 [81] reported about a computer-interfaced TV system, called SYDAT, that was built in the period 1972–1974 at the Instrumentation Laboratory of the Royal Institute of Technology in Sweden. The work carried out by the SYDAT laboratory included photodiode arrays and other image detectors in IR and X-ray; signal processing and signal processing circuits; special cameras with built-in processing, "smart sensors"; man–machine interfacing problems; laboratory system development, computer systems, and software as an early effort for smart camera systems.

1.4 Breakthrough of the Smart Camera

To our knowledge, the name *smart camera* was published for the first time by Ron Schneidermann in 1975 [472]. He described techniques used by camera manufacturers to achieve automatic exposure control where the major effort is directed toward developing systems for controlling the shutter (aperture-preferred systems).

The optical mouse was then the first realized smart camera combining an imaging device and an embedded processing unit in a compact system. This optical mouse was invented by Richard Lyon [344] at Xerox in 1981 and patented in 1983 [345]. Figure 1.9 depicts Lyon's optical mouse chip built by Xerox. The mouse used a 16-pixel visible-light image sensor with integrated motion detection on the same chip and tracked the motion of light dots in a dark field of a printed paper or similar mouse pad. This mouse was successfully commercialized and sold for Xerox Star office systems, Xerox Interlisp workstations, high-end Xerox copier-duplicator systems, and Tektronics Smalltalk workstations in the 1980s.

Fig. 1.9 Photo of the Xerox optical mouse chip, in a transparent plastic DIP package

In the same period, Steve Kirsch introduced in 1982 another optical mouse using infrared sensors. Unlike Lyon's mouse, Kirsch's mouse did not contain a camera. It was rather an arrangement of a few discrete detector components (infrared photodiodes) assembled on a board. It used an infrared LED and a four-quadrant infrared sensor to detect grid lines printed with infrared absorbing ink on a special metallic surface. Predictive algorithms in the CPU of the mouse calculated the speed and direction over the grid. This optical mouse was quite successful in the 1980s and Kirsch went on to found his own company Mouse Systems Cooperation — shipping this optical mouse with every Sun workstation and some others, and even some for PCs, along with the PC Paint software, starting in 1984.

The next optical mouse was the remarble trackball mouse invented by Logitech in 1995. This optical mouse uses large ball "marble" with a special texture for cursor motion. It reduces the hand movements and space requirements. Agilent (Spinoff company of HP) developed a high-speed and high-resolution mouse camera in 1999,

with 18×18 pixels and 1500 images per second, using a built-in DSP to allow real-time detection and tracking of changes in the images. The Agilent optical mouse is the most successful as it was commercialized for the home-use market.

1.5 Emerging Smart Cameras

The optical mouse, as discussed in the previous section, is recorded to be the most widely sold smart camera. In 2005, Agilent technology reported having sold the 400th million optical mouse. In the mid-1980s, success of smart cameras raised the interest of industrial applications, robotics, and surveillance to exploit the advances in VLSI and embedded systems for building smart cameras for specific purposes.

Lyon's optical mouse [344] ushered in an era of novel sensor technology and concepts called *vision chips*, which are reviewed in detail in the book by Moini [385]. Vision chips, or smart visual sensors, are sensors with integrated image acquisition and parallel processing, often at the pixel level, using analog and digital circuits. These vision chips can be divided into two main categories: *(i) spatial* and *(ii) spatio-temporal* vision chips. In the late 1980s Carver Mead [369] introduced the neuromorphic concept to describe VLSI systems containing analog and asynchronous digital electronic circuits that mimic neural architectures present in biological nervous systems. This concept revolutionized the frontier of computing and neurobiology to such an extent that a new engineering discipline emerged, with the aim to design and build artificial neural systems, such as vision systems, auditory processors, or autonomous roving robots. The field is referred to as "neuromorphic engineering." The term neuromorphic has also been coined by Carver Mead in an attempt to name artificial systems that adopt the form of, or morph into, neural systems. Chapter 4 and Chapter 5 provide more details on pixels, detector arrays, and chip technologies.

The first spatial vision chip was the silicon retina chip developed in 1989 by Misha Mahowald and Carver Mead [350], who were the first to implement a biological facet of vision on silicon. The computation performed by Mahowald's silicon retina is based on models of computation in distal layers of the vertebrate retina, which include the cones, the horizontal cells, and the bipolar cells. Several spatial vision chips have been developed later on including the foveated *Charge-coupled device* (CCD) chip by Van der Spiegel et al. [545], Andreou and Boahen's silicon retina [18], Etienne-Cummings's single chip stereo vision system [426], [385]. The spatio-temporal vision chips or the so-called motion detection chips emerged from the Lyon's eye (optical mouse) [344]. Several motion detection chips have been developed such as Tanner's optic flow motion detection chip [525], Delbruck's velocity-tuned motion sensor [138], Moini et al.'s insect vision-based motion detection chip [385], Etienne-Cummings et al.'s motion detector chip [168] and, thus, many others listed in [385].

In parallel to the development of the vision chips, techniques for smart vision sensors have been investigated. In 1985, Espedal [162] explored methods to interface

special cameras with robots to build more sophisticated sensory devices that enable these "smart" robots to interpret various aspects of their working environment. In the same year Buechli et al. [90] described a simple concept for extracting relevant digital data from an image for a low-cost implementation of a smart camera. A prototype camera has been built and tested in applications such as metrology, motion detection, and bar code reading.

In 1986, Engel (CEO of Vision Components) presented a very compact smart camera. Kodak introduced Photo CD standard in 1990 and VLSI Vision introduced the imputer3, another smart camera (see Fig. 1.10) with a CMOS sensor [390].

Fig. 1.10 The imputer3 by VLSI Vision has dimensions of 105 × 105 × 180 mm and was built on an i960 CPU from Intel. Its modular concept allowed adding customized modules for direct interfacing to industrial peripherals (i.e., optocoupled I/O, ADC, and DAC converters, etc.)

Inspired by insect vision, Francheschini et al. [189] designed and developed a robot that moves around avoiding obstacles solely by evaluating the relative motion between itself and the environment. In [182], architectures, implementations, and applications using two smart sensors, LAPP and PASIC, are described. The basic idea behind these two designs is to integrate an image sensor array with a digital processor array in a single chip. The integrated camera and processor eliminates the bottleneck of sequential image readout that characterizes conventional systems in an attempt to provide fast, compact, and economic solutions for tasks such as industrial inspection, optical character recognition, and robot vision.

Bouzerdoum et al. [72] described a smart VLSI micro-sensor inspired by early visual processing of insects. The chip serves as a real-time visual micro-sensor initially designed for autonomous robot navigation, but it can be extended to other

applications such as smart cameras, smart rear vision mirrors, and smart bumper bars for collision avoidance.

In 1996, Shapiro [486] outlined the advantages of smart cameras for inexpensive machine vision systems. In the same year, Easton [155] described two examples of state-of-the-art digital video cameras which can enhance the ease and/or accuracy of product quality inspection. The first camera incorporates a progressive scan CCD and a built-in frame storage allowing capture of high-resolution still images of fast moving objects without the need for a strobe light, mechanical shutter, or external frame grabber. The second camera incorporates digital signal processing for improved dynamic range, color balance, and detail enhancement to allow more accurate determination of color or contrast attributes of objects being inspected. Barth et al. [47] introduced a system that can acquire panoramic images quickly, using the camera panning technique. The system makes use of a fast line scan camera, instead of a slower, conventional area scan camera. In addition, they developed a coarse-to-fine panoramic imaging technique that is based on smart sensing principles.

In [542], the problem of relative motion estimation is addressed for remotely operated vehicles by considering an offshore structure made of cylinders and a light-strip sensor. An experimental setup, tested "in air," has been described. It is based on smart cameras, which integrate the light-sensitive elements and three image processors on a single chip, driven by a Transputer network.

Hemanto et al. [234] patented the technique for remotely measuring layer thickness of transparent fluids and solids on surfaces, which has been incorporated into Canpolar East's Smart Camera (VE-262) and which has been validated for measurement of ice layer thickness. It addresses the need for reliable detection of icing on aircraft. The thickness measurement technique was carried out by directing a laser beam at the surface with the ice layer. A pattern of illumination appears on the surface as a result of internal reflection of the laser light within the ice layer. The layer thickness was calculated by a simple formula involving the size of the image pattern and the refractive index of the layer material. From the industrial point of view, *Image Industries* was a pioneer smart cameras provider from the early 1990s. This company was bought by *Cognex* in 2000. In 2007, a high-performance wireless smart camera was presented by Philips researchers [295], challenging the hardware for low-power consumption and high imaging performance. The wireless smart camera is based on an SIMD video-analysis processor and an 8051 micro-controller as a local host. Wireless communication is facilitated through the IEEE 802.15.4 standard. This camera targeted application research into distributed autonomous smart camera systems within a network (see Chapter 12 for more details on this camera).

Vision Components, a manufacturer of smart cameras, delivers a variety of smart cameras. Figure 1.11 shows, for example, the SBC4018, a smart camera module presented in 2006 with the dimensions 80×60 mm, a 3200 MIPS TMS320DM640 DSP, and sensors available in grayscale/color from 640×480 to 1024×768 pixel.

The following chapters present fundamentals, technologies, applications, and markets of smart cameras. Smart cameras will gain more and more importance in

Fig. 1.11 The SBC4018 by Vision Components. A 3200 MIPS DSP and high resolution offer a wide range of applications for this state-of-the-art camera module

the future with the development of more powerful processing. We look forward to that time. Finally, we conclude this chapter with interesting quotes on smart cameras by UK-based Don Braggins,[1] director of Machine Vision Systems consultancy:

> To my mind, the smart camera is a low cost, low risk way of getting people to use vision for the first time. With technology such as GigEvision there is really no need to have one processor per camera, and I would advocate using cameras up and down the production line so that you can stop adding value to an already defective product wherever the problem arises. Sometime during the 1990s a former client phoned me to ask if I knew of an alternative supplier to Image Industries.[2] I asked what was wrong with them, and he replied - Nothing, technically, but I need six cameras this week and they cannot supply that quickly-. It appeared that they had a production problem making plastic bottles, and although they knew what the problem was they would not be able to fix it for some time, so temporarily they would simply reject defective bottles. I think this was a scenario where smart cameras were the best solution – I suspect that they remain primarily a marketing tool or a 'sticking plaster' for specific problems and not the best solution on a long-term factory-wide basis.

[1] http://www.braggins.com

[2] Image Industries was a smart cameras provider in the 1990s. Now it is part of Cognex.

Chapter 2
Smart Cameras: Fundamentals and Classification

Yu Shi and Fábio Dias Real

Abstract Since the late 1990s smart cameras have gained significant popularity and market acceptance, especially in surveillance and machine vision industries. A smart camera is a vision system that can perform tasks far beyond simply taking photos and recording videos. Thanks to the purposely developed intelligent image processing and pattern recognition algorithms running on increasingly powerful micro-processors, smart cameras can detect motion, measure objects, read vehicle number plates, and even recognize human behavior. They are essential components for building active and automated control systems for many applications and hold great promise for being pervasive and intelligent sensors in the future. In this chapter we provide a technical definition of smart cameras and analyze the reasons behind their increasing popularity. We also discuss the characteristics and advantages of smart cameras. Later in the chapter a tentative classification of smart cameras is provided based on their system architectures.

2.1 Introduction

Among the six major human senses, vision, smell, taste, hearing, touch, and non-touch feelings, vision is probably the one that can capture most amount of information in a short period of time about the environment a person is in. However, making sense of this large amount of information is not an easy task, as it requires brain power for fast and reliable information processing. The ultimate purpose of a smart camera is to be able to functionally mimic the human eyes and brain and to interpret what the camera "sees" through artificial intelligence.

Since the 1990s, smart cameras have attracted significant interest from research groups, universities, and many industry segments especially in video surveillance and manufacturing industries. This is because smart cameras offer distinct advantages over normal (or standard) cameras by performing not just image capture but also image analysis and event/pattern recognition,all in one compact system. The

Y. Shi (✉)
National ICT Australia, Sydney, Australia
e-mail: yu.david.shi@gmail.com

A.N. Belbachir (ed.), *Smart Cameras*, DOI 10.1007/978-1-4419-0953-4_2,
© Springer Science+Business Media, LLC 2010

growing popularity of smart cameras can be attributed to the progress made in semi-conductor process technology, embedded computer vision techniques, along with socio-economic factors such as safety and security, increase in productivity and cost savings. Today, smart camera products are used in many real-world applications, especially in video surveillance, industrial machine vision, robotics, games and toys, and human–computer interfaces.

Building smart cameras involves applying technologies from computer vision, machine vision, and embedded systems. As technology fields, both computer vision and machine vision are concerned with building devices or systems that can see and extract useful information from images and make certain decisions based on that information. Embedded system technology involves building low-power, low-cost, and real-time systems that are robust enough to work reliably in real-world conditions. A smart camera is an embedded system implementing computer vision technologies for machine vision applications. Building smart cameras is a challenging endeavor which also requires skills in solid-state image sensors, optics, computer architecture, and in some cases mechanical engineering. As smart cameras are, as of now, not designed for general purpose but usually for particular applications, a good business model is also important to ensure market success and acceptance by the end users. As technologies and products used by consumers and society continue to have more integration, processing power, and intelligence (three key attributes of smart cameras) there can be no doubt that these cameras will continue to become more popular, more advanced, and increasingly part of real-time, pervasive, and automatic information systems in the future.

This chapter and next chapter aim to present an overview about smart cameras. In this chapter, Section 2.2 discusses the fundamental aspects of a smart camera, in which we attempt to give a technical definition of smart cameras and discuss the characteristics and advantages of smart cameras. In Section 2.3 a classification of different types of smart cameras is presented, based on their system architectures and technologies involved in the design and implementation of the most essential part of the camera, the application-specific information processing (ASIP) block. In the next chapter, hardware components and technologies for smart cameras will be presented, together with discussion of some state-of-the-art smart camera devices and applications.

2.2 Smart Camera Fundamentals

The earliest commercial smart cameras can probably be traced back to the 1980s.[1] The sensing and processing capabilities of early smart cameras were very limited. Their applications were very limited as well, mostly to perform simple machine vision tasks. Modern smart cameras have very large processing power and have been successfully applied to many industry sectors. Recently there has been a significant

[1] Optical mouse of Xerox invented in 1981.

amount of academic and industry research on smart cameras, which also contributed to their increasing popularity. In this section we take a look at what a smart camera is and what the reasons are behind their popularity.

2.2.1 What Is a Smart Camera?

Smart camera is a label which refers to cameras that have the ability to not only take pictures but also more importantly make sense of what is happening in the image and in some cases take some action on behalf of the camera user. For example, a camera that can monitor a door entry and trigger an alarm or send an e-mail to a user when an entry is attempted outside of opening hours would qualify to be a "smart camera" because it can figure out what is happening (detecting a prohibited entry) and take action (triggering an alarm or sending an e-mail).

While this may be a good description of what a smart camera is, it is not a technical definition for it. There are many "definitions" of smart cameras in the public space, offered by media, camera manufacturers, developers, etc., but there does not seem to be a well-established or agreed-upon definition for smart cameras. Many definitions emphasize the fact that smart cameras have built-in image processing ability. We believe these are not sound technical definitions because virtually all digital cameras, consumer or industrial, have built-in image processing capability. For us, what separates a smart camera and a non-smart camera is the nature of the tasks performed by the built-in image processor and the primary outcome or output generated by a smart camera. For the purpose of this book, we define a "smart camera," or an "intelligent camera," as an embedded vision system that is capable of extracting application-specific information from the captured images, along with generating event descriptions or making decisions that are used in an intelligent and automated system.

There are several important aspects in this definition, which are analyzed below:

- "Vision system" means that the camera has, obviously, the ability to "see," or take pictures. "Vision" is not limited to visible light; it can also include other light spectrums such as infrared and thermal imaging. "System" means that all components of the camera do not have to be physically built into a single camera housing, even though strictly speaking, they are.
- "Embedded" means that the camera, as an embedded system, employs all necessary components, such as microprocessor(s), memory, power, communication interface, so that it can function in an autonomous and automatic way.
- "Generating event descriptions or decisions" means that the primary function of the camera is not to produce better quality images or videos for people to see, but to detect whether a pre-defined event has occurred, and to do something about it.

It should be noted that a camera that comes with a built-in image processing capability does not necessarily qualify as a smart camera; it depends on the purpose of the image processing. Many consumer digital cameras, camcorders, and

other general-purpose cameras have non-trivial built-in signal and image processing power to complete functions such as auto-focusing, automatic white balance, automatic exposure control, auto-focus, and image compression, to name just a few. However, most of these functions are for the main purpose of producing pictures of better quality for people to view or watch, to print or for efficient transmission. The primary purpose of image processing in smart cameras, on the other hand, is to generate event descriptions and decisions for other devices in an automated control system. This is evident in two of the most popular applications for smart cameras: video surveillance and industry machine vision. If a normal camera is "light in, image out," a smart camera is "light in, information or decision out."

Figure 2.1 shows the simplified functional structure of a typical smart camera. The "optics" ensures efficient capture of light. The "image capture" block generally consists of a solid-state image sensor and associated circuits or components that ensure conversion from light to digitized image array. The application-specific information processing (ASIP) block is the most essential component of a smart camera. The goal of ASIP is usually not to provide better quality images for human viewing or printing but to try to understand and describe, autonomously, what is happening in the images for the purpose of better decision making in an intelligent control system. The "communication interface" and I/O ports can receive commands or instructions from a user or host, and send out data or decisions to a user or an intelligent system.

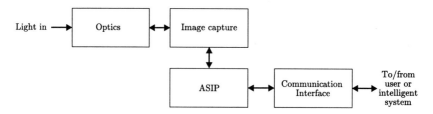

Fig. 2.1 A simplified functional structure of a typical smart camera. ASIP: application-specific information processing

If the image capture block can be likened to being the eyes of the camera, the ASIP block can be thought of as its brain, which is like a computer that makes the camera smart. On the hardware side, the ASIP block consists of one or more microprocessors with associated memory, communication buses, and other circuits or components. Depending on the architecture and hardware configuration of the ASIP, smart cameras can be divided into several categories, as discussed in Section 2.3.

The microprocessors in the ASIP can be either general-purpose CPU (central processing unit), DSP (digital signal processor), FPGA (field programmable gate array), media processors, or special-purpose processors for embedded systems. A more detailed discussion on these processors can be found in the next chapter. On the software side, the ASIP runs efficient and autonomous video analytics algorithms that analyze captured images, extract useful information, recognize patterns,

detect events, and generate decisions. The complexity of video analytics software varies from application to application. It can be as simple as motion detection or as complex as human gesture recognition and behavior description. A key challenge in designing and developing smart cameras is to select suitable ASIP hardware platforms on which algorithms can run efficiently. Both hardware and algorithms selection has to be based on application requirements, performance specifications, and business considerations.

Since the 1990s, smart cameras have enjoyed growing popularity and market acceptance. The availability of affordable personal computers, analog CCTV cameras, and video frame grabbers made it possible for researchers and developers to have a "smart camera development platform" by integrating these devices and components, and by applying, testing, and developing computer vision methods and techniques. The coming of age of solid-state CMOS (complementary metal oxide semiconductor) image sensors based on APS (active pixel sensing) technology in the late 1990s was a significant event in the evolution of smart cameras. Before CMOS image sensors, most cameras used a CCD (charge-coupled device) chip set as the camera front end. There were only a few companies that manufactured CCD chip sets. CMOS image sensors can be manufactured using the same process technology which is applied to semiconductor chips. This means many chip manufacturers were able to produce CMOS image sensors and thus offered more choice and competition and drove prices down. The availability of CMOS image sensors made it possible for researchers and developers to build cameras and smart cameras from scratch (e.g., by connecting a CMOS image sensor to a DSP or an FPGA and adding a communication interface), not relying on using COTS (commercial-off-the-shelf) cameras. Other drivers behind the technological and market growth of smart cameras include the following [488]:

- Progress in VLSI (very large scale integration) technologies and embedded system technologies. Moore's law consistently improved performance of imagers and microprocessors which reduced their physical size and drove prices down. Embedded system designs are becoming more and more mature, even for mission critical applications.
- Progress in computer vision and especially in embedded computer vision. The availability of open-source computer vision resources such as Intel's OpenCV library played a supporting role for wide-spread smart camera development.
- Increasing interests from both industry and academic research on computer vision and video surveillance. A large number of annual IEEE and IEE workshops and conferences have been held on topics such as smart cameras, embedded computer vision, visual surveillance.
- Society's concern about safety and security which led to a high demand in smart cameras for video surveillance. After 9/11, visual surveillance, including smart surveillance, has received noticeably more attention and funding from industry and government.
- In the machine vision industry, the pursuit of productivity and quality further spurred the development of smart cameras, especially in manufacturing industries.

2.2.2 Examples of Smart Cameras

There are many examples of smart cameras in action in real-world applications, especially for video surveillance and industrial machine vision. Industrial machine vision is probably the most mature application area for smart cameras, where these cameras perform tasks such as bar code recognition, parts inspection, surface inspection, fault detection, and objects counting and sorting. In video surveillance applications, typical tasks of smart cameras include motion detection, intrusion detection, crowd profiling, number plate recognition.

Figure 2.2 shows one example of smart cameras from Intellio. Intellio's ILC-210^2 is a smart camera for security and surveillance applications. It has an XGA resolution $(1,024 \times 768)$ CMOS image sensor as capture device and can operate in both day and night conditions. The ASIP unit onboard the camera can perform various types of event detection, such as motion detection, abandoned object detection, intrusion detection, crowd profiling. Intellio also has smart cameras for traffic surveillance applications. Another example of smart cameras is Sony's XCI-SX1^3. The XCI-SX1 smart camera has an SXGA resolution $(1,280 \times 1,024)$ CCD image sensor as capture device and an AMD Geode GX533 400 MHz microprocessor at the heart of the ASIP. The processor runs a MontaVista Linux real-time operating system providing both performance and flexibility. Communication interfaces include VGA display, ethernet, USB, RS232. The camera allows OEMs (original equipment manufacturers) and system integrators to develop solutions for a variety of industrial machine vision applications.

Fig. 2.2 A smart camera example: Intellio's ILC-210. Image courtesy of Intellio

[2] Intellio Intelligent Cameras. *Information available at the Intellio web site and accessed in January 2009.*

[3] Sony First Generation Smart cameras. *Information published at the Sony web site and accessed in January 2009.*

Apart from video surveillance and industrial machine vision, smart cameras have found applications in areas such as driver assistance systems, medical research, health care, entertainment, interactive advertising, human–computer interfaces, toys, robotics. We will show more examples of smart cameras for these applications in the next chapter and in Part VI of this book.

2.2.3 Characteristics and Advantages of Smart Cameras

Compared to normal cameras, such as CCTV cameras, web and IP (Internet Protocol) cameras, industrial video cameras, and other general-purpose cameras, smart cameras may look quite similar from the outside, but they have some distinct characteristics which make them smart and useful. These include the following:

- The defining component in a smart camera is its ASIP block, as shown in Fig. 2.1. The ASIP block consists of one or more powerful embedded microprocessor(s), which run specially designed real-time image processing and pattern recognition algorithms, for the targeted applications. For example, in automatic number plate recognition, an ASIP block could consist of a digital signal processor (DSP) that runs algorithms to detect and segment number plate area of a vehicle and to recognize the numbers and letters on the plate, automatically, autonomously, and in real time.
- Because the primary function of a smart camera is not to produce images and video of better quality for people to watch but to extract useful information from the images and make decisions, the output from a smart camera is usually of very low bandwidth. For example, in the case of successful number plate recognition, the output from the smart camera can be as little as a few bytes, representing the numbers and letters, every several seconds. Low output bandwidth requirement is particularly important for wireless smart cameras (refer to Chapter 12). Some smart cameras may still be required to transmit video to other devices, but this transmission may be infrequent (when events occur), or in compressed form, or at a lower resolution. A non-smart camera alternative would be a CCTV camera which produces and sends full resolution video to a centralized computer for processing and recognition or for people to watch. In this case the bandwidth requirement at the output of the camera can be very high.
- Some smart cameras can be programmable so as to perform different tasks for a particular class of applications. For example, some smart cameras for video surveillance application can be programmed to perform different types of event detection, such as intruder detection, abandoned object detection, and stolen object detection. This re-programmability is possible due to the re-programmability of the microprocessor(s) in the ASIP block.
- Low power consumption. This is an important requirement for battery-operated smart cameras.

- Small physical size. Small size cameras facilitate deployment. This can be very important for security and surveillance applications where cameras may need to be hidden.

To discuss advantages of smart cameras, we should not compare them with conventional cameras such as CCTV cameras that are primarily designed to perform video capture function, which they generally do very well. However, we can compare smart cameras with normal camera-based solutions or alternatives for typical tasks in video surveillance and machine vision applications. For example, assume we need to propose a solution for an automatic vehicle number plate recognition task for a road congestion charge system. We could propose a smart camera solution, or an alternative which consists of a non-smart camera connected through cables or a network to a general-purpose computer (e.g., a PC) or a centralized server. In the smart camera solution, the camera mounted on a gantry on a road, will perform image capture and number plate recognition in the camera and send recognized alphanumeric strings to the congestion charge system. In the alternative solution, the similarly mounted conventional camera will perform image capture and send the images to the computer for number plate recognition. In this context, we could analyze, more fairly, the advantages of smart camera solutions.

- Smart cameras perform signal and image processing where the signal is captured and where signal quality is best. This avoids signal degradation caused by repetitive digital-to-analog conversion and analog-to-digital conversion, by network errors, and by video compression.
- Smart cameras use high-performance microprocessors (such as DSP, FPGA) that are tailored to perform data-intensive signal and image processing tasks. Processors like FPGA provide massive parallel processing capability to support real-time requirements. General-purpose computers such as PCs are usually not suitable for high-speed signal and image processing tasks.
- Smart cameras make it easier to perform "active vision" [103], which means that image sensor or capture unit can be actively and dynamically controlled so that better quality images are captured (not to facilitate human viewing but to facilitate subsequent processing). Active vision gives more autonomy and flexibility to image capture, allowing a finely controlled image acquisition process.
- Smart cameras are autonomous systems and do not need a great deal of intervention once calibrated.
- Because they are autonomous, smart cameras can significantly simplify the design and management of an intelligent system, such as an automatic road congestion charging system. This is because smart camera solutions have a smaller part count.
- By performing image processing and pattern recognition, smart cameras greatly reduce the amount of data that need to be passed on to higher level systems. This can offer a significant bandwidth saving at the output of the cameras.
- Because of their compact size, smart cameras are easier to be deployed in real-world applications. In some cases, as in machine vision applications, this could prove to be a very important factor.

- Reliability (partly), as a result of lower device count, higher level integration, and less data conversion and transmission.
- Thanks to the built-in microprocessors and autonomous operations, smart cameras are especially suited for intelligent networked or distributed vision applications. Distributed processing using smart cameras has major advantages over a centralized processing system, since it avoids the transmission of large amounts of information. In fact, the distributed smart camera network has recently received significant interest from both academia and industry alike.
- In many cases and applications, smart cameras can offer long-term cost savings, compared to PC-based or complex vision systems.

Smart cameras can exist where a camera is not expected to be. A good example is the ubiquitous optical mouse for PCs. Most optical mice contain a miniature digital video camera inside the mouse casing. They work by shining a bright light onto the surface below and using a camera to take up to 1,500 pictures a second of that surface. An intelligent image processing circuit inside the mouse performs image enhancement and calculates the mouse motion based on the image difference between successive frames. This difference is then used to displace the mouse cursor on the screen. The optical mouse is a good example of a smart camera in three ways: first, it is a stand-alone camera with camera and processing in a single embedded device; second, the camera is used not to take pictures or video for human consumption but to produce a feature vector (motion vector in x- and y-directions) to represent the object (the mouse in this case) displacement; third, it shows that smart cameras are not restricted to a niche market but can be used very widely (human–computer interface in this case). In future, smart cameras are expected to become an important component of pervasive information systems, either as input device, as tracking device, or as communication sub-systems [570].

However, not everything is perfect in the smart camera world. There are also disadvantages in adopting smart camera solutions, when compared to other vision system solutions. The disadvantages may include the following:

- Despite growing popularity and technical progress, smart cameras are still not a mature solution, except in machine vision applications where smart cameras have a significant and well-established presence.
- Compared to a smart camera solution, it can be easier and quicker to start a conventional camera-based solution, because both the camera and the general-purpose computer are "standard" components, easy to find and maintain.
- A conventional camera with a general-purpose computer solution offers more flexibility than smart camera solutions.
- Smart cameras usually provide limited user interface.

2.3 Classification of Smart Cameras

A Google search for "smart camera" returns hundreds if not thousands of links to a great variety of "smart cameras." Different camera manufacturers, researchers,

developers, and system integrators have different definitions and even classifications for smart cameras, which led to some confusion of what exactly a smart camera is and to which category a particular smart camera should belong. Without a sensible technical definition for smart cameras, it is difficult to provide a good classification of different types of smart cameras. In this section, first we attempt to classify vision systems and then proceed to classify smart cameras. The classification of smart cameras will be based on the definition provided in Section 2.2.1 and on their system architecture. In particular, we focus on the hardware realization of the ASIP (application-specific information processing) block and on the level of integration between ASIP and image capture front end.

An easy way to classify smart cameras would be based on their functionality and/or applications, for example, smart machine vision cameras, smart surveillance cameras, smart automotive cameras. The obvious advantage of this classification method is to provide simple and clear indications about where the smart cameras are expected to be used. However, this classification does not provide insight into how the camera is constructed nor does it indicate what type of embedded system architecture is involved in building the camera. Also, as some smart cameras are and will be (re-)programmable so that they can be used for different applications, this classification based on applications could be obsolete in these cases.

Recently, several attempts have been made to classify smart cameras [388, 447]. In [388] smart cameras are divided into three main categories: artificial retinas, PC-based systems, and stand-alone smart cameras. This classification does not take into account the emergence of distributed smart camera systems. Also, whether PC-based systems can be considered as smart cameras or not is questionable. In [447] smart cameras are also classified into three categories: single smart cameras, distributed smart cameras, and networked smart cameras. While emphasizing the emergence of distributed and networked smart cameras, this classification does not seem to account for several types of "single smart cameras" currently available on the market.

2.3.1 Classification of Vision Systems

Vision systems, or artificial vision systems, are computer-based devices or systems where hardware (e.g., sensors, processors, computers, networks) and software (e.g., computer vision algorithms) work together to perform tasks similar to human vision. Vision systems can be classified into three categories:

- Embedded vision systems. These systems perform ASIP using embedded hardware. They are generally more compact, have higher performance (because in most cases embedded processors provide higher processing capability than general-purpose desktop CPUs), but with less flexibility. In some cases, the embedded hardware may be an extension card plugged into a computer which acts as a host to the embedded vision system. Embedded vision systems are

widely used in machine vision, robotics, automotive, and other emerging applications. Embedded vision systems can further be divided into two categories:

- Single device systems, including consumer digital cameras, industry standard cameras, and smart cameras. Smart cameras integrate image capture and ASIP into a single device.
- Compact vision systems. These systems usually consist of two parts: a camera and an embedded processing unit "nearby" or closely connected to the camera through a dedicated data bus or communication interface. The camera may perform part of the system ASIP or leave it up to the embedded processing unit to perform ASIP. Some of these systems are also referred to as smart cameras in the scientific literature.

- General-purpose computer-based (or PC-based) vision system. These systems perform ASIP using computer CPUs. They allow the use of general-purpose cameras which can be connected to a computer through a frame grabber or a popular communication interface. They are generally more bulky, have lower real-time performance, but enjoy higher flexibility. PC-based vision systems are widely used in consumer and industry applications such as video surveillance and machine vision.
- Network-based vision systems. These systems consist of more than one single camera managed and controlled through a network. Each camera within the network may be an embedded system or a PC-based system. Network-based vision systems hold great promise for future intelligent video surveillance and security applications and for future pervasive information collection systems.

2.3.2 Classification of Smart Cameras

As described in Section 2.2.1, the ASIP, or application-specific information processing, is the most essential and defining component of a smart camera. It consists of one or more embedded microprocessor(s) and supporting memory, data buses and other components; its purpose is to provide an efficient computing platform on which powerful and intelligent image processing and pattern recognition algorithms run. The ASIP is at the heart of a smart camera.

Strictly speaking, a smart camera is a particular type of embedded vision system, in which all necessary system components – image sensor, capture front end, ASIP, communication interface, I/O – are or can be integrated into a single practical camera casing. However, there exist other embedded vision systems, especially some compact vision systems as described in Section 2.3.1, which could also be classified as smart cameras even though they do not appear to be stand-alone cameras. In fact, many of these systems are referred to as smart cameras within academia and in the research literature.

Distributed smart cameras have recently attracted much interest from the research community. Distributed smart cameras usually involve some sort of networking

among multiple cameras, each of them being either a smart or a standard camera. We believe that in some cases these networked cameras can be viewed as a single "virtual" smart camera, where the system ASIP or part of it is supported by the coordination among cameras and network topology.

Based on the above discussions, we propose to classify smart cameras into three categories: integrated smart cameras, compact-system smart cameras, and distributed smart cameras. The integrated smart cameras category can be further divided into three types. This integration-level-based classification is presented below and shown in Fig. 2.3. The inclusion of compact-system smart cameras and distributed smart cameras into the classification can be controversial, but this classification does seem to cover most reported work on smart cameras and actual commercial products.

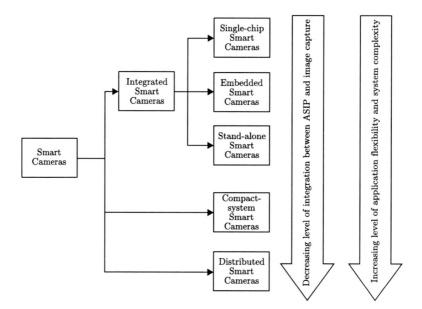

Fig. 2.3 A classification of smart cameras based on levels of integration. From top to bottom, the camera systems have decreasing level of integration

- Integrated smart cameras. These are the real smart cameras and can be sub-divided into three types:

 - Smart camera on a chip or single-chip smart cameras.
 - Embedded smart cameras.
 - Stand-alone smart cameras.

- Compact-system smart cameras.
- Distributed smart cameras.

In Fig. 2.3, from top to bottom, the level of integration between the ASIP and image capture parts of the camera system decreases, while the flexibility and complexity of the camera system increase. By flexibility we mean how flexible a camera can be re-programmed or adapted to different applications. Complexity refers to the camera system configuration complexity (e.g., single-chip smart cameras are the least complex in that the ASIP and image capture are on a single and same chip, and the device count or chip count of the camera is the smallest). With the continued progress in both embedded hardware and software technologies, the flexibility issue of the integrated smart cameras will be improved, together with their performance and market appeal.

A single-chip smart camera has all or part of the ASIP implemented on the same chip as the solid-state image sensor, mostly a CMOS image sensor. An embedded smart camera is a smart camera embedded in another device, for example, a mobile phone or an optical mouse. A stand-alone smart camera is probably the most "natural" smart camera, either by appearance or by definition. A compact-system smart camera is an embedded vision system that usually has two major components: a camera which may be a conventional camera or which may house part of the ASIP block; and a nearby unit containing the ASIP block and I/Os. A distributed smart camera system is composed of several cameras or smart cameras networked together, the whole system can sometimes be viewed as a single virtual smart camera, and some of the system ASIP functionality is not provided at each node, but across the network, in a distributed manner.

Detailed discussions about each of these five types of smart cameras are presented in the following sections.

Table 2.1 shows some typical sample applications for each of these types of smart cameras.

Table 2.1 Types of smart cameras, typical characteristics, and sample applications

Type	Characteristics	Applications
Single-chip smart cameras	ASIP on the same chip as the image sensor, extremely low power, small size	Toys, pervasive information sensors
Embedded smart cameras	Camera is embedded in another device such as a mobile phone	Optical mice, fingerprint readers, smart camera phones
Stand-alone smart cameras	"Normal" smart cameras, all in one camera casing	Industrial machine vision, human–computer interfaces
Compact-system smart cameras	ASIP in a separate embedded system nearby	Security, traffic surveillance, machine vision
Distributed smart cameras	Part of the system ASIP rendered by the network topology	Intelligent and pervasive video surveillance, industrial machine vision, pervasive information gathering systems

2.3.2.1 Single-Chip Smart Cameras

A single-chip smart camera has all or part of its ASIP implemented on the same chip as the solid-state image sensor, mostly a CMOS image sensor. Arguably, the most important advantage of CMOS image sensors over CCD sensors lies in its ability to have image sensor array and intelligent image processing circuits side by side on the same chip, producing "smart sensors." It has even been possible to embed image processing circuitry inside each pixel, making smart pixels possible and creating a new paradigm of image processing. This feature of the CMOS image sensor makes a single-chip smart camera possible, a real system-on-a-chip integration. Advantages of the single-chip smart cameras, sometimes called artificial retinas, include high efficiency, low power consumption, small device count, and very small form factor. As an example, the VISoc single-chip smart camera [10] integrated a 320 × 256 pixel CMOS image sensor, a RISC processor, a vision co-processor and I/O onto a single chip. The disadvantages of these smart cameras are less flexibility because of largely hard-wired functionality, less modular design [180], and higher manufacturing costs (when compared to the manufacturing of standard image sensors).

2.3.2.2 Embedded Smart Cameras

An embedded smart camera is a camera embedded inside another device, for example, a mobile phone. Sometimes the camera is completely hidden inside another device and people may be unaware of its existence. Examples are vision-based optical mice, vision-based fingerprint readers, cameras used in some robotic and automobile applications. Some mobile phones come with a camera that can read and recognize barcodes or other similar codes of a product or a company and then direct users to the web pages of the product or company, which are displayed on the phone screen. In this kind of smart camera, the ASIP functionality is made possible by either a dedicated processor or the processor of the device in which the camera is embedded. Embedded smart cameras are often enablers for new applications and novel products, especially in mobile devices [290].

2.3.2.3 Stand-Alone Smart Cameras

Stand-alone smart cameras are probably the most natural and common smart cameras, especially in industrial machine vision where smart cameras have reached a certain level of maturity and established a solid market presence. They look like normal cameras, much like CCTV cameras or general-purpose industry cameras. The ASIP functionality is provided by dedicated embedded processors and intelligent algorithms running on the processors. Many cameras also run a real-time operating system, to simplify the programming of the cameras and improve the user interface. An example of stand-alone smart camera is shown in Fig. 2.2.

2.3.2.4 Compact-System Smart Cameras

Typically, a compact-system smart camera is a normal camera connected through dedicated cables or communication interfaces to a separate, external but dedicated image processing unit nearby. The camera performs image capture and sometimes some ASIP functionality, such as pre-processing to reduce the amount of data, or feature extraction. The remaining system ASIP is performed by the external unit. The advantage of this type of smart camera is that the camera can be "standard" and is usually not expensive and easy to be replaced or upgraded. The external processing unit can afford more processing power due to availability of more memory, storage, and other resources. There are many examples of this type of smart camera in video surveillance applications for either security or traffic flow analysis. In industrial machine vision, this type of smart camera is called compact vision systems (CVS). Examples of the CVS are the NI CVS-145x camera systems by National Instruments.[4] Some so-called compact-system smart cameras are in fact PC-hosted smart cameras in that the external processing unit is usually a dedicated image processing card or cards plugged into the internal extension slots of a PC or of a computer. This type of smart camera seems to be popular within academic circles. In fact, the often-cited smart camera project by W. Wolf et al. at the Princeton University [571] was a PC-hosted smart camera, designed and developed for real-time gesture recognition for human–computer interface and surveillance applications. Their camera system consisted of a couple of cameras, each connected to a Philips TriMedia video processor card inserted into the PCI slot of a host computer. PC-hosted smart cameras offer a high level of flexibility and better user interfaces.

2.3.2.5 Distributed Smart Cameras

Thanks to the progress in networking, sensor networks, and wireless communication technologies, distributed or networked smart cameras have recently attracted significant interest from both academia and industry. The participating cameras may or may not have overlapping fields of view but the images captured by these cameras are often processed jointly to achieve planned ASIP functionality [448]. Sometimes this network of distributed smart cameras can be thought of as a single virtual smart camera, especially when video analysis or ASIP is performed collaboratively across the cameras in a distributed fashion. In these cases, the camera network can achieve better performance than each camera independently together. This distributed vision system presents a novel and powerful computing platform that holds promise of solving many tough problems encountered with single smart cameras. For example, carefully deployed multiple cameras can help to resolve problems such as occlusion of view, both static and dynamic [448], depth information about foreground objects, object tracking, and the pixels-on-target problem [448]. Applications that should benefit most from this type of smart camera include video surveillance, machine

[4] Compact Vision Systems NI CVS-145x Rugged Systems Run LabVIEW Real-Time. *Information available at the web site of National Instruments and accessed in January 2009.*

vision, and the automotive industry. While there are still challenges in calibration and coordination among multiple cameras in a network, distributed or networked smart cameras will represent very probably the future of real-time and pervasive information collection and analysis systems (refer also to Chapters 9, 13, and 17).

Chapter 3
Smart Cameras: Technologies and Applications

Fábio Dias Real and François Berry

Abstract Scientific and industrial communities are showing a growing interest in embedded systems. Technological advances in microelectronics and *very large scale integration* (VLSI) allow today to obtain more and more complex systems in a single device. Smart cameras are part of this evolution process and can be defined as embedded systems dedicated to image acquisition and processing. Pre-processing images and video flow within the camera presents several advantages, giving more autonomy to the system, lightening the processing load of the host device, and preventing communication bottlenecks. The goal of this chapter is to propose an overview on smart camera technologies, including hardware devices, design, and application of such systems.

3.1 Introduction

Embedded systems, such as smart cameras, can have specific architectural, physical, and operational requirements, according to the application domain. Power consumption, size limitation, real-time operation, and system autonomy can appear as strong constraints, making the design task harder when compared to "desktop" style systems.

Fortunately, today's microelectronics and VLSI technologies offer a wide range of devices for data acquisition, processing, and communication, each presenting different advantages and drawbacks. The chosen hardware components are a predominant factor for system's performance, flexibility, and programmability. They will often determine the suitability of an embedded system to host a given application or a given class of applications.

In this chapter, several solutions adopted on smart camera design are presented and discussed. The main goal is to propose an overview on the hardware and architectural issues encountered when designing such systems.

F. Berry (✉)
LASMEA CNRS, Clermont-Ferrand, France
e-mail: francois.berry@lasmea.univ-bpclermont.fr

A.N. Belbachir (ed.), *Smart Cameras*, DOI 10.1007/978-1-4419-0953-4_3,
© Springer Science+Business Media, LLC 2010

The chapter is organized as follows: the next section discusses general hardware and software requirements when dealing with image processing tasks. The active vision paradigm is briefly introduced and the concept of "early vision" is explained.

Section 3.4 is dedicated to hardware issues. The main features of currently employed devices for smart camera design are presented and discussed, covering the perception, processing, and communication components. Section 3.5 describes the technological choices of several industry- and research-issued smart cameras. The last section is dedicated to the applications of smart cameras.

3.2 General Hardware and Software Requirements

Image processing is a computational-intensive task, dealing with huge amounts of data (an image can count several millions of pixels/bytes) and performing a large number of repetitive calculations over the whole image data set or part of it.

Low-level processes will often involve operations performed on a group of adjacent pixels, like mask convolution for filtering or sample correlation for feature matching. These "neighboring" operations require a large number of memory transactions and can quickly become a bottleneck if the system's hardware and architecture are not tailored for such a kind of processing.

Furthermore, "medium-level" (e.g., segmentation) and "high-level" processes (e.g., recognition) can require complex iterative or recursive mathematical routines like matrix inversion or minimization methods. These processes are quite challenging, especially in an embedded context where clock frequencies must be kept low to reduce power consumption.

Figure 3.1 illustrates the inverse relationship between data amounts and algorithm complexity. Low-level image processing performs a few simple repetitive operations over huge amounts of raw data. These processes are strongly parallelizable and suitable for processing structures such as FPGAs or SIMD processors (single instruction multiple data). Meanwhile, higher level processes often involve complex sequential routines with a large number of instructions and operations

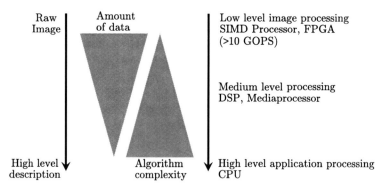

Fig. 3.1 Amount of data vs. algorithm complexity *(GOPS = Giga (10⁹) operations per second)*

applied over a reduced set of feature descriptors. Dedicated signal processing structures and high-level programming are desirable features, making these processes suitable for CPU-based devices like DSP and media processors.

Hence, before analyzing and defining the hardware components for an embedded image processing system, it seems cautious to first understand and extract the main specificities of those tasks which this system is supposed to execute.

In the context of a smart camera, the tasks to be executed are more often related to early vision processes. "Early vision" defines those processing routines which allow obtaining some basic and relevant information from the scene, through several operations performed on the pixels composing the image. Examples of early vision tasks are motion detection, object tracking, and feature extraction. Some of them are discussed in part IV of this book.

3.3 Active and Early Vision

Computer vision algorithms are known for their high complexity. At one time, research efforts in computer vision were guided by the idea that an image understanding system must transform two dimensional data into a description of the three dimensional world, inferring surfaces, volumes, boundaries, shadows, occlusion, depth, and motion (Marr's paradigm). However, many attempts to build full representations of a three-dimensional scene were unsuccessful, and even with breakthrough evolutions observed in related technological domains, such tasks are still challenging.

In the late 1980s, the Active Vision paradigm [11, 40, 43] appeared as an alternative approach to dealing with computer vision problems. Inspired by biological vision systems, the central idea is to take into account the perceptual aspect of visual tasks. So, instead of a full three-dimensional representation of the observed scene, the system is supposed to extract only the useful information to solve a given problem, through a task-driven observation strategy. This approach was proposed, developed, and applied by several researchers, each focusing on different aspects of visual perception.

Among the several approaches composing the active vision paradigm (Animate Vision, Active Perception, etc.), some common points are found. Two of these common points are task-driven perception and processing-acquisition feedback. It means that a feedback loop drives the dynamic adaptation of data acquisition processes, depending on the state of the system and on the task to perform. In artificial systems, this retroactivity may appear in different forms: mechanically (e.g., camera movements), optically (e.g., zooming), electronically (e.g., image acquisition control), or algorithmically (e.g., acquisition strategy).

The early vision concept deals exactly with this selective process of information extraction and context adaptation [143]. In the human vision system, early vision tasks are performed unconsciously by the eyes and the visual cortex, through acquisition, adaptation, and basic features extraction, before the information arrives at the "conscious" region of the brain. In artificial vision systems, the purpose of early

vision tasks is to identify which zones of the image are propitious to containing the information we need to answer a given question and adapt the acquisition and processing strategies to extract such information from these zones. That way, instead of analyzing several megapixels from a given image, the system can concentrate its processing efforts and resources on a reduced data set.

However, even if an active approach, when compared to a traditional passive method, tends to simplify some vision tasks, its processing remains relatively resource consuming. As early vision often deals with low-level image processing, data parallelism exploitation is an interesting point. Task parallelism is also a desirable feature due to intrinsic characteristics of some algorithms which suppose the concurrent execution of different tasks. Moreover, an autonomous system might need to perform some higher level tasks, such as recognition/identification, which have different hardware requirements than low-level image processing.

All these aspects must be considered when conceiving the hardware architecture for a smart camera, in order to offer a suitable platform to host the desired application.

3.4 Components and Technologies

Generally, the hardware of smart cameras can be divided into three main modules:

- Data acquisition module: essentially composed of an image sensing device. However, other types of data acquisition devices can be integrated in order to obtain supplementary information about the scene or the environment
- Data processing module: the application-specific information processing (ASIP) is performed by this module. The obtained results can be sent to an external host or network, trigger an event, and/or be used for a feedback loop to control the data acquisition module
- Communication interface module: connects the smart camera to the external world (host or network)

The remainder of this section draws a panorama of existing technologies suitable for integration into these modules; it analyzes their potential use for smart camera design, describing their main advantages and limitations.

3.4.1 Image Acquisition and Sensing Devices

When talking about cameras and vision systems it seems obvious that the image acquisition device will play a central role in a system's performance. Even if image quality (sensitivity, dynamic range) and resolution (number of pixels) are very important features for characterizing an image sensor, other characteristics have to be carefully taken into account. These include frame or pixel rates (number of images or pixels acquired per second), addressing modes (sub-sampling skills, random addressing), integration easiness, and the required logic for acquisition control

(e.g., do a few signals suffice to synchronize the operation or are dozens of parameters and triggers necessary?).

CCD and CMOS are the two most common technologies used today in image sensors. CCD sensors are based on a shift-register readout technique, meaning that the electric charges accumulated in one photodiode (pixel) are transferred to its neighbor and so on, the last photodiode being connected to the output amplification and sampling circuitry. A controlling circuit allows to synchronize the charge transfers until the whole photosensitive matrix is read. Due to its construction principle, a well-known problem occurs in CCD sensors when a photosensitive zone is overexposed. If the maximum storage capacity of a photodiode is reached, excess charges can overflow to adjacent photodiodes, causing what is currently referred to as "blooming." Anti-blooming techniques, by the incorporation of drain structures, exist. The advantages of CCD are low noise, high image uniformity, and high fill factor (light sensibility).

CMOS imagers adopt a digital memory style readout, using row decoders and column amplifiers. That way, random access of pixel values becomes possible, allowing selective readout and WOI (window of interest) acquisition. In fact, while the acquisition rate for CCD devices is expressed in images per second, in CMOS sensors it is more realistic to speak of pixels per second. That way, opposite to CCD imagers, CMOS technology makes it possible to obtain very high frame rates by addressing only a small portion of the photosensitive matrix. Other advantages of CMOS imagers are a large dynamic range, integration simplicity, and low blooming.

However, despite these advantages, CMOS image sensors have poorer imaging performances when compared to CCD devices, and in particular a higher fixed pattern noise (FPN). This noise is due to non-uniformity of the electrical characteristics of in-pixel circuitry, as well as of arrayed readout components like column amplifiers, resulting in a final image with a static offset pattern. This pattern can be removed from each image to yield a better result, but its suppression implies an extra burden for the processing system. Finally, both technologies present advantages and drawbacks, while neither is categorically superior to the other.

Other imaging technologies are infrared and thermal imaging, for night vision or nondestructive testing applications, for example. Image sensing devices and data acquisition modules are discussed in more detail in Part II of this book.

3.4.1.1 Other Potential Sensing Devices

Inertial sensors, compasses, microphones, and GPS (global positioning system) modules can be integrated close to the imaging units to provide supplementary information about the camera situation, for applications like image stabilization, reconstruction, navigation, robot control.

Inertial sensing has existed for several decades, but this technology has long been almost exclusively developed for large-scale and costly applications, such as military projects. Only in recent years, with the advancement of silicon and micromachining fabrication techniques, accelerometers and gyroscopes have become available for use in consumer markets. These inertial sensors, devoid of external

references and decreasing in size and pricing, are the logical motion-sensing choice for consumer proprioceptive device applications [104]. Proprioception is the ability to measure position, location, orientation, and movement of one's own system (camera). In moving camera contexts, proprioceptive information can be used to compensate for camera movements in tracking applications or image stabilization. Furthermore, being able to estimate camera position and orientation allows to perform stereo matching on pairs of images captured with a single moving camera.

A number of other devices available in OEM (Original Equipment Manufacturer) modules can be embedded within a smart camera. For example, GPS modules can be used to evaluate the absolute position of an outdoor camera in a surveillance network. Consequently, the position of the Sun can be calculated and challenging lighting problems can be easily eliminated [563].

Microphones can also be integrated. Sound events can be a useful information source for tasks such as intrusion detection, and a stereo system can provide localization clues for tracking applications [596]. Microphones can be integrated into the body of the camera, or as smart nodes on a distributed cameras' network [572].

3.4.2 Embedded Processing Devices

Smart cameras can be equipped with different types of data processing devices. The most commonly employed are general-purpose embedded RISC (reduced instruction set computer) microprocessors or microcontrollers [457, 233], DSPs [77], FPGAs [389], and media processors [571]. However, other devices such as ASICs (application-specific integrated circuit), SIMD processors [296], or soft-core processors instantiated on FPGA devices [143] can also be employed.

Sometimes, the processing module can be composed of several devices, in heterogeneous architectures (e.g., FPGA + DSP, such as the SeeMOS architecture presented in Section 3.5) or multi-processor architectures, exploiting an embedded network of several identical processing units [78]. The choice of a processing device and architecture must best fit the application requirements, taking into account physical, design, and computational constraints:

- Physical constraints are, for example, the size of the device, power consumption, and the number of I/O ports or pins.
- Design constraints are the cost of the device, NRE (non-recurring engineering) cost, integration easiness (device packaging), and required surrounding circuitry (resistors, capacitors, power supplies, oscillators, etc.).
- Computational constraints are related to processing power (e.g., number of instructions or operations executed per second), programmability (e.g., high-level languages, assembly, hardware description languages), and application flexibility.

More often, a compromise has to be found among these different features and constraints, according to the expected production volume and desired system scalability [288, 289]. Figure 3.2 depicts a rough comparison between ASIC, DSP,

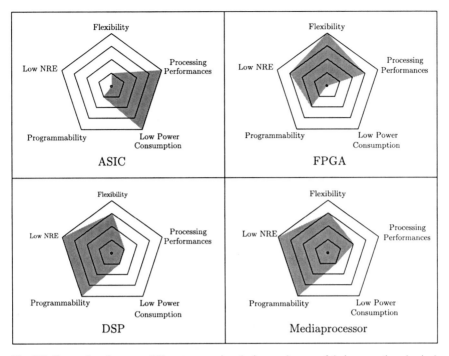

Fig. 3.2 Comparison between different processing devices and some of their respective physical, design, and computational characteristics

FPGA, and media processors based on some of the main constraints found when designing an embedded system.

In terms of performance and power consumption, ASICs can be considered as being the ideal choice. Of course, developing a dedicated SoC (system on chip) for a given application allows to fully exploit the silicon, implementing custom architectures to fit the ASIP data flow, and optimize power consumption. However, the development costs for such devices can be prohibitive, making this solution interesting only for consumer products (i.e., a production volume of several thousand units). As a consequence of dedication, ASIC devices suffer from very low or almost zero flexibility and programmability.

FPGA appears to be an excellent option for high-performance applications with low or medium production volumes. In fact, in the last several years, FPGA technology has experienced an impressive evolution and growing popularity in aerospace, military, industrial, and research communities. Thanks to an increasing number of available logic elements (LEs) per device, increasing clocking frequencies, and the possibility of exploiting massive parallelism, FPGAs are today in a position to achieve processing performances close to ASIC, with the advantage of being completely reconfigurable. Consequently, FPGAs are extremely flexible and can fit the requirements of almost every application. The possibility to instantiate DSP or

general-purpose CPU cores (soft-core processors) in such devices is also an attractive feature. However, FPGAs' power consumption is relatively high, and even if design methodologies and development environments exist, FPGA-based solutions require more development time and expertise than CPU-based solutions (DSP, microcontroller, etc.). The major FPGA manufacturers are ALTERA and XILINX.

DSP devices and media processors share many common characteristics with embedded general-purpose RISC processors (PowerPC, ARM, etc.) and microcontrollers. All these devices are CPU based, i.e., based on a processor core. Consequently, they all feature excellent programmability, using high-level languages as C/C++ and dedicated development environments. NRE costs are quite low, and they present very good flexibility, making them suitable for most applications.

The main differences between CPU-based devices appear at the performance level. Microcontrollers can be seen as augmented RISC processors, by adding to the CPU core memories (RAM, ROM, Flash), peripherals, and I/O interfaces (ADCs, DACs, etc.). Additionally, DSP cores present a dedicated architecture and some particular hardware structures in order to optimize the execution of arithmetical operations, like MAC (multiply–accumulate) and SIMD units. Finally, media processors are a class of DSP devices dedicated to audio and video processing and suitable to deal with data streaming. DSPs and media processors can have VLIW (very long instruction word) architectures, such as the TriMedia processor by NXP.

3.4.3 Communication Interfaces and Protocols

A multitude of factors go into consideration when building or buying an interface for a camera. Even if smart cameras are supposed to internally process the acquired data and transmit only pertinent information about the observed scene, the ability to transmit full-resolution images if necessary remains a key point for several applications. In these cases, the communication interface bandwidth must be high enough to bear a video transmission flow, even if the camera will not be transmitting at video rates all the time.

In fact, the required bandwidth is strongly related to the image sensor, which supports a specific resolution and data rate. Hence, it seems to be a wise choice to keep possible the best exploitation of the image sensor capabilities. As such, that sensor will require a communication interface compatible with its output rates.

However, the transmitting bandwidth is not the only important characteristic when dealing with communication protocols. Traditionally, camera interfaces can be classified according to four main factors:

1. Bandwidth (data reception/transmission rates)
2. Compactness and cables (wired or wireless, maximum cable length, wireless range)
3. Determinism and responsiveness (communication latencies, robustness)
4. Vendor interchangeability (compatibility issues, software drivers)

The main existing protocols are listed in Table 3.1 for wired and Table 3.2 for wireless communication.

Table 3.1 Most common wired communication protocols

Protocol	Theoretical bandwidth in bits per second (bit/s)
RS-232 serial link	19,200 bit/s
USB 1.x Full-speed	12 Mbit/s
USB 2.0 Hi-speed	480 Mbit/s
FireWire or IEEE 1394a/b	400/800 Mbit/s
Camera Link	2.04, 4.08, or 5.44 Gbit/s
Ethernet, Fast Ethernet	10/100 Mbit/s
GigE Vision (Gigabit Ethernet)	1 Gbit/s

Table 3.2 Most common wireless protocols

Protocol	Theoretical bandwidth (bit/s)	Wireless range (m)
WiFi IEEE 802.11a	54 Mbit/s	up to 10 m
WiFi IEEE 802.11b	11 Mbit/s	\sim50 m indoor, \sim200 m outdoor
WiFi IEEE 802.11g	54 Mbit/s	\sim27 m indoor, \sim75 m outdoor
Bluetooth	1 Mbit/s	\sim10–100 m
ZigBee (IEEE 802.15.4)	250 Kbit/s	\sim10–30 m indoor, up to 150 m outdoor

As an example, if a camera is equipped with the MT9M413 image sensor from Aptina Imaging (formerly Micron Imaging), able to deliver up to 660 Mpixels/s, a Camera Link interface is necessary to exploit this sensor to its best (5.44 Gbit/s (680 MBytes/s) in its full configuration). However, in some cases and a favor of other constraints, the rule of keeping data rates compatible between sensors and communication interfaces can be broken (this is what rules are for after all). For an autonomous battery-operated smart camera, for example, the wireless ZigBee protocol would be preferable, due to its very low power consumption [233, 296], even if the 250 Kbit/s bandwidth renders real-time video transmission impossible. The design of a wireless smart camera and camera networks are discussed in Part V of this book.

A solution to reduce bandwidth requirements is compression algorithms [389]. However, compressing and decompressing images represent an extra processing burden for the camera and the host and can imply quality losses depending on the necessary compression ratio.

Finally, as mentioned above, bandwidth is not the only decisive factor. For example, implementation costs for a GigE Vision system might look interesting on paper, but the end result could hinder the application's responsiveness and development time. GigE Vision is in its infancy, whereas Camera Link and IEEE 1394 are field-proven. The completeness of the standard must also be considered. USB 2.0 runs on proprietary protocols; in fact, a video transmission standard over USB 2.0 does not even exist! GigE Vision and IEEE 1394 cameras are compatible between vendors and are easier to configure than Camera Link.

3.5 State-of-the-Art Smart Cameras

The goal of this section is to present and describe some industry- and research-issued smart cameras. Examples of smart cameras are provided in the first section followed by a presentation of leading research organizations, companies, and selected smart camera projects.

3.5.1 Smart Camera Examples

Figure 3.3 depicts four examples of research-issued smart camera systems. The WiCa camera mote [296] from NXP research (formerly Philips) embeds one or two VGA (300 kpixels) color image sensors, connected to the IC3D SIMD processor from the Xetal family (refer to Chapter 12). The communication interface is composed of a low-power ZigBee module. An ATMEL 8051 controller is used

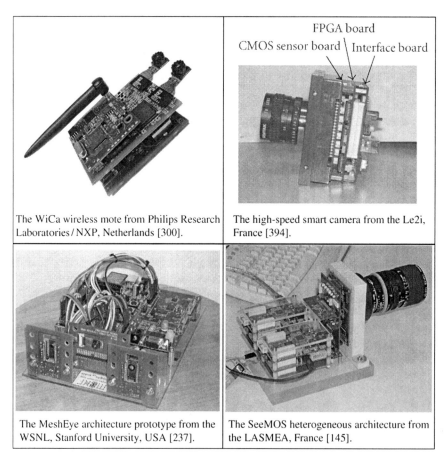

	FPGA board CMOS sensor board \ Interface board
The WiCa wireless mote from Philips Research Laboratories/NXP, Netherlands [300].	The high-speed smart camera from the Le2i, France [394].
The MeshEye architecture prototype from the WSNL, Stanford University, USA [237].	The SeeMOS heterogeneous architecture from the LASMEA, France [145].

Fig. 3.3 Examples of some research projects on smart cameras

to manage system operation and communication. The IC3D device presents an LPA (linear processor array) with 320 processing elements, fed by 64 line memories of 3200 bits. This architecture is extremely powerful to perform low-level image processing, with the same operations being performed for each pixel. For instance, if dealing with QVGA images (320 × 240), a whole row can be stored in each line memory and processed simultaneously with 1 pixel being assigned to each PE (processing element) of the LPA.

The MeshEye wireless architecture from Stanford [233] presents an interesting multi-sensor hybrid-resolution approach, based on a CMOS VGA color image sensor and two or more kpixel sensors like those found on optical mice. The system is completed by an ATMEL microcontroller incorporating an ARM7TDMI processor core and a ZigBee interface. The hybrid-resolution sensor system allows to optimize the data acquisition process in a typical early active vision approach. For instance, one low-resolution sensor can be used for motion detection in the scene. If a moving object is detected, a second low-resolution sensor can be used for stereo matching, and once the position and size of the moving object are estimated, a WOI containing such an object can be finally acquired by the VGA sensor. This high-resolution WOI can be stored for further processing (identification or classification), transmitted to a host computer, or exchanged with neighboring cameras in a network context.

The high-speed smart camera from the Le2i Laboratory at Bourgogne University [389] features a 1.3 Mpixel high-speed CMOS image sensor (MT9M413 from Aptina, formerly Micron), a Virtex II FPGA device from XILINX, and a USB 2.0 interface. The image sensor is able to acquire up to 500 fps at full resolution, implying a data rate of 6.55 Gbits/s. In order to allow the video flow transmission through the USB 2.0 link (480 Mbits/s), compression algorithms are implemented in the FPGA device (compression rate 30:1), as well as some image processing tasks such as Sobel filter, erosion/dilation, and center of mass calculation for markers' extraction.

The SeeMOS architecture presented by the LASMEA [144] features a LUPA4000 monochrome 4 Mpixel CMOS image sensor from Cypress Semiconductor, a Firewire interface, and a heterogeneous processing module composed of an ALTERA Stratix FPGA device and a TMS320C6455 DSP device from Texas Instruments. In addition, a three-dimensional inertial sensing unit is integrated on the image sensor board, composed of three accelerometers and three gyroscopes. The FPGA device is responsible for controlling and synchronizing the whole system through a custom programmable controller core. This way, different applications can be implemented with a minimum (or null) effort of HDL programming. The random addressing skill of the 4 Mpixel sensor is fully exploited, allowing to achieve high frame rates (e.g., 1000 fps for 140 × 140 frames). Data processing can be performed by SIMD units instantiated in the FPGA or by software routines executed by the DSP. The latter communicates with the FPGA through the EMIF protocol (Extended Memory Interface) and five independent 2 MByte memory banks. Its fine grain image acquisition control, inertial sensing skills, and a high level of exploitable parallelism make the SeeMOS smart camera a suitable platform for active and early vision algorithms.

Other interesting examples of research-issued smart cameras are the CMU-cam project by Carnegie Mellon University and the SmartCam project by Graz University of Technology. The CMUcam project [457] gave birth to three generations of smart cameras, all available for sale. The "CMUcam3 Open Source Programmable Embedded Color Vision Platform" features a CIF resolution color image sensor (352 × 288) and an ARM7TDMI core-based processor. An analog video output is available and it is possible to integrate a ZigBee wireless communication module. The CMUcam3 platform also includes an open-source development environment, a basic image manipulation library, and other software utilities like a language interpreter, a frame grabber, and other prototyping tools.

The SmartCam project [77, 446] has developed a platform using a CMOS VGA image sensor and two TMS320C6415 DSPs from Texas Instruments, interconnected through an onboard PCI bus. Thanks to an embedded network processor (Intel IXP425), several communication systems such as Ethernet, USB, RS232, WLAN, and GSM can be exploited. A traffic surveillance system was implemented in such a platform and a scalable version with up to 10 DSP devices has been proposed. This platform has also been deployed in a distributed surveillance system [78].

Industrial smart cameras account today for hundreds of references from several manufacturers all around the world, and for a wide range of possible applications. VC Vision Components from Germany proposes several device families. The *Optimum* family (VC44xx) includes six high-performance smart camera models, equipped with CCD image sensors with resolutions of up to 2 Mpixels, a 1 GHz DSP, RS232, and Fast Ethernet communications, plus digital I/O for external equipment control.

The Smart Systems division of the Austrian Research Centers GmbH proposes a traffic surveillance smart sensor [50] and a people-counting smart sensor, both based on a new imaging technology of autonomous, self-signaling pixels responding to relative changes in light intensity, specially suitable for moving objects detection and robust to scene illumination.

National Instruments presents five smart camera models (NI 17xx), with CCD monochrome image sensors (resolution: 640 × 480 or 1, 280 × 1, 024), embedded PowerPC processor cores, and Gigabit Ethernet interfaces. The 1762 and 1764 models also feature a 720 MHz DSP coprocessor from Texas Instruments. Integrated lighting controllers allow to control the illumination of objects under the camera. This feature can be useful for industrial applications such as quality control. A development environment (NI Vision Builder for Automated Inspection) is available, as is a development bundle for camera programming with LabVIEW.

SICK IVP presents two smart camera models for industrial environments: the IVC-2D and the IVC-3D. Both are equipped with an 800 MHz processor, an FPGA processing accelerator, and Fast Ethernet interface. The IVC-2D features a CCD image sensor (640 × 480 or 1, 024 × 768). The IVC-3D features a CMOS chip optimized for three-dimensional imaging and is able to perform height measurements using a laser embedded in the camera housing and a triangulation method. The laser draws a line on the object, and the camera, which is viewing this line from an angle, sees a curve that follows the height profile of the object. As the object passes under

the laser beam, a three-dimensional image is built up from multiple height profiles of this object. The IVC Studio user-friendly programming tool is used for camera programming and configuration.

Other examples are Sony XCI and Intellio ILC smart cameras, presented in the previous chapter, and the NeuriCam VISoc CMOS Intelligent Vision System-on-Chip [10].

3.5.2 Leading Research Organizations, Companies, and Selected Projects

All through this chapter, several manufacturers and research projects involving smart cameras are presented. Table 3.3 provides a brief outline. Of course, this table is far from being exhaustive and contains only some references for the devices and projects already mentioned here. For more information, the webpage *http://www.smartcamera.it/links.htm* contains several links to the web sites of most known smart camera manufacturers and some research projects.

Table 3.3 Some leading companies and research organizations on smart cameras

Organization/company	Project/product [reference]	Country
SCS – Carnegie Mellon University	CMUcam Vision Sensors [457]	USA
WSNL – Stanford University	MeshEye architecture [233]	USA
LASMEA – Blaise Pascal University/CNRS	SeeMOS project [144, 104]	France
Vision Components	VC series	Germany
Smart Systems – Austrian Research Centers	Smart eye sensors [50]	Austria
Le2i – Bourgogne University/CNRS	High-speed smart camera [389]	France
Intellio	ILC series	Hungary
Sony	XCI series	Japan
National Instruments	NI 17xx series and CVS	USA
SICK IVP	IVC 2D and IVC 3D	Sweden
Philips/NXP Research	WiCa wireless mote [296]	Netherlands
NeuriCam	VISoc Vision System-on-Chip [10]	Italy
ITI – Graz University of Technology	SmartCam project [77, 446]	Austria

3.6 Applications

Smart cameras have a wide application domain and touch upon many everyday sectors of activity. As has been explained in the previous sections, the crux of a smart camera lies in the subtle integration of the perception, image processing, and interconnecting communication protocols. These defining characteristics mean that smart cameras play an important role as a "high-level" sensor, therefore presenting particular requirements:

- the image contains a very large quantity of complex and rich information;
- the associated image processing should allow to extraction of several levels of varying information;
- the nature of the information should be allowed to vary according to the context.

In the remainder of this chapter, several different applications for smart cameras will be described with the aim of demonstrating the importance of such systems and most importantly highlighting their large versatility. A non exhaustive review of different application domains will be provided and associated with some specific examples. For more details, Part VI of this book is entirely dedicated to applications of smart cameras.

3.6.1 Security

Video surveillance systems are becoming increasingly important in public access facilities such as airports, transport stations, and banks to provide security [224, 392]. The fundamental problem with traditional video surveillance systems is that they are often monitored by human operators, which implies two relevant points:

1. Finding and funding human resources to observe the video feeds is very expensive, even if mounting more video cameras is relatively cheap. Moreover, human operators performing the surveillance monitoring rapidly become tired and inattentive due to the dull and boring nature of the activity.
2. The observation, recording, and use of sensitive information often imply certain ethical problems which can be avoided when the data processing is purely automatic and without human intervention. Such scenarios include the use of personal data (i.e., biometric data) or the observation of protected and confidential zones.

In this case the use of smart cameras can provide a solution to these problems by ensuring the efficiency and security of the data processing.

Furthermore, the flexibility of smart cameras allows them to be used in various configurations including

- In an autonomous mode (such as in the case of biometric access control). As mentioned above, they allow to treat sensitive information in a confidential manner and provide a simple way to validate access.
- In a networked mode that allows to realize a collaborative system with a distributed computational strength [405].

3.6.2 Automotive

In numerous metropolises, the streets, the intersections, and the freeways are monitored by video systems. In general these systems allow for the evaluation of three types of problems:

1. The estimation of vehicle flow in order to optimize and regulate traffic [560].
2. Detect dangerous situations such as accidents and vehicles traveling in the wrong direction [77].

3. Control the access of certain vehicles to protected or reserved zones (i.e., parking lots, city centers such as London).

Nevertheless, automotive applications can also be found in the interiors of vehicles [311]. Indeed, cars that are actually in production are made up of between 50 and 100 embedded processors along with a multitude of proprioceptive sensors. The use of smart cameras in particular is beginning to see the light of the day for specific tasks requiring the use of vision. Among such tasks, several applications related to security and safety can be referenced:

- The surveillance and measurement of driver awareness and their level of drowsiness.
- The detection of obstacles on the road.
- Adaptive Cruise Control (ACC) techniques.

3.6.3 Human–Computer Interaction

As the field of human–computer interaction evolves to exploit smart cameras, new problems of human–system and human–environment interaction will arise. Some methods may find new applications as software add-ons for digital cameras, cellular phones, and personal data assistants. For example, multimodal human interaction methods could be adapted for smart camera systems. With a microphone and speakers already in camera phones, techniques that recognize speech and emotions via both audible and visual cues can be implemented using the same embedded processors. Thus interactive dialogue systems may emerge where smart cameras are deployed. New ideas will lead to new kinds of handheld and wearable vision system tools. Among the possibilities, gesture-based recognition algorithms can be implemented in personal smart cameras for rooms and vehicles to provide interactive remote controls [490]. A camera phone can be mounted on the back of a bicycle helmet to serve as a proactive "rear view mirror" monitoring system. And small smart cameras will enable new concepts for interactive toys and games.

Challenges for algorithms in this regard are to achieve sufficient robustness in wide-ranging imaging conditions. To be most useful, algorithms will need to operate reliably amid diverse ambient lighting conditions and backgrounds, indoors and outdoors. Perhaps the biggest challenge facing the use of handheld vision systems for human interaction, or to devise new types of handheld vision tools, is that the cameras are moving during operation. In the classic human–computer interaction environment, the computer and connected camera(s) are in a fixed position and the user is seated in a chair, providing key geometric constraints to help reduce the complexity of image and video analysis. Much more vision research is needed to develop reliable algorithms and applications for human interaction using smart cameras in motion.

3.6.4 Mobile Devices

Cellular phones with digital still cameras, digital video recording, and interactive videoconferencing features are rapidly evolving [527]. The early camera phones introduced VGA-sized picture snapshot capabilities. Now the image sizes are moving up to 8 Mpixels in current and next-generation phones. Whereas the early video recording and streaming capabilities of various phones were limited to SQCIF, QCIF, or QVGA-sized video, they are moving up to VGA and are anticipated to reach television quality for digital camcorder-like video recording capabilities. As in other smart cameras, the high-complexity video encoding and decoding computations of cellular phones can be implemented in DSP software. Video standards such as H.263 and MPEG-4 are used, as are some proprietary formats. Various camera phone products are using programmable multimedia application processors such as OMAP1510 and OMAP-DM270 for image and video functions. These multiprocessor systems on a chip also enable many other software functions for camera phones, including "smart" functions such as face tracking for videoconferencing or face recognition for access control.

Part II
Imaging Technologies and Architecture of Smart Cameras

Chapter 4
Detectors, Pixels, and Signal Processing

Christoph Posch

4.1 Introduction

Imaging systems comprise the processes involved in the formation of a usually 2-D image from an object or a scene in the real world and in the majority of cases provide a direct point-to-point correspondence between points of the objects in the 3-D world and at the image plane.

Practically all smart cameras and machine vision systems include a sensor that converts electromagnetic radiation into electrical signals and devices which convert these analog signals further into digital signals that can be processed by a computer. The basic functional blocks are similar across most types of machine vision systems:

1. Collection of radiation and projection onto the image plane (e.g., lens, optics)
2. Detector for radiation-to-electrons conversion (e.g., photodiode)
3. Electronics for detector readout and signal conditioning (e.g., APS pixel circuit)
4. Device that implements a procedure to readout the pixel signals (e.g., CCD shift register)
5. Timing and control circuits for the sensor elements and the array (e.g., electronic shutter)
6. Signal processing electronics (e.g., correlated double sampling)
7. Analog-to-digital conversion
8. Interface blocks

After reviewing some basic properties of radiation in the context of imaging, the following section deals with the detector that receives electromagnetic radiation emitted by the observed object or scene and converts its energy into an electrical signal suitable for further processing. In an imaging system, usually a 2-D array of sensors is used for resolving the spatial distribution of the radiation[1]. It is often this

[1] One prominent exception is the 1-D array of a line-scan sensor that is used for imaging objects moving perpendicular to the line of sensor elements.

C. Posch (✉)
AIT Austrian Institute of Technology, Austria
e-mail: christoph.posch@arcs.ac.at

A.N. Belbachir (ed.), *Smart Cameras*, DOI 10.1007/978-1-4419-0953-4_4,

distribution, or the relative difference in radiation received by the individual sensor elements in the array, that carries the desired information about the scene.

The unit of a radiation detector plus front-end electronics responsible for the formation of the radiation-dependent electrical signal is called photoreceptor and constitutes the basic sensing element of a vision or image sensor. Several basic types of photoreceptors are in use in today's imagers and vision sensors. Different sensor and readout techniques often require additional circuitry within each of the sensor elements in the array, leading to more complex pixel circuits.

The conditioning or some form of pre-processing of the raw detector signal is frequently being done at the pixel level. The range of pixel-level signal processing is wide – it spans from none, only an integrating photoreceptor, a simple buffer like in standard CCD and CMOS imagers, to complete digital or programmable analog microprocessors in each pixel, found in some advanced vision-systems-on-chip. Also a conversion of the (pre-processed) analog signal to some form of digital representation can be done at the pixel level. The last section of this chapter provides an overview of pixel circuitry for early vision, signal pre-processing, and signal conversion.

4.2 Radiation and Imaging

4.2.1 The Electromagnetic Spectrum

Machine vision is not confined to visible radiation emitted by objects or illuminating scenes. The development of a multitude of imaging detector technologies allows using other types of radiation to probe scenes and objects of interest. The spectrum of electromagnetic radiation relevant for imaging applications spans from the Terahertz band with wavelengths between 1 mm and 100 μm to x-rays with wavelengths of 10 nm and shorter. Even shorter wavelengths – gamma rays – are used in nuclear medicine, high-energy physics, and astronomy applications. Imaging with very long wavelengths of the microwave and radio band is found in imaging radar applications for, e.g., earth observation and again in medicine (magnetic resonance imaging – MRI) and astronomy. In between lies the very narrow band of visible light between 380 and 780 nm and the adjacent infrared (IR) and ultraviolet (UV) bands above and below. The most widely used region of the electromagnetic spectrum for camera and imaging applications including machine vision is the visible light band followed by near and thermal infrared. Figure 4.1 depicts the spectrum of electromagnetic radiation.

Electromagnetic radiation can be treated as *electromagnetic waves* or as a flow of *particles*, constituting discrete packets of energy, called *photons*. A photon travels through space at the speed of light and carries an amount of energy which is proportional to the frequency v (or anti-proportional to the wavelength λ) of the associated electromagnetic wave:

$$E_{ph} = hv = \frac{hc}{\lambda}. \tag{4.1}$$

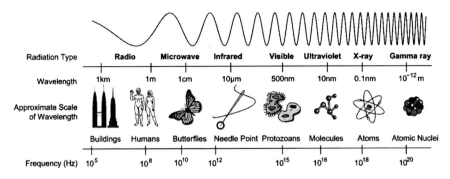

Fig. 4.1 Spectrum of electromagnetic radiation

Planck's constant $h = 6.626 \cdot 10^{-34} \text{J} \cdot \text{s}$; the speed of light $c = 2.998 \cdot 10^8 \text{m} \cdot \text{s}^{-1}$. The natural constant c relates the wavelength of an electromagnetic wave to its frequency. The energy of a single photon is commonly given in electron volts (eV), with 1 eV constituting the energy of an electron accelerated by an electric field with a potential difference of 1 V.

Although photons are neutral particles that do not carry electrical charge, using this unit is convenient as electromagnetic radiation is usually detected through the interaction of radiation with electrically charged particles in matter. In solid-state sensors, for example, the energy of impinging photons lifts electrons from the valence band into the conduction band of the semiconductor, allowing them to be turned into an electronic signal that can be read out and processed. The bandgap energy E_g, a material property, defines the minimum photon energy required for this process. Consequently, as a rule-of-thumb, the detector material is sensitive to radiation with photon energies $E_{ph} > E_g$. For example, silicon (Si) has a bandgap energy of 1.1 eV and hence can detect only wavelengths below 1.1 μm. A different semiconductor material, indium antimonide (InSb), with a bandgap energy of only 0.18 eV is sensitive to wavelength below 6.9 μm. As a consequence, InSb is used as detector material for infrared cameras in the 3–5 μm wavelength range, while silicon sensors are commonly used for visible light.

4.2.2 Quantities and Units

The energy of the single photon depends on the wavelength of the associated electromagnetic wave, yet the intensity of light, connected to the perceived brightness, depends on the number of photons per units of time and area. For visible light, the human eye sensation of electromagnetic waves of different wavelengths is called color. Visible chromatic (color) light is sensed by the human eye in the wavelength range between 380 and 780 nm. Light that contains a relatively balanced mix of wavelength in this range is perceived colorless or monochromatic. The only attribute of monochromatic light is the amount of light or the monochromatic intensity. The associated perception is a gray level between white and black.

While brightness is a highly subjective measure of light perception connected to the achromatic notion of intensity, physical attributes of radiation can be measured. Radiant flux is the total amount of energy that flows from a radiation source and is measured in watts (W), and irradiance (W/m²) the energy received per unit area by, e.g., a radiation detector (Table 4.1). By weighting the spectral response of the human eye, the radiometric quantities can be converted to the photometric quantities luminous flux (lm) and illuminance (lm/m² or lux).

Table 4.1 Basic radiometric and photometric quantities

Radiometric quantity	Unit	Definition	Photometric quantity	Unit	Definition
Radiant flux	W	Power (emitted or received)	Luminous flux	lm (lumen)	Luminous power (emitted or received)
Irradiance	W/m²	Power received at unit area	Illuminance	lm/m² = lx (lux)	Luminous power received at unit area

For photopic vision , the conversion from a radiometric to a photometric quantity is given by

$$Q_v = 683\,\mathrm{lmW}^{-1} \int_{380\,\mathrm{nm}}^{780\,\mathrm{nm}} Q_{e,v} V(\lambda)\,\mathrm{d}\lambda, \qquad (4.2)$$

with $V(\lambda)$ being the photopic spectral luminous efficiency function of the eye. It accounts for the wavelength-dependent response variation of the eye. The peak of

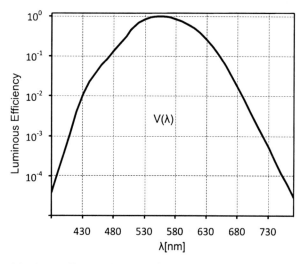

Fig. 4.2 Spectral luminous efficiency function of the "standard" light-adapted eye for photopic vision V(λ)

the relative spectral luminous efficiency curve for photopic vision lies at 555 nm (Fig. 4.2). The curve is standardized by the International Lighting Commission (CIE); tabulated values of $V(\lambda)$ can be found in [121].

Converting radiant energy into an electrical signal is the task of the radiation detector. The following section outlines the basic properties of imaging detectors relevant for a quantitative radiometric interpretation of images. The focus is on the technologies used in the visible light range.

4.3 Detectors for Imaging

Various technologies for detecting electromagnetic radiation have been the subject of extensive research over the past decades. Almost all detectors fall into one of three fundamental categories, whose distinction is based on the physical process involved in the conversion of radiative energy into an electrical signal.

- Quantum detectors
 This detector type is based on the quantum photoelectric effect and directly responds to single photons. Each absorbed photon generates free charge carriers that can be read out as an electrical signal. Photon detectors are the most important sensor types for machine vision applications. They cover the entire range of electromagnetic radiation from x-rays, to ultraviolet and visible light, down to the infrared region. Important examples are solid-state sensors.
- Thermal detectors
 Thermal detectors rely on a detector material with a temperature-dependent electrical property. Absorbed electromagnetic radiation changes the temperature of the detector element and hence the linked electric variable. The signal of a thermal detector is proportional to the instantaneous temperature of the detector element that is permanently trying to establish thermal equilibrium with its environment. The photo sensitivity of thermal detectors is largely independent of the wavelength. Microbolometer arrays for thermal infrared imaging are widely used examples of the thermal detector type.
- Coherent detectors
 Coherent receivers directly measure the electromagnetic field of the incident radiation by mixing the electromagnetic field of the incoming photons with an internal reference field of similar frequency, produced by a local oscillator. Coherent detectors are used for relatively low-frequency radiation from the radio and microwave band to sub-millimeter waves.

In the next section, we will focus on the quantum detector, the most common detector type used in machine vision systems for the infrared, visible light, and ultraviolet bands of the electromagnetic spectrum and cover function and applicability with regard to the underlying physical mechanisms and radiometric properties.

4.4 Semiconductor Photodetectors

Quantum photodetectors based on semiconductor materials are the most widely used
detector type for wavelength of the infrared, visible light, and ultraviolet bands.
The photodetector turns an optical signal, received in the form of electromagnetic
radiation or photons, into a preliminary electrical signal in the form of free charge
carriers. This operation comprises the basic functions of (1) generation of free
charge carrier pairs in response to incident light and (2) separation and collec-
tion of electrons and holes. The generation of an electrical output signal, that can
be transmitted and further processed, requires the interaction with other electrical
components.

4.4.1 Introduction to Solid-State Photosensing

Without going into detail about semiconductor physics, the fundamentals of solid-
state photo-transduction are briefly reviewed in this section and some important
terms and expressions are introduced and defined. A classic and very comprehen-
sive reference on this subject is [517]. Further excellent references are available
[597, 500].

Quantum mechanics shows that electrons bound to an isolated atomic nucleus
can occupy only discrete energy levels with forbidden gaps in between. When many
atoms form a crystal, the discrete levels are widened to form continuous energy
bands, again with forbidden gaps between the bands. At a temperature of 0 K, the
lowest energy band that is not fully occupied and all higher bands are called con-
duction bands. All lower bands, completely filled with electrons, are called valence
bands. In electrical conductors, the lowest conduction band is partially occupied,
while all conduction bands are empty for insulators and semiconductors at 0 K.

The separation between the highest valence band and the lowest conduction band
is the so-called bandgap energy E_g which plays an important role in the classifi-
cation of materials and their aptitude for being used as radiation detectors. E_g is
crucially larger in electrical insulators than in semiconductor materials.

In electrical conductors, negatively charged electrons are the only charge carriers
available. In a semiconductor crystal, when its temperature rises above 0 K, elec-
trons in the valence band can acquire enough energy to leave the valence band and
jump into the conduction band. The freed position in the valence band can now con-
sidered to be positively charged. These states are called holes. Both the conduction
band electrons and the valence band holes contribute to the electrical conductivity
and hence are subject to charge transport in the semiconductor. The holes do not
actually move. However, moving electron can fill a hole, leaving behind a hole at
the place in the crystal lattice it moved away from. Thus the holes change their place
and appear as if they were actual positively charged moving particles.

When an electric field **E** is applied to a semiconductor, the electrically charged
electrons feel a force equal to $|q\mathbf{E}|$ where q is the elementary charge. The average
velocity of carriers in a semiconductor due to the applied electric field **E** depends on

the carrier mobility μ, a material constant, and the electric field: $|\mathbf{v}| = \mu\,|\mathbf{E}|$. The mobility of holes μ_p is usually smaller than the mobility of electrons μ_n.

A semiconductor crystal without impurities or defects is called an intrinsic semiconductor. As described above, in intrinsic semiconductors charge carrier pairs are generated through thermal excitation. Hence the number of available mobile charge carriers depends on the temperature. The number of holes and electrons is equal. In silicon (Si), for example, the intrinsic carrier concentration at 300 K is $1.45 \cdot 10^{10}\,\mathrm{cm}^{-3}$.

The conductivity of semiconductors can be modified by introducing impurities into their crystal lattice. The process of controlled adding of impurities to a semiconductor is called doping. Doped semiconductors are commonly referred to as extrinsic semiconductors. By adding impurity to pure semiconductors, the electrical conductivity may be enhanced not only quantitatively, but also by the type of impurity atom, thus increasing the number of either electrons or holes. Hence, in extrinsic semiconductors the numbers of electrons and holes are no longer equal. As a result, two types of doped semiconductors can be fabricated, namely n-type with electrons as the abundant carrier and p-type with an abundance of holes. The predominant carrier in a semiconductor material is called majority carrier, the other minority carrier. Semiconductors of both types can be combined to achieve certain functions or characteristics. The simplest example is the p-type/n-type junction of a diode.

Besides through thermal energy, electrons can also be excited into the conduction band by energetic particles, e.g., photons, absorbed in the semiconductor material. This process is known as induced electron–hole pair generation. The minimum energy a photon must carry to trigger such a band transition is equal to the bandgap energy E_g. In the absence of an electric field to separate the charge carriers, electron–hole pairs recombine after an average period of time, called carrier lifetime, and emit the previously absorbed energy in the form of light or heat. In order to detect and make use of an optical signal, the photon-generated free charge carriers must be prevented from recombining and be collected. Succeeding in doing so allows the charge carriers generated by impinging radiation to be turned into an electrical signal, hence the semiconductor crystal to work as a radiation detector.

4.4.2 Figures of Merit of Photodetectors

Common parameters to quantify the operation of photodetectors are *responsivity*, *quantum efficiency*, *noise-equivalent power* (NEP), and *detectivity*.

Responsivity denotes the input–output relationship or gain of a detector. The responsivity R_{ph} of a photodetector is the ratio of light-induced photocurrent density J_{ph} and the incident optical power per unit area P_o:

$$R_{ph} = \frac{J_{ph}}{P_o}\ \left[\frac{\mathrm{A}}{\mathrm{W}}\right]. \tag{4.3}$$

Quantum efficiency η is defined as the number of photon-generated free charge carriers per impinging photon usually given in percent. The number of charge carriers is the photocurrent divided by the electron charge J_{ph}/q and the number of photons is the incident optical power divided by the energy of one photon $P_o/h\nu$:

$$\eta = \frac{\frac{J_{ph}}{q}}{\frac{P_o}{h\nu}} = R_{ph}\frac{h\nu}{q}. \tag{4.4}$$

For a given quantum efficiency, R_{ph} increases linearly with the wavelength until the cutoff wavelength at the bandgap energy of the material is reached, e.g., 1.12 μm for Si, and R_{ph} drops to zero.

The lower limit of light detection is determined by the noise characteristics of the device. The photodetector noise i_n is the sum of thermal noise and shot noise from dark current and photocurrent,

$$i_n = \sqrt{i_{th}^2 + i_{sd}^2 + i_{sph}^2} \left[\frac{A}{\sqrt{Hz}}\right], \tag{4.5}$$

with the thermal noise of an equivalent shunt resistance $i_{th} = \sqrt{\frac{4kTB}{R_{sh}}}$ and current shot noise $i_s = \sqrt{2qI_sB}$ of dark current and photocurrent and B the noise bandwidth. The noise-equivalent power (NEP) is defined as the intensity of incident light required to generate a current equal to the noise current – or yielding a signal-to-noise ratio (SNR) of unity in a 1 Hz bandwidth:

$$NEP = \frac{I_n}{R_{ph}} \; [W]. \tag{4.6}$$

The detectivity D^* is defined as the ratio of detector area A and bandwidth B to the NEP:

$$D^* = \frac{\sqrt{AB}}{NEP} \left[cm \cdot \frac{\sqrt{Hz}}{W}\right]. \tag{4.7}$$

The response time is another important performance parameter for photodetectors particularly when used in high-speed optical communications systems. Refer to [517] for a comprehensive study on semiconductor photodetectors.

4.4.3 Types of Semiconductor Photodetectors

4.4.3.1 Photoconductor

Photoconductors respond to incident light by changing resistance/conductance of the detector material. Intrinsic photoconductors are the simplest way to build a solid

state photodetector, consisting of just a piece of semiconductor with ohmic contacts at both ends (Fig. 4.3a). At normal temperatures, relatively few electrons occupy the conduction band of the semiconductor, resulting in a low electric conductivity of the material. Impinging photons generate charge carriers that increase the conductivity. The current flowing through the device in response to an applied external voltage is dependent on the incident optical power. The minimum photon energy that can be detected is determined by the bandgap energy of the detector material. Intrinsic photoconductor detectors exhibit good uniformity and quantum efficiencies typically of the order of 60%. The main shortcomings of photoconductors are high noise and slow response speed. Photoconductors are not widely used in image sensors.

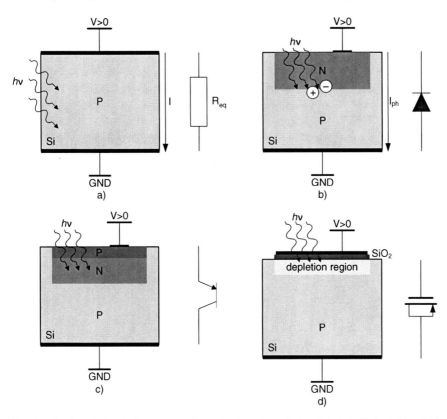

Fig. 4.3 Semiconductor device cross sections of (**a**) photoconductor, (**b**) photodiode, (**c**) (vertical p–n–p) phototransistor, and (**d**) photogate

4.4.3.2 Photodiode

The photodiode (Fig. 4.3b) is the most widely used detector type in CMOS image sensors for visible light and adjacent NIR and UV. A photodiode is based on a junction of p-type and n-type semiconductor or a p-type – insulator – n-type structure (PIN diode). Close to the contact region the material is depleted of free

charge carriers, forming a depletion layer with an electric field that separates photogenerated electron–hole pairs. For fast transit times needed for high-speed operation, the depletion region should be made narrow, while in order to maximize quantum efficiency, the depletion layer should be as thick as possible to allow a large fraction of the incident photons to be absorbed. This leads to a design trade-off between speed and quantum efficiency.

The photodiode can be operated in three modes of biasing: photovoltaic (solar-cell mode), photoconductive (photodiode mode), and avalanche mode (Fig. 4.4). As a detector for imaging, the device is normally operated in photodiode mode and is reverse biased. The current flowing through the photodiode is the sum of diffusion (dark) current I_{dark} and photocurrent I_{ph}. The photocurrent has a linear relation to the incident light intensity. In the near infrared (NIR) region between 0.8 and 0.9 µm, silicon photodiodes with antireflective coating can reach quantum efficiencies of close to 100% [517].

In photovoltaic or solar-cell mode, no external voltage is applied to the diode. When photons of energies greater than the bandgap energy are absorbed in or close to a p–n junction of a photodiode, the resulting electron/hole pairs are pulled by the electric field of the contact potential across the p–n junction. Electrons are swept from the p-region into the n-region, and holes in the opposite direction. As the charge carriers are spatially separated across the detector, a resulting voltage appears. If the n- and the p-type regions are electrically connected, a current can flow between both regions, giving rise to the so-called photovoltaic effect.

In avalanche mode, photodiodes show a current gain effect as a result of impact ionization under avalanche breakdown conditions, i.e., each absorbed photon leads to a multitude of photogenerated charge carriers. Avalanche PDs are used, e.g., as particle detectors in high-energy physics experiments and related imaging applications like positron emission tomography (PET).

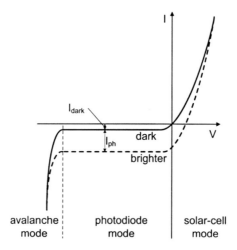

Fig. 4.4 Photodiode I–V characteristics

4.4.3.3 Phototransistor

A phototransistor is usually a vertical or lateral n–p–n or p–n–p bipolar transistor structure whose base-collector junction is exposed to light (Fig. 4.3c). It can be viewed as a photodiode with built-in amplifier and offers current gain >1. Phototransistors suffer from poor high-frequency performance and are rarely used in solid-state imagers.

4.4.3.4 Photogate

A photogate is a MOS capacitor which converts impinging photons into stored charge rather than into photocurrent or voltage signals (Fig. 4.3d). The capacitor is charged in proportion to the light intensity to which it is exposed by accumulating photogenerated carriers in the depletion region under the gate when the device is biased accordingly. Unlike in most other photodetectors, there is no external photocurrent flowing during light exposure. Photogates are the basic element in a CCD image sensor, which is described in the following section.

4.5 Basic Pixel Structures

4.5.1 Charge-Coupled Device (CCD)

A CCD pixel is based on the photogate detector, a MOS capacitor with a polysilicon gate as the top terminal. In an imager, the CCD pixels are placed close to each other in rows that can act as analog shift register. During the exposure interval, an electrical potential applied to the gate electrode holds the accumulating, photogenerated charges in the potential well underneath the gate. Typical exposure times range from $100\,\mu s$ to $100\,ms$.

The accumulated charge can be displaced to a neighboring well by applying a synchronized sequence of voltage signals to the two gates. Figure 4.5 illustrates the transfer of charge in a CCD device. To initiate the charge transfer, the voltage applied to the gate G2 is quickly raised. Subsequently the voltage at neighboring gate G1 decreases slowly. Thereby, the charge stored under gate G1 during the exposure phase is transferred to the potential well under gate G2. By repeating this process, the accumulated photo charge of each pixel eventually reaches the end of the row where it gets processed by a charge-sensitive amplifier and is turned into a voltage or current signal. Transfer efficiencies between two wells of 99.99% can be achieved by using fringing fields and clock frequencies of several tens of megahertz [517].

4.5.2 CMOS Photoreceptors

The unit of optical detector plus front-end electronics in CMOS pixels is called photoreceptor. In this section, photoreceptor circuits based on photodiodes that

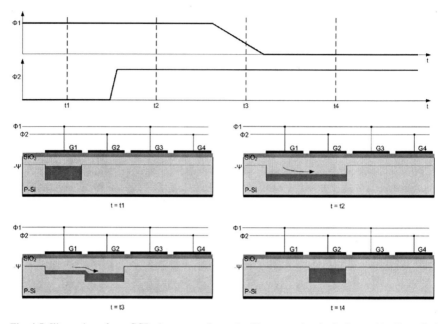

Fig. 4.5 Illustration of one CCD charge transfer cycle. Shown are the clock phases $\phi1$, $\phi2$ applied to the gates G1–G4 and the surface potential ψ with charge packets moving between the changing potential wells as response to the clock signals

transduce the optical input into electrical charge, current, or voltage are investigated and compared. The most fundamental classification of photoreceptor circuits is based on their mode of operation, integrating/sampled or continuous time.

Sampling pixels integrate the induced photocurrent from the detector onto a capacitor during a given integration period. Often the parasitic capacitance of the photodiode itself is used as the integration capacitor. Before each integration cycle, the photodiode is reset and the capacitance is pre-charged to a reference value. The voltage across the capacitance at a given point in time after the reset constitutes the output signal and carries information of the incident light during this time. Continuous-time photoreceptors transduce the continuous photocurrent directly into an output voltage or current for direct processing. Many "smart" vision sensors use continuous-time photoreceptors to perform early processing of the visual information in the temporal and/or spatial domain.

Three elementary photoreceptor types, charge mode, current mode, and voltage mode, can be distinguished. The charge mode circuit is the basic structure of integrating/sampled pixels whereas current mode and voltage mode circuits constitute the basic continuous-time photoreceptors types. In [578], a detailed comparison of the elementary photoreceptor types based on achievable information rate is shown.

The integrating (charge mode) photoreceptor (Fig. 4.6a) consists of a photodiode and a reset transistor. Complete with a row select switch transistor and a source follower buffer, this structure forms the basic CMOS APS pixel which can be found in

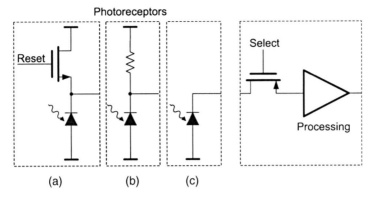

Fig. 4.6 Basic CMOS photoreceptors (**a**) charge mode (integrating), (**b**) voltage mode (continuous), and (**c**) current mode (continuous)

most mainstream CMOS image sensors. The linear voltage mode circuit (Fig. 4.6b) converts the photocurrent into an output voltage based on an ohmic resistance. By using a load element with a logarithmic I–V characteristic, logarithmic encoding of the illumination information can be achieved. This is useful, e.g., to increase the dynamic range of the sensor. Continuous-time voltage mode photoreceptors are used in many "smart" vision and image sensors and will be covered later in this section. In the current mode photoreceptor (Fig. 4.6c) the photocurrent is directly routed to a processing circuit. This scheme has certain advantages in relation to pixel-level signal processing and will be discussed in Section 4.6.1.

The remainder of this section deals with CMOS image sensors and concludes with a comparison of CCD and CMOS as basic technologies for image sensing. Overviews of CMOS image sensors and applications can be found in [188, 62, 585, 414].

4.5.3 CMOS Passive Pixel Sensor (PPS)

The photodiode-type integrating passive pixel approach, first suggested by Weckler in 1967 [558], is shown in Fig. 4.7. The pixel circuit consists only of a photodiode and an access transistor, the operation is similar to dynamic random access memory (DRAM). When the access transistor is activated, the photodiode is connected via a vertical column bus to a charge-integrating amplifier (CIA). With the access transistor off, the photodiode discharges at a rate proportional to the incident light. When the photodiode is accessed, the voltage on the photodiode is reset to the column bus voltage, and the charge, proportional to the optical signal, is converted to a voltage by the CIA.

The single-transistor photodiode passive pixel allows the highest fill factor, the ratio of photodiode area to total pixel area, of up to 90%. On the other hand, PPS sensors suffer from low sensitivity and readout noise due to the large bus capacitances which are directly connected to the pixel circuit during readout and the

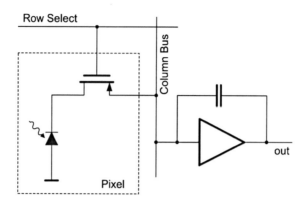

Fig. 4.7 Basic pixel circuit of a CMOS PPS with column charge amplifier readout

consequential limited scalability to larger array sizes or high frame rates. PPS arrays are prone to column fixed patter noise (FPN) due to column amplifier mismatch.

4.5.4 CMOS Active Pixel Sensor (APS)

First experiences with the CMOS PPS led to the finding that a buffer/amplifier could potentially improve the performance of the pixel [403]. A sensor with an active amplifier within each pixel is referred to as an active pixel sensor or APS. The CMOS APS trades pixel fill factor for improved performance as compared to passive pixels due to the pixel-level amplifier. Current APS pixels typically reach fill factors of 50–70%. Loss in optical signal is more than compensated by a reduction in read noise, leading to an increase in signal-to-noise ratio (SNR) and dynamic range.

The applied active circuit is usually a simple source follower that acts as both an amplifier and a buffer that isolates the photodetector charge from the large capacitances of the readout buses. Power dissipation is kept low because each amplifier is only activated during readout. APS pixels mostly use photodiodes or photogates as detectors and operate in integration mode. While a PPS directly transfers the accumulated signal charges to the outside, an APS transduces the charges to a voltage at the pixel level. Conventional APS's suffer from a high level of fixed pattern noise (FPN).

4.5.4.1 Photodiode (PD) APS

The photodiode-type APS was first described by Noble in 1968 [403] and further investigated by Andoh [17] since the late 1980s. In its fundamental form, the pixel contains three transistors: a photodiode reset transistor (MR) for resetting the photodiode voltage, a source follower transistor (SF) for buffering the photodiode voltage to a column bus, and a row select transistor (MS) (Fig. 4.8). The conversion of signal charge to voltage takes place at the photodiode node capacitance which is the sum

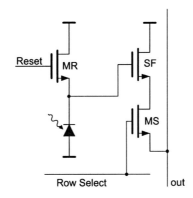

Fig. 4.8 CMOS photodiode APS schematic

of device capacitances of the diode and connected transistors. The load of the source follower is connected to the column bus and is common to all pixels in the column.

During the reset phase, the reset transistor is on and the photodiode is connected to a reference voltage. The photodiode node capacitance is charged accordingly. During integration, the reset transistor is switched off and the capacitance is discharged by the incident light proportional photocurrent. At the end of the desired exposure time, the resulting voltage is read out. The output voltage is higher for darker and lower for more brightly illuminated pixels.

The SNR performance (compare Section 4.4.2) decreases for smaller pixel sizes since photocurrent shot noise and reset voltage noise, also known as kTC noise, scale as $1/\sqrt{C_{PD}}$, where C_{PD} is the photodiode capacitance. The dynamic range (DR) of an integrating APS pixel is defined as the ratio of the maximum output voltage V_{max} and the minimum detectable signal V_{min} (compare Section 4.4.2) given in dB where V_{max} is limited by the full-well capacity, the number of charges that can be accumulated in the PD. The conversion gain is defined as the voltage change due to one accumulated elementary charge (V/e^-) and equals $1/C_{PD}$.

Consequently, in minimizing chip area, design trade-offs can be made between pixel fill factor (PD area), dynamic range (full-well capacity), and conversion gain.

4.5.4.2 Pinned Photodiode (PPD) APS

In order to decouple photodetection and photoconversion areas and resolve the trade-off of the PD APS, the "Pinned Photodiode" APS (PPD APS) has been developed. The accumulated photocharge is transferred to a floating diffusion (FD) via a transfer gate (TX) (Fig. 4.9). The conversion of charge to voltage is done at the FD capacitance. The circuit topology allows a straightforward correlated double sampling (CDS) implementation for noise suppression. The PPD APS is superior to the standard PD APS in terms of noise performance; however, due to the additional transistor, the achievable fill factor is smaller and the charge capacity is limited. PPD APS can compete with CCD imagers in terms of image quality. An important

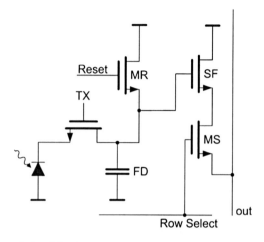

Fig. 4.9 Pinned photodiode APS schematic

drawback of the pinned photodiode is that it cannot be fabricated in a standard CMOS process [339, 415].

4.5.4.3 Photogate (PG) APS

The photogate APS was introduced in 1993 [373, 372, 374]. It combines the CCD principle of operation of integration and charge transport in the pixel with random access readout. Initially the signal charge is accumulated under a photogate. For readout, a floating diffusion is reset and the resulting voltage measured. The signal charge is then transferred to the output diffusion by pulsing the photogate accordingly. Again the voltage is measured and the difference between the reset level and the signal level is read out, realizing true correlated double sampling (CDS) with known benefits of suppressing reset kTC noise and offset FPN. The PG APS uses five transistors per pixel (Fig. 4.10). The improvement in noise performance is partially outweighed by a reduction in quantum efficiency due to the optical properties of the polysilicon gate. The photogate pixel can be operated at higher charge capacity as compared to the pinned photodiode. PG APS is suitable for high-performance and low-light applications but requires a specialized fabrication process.

4.5.4.4 Logarithmic PD APS

Increasing the dynamic range of CMOS image sensors (typically 60–70 dB) toward the dynamic range of natural scenes of > 120 dB has been the subject of extensive research over the past decade. A logarithmic transformation of the photo-signal (the pixel output signal is proportional to the logarithm of the photo-signal) allows for an increase in intra-scene dynamic range as the photo-signal is companded. A MOS transistor that operates in the sub-threshold region, e.g., shows a logarithmic I–V characteristic. This property can be exploited to achieve logarithmic transformation

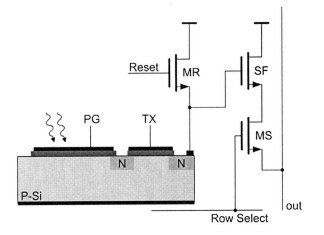

Fig. 4.10 Photogate APS schematic

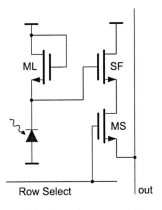

Fig. 4.11 Logarithmic photodiode APS schematic

of the photo-signal. Figure 4.11 shows an example circuit which exhibits the logarithmic characteristic for typical light levels and photocurrents in the pA to nA range where the load transistor ML operates in sub-threshold. The circuit is of the continuous-time (non-integrating) type.

Drawbacks of the continuous-time approach include slow response time for low light levels and a small voltage swings; however, the main obstacle faced when using continuous-time logarithmic photoreceptors has been the large FPN. Various pixel-level and chip-level calibration techniques and approaches employing combinations of linear and logarithmic pixel response have shown promising results. Intra-scene dynamic ranges of more than six decades have been achieved with logarithmic PD APS at FPN levels of a few percent [283, 466, 333, 112].

Continuous-time logarithmic PD photodetectors can be operated in a high-gain feedback configuration to reduce charging/discharging times of parasitic and

junction capacitances. Bandwidth and speed of the photodetector are greatly enhanced [331]. Figure 4.12 shows a logarithmic photoreceptor circuit based on a common-source gain stage (M1, M2) feedback loop. This type of photodetector is used in smart sensors with pixel-level analog signal processing and will reappear in Section 4.6.5.

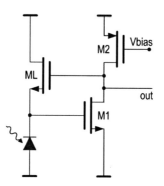

Fig. 4.12 Logarithmic photoreceptor with common-source feedback

4.5.5 CMOS Versus CCD

CMOS and CCD image sensors are both made from silicon and convert incident light into electrical charge based on the similar physical processes. Both technologies support photogates and photodiodes as detector elements and have similar fundamental properties of sensitivity in the visible and NIR ranges of the electromagnetic spectrum.

CCDs provide excellent image quality at excellent noise performance. Although it is possible, it is in fact not economical to integrate other camera functions like clock drivers, logic circuits for timing control, signal processing blocks. on the CCD chip. Most CCD camera systems contain several chips, at least three or more. The amplitude and shape of the various clock signals controlling the charge transfer in CCDs are critical. Generating correctly sized and shaped clocks is usually done in a specialized clock driver chip. Multiple, uncommon supply voltages and high power consumption are standard in most CCD systems.

CMOS imagers sense light in the same way as CCD but this is where the similarities end. The accumulated charge packets are not transferred, but converted as early as possible by charge-sensitive circuits. CMOS sensors can be manufactured on standard fabrication processes. The main problem with CMOS sensors is the matching of the individual amplifiers in the pixels leading to significant fixed pattern noise (FPN); however, the issue has been resolved to a great extent by using on-chip correction techniques. Higher dark currents contribute to the inferior noise performance. A major benefit of CMOS cameras over CCD lies in the possibility of implementing virtually all of the electronic camera functions onto the sensor chip. It is common to integrate the A/D conversion but also signal processing, timing

logic, exposure control, etc., on-chip resulting in complete single-chip cameras. The major benefits are one-rail supply requirements and significant power savings over CCD. Competitiveness and abundance of CMOS technologies combined with the high level of camera integration entails substantial cost advantages over CCD. The main differences and common features of CCDs and CMOS image sensors are summarized in Table 4.2.

Table 4.2 Comparison between CCD and CMOS sensors

CCD	CMOS
Excellent image quality	Medium to high image quality
High SNR (low noise <40 electrons)	Lower SNR (>20 noise electrons)
Low FPN (dark non-uniformity <1%)	Higher FPN (requires on-chip correction)
Low dark current ($<10\,pA/cm^2$)	Higher dark current (nA/cm^2)
Rare technology	Mainstream technology
No on-chip ADC, signal processing, control	On-chip device integration – smart sensors
Serial scanning readout	Random access readout
Complicated driving and interfacing	Simple data interface
Multiple high-voltage supplies	Single supply operation
Higher system cost	Lower system cost

<div align="center">

Common characteristics:

Spectral response (400–1000 nm)
Minimal pixel size (2–5 μm)
Charge storage per unit area
Chip size and number of pixels

</div>

4.6 Pixel-Level Signal Processing

"Smart" vision sensors, as opposed to standard image sensors like CMOS APS or CCD as covered in the preceding sections, perform processing tasks on the optical information early in the signal chain, typically at the pixel level. Other synonyms for this type of sensor technology/signal processing are "early vision," for its relation to biological paradigms, or "focal-plane processing" (FPP).

This section covers some selected circuitry for early vision and signal pre-processing found in the pixels of various "smart" vision sensors. The range of pixel-level signal processing is wide – it spans from simple amplifiers to complete programmable digital or analog microprocessors in each pixel. Two fundamental classes of pixel-level signal processing can be distinguished – intrapixel, where the processing is performed on the individual pixel signals, and interpixel, where the processing is performed locally or globally on signals from several pixels. An excellent overview of this topic has been published by Moini [385] and covers all significant developments up to 1997 in great detail. Reference [159] provides an introductory overview of the topic. Later developments are covered in [408].

Pixel-level processing implies that photo-induced signals from non-integrating photoreceptors can be directly processed in continuous time, and photocurrents and

derived voltages from integrating photoreceptors are available for processing during integration. Many pixel-level processing efforts, mainly of the interpixel type, aim to improve the quality of an image sensor by enhancing noise performance, SNR, dynamic range, or speed. The transition from PPS to APS by adding a source follower to the pixel circuit is a simple but prominent example.

But many more useful functions can be implemented or supported at the pixel level such as electronic shuttering [579], correlated double sampling (CDS) [372], and frame differencing [145].

Interpixel processing opens the arena for computational vision sensors that are, e.g., able to extract information or features from the scene and perform tasks like motion detection, edge detection, optical flow, or segmentation [385, 408, 159]. Massively parallel pixel-level processing allows reducing the required speed of the single processing element to the point where analog circuits operating in the sub-threshold domain can be used to perform complex computations while consuming very little power [369]. This paradigm gives rise to the development of continuous-time dynamic vision sensors that, like their biological role models, use asynchronous pulses (spikes) to transmit information about scene dynamics – changes in the scene – with very high temporal resolution and low communication bandwidth requirements, e.g., [317].

Illumination can be encoded in time or frequency by controlling the timing of pulse signals proportional to the pixel's illumination. Pulse frequency or time between pulses can be converted to digital data at the pixel level or can be communicated off-chip using synchronous or asynchronous digital buses.

Current mode pixels allow straightforward implementations of arithmetic functions like additions or multiplications, hence simple to medium-complex image processing tasks are to be performed directly in the sensor.

In this section, several approaches that implement basic vision tasks or some form of processing of the visual information at the pixel level are presented. This section does not claim completeness for the great number of different designs that have been implemented. Some of the circuits presented have only recently been implemented in smart camera or imager products for the first time or are about to be.

4.6.1 Current Mode Pixel and Analog Focal-Plane Processing

Current mode imaging provides an attractive alternative to the common voltage mode APS if focal-plane image processing is desired. In current mode circuits, basic arithmetic functions like addition, subtraction, or multiplication can be implemented in a straightforward way, but also integration and non-linear transformations are available in the current mode domain. Analog memories based on current copier circuits, current scaling circuits, and current mirrors with programmable mirror ratios have been demonstrated [450, 206]. In the context of image sensor arrays, these paradigms can be applied to continuous-time or integrative photocurrents to implement various intrapixel and interpixel signal processing tasks.

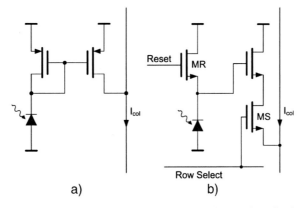

Fig. 4.13 Continuous-time (**a**) and sampled (**b**) current mode pixel readout circuits

The basic circuit of a continuous-time current mode pixel with current mirror readout is shown in Fig. 4.13a. Non-unity current mirror ratios can be used to amplify the photocurrent. Like other continuous-time photo-circuits, this architecture suffers from low sensitivity at low light, non-linearities, and high fixed pattern noise. Figure 4.13b shows the schematic of an integrating PD current mode pixel. Current mode imagers are still far less common than voltage mode CMOS APS sensors due to their generally lower image quality [368]. However, methods like multiple sampling or velocity-saturated readout for reducing FPN have shown promising results [395, 427, 220, 585, 586]. A low-power technique for mega-pixel current-mediated imagers [368] is presented in [70].

In the field of focal-plane image processors and hardware array implementations of cellular neural networks, current mode pixel circuits and signal processing are omnipresent. An in-depth coverage of current mode techniques suitable for focal-plane processing can be found in [450] and their application for image sensing and processing in [165]. In [202], basic current mode early vision in a 256×256 pixel array is presented, and in [148], an analog array processor with binary imaging and programmable inter pixel processing for simple vision tasks is described. A biology-inspired analog parallel array processor based on current mode techniques is shown in [94]. Complex spatiotemporal processing has been realized in various designs in the past years [101, 169, 219, 206, 360, 359, 391].

The SCAMP family of software-programmable single-instruction-multiple-data (SIMD) processor arrays for focal-plane low-level image processing applications, based on current mode analog circuit techniques is presented in [151, 152]. The ACE16k [323, 451], the third generation in a family of complex vision-systems-on-chip [164, 163, 148], contains an array of 128×128 mixed-signal SIMD processing elements with configurable optical sensors which is able to perform various early vision tasks at a speed corresponding to 300 giga operations per second (compare Table 4.3).

Table 4.3 Comparison of vision chips with programmable analog and/or digital processing elements in each pixel [335]

Vision chip	PVLSAR 2,2 [413]	NSIP [158]	SPE [300]	ACE16k [323]	SCAMP [152]	ASPA [335]
Array size	128 × 128	32 × 32	64 × 64	128 × 128	128 × 128	128 × 128
Cell size, μm²	60 × 60	118 × 118	67.4 × 67.4	75.7 × 77.3	49.4 × 49.4	100 × 117
Technology, μm	0.8	0.8	0.35	0.35	0.35	0.35
Processing type	Digital	Digital	Digital	Analog	Analog	Digital
Memory per cell	5 bit	8 bit	24 bit	8 analog registers, 4 bit binary	9 analog registers	64 bit
Performance GOPS	49	1.9	6.4	330	20	157
Die size, mm²	76	25	29.2	145.2	50	213.5
Power per chip	1 W	0.1 W	N/A	2.9 W	240 mW	5.4 W
Perf/area MOPS/mm²	92.6	1.1	343	3800	512	820.8
Perf/energy GOPS/W	5.4	25.2	N/A	180	85.3	29

4.6.2 Time-Based (PM) Pixel

In time-based or pulse modulation (PM) imaging the incident light intensity is not encoded in amounts of charge, voltage, or current but in the timing of pulses or pulse edges.

Two basic approaches to time-based imaging can be discerned. The first technique is called pulse width modulation (PWM) or synonymously time-to-threshold and time-to-first-spike (TTFS) imaging. Instead of integrating photogenerated current for a fixed period of (exposure) time, the integration is stopped when the pixel signal reaches a certain value. In the basic PWM implementation, the pixel voltage is reset to a fixed DC voltage and then the photodiode capacitance is discharged by the photogenerated current. A comparator compares the pixel output voltage to a voltage reference. The comparator output switches when the threshold is reached. The time between reset and the switching of the comparator carries the information on the average pixel illumination during that period. In [158, 401, 394, 75, 523, 254] early image sensors with PWM pixel circuitry are presented.

The second fundamental approach to pulse modulation imaging is called pulse frequency modulation (PFM) and encodes the information about pixel illumination in the instantaneous frequency of digital pulses or inter-pulse intervals. The pulses are generated by a photocurrent-controlled oscillator in each pixel. Again the pre-charged photodiode capacitance is discharged by the photocurrent. When the fixed threshold is reached, a pulse is generated, the comparator resets the photodiode and the integration cycle starts again. The time between the pulses, respectively the pulse frequency, is proportional to the instantaneous pixel illumination. The first PFM

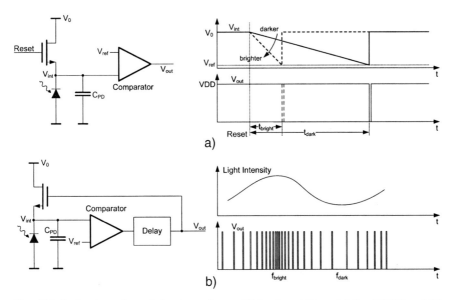

Fig. 4.14 Basic schematics and signal waveforms of (**a**) pulse width modulation (PWM) and (**b**) pulse frequency modulation (PFM) pixels

circuit was reported by Frohmader et al. [192] in 1982. The first PFM-based image sensor was proposed in 1993 [524] and demonstrated in 1994 [584].

Basic PWM and PFM circuits are shown in Fig. 4.14 (a) and (b).

The time-based scheme can represent a much wider dynamic range of pixel intensities than conventional CMOS APS image sensors. Since the integration time is inversely proportional to the photogenerated current, the dynamic range of the imager is limited to the dynamic range to which integration time can be measured and hence is no longer limited by the power supply rails. Or, from another point of view, the time-based approach allows each pixel to choose its own optimal integration time, by this means achieving high dynamic range and improved SNR.

PWM or PFM techniques are frequently used as part of a pixel-level analog-to-digital conversion scheme. This subject is addressed in the following section.

PWM/PFM pixels can be combined with asynchronous, digital array readout (address-event representation, AER) [65, 66] to instantaneously and asynchronously transmit the pixel pulses off-chip when they occur. This approach has yielded a variety of devices like "time-to-first-spike" (TTFS) type imagers [435, 340, 221, 492] or the Biomorphic Digital Image Sensor [133]. PFM digital pixels are also suitable for retinal prosthesis, where asynchronous and independent operation are desired [271, 272, 399].

Some of these vision devices have left the realm of synchronous, frame-based operation that is common to practically all image sensors covered up to now. Section 4.6.5 expands on the asynchronous, event-based vision approach.

4.6.3 Pixel-Level ADC

Many CMOS imagers provide their data in digital form, implying analog-to-digital conversion on-chip, usually one per array or one per pixel column. Miniaturization trends in semiconductor technology allow ever greater numbers of devices per unit area, and inspired research toward putting an ADC into each pixel of the imager array, thus realizing a digital pixel sensor (DPS). Digital pixel sensors are not meant to compete with conventional APS pixels in terms of fill factor or sensor resolution (hence image quality), but are designed to serve in specialized areas like high-speed imaging, video-oriented applications, and machine vision.

One-bit pixel-level AD conversion, or thresholding, has been reported in [60]. The first true pixel-level AD conversion technique appears in [188] and [581] with advancements in [582] and [583]. In a further development, Kleinfelder et al. [297] report a 10 kfps pixel-level single-slope conversion imager with global gray counter and in-pixel 8-bit memory.

PWM or PFM encoding of the illumination information is the basis of various pixel-level AD conversion schemes [58, 530]. In this case pixel pulses are not directly transmitted off-chip but their timing is converted to digital numbers and stored on-chip until read out.

For PWM, the pulse duration can be measured in cycles of a clock which is common to all pixels in the array using pixel-level counters [252]. In [291, 292] PWM pixel-level AD conversion with a global Gray code counter and pixel-level digital memory is presented. Bermak et al. [59] show a digital pixel sensor array with PWM-based AD conversion and linearization of the 1/x PWM encoding of the illumination information. Xu et al. [577] present a complementary pixel architecture (CAPS) for low-voltage (1 V) operation in 0.25 μm CMOS with PWM encoding and Kagawa et al. [273] show a 3-transistor PWM pixel.

In the case of PFM, the pixel-generated pulses are counted for a given period of time. Early image sensor implementations include a 32×32 PFM pixel array with the pulse counting done off-chip [584] and a 128-pixel PFM line sensor [147]. McIlrath et al. [367] use a sampled free-running photocurrent-controlled oscillator in each pixel to implement a first-order sigma-delta converter. Andoh et al. [16] report a 64×64 PFM pixel array with 8-bit counter in each pixel and line-wise successive readout. Wang et al. [556] present a 130 dB dynamic range 28×28 PFM sensor with shift-register counters and Boussaid et al. [71] present a scalable PFM pixel architecture with in-pixel 8-bit counter/memory and random access readout. In [493] a recent development of a 64×64 prototype PFM-based digital sensor with in-pixel 8-bit Gray-code counter/memory and intermediate (integration time) readout is reported.

4.6.4 Pixel-Level Digital Processing

Again driven by shrinking feature sizes of modern semiconductor processes and inspired by the progress made in pixel-level AD conversion, recent efforts were

targeted toward pixel-level digital signal processing. The most advanced devices integrate a fully programmable digital signal processor in each pixel of a sensor-processor array. Much like analog and cellular neural network (CNN) array processing architectures, this approach allows massively parallel operation and provides complex vision and image processing at high frame rates.

Ishikawa et al. [252] report an early 16×16 SIMD vision processor array with 512 digital transistors per pixel and 20 MHz clock frequency. In [270, 301] a 64×64 SIMD vision processor array for real-time image processing is shown.

Dudek et al. report the ASPA focal-plane digital processor array with asynchronous processing capabilities [334, 335].

Table 4.3 contains a comparison of analog and digital vision chips with programmable focal-plane processing [335].

4.6.5 Asynchronous Event-Based Vision

Classical image processing is based on the evaluation of data delivered by an image sensor system in the form of frames. Conventional, clocked image sensors acquire the visual information from the scene either sequentially for each sensor element (pixel) or each pixel line/column or in various patterns, pixel parallel, but always time-quantized at some frame rate. Each frame of data, that is recorded, transmitted, and needs to be post-processed in some fashion, carries the information from all pixels, regardless of whether or not this information has changed since the last frame had been acquired, usually not long ago. This method obviously leads, depending on the dynamic contents of the scene, to a high degree of redundancy in the image data. In addition, each frame imposes the same exposure time on every pixel, making it difficult to deal with scenes of high dynamic range.

The paradigm of asynchronous, event-based vision, as opposed to frame-based image sensing, is modeled after biological vision systems like the human retina. Biological visual systems have no notion of a frame – retinal outputs are asynchronous, massively parallel, and data driven. The output data volume of a self-timed, event-based vision sensor depends on the dynamic contents of the target scene – pixels that are not visually stimulated do not produce output. The result is a near-complete suppression of image data redundancy as compared to traditional, frame-based image sensors, drastically reducing demands on processing power, memory, transmission bandwidth, energy supply, etc.

The output of an asynchronous, address-event representation (AER) vision sensor is in the form of digitally coded addresses, specifying the x, y-address of the pixel in the array, communicated via an asynchronous, arbitrated digital data bus. The events are generated locally by the pixels, meaning that pixels operate autonomously and individually decide when to quantize the vision information, usually after some form of local gain control, and spatiotemporal processing and redundancy reduction.

Various different designs of AER vision devices have been developed during the past few years including the following:

- Imaging with TTFS encoding [492, 221]
- Imaging with PFM encoding in standard CMOS [133] and silicon-on-sapphire for backlight operation [132]
- Spatial contrast [126]
- Temporal contrast [317]
- PWM imaging with temporal contrast-event controlled conditional intensity readout [432]

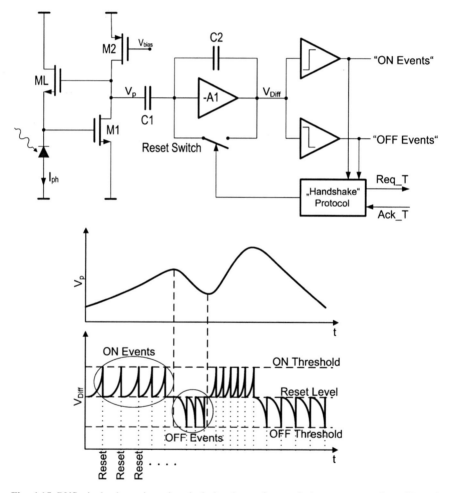

Fig. 4.15 DVS pixel schematic and typical signal waveforms of photoreceptor voltage V_p and spike events V_{Diff} over time. The rate of change is encoded in the inter-event intervals while the polarity of the gradient, going brighter or darker, is determined by the signal reaching the upper or lower threshold, respectively ("ON" or "OFF" events)

- Orientation-selective filtering [111]
- Exotic devices like foveated imagers with multiple pixel types [36] and dark-active imaging [222]

One recent example of an asynchronous AER event-based vision device is the temporal contrast *Dynamic Vision Sensor* (DVS) developed by T. Delbruck et al. [316, 317]. This sensor is modeled after the transient pathway of the human/vertebrate retina and performs local relative change detection in an array of autonomous pixels. Kramer [304] reported the predecessors to this device. The data delivered by this type of sensor contain high temporal resolution information about changes in the observed scene which can, in most cases, be attributed to object motion. Because output bandwidth is automatically dedicated to dynamic parts of the scene, these devices are especially suited for applications involving motion detection and analysis. Absolute (DC) levels are discarded in the pixel, hence there is no intensity information contained in the sensor data.

Figure 4.15 shows the DVS pixel schematic and typical signal waveforms. The pixel circuit contains a fast logarithmic photoreceptor circuit with common-source feedback (PD, ML, M1, M2), a differencing circuit that amplifies changes with high precision (A1, C1, C2) and two common-source comparators for positive and negative gradient events. The photoreceptor circuit automatically controls individual pixel gain by its logarithmic response while, at the same time, responding quickly to changes in illumination. The continuous-time photoreceptor FPN is removed by capacitive coupling and by balancing the output of the differencing circuit to a reset level after the generation of each event to re-establish the operating point of the circuit. The gain of the change amplifier is determined by the well-matched capacitor ratio C1/C2. Because the differencing circuit removes DC and due to the logarithmic conversion in the photoreceptor, the pixel is sensitive to temporal contrast and quantizes relative rather than absolute changes in pixel illumination.

Several devices have been built based on the temporal contrast DVS pixel circuit – low- and medium-resolution array sensors [316, 317], line sensors with on-chip event time-stamping for high-speed industrial vision [431], microbolometer-based transient IR sensors [363], and a QVGA vision sensor with asynchronous, redundancy-free PWM grayscale imaging [432].

Chapter 5
Image Sensor Architectures

Alireza Moini

5.1 Introduction

Chapter 4 presented fundamental concepts of vision sensor technologies in terms of photoreceptors, pixels, and signal processing circuits. This chapter provides a survey of vision sensor architectures and physical structures. Typical image sensor floorplans as well as exotic geometries realized over the past two decades are presented. Furthermore, this chapter presents typical pixel readout strategies and interfaces. Finally, a brief introduction to vision system-on-chip is given.

5.2 Architecture, the Floorplan of an Image Sensor

The physical structure or floorplan of sensor arrays usually consists of a central regular array, with row and column circuits on one or both sides. Figure 5.1 shows a micrograph of a typical image sensor and the schematics of its floorplan: the largest and most dominant part is the photosensitive array. This array consists of photosensitive elements ("picture elements" or "pixels"). For large sensor arrays this can consume more than 90% of the total chip area in a typical image sensor chip. The pixels are responsible for converting the light intensity focused onto them by optics into voltage, current, or charge. Section 5.3 will outline the properties of the pixel array.

The row and column building blocks attached to the pixel array build the periphery that is necessary to receive, convert, and buffer the signals produced by the pixels or provide signals to control and configure the pixels. Obviously for two-dimensional sensor arrays, it becomes inhibitive to route direct signals from every pixel to the boundary of the array. Therefore, multiplexing techniques are employed to allow control and readout from the array. Section 5.4 will introduce and discuss the common readout strategies.

A. Moini (✉)
Silverbrook Research Pty. Ltd, Australia
e-mail: alireza.moini@silverbrookresearch.com

A.N. Belbachir (ed.), *Smart Cameras*, DOI 10.1007/978-1-4419-0953-4_5,
© Springer Science+Business Media, LLC 2010

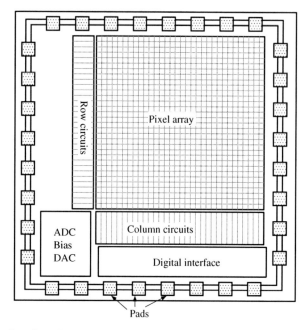

Fig. 5.1 Floorplan of a typical imager chip

In addition to control and readout signals, pixels also require power and biasing circuits to optimize their performance. Pixel data are often converted to digital image data on chip. Image data may be sent off-chip or processed on-chip. In either case the data transfer is carried out on a dedicated image data bus and using special interface blocks. Section 5.5 explains the most common methods for data conversion and transfer from an imager.

At the very physical boundary of the imager chip we find the pad frame that provides the chip connection to the outside world. Thin bonding wires soldered to these pads provide electrical connection to the pins of the chips package and furthermore to the printed circuit board of the smart camera system. The pads are equipped with I/O buffers and contain special circuits that safeguard the chip from electrical overstress and electrical discharge (EOS/ESD) during manufacturing and handling. The pads further connect to the chips periphery blocks and to the power buses that run along the chips edges.

5.3 Pixel Array

The pixel array, a regular assembly of photosensitive elements, resembles the heart of each image sensor. The most common geometry for the array is a rectangular matrix with a fixed distance between pixels. Not only does the chip design favor this layout for technical reasons but also image-processing techniques rely on a

rectangular arrangement as otherwise many mathematical operations used by image processing algorithms would become far more complex to apply to alternative systems.

5.3.1 Important Array Parameters

Figure 5.2 shows a simplified view of a rectangular 4×4 pixel array.

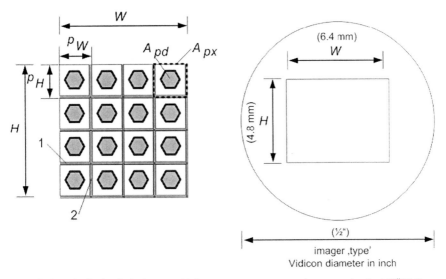

Fig. 5.2 Sketch of a 4×4 pixel array with important parameters and an example of a $1/2''$ Vidicon imager type

The pixels are arranged at equal vertical and horizontal distances p_H, p_V called the "pixel pitch." Usually the vertical and horizontal pitches are equal. Imagers with different pixel pitches are very uncommon. Pixels have an area $A_{px} = p_H \cdot p_V$ and contain the photosensitive area of the photodiodes (A_{pd}). The rest of the pixel space is used by circuitry to pre-process the signal and communicate to the periphery as well as the horizontal and vertical signal lines routing the information toward the periphery.

The more space needed for circuitry, the lower the "fill factor" becomes. Fill factor is the ratio of the photosensitive area (the photodiode area) A_{pd} to the total area of the pixel, $A_{px} = p_H \cdot p_V$: fill factor $= A_{pd}/A_{px}$ in percent. In CCDs this value can easily exceed 90% as there is no extra circuitry needed inside the pixels, in CMOS APS imagers and chips with focal plane pre-processing fill factor can be as low as 10%.

The total dimensions of the matrix W (width) and H (height) can be calculated by the number of pixels N_H, N_V (usually referred to as the "resolution" of the image

sensor) and the pixel pitches p_H, p_V, the distances in the horizontal and vertical direction:

$$H = p_H \cdot N_H, \quad W = p_W \cdot N_W. \tag{5.1}$$

The size of the imager array is important to know for choosing the correct optics to use for an imager. The optics are still specified for imager "types" or sizes given in inch referring to the diameter of the "Vidicon" tubes that have been used in the past for television recording. Table 5.1 gives an overview of the common sizes and the related array width and heights that can be used when choosing the optics for a certain size.

Table 5.1 Imager types vs. effective pixel array sizes

	W (mm)	H (mm)
1/4"	3.2	2.4
1/3"	4.8	3.6
1/2"	6.4	4.8
2/3"	8.8	6.6
1"	12.8	9.6

5.3.2 Line Sensors

Linear arrangements of pixels are used in "line sensors." The advantage is that such sensors can be used to image a constantly moving object in the field of view of the imager, such as a conveyor belt, for example, at high speeds and comparably low data rates. They consist of a single (or a few) line of pixels instead of an array or matrix. The constraints for putting readout circuitry on-chip and for connecting signal lines to the pixels are thus very much relaxed. Line sensors are among the fastest imagers available today, reaching readout frequencies of more than 100 kHz.

5.3.3 More Exotic Imager Geometries

Sensors can also be found in non-rectangular arrangements. These arrangements are often used to suite particular types of image processing algorithms.

For example, when an algorithm relies on having equidistance metrics between a pixel's nearest neighbors a hexagonal or honeycomb structure could provide a more optimal sampling of the image plane. A rectangular tessellation only provides two horizontal and vertical directions. The hexagonal tessellation has three main axes with 60° orientations. There are other tessellation structures, such as triangular, but they are more complicated and do not offer significant advantages for general image processing.

Assuming that the density of the detector per unit area is the same for either tessellation (see Fig. 5.3), the spacing between detectors relative to the rectangular tessellation can easily be found and expressed as

$$sh = \frac{\sqrt{2}}{\sqrt[4]{3}}sr \approx 1.075sr, \qquad (5.2)$$

where sr and sh are the spacing between detectors for the rectangular and hexagonal tessellations, respectively.

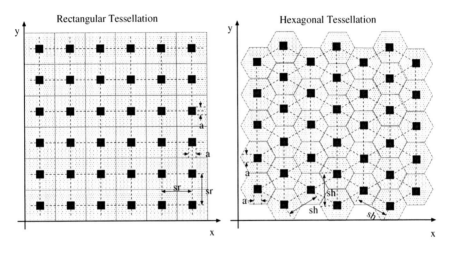

Fig. 5.3 Tessellation structures

The spatial frequency domain representation, referred to as "reciprocal lattice," of each tessellation is shown in Fig. 5.4. The shaded areas show the Voronoi cell of a lattice structure. The Voronoi cell is the common area between all the half-planes created by the perpendicular bisectors of the lines between the cell and all other cells, which include the cell. The Voronoi cell is in fact the area where the spatial frequency response can extend without any aliasing. The minimum distance of a cell to the edge of its Voronoi cell in the vertical and horizontal directions for the two tessellations, and assuming the same detector density, is

$$\begin{aligned}
Vr_x &= Vr_y = \tfrac{1}{2sr} = 0.5\tfrac{1}{sr} && \text{for rectangular tessellation} \\
Vh_x &= \tfrac{1}{\sqrt{3}sh} = \tfrac{1}{\sqrt[4]{12}sr} \approx 0.537\tfrac{1}{sr} && \text{for hexagonal tessellation.} \\
Vh_y &= \tfrac{2}{\sqrt{3}sh} \approx 0.667\tfrac{1}{sr}
\end{aligned} \qquad (5.3)$$

In conventional image sensors, the spatial distribution of the photodetectors forms a regular periodic pattern. A distinct class of imagers perform re-mapping of a two-dimensional image from Cartesian coordinates to other coordinates, such as log-polar and linear-polar. The mapping provided by these sensors facilitates

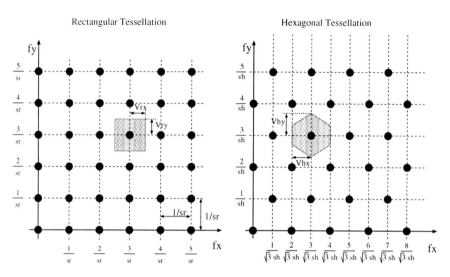

Fig. 5.4 Reciprocal lattice for the rectangular and hexagonal tessellations

some image processing operations, such as scaling and rotation invariance. Foveated image sensors are a class of space-variant detectors, with a central region of high detector concentration, and low detector density in the periphery. The most common foveated structures are illustrated in Fig. 5.5. The linear-polar sensor in Fig. 5.5(a) performs the mapping:

$$\theta = \tan^{-1}\left(\frac{y}{x}\right) \\ \rho = \sqrt{x^2 + y^2}.$$

(5.4)

Image rotation in the new coordinates is performed by a simple shift operation in the θ-axis. In this sensor all the detectors have the same size. In practical situations,

Fig. 5.5 (**a**) linear-polar sensor, (**b**) log-polar sensor, and (**c**) log-polar with Cartesian center

due to the finite size of the detectors, there are fewer detectors in the central circles than in the outer circles.

The log-polar sensor shown in Fig. 5.5(b) performs the mapping:

$$\theta = \tan^{-1}\left(\tfrac{y}{x}\right).$$
$$\rho = \log\left(\sqrt{x^2 + y^2}\right) \tag{5.5}$$

In this structure, rotation and scaling are performed by shift operations in the θ- and ρ-axes, respectively. Again, physical size limits the fine placement of detectors in the center. The third sensor presents a regular and high-density detector structure in the center and log-polar mapping in the periphery.

Due to their non-uniform detector distribution these structures are often useful for tasks other than conventional imaging. In special image processing applications, such as tracking, the periphery of the detector provides a wide field of sparse detectors. When a target is detected in the periphery, the sensor can be directed toward it so that it is imaged with more detail by the central region. For examples of this type of sensors see [545, 569, 414, 549].

5.3.4 Color Patterns and Microlenses

Depending on the application, color image sensors may be required to provide the additional information about the environment. For example, traditional shape-based image processing applications only require grayscale images, while a large number of human face detection algorithms rely on skin color for face and hand segmentation and recognition.

5.3.4.1 Detecting Color

Almost all image sensors used for the visible spectrum are based on silicon. The exact spectral response of silicon-based image sensors depends on many factors, most importantly the semiconductor doping density and the doping profile across the photodiode. The spectral response of a typical silicon-based sensor is shown in Fig. 5.6.

In theory in order to detect an exact color, the input light to the sensor has to be filtered with an ideal band-pass color filter which only passes the required color. In theory this filter has to be a delta dirac function. In order to detect all colors in the visible spectrum, many ideal filters covering all the spectrum have to be used. This is of course impractical.

In a large number of color image sensors only three filters are used, mainly centered around the blue, green, and red wavelengths. These filters are non-ideal, do not have a flat response, and most importantly overlap with each other. Without overlapping of the filters, however, it would be impossible to recover the color information from a single pixel in the sensor.

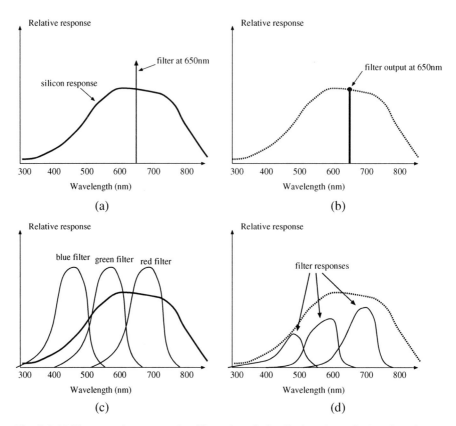

Fig. 5.6 (**a**) The spectral response of a silicon photodiode, (**b**) detecting a single color using an ideal filter, (**c**) typical characteristics of three-color filters, (**d**) and the response of color filters

There are three different methods for implementing color filtering, shown in Fig. 5.7. In the first method, a single sensor array is used along with a rotating color wheel. With this technique a single color frame is constructed from three samples, which will naturally be taken at different times. The advantages of this method are the ability to use accurate filters and its use of only a single sensor array. Its main disadvantages are the time-domain color distortion, the need for the threefold increase in image capture and bandwidth, and the mechanical issues associated with a fast rotating wheel.

The second method employs three sensors each with a different color filter mounted in front of them. The advantages of this technique are again the ability to use an accurate filter, not having any moving parts, and the simultaneous capture of the three colors. Its disadvantages are its use of three sensors and the mechanical alignment of these sensors with respect to each other. Currently, all high-end video cameras use this technique.

The third method, which is also the most widely used, is based on using color mosaic patterns. The sensor pixels are covered with different filters in a regular

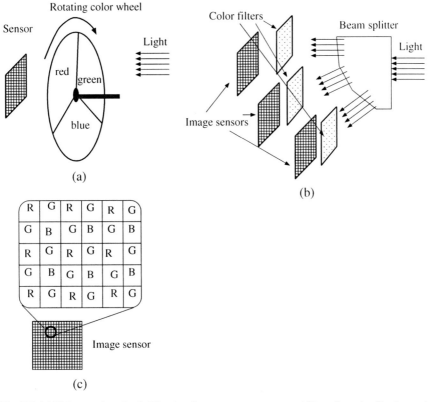

Fig. 5.7 (**a**) Using a color wheel, (**b**) using three separate sensors and filters for color filtering and (**c**) using color mosaic patterns

mosaic pattern. The most common is the Bayer mosaic pattern in Fig. 5.7(c). The main advantage of this method is its high integration. However, as the spatial sampling of the image for different colors happens at different positions, there will always be spatial artifacts present in the image, particularly at image discontinuities around the object edges, and at the boundary between two different colors.

For all techniques white balancing and color correction has to be used, as the output signals for each of the color channels depend on the filter characteristics. With the simplest technique color correction involves adjusting the gain of each color channel. For color mosaic patterns, as the spatial sampling of colors is different, more complex techniques have to be used to interpolate color, adjust the gain, and also take into account image boundaries.

5.3.4.2 Microlens

As the pixel dimensions shrink and the pixel fill factor in CMOS image sensors decreases, it becomes important to compensate for the associated loss (Fig. 5.8).

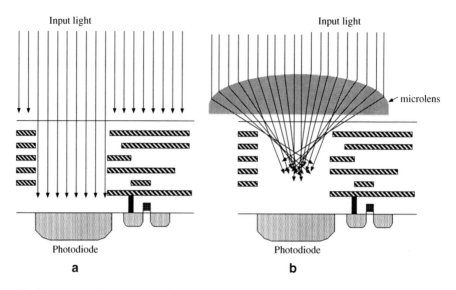

Fig. 5.8 (a) Input light loss due to fill factor and (b) using a microlens to redirect light to the active area of the sensor

Microlenses are often used to redirect light to the active area in the pixel, which would otherwise be lost in the inactive parts of the pixel, or reflected back from the surface of the routing metal layers. The effective gain of microlens structures typically ranges from 1.0 to 3.0 depending on the wavelength, pixel dimensions, and the vertical profile of the pixel stack. Although this may not seem significant, it is important as this gain enhances the input signal strength, and improves the signal-to-noise ratio.

5.4 Pixel Readout

In almost all image sensors the pixel provides the mechanism for converting the light energy into charge. This charge then has to be transferred and converted to a voltage and readout. The methods for readout largely depend on the system requirements and are determined by factors such as speed, noise, and power dissipation.

5.4.1 Charge Readout (CCD)

CCDs are naturally charge-based devices. The only method for reading out charge values from pixels is by shifting charge in the pixels across the sensor array rows and columns.

Charge-coupled devices (CCD) operate on charge packets in potential wells created by applying voltages to the gate of MOS capacitor structures. Figure 5.9 illustrates the concept. For proper operation, the order and the amplitude of voltages

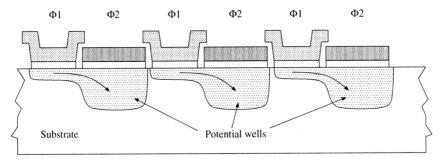

Fig. 5.9 (a) CCD operation. Charge is transferred from one potential well to the next by controlling the gate voltages in a sequence

applied to the CCD elements should be properly selected. Due to the highly optimized fabrication process for CCDs other circuits cannot be integrated on the same chip, and as such CCDs require a separate control and readout chip.

The first step in a CCD readout is transferring the charge from the array to its boundary. There are three main CCD imager architecture: interline transfer, frame transfer, and full transfer, as shown in Fig. 5.10.

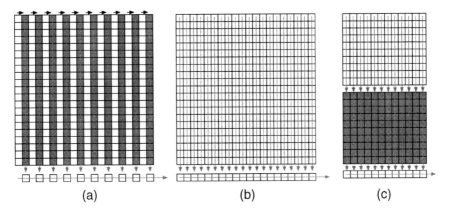

Fig. 5.10 (**a**) Interline transfer, (**b**) frame transfer, and (**c**) full-frame CCD structures

In an interline transfer CCD the charge in the entire array is shifted down one row at a time, and then serially shifted in the horizontal charge transfer row at the bottom of the array. If the readout is relatively slow, or there is a high-intensity input light, the image can be smeared, as charge is still collected while the image is being read out.

In a frame transfer CCD the photoelectric charge is integrated in the charge collection cells (shown in white) during the exposure. During readout, charge is first transferred to the charge transfer cells (depicted in gray). The rest of the process is similar to the interline transfer CCD. The charge transfer cells are covered with opaque layers to avoid any exposure to light.

Naturally the fill factor for frame transfer CCDs is about half of that of a full-frame CCD. In a full-frame CCD the entire array is shifted into a frame store array the same size as the imaging array. The frame store array is then read out similar to an interline transfer CCD. The main advantage of a full-frame CCD is that the fill factor in the imaging array is not reduced. It also presents a relatively fast image transfer out of the imaging array and is thus not affected by smearing as much as an interline transfer CCD.

The next step in CCD readout is converting the charge into voltage that can be sent off-chip and to the ADC for conversion. This is done using the circuit shown in Fig. 5.11. In this circuit the charge transferred from potential wells in the horizontal shifter is transferred to the sense node, which is connected to the gate of a transistor. The resulting voltage on the gate is then buffered using the source follower circuit and sent off-chip.

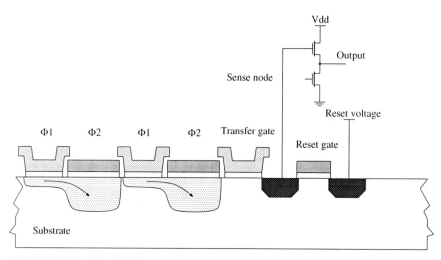

Fig. 5.11 CCD readout circuit

The overall readout time for a frame in all these techniques is almost the same. Also due to the fact that charge can only be read out by shifting from one cell to the next either in the horizontal or vertical direction, random access to a single pixel or a region in the imager is not readily available.

5.4.2 CMOS Imager Readout

The readout structures and mechanisms in CMOS image sensors are much more varied than CCDs. The variety goes all the way from the pixel circuits to column circuits, to ADC architectures, to on-chip image processing, and to image/information transfer off-chip.

In this section, we try to cover the most commonly used techniques at each stage. The readout circuits at the pixel level have already been discussed earlier in Chapter 4.

5.4.2.1 Passive and Active Readout

There are two distinct methods for transferring the image data between the imager and the rest of the system. In a *passive transfer* mode the imager produces and delivers output at a known pace, often limited by parameters such as bandwidth and power. In an *active transfer* mode the imager directs the acquisition of information from the chip. The obvious advantages of the active method are its more efficient management of bandwidth and energy. For many applications the active transfer method provides a way to reduce the amount of redundant input to the system, thereby increasing processing performance.

5.4.3 Array Readout

The pixel values from the imager array can be read out using one of the following methods.

1. **Scanning using decoders:**
 In this method each cell is selected by two N-to-2^N decoders in the X-and Y-axes. For random access readout this method is the only choice.
2. **Scanning using shift registers:**
 In this method a "1" is shifted through the shift register, and rows and columns are selected sequentially. Using this method several rows or columns can be selected simultaneously, and if the output of the cells is a current then summation of the output of the selected cells can be realized. This method has been used by [201] and [308] in their vision chips. An advantage of this method over the decoder-based method is the small number of lines required to control the operation of the shift register, although this is not a significant factor when the control logic is integrated on the same chip. These methods are illustrated in Fig. 5.12.
3. **Synchronous address-event representation (SAER):**
 In a conventional image sensor, the output of every pixel is read out, even though in many cases only a fraction of the pixels may indicate the occurrence of a spatial or temporal event. If a pixel activates a flag on the occurrence of an event, only those pixels with an activated flag need to be read, and a significant reduction in data acquisition time can be achieved. The values of the activated pixels along with their addresses can then be processed. This method has been used in some motion detection and compression smart sensors [8].
 In SAER each pixel requires some extra circuitry to detect the event and activate the flag signal. The readout multiplexers should also be able to detect the activated flags and bypass the reading of the rest of the pixels.

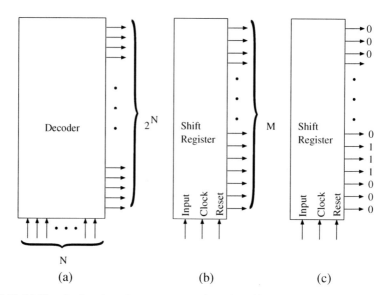

Fig. 5.12 (**a**) Decoder-based random access scanning, (**b**) shift register-based serial scanning, and(**c**) using shift register scanning to select several cells at a time

4. **Asynchronous address-event representation (AAER):**

 In SAER, events are checked during the readout phase. In AAER, whenever an event at a pixel occurs the value of that pixel is read out immediately. In a real situation several pixels may simultaneously be triggered by an event, so special arbitration circuits are required to allow only one cell at a time to be read out. The basic arbitration circuit checks the *acknowledge* and *request* signals for a pair of cells and only selects one of them. After the output of the selected cell is read, the other cell is selected. The arbitration circuits form a binary tree to ensure that only one cell can be selected.

 AAER has been applied to silicon auditory processors [309], but can also be used for any one-or two-dimensional arrays, including smart image sensors. In a simplified version of this method, the analog signal values are represented using the pulse-mode signals. Therefore, each pulse triggers an event. As the only important information from a pulse in this representation is its location (address) within the array and its occurrence time, only the address needs to be transmitted over the channel. However, the speed of the AER circuits should be higher than the rate at which the events occur, in order to preserve the temporal information in each pulse.

5. **Multi-channel readout:**

 In each of the above methods the transfer bandwidth can be increased by using multiple output lines. This is often more economical for the first two methods, as they do not require the address lines to be sent off-chip along with each data channel. Multi-channel readout is also more economical for chips with analog

outputs, as each output requires only one line for single-ended signals or two lines for differential signals.

The majority of image sensor architectures require random access to pixels or regions. The decoder-based scanning method provides this feature at no extra cost, while the shift register-based method requires some modifications to the control logic to provide random access. For SAER and AAER, the system has no control over which pixels or areas are read out, as the location of pixels which are read out depends only on their activity.

For most active pixel image sensors it is not really feasible to have a true random access mechanism, as the readout often involves resetting all pixels in a row, and therefore once a row has been accessed its contents are erased and no further reading of that row is possible.

Windowing on a small region of the array is another feature, which is often used in tracking systems. The decoder-based scanning method intrinsically supports this feature. The address-event methods can support this feature only by looking at those outputs whose address is within the required region. This can be achieved by ignoring the events coming from areas outside the required window.

5.5 Imager Interfaces

In a system where the image sensor chip is separated from the other components, such as image processing, or system processor, the output data from the imager have to be transferred via an image bus. The main imager interface buses are analog and digital, as shown in Fig. 5.13. In an analog interface, the output data are in analog form.

For analog video interfaces, the data are superimposed with horizontal and vertical sync signals to help identify the start of a frame and a line in a raster format. At the receiver end, first the frame and lines have to be identified. Then the analog data are sampled and converted to digital format. In an analog interface the number of pixels and the frame rate have to be known, so that the analog signal for each line is sampled for the correct number of horizontal pixels.

When the imager is integrated with an ADC and control logic, the image data are output on a digital imager bus. Here the horizontal and vertical sync signals provide markers for the valid data on the parallel data output. At the receiver end, the image can be reconstructed without any loss. Although a parallel digital bus may be suitable for small imager arrays, the data transfer bandwidth becomes restrictive for larger arrays, and system-level issues such as signal integrity and IO power dissipation may limit the achievable image transfer rates.

With the improved device integration new serial imager interface standards are introduced to decrease pin count, reduce power, and simplify system-level interfacing. For example, the Mobile Industry Processor Interface (MIPI) standard for image sensors, MIPI–CSI2, tries to address some of the interfacing issues for image sensors, in the context of mobile applications. At the physical level MIPI–CSI2 consists

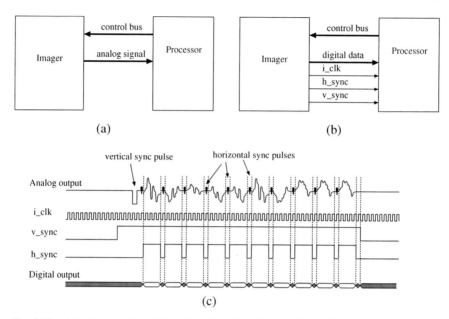

Fig. 5.13 (**a**) Analog interface, (**b**) parallel digital interface, and (**c**) typical signaling for analog and digital signals

of two or more pairs of sub-LVDS (low-voltage differential signaling) connectors. Image and control data are transmitted in packets. The transmission protocols are relatively complex and require dedicated capabilities at both the transmitter and receiver ends. A MIPI–CSI2 interface with four data lines is capable of transmitting about 4 Gb/s.

5.6 Vision System-On-Chip

Many image sensors have some degree of image processing capabilities, such as color correction and image compression. With the introduction of specialized image sensor processes into existing process technology nodes, for example, at $0.13\,\mu$m, it is now possible to create complex system-on-chip (SOC) designs where the image sensor is integrated with processor cores and specialized image processing hardware. Although the development cost and time for SOC designs can be high, they provide a significant improvement in power and performance, which are of high importance in portable smart camera applications. In the context of imager SOC architectures, the imager is considered as a block of IP (intellectual property), similar to other IP blocks, such as ADC and memory.

Part III
Embedded Vision

Chapter 6
Embedded Vision Challenges

Oliver Sidla, Norbert Brändle, Wanda Benesova, Marcin Rosner, and Yuriy Lypetskyy

Abstract The processing power of modern smart cameras allows more than just simple pixel manipulations for machine vision and inspection tasks. Smart cameras can run complex vision algorithms and thus gradually move the processing and analysis of video streams from large centralized servers to processing 'on the edge'. This chapter deals with the challenges of bringing high-level vision software from PCs to the limited and constrained development environments of smart cameras. We show that software development on smart cameras can be nearly as comfortable as on a regular PC platform and that processing speeds are sufficiently high for real-time analysis. We use two examples to illustrate how the actual porting of software to a smart camera is achieved. Finally, by employing a very complex pedestrian tracking algorithm as demonstration, we highlight the practical challenges of porting a large software system to a device with limited computing resources.

6.1 Introduction

Ever since the successful deployment in machine vision applications of usable and commercial smart camera models in the 1990s by the German manufacturer Vision Components in Karlsruhe, such devices have matured tremendously. Today, many different models with a broad range of underlying hardware architectures are available, ranging from small ARM5 CPU types to DSPs by *Texas Instruments* (TI) running at 1 GHz clock frequency. In this chapter we report on developments and the related challenges of implementing complex vision algorithms on smart cameras for surveillance. We describe ways in which software development on a smart camera can be made as efficient as possible by porting a standard vision library to a Vision Components camera. In addition, we present benchmarking results on several algorithms and finally, we provide insights into the complexity of a pedestrian tracking and counting algorithm.

O. Sidla (✉)
SLR Engineering, Austria
e-mail: os@slr-engineering.at

A.N. Belbachir (ed.), *Smart Cameras*, DOI 10.1007/978-1-4419-0953-4_6,
© Springer Science+Business Media, LLC 2010

An increasing demand for monitoring, event detection, and surveillance over extended spatial areas makes these tasks the ideal application areas for smart cameras. Instead of transmitting raw video data (possibly filtered by simple motion analysis), smart devices would analyze images on their own (on the edge) and send only high-level event information to a server. This way, the required processing power which is needed to analyze tens or hundreds of video streams in real time can be elegantly distributed over the network. The local processing approach is very conservative in the use of network bandwidth, it is much more fail-safe than a centralized server installation, and it can save large amounts of electrical power. However, when developing smart camera systems and vision software, the following issues are of great importance:

1. How to organize communication between cameras?
2. How to make the network structure scalable?
3. How to enable distributed processing over the network?
4. How to deal with the (still) limited resources on a smart camera?
5. How to organize the general software development cycle on the smart camera?
6. What are the necessary efforts to scale algorithms to the lower processing power of smart cameras?

This chapter deals with issues 4–6: how can one efficiently develop real-time vision on smart cameras?

Looking back 10 years, the first model introduced by *Vision components GmbH* (VC), the VC11, had an ADSP2181 processor, 512 kBytes of flash memory, 2 MBytes of RAM, and a 1/3" Sony grayscale CCD sensor with a resolution of 752×582 pixels. As an embedded computer with an integrated imaging sensor and a software development environment which allowed the developer to realize any application, this device was revolutionary. The use of the ADSP2181 processor with its segmented memory addressing requirement (very similar to the first Intel processors) made the handling of larger images and data arrays tedious and complicated to program. Still, the support libraries from Vision Components and their operating systems were highly optimized, very fast, and they allowed the development of robust real-time applications. A machine vision developer then had to learn the peculiarities of the hardware and the Vision Components operating system in order to efficiently work with the camera. Furthermore, the image processing code for the device from other sources had to be re-designed and rewritten in order to make good use of the camera.

In part, it is still true today that one has to take into account hardware-specific properties of smart cameras, but the dependencies on low-level system specifics have been greatly reduced since the introduction of the VC11. Nowadays vendors integrate more powerful processors into their devices and they use standard operating systems – predominantly Linux and Windows CE – all of which makes the software development process much easier. The following three camera models are typical devices belonging to the class of low, medium, and high performance, respectively, the FESTO camera, the Sony model, and the VC smart camera.

As a very small and compact Linux system, the FESTO SBOC-M-R1B camera has dimensions of only $85 \times 45 \times 45$ mm. It runs an Intel XScale PXA255 processor, has 32 MBytes of flash memory and 64 MBytes of RAM on-board, and is equipped with a Sony CCD sensor of 640×480 pixels resolution. It is the compactness of the embedded Linux operating system which makes such a small device possible. We were able to port the *Open computer vision library* (OpenCV) and a medium-sized application to this camera within days.

The latest Sony XI-V100 smart camera and its variations use a ULV Eden processor that is x86 compatible and runs at 1000 MHz clock frequency. The camera has 512 MBytes of internal RAM and supports between 1 and 4 GBytes of flash memory. It runs the Windows XP embedded operating system and thus provides a comfortable software development environment.

A TI TMS320C644x processor is built into the powerful VC44 smart camera series from Vision Components. These processors operate at a clock frequency of 1000 MHz and the cameras provide 4 MBytes of onboard flash memory, an SD card slot for up to 512 MBytes of additional flash storage, and 64 MBytes of dynamic RAM. The camera is equipped with different sensor types and resolutions to choose from. The 1 GHz TMS320C644x DSP is one of the fastest DSPs available today; it features a RISC-like instruction set which can schedule up to eight instructions in parallel, two L1 cache memories (32 KBytes each) and a 256 KByte L2 cache on chip. The VC44 smart cameras can deliver processing performance very close to that of a modern PC due to the power of the TMS320C644x architecture. Although Vision Components still uses the API of its original operating system and image processing libraries (with many new additions over the recent years), the convenience of a flat address space and the TI development software makes application development relatively comfortable.

Looking at the range of devices described above, it is obvious that the processing power of modern smart cameras allows much more than simple pixel manipulation. The CPUs in these high-performance smart cameras can run algorithms with a speed almost comparable to that of a modern PC architecture. However, there are some fundamental challenges arising from the properties and usual implementations of modern vision algorithms: the use of floating-point operations, fast memory/pixel access, vector/matrix operations on large data sets and software environments.

6.1.1 Use of Floating-Point Operations

Most of today's vision algorithms are designed with floating-point operations in mind, algorithms rarely involve integer arithmetic. This is in stark contrast to most of the embedded CPUs built into smart cameras – they usually do not provide floating-point hardware logic. This need to emulate the *float* or *double* data type in software makes computations at least 10 times slower than pure integer arithmetic. Standard machine vision for inspection, part counting, or metrology mostly deals with pixel-neighborhood processing for convolution or thresholding operations. The low floating-point requirements for such applications can easily be handled with

software emulation, but modern vision cannot rely on floating-point emulation if fast code execution is required.

Typical examples for high-level algorithms which are very common in object detection tasks are neural networks (NN), *support vector machines (Support vector machines (SVM))* [129], *Principal component analysis* (PCA), or the *Kanade Lucas Tomasi point tracking algorithm* (KLT) [532]. More recently, different kinds of feature computation methods which rely on normalization of feature vectors like histogram of oriented gradients (HOG) [134] depend heavily on floating-point math. The only way for such algorithms to run at acceptable speed on an embedded system is to rewrite them to fixed-point arithmetic and use 16-, 32-, or 64-bit integer operations wherever possible. Section 6.3.1 describes the porting of the floating-point-intensive KLT algorithm to fixed point, resulting in a tenfold speedup compared to the original program code.

6.1.2 Fast Memory/Pixel Access

Fast pixel access is required for many higher level vision algorithms computing local statistics, histograms, or gradients. Pixel access can easily become a bottleneck for embedded systems with a slow path from CPU to memory, and the problem is further compounded by the small caches given in embedded CPUs. In addition, the lower clock frequency of embedded CPUs compared to desktop architectures limits the number of machine instructions which can be executed per second, further slowing down the speed of feature computation.

A solution to this processing bottleneck can be found by algorithm design optimization or code optimization. It is usually much more rewarding to improve the design of an algorithm instead of squeezing out every bit of performance in its implementation (this later process of SW optimization is necessary of course, but relative speedups are lower). For example, the use of integral images [552] for feature computation at the cost of higher memory requirements can speed up the computation of local histograms by more than 100 times.

Memory is usually not a scarce resource in smart cameras and can therefore be easily traded for speed. Another hardware-based solution to the processing bottleneck is the use of specific instruction sets which help to improve instruction throughput on embedded DSP systems. The TI TMS320C644x CPU, for example, implements a very large instruction set architecture which can perform several instructions simultaneously in one clock cycle.

6.1.3 Vector/Matrix Operations on Large Data Sets

Many high-level vision algorithms such as PCA or SVM make use of vector/matrix operations, multiplying the problems described above and resulting in requirements that can considerably slow down the execution of such an algorithm on a smart camera. Facing the reality that with the typical sliding window/detector scanning

approaches thousands of PCA/SVM classification operations must be performed per image (see [129], [384], for example), developers seldom dare to use smart cameras for such tasks. Solutions for this type of processing obstacles need to operate on an algorithmic level. One way toward a solution is to downscale the processing requirements by 1 or 2 orders of magnitude by reducing the complexity of the underlying classifier (e.g., move from polynomial to linear SVM kernels instead). Another solution would be the cascading of classifiers and using only the more demanding computations (= complex classifiers) when most false detections have already been eliminated in earlier stages. The latter approach has proved to be very successful and is now standard in high-level vision; see [552] for more details and a very good introduction.

6.1.4 Software Development Environments

Finally one obstacle, albeit more psychological in nature today, is the complexity of embedded development solutions and the need to specialize explicitly in smart camera architectures and vendor-provided software development platforms. Smart cameras today support embedded Linux, or sometimes, embedded Windows variants.

Summarizing the latest hardware developments and looking at the challenges described above, we can observe that smart cameras have come a long way since their realization and commercialization in the 1980s. Writing software for these devices is nearly as convenient in terms of the developing, debugging, and testing process as it is for desktop systems. And their performance makes them very attractive candidates when it comes to the deployment of smart, distributed monitoring and surveillance systems. This was, for example, proven by the Israeli company ioimage.

The remainder of this chapter is organized as follows: Section 6.2 describes the porting of the *OpenCV* to a smart camera from Vision Components. Section 6.3 then describes the porting of two applications, motion analysis with KTL tracking and a complex pedestrian tracking algorithm.

6.2 The Use of High-Level Vision Libraries in Smart Cameras

Although initially devised as a library optimized for Intel processors, the source code of *OpenCV* is very portable and well suited to run on different types of operating systems and compiler environments. This section describes some of the conceptual and coding effort which was necessary in order to compile the code on the TI DSP developer framework. The tests and experiments presented in this section are based on the VC4465 model. It runs at 1 GHz, has 64 MBytes RAM, and a sensor of 640×480 pixel resolution. VC provides a software package which includes an image processing library for the development of applications in C or C++. This image processing library is very efficient and optimized for the TI C64xx processor

family and for the VC smart camera hardware. A drawback of this library is that its functionality is limited to classical image processing, without any support for high-level data structures or vision algorithms. We have therefore ported the *OpenCV* computer vision library to the VC smart camera. In the following, we first describe how we have adapted *OpenCV* for a VC camera and then compare execution times with a standard PC based on two benchmark tests.

6.2.1 Adaptation of the OpenCV Library for a VC Smart Camera

The *OpenCV* source code should be extended for the smart camera without loss of source code compatibility with the PC platform. The compiler must therefore be provided with information about the current processor architecture in order to choose the correct operating system functions. In our solution this knowledge is provided by a compiler variable (VC_DSP).

The most crucial point to be solved when porting the *OpenCV* is its memory allocation/deallocation compatibility with the memory management system used internally on the VC camera. The following three steps describe the adaptions on a source code level.

1. Memory allocation or deallocation can be carried out by using the VC system functions sysmalloc() and sysfree(). In order to assure the functionality of these two crucial functions with *OpenCV* on the smart camera, one needs to modify the original functions icvDefaultAlloc() and icvDefault Free() and also to create a new alloca() implementation using the VC sysmalloc() and sysfree() system calls:

 a. Insert additional prototype definitions stored in cxcore.h in case of using a VC smart camera:

   ```
   #if defined VC_DSP
        void*  VCmalloc( size_t size );
        void*  VCfree( void* point );
   #endif
   ```

 b. Implement the corresponding functions VCmalloc and VCfree and also an additional VC_DSP-specific implementation of the function icvDefault Alloc and icvDefaultFree performed in the file cxalloc.cpp. The following code snippet provides information about the implementation:

   ```
   #if defined VC_DSP
   // includes needed for VC smart camera
   #include <vcrt.h>
   #include <macros.h>
   #include <sysvar.h>

   void*  VCmalloc( size_t size )
   {
       void *pPointer = NULL;
       pPointer = sysmalloc( size, MDATA );
       return pPointer;
   }
   ```

```
void*  VCfree( void* point )
{
    sysfree( point );
    return NULL;
}

static void* icvDefaultAlloc( size_t size, void* )
{
    char *ptr, *ptr0 = (char*)sysmalloc(
            (size_t)(size + CV_MALLOC_ALIGN*((size >= 4096) + 1)
            + sizeof(char*)),MIMAGE);

    if( !ptr0 )    return 0;
    // align the pointer
    ptr = (char*)cvAlignPtr(ptr0 + sizeof(char*) + 1, CV_MALLOC_ALIGN);
      *(char**)(ptr - sizeof(char*)) = ptr0;
    return ptr;
}

static int icvDefaultFree( void* ptr, void* )
{
    // Pointer must be aligned by CV_MALLOC_ALIGN
    if( ((size_t)ptr & (CV_MALLOC_ALIGN-1)) != 0 )
        return CV_BADARG_ERR;
    sysfree( *((char**)ptr - 1) );
    return CV_OK;
}
#else
...
#endif
```

c. Activate the VC-specific memory allocation and deallocation functions found in file cxmisc.h:

```
/* get alloca declaration */
#ifdef __GNUC__
    #undef alloca
    #define alloca __builtin_alloca
#elif defined WIN32 || defined WIN64
    #if defined _MSC_VER || defined __BORLANDC__
        #include <malloc.h>
    #endif
#elif defined HAVE_ALLOCA_H
    #include <alloca.h>
#elif defined HAVE_ALLOCA
    #include <stdlib.h>
#elif VC_DSP
    #undef alloca
    #define alloca VCmalloc
#endif
```

2. For the sake of completeness, the function icvInitProcessorInfo() should also be extended with the cpu_info() details for the case of the TI processor. This additional initialization has to be carried out in the file cxswitcher.cpp:

```
static void icvInitProcessorInfo( CvProcessorInfo* cpu_info )
{
    memset( cpu_info, 0, sizeof(*cpu_info) );
    cpu_info->model = CV_PROC_GENERIC;
#if defined VC_DSP
    #ifndef PROCESSOR_ARCHITECTURE_TI64XX
    #define PROCESSOR_ARCHITECTURE_TI64XX 99
    #endif
    cpu_info->model = CV_PROC_TI64XX;
```

```
    cpu_info->count = 1;   // Number of processors;
    cpu_info-> frequency = getwar(CPUCLK) / 1000000;
#else
...
#endif
```

3. It shall be pointed out that attention must be paid when it comes to the functions
 `icvCreateContext()` and `icvDestroyContext()`. Their redefinition
 for usage on the smart camera requires special care. The reader is therefore
 encouraged to go through the modifications done in the file `cxerror.cpp`
 while reading the following source code:

```
#if defined VC_DSP
#include <vcrt.h>
#include <macros.h>
#include <sysvar.h>

static CvContext* icvCreateContext(void)
{
    CvContext* context = (CvContext*)sysmalloc( sizeof(CvContext), MDATA );
    context->err_mode = CV_ErrModeLeaf;
    context->err_code = CV_StsOk;
    context->error_callback = CV_DEFAULT_ERROR_CALLBACK;
    context->userdata = 0;
    return context;
}

static void
icvDestroyContext(CvContext* context)
{
    sysfree(context);
}
#else
...
#endif
```

Fixing the memory allocation functions for the VC development environment is
essentially all that has to be done for porting *OpenCV* to the camera. There are still
some minor issues remaining with I/O functions, but these incompatibilities can be
relatively easily emulated with existing functionalities from the Vision Components
software development libraries.

6.2.2 Running the OpenCV Library on the VC Camera

Industrial real-time applications are an important application domain of smart cam-
eras; hence it is important to know whether real-time performance can be achieved
on such devices. This section compares the performance of the *OpenCV* running
on a VC4465 camera and a 2–4 GHz Intel Pentium 4 PC with 1 GByte of memory
using two benchmark tests.

The first benchmark compares computing times for basic image processing func-
tions and is denoted as *low-level test*. The low-level test results of Table 6.1 show
that the PC is between 4 and 10 times faster than the VC smart camera. The only
outlier is the *erosion* function which is significantly faster on the PC. The differ-
ence between the VC native library and the *OpenCV* is small, especially taking into

consideration that the *OpenCV* functions have not been optimized in any way for the TI processor or the TI compiler.

Table 6.1 Results of the low-level benchmark test. All evaluated operations were carried out using an image of the size of 640 × 480 pixels. An n/a entry means that no exact corresponding function was available

| Operation | VC function | OpenCV function | Time on VC camera [ms] | | Time on PC [ms] |
			VC library	OpenCV library	
Filling image data with constant value	cset()	cvSet()	1.0	2.0	0.22
Pixelwise subtraction of two images	sub2()	cvSub()	6.3	8.8	1.26
Copying data from input image to output image	copy()	cvCopy()	3.5	3.3	0.74
Convolution with 7 × 7 Gaussian kernel	n/a	cvSmooth()	n/a	20.0	5.46
Erosion with 3 × 3 rectangular structuring element	n/a	cvSmooth()	n/a	35.3	0.72

The second, high-level benchmark test compares computation times of the *OpenCV* Viola Jones face detection implementation for one image in three different resolutions, using the same hardware configuration as for the low-level test.

The results listed in Table 6.2 show that the speed of the face detection function is about 10–13 times faster on the PC compared to the smart camera. Although this may seem much at first glance, the differences are mainly due to the challenges described in Section 6.1: the lower memory access speed of the VC camera and the use of floating-point and double operation in *OpenCV* for the Haar feature computation. Eliminating the floating-point operations , or at least optimizing these parts of the code, would certainly speed up the Haar detector function by at least twofold. The benefits of optimizing an algorithm for fixed-point arithmetic are demonstrated in Section 6.3.1.2.

Table 6.2 Face detection benchmark results

Image size [pixels]	Time on VC smart camera [ms]	Time on PC [ms]
782 × 582	5162	455
391 × 291	1336	105
195 × 145	272	28

6.3 Applications

This section describes the porting of two important computer vision applications to a smart camera. Section 6.3.1 describes the porting of the KLT feature tracker and

Section 6.3.2 shows a more elaborate example of pedestrian detection, tracking, and counting algorithms suited for crowded situations.

6.3.1 Motion Analysis

This section describes the feasibility of real-time tracking on a smart camera by the example of implementing and testing the KLT tracking algorithm [532] on a Vision Components VC4465 model with a 1 GHz TMS320C64x processor and a sensor providing 768×582 pixel images. The main idea of the KLT algorithm is to track significant image features in a series of images. Features are small image windows W (typically 7×7 pixels) that contain some texture information. They are chosen by first smoothing (to suppress noise), then differentiating the image, and choosing windows where both horizontal and vertical edges have the highest amplitude. Each window is then tracked from one frame to the next by an iterative procedure that estimates displacement and then matches the feature with subpixel accuracy. The procedure is repeated until the matching error drops under a given threshold. The displacement estimation is based on information about image gradients and involves calculation of the determinant of four integrals over the window W. Although the estimation is itself quite time-consuming, it reduces the calculation time essentially by reducing the number of matchings of W.

6.3.1.1 Methodology

The VC4465 camera communicates with its environment through a LAN which has not enough bandwidth to transmit raw images at a rate such that a sequence of images could be stored and used for tests. Saving images in the camera's internal memory is also not an ideal solution, since only 64 MB of RAM and 4 MB of flash memory are available. That is why most of the statistical calculations on image sequences were calculated on a PC in order to achieve replicable results. To this end, apart from the adaptations concerning memory management and input/output functions described in Section 6.2.1, exactly the same code has been used in the Intel/Windows environment and on the smart camera.

6.3.1.2 Optimizing the Floating-Point Version of the KLT Tracker Code

The first step in implementing the code on the smart camera was to modify our existing PC code so that it would compile correctly and without warnings on the DSP of the camera. The first FlKlt running on DSP used pure floating-point numbers for every pixel computation and achieved only 1.1 frames per second (fps) on image sequences with little motion, and 0.6 fps on sequences with very high motion content. High motion content causes the algorithm to go through all eight iterations of the search window fine-tuning process. In an initial attempt to speed up computation times, we have used the TMS320C62x/64x Fast Run-Time-Support

Library (FastRTS) from TI[1] which contains hand-optimized functions for floating emulation, both single precision and double precision. Replacing the slow original functions resulted in a speedup of approximately $2.5\times$ of the tracker. Still the code was by far not fast enough for practical application.

6.3.1.3 Porting to Fixed-Point Arithmetics

Emulation of floating-point calculations on a fixed-point processor is very ineffective – multiplication of two floating-point numbers can take 35 clock cycles, addition up to 81 clock cycles. Hence our goal was to attempt eliminating floating-point calculations in all critical sections of the code. In particular, the following functionalities needed to be optimized by replacing them with a fixed-point (integer only) arithmetic version:

- calculation of horizontal and vertical gradients on the image;
- horizontal and vertical smoothing of the image;
- interpolation of the feature window for subpixel accuracy (needed in calculating integrals, because W has to be matched with subpixel accuracy);
- calculation of the integrals of feature windows.

The main problem to solve was, how to represent numbers ranging from 0 to 1 with integers? This issue would occur in calculating gradients, smoothing image, interpolating image, and calculating displacement. If one considers a number stored with n bits, one can assign i bits to the integer part and the remaining $(n - i)$ bits to the fractional part. The amount of possible numbers in the integer part (2^n) will define the range and the smallest difference between two successive values in the fractional part ($1/2^n$) will define the precision. Here is a simple example of an 8-bit unsigned integer:

$$\frac{|2^7 \; |2^6 \; |2^5 \; |2^4 \; |2^3 \; |2^2 \; |2^1 \; |2^0|}{|128 \; |64 \; |32 \; |16 \; |8 \; |4 \; |2 \; |1|} \; .$$

This is a number with a range of 256 and a precision of 1 because it can represent $2^8 = 256$ different values, and the smallest difference between two successive values is $1/2^0 = 1$. This representation is denoted as 256.1. If one assigned 4 bits to integer part and the remaining 4 bits to fractional part this would yield

$$\frac{|2^3 \; |2^2 \; |2^1 \; |2^0 \; |. \; |2^{-1} \; |2^{-2} \; |2^{-3} \; |2^{-4}|}{|8 \; |4 \; |2 \; |1 \; |. \; |0.5 \; |0.25 \; |0.125 \; |0.0625|} \; .$$

This is a number with a range of $2^4 = 16$ and a precision of $1/2^4 = 0.0625$ (fixed point 16.16). Arithmetical operations on fixed-point numbers are rather simple. However, one must be aware that the multiplication of two 16-bit numbers will

[1] FastRTS Library for the TMS320C62x/64x processor, Texas Instruments.

normally produce a result which is 32-bit wide and of which the fractional part is 16-bit wide. If these additional bits are not available (multiplying 16-bit numbers into a 16-bit result) an overflow might occur. The solution is to use actually only half of the available bits for storing numbers.

After carrying out arithmetic operations, the result must be shifted back by an appropriate number of bits to obtain a fixed-point number with correct range and precision. The disadvantage of this approach is that in 32-bit integers one can effectively store only 16-bit values. The final data representation scheme in the KLT code looks as follows:

- 16-bit signed integer values represent all values in the code (exceptions see below);
- 8 bits are reserved for the integer part (since image pixels are represented normally as with 8-bit values);
- the remaining 7 bits represent the fractional part of a value;
- coordinates are stored as 32-bit signed values (7 bits of precision); fixed-point formats are converted when needed, this allows the algorithm to operate on images greater than 256 pixels width or height, respectively.

Variables are stored as 16-bit values only, but intermediate results in longer computations are kept as 32-bit temporary values as long as possible. Only when necessary, these values are converted back to 16-bit values. Since the determinant calculated to estimate the feature displacement requires a very large dynamic range, 80-bit integer numbers (supported by the TI compiler) had to be used in this case. This choice did not result in a significant decrease in program execution time because the determinant needs to be evaluated only once per matching of feature window W, and computation with 80-bit integers is still faster than using floating-point arithmetic.

The use of integer arithmetic within the C code of the algorithm implementation was quite transparently replacing the original floating-point code, because variables and their use could be identical most of the time. Only their underlying data type had to be changed and their interpretation had to be adjusted for visualization purposes.

We also attempted to optimize the code with *single instruction multiple data* (SIMD) instructions. However, SIMD instructions work on either 16- or 8-bit numbers on this processor. After decreasing the range to 3 bits and the precision to 4 bits, the algorithm stopped working properly and this idea had to be abandoned.

6.3.1.4 Execution Times

We have measured the execution time of a single tracking iteration for all implementations. For scenes containing little motion, mainly the gradient computation and smoothing parts of the KLT algorithm are executed, and the time invested for calculating the determinant is expected to be significantly less than for a scene with high motion content. We have therefore selected two different kinds of scenes (low and high motion) as described in Section 6.3.1.2 to evaluate the effects of different optimization efforts. The following configuration was used for the KLT tracker in all tests:

- image size of 384 × 291 pixels;
- 150 tracking points;
- window size of 7 × 7 pixels;
- at most eight iterations of feature fine tuning.

Table 6.3 shows how the time of a single tracking iteration could be reduced after each step of optimization.

Table 6.3 Time in milliseconds of a single tracking operation. The times have been measured on the VC4465 smart camera with a TI DSP at a clock frequency of 1 GHz

	FlKlt [ms]	FlKlt and FastRTS [ms]	FxKlt [ms]
Low motion	915	365	35
High motion	1675	630	68

Compiled for the PC, the fixed-point version with 22 ms per frame is slightly faster than the original floating-point code which takes 24 ms. This means that even on the PC a moderate speedup can be achieved with the fixed-point code (without the use of SIMD instructions which are now available on all modern processors).

6.3.1.5 Tracking Accuracy: Fixed Point vs. Floating Point

In order to test the accuracy of the implementation, a sequence of images with a crowd of people moving toward an elevator in an underground station was used. The sequence consisted of 799 images and was acquired with a frame rate of 15 Hz. For the evaluation 150 tracking points were chosen and the tracking process was performed for each point for all 798 frames. Subsequently, the absolute differences between all point positions of the fixed-point and floating-point implementations were binned in a histogram. The results can be seen in Fig. 6.1. The point coordinates have an average accuracy of 0.75 pixels.

Fig. 6.1 Histogram of accumulated differences between tracked point positions

In summary, a real-time point tracking algorithm can be ported to a smart camera with a fixed-point arithmetic processor with reasonable effort and satisfying accuracy. By making a sensible choice of the integer/fractional representation of variables in the code, a trade-off between speed and precision of the implementation is

possible. The resulting KLT tracker runs at a resolution of 384×291 pixels with a frame rate of 30 Hz on a 1 GHz TI digital signal processor.

6.3.2 Toward Pedestrian Tracking and Counting on Smart Cameras

This section describes a more elaborate vision algorithm for pedestrian detection and tracking, which is able to count people in very crowded situations such as escalator entrances in underground stations. Much progress has been made in the detection and tracking of individuals in groups, where the algorithms are often tested with a small number of people in laboratory settings [179, 449]. Realistic scenarios contain not only loose groups of people but also dense crowds of individuals. For imaging situations with shallow angles, mutual occlusions become so severe that no tracking algorithms can handle them effectively, even with a multi-camera approach. Our proposed algorithm for pedestrian tracking and counting tries to tackle this problem with a twofold strategy: (i) detect as many pedestrians as possible and accept false detections and (ii) integrate counting statistics over time.

Our approach for counting in crowds is based on the integration of multiple hypotheses for the detection of human head–shoulder regions in time and space. The algorithm does often not produce unique trajectories for each pedestrian (although those are usually very close) but we can show that after a one-time estimation of a systematic correction factor based on manually labeled ground truth data, accuracies of up to 98% can be achieved in very difficult real-world scenarios. Figure 6.2 shows one of the tested camera views in the underground station scenario, with superimposed tracks and a line for cross-sectional counting. A detailed description of our algorithm can be found in [495].

Fig. 6.2 Crowded scene in an underground station

There are publications that deal with realistic scenarios without resorting to people tracking, e.g., [87, 437, 106]. It seems, however, that their execution times are far from real time and therefore not yet portable to a smart camera. We show in Section 6.3.2.3 the porting of our algorithm to smart cameras.

6.3.2.1 Crowd Tracking Algorithm

Our tracking algorithm is based on the observation that pedestrians – regardless of their clothing and other characteristics – display a typical Ω-like shape which is formed by their heads and shoulders. The detection of these shapes by means of an active shape model (ASM), an attention filter which is built from a simple background model and the use of motion detection for prediction, forms the core of our proposed pedestrian tracking system.

The use of a simple *background*(BG) model for motion estimation allows us to remove many uninteresting pixels from each video frame and thus saves time for all subsequent detection stages. The BG model can be easily implemented in fixed-point arithmetic. It averages new frames into an accumulator frame whereby α controls the update rate:

$$BG_{new} = (1 - \alpha) \cdot BG_{prev} + \alpha \cdot Image_{new}. \tag{6.1}$$

After a coarse detection mask has been computed, potential pedestrian candidates are located with a very efficient histogram of oriented gradients (HOG) pattern detector [134]. This implementation is completely done in fixed point, including the linear support vector machines for classification.

We test with our active shape model (ASM) at every possible pedestrian location whether a particular spot in the image is likely to really contain a pedestrian or not. Our ASM implementation follows closely the method described by Cootes et al. [123]. A pedestrian contour in our work is represented as a model which consists of 23 shape points $M_i = (x_1, y_1, \ldots, x_{23}, y_{23})$. The local angle ϕ of a model point is defined as the direction of the vertex on its right-hand side when the contour is traversed in clockwise direction. A database of 130 shapes from real samples was used to train the ASM. The first five eigenshapes are used in the model and the volume covered by the training samples in this five-dimensional eigenspace defines the range for all newly detected shapes. We ensure that the model only deforms into shapes consistent with the set of training shapes by enforcing that the ASM coordinates in the eigenshape space lie within a maximum specified Euclidean distance to the closest training sample point.

Every pedestrian is characterized by a description which is calculated from a histogram feature vector. This description serves as a means to recognize individuals from frame to frame and to detect occlusions or disappearing pedestrians. In such cases the history of a known trajectory is extrapolated with a Kalman filter for a short period of time to fill these gaps in detection. Finally, the counting of passing pedestrians is performed with a virtual gateway and a simple trajectory-based heuristic. The tracking/counting algorithm can be summarized as follows:

1. Compute a simple background model
2. Create HOG candidates within the foreground mask
3. Remove false positives with the ASM, resulting in new pedestrian candidates
4. Merge similar overlapping shapes from Step 3 and from the previous video frame
5. Compute histogram features of remaining shapes
6. For each ASM shape

 a. Project the shape into the next frame using either KLT motion information or motion prediction
 b. In an area around the prediction from Step fa, find the most similar histogram feature vector for the predicted shape. Unmatched shapes remain at their predicted location
 c. Merge the results of Step fb with the candidates from Step fa to reduce the number of redundant shapes
 d. ASM matching at the location specified in Step fa with the initial shape model from the previous frame – the new shape is only allowed to differ slightly from the previous frame

7. Link new shape locations to their respective trajectories
8. Pedestrian candidates from Step 3 start new trajectories
9. Remove trajectories that have been predicted more than eight times

6.3.2.2 Statistical Counting Performance Analysis

We have performed a thorough statistical analysis of the counting accuracy based on the algorithm described above. We show sample results for the indoor underground scenario depicted in Fig. 6.2, where counting is performed for the two ascending escalator lanes.

Figure 6.3(a) shows the evaluation of counting results for a 1-h period on a working day between 8 a.m. and 9 a.m. The manual (ground truth) counts have been obtained with a video annotation software. The accumulated sum reveals that the automatic count is systematically overestimated. Figure 6.3(b) depicts a linear regression line through a scatter plot of the manual vs. automatic count for accumulation bins of approximately 20 s. Figure 6.3(c) shows the same for longer accumulation bins of approximately 120 s. Interestingly, the slope of the regression line for both accumulations is approximately 89%, meaning that the counting algorithm systematically overestimates the true counts by the same extent for the two binning intervals. In fact, the strong linear dependence can also be observed for all other binning intervals and the slope varies within a small range.

Figure 6.3(d) shows statistics for the cross-validation of the linear model: 50% of the data are used for the modeling and the remaining 50% are used as a test set. The mean absolute error decreases with increasing counting intervals and reaches 10% for an accumulation time of 240 s. The limited amount of 1-h manual annotation data do not produce statistically meaningful results for larger accumulation times. However, the counting example in Fig. 6.3(a) shows that after applying a correction factor of 0.89 to the automatic counts, the relative error can be decreased to 5%

for a counting interval of 30 min and 2% after 1-h. We have also evaluated a completely different outdoor scenario, with similar systematic dependencies, indicating a statistically sound basis of the counting approach; see [495] for more details.

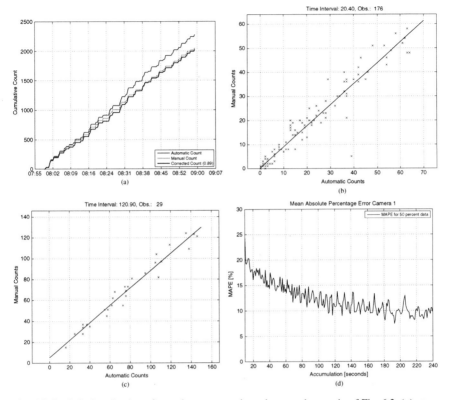

Fig. 6.3 Statistical evaluation of counting accuracy in underground scenario of Fig. 6.2: (**a**) accumulated manual, automatic and corrected counts for 1-h; (**b–c**) linear regression of automatic and manual counts for approx. 20 s counting periods (accumulation bins) and approx. 120 s counting period; and (**d**) validation of the linear model

6.3.2.3 Running the Algorithm on an Embedded System

The implementation of the crowd tracking algorithm will eventually run in real-time on a smart camera. Some parts of the algorithm currently run as prototype modules on a smart camera, although not all of its components can be executed in real-time yet. This section provides an estimation of execution performance and current bottlenecks on a Vision Components VC44 smart camera. The main components of the pedestrian tracking algorithm are the KLT Motion analysis, the HOG pedestrian detection stage, and the ASM verification stage. The requirements on the runtime performance of each algorithm for a typical real-world scenario can be estimated as follows:

- Frame resolution: 384 × 288 pixels
- Frame rate: 15 frames/s
- Track 20 pedestrians per frame
- Test 1500 HOG detector windows per frame
- Test 20 HOG detector results in first stage with ASM with four iterations each
- Track 20 pedestrians per frame with ASM model, eight iterations each

A real-time implementation of the KLT point tracker is described in Section 6.3.1. This implementation can directly be used on the smart camera. The HOG pedestrian detector has been completely implemented in fixed- point arithmetic. The cells to block accumulation and normalization are computed in fixed point using 32-bit arithmetic with an effective fractional accuracy of approximately 6 bits. In order to speed up feature computation, 9-bin integral histograms (32 bits per entry) were implemented, since memory was not a bottleneck in the camera. All subsequent cell computations are performed on these integral images which make the HOG detector essentially independent of the detector window size.

When designing the actual implementation of the ASM it was crucial to make sure that the code be suitable for fixed-point architectures in the long term. The Sobel operator is used for gradient magnitude and orientation computation (its output is also directly used for HOG processing), and all time-consuming mathematical operations are replaced by look-up tables.

Table 6.4 summarizes the estimated and benchmarked timing results for the main processing stages. It can be seen that the current implementation of the pedestrian tracker cannot yet achieve real-time performance, since only about 6 frames/s can be processed. The slowest algorithm is clearly the ASM, which uses about 96 ms per frame. In order to improve the speed of the implementation on the smart camera, the following measures will be taken:

- Improve the ASM implementation, some parts are still using floating point, speedup of about 30%
- Use fewer ASM iterations, six instead of eight per pedestrian, speedup of 25%
- Improve the KLT implementation further, speedup of 20%

Table 6.4 Timing results for the crowd tracking core algorithm – all times are in milliseconds for an average number of 20 pedestrians per frame. Column *PC timing* lists the measured times for a PC x86 architecture at 2.0 GHz, column *SC timing (est)* lists the estimated times on a 1 GHz Vision Components VC4465 smart camera model running at 1 GHz. *Total SC time* lists the total time used for the algorithm for all detections in a frame according to the requirements for runtime performance specified above

Algorithm	PC timing	SC timing (est)	# Runs/frm	Total SC time/frm
BG model	0.500	2.000	1	2
Sobel	5.000	10.000	1	10
KLT	10.000	40.000	1	40
ASM	0.100	0.400	240	96
HOG	0.002	0.008	1500	12
Total				**160**

Accounting for the possible speedups, we estimate that on the VC44 smart camera, the pedestrian counting application will run at about 10 frames/s for an average of 20 pedestrians in the video frames. This is below the minimum frame rate for good counting performance which we have defined above, but it might be sufficient for some applications. Further significant improvements can only be achieved by modifying and improving the algorithm itself.

Chapter 7
High-Performance Smart Cameras

Johannes Fürtler, Ernst Bodenstorfer, Michael Rubik, Konrad J. Mayer,
Jörg Brodersen, and Christian Eckel

Abstract This chapter describes a high performance smart linescan camera develo-
ped to be used in quality inspection systems for high grade printed matter. Such an
inspection system has to meet many demanding requirements as very high inspec-
tion resolution (better than 100 m) at high production speeds (up to 20 m/s). A total
data rate of several Gigabytes per second has to be processed continuously. Under
consideration of reasonable system costs, the term high performance is related to the
most critical design factors: resolution, speed, throughput, and inspection quality.
The smart camera approach overcomes the bottleneck between high speed imager
and remote image processing system. Powerful processing units like high end field
programmable gate arrays and digital signal processors are integrated into the cam-
era housing. Thereby, it enables outstanding quality inspection in terms of accuracy
and economical feasibility. Architectural elements covered in this chapter include
the multiple exposure method, which allows the design of high speed linescan cam-
eras based on area scan images, high throughput image processing, high level image
processing, as well as a fiberoptic-based 10 Gbit Ethernet used as camera interface.
The chapter concludes with an outlook to future developments in the field of high
performance smart cameras.

Keywords Machine vision, surface inspection, real-time image processing, Field
Programmable Gate Array (FPGA), Digital Signal Processor (DSP), SoC, multiple
exposure, embedded vision system, 10 Gbit Ethernet, fiberoptic interface

7.1 Introduction

Over the last few decades the concept of smart cameras has evolved from sim-
ple devices to today's complex vision systems (see Chapter 1). A broad range of
applications has been realized by implementing the smart camera paradigm. Smart

J. Fürtler (✉)
AIT Austrian Institute of Technology GmbH, Donau-City-Straße 11220 Wien, Austria,
http://www.ait.ac.at
e-mail: johannes.fuertler@ait.ac.at

A.N. Belbachir (ed.), *Smart Cameras*, DOI 10.1007/978-1-4419-0953-4_7, 119
© Springer Science+Business Media, LLC 2010

camera-based products can be found in many different markets, including consumer electronics, video surveillance (see Chapter 17), biometry, transportation, and machine vision (see Chapters 16 and 19). It is not surprising that the 2008 market study conducted by the AIA revealed that smart cameras make up the fastest growing sector in the machine vision market [29]. Therefore, smart cameras can be considered as a technology driver for the entire machine vision business.

This chapter presents a *high-performance smart camera* (HPSC) which has been developed for application in print inspection. Print inspection systems are used for automatic quality assessment of printings on substrates like paper, metal foil, and plastic foil. Among them, a class of products exists where a maximum quality of the print must be maintained. Examples are security printings like banknotes and stamps. The quality of a country's banknotes has a direct impact on the likelihood of counterfeiting and, therefore, on the stability of that currency. Another example is consumer goods packaging. There is a strong link between the perception of the package and the quality of the product, especially when well-known brands are considered. Both examples show that in some industries there are strong forces to ensure *perfect* print quality. Moreover, high production throughput is required in order to keep costs per unit low.

Today, automatic quality inspection systems can solve this task. However, for the above applications it is still a big challenge because of demanding requirements. Taking into account excellent inspection accuracy and economic feasibility these are resolution, speed, and throughput.

Typically, a number of cameras (more than a dozen) are used to acquire images of the printed matter. Spatial resolutions of better than 100 µm/pixel and transport speeds of up to 20 m/s can easily result in a total acquisition data rate of several Gigabytes per second. Roughly spoken, within a second, each camera delivers the equivalent amount of data stored on a maximum capacity compact disk. The capability of adequately processing this huge data volume in real time is one of the main differences of the HPSC compared to common smart cameras.

Based on the image data stream, the task of the image processing unit is to compute the quality decision. Extremely spoken, the input data have to be reduced to a single bit of information: either the quality of the inspected print is acceptable or not (the print has to be rejected).

In most cases, the image processing unit involves a number of succeeding processing stages. The aim is to suppress irrelevant information and/or to extract relevant information. Unnecessary information can be discarded, thus reducing input data to be processed by subsequent stages. However, in some cases information has to be added before effective data reduction takes place.

To cope with the enormous amount of collected image data, it is desirable to move image processing tasks into the camera to reduce the bandwidth requirement for the data that have to be transferred from a camera to a separate higher level processing unit. The smart camera principle allows an integration continuum which

spans from integration of low-level image processing to integration of the complete inspection system that delivers just the one bit of final information.

Inherently, an imaging solution requires very complex interactions between many components (cameras, optics, lighting, and mechanical components) on the one hand and the manufacturing process on the other hand. Hence, to reach optimal results the quality inspection system must be tailored to the specific application. Consequently, it is difficult or even impossible to lay down general rules for how to design or how to compare high-performance smart cameras.

The aim of this chapter is to show a powerful vision system integrated into a small camera housing [566] and to give ideas for future progress of high-performance smart cameras. The focus is on results of a research project which was set up to replace a traditional inspection system (cameras are connected to a remote image processing unit via high-bandwidth links) by a number of interconnected *High-performance smart camera* (HPSC)s. Thereby, the inspection accuracy can be increased as more data from the image sensor can be processed. Furthermore, system costs can be lowered.

To minimize development risks the project was divided into four phases. The first goal was a feasibility study for an inspection system based on *field programmable gate array* (FPGA) and *digital signal processor* (DSP) technology. In 2006 a prototype was presented [194]. In the second phase (2007), a smart high-speed color linescan camera was developed [364, 195, 67]. In the third phase (completed in 2008) the Camera LinkTM [434] interface was replaced by a fiberoptic 10 Gbit Ethernet interface; additional FPGA resources were integrated as well. The final step to downscale the prototype *digital signal processor* (DSP) module to fit into the camera's housing will be completed in 2009. This chapter extends previous publications and adds results of the last two phases.

Section 7.2 introduces most important aspects of automatic print inspection systems. As many design trade-offs can be explained only with regard to the specific application, the requirements for the presented camera are summarized. The term *high performance* is defined, as it only makes sense in context of the application. As the presented camera is a linescan device, the linescan operation principle is briefly discussed and advantages of sensors in *complementary metal oxide semiconductor* (CMOS) technology for high-speed linescan applications are addressed.

Section 7.3 covers the image processing algorithms that are implemented into the HPSC. The *Multiple Exposure*TM (MX) method is described, which enables the design of high-speed linescan cameras based on areascan image sensors and, therefore, represents a key element in the proposed camera architecture. To emphasize the complex image processing implemented in the HPSC (with concentration on high-throughput computation in the FPGA), the complete image inspection pipeline as proposed for the print inspection task is described.

Section 7.4 focuses on the implementation of the HPSC. The partitioning of image processing functions to hardware and software is discussed.

Finally, Section 7.5 tries to give an outlook to future developments in the high-performance smart camera sector.

7.2 Fundamental Aspects

In the field of industrial print inspection image acquisition in high resolution, from several viewpoints and with different spectral sensitivities (color, infrared, ultraviolet), is required to meet the inspection quality goals. The basic principles of print inspection systems are described in Section 7.2.1.

Section 7.2.2 shows that off-the-shelf smart cameras are far from meeting requirements for high-end industrial print inspection. Therefore, the term *high performance* is defined in the context of print inspection.

The operation principle of a linescan camera, such as the HPSC, is described in Section 7.2.3. The *time-delayed integration* (TDI) mechanism, which is the foundation of the MX method, is explained in Section 7.3.1.

The MX method exploits unique features of CMOS imagers; hence, the most important features of CMOS sensors are summarized in Section 7.2.4.

7.2.1 Embedded Vision System for Print Inspection

Different classes of print flaws can be distinguished, for example, lack of parts of the print, blotches of ink, smears, or scratchers. Figure 7.1 shows examples. In order to automatically detect these flaws by means of image processing methods, one possible solution can be outlined by (i) acquiring images, (ii) extracting characteristic features, for example, color-separated or edge-enhanced images, and (iii) checking these features against a reference set, which is usually derived from images of acceptable prints, also known as training set or *master image* set.

Fig. 7.1 Typical print flaws. Austrian stamps "200. Geburtstag von Johann Nestroy" (motif by O. Stefferl and W. Pfeiler, 2001) and "Weihnachten 2001" (motif by W. Seidel)

A number of samples are required to compensate small variations inherent to the printing process, which still result in *acceptable* prints. Also, variances that are perceived as flawless by the human eye should be tolerated. Furthermore, the inspection should be insensitive to small deformations of the print resulting from substrate expansion and/or contraction. However, severe deviations should be recognized.

Using different color separations for print flaw detection relates to the human eye's tolerance for gradual changes in intensity, which might be caused by variation of inking. These fluctuations can be tolerated, if they do not exceed a certain level. On the other hand, the human eye is especially sensitive to fine lines or scratches. A common print flaw in intaglio printing processes are so-called doctor streaks, which are typically very thin lines in parallel to the moving direction of the print roll. Doctor streaks serve as a good example for print flaws which can be easily detected by humans, whereas machine-based detection is very difficult and requires high-resolution images. Hence, it is important to detect these structural deviations related to local changes of image intensity values, which can be enhanced by edge filters.

Figure 7.2(a) shows main elements of a classical print inspection system for sheets of paper, e.g., banknotes or stamps. The printed matter is transported by means of a conveying mechanism. Hence, linescan cameras can be used for image acquisition. The acquired image data are fed into the *image processing system* (IPS), which computes the decision to separate waste from high-quality products in real time. Usually, the processing system is at a distance (above 10 m) from the high-speed cameras. Typically, the machine's speed is in the range of 10 m/s and faster. In order to acquire images for required spatial resolution down to 100 μm, the line rate of the cameras has to be in the range of 100 kHz and above, resulting in several Megabytes of image data per second (100 kHz · 10 pixel/mm · 30 bit/pixel · number of cameras) and for every millimeter of the inspected surface's width.

Fig. 7.2 (**a**) Classical system: cameras and remote image processing system. (**b**) Smart camera-based solution

The bottleneck of the traditional image processing system shown in Fig. 7.2(a) is the link between the cameras and the image processing unit because of the amount of raw image data that have to be transferred. In many cases the necessary computing power of the image processing unit has to be provided by a number of high-performance DSPs, which are linked by high-speed data communication channels.

To cope with the enormous data rate from the image sensors, it is desirable to move image processing into the camera to reduce the amount of data that have to be transferred. Additionally, the camera should support high-resolution inspection with respect to human perception of quality.

The HPSC is based on the same camera module described earlier [195, 67]. However, additional processing and interfacing has been integrated directly into the

camera. This will lead to a system architecture as depicted in Fig. 7.2(b), where all processing units are integrated into the camera. Multiple cameras are connected via a switching unit. The *machine control unit* (MCU) is required for interfacing with the printing or sorting machine. The proposed architecture enables improved inspection accuracy as more image data can be processed. Additionally, system costs can be reduced due to integration of components.

7.2.2 Definitions

There are many different smart cameras available on the market, including smart cameras aimed for surface inspection, for example, [53, 116, 568, 25]. If a smart camera solves an intended task it will obviously provide *enough* performance. But when to call it *high*-performance smart camera?

According to the AIA study, only 0.8% of all smart cameras sold in North America in 2007 were equipped with an image sensor capable of 500 frames/s and more [29], while 98.0 % fall in the range $30 - 60$ frames/s. Only 19.0% of all smart cameras sold were linescan devices. Moreover, the market share of color cameras was 33.6%. Hence, the HPSC addresses a very narrow market. However, today's leading-edge technology can be the foundation for tomorrow's mass market.

In the context of computer systems, the term *performance* is often associated with simple characteristics like clock rate or number of operations per second. At the next level, benchmark suites are used to figure out a single number describing a computer system. However, if a benchmark suite does not reflect the program flow of a specific application, benchmarks can be very misleading.

Equally, a smart camera can perform very well for a specific machine vision task, but very poorly for other tasks. From our point of view, the performance of a smart camera has to be defined in the context of its application. Obviously, the set of characteristics chosen for the assessment mostly depends on the specific application. Consequently, it is very difficult to compare smart cameras, except in the rare case that they were designed for the same application. Hence, the few high-performance smart cameras mentioned in the literature, for example, [388, 389], as well as commercially available high-speed smart cameras, for example, Vision Components VC44xx series and Photonfocus SM2-D1024-80, cannot really be compared with the HPSC.

The attribute *high performance* is used for the HPSC, as it has not only outstanding application-specific performance (refer to Section 7.3) but the camera also features top performance characteristics that are independent from the application. For example, with up to 100 kHz line rate the HPSC was the fastest color linescan camera available on the market in 2007 (first phase). The high line rate was achieved by integrating the *Multiple exposure* (MX) method directly into the camera.

7.2.3 Linescan Cameras

Linescan cameras play a predominant role in the field of quality inspection of printed matter [29]. The advantage of linescan cameras is that objects can be

continuously scanned. Furthermore, illuminating a single line is most often easier to accomplish than illuminating a two-dimensional field of view using areascan cameras.

In the past, the majority of linescan cameras were based on CCD image sensors [258]. Recently, more and more linescan cameras based on *Complementary metal oxide semiconductor* (CMOS) image sensors were introduced [259, 324, 325, 49]. For print inspection applications, often color cameras are required. Three methods are commonly used for color linescan cameras: (i) beam splitting and three sensors, (ii) trilinear sensors, and (iii) alternating color filters on one or two active sensor rows (mosaic filters).

Cameras utilizing beam splitting by means of prisms are known for highest color fidelity. However, high-quality color filters (mostly interference filters), three separate image sensors, and sophisticated mechanical adjustment contribute to a bigger size and higher costs compared to other methods.

Trilinear cameras take advantage of imagers with three rows of pixels being sensitive to different spectral bands, for example, Chromasens' Aleos™ camera [113] or Dalsa's Piranha Color [135]. The temporal delay between these three images is compensated within the camera. The main advantage is the lower price of this type of camera.

Mosaic filter-based linescan cameras are similar to areascan cameras with the Bayer filter [51]. Within the row(s), pixels with different color sensitivities are arranged, for example, Basler's sprint™ camera [49]. Consequently, some color components delivered by the camera are interpolated between luminance values of neighboring pixels.

Images are acquired by triggering the camera with a line trigger signal. This signal can be derived from the object's speed by means of a shaft encoder. At every trigger impulse, the camera delivers pixels of a one-dimensional line. The two-dimensional image of the inspected object results from the repeated triggering of the camera, while the object passes across the camera's lens.

Figure 7.3 illustrates the tight coupling between speed, v, aimed constant spatial resolution in transport direction, d, and the line trigger frequency, f_T, given by $f_T = v/d$. The spatial resolution perpendicular to the transport direction depends on the reproduction scale defined by the optical system and the pixel size, whereas d is defined by the shaft encoder's resolution.

In practice, the exposure time is a fixed parameter and will be set to the longest possible value, but has to be shorter than the minimal line trigger period, $1/f_T$. On the other hand, the exposure time is not a completely free parameter. A better (smaller) resolution in transport direction and/or higher transport speeds can only be achieved by reducing the exposure time. This obviously leads to problems associated with the limited sensitivity of the sensor pixels and limitations in the illumination power that can be achieved.

Line rate of 100 kHz as used in industrial print inspection leads to an exposure time below 10 μs. Compared to consumer cameras, where exposure time in the range of milliseconds is common, this is a very short exposure time. Hence, very intensive illumination of up to several hundred thousand lux is used. Additionally,

the light is directed to a thin zone with a profile as indicated in Fig. 7.3. Nevertheless, signal levels are very small and noise becomes a limiting factor.

Fig. 7.3 Linescan camera principle

A solution to enhance light sensitivity and to improve image quality is to use CCD-based TDI cameras [136]. Like areascan imagers, CCD-*Time delayed integration* (TDI) imagers have a few rows (stages) for image acquisition. However, the rows are used to accumulate photoelectric charges while shifting them from row to row with the same speed as the object. Consequently, the generated charge is collected over several exposure cycles without reducing the resolution by motion blur.

Advantageously, TDI improves the signal-to-noise ratio [505]. The signal is accumulated proportionally to the number of summation stages, N. On the other hand, uncorrelated noise components are summed up proportionally to \sqrt{N}. Hence, a TDI camera with N stages improves the signal-to-noise ratio by the factor \sqrt{N}.

Most TDI cameras are monochrome and based on CCD imagers. Recently, attempts have been made to apply the TDI principle to CMOS sensors [313]. The reasons for this are the improvements in the CMOS technology for imagers, the better availability of the CMOS process, and finally the manufacturing costs. In Section 7.3.1, it is shown how the MX method (a digital equivalent to the CCD-TDI) can be used to enhance light sensitivity of a CMOS sensor.

7.2.4 CMOS Image Sensors

In contrast to CCD technology CMOS imagers offer several advantages [259, 324, 325] (also refer to Chapters 4 and 5). Features of the CMOS technology which enabled the realization of the HPSC include (i) read-out of arbitrary regions, (ii) simple exposure control, (iii) high speed due to on-chip column-parallel analog-to-digital converters, and (iv) almost no pixel blooming and smearing.

Especially important is the unique feature to read-out regions of interest, thus increasing the speed by reducing the image size. Combined with the exposure control, the MX method enables high-speed linescan cameras based on areascan devices.

7.3 Data Processing Pipeline

Image processing effort in print flaw detection largely depends on the spatial resolution, which must be chosen in order to reliably distinguish fine structures of the print

from defects. Consequently, resolution and production speed determine the amount of image data that have to be acquired and processed per second. Contemporary image sensors deliver a raw image data rate of more than 1 Gigabyte/s. In context of quality inspection it is usually impossible or at least too expensive to extensively process the raw data rate. Hence, it has to be drastically reduced. The challenge is to extract the information which is necessary for the quality decision. All other data can be discarded. However, this differentiation is not a trivial task. Therefore, trade-offs regarding computational effort, available resources, costs, etc., have to be made.

For high-speed print inspection enabled by the MX method we propose a five-stage image processing pipeline applied to the acquired raw image data as depicted in Fig. 7.4: (i) timing accurate accumulation of multiple exposures, (ii) image conditioning, (iii) extraction of features, (iv) examination for deviations to the reference image, and (v) analysis and classification of the print flaws.

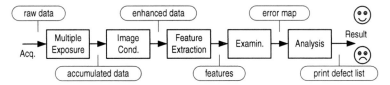

Fig. 7.4 Image inspection pipeline from image sensor data to inspection result

In this section the data flow through the image inspection pipeline is presented. Simultaneously to the data flow a quite complex control flow has to be maintained. For example, parameters have to be adapted dependent on the inspected image region. However, control flow issues are beyond the scope of this chapter.

Image inspection is a computationally demanding task. Other criteria that have to be considered do not contribute as much to the required processing performance. Extensions to the basic image inspection pipeline are discussed as applicable.

7.3.1 Multiple Exposure Stage

The MX method enables high-speed linescan cameras based on CMOS areascan imagers [364, 67, 365]. The MX algorithm transfers the accumulation of photogenerated charges known from CCD-TDI imagers to the digital domain. Hence, images taken with a CMOS area imager are summed up in an FPGA. For color imaging, a Bayer filter matrix [51] is used. The typical Bayer pattern results from alternating green and red (GR) pixels in even rows and blue and green (BG) pixels in odd rows.

Figure 7.5 shows a sequence of six sequentially acquired area images (at time instants t_1–t_6). The object to be inspected is the letter A printed on a sheet of paper, which moves from left to right. Between two consecutive images the sheet moves exactly by a distance corresponding to the height of one sensor row. Figure 7.5

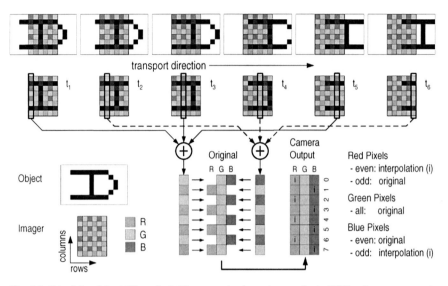

Fig. 7.5 Principle of the MX method. The example shows how a single RGB color output row is calculated from six color images of a moving object at times t_1–t_6

illustrates that every pixel of the A is scanned six times (as a result of the six rows of the image sensor). Due to the Bayer pattern every object point is sampled three times by BG rows and GR rows, respectively. Consequently, three corresponding pixel values can be summed up. As G is available at every pixel column, all green pixels have been acquired by the imager, whereas B/R is only available in even/odd columns. Missing B/R pixels have to be interpolated. Such interpolation algorithms are known as color filter array de-mosaicing algorithms [354].

The number of accumulation operations per second is equal to the number of pixels read out from the image sensor. For example, a camera with 82 kHz operation using four sensor lines (two accumulations) of 2,352 pixels, the number of 14 -bit-wide accumulations is 771×10^6 (82 kHz · 4 rows/image · 2,352 pixels/row).

The MX method can be applied to any CMOS areascan imager. For sensors with a global shutter, the behavior is the same as for CCD-TDI. However, when a rolling shutter is considered, the rows of the sensor are not exposed simultaneously. Rather, for each row charge accumulation starts at a different point in time, causing a small asynchronicity between acquired lines. Consequently, the acquired area image will appear compressed or stretched a little in transport direction which depends on the relation between the object's transport speed and the read-out speed. To compensate the scaling, the line frequency f_T for exact synchronicity has to be adjusted by the factor $(N \pm 1)/N$. N denotes the number of active rows for accumulation, $+$ or $-$ depends on the relation of readout direction and transport direction.

7.3.2 Conditioning Stage

The image conditioning stage summarizes image processing aimed to compensate or reduce imperfections in the acquired sensor data. In the HPSC this stage contains flat field correction to compensate pixel-wise sensor *dark signal non-uniformity* (DSNU) and *photo response non-uniformity* (PRNU), color filter array de-mosaicing to interpolate missing color components [354], color correction with a configurable 3×3 matrix [247], and a correction of geometric distortion [255]. For the definitions of DSNU and PRNU, refer to [236]. The main reason for geometric distortion is the imperfection of the optical system, i.e., the camera lens, which leads to a variation of the local resolution over the field of view. For linescan cameras the distortions can be compensated with significantly less effort than in the two-dimensional case, as just a coordinate transformation in one dimension (parallel to the line of pixels) has to be applied to the image data. Consequently, lenses with greater distortion can be accepted, thus allowing the use of cheaper optical components.

7.3.3 Feature Extraction Stage

The aim of the feature extraction stage is to extract relevant information, while irrelevant information can be thrown away. For detection of print defects, separation of chrominance in lower spatial image frequencies and luminance in higher frequencies turned out to be suitable. High frequencies contain information on local intensity variances where deviations are easily caught by human eyes. To reduce data, the color information can be removed without losing too much information on image details. On the other hand, chrominance information in low-pass filtered images can be used to reveal stains or similar deficiencies which commonly refer to gradual intensity changes without showing fine details. Resolution can be reduced by decimation with little impact to the detection process.

Figure 7.6 shows the suggested image processing for the feature stage. The luminance image L_M is generated in the RGB-Mixer unit by taking the weighted sum of the R, G, and B color components according to $L_M = R \cdot w_R + G \cdot w_G + B \cdot w_B$, $w_R + w_G + w_B = 1$. To reduce camera noise in L_G, L_M is low-pass filtered (three by three Gaussian, G3xG $G3 \times 3$). The Gaussian filters are implemented as two-dimensional binomial filters [255]. To enhance the local intensity variances of L_G, edge filtering is applied using high-pass Sobel [137] filters SH (horizontal) and SV (vertical). The gradient image, E_{Grad}, is calculated by approximation of quadratic summation of E_{SH} and E_{SV}. Depending on the image region, either E_{SH}, E_{SV}, or E_{Grad} can be selected by the multiplexer (Mux) to pass the Max2x2 (maximum value of two by two neighborhood) unit. The Max2x2 operation keeps the edge positions and it makes the inspection process robust against marginal displacements, which are not perceived by the human eye [366]. Additionally, the feature generated by the rising/falling edge detector (R/F-Edge) can be used to emphasize edges in transport direction. The low-pass filtered representation of the color image is calculated by using Gaussian filters with a five by five kernel (G5x5)

7.3.4 Examination Stage

The examination stage focuses on the comparison of the actual image features to the corresponding master features (see Section 7.2.1). Figure 7.6 shows that all of the features extracted in the feature stage are compared to their reference deduced from the master image set.

It is important to note that before examination, the actual image and the master image have to be registered to each other. This is required because of inherent production tolerances. For example, the substrate is subject to many forces when it traverses a printing machine. Hence, the acquisition position varies and, moreover, the substrate can be stretched, shrunk, or otherwise distorted. These tolerances are the reason that no two prints match each other exactly. The deviations might be small for succeeding prints; however, they can become substantial when a longer period of time is considered.

A good overview on registration methods is given in [600]. In the warping unit [197, 198] point correlation in image pyramids [417] is used because of its high data throughput. Different correlation algorithms are compared in [181]. The so-called *tie points* are used to define the transformation system of the registration process.

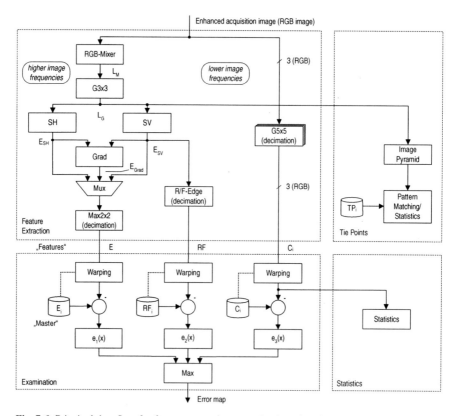

Fig. 7.6 Principal data flow for feature extraction, examination, tie point search, and statistics

Tie points also result in a quality measure which describes how reliable a tie point was found, thereby indicating missing parts of the print.

With the so-called error functions $e_i(x)$ a region-specific weighting can be applied to the pixel deviations. This allows a fine tuning of the segmentation process and affects detection sensitivity. For the assessment of each pixel, all modified deviations are combined. For example, the maximum value can be chosen as the result of the examination stage. The result is stored in a two-dimensional error map which serves as the basis for the subsequent analysis stage.

7.3.5 Analysis Stage

A high value for an element in the error map points to a big deviation between the actual inspected print and its reference set on that position, while a small value indicates a good match. The extent or the strength of print flaws can be identified by analyzing segments of connected error levels. Such segments are found by applying different thresholds to the error map. Resulting segments, or clusters, are called *blobs*.

In order to demarcate the blobs from each other they are labeled. For a general introduction to labeling, see [137, 462], and for high-speed labeling refer to [231].

Several characteristics of the resulting blobs can be used for print flaw discrimination and classification. For instance, the size of a blob refers to the size of the related print flaw. As well, the sum of all deviations of a blob reflects the strength of a print flaw. Refer to [196] for additional quality measurements based on blobs.

In addition to the inspection task several other tests are utilized to determine the print's quality, for example, image statistics (overall brightness of regions), position measurements of characteristic features, optical character recognition, and several plausibility checks. The total result is based on all these subresults.

In principle the only bit of information that the inspection system has to deliver is whether an inspected print meets the quality criteria or not. However, many practical conclusions can be drawn by examining the individual results. For instance, statistics are used to tune and improve the printing process to minimize print flaws. This minimizes waste and maximizes productivity.

7.4 Implementation

The key issue for the design of high-performance smart cameras is to match algorithms and architecture. It is essential to find a balance between algorithms implemented in hardware and others running as software tasks. For implementation, high-speed image sensors, high-end *Field programmable gate array* (FPGA)s, and fast DSPs can be used.

Section 7.4.1 summarizes practical design constraints, Section 7.4.2 describes the principal hardware architecture, and Sections 7.4.3 and 7.4.4 discuss what functions were assigned to FPGAs and to software tasks, respectively.

7.4.1 Constraints

Although the HPSC is based on a modular, very flexible architecture, there is no claim for it to be a perfect solution for all high-performance image processing tasks. One reason can be found in the nature of the intended application. Hence, if there were trade-off decisions to be made, the focus was on print inspection.

In order to maintain a reasonable development risk, the HPSC evolution was split in several phases. The goal for every phase was a functioning image processing system. However, the integration density and smartness of the HPSC was increased in every phase. Note that the HPSC was aimed at low-volume production and application-specific flexibility. Hence, it did not seem advantageous to integrate functions in *application-specific integrated circuit* (ASIC) technology.

In the first and second phases a 100 kHz color linescan camera with many processing stages included in the camera was developed [195, 67]. In order to attach this camera to existing image processing hardware, its output data rate had to be matched with camera link base mode specifications. Therefore, image processing was moved into the camera to address this data transfer bottleneck.

Fiberoptic 10 Gbit Ethernet was chosen to cover long distances between the camera and the remote processing system. The 10 Gbit Ethernet is already a mature technology in telecommunications and will probably penetrate the mass market like its predecessors. Hence, components will become cheaper. Furthermore, GigE Vision™ might be supported in future.

In the final phase, the DSP prototype board will be shrunk to fit into the camera's housing. Although the 10 Gbit Ethernet link is not required for the inspection task (1 Gbit Ethernet is used instead) it is essential for on-the-fly storage of acquired images to a remote database server for later reference.

7.4.2 Hardware

Figure 7.7 shows the main components of the HPSC. It consists of four printed circuit boards (modules M1–M4). Images of the HPSC are shown in Fig. 7.8.

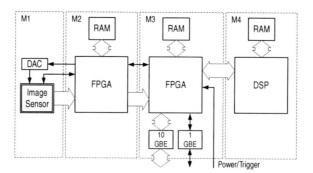

Fig. 7.7 Main components of the HPSC

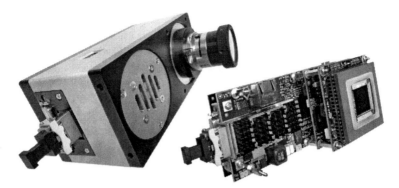

Fig. 7.8 Images of the HPSC

The sensor module (M1) carries the image sensor (Aptina MT9M413/MT9M440) and several *digital to analog conveter* (DAC) devices which generate the various analog reference voltages and biases for the sensor [379]. The DACs can be controlled from the FPGA, therefore enabling adaptive feedback loops if required by an application. For example, the HPSC features an analog input which can be used to adapt the analog sensor gain for automatic global brightness correction.

The processing module (M2) is equipped with an Altera 2S60 device [12] and external image memory for temporary storage of images or image regions.

The interface module (M3) contains both Ethernet interfaces and the necessary driver components. Additionally, there is also external memory as on M2. It is important to note that trigger signals for the acquisition process (e.g., line trigger signal) have to be directly fed into the camera as Ethernet cannot maintain exact timing behavior required for high-speed linescan imaging. In addition the HPSC can generate output signals which can be used for direct machine control.

Finally, the analysis module (M4) provides the DSP (TI C64xTM family DSP).

The first phase camera comprises modules M1, M2, and an optional module M3cl (not shown) which provides the camera link interface. The second phase is realized by modules M1–M3, while phase 3 is completed by all four modules.

7.4.3 Functions Mapped to Hardware

In this context hardware-mapped functions refer to algorithms that have been implemented on the FPGA. There are no common design rules for assigning functions to hardware or to software. Rather, the assignment of functions depends on application-specific constraints. Not always are technical requirements the deciding factor. For example, FPGA development tends to be more time consuming and hence more expensive than implementing software. On the other thand, there are image processing functions which can be executed substantially faster on FPGAs than on DSPs [212]. Usually, low-level image processing such as filter kernels or image statistics benefit from parallel FPGA resources, especially when high

throughput is required. If random pixel access to a large image region is a major concern, it is very expensive to implement such functions into FPGAs in most cases. Typically, algorithms are chosen which allow separation of a large image into smaller tiles (size should be optimized according to the resources in the FPGA) and then processing one tile after the other. In summary, major FPGA advantages include huge input and output bandwidth, as well as the potential for massive parallelization [199].

In the FPGA design of the HPSC both approaches to parallelization (data parallelism and algorithmic parallelism [137]) are exploited. For example, in the feature extraction stage (Fig. 7.6) pipelining is used to exhaust algorithmic parallelism, while the camera's performance benefits from data parallelism as lower and higher image frequencies are processed simultaneously.

Functions implemented in the FPGA include the following stages shown in Fig. 7.4: MX stage, image conditioning stage, feature extraction stage, and examination stage. For implementation details, refer to [194, 195, 67, 198, 199, 156].

7.4.4 Functions Mapped to Software

In the HPSC two classes of processors are available: (i) high-speed DSP and (ii) Altera's soft core NIOS™ *central processing unit* (CPU) implemented in FPGA [13]. Hence, software tasks are distributed to multiple processors. However, as there is a distinct performance difference, the DSP is primarily used for number crunching, while the soft core CPUs execute control tasks.

Regarding the image processing pipeline, the analysis stage outlined in Section 7.3.5 is implemented as a software task in the DSP. Functions included are blob labeling, high-level algorithms for classification, and optical character recognition.

7.5 Conclusions and Outlook

In this chapter a high-performance smart camera (HPSC) has been presented. The HPSC is a color linescan camera which enables next-generation print quality inspection by integrating high-end image processing power next to the image sensor. The main contribution of this chapter is to show the feasibility of the smart camera concept to overcome the data transfer bottleneck between high-speed imager and remote processing system in high-performance machine vision which was not covered by smart cameras available so far.

Although the HPSC was designed with specific requirements in mind, all applications are addressed which require high-speed imaging combined with outstanding processing performance. Enabled by the multiple exposure method, line rates beyond 100 kHz can be achieved by exploiting standard CMOS areascan imagers. Interesting details of the linescan HPSC are easy mechanical adjustment due to areascan operability and integrated compensation of lens distortions.

The modular architecture allows different levels of smartness: (i) high-speed line-scan camera operation with high-performance image processing in an FPGA and standard camera link interface, (ii) fiberoptic 10 Gbit Ethernet interface (the HPSC is probably the first camera available with this interface, compare [565]), 1 Gbit Ethernet and extended application-specific processing resources in an additional FPGA, and (iii) addition of DSP processing power for high-level image processing.

New imagers that will be available soon will increase the data rate beyond 10 Gbit/s as image quality, speed, and resolution are improved. Examples include Awaiba's 16k linescan sensor [564] and Austrian Research Centers' xposure 1 imager, which will push the leading edge in line rate and/or image quality. Moreover, inspection requirements will also rise, which will result in more complex image analysis algorithms. Future smart cameras must cope with these data rates. Two challenges seem to be eminent: (i) getting the raw data into the processing sub-system and (ii) executing complex algorithms in order to squeeze out the required information.

While FPGAs will be a good target to address the first issue, even next-generation FPGAs will not be suitable to fulfill algorithmic requirements for the second issue. On the other hand, current DSPs cannot be fed with the required data rate nor do they offer appropriate processing performance, even when next-generation DSPs which incorporate multiple cores (for example, Freescale's StarCore™MSC8156[1]) are considered.

Following the trend to many-core architectures might be one way out of this dilemma. Several interesting processors are available today, for example, Tilera's TilePro64™ and Intel's Larrabee™. Both processors incorporate 64 powerful cores [57, 478]. General purpose graphics processing units (GPGPU) are probably not suitable for camera integration, due to high-power consumption and, despite ongoing improvements [37], drawbacks in general programmability.

The number of cores per chip will probably increase substantially over the next years, which will also affect the design of high-performance smart cameras. However, the key to exploiting hundreds of cores lies in (i) the design of algorithms, (ii) the implementation of software architectures, and (ii) the existence of development environments. This will be the most important challenge for the future.

[1] Freescale Semiconductor: MSC8156 product brief of 2008.

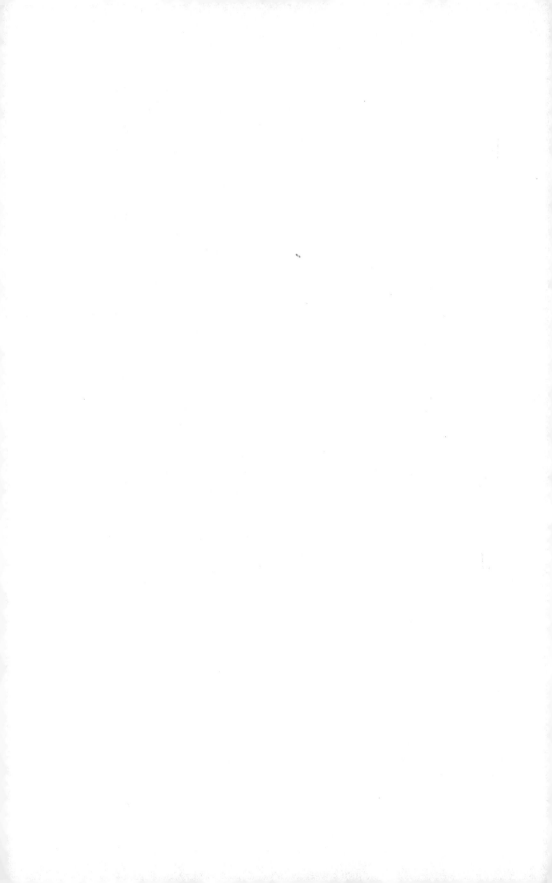

Chapter 8
Embedded Stereo Vision

Kristian Ambrosch, Martin Humenberger, Sven Olufs, and Stephan Schraml

Abstract In the last few years, stereo vision has become a very interesting sensing technology for robotic platforms. Especially for indoor applications, stereo vision brings many advantages. It is passive, so it does not affect its environment, it is small in size, and it is very flexible. In this chapter, the possibilities of integrating stereo vision into smart cameras are explained. Stereo vision may involve a high algorithmic and computational effort, therefore not all stereo vision algorithms are suitable for real-time applications. This chapter gives a detailed description of two real-time stereo vision algorithms and presents possibilities to implement these concepts in a smart camera. Furthermore, it presents stereo vision using biologically inspired vision sensors for the depth estimation of scene dynamics.

8.1 Introduction

The idea of stereo vision is to calculate the depth of a scene by finding correspondences between synchronously captured images of two parallel mounted cameras. Each scene point, visible for the camera, is projected on the digital sensor chip and represented by a pixel in the camera image. If assumed that a scene point is visible on both camera images, the corresponding pixels of the same scene point can be found in both camera images. The search for correspondences in a stereo image pair is called stereo matching. The horizontal displacement, called disparity, can then be used to calculate the depth of the scene point. If this is done for all pixels it results in a dense disparity map, which is a data structure of the same size as the camera image that holds the disparities for each pixel. Because of the fact that not all scene points can be seen in both images, the disparity map is not complete. Those missing pixels are called occluded. The disparity map is always aligned to one camera image. Dense stereo is one possibility of stereo matching, the other is to find features, like edges or rectangles, in the images and to search for their disparity. In this case the

K. Ambrosch (✉)
Safe and Autonomous Systems, Safety & Security Department, AIT Austrian Institute of
Technology, Vienna, Austria
e-mail: kristian.ambrosch@ait.ac.at

A.N. Belbachir (ed.), *Smart Cameras*, DOI 10.1007/978-1-4419-0953-4_8,
© Springer Science+Business Media, LLC 2010

resulting disparity map is not dense and the method is called feature-based stereo. This chapter deals with dense stereo only, which makes the results more general in application.

Figure 8.1(a) illustrates the projection of a scene point P onto the image planes, π_l and π_r, of two cameras, separated by the baseline b, with the optical centers O_l and O_r. The scene point $P = (x, y, z)^T$ is given in world coordinates and its projection onto the image planes in image coordinates (pixels) $p_l = (u_l, v_l)^T$ and $p_r = (u_r, v_r)^T$.

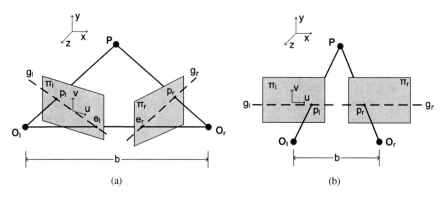

Fig. 8.1 Stereo vision geometry: (a) unrectified and (b) rectified

The points p_l and p_r lie on their epipolar lines g_l and g_r, which are defined by the epipoles e_l and e_r. As can be seen, the epipoles are the intersections between the image planes and the baseline. Each possible corresponding pixel lies on the corresponding epipolar line in the other image. The epipolar line g_r corresponds to the pixel p_l and g_l to p_r.

As can be seen in Fig. 8.1(b) it would be advantageous if the epipolar lines were in parallel to the baseline and were to correspond to the image rows because this reduces the search for corresponding pixels to searching along one single image row instead of across the whole image or along a skewed epipolar line. This setup can be reached with rectification. In rectified images, all epipolar lines are horizontal, the epipoles are mapped to infinity, and corresponding pixels have the same v-coordinate. Rectification can be done if the geometry between the cameras is known which can be calculated with stereo camera calibration.

The assumption of ideal central projection, used in this chapter, usually fails when real lenses are used because of lens distortion. To overcome this problem, the camera images have to be undistorted using a radial and tangential distortion model, produced by the distortion coefficients which can be calculated by single camera calibration. Unlike the rectification, undistortion is done for each camera separately. Detailed information about single and stereo calibration can be

found in [592, 504, 205, 74]. Commonly used implementations include the Caltech Calibration Toolbox[1] and can be found in the OpenCV library.[2]

For fast Rectification and undistortion, certain backward transform maps are calculated off-line. They can be used to rectify and undistort the images at once as shown in Fig. 8.2.

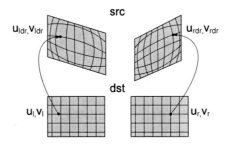

Fig. 8.2 Backward transform for undistortion and rectification

Once the maps are calculated at start-up, the same image transforms can be applied to all images at run-time. In detail, a backward transform is used to calculate the pixel coordinates $(u, v)^T$ of the undistorted, rectified image from the distorted and unrectified ones $(u_{dr}, v_{dr})^T$ as shown in

$$\text{dst}(u, v) = \text{src}(\text{map } x(u, v), \text{map } y(u, v)), \tag{8.1}$$

where

$$\text{map } x(x, y) = u_{dr} \quad \text{map } y(x, y) = v_{dr}. \tag{8.2}$$

In this chapter it is assumed that the stereo images are undistorted and rectified. Using the disparity map the depth for each pixel can be computed via triangulation as denoted in

$$z = \frac{b \cdot f}{d}, \tag{8.3}$$

where z is the distance between the scene point and the corresponding camera, b is the stereo camera baseline, f is the camera's focal length, and d is the pixel's disparity. For 3D data in camera coordinates,

$$\begin{pmatrix} x_c \\ y_c \\ z_c \end{pmatrix} = K^{-1} \begin{pmatrix} u \cdot z_c \\ v \cdot z_c \\ z_c \end{pmatrix} \tag{8.4}$$

[1] Camera calibration toolbox for Matlab by J.Y. Bouguet (version 2008). *http://www.vision.caltech. edu/bouguetj/calib_doc/*.

[2] http://sourceforge.net/projects/opencvlibrary

can be used where K is the camera calibration matrix, the pixel is given in homogeneous coordinates $(u \cdot z_c, v \cdot z_c, z_c)^T$, and z_c is calculated with (8.3). K and f have to be determined using single camera calibration. More information about stereo vision and 3D reconstruction can be found in [172, 504].

After explaining all important fundamentals of stereo vision, a few stereo matching algorithms, suitable for smart cameras and embedded systems in general, are described in the following section.

8.2 Stereo Matching Algorithms

Many different stereo matching algorithms have been published since the topic came up in the 1980s. Many of them deliver quite good results, without taking into account the processing time. For embedded systems, processing time and high frame rates are essential. A minimum of 10 fps should be reached in any case and the algorithm has to be suitable for real-time applications, which means that the calculation has to be finished in that time frame and has to be independent from the actual scene. It has been shown that correlation-based algorithms seem to be most suitable for embedded realization. The authors of [89] give a good overview about state of the art of real-time stereo matching, where only correlation-based algorithms are mentioned. In this chapter two correlation-based stereo matching algorithms are described in detail. The first one is the very well-known sum of absolute differences (SAD) and the second one the more complex census transform, introduced in [588].

In general, a correlation-based stereo matching algorithm works as follows. First, the matching costs are calculated for all pixels and all possible disparities stored in a 3D data structure called disparity space image (DSI). The costs define the probability of a correct match. The lower the costs, the higher the probability. To increase the probability of a correct match the assumption can be made that neighboring pixels have the same disparity, except at disparity discontinuities. So the next step is a cost aggregation within a certain window around each pixel. The drawback is that object borders become broader in the disparity map. The DSI holds now the aggregated costs for all pixels at all disparity levels. The final step is to find the disparity level for each pixel with the lowest costs. Local methods select the match with the lowest costs independent of the other pixels aside from the nearest neighbors. The most common is a simple winner takes all (WTA) minimum or maximum search across all possible disparity values. Global methods use the scanline or the whole image to assign a disparity value to each pixel. Global methods are dynamic programming [409, 63, 215], graph cuts [73, 299], or belief propagation [515]. Most global approaches are computationally very expensive and are nowadays not used for real-time implementations. Only dynamic programming has been used for real-time matching [185], but the resulting disparity maps suffer from horizontal streaks, which is a major drawback. The matching can be done from right to left and vice versa, so occlusions and uncertain matches can be filtered with a left/right consistency check. This means, only disparities with the same value (within a certain

range) for both directions are set as valid. Finally, a 3D reconstruction is done where the orthogonal distance and the 3D point cloud with respect to one camera's optical center are calculated. Figure 8.3 shows the principle workflow of the proposed stereo matching algorithms.

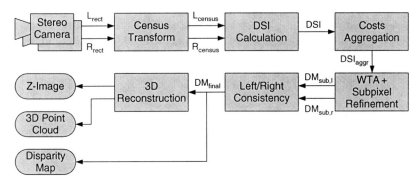

Fig. 8.3 Stereo matching block diagram

The first step of the workflow is the stereo image acquisition (assumed as undistorted and rectified) by the stereo head. The proposed algorithm uses monochrome input images, so it would be advantageous to use monochrome cameras instead of converting color to grayscale. Monochrome cameras deliver sharper images than, e.g., Bayer-patterned ones and suffer less from noise. Another important aspect is the exact synchronism of the stereo image capturing. Especially when the camera head or the captured scene is in motion, the acquisition has to be done as simultaneous as possible. (Many cameras have an external trigger input which offers the possibility of triggering two cameras exactly at the same time.)

In the census matching algorithm, the image pair is first census transformed. This transform is based on local intensity relations between the actual pixel and the pixels within a certain window. This relation is defined by the function

$$\xi(p_1, p_2) = \begin{cases} 0 & p_1 \leq p_2 \\ 1 & p_1 > p_2 \end{cases}, \tag{8.5}$$

where p_1 and p_2 are pixels in the image. The census transform uses (8.5) to create a bit string for every pixel in the left or right image L_{census} and R_{census}, as shown in (8.6) and (8.7) where the operator \otimes denotes a bit-wise catenation and $n \times m$ the window size:

$$L_{census}(u, v) = \bigotimes_{i=-n/2}^{n/2} \bigotimes_{j=-m/2}^{m/2} \xi(L_{rect}(u, v), L_{rect}(u + i, v + j)) \tag{8.6}$$

and

$$R_{census}(u, v) = \bigotimes_{i=-n/2}^{n/2} \bigotimes_{j=-m/2}^{m/2} \xi(R_{rect}(u, v), R_{rect}(u + i, v + j)). \qquad (8.7)$$

The next step is the matching part itself. For each pixel, the costs for each possible match have to be calculated. Matching is done within a certain disparity range from d_{start} to d_{stop}. The calculated costs are stored in the DSI of the size disps × width × height. For each disparity level there is a slice of a 3D matrix as shown in Fig. 8.4.

Fig. 8.4 Two DSI possibilities: (a) normal and (b) Memory reduced

On the left side, a classic DSI and on right side a memory-reduced version is illustrated. It is possible to reduce the size of the DSI because per disparity level only $width - d$ pixels are possible matching candidates. If the matching is done from right to left, the pixels on the right side of the right image have no matching candidates as can be seen in Fig. 8.5. The amount of these pixels increases with the disparity level.

Fig. 8.5 The widths of the DSI levels shrink with the disparity

The cost calculation for two census-transformed pixels equates to the calculation of the hamming distance between the two bit strings. In (8.8) the whole DSI for the census is calculated:

$$\forall d \in [d_{start}, d_{stop}] : DSI_d(u, v) = \text{Hamming}(R_{census}(u, v), L_{census}(u+d, v)). \quad (8.8)$$

For SAD the cost calculation is the absolute difference between two pixel intensities which changes the DSI calculation to

$$\forall d \in [d_{\text{start}}, d_{\text{stop}}] : \text{DSI}_d(u, v) = |R_{\text{rect}}(u, v) - L_{\text{rect}}(u + d, v)|. \quad (8.9)$$

For cost aggregation a simple squared window filter is used and is defined as

$$\forall d \in [d_{\text{start}}, d_{\text{stop}}] : \text{DSI}_{d,\,\text{aggr}}(u, v) = \sum_{i=-n/2}^{n/2} \sum_{j=-m/2}^{m/2} \text{DSI}_d(u + i, v + j). \quad (8.10)$$

After calculation of all possible matches, the best match has to be found. From now on, the processing steps are the same for SAD and census. As explained above, the best match is the one with the lowest costs. Figure 8.6 shows a typical cost function. The black circles show the costs at integer disparity levels. It can be seen that the lowest costs are at disparity level d_{min}. This level wins by the use of a winner takes all (WTA) minimum search.

Fig. 8.6 Example of a cost function

It delivers integer disparities, but in most cases the true disparities lie in between. To calculate the so-called subpixel disparities, a parabola fitting is used. The best integer disparity and its neighbors are used to span the parabola shown in Fig. 8.6, and its minimum yields the disparity in subpixel accuracy. From now on, $y(d)$ means the costs of a match at disparity d for a certain pixel. The subpixel disparity for one pixel is calculated with

$$d_{\text{sub}} = d_{\text{min}} + \frac{y(d_{\text{min}} + 1) - y(d_{\text{min}} - 1)}{2(2y(d_{\text{min}}) - y(d_{\text{min}} - 1) - y(d_{\text{min}} + 1))}, \quad (8.11)$$

where the coordinates (u, v) are omitted in the equation. The whole disparity map in subpixel accuracy for both matching directions is calculated with

$$DM_{\text{sub},l}(u, v) = d_{\text{sub},l}(u, v) \quad (8.12)$$

and

$$DM_{\text{sub,r}}(u, v) = d_{\text{sub,r}}(u, v). \tag{8.13}$$

To filter occluded and uncertain matches, a left/right consistency check is applied on $DM_{\text{sub,l}}$ and $DM_{\text{sub,r}}$ to determine the final disparity map, DM_{final}, with

$$DM_{\text{final}}(u, v) = \begin{cases} |a - b| \leq 1 : |\frac{a+b}{2}| \\ |a - b| > 1 : \quad 0 \end{cases}, \tag{8.14}$$

where

$$a = DM_{\text{sub,l}}(u, v) \quad b = DM_{\text{sub,r}}(u - a, v). \tag{8.15}$$

The last step is the calculation of the z-image with (8.3) and the 3D point cloud with respect to the left camera's coordinate system with (8.4).

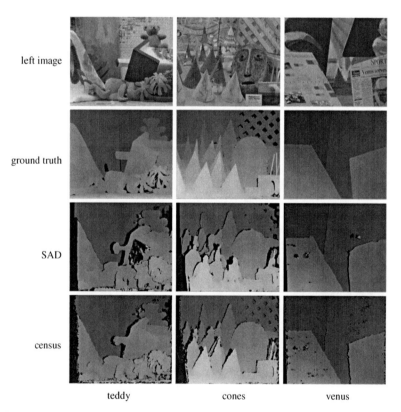

Fig. 8.7 Data sets with the resulting disparity maps for SAD and census

Figure 8.7 shows three data sets from the Middlebury Stereo Evaluation web site[3] with the final disparity maps for SAD and census.

8.3 Realization of Embedded Stereo Matching

8.3.1 Overview

Stereo matching is a computation with high computational complexity. Recently, it has been shown by Zinner et al. [598] that a processor-based real-time implementation of a stereo matching algorithm can be performed using DSPs. However, they had to make severe restrictions about the frame rate, image resolution, and disparity range. Furthermore, their solution is non-embedded.

Fortunately, there exist various embedded hardware-based implementations in the literature, with far fewer restrictions. For the SAD algorithm, Cuadrado et al. [130] proposed a stereo matching architecture using an Altera Stratix II FPGA. They use a block size of 4×4 and a disparity range of 90 pixels, achieving 85 fps for 1024×1024 camera images. Another work on the SAD was proposed by Perri et al. [420], who use a 5×5 SAD on 512×512 images, implementing a considerably high disparity range of 255 pixels at a frame rate of 25.6 fps. For the census transform, Woodfill et al. [573] proposed the DeepSea, an *Application-specific integrated circuit* (ASIC) dedicated to stereo matching. This ASIC implements a 7×7 census transform, achieving 200 fps on 512×480 images at a disparity range of 52 pixels.

These implementations show that hardware-based solutions are highly amenable for the implementation of stereo matching algorithms. Therefore, this section describes, how the SAD and census transform can be implemented using FPGAs.

8.3.2 System Concept

The main tasks of the FPGA for the implementation of a stereo vision system are to capture the stereo images from the camera interface, the undistortion as well as the rectification of these images, the stereo matching, and finally the output of the resulting disparity map as depicted in Fig. 8.8. While interfaces for the input and the output of camera images can be implemented using IP cores, the undistortion and rectification units can be easily implemented using look-up tables, which contain the transform maps. However, the implementation of the stereo matching unit is not straightforward and therefore described in detail in the following.

[3] Middlebury computer vision and stereo evaluation. http://vision.middlebury.edu/stereo

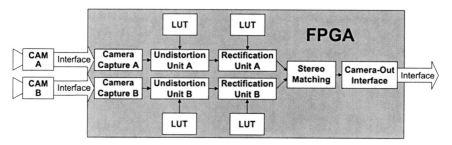

Fig. 8.8 FPGA-based architecture

8.3.3 FPGA-Based Stereo Matching

8.3.3.1 Scaling the Complexity – The Sparse Census Transform

The implementation of the census transform with large block sizes as required for stereo matching of low-textured surfaces leads to a high computational complexity for the algorithm. To keep this complexity manageable and the logic requirements for the implementation low it is possible to reduce the number of hamming distance bit comparisons by analyzing every nth bit only. Thus, only every nth pixel in the block is used in the matching procedure, as depicted in Fig. 8.9 for $n = 2$. This leads to an under-sampling of the pixel blocks, which allows the implementation of large block sizes for the matching of low-textured surfaces, while keeping the resource utilization low. Furthermore, it allows scaling the algorithms complexity at a constant block size.

Fig. 8.9 Sparse census transform, having $n = 2$

Of course, this sparse computation also leads to a decrease in accuracy. However, as shown in Table 8.1, for $n = 4$ this decrease is very small. After all, the total accuracy on these three data sets is still far higher than for the SAD.

Table 8.1 Percentage of false matches for the census transform, sparse census transform, and SAD

Stereo algorithm	Teddy(%)	Cones(%)	Venus(%)
Census transform 15 × 15, Agg. 5 × 5	8.509	5.946	2.943
Sparse census transform 15 × 15, Agg. 5 × 5	9.181	6.159	3.877
SAD 19 × 19	17.503	12.194	8.49

8.3.3.2 Stereo Matching Unit

The presented FPGA-based stereo matching unit consists of three major pipeline stages, as depicted in Fig. 8.10. These are the input, the calculation, and the extraction stages, which are designed to work in parallel after a primary synchronization phase.

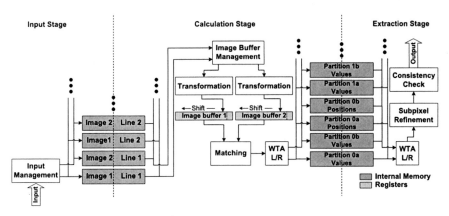

Fig. 8.10 FPGA-based stereo matching

The input stage reads the image line per line from the input port and stores it in the chip's internal memory. This memory is organized as cyclic memory, where each image line is stored in a separate memory block. This way, the input stage can access one block while the next stage, the computation stage, accesses the others. The computation stage reads the stored image lines from the memory. Since each line is stored separately, it is possible to read the pixels of one vertical column in the block at each clock cycle. Then, if the census transform is selected, the read block is transformed and the resulting bit vector stored in registers. If the SAD is being used, the intensity values are stored here. Afterward the matching costs for the different disparity levels on these values are computed, using either the hamming distance or the absolute differences. Now, the position of the smallest matching costs is evaluated using the WTA algorithm for both the left and right disparity maps.

This stage is highly pipelined and would be capable of computing the matchings costs for each pixel at all disparity levels in a single clock cycle. Unfortunately, this would result not only in a high frame rate but also in highly increased logic

consumption. Furthermore, for most applications camera frame rates of about 30 fps are sufficient, making higher frame rates a waste of resources.

Therefore, we divide the disparity range into separate partitions, computing each one separately, resulting in multiple computation rounds per line. The resulting intermediate values, i.e., the position and value of each position's best match are stored in internal memory. After all partitions for an image line are computed, the extraction stage reads the intermediate values for the last image line, and again computes the best match using the WTA algorithm. Then, these matches are subpixel refined and checked for consistency. Afterward, the resulting value is put on the output port as the final pixel value for the disparity map.

To enable the parallel computation of the calculation and the extraction stage, these stages are using different memory sets that are being switched after each line's computation.

Besides the fact that this round-based computation gives the possibility to scale the logic consumption based on the frame rate, it makes it possible to scale the frame rate of the stereo system by reducing the number of computed partitions, i.e., the disparity range. While scaling the logic consumption is only possible by the time of synthesis, scaling the frame rate against the disparity rage is also possible during run-time [14], which used to be the domain of software-based stereo systems.

Figure. 8.11 reveals the logic consumption of the described architecture on 750×400, 60 disparity levels, at 60 fps for the SAD algorithm as well as the census transform. For the latter, we used the original as well as the sparse one, with $n = 4$. Here, for the census transform and the sparse census transform, block size 15×15 combined with a 5×5 aggregation is used. For the SAD, 19×19 is used. Thus, all

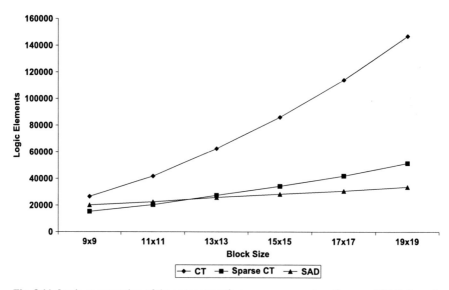

Fig. 8.11 Logic consumption of the census transform sparse census transform, and SAD depending on the total block size

algorithms evaluate the same total block size for the stereo matching. As can be seen, the sparse computation gives the possibility to reduce the logic consumption of this robust algorithm even below the SAD's for total block sizes of 11×11 and below. For the others it is still competitive, when comparing the difference in accuracy to the SAD. This makes the sparse census transform an interesting choice for smart cameras, where resources are very limited and a compact solution is required.

8.4 Applications of Stereo Matching Systems

For the application of stereo vision for domestic robot navigation, obstacle avoidance, and map building we provide a brief introduction of state-of-the-art algorithms. We explain how stereo vision can be used for this challenging task. Furthermore, we contrast the results for stereo vision and laser range scanners, discussing their advantages and disadvantages.

Navigation is one of the most challenging competences required of a mobile robot. A control program, the so-called *behavior*, steers the robot through a known or unknown environment without endangering a person, the environment, or the robot itself. The task requires the knowledge of a relative position to an a priori known map or currently learned map and the knowledge of a potentially dangerous object. Depending on the robot domain such a dangerous object can be a huge rock for a driving car, i.e., the rock is dangerous for the car/robot. In the domestic robots domain it is vice versa: The robot might be dangerous for a human. This process is called *obstacle avoidance*. But first let us start by learning a map from an environment.

A typical approach for the domestic environment is the occupancy grid method, see Fig. 8.12. The map is made of cells (bins) that reflect the real environment in a matrix. Each cell represents a real *area* (e.g., typical $5\,\text{cm}^2$) which can be *free*, *occupied*, or *unknown* in the map. A cell that is *free* represents a drivable area, whereas the robot cannot navigate *occupied* cells. For instance a table would also be *occupied*, if the robot were to collide with the table. The cell type *unknown* is a *not* drivable area that is not yet explored by the robot. Therefore, it is simply not known (and not necessary). The main idea for localization with occupancy grids is rather simple: We use a sensor that detects drivable areas as *free* and walls, tables, etc., as *occupied*. The position of the robot is estimated using a matching of the stereo features to the environment with non-linear optimization or Bayesian filters.

Figure 8.12 demonstrates the method that has been proposed by Sim and Little [497]. The robot extracts the walls and free areas using stereo vision and adds the information successively to a map. While the robot moves, it adds new data (wall, etc.) to the map with the *scan matching* alignment method. This method is rather simple: First, the virtual robot position on the map is moved according to the sensor readings of the wheels (*odometry*). Then, the new sensor data are adjusted to the previous map using a simple error minimizer. This is necessary due to drift and slip

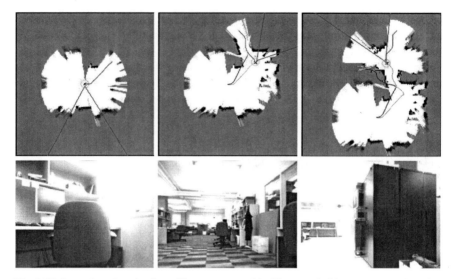

Fig. 8.12 Stereo-based navigation with occupancy grids: The *round object* represents the robot with the corresponding field of view of the cameras. *White area* represents *free* cells, *black* occupied and *gray* unknown

of the wheel that cannot be sensed by sensors. Sim et al. demonstrated that using stereo sensors can be more efficient than using laser scanners commonly used in the robotics domain: A discriminative descriptor is used to re-detect a (previously seen) wall by using visual information of the stereo image. This is quite important to overcome the so-called *loop closing* problem in map building: A previously visited place is not re-recognized and is considered a new place on the map. This problem derives from the noise of the sensors, e.g., wheel encoders, stereo vision. Even a small error in the sensors or an alignment error can have a tremendous impact. The method developed by Sim et al. is able to correct the map at an early stage using the discriminative features for re-detection. Even an enormous error can be corrected by using such features. Let us now consider *obstacle avoidance* by means of stereo vision.

Figure 8.13 illustrates the method that is usually employed for domestic robotics: the *ground space detection* method. The robot extracts a region that is *safe to navigate*. The region is used to plan a safe path through the area itself. The green area represents the extracted ground using stereo vision, while the red one uses a conventional laser scanner. One can see that the laser scanner is not truly extracting a region on the left image. This is due to the fact that a laser scanner senses in 2D at a specific height. This leads to unwanted side effects: For instance the bicycle wheels on the left side are overlooked in the range scan (right).[4] On the right side of the image we see that the open cupboard is not detected either. Both objects are invisible to

[4] The gray area on the right picture shows the position of the true objects.

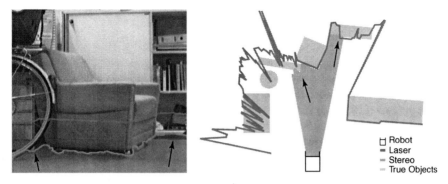

Fig. 8.13 Stereo vs laser sensors for ground detection: The *left picture* shows the input camera image with the ground extracted by laser scan and stereo vision. The extracted range information is shown in the *right image*.

the laser scanner. The stereo camera is able to detect the proper *safe* area. Why are stereo sensors still not so common in the domestic robotics domain? First there is no guarantee that a stereo system will always detect all objects in an image due to motion blur or poor lighting conditions. A laser scanner provides almost a true existing result.[5] Another fact is that the field of view of the stereo sensor (usually 30–100°) is much smaller than that of a laser scanner (usually 180°). The precision of a laser scanner is typically 1 mm while the stereo vision system yields a precision of 5–20 mm.

In the following section, stereo vision using a pair of biologically inspired vision sensors for a sparse depth map is presented and discussed.

8.5 Stereo Vision Using Biologically-inspired Vision Sensors

This section presents another variety of vision sensors, namely biologically-inspired optical sensors. These sensors allow the use of a compact stereo smart camera for sparse depth (disparity) map estimation of moving objects. A pair of transient vision sensor (TVS) [317] is hereby used as front-end elements. This sensor contains an array of autonomous, self-signaling pixels which asynchronously respond to the relative temporal changes (transients) of local brightness and use sparse output representation of visual information with a complete redundancy reduction. The transient sensor seems to be a reasonable choice for applications which mainly consist of highly correlated time-variant scenes coupled with large static background regions. On-chip pre-processing of visual information coupled with sparse coding allows the implementation of (as a general rule) computationally very intensive stereo depth calculation on an embedded single low-power DSP.

[5] But it might be the distance to an *unwanted* object.

8.5.1 System Architecture

The hardware architecture of the presented embedded transient stereo system, shown in Fig. 8.14, consists essentially of the following groups of functions: two optical TVS as sensing elements, a buffer unit consisting of multiplexer and first-in first-out (FIFO) memory, and a DSP as processing unit.

The TVS used here [317, 304] consists of an array of 128×128 pixels, built in a standard $0.35\,\mu m$ CMOS technology. It is a compact continuous-time photoreceptor, whose individual pixels adapt to background illumination and react to relative temporal illumination changes. As a communication protocol the compact address-event (AE) representation is used [65].

AEs generated in the transient vision sensors are communicated asynchronously to the DSP. The bus arbiter transfers them to the multiplexer unit which performs Round Robin scheduling, by alternately selecting an address event from the left and the right sensors. Subsequently, they are forwarded to the DSP via a FIFO buffer memory. Every AE received by DSP is labeled by attaching the processor clock ticks with 1 ms or less precision as a timestamp. These AE data are used as input stream for subsequent processing, as described in the next section.

All major steps of stereo processing algorithm including rectification, matching, and disparity calculation are implemented on Blackfin BF537 DSP from Analog

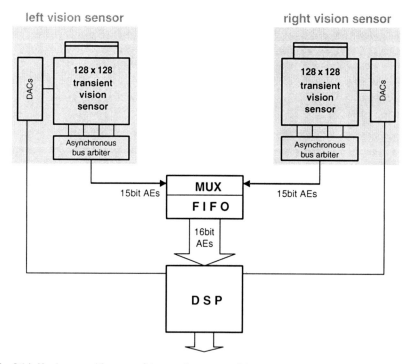

Fig. 8.14 Hardware architecture of the transient stereo vision sensor

Devices at 600 MHz, with 32 MB SDRAM and 4 MB flash, on-chip memory. The embedded system supports on board Ethernet function and consumes roughly 4 W of electrical power. This system can be used as a compact remote stand-alone system, since it is suitable for battery or solar energy supply and output data can be distributed to any host computer or other IP client for further high-level vision tasks.

8.5.2 Address-Event Processing

In contrast to common image processing, which is based on a sequential processing of frames, the presented algorithm works with the asynchronous address-event stream directly. An address-event stream can be modeled as a temporal impulse sequence:

$$\text{AE}_{\text{stream}}(t) = \sum_{t_{\text{ev}}} \text{AE}(t_{\text{ev}}). \tag{8.16}$$

Individual AEs can occur at any time $0 < t_{\text{ev}} < \infty$. As the relevant time information is coded in t_{ev} and the real impulse shape is irrelevant, individual events can also be written as

$$\text{AE}(t_{\text{ev}}; x_{t_{\text{ev}}}, y_{t_{\text{ev}}}, \omega_{t_{\text{ev}}}) = \omega_{t_{\text{ev}}} \delta(t - t_{\text{ev}}) \delta_{x, x_{t_{\text{ev}}}} \delta_{y, y_{t_{\text{ev}}}}. \tag{8.17}$$

So each AE contains information about the time of the occurrence, as well as the appropriate coordinate of the sending pixel $x_{t_{\text{ev}}}$, $y_{t_{\text{ev}}}$ and the polarity ωt_{ev}. Since static scenes produce no signal output, in the frame representation of sensors field of view moving objects are represented as a set of coherent edges (see Fig. 8.16). Compared with conventional frame-based digital stereo processing, the computation of address events is obviously much more efficient and requires less memory and computational effort for applications where no dense disparity information of dynamic scenes is needed.

8.5.3 Address-Event-Based Stereo Vision

The implemented algorithm for real-time depth estimation consists of three major processing steps, which solve the primary problems in computational stereo [89], these are as follows: (i) camera *calibration* and rectification, (ii) stereo *correspondence* calculation, and (iii) *reconstruction*. For the presented system an adapted area-based method is implemented, although other stereo matching procedures could be used as well.

The organization of the proposed stereo algorithm is shown in Fig. 8.15. As this stereo procedure deals with AEs there are some major differences to conventional stereo systems. These differences are as followes: (i) address events need to be accumulated in a particular manner in order to find significant correlations between

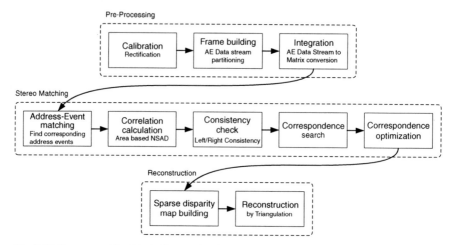

Fig. 8.15 Stereo matching block diagram for the transient vision sensors

the left and right sensor information, (ii) the correlation calculation can be done for relevant sensor array areas only, which helps minimizing the needed processor resources. The function blocks *frame building*, *integration*, and *address-event matching* reflect these differences, they are necessary to bring the address events into an appropriate form and to prepare the AE data for the following correlation calculation. Furthermore, the stereo correlation calculation, using standardized area-based algorithm, is modified in order to take advantage of AE-based processing.

Calibration: Camera *calibration* is done by applying a translation factor such that pairs of conjugate epipolar lines become collinear [204].

Frame building: Since the address-event data stream is asynchronous the *frame building* block is used for partitioning it in timeslots of duration DT, named frames. DT determines the temporal resolution of the 3D sensor system and is a variable parameter which can be chosen regarding the characteristic time scale of the scene and settings of the temporal vision sensor bias values. The typical achievable value of DT with this system lies between 5 ms and 50 ms, which is equivalent to the effective frame rate of 200 fps – 20 fps if compared to the conventional frame-based stereo systems.

Integration: These address events are then accumulated according to their pixel coordinates and polarity (ON or OFF). The accumulated event rate at time kDT and location x, y is encoded in the magnitude of AE_{act} as follows:

$$AE_{act}(kDT; x, y) = \int_{kDT}^{(k+1)DT} AEP(t_{ev}; x, y)dt \qquad (8.18)$$

with $k = 0,1,2,\dots$ where $AEP(t_{ev}; x, y)$ is the polarity of a single AE at time t_{ev} and coordinate x, y, coded as -1 for an OFF event and $+1$ for an ON event.

Address-Event matching: The events are stored in the form of a list, containing, for each frame, references to pixels which actually spiked in that time interval DT. This function block does the finding of possible matching candidates by searching for each spiking pixel in the left vision sensor its corresponding spiking pixels in the right vision sensor. The search is performed w.r.t. the epipolar line (same line index in both sensor arrays) and to the disparity range to create a list of matching candidates. That way, relevant array areas can be accessed directly, avoiding a correlation calculation of the whole array. The algorithm then scans the pixels in the left array for the best matching candidate in the right array by evaluating the similarity metric. This process is iterated for the successive AEs along each sensor line.

Correlation calculation: The stereo matching procedure is an optimization task that finds the best disparity d_{opt} between two accumulated event rates from the left and right inputs based on a *similarity metric F*:

$$d_{opt} \rightarrow \max_d \left\langle F \left(AE^L_{act}(kDT; x, y), AE^R_{act}(kDT; x, y) \right) \right\rangle. \qquad (8.19)$$

Several types of similarity metrics were employed and tested, like normalized cross-correlation, sum of squared differences, and census transform [588], but the best overall performance was achieved using normalized sum of absolute differences (*Normalized sum of absolute differences* (NSAD)), which is an adapted block matching method with respect to the properties of AE. The quantity of the match for a given disparity d was therefore evaluated according to the NSAD score, defined as follows:

$$NSAD(d) = \sum_{x=-B}^{+B} \sum_{y=-B}^{+B} \frac{\left| AE^L_{act}(x, y) - AE^R_{act}(x + d, y) \right|}{AE^L(x, y) + AE^R(x + d, y)}. \qquad (8.20)$$

B defines the size of the matching kernel (it has been set in this case to 15×15). $AE^L(x, y)$ and $AE^R(x, y)$ are the sum of AE generated from, respectively, the left and right sensor, for the pixel address (x, y).

Consistency check: The stereo matching is done by a left to right match, i.e., for each array element in the left frame a correlation calculation is done for corresponding elements in the right frame. The *consistency check* adjusts the correlation calculation with the results of a right to left match, reducing the amount of possible pixel matches. That way it is possible to increase the reliability of the outcome and it helps eliminating false matches in areas where no depth information can be acquired, e.g., due to overlapping.

Correspondence search and optimization: The correspondence search and optimization steps are optimization tasks that find the best disparity for each pixel by maximizing the summed correlation for a whole array line.

Sparse disparity map building: The disparity map is built by collecting individual disparities of all pixels. An example of a sparse disparity map is shown in Fig. 8.16.

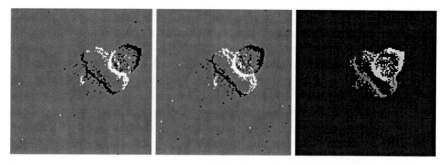

Fig. 8.16 Depth profile example of a surveillance scene with integrated address-event representation (*left and middle*) and resulting sparse depth map (*right*). In order to visualize the AE data, events have been accumulated for a 20 ms interval and restored like a video frame

Reconstruction: Finally a *reconstruction* step is performed to calculate the depth information for every pixel using the resulting disparity map and the stereo system's geometry. The depth information can be extracted and represented as a third coordinate $Z(d)$ using this triangulation equation:

$$Z(d) = \frac{f * T}{d}, \tag{8.21}$$

where f is the focal length of the system object lens, the baseline T is the distance between the sensors (focal points), and d is the disparity.

8.5.4 Evaluation of Stereo Transient Vision Sensors

This stereo system has been evaluated under realistic circumstances and deployed in an indoor environment. The result of a typical surveillance scene is shown in Fig. 8.16: left and middle figures show a moving person captured by the left and right transient vision sensors illustrating the accumulated events according to (8.18).

Black pixels correspond to OFF events and white pixels correspond to ON events. Gray areas indicate that no AEs were generated. In the right figure the corresponding sparse depth map is plotted. The depth values are grayscale-coded. Lightest gray correspond to objects near to the sensor, while darkest gray objects are far from the sensor.

8.6 Summary

In this chapter, we described stereo vision based on the SAD and the census transform. These two algorithms are highly amendable to embedded implementations especially when implemented in hardware. Therefore, we described an architecture for the implementation of these algorithms using FPGAs. Furthermore, we showed

how the resource utilization of the census transform can be reduced to make this robust algorithm suitable for resource-aware applications. We provided as well an overview about especially interesting embedded stereo vision applications. Finally, we presented an architecture and implementation of an embedded stereo algorithm using biologically inspired vision sensors. In this first attempt, a frame-like stereo matching has been used. Our perspective is to investigate event-based stereo vision to better exploit the sparse data representation of TVS sensors.

Acknowledgments The research leading to these results has received funding from the European Community's Sixth Framework Programme (FP6/2003-2006) under grant agreement no. FP6-2006-IST-6-045350 (robots@home).

Part IV
Computer Vision for Smart Cameras

Chapter 9
Self-Calibrating Cameras in Video Surveillance

Roman Pflugfelder and Branislav Mičušík

Abstract This chapter introduces intrinsic camera calibration with focus on video surveillance. Calibration of camera-specific parameters such as the focal length is mandatory for metrological problems, for example, measuring a vehicle's speed. However, it also improves target classification, target detection, and target tracking. Geometry has become important in multi-camera systems that hand over and track objects across cameras. We present the basic geometric concept behind calibration and show which information about the cameras, the scene, and the images is necessary to realize automatic methods. Self-calibration will be a key technology for the practical deployment of future smart video cameras.

9.1 Introduction

In recent years video surveillance has become omnipresent all over the world. Hundreds of new surveillance cameras pop up every day. Watching this massive amount of video data is impossible; therefore, automated video analysis has become important. Essential tasks of automated video analysis are detection (recognition) of target objects and object tracking in single and multiple camera views. The need for multiple cameras for covering large environments is obvious. Observing the same environment by more than one camera introduces important visual redundancy which can significantly contribute to robustness and accuracy in object detection and tracking [161].

Multi-camera object detection and tracking is a highly active research field [263] and it is unclear if these tasks will rely only on visual information to develop practical systems. Cameras arranged in networks of surveillance systems are often placed arbitrarily, however, in mutual vicinity, with no or small overlap in their views to maximize the overall observed space. Known geometry among the cameras and between the cameras and the environment, i.e., *camera calibration*, significantly

R. Pflugfelder (✉)
Video and Security Technology Unit, Safety and Security Department, AIT Austrian Institute of Technology, Vienna, Austria
e-mail: roman.pflugfelder@ait.ac.at

A.N. Belbachir (ed.), *Smart Cameras*, DOI 10.1007/978-1-4419-0953-4_9,
© Springer Science+Business Media, LLC 2010

helps to overcome the fundamental correspondence problem which arises as a result of the necessity to match and classify potential objects within and across cameras [423]. Furthermore, object classification based on geometrically rectified object and environmental features is inherently more unambiguous than target classification based on projectively distorted images [511].

The whole camera system can be described (i) by position and orientation of each camera w.r.t. a common coordinate frame, referred as extrinsic camera parameters (or camera pose, camera external parameters, exterior orientation) and (ii) by intrinsic camera parameters (or internal parameters, interior orientation), mainly the focal length. To retrieve all those parameters with procedures utilizing calibration targets is time-consuming, requiring an expert, and becomes quickly infeasible for higher number of cameras. Therefore, researchers have been focusing on *self-calibration* methods to make cameras autonomous as much as possible.

In case of multiple cameras, if their views overlap, self-calibration methods replace the calibration targets by automatically established point correspondences across more views. If there is no overlap, but the cameras are in vicinity, motion cues of moving objects are usually employed like constant velocity, smooth trajectory. In case of a single view only scene priors like common ground plane, vanishing points [611], object size, give the necessary constraints toward the calibration. The self-calibration methods do not reach the same accuracy as the off-line methods with calibration targets, however, offer practically very interesting alternative with sufficiently low error to help further tasks like object tracking and identification.

This chapter confines itself to the intrinsic self-calibration with connection to video surveillance. First, we present the basic geometric concept useful in the self-calibration procedures. Second, we show key principles with extensive list of literature to the most important work. Finally, we show practical examples and hints toward detection of vanishing points as basic elements to calibrate the cameras and their possible applications. The reader interested further in extrinsic calibration – sometimes called camera localization – is referred to Chapter 13.

9.2 Notation and Background

In this section we briefly introduce the basics of projective geometry and important geometrical concepts in conventional notation. A more in-depth description can be found in [173, 229, 346, 15, 479].

9.2.1 Points, Lines, and Conics

Instead of a 2-vector on the Euclidian plane, a point on the projective plane is a 3-vector $\mathbf{x} = (x_1 \, x_2 \, x_3)^\top$ with a third homogeneous coordinate. Projective points are *projected* to the Euclidian plane by $[\mathbf{x}]_A = (x_1/x_3 \, x_2/x_3 \, 1)^\top$, thus projective points are defined up to a non-zero scale factor λ and $[\mathbf{x}]_A = [\lambda \mathbf{x}]_A$. Points are analogously represented by 4-vectors in a projective space.

Lines on the projective plane are as well as points 3-vectors $\mathbf{l} = (l_1\ l_2\ l_3)^\top$. The vector coordinates are the coefficients of the well-known standard line equation

$$\mathbf{l}^\top \mathbf{x} = 0, \tag{9.1}$$

which expresses line and point coincidence. The standard line equation and thus projective lines are also defined up to a non-zero scalar factor.

Two points \mathbf{x}_1 and \mathbf{x}_2 define a line with

$$\mathbf{l} = \mathbf{x}_1 \times \mathbf{x}_2, \tag{9.2}$$

which is a linear relation. This linearity is one advantage of the homogeneous representation in contrast to quadratic trigonometric relations in the Euclidian case.

A conic, for example an ellipse or a circle, is a curve on the Euclidian plane described by the quadratic conic equation:

$$c_1 x_1^2 + c_2 x_1 x_2 + c_3 x_2^2 + c_4 x_1 + c_5 x_2 + c_6 = 0, \tag{9.3}$$

which expresses conic and point coincidence and is equivalent to the standard line equation up to a scalar factor. Introducing a homogeneous coordinate by replacing $x_1 \to x_1/x_3$ and $x_2 \to x_2/x_3$ leads to the projective conic equation:

$$c_1 x_1^2 + c_2 x_1 x_2 + c_3 x_2^2 + c_4 x_1 x_3 + c_5 x_2 x_3 + c_6 x_3^2 = 0, \tag{9.4}$$

or more conveniently written as a bilinear equation

$$\mathbf{x}^\top C \mathbf{x} = 0, \tag{9.5}$$

where the six coefficients are compactly written as the matrix

$$C = \frac{1}{2} \begin{pmatrix} 2c_1 & c_2 & c_4 \\ c_2 & 2c_3 & c_5 \\ c_4 & c_5 & 2c_6 \end{pmatrix}.$$

The conic has as analogon a curved surface (quadric) in space.

9.2.2 Infinity

The homogeneous coordinate has another important advantage, namely the representation of points, lines, and conics at infinity. For example, an infinite, planar point has a zero homogeneous coordinate and represents a direction on the plane. A pair of points \mathbf{x}_1 and \mathbf{x}_2 can be chosen to compute the plane's line-at-infinity:

$$\mathbf{L}_\infty = (x_{11}\ x_{12}\ 0)^\top \times (x_{21}\ x_{22}\ 0)^\top = \lambda\,(0\ 0\ 1)^\top. \tag{9.6}$$

The equation shows that regardless of which pair we choose, \mathbf{L}_∞ for a particular plane is always the same as all possible planar directions collapse to one line. Note that making a distinction between different planes is impossible until the reference frame is the Euclidian 3-D space: hence, \mathbf{L}_∞ is a constant vector.

Similarly, infinite, 3-D points, which are 4-vectors, represent all possible directions in space, for example, if the universe were our space, then all the stars in the sky would be particular directions completing the space at infinity. The sky is geometrically a sphere and is called plane-at-infinity Π_∞ (Fig. 9.1). All infinite, planar points of possible planes compose all possible infinite, spatial points, thus constituting Π_∞.

Π_∞ embeds two important geometrical entities, the circular points and the absolute conic which encapsulate the scene information for intrinsic calibration. Two complex and conjugant circular points, $\mathbf{X}_I = (1\ i\ 0)^\top$ and $\mathbf{X}_J = (1\ -i\ 0)^\top$, exist on \mathbf{L}_∞ and are the same for all Euclidian planes. The name derives from the fact that the circular points are the intersection points of every possible circle on a plane and \mathbf{L}_∞. Circles are special conics with $c_1 = c_3$ and $c_2 = 0$. The circular points capture the metric properties of Euclidian planes such as angles and length ratios.

When we shift the reference frame once more from planes to space, a geometric entity – the absolute conic Ω – appears on Π_∞, which in this case is composed of all circular points of all possible planes. By considering \mathbf{X}_I and \mathbf{X}_J one sees that Ω is actually a circle with the radius i that is $\Omega = \mathbf{I}_3$ the 3×3 identity matrix. Each \mathbf{L}_∞ of a particular plane in space intersects with Ω in the plane's two circular points (Fig. 9.1). Ω was introduced in [174] and plays a central role in intrinsic calibration (Section 9.3).

Fig. 9.1 Each plane Π in a Euclidian 3-D space intersects the plane-at-infinity Π_∞ in a line which is composed of points that represent all possible world directions confined by Π. Π_∞ is a theoretical, geometric construct that closes the space at infinity. Two points – the circular points – \mathbf{X}_I and \mathbf{X}_J have a special meaning. They constitute metric properties such as angles and line ratios. These two points are the intersection points of the plane's line-at-infinity and the absolute conic Ω which is composed of circular points of all possible planes in space

9.2.3 Perspective Camera Model

The perspective projection is the most common model for video cameras and is described by the equation

$$\lambda \mathbf{x} = P\mathbf{X}. \tag{9.7}$$

It maps a point \mathbf{X} in the projective space to a point on the (projective) image plane. P is factorized into

$$P = KR[I_3 \ - \mathbf{C}], \tag{9.8}$$

where matrix

$$K = \begin{pmatrix} f & s & p_1 \\ 0 & rf & p_2 \\ 0 & 0 & 1 \end{pmatrix}$$

contains the intrinsics (internal camera parameters), R a 3×3 orthonormal matrix representing the camera orientation, and \mathbf{C} a 3-vector representing the camera position. Orientation and position are the extrinsics (external camera parameters) which express the camera pose relative to an arbitrarily definable world coordinate frame. The intrinsics are (i) the intersection point $\mathbf{p} = (p_1 \ p_2)^\top$ (principal point) of the line of sight normal to the image plane (optical axis) passing through \mathbf{C}, (ii) the distance f measured along the optical axis between \mathbf{C} and \mathbf{p} in world coordinates (focal length), (iii) the aspect ratio r, and finally (iv) the aspect shear s of a pixel (skew).

9.2.4 Lens Distortion

Lenses of practical interest with a small to moderate focal length usually cause image distortion. Surprisingly, many people neglect lens distortion, although intrinsic calibration depends on rather sensible image measurements which can yield severe errors even for small distortions.

Several models of distortion have been discussed in the literature [115, 190]. The most widely used and sufficient for modern lenses with good quality is the first-order radial distortion model which is a polynomial function in the pixel position, the distortion coefficient k, and the radial center $\mathbf{c}_k = (c_{k1} \ c_{k2})^\top$. Zhang [593] showed an average error of $1/10$ pixel in the image with first-order polynomials. Positive values of k indicate pincushion, negative values indicate barrel distortion, and further, the larger the magnitude of k, the larger the distortion. The distortion increases isotropically with the distance from the radial center.

For example, consider a distorted point $\mathbf{x}_d = (x_1 \ x_2)^\top$ in the image plane with the image center \mathbf{c}. The undistorted point \mathbf{x} is represented by

$$\mathbf{x} = \mathbf{x}_d + k(\mathbf{x}_d - \mathbf{c}_k)\frac{\|\mathbf{x}_d - \mathbf{c}_k\|^2}{\mathbf{c}^\top \mathbf{c}}. \qquad (9.9)$$

\mathbf{c}_k is for real lenses usually neither the camera's principal point nor the image center, because the lens is never perfectly centered above the image sensor [228].

Moreover, Devernay and Faugeras [141] showed that the aspect ratio of the image sensor is not necessarily the same as the pixel aspect ratio used in the radial distortion model. This difference accounts for a tangential distortion of the lens. We omit a modeling of the tangential distortion, because the radial model is applicable for a large variety of real lenses. Furthermore, more complicated models are even more vulnerable to noisy line segments; hence, we try to keep the model simple. This decision is supported by observations [7] that report an instable calibration when including the coefficients of the tangential distortion.

The effect of radial distortion is independent of the imaging process; hence, the estimation of the parameters of the radial lens distortion model can be completely decoupled from the calibration of the internal parameters [141, 79, 314, 124]. To find the parameters of the distortion model, Devernay and Faugeras [141] used the invariance of straightness with respect to a projective transformation, that is, following a pinhole camera model straight lines in space are projected to straight lines in the image. The approach detects short edges and fits a polygon onto them with high tolerance. Then, the image and edges are straightened out iteratively by following the distortion model and optimizing its parameters until a best fit transforms the edges to line segments. The method is completely automatic and makes only the assumption of a man-made world where only straight lined edges exist. The handicap of this method is the tolerance level in the polygon fitting. If the value is too large, the algorithm will try to transform edges to line segments which perhaps are not images of straight lines. Contrary, if the value is too small the algorithm will fail to succeed.

Another well-known approach is to use the fact that parallel lines intersect all in a vanishing point after a projective transformation [52, 7]. This idea is rooted in photogrammetry and can be traced back to the so-called "plumb-line method" [88]. Especially with simultaneous vanishing point detection this approach is useful [79, 544, 216, 421]. Bräuer-Buchardt [79], for example, computes alternatingly vanishing points and the distortion. He constructs an ideal line passing through the vanishing point and the midpoint of a line segment. Then, the points composing the line segments are projected onto the line. These projected points and the original ones allow for an estimation of the coefficients of the polynomial models and the radial center. Pflugfelder [421] uses the fact that the columns of the infinite homography can be interpreted as pairwise orthogonal vanishing points. After intrinsic calibration the method computes the vanishing points and performs lens undistortion by minimizing the normal error distance between the line segments' endpoints and ideal straight lines passing through the vanishing points. The undistorted line segments are then used to intrinsically calibrate again (Fig. 9.2). The difficulty with the "plumb-line" approach is the requirement of a rectilinear and orthogonal structure

(a) distorted (b) undistorted

Fig. 9.2 Barrel distortion is automatically reduced [421], but not completely removed, because the upper *left* image part has low resolution (weak edge information)

in the scene and knowledge about the assignment of a structure's edge to a particular vanishing point.

Therefore, undistortion approaches using point correspondences between different views of a rotating camera could have potential in much more general settings. Undistortion decoupled from intrinsic and extrinsic calibration with multiple cameras has recently shown success [314, 228]. To our knowledge no work currently exists that has shown the applicability of this idea for a rotating camera.

Let us assume in the following that an image is radially undistorted, meaning that the camera pinhole model is a valid geometric representation for further investigation.

9.2.5 Planar and Infinite Homography

More restrictive w.r.t. P, a 3×3 homography H and its inverse H^{-1} are projective transformations which map points between projective planes, for example, from a world plane to the image plane or vice versa:

$$\lambda \mathbf{x}' = H\mathbf{x}, \tag{9.10}$$

$$\lambda \mathbf{x} = H^{-1}\mathbf{x}'. \tag{9.11}$$

Homographies map also lines between projective planes, especially \mathbf{L}_∞ is mapped by H with

$$\lambda \mathbf{l}_\infty = H^{-\top} \mathbf{L}_\infty, \tag{9.12}$$

to its image in the image plane – the vanishing line. Identifying the vanishing line allows the reconstruction of the perspective part of H. Projective transformations are analogously possible for conics with

$$\lambda C_1 = H^{-T} C_2 H^{-1}. \tag{9.13}$$

A special homography is the infinite homography H_∞ which maps a direction in space **d** with

$$\lambda \mathbf{v} = H_\infty \mathbf{d} \tag{9.14}$$

to a point **v** on the image plane – the vanishing point. As directions in space are independent of the actual camera position, H_∞ encodes the projective transformation without camera translation given by **C**, in fact $H_\infty = KR$.

9.3 Intrinsic Calibration

Intrinsic calibration is based on an important result [174] – the estimation of K is in the "language" of projective geometry intrinsically tied to the image of Ω, described by a 3×3 matrix

$$\omega = \begin{pmatrix} \omega_1 & \omega_2 & \omega_4 \\ \omega_2 & \omega_3 & \omega_5 \\ \omega_4 & \omega_5 & \omega_6 \end{pmatrix}, \tag{9.15}$$

called the IAC.

The previous section introduced H_∞ as part of P that maps infinite geometrical entities to the image plane (Fig. 9.3); hence, we can write ω as a conic mapping of Ω by

$$\omega = H_\infty^{-T} \Omega H_\infty^{-1} = (KR)^{-T} I_3 (KR)^{-1} = K^{-T} RR^{-1} K^{-1} = (KK^T)^{-1}. \tag{9.16}$$

Fig. 9.3 H_∞ maps entities on Π_∞ to the image plane. For example, Ω is mapped to ω, the circular points of a plane are mapped to points **I**, **J** that lie on ω and *therefore* constrain ω

The IAC ω and the K are in a bijective relationship; a known K yields directly ω and knowing ω lets us compute K by matrix inversion and Cholesky factorization.[1] ω is like Ω an imaginary point conic and allows contrary to K the *direct* formulation of constraints for its computation from visual, scene, and camera information.

Five constraints (Table 9.1) are necessary and sufficient to compute ω which is a symmetric, homogeneous 3×3 matrix of rank two, thus $6 - 1 = 5$ unknown elements are independent; ω's number of independent elements is equal to K's number of unknown elements. Fortunately, all constraints are linear, so they can be stacked together to a matrix A [229, Algorithm 8.2, p. 225] to form a homogeneous linear equation system

$$A\mathbf{w} = 0 \tag{9.17}$$

in the unknowns of ω, vectorized by $\mathbf{w} = \left(\omega_1 \cdots \omega_6\right)^\top$. Five independent equations plus the assumption $\|\mathbf{w}\|_2 = 1$ yield a distinct solution, for example, by using SVD which factorizes A into $A = UDV^\top$. D has positive diagonal elements with zero off-diagonals. If D's diagonal elements are arranged in a descending order down the diagonal, then ω is the last column of V. The flexibility to arbitrarily use equations of different constraints (information sources) has made this framework very popular for intrinsic calibration. The alternative would be to formulate the quadratic, trigonometric constraints directly in the elements of K where this flexibility is obviously not existent.

Table 9.1 Computation of ω with visual, scene, and camera information. $[\,\cdot\,]_\times$ is the skew-symmetric matrix operator (Eq. 9.22)

#	Information	Relation	Constraints
1	Two orthogonal vanishing points	$\mathbf{v}_1^\top \omega \mathbf{v}_2 = 0$	1
2	Orthogonal vanishing line and point	$[\mathbf{l}]_\times \omega \mathbf{v} = 0$	2
3	Circular point	$\mathbf{x}^\top \omega \mathbf{x} = 0$	1
4	Homography	$\mathbf{h}_1^\top \omega \mathbf{h}_2 = 0$	2
		$\mathbf{h}_1^\top \omega \mathbf{h}_1 = \mathbf{h}_2^\top \omega \mathbf{h}_2$	
5	Infinite homography	$\mathbf{h}_1^\top \omega \mathbf{h}_2 = 0$	4
		$\mathbf{h}_1^\top \omega \mathbf{h}_3 = 0$	
		$\mathbf{h}_2^\top \omega \mathbf{h}_3 = 0$	
		$\mathbf{h}_1^\top \omega \mathbf{h}_1 = \mathbf{h}_2^\top \omega \mathbf{h}_2$	
7	Zero skew	$(1\,0\,0)\,\omega\,(0\,1\,0)^\top = 0$	1
8	Aspect ratio	$(1\,r\,0)\,\omega\,(1\,-r\,0)^\top = 0$	1
9	Principal point	$\omega\mathbf{p} = (0\,0\,1)^\top$	2

Sometimes more equations than unknowns are available which leads to an over-constrained equation system without any solution. Nevertheless, a "best" approximation that minimizes the residuum $\|A\mathbf{w}\|_2$ is computable by SVD which makes

[1] The Cholesky factorization will fail when ω is not positive semi-definite. Noisy visual information can cause failure in practice.

it a convenient tool for solving exactly constrained and overconstrained equation systems.

We will now take a closer look at the various sources of information that allow us to compute ω. Some relations are mutually related and we will discuss these cross-links.

9.3.1 Vanishing Points

Vanishing points of two world directions knowing their enclosing angle are a good example of exploitable visual information and scene information. Let us assume without restriction of any kind that the world coordinate frame rests in the camera center and is equal to the camera coordinate frame, or more formally, $P = K[I_3 \; \mathbf{0}]$. Each ray emanating in the camera center has a particular orientation and thus follows a particular world direction. These rays pierce the image plane in points which are vanishing points. Intuitively, the enclosed angle tells us the shortest distance of the image plane to the camera center, that is, the focal length, which is one element of K. One can imagine that more independent ray pairs and angles will allow computing all intrinsics.

Mathematically, we can express the angle ϕ between two directions \mathbf{d}_1 and \mathbf{d}_2 by

$$cos\phi = \frac{\mathbf{d}_1^\top \Omega \mathbf{d}_2}{\sqrt{\mathbf{d}_1^\top \Omega \mathbf{d}_1}\sqrt{\mathbf{d}_2^\top \Omega \mathbf{d}_2}}. \qquad (9.18)$$

This relation is the inner product of the directions in an Euclidian world, that is, $\Omega = I_3$. Mapping these directions to their vanishing points by using K and then replacing $K^{-\top}K^{-1}$ with ω (Eq. 9.16) yields

$$cos\phi = \frac{\mathbf{v}_1^\top \omega \mathbf{v}_2}{\sqrt{\mathbf{v}_1^\top \omega \mathbf{v}_1}\sqrt{\mathbf{v}_2^\top \omega \mathbf{v}_2}}, \qquad (9.19)$$

a non-linear relation between the unknown ω, two vanishing points (visual information), and ϕ (scene information).

The special case $\phi = \frac{\pi}{2}$ (Fig. 9.4) simplifies this relation to

$$\mathbf{v}_1^\top \omega \mathbf{v}_2 = 0, \qquad (9.20)$$

which is bilinear in the unknowns of ω but can be re-formulated as linear relation (Eq. 9.17) where ω is replaced by \mathbf{w} [229]. This relation provides one constraint on ω; therefore, five independent pairs of orthogonal vanishing points are sufficient to compute ω.

Orthogonal vanishing points tell us also the relative rotation of the camera to the world; the orthogonal vanishing points are the imaged coordinate axis directions

Fig. 9.4 Vanishing points of orthogonal directions are conjugate w.r.t. ω and *therefore* constrain ω. For example, parallel lines (Section 9.4) on orthogonal world planes are imaged with the vanishing points **u** and **v**. Geometrically, **v** lies on the polar line of **u** w.r.t. ω, and **u** lies on the polar line of **v**. Polar lines are defined by the tangents of ω passing through **u** and **v**, respectively (called poles) [479]

of the world coordinate frame. Changing the pixel position of the vanishing points would change the orientation of the camera. Unfortunately, absolute rotations are not identifiable without further scene information as above, below, left, and right in the world is unknown.[2]

9.3.2 Vanishing Lines and Vanishing Points

Vanishing points of world plane normals with known are also an information source for intrinsic calibration. For example, the horizon in an image is the vanishing line of the earth's surface providing some information about the camera's pan and tilt; however, it provides no information about camera yaw and the intrinsics. The farther vanishing point which provides the missing scene information (world plane normal) gives the constraint on ω and also the missing information about the relative rotation. Formally, this is written as

$$[l]_\times \omega \mathbf{v} = 0, \tag{9.21}$$

where

$$[l]_\times = \begin{pmatrix} 0 & -l_3 & l_2 \\ l_3 & 0 & -l_1 \\ -l_2 & l_1 & 0 \end{pmatrix}, \tag{9.22}$$

is the skew-symmetric matrix of vector **l**. This relation provides two constraints on ω; therefore, three pairs of vanishing lines with orthogonal vanishing points are sufficient to compute ω.

[2] The real directions of the coordinate axes are unidentifiable.

9.3.3 Circular points

An obvious method to define ω is to provide explicitly a conic point **x**. Such a point constrains ω by

$$\mathbf{x}^\top \omega \mathbf{x} = 0. \tag{9.23}$$

Five points define clearly ω. For example, the images **I** and **J** of a world plane's conjugant circular points (Section 9.2), that is, $\mathbf{I} = \mathrm{H}_\infty \mathbf{X}_I$ and $\mathbf{J} = \mathrm{H}_\infty \mathbf{X}_J$, are such points, because the world plane's circular points lie on the absolute conic (Fig. 9.3). The imaged circular points can be independently computed from scene (world plane) information such as a known length ratio, a known angle of two intersecting straight lines or known equal angles of two pairs of intersecting straight lines on the world plane [320]. Identifying the circular points of at least three world planes is sufficient to calibrate the intrinsics. The reader should also imagine the cross-links between imaged circular points and vanishing lines. As the imaged circular points define the world plane's vanishing line one could combine them indirectly with a vanishing point representing the world plane's normal. In this case, the vanishing line is a polar and the imaged circular points are the two intersection points of tangents and ω.

9.3.4 Planar Homographies

Homographies between a world plane and the image plane are bijective transformations between a world plane's point and an image point. Hence, a homography must capture information about K and must provide constraints on ω. This becomes obvious when the first two columns of

$$\mathrm{H} = (\mathbf{h}_1 \ \mathbf{h}_2 \ \mathbf{h}_3) = (\lambda_1 \mathbf{v}_1 \ \lambda_2 \mathbf{v}_2 \ \mathbf{h}_3) \tag{9.24}$$

are identified as two orthogonal vanishing points defining the world plane's vanishing line [318] which yields obviously one constraint on ω (Eq. 9.20), namely

$$\mathbf{h}_1^\top \omega \mathbf{h}_2 = \lambda_1 \lambda_2 \mathbf{v}_1^\top \omega \mathbf{v}_2 = \mathbf{v}_1^\top \omega \mathbf{v}_2 = 0. \tag{9.25}$$

But \mathbf{h}_1 and \mathbf{h}_2 encapsulate besides the orthogonal vanishing point pair the projective depths which give a further constraint on ω, namely

$$\mathbf{h}_1^\top \omega \mathbf{h}_1 = \mathbf{h}_2^\top \omega \mathbf{h}_2. \tag{9.26}$$

This relation is derived from the fact that λ_1 depends on λ_2 for a given H or mathematically

$$\frac{\lambda_1}{\lambda_2} = \frac{\mathbf{v}_2^\top \omega \mathbf{v}_2}{\mathbf{v}_1^\top \omega \mathbf{v}_1} = 1. \tag{9.27}$$

Intuitively, H fixes the horizontal world plane spanned by the two horizontal axes of the world coordinate frame. Three known world planes and their induced homographies are therefore sufficient to compute ω.

9.3.5 Infinite Homography

H_∞ provides the same constraints as planar homographies, thus our discussion about planar homographies also includes H_∞. However, contrary to planar homographies the last column of H_∞ can also be interpreted as vanishing point orthogonal to \mathbf{v}_1 and orthogonal to \mathbf{v}_2, that is,

$$H_\infty = (\mathbf{h}_1\ \mathbf{h}_2\ \mathbf{h}_3) = (\lambda_1 \mathbf{v}_1\ \lambda_2 \mathbf{v}_2\ \lambda_3 \mathbf{v}_3), \tag{9.28}$$

which yields four additional relations

$$\mathbf{h}_1^\top \omega \mathbf{h}_3 = \lambda_1 \lambda_3 \mathbf{v}_1^\top \omega \mathbf{v}_3 = \mathbf{v}_1^\top \omega \mathbf{v}_3 = 0, \tag{9.29}$$

$$\mathbf{h}_2^\top \omega \mathbf{h}_3 = \lambda_2 \lambda_3 \mathbf{v}_2^\top \omega \mathbf{v}_3 = \mathbf{v}_2^\top \omega \mathbf{v}_3 = 0, \tag{9.30}$$

$$\mathbf{h}_1^\top \omega \mathbf{h}_1 = \mathbf{h}_3^\top \omega \mathbf{h}_3, \tag{9.31}$$

$$\mathbf{h}_2^\top \omega \mathbf{h}_2 = \mathbf{h}_3^\top \omega \mathbf{h}_3. \tag{9.32}$$

At a first look, H_∞ gives six constraints and one would believe that knowing H_∞ is sufficient to compute ω. Contrary to the relation $\lambda_1/\lambda_2 = 1$, H_∞ does not fix the relations λ_1/λ_3 and λ_2/λ_3, because one can multiply H_∞ by an arbitrary scalar, hence the two relations given by Eqs. (9.31) and (9.32) are dependent. Therefore, we have only four independent constraints. Intuitively, we cannot fix the two vertical world planes spanned by the vertical coordinate axes and each of the horizontal ones.

9.3.6 Camera Information

Vanishing points are properties of the scene. However, some properties of the camera itself, i.e., some known elements of K, can be utilized and can significantly simplify the self-calibration procedure.

Pixel aspect ratios r of modern image sensors are typically one (square pixel) or at least constant and known and pixel skew is usually negligible and zero. This camera information provides two independent constraints:

$$(1\ 0\ 0)\,\omega\,(0\ 1\ 0)^\top = 0 \quad \text{(zero skew)}, \tag{9.33}$$

$$(1\ r\ 0)\,\omega\,(1\ -r\ 0)^\top = 0 \quad \text{(known aspect ratio)}. \tag{9.34}$$

Some methods assume the principal point to be the midpoint of the image. This information provides the last conceivable constraint, that is,

$$\omega \mathbf{p} = (0\ 0\ 1)^\top. \tag{9.35}$$

The reader should use this constraint carefully, because the deviation of principal point and midpoint is usually significant, especially when images are cropped for example, in critical cases when available visual and scene information is not sufficient for computing ω.

9.4 Automatic Detection of Image Features for Self-Calibration

We discuss and compare now promising automatically recognizable image features and selected environments that capture the visual information necessary to form the previously discussed relations with higher emphasis later on detection of vanishing points. Depending on the spatial setup of cameras, one can utilize multi-view geometry, motion, or scene cues.

9.4.1 Multi-view Geometry Cues

Point correspondences across more views, established by local descriptors, e.g., SIFT [337] or MSER [362], deliver constraints on the IAC and thus allow to estimate the intrinsic parameters. There is extensive work [229] on self-calibration for standard, non-rotating cameras. However, in surveillance applications, the multi-view geometry cues are often impossible to be used because of common camera arrangement with camera views. An exception is active pan-tilt cameras often present in surveillance applications, where the point matches can serve to compute the infinite homographies between pairs of images acquired by the same camera at different orientations. The standard approach is described in detail in [6, 229].

9.4.2 Motion cues

Moving objects, e.g., pedestrians or vehicles, are another source delivering visual information, see Fig. 9.5. Imagine a scene with a dominant ground plane on which people are essentially vertical segments of constant height. Measuring the same person in different positions provides line segments representing the same world length and parallel as well as vertical straight lines which define the vertical vanishing point orthogonal to the ground plane. In addition, all lines connecting the upper points of pairs of segments and lower points of the same pair are also parallel and their images intersect at the image of the ground plane's vanishing line. Several positions that

Fig. 9.5 Motion cues. Moving objects tell us a lot about the structure of the environment just by their tracking over the time. Image was downloaded from `http://www.flickr.com`

are neither collinear nor identical provide several distinct vanishing points which compose clearly the vanishing line.

Several approaches have been developed in this context [342, 303, 269]. Lv, Zhao and Nevatia [342] use a tracking method to record multiple observations of a person moving about the scene. Joining the same point observed in different observations leads to estimates of the horizon line and the vanishing point. As their approach is not robust to outlier trajectories, Krahnstoever and Mendonca [303] proposed a probabilistic approach where the foot-to-head homology[3] is decomposed to extract the vanishing point and the horizon line. The homology is computed from foot and head detections of pedestrians walking along the ground plane in different direction. The homology can be estimated more accurately than direct estimation of the horizon line and vanishing point. As their approach is inherently non-linear, Junejo and Foorosh [269] proposed a linear robust homology-based approach.

Vehicles are a second class of objects that could be tracked. For example, Bose and Grimson [69] use assumptions such as constant speed to compute the imaged circular points of the road. Pflugfelder and Bischof [422] use the cubic form of trucks to compute the three orthogonal vanishing points.

Although robustness of calibration has been improved significantly, these methods still lack in accuracy especially in critical cases, for example, the image plane is orthogonal to the ground plane. Furthermore, the relative error between intrinsics and ground truth exceeds 5%.

[3] Homography between two parallel world planes in the image.

9.4.3 Scene Cues

Buildings or rooms have usually rectilinear, parallel, and orthogonal details, for example, window frames or edges of floor tiles which remain rectilinear in images. Parallelism and orthogonality are not conserved by camera projection; therefore, parallel edges intersect in a single vanishing point and a right angle appears arbitrarily. Since the 16th century painters have been adding realism to their paintings by exploiting these geometric properties [284, 127] using underline drawings of orthogonal vanishing points reflecting this perspective law.

Intrinsic calibration does exactly the opposite. By assuming man-made structures one tries to find methods to automatically detect vanishing points and compute K and the rotation R of the camera to the structure which can be seen as one calibration object. The structure is imaged as line segments that can be detected by common line segment detectors [92]. The first attempts to develop methods for the detection of vanishing points date back to the late 1970s [38]. A comprehensive review of vanishing point detection can be found in [421].

Vanishing points are often distant to the image center. Nearly all methods use line segments as source of information to compute vanishing points and small errors in the line segments forming concurrent lines have a drastic effect on the location of vanishing points, a fact that makes an accurate detection method difficult to develop.

The seminal work by Caprile and Torre led to significant developments in intrinsic calibration based on vanishing points [95]. They used the projected edges of a cuboid to compute the three finite, orthogonal vanishing points in the image. Together with zero skew and constant aspect ratio, they were able to estimate the focal length and principal point. After a careful study of the literature we can summarize the following:

- One should locate vanishing points on the projective plane [275, 465, 319, 514, 456, 424]. A homogeneous vector simultaneously represents finite and infinite points. The mapping from the image plane to a sphere [38, 46, 349, 436, 118, 341, 80, 114, 494, 543, 19, 208, 302] or from the image plane to Tuytelaars's subspaces [539, 481] does not preserve the distances. Hence, the cost function can be arbitrarily small and flat.
- Figure 9.6 shows a comparison of different intersection point methods for computing a vanishing point from the intersecting line segments. Different distances measuring the error of this intersection exist. Liebowitz's error distance [465, 319, 456, 424] is independent of the location of vanishing points in the image plane and behaves well, i.e., (i) will have no singularities, (ii) will be optimal under a Gaussian error mode, (iii) will be locally continuous to the second order, and (iv) will be locally quadratic.
- The detection of vanishing points is a simultaneous clustering and estimation problem, whereas promising solutions follow the expectation-maximization algorithm [477, 383, 19, 302, 424].
- Vanishing points are not arbitrarily located within the search space. In most cases knowledge about the scene and the camera is available. This knowledge can be utilized to guide the search.

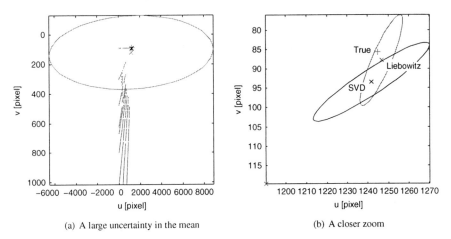

(a) A large uncertainty in the mean (b) A closer zoom

Fig. 9.6 Comparison between possible intersection points. (**a**) The mean of the intersection points between pairwise synthetic line segments (bold cross, relative error 4.57% in u, 28.44% in v) (**b**) the intersection point computed by SVD with minimal normal Euclidean distance to all elongated line segments (relative error 0.24% in u, 8.30% in v) and finally the optimal intersection point computed by the Liebowitz's method (relative error 0.15% in u, 2.47% in v). The ellipses depict 99% of the confidence interval. The mean has large uncertainty and is by far the worst estimation. As expected the optimal intersection point yields the best result (more than three times better)

- Lens distortion is usually not negligible. A radial distortion model is sufficient with lenses of good quality. The estimation of the lens distortion should be part of the intrinsic calibration [79, 544, 216].
- Computation of the intrinsics is not a post-processing step after vanishing point detection. The unknown internal camera parameters are the objective of optimization [470, 421]. As we have seen, vanishing points are the columns of $H_\infty = KR$.

Experiments with realistic scenarios (Fig. 9.7) showed that on average the relative error in the intrinsic parameters compared to the ground truth is below 5% [421]. This error still allows applications in surveillance, because the resulting errors in reality were always between half a meter and a meter which is the average width of a person. When the line segments are evenly distributed within the image and all three orthogonal directions are well represented, the relative error drops below 1%, which is in the range of standard calibration using calibration patterns [537].

Vanishing points encode very strong information about observed scene and can be further facilitated for another higher level task, e.g., detection of rectilinear structures. The rectilinear geometric structures are one of the most commonly encountered structures in man-made indoor and outdoor environments. In many instances one can directly associate semantic labels with detected regions of rectangular shape such as doors, windows, posters, tables, building facades. As planar structures, they can also be viewed as large support regions of co-planar points and hence provide an effective alternative for difficult ground plane detection, wide baseline matching tasks and subsequent piecewise planar 3-D reconstruction, and computation of geometric context. The rough scene geometry can help in surveillance applications

Fig. 9.7 Realistic scenarios: The images show results of Pflugfelder's intrinsic calibration [421] in indoor scenes. Line segments are grouped to at least two orthogonal vanishing points. Intrinsic parameters and the orientation are then computed. The re-projected cubes in the images illustrate the estimated orientation, vanishing points (intersection points of the cube's edges), and principal point (the cube's center of gravity)

to restrict the space of possible object detections. These are just few reasons why efficient and reliable detection of the vanishing points is of importance, see Fig. 9.8 for an example. Furthermore, one can possibly incorporate vanishing points, so important for estimating camera intrinsics, as additional parameters and search for them simultaneously with the rectilinear structures.

Fig. 9.8 Detection of rectilinear structures. From *left*: (i) Input image with in-plotted vanishing lines. (ii) The detected quadrilaterals by the method of Micusik et al. [380]. (iii) A Markov random field-based method [381] for segmentation of a single image into three orthogonal planes utilizing the extracted quadrilaterals. Each plane is depicted in a different *gray* level, where the brightest denotes "undecided" pixels

9.5 Discussion

The geometric fundamentals of intrinsic calibration have been studied intensively over the past decades and today the theory is well established. We have presented the image of the absolute conic as the central geometric construct for the computation of the intrinsics. This conic is constrainable by various visual, scene, and camera information such as vanishing points, vanishing lines, circular points, the fundamental matrix, and known camera aspect ratio, zero skew or known principal point.

The *robust* and *accurate* recognition of image features capturing the visual information is, however, solved in an unsatisfactory manner and requires further research.

The use of massive pedestrian or car data when using moving targets for calibration is one option which allows conservative incremental improvement of the calibration over time by following the law of statistics. Another trend for improvement is to exploit much more the various cross-links between recognition, tracking, and calibration [312].

Self-calibration by panning, tilting, and zooming an active camera is also a promising direction, because on the one hand rather limiting scene assumptions such as rectilinear, orthogonal, and parallel structures are not necessary anymore and on the other hand strategies in matching image points in general settings are rather successful.

Chapter 10
Change Detection for Object Segmentation

Andrea Cavallaro

Abstract Object segmentation based on motion or change detection is the first step in many smart camera applications, such as video surveillance, human computer interaction, and immersive gaming. Efficient and accurate techniques are required to detect and label the changes in the observed scene. Different change detection techniques can be employed for moving camera and static camera conditions. If the camera moves, change detection aims to recognize coherent and non-coherent moving areas. The former correspond to background areas, the latter to moving objects. If the camera is static, the goal of change detection is to recognize moving objects (foreground) and the static background. In this chapter, we focus on change detection applications when the background is static. The methods discussed here are applicable in the case of a moving smart camera after global motion compensation. Change detection algorithms proposed in the literature are discussed based on four building blocks of a proposed general model.

10.1 Introduction

Change detection is an important step in vision-based applications such as video surveillance, smart homes, interactive and immersive gaming. In particular, change detection is a pre-processing step in smart camera applications as it reduces the amount of information to be analyzed by subsequent modules or to be exchanged in distributed smart camera settings. Depending on the application, on the available computational power, and on the accuracy required, the complexity of a change detection algorithm will vary.

The general requirements for change detection algorithms are accuracy in the detection of object contours (*spatial accuracy*) and temporal stability of the detection (*temporal coherence*). Moreover, *sensitivity* and *robustness* are desirable features in a change detection algorithm. Sensitivity refers to the ability of detecting changes of small magnitude. Robustness can be seen as the property of providing

A. Cavallaro
Queen Mary University of London, UK
e-mail: andrea.cavallaro@elec.qmul.ac.uk

A.N. Belbachir (ed.), *Smart Cameras*, DOI 10.1007/978-1-4419-0953-4_10,
© Springer Science+Business Media, LLC 2010

good accuracy under varying conditions, for example illumination changes. Other requirements may also be introduced depending on the application. For example, a priori constraints of spatial connectivity can be applied, if this property characterizes the objective of the detection process [97].

Let us denote the frame under test as $f(x, y, n)$. In this chapter, we represent a general sequence as function f of three variables: two spatial, x and y, and one temporal, n. When the function is multi-band or a random variable, we denote it in bold font, \mathbf{f}. The problem of change detection consists in finding, for each frame n, a binary map $c(x, y, n)$, defining the pixels in $f(x, y, n)$, which have changed with respect to the reference image $f(x, y, r)$. The binary mask $c(x, y, n)$, resulting from the change detection analysis, is defined as

$$
c(x, y, n) = \begin{cases} 1 \text{ if a change has occurred at } (x, y) \text{ at time } n, \\ 0 \text{ otherwise.} \end{cases} \tag{10.1}
$$

Different strategies \mathcal{M} can be adopted to compute $c(x, y, n)$ as a function of $f(x, y, n)$ and $f(x, y, r)$:

$$
c(x, y, n) = \mathcal{M}(f(x, y, n), f(x, y, r)). \tag{10.2}
$$

We decompose \mathcal{M} into four major steps, namely *feature extraction*, *feature analysis*, *classification*, and *post-processing*. This general structure allows us to compare the different techniques proposed in the literature. The block diagram of the proposed scheme is shown in Fig. 10.1.

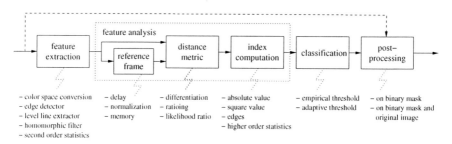

Fig. 10.1 The main steps of a change detection algorithm and different techniques used in the literature

The choices related to the algorithm \mathcal{M} comprise the features to extract from $f(x, y, n)$ and $f(x, y, r)$, the distance metric to quantify changes, and the classification strategy to detect changes.

The first step toward change detection consists in transforming each input frame of the image sequence $f(x, y, n)$ into the most appropriate feature space by means of the transformation \mathcal{F}. The choice of the feature space depends on the applications the algorithm is aimed at. The result of this first step is a sequence $g(x, y, n)$, defined as

$$g(x, y, n) = \mathcal{F}(f(x, y, n)), \qquad (10.3)$$

representing the signal on which the change detection operation will be performed. A feature analysis step, \mathcal{T}, follows the feature extraction step in order to derive an indicator of the level of activity in the frame under consideration, the activity index. The activity index is computed by comparing $g(x, y, n)$ with a reference image, $g(x, y, r)$. The result of this step is a sequence $t(x, y, n)$, defined as

$$t(x, y, n) = \mathcal{T}(g(x, y, n), g(x, y, r)). \qquad (10.4)$$

This indicator of the level of activity has to be classified in one of the two classes: *changed* or *unchanged*. To obtain the classification, $t(x, y, n)$ is binarized by thresholding. The decision is made according to the following test:

$$c(x, y, n) = \begin{cases} 1 \text{ if } t(x, y, n) > \tau, \\ 0 \text{ otherwise.} \end{cases} \qquad (10.5)$$

The threshold τ may be set empirically or computed adaptively. The result of the classification step is affected by noise coming from different sources. Apart from camera noise, imperfections may arise from approximations of the model used in the change detection algorithm. To reduce the false alarms, a post-processing step is often applied.

In the following sections we present an overview of the different techniques proposed in the literature to solve the change detection problem. Furthermore, we discuss the choices related to the above-mentioned model.

10.2 Feature Extraction

Each input frame $f(x, y, n)$ is transformed into the most appropriate feature space for the specific application. The result of the feature extraction step is a sequence, $g(x, y, n)$, on which the change detection operation will be performed. The signal $g(x, y, n)$ is derived from one image only (i.e., it does not contain motion information). To simplify the notation in this section, we will omit the time variable n. The signal $g(x, y)$ may represent the *luminance*, the *color* components, or more complex features. More complex features are usually employed in applications where the illumination of the scene cannot be easily modeled. Finally, the parameters of a *region-based model* of the input image can be used. In the following we highlight the details of the above-mentioned features.

10.2.1 Intensity Features

Analyzing pixel intensity is the most straightforward approach to change detection. This analysis can be performed by using luminance or color values. *Luminance is*

the most common feature used in change detection [398, 502, 240, 2, 330, 370]. In case of a monochromatic camera, no operation is needed to obtain $g(x, y)$. Frames in color video typically consist of three color components, $\mathbf{f}(x, y) = (R(x, y), G(x, y), B(x, y))$. In this case, the luminance can be computed as a weighted combination of color components

$$g(x, y) = Y(x, y) = w_1 R(x, y) + w_2 G(x, y) + w_3 B(x, y), \tag{10.6}$$

where w_i are weights which account for the different sensitivities of the human visual system to the color components.

Besides intensity images representing the luminance, *color* features can be used [98, 125]. The color information coming from the camera sensors (usually RGB) can be used either directly or after transformation into other color spaces. The choice of the color space depends on the application at hand.

10.2.2 Illumination-Invariant Features

When illumination varies, traditional approaches to change detection based on image intensity fail, because the fluctuations of the intensity values produce false positives. This problem can be overcome by using illumination-invariant features. Note that to obtain a change detection algorithm that is robust to illumination variations, illumination-invariant transformations can be used as alternative to illumination-invariant features. Illumination-invariant transformations will be discussed in the next section.

Level lines [28], edge maps [351], vector representation of image regions [153], and albedo images [535] are examples of features which are more robust than intensity images for change detection under varying illumination.

Let us examine the different features. A method based on *level line* image representation is presented in [28]. This approach exploits the fact that a global illumination variation changes the number, but not the geometry of the level lines. A level line λ is the boundary of a level set. A level set S_λ consists of all image pixel positions with a luminance value at least equal to λ:

$$S_\lambda = \{(x, y) : f(x, y) \geq \lambda\}. \tag{10.7}$$

The image containing the level lines can be expressed, starting from the input $f(x, y)$, as a *level line map*, $g(x, y)$. A level line map can be defined as

$$g(x, y) = \begin{cases} 1 \text{ if } f(x, y) = \lambda_i \text{ with } i = 1, \ldots, N, \\ 0 \text{ otherwise,} \end{cases} \tag{10.8}$$

where N is the number of level lines considered for creating the map.

Based on the same principle as level lines, algorithms based on *edges* avoid illumination variations to be interpreted as structural changes [351]. The use of edges

provides good spatial accuracy. In addition, since edge maps are bi-level images, they are convenient in terms of computation and storage.

Another illumination-invariant feature for change detection is the *albedo image*. The albedo image represents the reflectance component of an image, which is independent from the illumination and contains mainly physical object information. If we model the intensity $f(x, y)$ as the product of reflection $r(x, y)$ and illumination $i(x, y)$ [428],

$$f(x, y) = r(x, y)i(x, y), \tag{10.9}$$

it is possible to extract the reflectance component (albedo) by applying a homomorphic filter [535] to the input intensities. First, the illumination and the reflectance component are separated by applying a log-filter

$$\log f(x, y) = \log r(x, y) + \log i(x, y), \tag{10.10}$$

which transforms the multiplicative relation between $r(x, y)$ and $i(x, y)$ into an additive one. Logarithmically transformed images basically have two spectral components: a low-frequency peak mainly associated with illumination and a mid- and high-frequency plateau mainly associated with reflectance. To extract the reflection component, the high frequencies are eliminated through low-pass filtering \mathcal{LP},

$$g(x, y) = exp\Big[\log f(x, y) - \mathcal{LP}\big[\log f(x, y)\big]\Big], \tag{10.11}$$

thus providing the illumination-invariant feature on which the change detection analysis can be applied.

10.2.3 Second-Order Statistics

A different approach to extracting features $g(x, y)$ for change detection involves modeling the intensity distribution of the signal $f(x, y)$. The model is generally characterized by region-based statistics. A second-order model is usually employed to describe the local intensity distribution in a region of an image, for example the variance and the mean of the region [257], a quadratic function modeling the region [242], or its partial derivatives [502]. The region $W_{(x,y)}$ surrounding pixel (x, y) is usually in a $N \times N$ window, and therefore the mean is computed as

$$\mu(x, y) = \frac{1}{N^2} \sum_{(i,j) \in W_{(x,y)}} f(i, j) \tag{10.12}$$

and the variance as

$$\sigma^2(x, y) = \frac{1}{N^2} \sum_{(i,j) \in W_{(x,y)}} (f(i, j) - \mu(x, y))^2. \tag{10.13}$$

The pair $\left(\sigma^2(x, y), \mu(x, y)\right)$ is used to characterize the region $W_{(x,y)}$ [257].

Alternatively, the intensity distribution can be modeled by a quadratic picture function (QPF) [242]. The quadratic picture function represents the surface model on the region $W_{(x,y)}$. The intensity distributions over the region $W_{(x,y)}$ are described by the second-order bivariate polynomial $g_W^Q(x, y)$. To make it more robust, the partial derivatives of $g_W^Q(x, y)$ can be used [502] (derivative-QPF):

$$g(x, y) = g_W^D(x, y) = \frac{\partial g_W^Q(x, y)}{\partial x} + \frac{\partial g_W^Q(x, y)}{\partial y}. \tag{10.14}$$

These methods based on second-order statistics have been employed in early change detection techniques. They are based on modeling the unknown signal. Due to their performance, they are not used in modern change detection and they are reported here only for the sake of completeness.

The different features used in change detection are summarized in Table 10.1.

Table 10.1 Typical features used in change detection

Feature	Computation	Algorithm
Luminance	Eq. (10.6) or identity	[398, 502, 240, 2, 330, 370]
Color	Color space conversion or identity	[98, 125]
Edge map	Edge detector	[351]
Level line map	Eq. (10.8)	[28]
Albedo image	Eq. (10.11)	[535]
Second-order statistics	Eq. (10.12) and Eq. (10.13)	[257]
Surface model	Eq. (10.14)	[502, 242]

10.3 Feature Analysis

Once the images are transformed into an appropriate feature space, they are analyzed to detect areas of change as described in the following section. The feature analysis stage processes $g(x, y, n)$ to compute the activity index in the current frame. The activity index is computed by comparing $g(x, y, n)$ with a reference image, $g(x, y, r)$, through a transformation T. Both $g(x, y, n)$ and $g(x, y, r)$ are derived with one of the techniques described in the previous section. The result of this second step is a sequence $t(x, y, n)$. In the following, we discuss the spatial support on which the feature analysis is performed, the reference frame $g(x, y, r)$ used for the comparison, and the different transformations T which have been proposed in the literature to extract the activity index $t(x, y, n)$.

10.3.1 Spatial Support

In the ideal case, the transformation T would be applied separately to each pixel. In real images, a more robust analysis is required to cope with noise from different

region set window

Fig. 10.2 Pixel neighborhood types used to obtain robustness to noise

sources. To this end, a larger spatial support, that is, a neighborhood of each pixel, is used to compare the features in the current and reference images. This approach helps decrease the effect of noise in the change detection process. The neighborhood can be a single region with a generic shape, an unconnected set of pixels, or a rectangular window (see Fig. 10.2). A *region with a generic shape* can be adapted to the signal or to some projection from the past frames. *Unconnected sets of pixels* [240] can be used to speed up the detection process. This approach facilitates a fast detection of change, but limits the spatial accuracy of the change detection method. A *rectangular window* is the most commonly chosen pixel neighborhood [99, 2]. In particular, a square window may be considered when no a priori knowledge of the scene is available. As the window size increases, so does the robustness to noise. However, the accuracy of the detection decreases. The window size is selected so as to have a trade-off between robustness to noise and detection accuracy.

A related problem is the scale at which the detection process is performed. The scale depends on the requirements of the application, and it is implemented either through *non-overlapped windowing* or *overlapped windowing* (Fig. 10.3). In the former case, non-intersecting spatial windows form the support for the detection process. In the latter case, the information derived from the neighborhood of a pixel is attributed to the pixel itself. The choice of which approach to take is a trade-off between precision and computational complexity. Overlapped windowing provides a better precision, but in some cases, real-time constraints require that the change detection process be applied to a smaller image (non-overlapped windowing [502, 153]). When non-overlapped windowing is applied to the input, blocking artifacts may be introduced.

10.3.2 Reference Frame

In order to detect significant changes, features in the current frame $g(x, y, n)$ are compared to those in a reference frame $g(x, y, r)$. The selection of the reference image is an important choice in change detection. The reference frame may be the *previous frame* in the sequence or an image representing the *background* of the scene. The background frame can be fixed or it can be updated periodically. In the former case, it is usually a frame taken from the sequence (e.g., the first frame

Fig. 10.3 Sliding windows used for change detection at different scales. *Left*: non-overlapped window. *Right*: overlapped window

Table 10.2 Different strategies for selecting a reference frame for change detection

Reference frame	Notation	Algorithm
Fixed previous frame	$g(x, y, n - 1)$	[398, 2]
		[370, 535]
Normalized previous frame	$\bar{g}(x, y, n - 1)$	[321, 540]
Fixed background frame	$g(x, y, 0)$	[330, 98]
Updated background frame	$\tilde{g}(x, y, n)$	[99, 125, 28]
		[351, 356, 238]

[330, 98]). In the latter case, temporal integration of the previous frames [99] is used. The different strategies for selecting the reference frame are summarized in Table 10.2.

Many change detection techniques use the *previous frame* as reference frame [398, 2, 370, 535]:

$$t(x, y, n) = \mathcal{T}(g(x, y, n), g(x, y, n - 1)). \qquad (10.15)$$

This offers the advantage of reducing the detection of shadows. On the other hand, this approach introduces the undesirable detection of background uncovered by a moving object. Furthermore, it does not detect low-textured moving areas of objects. In some cases, the previous frame $g(x, y, n - 1)$ is *normalized* before the comparison. Data normalization is used to reduce or normalize the inter-scene variability resulting from different light or atmospheric conditions. The normalized previous frame $\bar{g}(x, y, r) = \bar{g}(x, y, n - 1)$ is created at region level before being used in the comparison. The normalization is performed with respect to the current

frame based on second-order statistics [321, 540]. The variance and the mean of each region W of current and reference images, (σ_n^2, μ_n) and (σ_r^2, μ_r), respectively, are used to compensate for varying illumination. The following transformation is applied to each region W of the image:

$$\bar{g}(x, y, r) = \frac{\sigma_r^2}{\sigma_n^2}\left[g(x, y, r) - \mu_n\right] + \mu_n. \tag{10.16}$$

If Eq. (10.16) is interpreted as a filter, σ_r^2/σ_n^2 and μ_n are respectively the gain and the offset of the filter normalizing the previous frame $g(x, y, r) = g(x, y, n - 1)$. After this normalization, the gray level distributions in corresponding regions of the two images have the same mean and variance.

The alternative approach is to use a *background frame* as the reference for change detection. This approach hypothesizes that foreground objects are absent from the scene at the beginning of the captured sequence. Usually the first frame of the sequence is chosen as reference:

$$t(x, y, n) = T(g(x, y, n), g(x, y, 0)). \tag{10.17}$$

This is a simple solution, which allows for the detection of objects in the scene even if they become stationary. In addition, it reduces the effects of uncovered background and improves the detection of low-textured moving objects.

However, this solution is not always practical. An initial frame of a sequence with no foreground objects is not available in every application. Moreover, if such a reference frame is fixed, it is not suitable for long outdoor sequences. In such a case, the illumination conditions change gradually, and the method cannot adapt to these variations.

For this reason, techniques for reconstructing the reference frame by integrating the background information from subsequent images in the sequence have been proposed [99, 125, 28, 351, 356, 238]. This solution consists in adding memory to the change detection process in order to create an *updated background*. To achieve this, a temporal filter integrates the information from past frames in the sequence. This process allows us to compute a prediction of the current frame without moving objects. The updated background is then compared to the current frame to detect changes. The background image, $g(x, y, r) = \tilde{g}(x, y, n)$, results from a weighted average of past frames:

$$\tilde{g}(x, y, n) = (1 - \alpha)g(x, y, n) + \alpha\tilde{g}(x, y, n - 1), \tag{10.18}$$

with $\tilde{g}(x, y, 0) = g(x, y, 0)$ and $0 < \alpha < 1$. Efficient methods exist that refresh the reference frame based on some statistics on a temporal window of the pixels in the image sequence [238]. In this case the value of α is adaptive. With simpler methods α is constant [99]. Only the unchanged pixels are eventually updated [356]. The updating process creates a background frame even if a frame without foreground

objects is not available. Furthermore, such an updated reference frame can be used to compensate for slow changes in illumination and weather conditions in outdoor scenes. In addition, this approach overcomes the problem of covered and uncovered background. However, it responds to shadows cast by moving objects. The solution to this drawback is discussed in Section 10.5.

10.3.3 Extraction of the Activity Index

Once the input images are transformed into the appropriate features and the reference frame has been generated, the next step is matching the corresponding features in $g(x, y, n)$ and $g(x, y, r)$ to estimate the level of activity. We propose to represent the general transformation T for comparing the features as a composition of a distance operator T_d and a function T_1

$$T = T_1 o T_d, \tag{10.19}$$

so that Eq. (10.4) can be expressed as

$$t(x, y, n) = t_1(t_d(g(x, y, n), g(x, y, r))). \tag{10.20}$$

The distance operator provides a pixel level feature distance and can be implemented as pixel-wise difference, image ratioing, vector difference, or a difference metric based on second-order statistics. *Pixel-wise difference* (image differentiation) can be expressed as

$$t_d(x, y, n) = g(x, y, n) - g(x, y, r). \tag{10.21}$$

This operator is applied to intensity images representing luminance [99, 356] or color [98] and to binary maps representing edges [351] or level lines [28]. *Vector difference* is a distance metric that can be expressed as Eq. (10.21), but it operates on vector features:

$$\mathbf{t_d}(x, y, n) = \mathbf{g}(x, y, n) - \mathbf{g}(x, y, r). \tag{10.22}$$

The vectors may consist of color features or region features [153]. The *image ratio* represents the ratio between the value of intensity of the same pixel at different time instants:

$$t_d(x, y) = \frac{g(x, y, n)}{g(x, y, r)}. \tag{10.23}$$

This computation can be performed at pixel or at region level and is robust to illumination variations. Difference metrics based on *second-order statistics* can also be used. These techniques compare the intensities in a region surrounding each pixel

in $g(x, y, n)$ and $g(x, y, r)$ by means of some characteristic functions. A difference metric based on second-order statistics in a region W is the *likelihood ratio* [257]

$$t_d(x, y, n) = L = \frac{1}{\sigma_n^2 \sigma_r^2} \left[\frac{\sigma_n^2 + \sigma_r^2}{2} + \left(\frac{\mu_n - \mu_r}{2} \right)^2 \right]^2, \qquad (10.24)$$

where (σ_n^2, μ_n) and (σ_r^2, μ_r) are the variance and the mean in W for current and reference images, respectively.

After the distance operator \mathcal{T}_d, the images $t_d(x, y, n)$ can be further transformed to derive the activity index which is used for change detection. In some cases, the result $t_d(x, y, n)$ of the distance operator is taken directly as activity index, and the function \mathcal{T}_1 is therefore the identity function. Examples of this transformation \mathcal{T}_1 are absolute value, square value, second- or fourth-order moments, and edges. They can be applied to different spatial supports. If the features are image intensities or binary masks, such as edges or level lines, the *absolute* or *square value* is applied after the distance operator *image difference*. Then

$$t(x, y, n) = \| t_d(x, y, n) \|_p \qquad (10.25)$$

with $p = \{1, 2\}$, representing the absolute or square value, respectively. *Moments* on rectangular windows W are computed when features are intensity images (luminance or color components). In this case, the index assumes the following form:

$$t(x, y, n) = \frac{1}{N^2} \sum_{(i,j) \in W_{(x,y)}} (t_d(i, j, n) - \mu)^s, \qquad (10.26)$$

where $t_d(x, y, n)$ is either a difference image or a ratio image, s is the order of the moment, and μ is the mean given by

$$\mu = \frac{1}{N^2} \sum_{(i,j) \in W_{(x,y)}} t_d(i, j, n). \qquad (10.27)$$

Different combinations of $t_d(x, y, n)$ and s have been used to compute the activity index. In [398], $t_d(x, y, n)$ is the result of image differencing on luminance intensities and $s = 4$, that is $t(x, y, n)$ is a fourth-order moment. In [502, 153], $t_d(x, y, n)$ is the result of image ratioing on luminance values and $s = 2$. Thus $t(x, y, n)$ is the second-order moment (shading model). This index of activity can be attributed to the entire region [502] (overlapped windowing) or to the central pixel [153] (non-overlapped windowing). This second solution provides a better spatial resolution.

An *edge detector* can be used as \mathcal{T}_1 after the distance metric to provide robustness to illumination variations. In [98] the edge detector is implemented with the Sobel operator, and the image differentiation is applied to the three color components.

Table 10.3 Feature analysis techniques used to compute the activity index

$T_d\downarrow$ \quad $T_1\rightarrow$	$\|.\|_1$	$\|.\|_2$	Second-order moment (σ^2)	Fourth-order moment	Edge detector	Identity
Image difference	[28, 351]	[2]		[398]	[98]	
Image ratioing			[502]			
Vector difference			[153]			
Likelihood ratio						[257]

Table 10.3 summarizes the different transformations that were analyzed in this section.

10.4 Classification

The indicator of the level of activity $t(x, y, n)$ computed in the previous section has to be classified in one of the two categories: *changed* or *unchanged*. To obtain this classification, $t(x, y, n)$ is binarized by thresholding. The decision is made according to the test in Eq. (10.5). The domain and the range of $t(x, y, n)$ vary according to the feature space and the feature analysis step used to compare the current and reference frame. For example, in the case of edges, the value of $t(x, y, n) \in \{-1, 0, 1\}$ and in the case of absolute difference, the value of $t(x, y, n) \in \mathbf{Z}^+$.

The threshold in Eq. (10.5) can be set empirically [502, 153, 257] or computed adaptively [99, 398, 240, 2, 1, 370, 535, 125]. In the former case, the threshold is fixed for all pixels in the frame and all the frames in the sequence. The value is usually determined experimentally based on a large database. In the latter case, the threshold is adapted according to some rules. In addition, the threshold may be global or local. Different methods for choosing the threshold are described below.

10.4.1 Empirically Determined Thresholds

Setting the threshold empirically is the most common approach to change detection. In the test

$$t(x, y, n) > \tau \qquad (10.28)$$

the value of τ is constant. Let us review how this value has been determined in previous works based on image differencing, image ratioing, and second-order statistics.

By considering the intensity of the difference map, the only hypothesis we can make about the magnitudes of a structural change is that they should be significantly large. The value of the threshold is critical: spurious changes will be detected if the value is too low, while high values will neglect structural changes. The correct value of the threshold depends on the scene, the camera noise, and the illumination conditions in time and space.

When the features used in the change detection process are edges or level lines, the index $t(x, y, n)$ is computed through edge map differentiation, followed by

absolute value. The index therefore represents a binary map, which takes one of the two values, 0 or 1. The value 1 corresponds to the edges not common to the current and reference frames: their locations mark the changes [28, 351]. The value of the global threshold is therefore zero. In a more compact form, this corresponds to $t(x, y, n) = g(x, y, n) \oplus g(x, y, r)$, where \oplus denotes the *exclusive or* operator and g is the edge map.

In [502, 153] changes are detected by using the ratio of the intensities of each pixel in corresponding regions in two images. A change in the region is detected when the intensity ratios vary inconsistently. The index $t(x, y, n)$ is the variance σ^2 computed according to Eq. (10.26). If the value of σ^2 is larger than a predetermined threshold, then a change is assumed to have occurred in the corresponding region. In [257] the index is the likelihood ratio. Here the threshold τ is chosen empirically and its value is changed manually according to the sequence under test. This is the typical limitation of empirical approaches, which require interactive tuning of the threshold according to the scene characteristics. This approach is therefore not suitable for automatic applications and long sequences. For optimal detection, the threshold should automatically adapt to the scene content and to the different kinds of noise.

10.4.2 Dynamically Determined Thresholds

Dynamic thresholds attempt to adapt to the input data. A simple solution for an *adaptive* and *global* threshold consists in linking the empirical threshold τ to a parameter describing a time-varying phenomenon which interferes with the detection of changes. Examples of these phenomena are variations in illumination conditions or the noise introduced by the acquisition process. Thus, the test becomes

$$t(x, y, n) > \tau(n). \qquad (10.29)$$

If the threshold adapts to global illumination variations, $\tau(n)$ is a function related to viewing conditions. For example, $\tau(n)$ can be based on color component ratioing [125]. If the threshold is expected to adapt to the noise introduced by the acquisition process, $\tau(n)$ might be a variable that depends on the variance σ_c of the camera noise.

To compute an *adaptive* and *local* threshold, a region-based statistical analysis can be used if the probability density function of the camera noise is known. The statistical analysis is based on modeling the intensity distribution of noise [99, 398, 240, 2, 370]. Instead of thresholding the difference image, this approach compares the statistical behavior of a small neighborhood at each pixel position in the difference image to a model of the noise that could affect the difference image. The comparison is based on a significance test. The noise model is defined based on the following assumptions: all pixels in the neighborhood have changed only because of noise (hypothesis H_0) and each frame of the sequence is affected by an additive Gaussian noise with a certain mean and variance. Under these hypotheses the noise

model is described by a χ^2 distribution, whose properties depend on the number of pixels in the neighborhood and on the variance of the Gaussian noise affecting each frame of the sequence. Given the χ^2 distribution and a significance level α, the adaptive value of the threshold τ_α can be computed through

$$\alpha = P\{\delta > \tau_\alpha | H_0\}, \tag{10.30}$$

where H_0 is the hypothesis that no change occurred in the pixel position under test. The significance level α is a stable parameter that does not need manual tuning.

A different way of computing an *adaptive* and *local* threshold is presented in [1], where the spatial contextual information of each pixel is taken into account. The threshold for the test is adapted to the label constellation $c(x, y, n)$ of a 3-by-3 window W. When scanning the image, only four neighboring labels in the causal part of the neighborhood W are available. For this reason, the value of the other four is approximated with the labels of the previous classification $c(x, y, n - 1)$. If $K(x, y, n)$ denotes the number of pixels detected as changed in the neighborhood W at time n, then the new test becomes

$$t(x, y, n) > \tau + \theta_1 \big[4 - K(x, y, n) \big] \tag{10.31}$$

with $0 \leq K(x, y, n) \leq 8$, and θ_1 is a positive potential which determines the range of $t(x, y, n)$. This spatially adaptive threshold allows the creation of compact and smoothly shaped regions of change and reduces scattered errors caused by noise.

An extension of this method is presented in [535]. Besides contextual spatial information, temporal information is integrated in to the computation of the adaptive threshold. In this case, the label $c(x, y, n - 1)$ of pixel (x, y) in the previous frame is also considered. The spatio-temporally adaptive threshold is given by

$$t(x, y, n) > \tau + \theta_1 \big[4 - K(x, y, n) \big] + \theta_2 \big[0.5 - c(x, y, n - 1) \big] \tag{10.32}$$

with $c(x, y, n - 1) \in \{0, 1\}$, and θ_1 and θ_1 are positive potentials.

The various approaches for determining the threshold for change detection are summarized in Table 10.4.

Table 10.4 Different approaches for choosing the classification threshold

	Global	Local
Empirical	[502, 28]	—
	[351, 153, 257]	—
Dynamic	[125]	[99, 398, 240]
		[2, 370, 535, 1]

10.5 Post-processing

The result of the classification step, $c(x, y, n)$, is affected by different kinds of noise. Examples are artifacts inherent to the specific change detection algorithms, shadows, uncovered background, and camera noise (which may be not completely eliminated by the detection algorithm). All these sources of noise are responsible for false alarms in the change detection mask $c(x, y, n)$. To reduce the probability of false alarms, various post-processing strategies have been proposed in the literature. These strategies are applied either to the binary image result of the classification only or to both the binary images and the original frame. The different post-processing methods are reviewed in this section and summarized in Table 10.5.

Table 10.5 Different techniques used for post-processing the change detection results

Strategy	Input frames	Algorithm
Connected component analysis	$c(x, y, n)$	[351, 28]
Morphological filtering	$c(x, y, n)$	[398, 125]
Color analysis	$c(x, y, n)$ and $f(x, y, n)$	[100]
Markov random field	$c(x, y, n)$ and $f(x, y, n)$	[2, 370]
Color analysis	$c(x, y, n)$, $f(x, y, n)$, and $f(x, y, r)$	[382]
Edge analysis	$c(x, y, n)$, $f(x, y, n)$, and $f(x, y, r)$	[506]

10.5.1 Post-processing Using a Binary Mask

The simplest approach to refine the result of the classification is to apply a post-processing strategy to the binary mask. The aim is to remove irregularities while preserving the contours and to reduce the spurious temporal variations of the map without any information on the original image texture. Post-processing using a binary mask may rely either on the current result of the classification or on a set of results. In the former case, the post-processing stage can be expressed as

$$p(x, y, n) = \mathcal{P}\big(c(x, y, n)\big). \tag{10.33}$$

The method \mathcal{P} is based on some a priori topological assumptions which can be used to regularize the mask $c(x, y, n)$. A typical assumption is the compactness of objects, that is, the areas detected as changed must be connected and have some geometric regularity. In this case, the post-processing is based on four- or eight-*connected components analysis* or *morphological filtering* [398, 125]. Morphological post-processing may be a simple opening [125] or a more complex composition of morphological filters. A cascade of four opening and closing morphological operators is used in [398]. The diameter of the circular structuring element is set empirically based on experiments over several sequences.

A different situation arises when edge maps or level line maps are used as features in change detection. In this case the technique itself introduces errors when

detecting moving edges, because the contours are often not connected after image differencing [28, 351]. A procedure to close the contours is therefore required. The procedure employed in [351], for example, does not allow the presence of more than one object in the scene.

Temporal analysis of the change detection mask is introduced in [257] to reduce the influence of noise. This post-processing can be expressed as

$$p(x, y, n) = \mathcal{P}(c(x, y, n - 1), c(x, y, n), c(x, y, n + 1)). \tag{10.34}$$

The classification of a pixel in $c(x, y, n)$ as *changed* is accepted only if the pixel respects two conditions: it possesses eight-connected neighbors in the current frame n, and changed pixels appear in a temporal 3-by-3 window W centered in the pixel under test and spanning the preceding and the following frame. Finally, connected components analysis is employed: the pixel is confirmed as *changed* only if it belongs to a group of four-connected pixels which have been classified as changed. The size of the group corresponds to 0.1% of the frame size.

The use of binary masks in the post-processing stage has the advantage of reducing the false alarm probability at low computational cost. However, the a priori topological assumptions (compactness and regular contours) on which they are based may not always be valid. For this reason, these techniques often result in blocky contours.

A post-processing strategy still based on binary images, but not affected by the above-mentioned problems, is to combine different change detection results. The results are generated by applying the same change detection algorithm using different reference frames. One example of this approach is proposed in [551], which basically combines the two approaches based on differencing the current and reference frames, and consecutive frames, using logical operators. This can be represented as

$$p(x, y, n) = \mathcal{P}(c(x, y, n - 1), c(x, y, n), c'(x, y, n), c(x, y, n + 1)), \tag{10.35}$$

where $c(x, y, n)$ is the result of the change detection based on comparing the current and reference frames, and $c'(x, y, n)$ is the result of the change detection between the current and previous frames. This approach reduces the detection of shadows, but it is sensitive to the background uncovered by moving objects. Since it uses the next frame, this system is not causal and therefore introduces delays.

10.5.2 Post-processing Using a Binary Mask and Original Image

Post-processing may use the visual content in order to refine the result of the classification. In this case, the original sequence is used along with the classification result. The regularization may be based on the analysis of the features extracted from the current frame only:

$$p(x, y, n) = \mathcal{P}(c(x, y, n), f(x, y, n)) \tag{10.36}$$

or from the current and reference frames:

$$p(x, y, n) = \mathcal{P}(c(x, y, n), f(x, y, n), f(x, y, r)). \qquad (10.37)$$

The reference frame, $f(x, y, r)$, is either the previous frame or the background frame. The post-processing makes use of features that are usually different from those of the classification. Motion, color, and edge information are typical examples. *Motion information* is used in [2, 370] to avoid holes and rough contours. A relaxation is applied to $c(x, y, n)$ for spatial homogeneity, based on the assumption that objects have smooth contours. The classification result is iteratively processed to adjust the pixels at the borders of the changed areas. This process is based on a local thresholding depending on the neighborhood of each border pixel. The decision is made according to a maximum a posteriori detector combined with a Markov random field. In [100] *color* information is used to eliminate shadows and residual background. The pixels in $c(x, y, n)$ detected as changed are grouped into regions. A color similarity metric is then applied to the regions to detect those which present similar color characteristics to the regions of the background. This approach merges the regions representing shadows and portions of residual background with the background.

Typical examples of post-processing techniques based on Eq. (10.37) are shadow detection techniques. Identifying shadows, which are typically detected as moving objects, can improve the change detection result. In [506], background regions which are occluded or uncovered by moving shadows are detected. The detection is performed by searching for static *edges* in the background texture from frame to frame. In [382], color information is used to detect shadows. The method uses a model of the change in appearance of a pixel when it is shadowed, given its appearance when it is illuminated. The relation between the color of a point in shadow and the color of the same point under illumination is modeled by a diagonal matrix. In addition, spatial smoothness is imposed to improve the results.

10.6 Conclusions

In this chapter we proposed a unified scheme to change detection and used this scheme to present and discuss change detection algorithms. The scheme is based on a decomposition of the change detection problem into four major steps: feature extraction, feature analysis, classification, and post-processing.

The proposed scheme provides useful guidelines for refining and improving a given change detection method. Moreover, it can be used as a basis for the design of new change detection algorithms that have to respect the limitations in computational power or in communication bandwidth of specific smart cameras.

Different change detection techniques can be employed for moving camera and static camera conditions. If the camera moves, change detection aims at recognizing *coherent* and *non-coherent* moving areas. The former correspond to background areas, the latter to moving objects. If the camera is static, the goal of change

detection is to recognize moving objects (foreground) and the static background. The methods discussed in this chapter could also be applicable in the case of a moving camera after global motion compensation.

Performance evaluation and validation is still an important open problem in change detection, due to the lack of commonly accepted test sequences and performance measures. Several efforts exist such as the PETS and CLEAR evaluation workshops [280]. Moreover, synthetic datasets are being generated for evaluation purposes because of the possibility to control specific scenarios as well as to produce ground truth data automatically [526]. Results based on change detection are discussed in [519] based on the CLEAR metrics.

The SPEVI initiative has set up a web site (www.spevi.org) to distribute datasets and evaluation tools to the research community. The aim of this initiative is to allow a widespread access to common datasets for the evaluation and comparison of algorithms that will in turn favor progress in the domain.

Additional references and results on change detection can be found in the surveys carried out by Hu [243] and Radke [438].

The results of a change detection algorithm are usually in the form of a blob (connected set of pixels), the bounding box of an object, or the coordinates representing the position of the object on the image plane (e.g., the center of mass of the bounding box or of the blob). As the current position of a target as well as its movements over time represent relevant information that enables applications such as for example activity analysis and objects counting, a tracking module usually follows or is integrated with a change detection algorithm. Object tracking will be covered in the next chapter.

Chapter 11
Object Tracking on Embedded Hardware

Gustavo Fernández Domínguez, Csaba Beleznai, Martin Lizenberger, and Tobi Delbrück

Abstract Object tracking is an extensively researched subject within the field of computer vision, in reference to the large number of published contributions in major computer vision conference proceedings and journals every year. This chapter presents object tracking achievements over the past years as well as research trends. It attempts to give a structured overview of a broad spectrum of modern approaches focusing on embedded platforms, where the application of computer vision techniques faces a challenge due to the limitation of available resources, mainly memory and CPU power. Constraints imposed by the embedded platforms are described, relevant issues from an application-oriented point of view are reviewed, and approaches using data originating from event-based cameras and multi-camera systems are discussed. Given the vast pool of available tracking algorithms, it is necessary to quantitatively assess the outcome of different tracking methodologies, which leads us to the issue of performance evaluation. A summary of tracking evaluation frameworks, associated metrics, strengths, and weaknesses of the presented approaches is also discussed. A discussion of future trends concludes this chapter.

Keywords Object tracking, Embedded hardware, Real-time applications, Performance evaluation

11.1 Introduction

Modern embedded smart cameras have a complex architecture (Chapters 2 and 3) that can perform a variety of image processing tasks, such as image enhancement and image compression, or run computer vision tasks such as self-calibration (Chapter 9), object detection, and object segmentation (Chapter 10). The current chapter deals with the object tracking task on embedded hardware, and it attempts to

G.F. Domínguez (✉)
Video and Security Technology, Safety & Security Department, AIT Austrian Institute of Technology, Vienna, Austria
e-mail: gustavo.fernandez@ait.ac.at

A.N. Belbachir (ed.), *Smart Cameras*, DOI 10.1007/978-1-4419-0953-4_11,
© Springer Science+Business Media, LLC 2010

provide a detailed description of the state of the art with respect to embedded object tracking. In recent years, embedded data processing has become a dynamically evolving field due to the widespread use of mobile devices and smart cameras. In order to envision possible implications of today's developments, this chapter also analyzes and describes current trends.

Object tracking is an intermediate-level computer vision task. The goal of tracking is to recover the motion paths or trajectories of objects using detected object locations, such that each recovered trajectory represents the motion of a single object. Here, the term motion represents the temporal sequence of object's trajectory, and the term object refers to image objects, such as low-level features (corner points, edge segments, centroid coordinates), image regions (blobs, image segments), or other spatial groupings.

Unfortunately, there exists no unifying tracking concept capable of tracking arbitrary objects under generic circumstances in arbitrary scenarios. Work over the last decades has produced a largely diverse collection of methodologies, which perform well in specific applied settings, but which nevertheless lack the desired generic-purpose character. There are multiple reasons behind this deficiency (many of them also apply to the entire computer vision domain).

- The enormous richness/variability of visual information present in data makes it difficult to represent objects in an invariant manner.
- Tracking concepts are often driven by an application-oriented view and constraints.
- The use of high-level information introduces specificities, which are usually beneficial for the given scenario, but can be limiting for others.

The main complexity of the tracking task stems from the fact that observed data are usually contaminated with noise, missing observations, or clutter. Hence, partitioning of observations into trajectories requires advanced techniques for data association and state estimation. With recent advances in embedded hardware development, real-time data association and state estimation for multiple interacting targets have become feasible on embedded platforms in the presence of substantial scene clutter. This chapter attempts to give a structured overview of a broad spectrum of modern approaches according to employed target representations (centroid, blob, contour, color, etc.) and to the type of tracking methodologies (deterministic and probabilistic approaches, such as kernel-based tracking, multiple hypotheses tracking, Monte Carlo techniques). The main focus is centered on techniques constrained by the limited computational resources of embedded hardware and specific implementation details achieving significant speedups. Important aspects driven by the embedded nature of the computational platform are described with special focus on networked, cooperative, and mobile devices. Relevant issues from an application-oriented point of view are discussed. At high object densities — such as for pedestrians or cars in a city scenario — occlusions increase the complexity of the tracking task significantly. In this context advanced part-based target representations and occlusion handling techniques are presented. Furthermore, when a single camera is not sufficient to reliably detect and track objects due to limited visibility or

occlusions, multiple cameras can be employed. Such cases are illustrated by multi-camera tracking approaches addressing overlapping and non-overlapping views. Hardware implementations of biologically inspired optical sensors also support object tracking. Implementations using sensors such as the DVS [317] (also called *Transient vision sensor* (TVS)) or the neuricam "VISoc" vision processor [10] are also described. Performance evaluation and algorithmic comparison play an important role in assessing which algorithms are the most adequate for a given application. This chapter presents established tracking evaluation frameworks, error measures, and data sets and describes strengths and weaknesses of the presented approaches. Finally, future trends in research and a summary of open problems in this field are identified.

An excellent survey of tracking algorithms can be found in [587]. Specifically, regarding video tracking a more concise survey can be found in [536] and concerning visual surveillance we refer the interested reader to the survey conducted by Hu et al. [243]. Applications of tracking algorithms in camera networks and for video surveillance are detailed in Chapters 13, 15, and 17.

11.2 State-of-the-Art Tracking

11.2.1 Object Tracking Algorithms

Video-based object tracking can be described as a correspondence problem. Given a video stream or an image sequence, its goal consists of establishing correspondences between objects detected in consecutive image frames. In order to lower the ambiguity associated with the task of correspondence search, specific and invariant representations of target properties are sought. In order to create such representations discriminative image features can be used. The spatial extent of a tracked target might range from a single point (e.g., centroid) to a set of points (e.g., image region). Increasing spatial extent increases typically the specificity of the target, since region-based descriptors such as histograms, shapes, or appearance-based templates convey more discriminative information. In the terminology of the tracking task, the measurement process of target properties by quantifying its features is called *observation*. Classifying the observations such that each observation within a category belongs to a single tracked object is a task of substantial complexity. This complexity arises from the inherent ambiguity of noisy observations with unknown origin, whether they are generated by true detections or false alarms. Typical examples for such situations can be encountered for instance in blob-based object detection approaches relying on background subtraction [20].

There is a large variety of object tracking methods available in the field of computer vision including Kalman filter trackers [86, 85], particle filter tracking [251, 149, 595], feature tracking [489], template matching methods [176, 476, 41], contour tracking [347, 108], kernel tracking [489, 35], model-based tracking [157, 225], color-based tracking [120, 277, 396], and tracking of spatially clustered objects [416].

Tracking algorithms can also be classified based on different criteria, such as the type of information used by the algorithm, how the information is generated, which kind of approach is used either deterministic or stochastic, or the kind of data used during the association process. A typical taxonomy of tracking methods is depicted in Fig. 11.1.

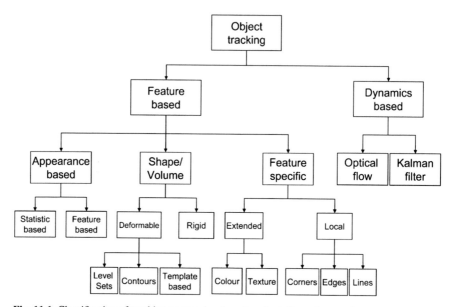

Fig. 11.1 Classification of tracking approaches based on the information used

In general, region-based simple statistics on raw pixel intensities — such as color, gradients, or filter responses — does not capture the underlying image structure or geometry of the tracked object. Purely bottom-up segmentation, techniques, such as moving foreground or blob-based segmentation, typically generate temporally unstable segmentation results, from which an accurate geometric description or other representation (color, texture) of the tracked object or of its parts cannot be inferred [172].

Histogram-based techniques, such as the color-based particle filter, do not necessarily require segmentation. Single-or multiple-region color histograms located on the target object provide a description. The measurement likelihood affecting the particle weights is then derived by computing a similarity measure or distance between the measured target histogram and the reference histogram of the target. The most commonly employed distance measure is the Bhattacharyya distance $-log \sum_{k=1}^{n} p_k q_k$, where p and q are the measured and reference histograms, respectively.

In case of using feature-based techniques, a comparison of detected features within search areas is carried out. A search for possible similarities between the previously detected (and tracked) objects and the newly detected regions has to be

done in order to connect the objects of the previous frame and the current one. On the other hand, dynamics approaches are based on the idea of motion estimation between two frames at each position or a pre-defined area in the image.

By considering how the information is generated, it is possible to divide the tracking algorithms into a low-level tracking or bottom-up approach and a model-based or top-down approach. In the first case, the image is segmented into different regions and the objects are identified and tracked by using the information available in the image. The second approach uses knowledge of the objects in the scene.

Another classification considers whether the problem is tackled in a deterministic way or by using a probabilistic approach. By using a deterministic approach the tracking is determined by an association rule which is governed by information obtained from previous frames, i.e., the tracking problem is solved as an optimization problem. With a probabilistic method, the new position is estimated using estimation techniques, such as particle filters or Kalman filter [274], which means a *Probability density function* (PDF) rules the tracking association.

If one considers which kind of data is involved in the association process, the algorithms can be classified in a multi-target data approach or a single-target data approach. Association by using multi-target data is related with a *Joint probabilistic data association Filter* (JPDAF) [45, 442] or by using the *Multiple hypothesis tracker* (MHT) [444]. This data association process is particularly useful when a Kalman filter or particle filters are applied for tracking multiple objects. When such filters assume a single measurement at each instant, it is necessary to determine the most likely correspondence between a particular object and the object's state because in such situations, i.e., tracking multiple objects, a solution of state estimation and data association is needed.

11.2.2 Computer Vision on Embedded Hardware

Recent efforts have focused on introducing computer vision algorithms on embedded hardware. Among others, systems running on a FPGA [487], a CMOS chip [109], and a DSP platform [21] were developed. Concerning computer vision tasks, Shashua et al. [487] developed an embedded system that is used for detecting pedestrians based on a clustered training set,while Sen et al. [480] applied simple vision tasks on a FPGA to perform gesture recognition. Chiu et al. [109] integrated a CMOS imaging chip and a RISC processor in an embedded vision system. Their goal is to perform car-counting in changing environment conditions. Schlessman et al. [471] presented a tracking system based on optical flow running on a FPGA. After a background subtraction based on a mixture of Gaussian model, they calculated motion vectors by using an optical flow approach which allowed them to perform the object tracking. Arth et al. [21] presented an embedded system that performs object detection and object tracking on sequences recorded on highways. Their tracking algorithm is based on a Kalman filter [274]. Glasl et al. [214] describes an embedded video-based computer vision system which collects traffic data on a highway in operation. Their approach is composed of a variant of the

AdaBoost algorithm for the detection task and a robust variant of the Lucas–Kanade algorithm for tracking. By using multiple hypothesis tracking, Polat et al. [430] present a framework for tracking objects in video sequences. They used a 3D model-based object tracking algorithm to collect more information. To determine the geometric transformation which delivers the best match, they used a probabilistic matching algorithm based on the Hausdorff distance.

Fleck et al. [178] implemented a network of distributed cameras which performs real-time multiple target tracking. The tracking algorithm is based on particle filtering, where a set of particles are instantiated for each potential target independently. The targets are represented by their color distribution in the HSV color space. The complexity of similarity computation is reduced by computing and combining individual distance measures in the HS and V spaces, respectively. For a small number of objects real-time tracking is achieved. Nevertheless, the performance drops significantly when the number of objects increases. The coordination of individual cameras and object handoff between cameras is performed on a central host.

Apewokin et al. [20] presented a simple kinematic model used on an embedded platform to track multiple pedestrians. The framework consists of a motion detection module and a tracking module. First, an adaptive background model is built. Next, a connectivity analysis is carried out to generate moving objects or blobs. After identifying moving blobs inter-frame correspondences (i.e., associations between objects of adjacent image frames) between detected blobs are established. Detected blob objects are represented by their center of mass or the so-called centroid. Data association is performed in two passes: first observations within a time span of three frames are associated based on kinematic smoothness, and then unmatched observations are examined for a possible match considering a longer frame span. The second pass is able to handle complex situations such as occlusions, blob merging, and blob splitting.

Arth et al. [23] present an embedded license plate recognition system, where the license plate detection step is coupled with a state estimation step using Kalman filtering. Using multiple, temporally aggregated license plate observations and the Kalman filter-based prediction, the detector's search region is confined to certain image regions. The proposed simple temporal association between individual observations thus improves the computation time and the overall character recognition performance.

Arth et al. [22] describe an embedded framework for feature-based object reidentification in disjoint camera views. Obtaining an object-specific representation is a key issue of the object tracking task, since a specific description of a target can be used to disambiguate when facing ambiguous situations of target association. The framework demonstrates the use of compact PCA–SIFT features arranged in a hierarchically structured manner (Vocabulary tree) in order to enable a fast comparison between a large number of potentially matching targets.

Arth et al. [21] demonstrate an embedded vehicle detection and tracking framework working in real time running on a DSP platform. Tracking is based on simple

nearest neighbor association between observations made at different time instances and Kalman filtering predicting future states of tracked objects.

The smart camera-based tracking system by Litzenberger et al. [327] applies an adapted version of a mean shift-based tracking algorithm to vehicle and human tracking. A neuromorphic temporal contrast vision sensor delivers so-called address events indicating the presence of moving objects. The address events are spatially clustered and their centroids are tracked by a mean shift algorithm. The mean shift algorithm is conceived to be computationally low weight: a spatially uniform kernel is employed and new cluster locations are computed in an incremental fashion, based on the locations found in the previous time step [122].

Chen et al. [107] present a distributed tracking system based on multiple networked wireless smart cameras. Given the low computational resources of the cameras, cameras perform only moving object detection using a simple background subtraction algorithm with a frame rate substantially lower than real time, and tracking is performed in a centralized manner. Object locations over time are aggregated from multiple cameras on a central server and a Markov Chain Monte Carlo data association step is used to cluster the aggregated data such that each category represents a trajectory of a single object.

Haritaoglu et al. [226] describe Hydra, a system capable of detecting and tracking multiple people by combining a silhouette-based shape model for detecting moving objects and classifying them, and a second-order motion model for tracking the classified objects.

Khalegi et al. [286] developed an embedded vision system running computer vision algorithms. The system performs different tasks such as background modeling and stereo matching. Among many others, a 3-D object tracking application is also mentioned.

Medeiros et al. [371] implement an color-based particle filter for an SIMD processor. The core of the implementation is the parallel computation of the particle weights. By using color histograms of detected objects [406, 410], the particle filter is used for tracking objects [24].

11.2.3 Real-Time Tracking Using Vision Chips

Visual object tracking systems can greatly benefit from the capabilities of focal plane processing vision sensors to pre-process scene information. This pre-processing step significantly reduces the computational burden on processors, compared to using frame-based imagers, enabling low-cost, low-power, and very compact implementation. A variety of different vision sensors have been presented that provide focal plane pre-processing for supporting a fast visual object tracking. The DVS [317], the "Bi-i" vision system by Analogic which uses the ACE16k vision chip [529, 590], the neuricam "VISoc" vision processor [10], or the sensor for contrast and orientation extraction by CSEM [460] are potential platforms for real-time object tracking. Hardware implementations of biologically inspired optical

tracking sensors have been described by Etienne-Cummings [110] and Indiveri [250], respectively. Whereas the former still require an additional processing stage to produce a tracking result, the latter already provide the object location coded as an analog voltage signal at dedicated output pins of the vision sensor. One drawback, however, with these sensors is that the additional space needed for extra signal processing circuitry on the chip reduces the effective pixel resolutions. A resolution below 320 × 240 pixel (QVGA) is very common with these chips. Furthermore, most of them are not able to output a human-readable image, but rather provide pre-processed, abstract data of the visual scene. Table 11.1 gives a comparison of the cited vision systems for tracking with key parameters and the temporal resolution as a figure of merit.

Table 11.1 Comparison of real-time tracking performance using different vision chips

System	Pixel resolution	Performance	Complexity	Reference
DVS + PC	128 × 128	1 μs (AER data stream time stamp resolution), 2.8 ms (system reaction latency)	DVS and PC with USB AER interface and jAER java processing	[140]
DVS + DSP	128 × 128	1 ms (AER data stream time stamp resolution)	DVS and embedded processing with 600 MHz DSP	[328]
Bi-i	64 × 64	2.84 ms (frame processing time)	ACE4k vision chip with DSP	[529]
Cummings	60 × 36	180–3580 track coordinates/s	Vision chip with analog voltage output	[110]
Indiveri	26 × 26	1.2 μs .. 6 μs response time	Vision chip with analog voltage output	[250]

An embedded vision system for object tracking applications based on the DVS and an efficient and fast tracking algorithm using asynchronous *Address Event* (AE) data have been presented by Litzenberger et al. [328] and Delbruck [140]. The embedded system is composed of a DVS that contains a 128 × 128 pixel array of biologically inspired autonomous, self-signaling pixels. These pixels respond to relative light intensity changes by instantaneously transmitting their address, i.e., their position in the pixel matrix, over a shared bus. This strategy of encoding scene information is called the *Address-event representation* (AER) [65]. The event-based approach to the detection of moving objects inherently overcomes the correspondence problem found in frame based tracking systems. As there is no temporal quantization of the information by the vision sensor, it generates events for every

pixel along the objects path of motion, regardless of object speed. The continuous object path is contained in a vector of pixel addresses and corresponding time stamp information. The object tracking algorithm is optimized to run on minimal memory and computing resources allowing the implementation in low-cost DSPs or even on microcontrollers. The detection of moving objects is provided by the imager itself, as its pixels suppress constant background information and react only to changes in the scenery. For a typical multi-object tracking task, a cluster buffer of 20 clusters is sufficient and it only requires a few kilobytes of memory. As events are processed on the fly, no event buffer is needed.

Figure 11.2 depicts the general architecture of the embedded system, which comprises an imager, a *First-in first-out* (FIFO) buffer memory, and the blackfin BF537™ DSP from Analog Devices. It has a clock frequency of 600 MHz, 128 KB internal memory, and 32 MB external SDRAM memory. This limited memory resource might be too low for the data processing of any high-resolution video system as it does not fit the conventional video processing needs. The vision sensor and DSP in total consume roughly 2.5 W of electrical power. The address of the event generating pixel within the array is transmitted to a FIFO on a 15-bit parallel bus, implementing a simple 4-phase handshake protocol. The FIFO is placed between the sensor and the DSP to cope with peaks of AE activity and is capable of handling up to 40 MHz memory access frequency. In the processing stage, every AE received by the DSP is labeled by attaching the processor clock ticks with 1 ms precision as a time stamp. The full processing comprises the AE acquisition and time stamping, clustering and tracking, as well as a rough speed estimation.

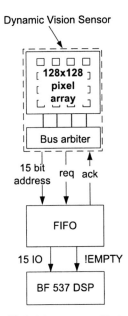

Fig. 11.2 Architecture of an embedded vision system with dynamic vision sensor

The simple algorithm can be summarized by the following steps:

1. Receive a new AE from the FIFO buffer.
2. Find a cluster in the cluster list that the new AE can be attributed to compute the distance R of its address $x_E = (i, j)$ from all existing cluster centers.
3. If a cluster is found where the distance from the cluster center x is smaller than a seek radius $R = |x - x_E| < R_K$, update all clusters features accordingly (see below).
4. If no cluster is found, seed a new cluster with center x_E and initialize it with low weight, default size, and creation time. A new label (unique identification number) is assigned to the cluster.

The cluster update process is illustrated in Fig. 11.3. If x_E is the address of an AE produced by the edge of a moving object with velocity v and $x(t)$ the original cluster center, then the new center coordinate $x(t + dt)$ is calculated as follows:

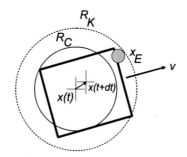

Fig. 11.3 Continuous tracking of address-event clusters

$$x(t + dt) = x(t) \cdot \alpha + x_E \cdot (1 - \alpha), \qquad (11.1)$$

where $0 < \alpha < 1$ is a parameter of the algorithm and dt is the time stamp difference between the current and the last AEs that were assigned to the cluster. This shifts the cluster's center by a certain amount controlled by α, which is usually chosen near 1 to obtain a smooth tracking. Furthermore, the bounding box size R_C is updated:

$$R_C(t + dt) = max \{R_{min}, R_C(t) \cdot \alpha + R \cdot (1 - \alpha)\}, \qquad (11.2)$$

where R_{min} is a parameter of the algorithm and the max(imum) function assures that the bounding box size is kept within certain limits. A seek-distance larger than the bounding box size allows the bounding box to grow and thus adapt dynamically to the size of the tracked object. Otherwise, clusters would be just allowed to shrink. We define the seek-distance R_K for each cluster as a multiple of the bounding box size R_C:

$$R_K = min \{R_{max}, R_C \cdot R_{multiple}\}, \qquad (11.3)$$

where $R_{multiple}$ (usually $1 < R_{multiple} < 3$) and R_{max} are parameters of the algorithm and the minimum condition assures that the bounding box size is kept within certain limits. The $R_{multiple}$ parameter is most important when two clusters approach each other during tracking. A reasonably chosen value will prevent one cluster from instantaneously "overtaking" the other cluster because its seek radius is limited. Also the maximum change of R_C is limited by the parameter α.

For the weight of the cluster W the mean frequency of events in this cluster is used, so that

$$W(t + dt) = W(t) \cdot \alpha + \frac{1}{dt} \cdot (1 - \alpha). \tag{11.4}$$

Very inactive clusters have low AE frequency and consequently low weights.

For practical application of the algorithm a separate definition of α for each single parameter position, size, and weight has proved to be advantageous (α_X, α_R, α_W).

The list of existing clusters is scanned periodically (from 10 times/s up to 100 times/s depending on the application) for old or inactive clusters which are then deleted from the list. The velocity vector of the cluster is also updated at the same time.

If a new event for an object edge lies outside the seek radius of the cluster the object belongs to, the object will split up into two overlapping clusters. This scenario is demonstrated in Fig. 11.4. Successive events might then be attributed to the new cluster C_2 instead of the long-standing C_1, and the object might be permanently split into two (or more) clusters. If all the events generated by the corresponding object are attributed to the new cluster instead of the long-tanding one, the new cluster might also incorporate the long-standing one. This leads to a discontinuity in the object's track because the object will consequently change its label.

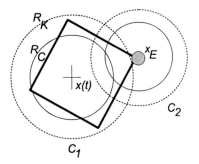

Fig. 11.4 Tracking of address events with overlapping clusters

To prevent this occurrence the cluster list is kept sorted by creation time. Consequently, when looping through the list to attribute AEs to clusters, older clusters will be preferred. Therefore, the new, overlapping cluster will "starve" and be deleted very quickly because fewer or no events will be attributed to it. Thus, a very smooth and continuous tracking can be achieved with the algorithm.

The algorithm consumes only a small amount of memory because only the cluster list has to be kept in memory. A cluster list of approximately 20 clusters is sufficient for most of the test scenarios (vehicle tracking, person tracking) discussed below. About 2 kB of memory is sufficient for the cluster list. The computational complexity is moderate. However, event-address to cluster-center distances have to be computed several times for each new event. Using rectangular bounding boxes instead of circular ones can further decrease the computational effort. The features of each cluster have to be updated once for every event. The presented tracking algorithm runs in real time on vehicle AE data with a time stamp resolution of 1 ms.

The system was used for lane change monitoring in a traffic surveillance application. It has been shown that an increase of lane change maneuvers can indicate an imminent traffic jam. The vision system was mounted overhead of a test track and AE data originating from driving-by vehicles were processed. Figure 11.5 shows three still images from a 3 s tracking sequence of two vehicles traveling at a speed of approximately 30 km/h. To visualize the AE data, the pixel activity occurring during a fixed time interval is histogrammed onto an image for an image-like representation of the AE data. The tracking result is presented as bounding boxes in the images enclosing the tracked objects. A trace is shown to visualize the objects track within the past second. For both lanes, lane changes can be observed with the tracking algorithm over a distance of typically 50 m. Figure 11.6 depicts examples of six vehicle tracks recorded on a two-lane road. Vision sensor coordinates have been transformed to world coordinates using a simple geometric projection based on the camera mounting height and optical parameters. The x-coordinate shows the road length in meters (containing the vehicle direction), while the y-coordinate indicates the road width in meters. The distance between two adjacent circles on the vehicle track is 0.2 s.

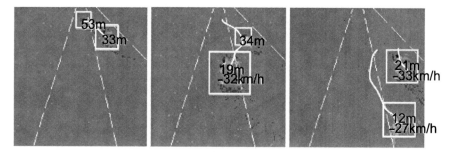

Fig. 11.5 Tracking of two cars on a road with a dynamic vision sensor

Figure 11.7 shows a demonstration of the algorithm on simulated AE data for a person tracking application. The AE data have been simulated from a video sequence with a resolution of 140 × 180 pixels. On the left, two images from a 2 s video sequence have been extracted for illustration. On the right side, the simulated

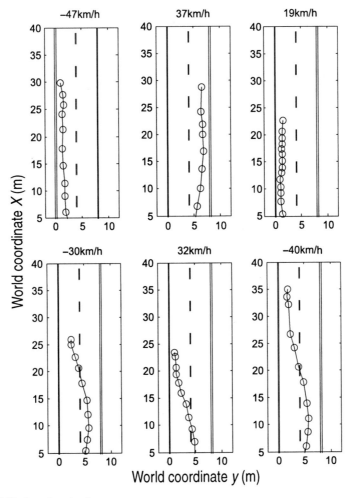

Fig. 11.6 Evaluated car tracks

AE data of the scene including the tracking results are provided. Figure 11.7 shows the different person's locations indicated by circles, a unique ID number identifying the object, and an arrow indicating the direction and speed of movement. As an example, ID 198 has been correctly tracked, while ID 227 was a shadow effect that disappeared in the next sequence.

Different implementations of the AER-based tracking algorithms are available through the open-source *jAER* project [139].[1]

[1] Volume available at http://jaer.wiki.sourceforge.net

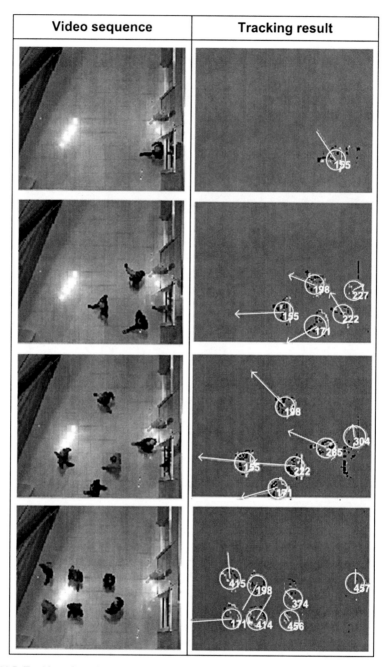

Fig. 11.7 Tracking of people using address-event data

11.3 Architecture

11.3.1 Description

Embedded platforms typically possess limited resources compared to personal computers in terms of computational power, available memory, and internal numeric representation. The resource limitation imposes several serious constraints on the choice of tracking algorithms. Algorithmic steps which

- compute computationally complex descriptors (e.g., multi-dimensional color histograms) representing the tracked targets,
- consider a vast number of association hypotheses (e.g., Markov Chain Monte Carlo enumeration, multiple hypothesis tracking) leading to combinatorial explosion of the search space dimensions,
- involve a large number of interacting targets requiring detailed occlusion handling, and
- require a large number of iterations or search steps to estimate new target states,

are typically too resource-hungry and in such cases real-time object tracking is difficult to achieve. On the other hand, emerging embedded parallel processing architectures such as highly parallel SIMD processing engines along with the increase in transistor density (Moore's law) continue to open up new possibilities for more complex tracking algorithms.

In embedded systems, there are a number of hardware- and software-related issues to consider. An effective hardware–software codesign is essential to achieve pre-defined goals and to improve the robustness of the system. In particular, a smart software design strategy is important due to resources limitation. Whenever possible, calculations that dynamically allocate memory have to be avoided, e.g., by using static arrays instead of dynamic lists; it is even better if such arrays are pre-dimensioned at compile time. A common improvement strategy is the use of integer arithmetic calculations instead of floating-point operations. Schlessman et al. [471] reported specific design decisions considering hardware and software by porting a tracking system with optical flow from a PC-based implementation to a FPGA platform. The authors pointed out the importance of avoiding arithmetic operations, such as root square calculations or divisions, and minimizing the number of bits used for pixel representation. In their hardware architecture, a processing unit for each task is used.

A possible architecture is composed of a camera, for instance a standard CCTV camera, and an embedded hardware platform where a video-based image processing system analyzes the current scene. Such an analysis can be carried out online to assess the current situation of the monitored scenario. Results of such an analysis, mainly typical parameters of the situation, can be stored in a database, where they can be further queried and processed. Figure 11.8 illustrates this idea.

Another interesting strategy consists of implementing the management of hardware resources outside the computer vision algorithms. Although this approach

Fig. 11.8 Possible architecture of an embedded platform running image processing algorithms

requires an increased effort during the implementation phase, the main advantages are the independence between hardware management and computer vision tasks and the inter-changeability of computer vision algorithms due to a common calling interface. Glasl et al. [214] apply this methodology to acquire traffic data parameters from a real scenario in real time.

When the hardware architecture has many processing units, it is possible to perform computations in parallel. In such architectures, the processor is composed of a number of processing units, each of them with a limited amount of memory and an arithmetic logic unit. After extracting the data from an image, an input/output unit parallelizes the data and stores it into a buffer. This buffer can be accessed by each of the processing units. Figure 11.9 depicts such architecture. An example of such implementation was recently presented by Medeiros et al. [371]. They apply a particle filter on a SIMD processor for human tracking. Their particle filter is based on a computation of histograms, which is done in parallel in the different processing units.

Fig. 11.9 Hardware architecture composed of many processing units

Finally, regarding specific software optimization, three major steps can be performed: compiler-based optimization, system-based optimization, and assembly level optimization. Compiler-based optimization intends to maximize the speed, while exploiting the architectural features (e.g., vectorization, pipelining) and compiler functions. By an appropriate partition of the memory and a correct data flow streaming an optimization at system level can be gained. The last optimization level consists of implementing critical sections of code in assembly language.

11.3.2 PTZ Cameras

In the last few years, the use of cameras with pan–tilt and zoom capabilities, so-called PTZ cameras, has increasingly attracted researchers attention. Especially in video surveillance scenarios, such sensors have gained attention due to the zoom functionality. Through this zoom functionality, PTZ cameras are also useful to focus the tracking on a specific object. A pre-defined set of rules define when the PTZ camera concentrates its field of view on a specific object, following its motion. Roughly speaking, by using PTZ cameras the tracking process can be performed as follows: The camera starts the process acquisition and the system runs the tracking functionality. Many objects can be tracked simultaneously. When a certain previously defined condition is fulfilled, the camera starts the PTZ functionality[2] and the tracking process is activated using this functionality. Then, the PTZ follows the tracked object until a specific criterion is met (for example, the tracked object stops for more than a certain amount of time) or the object moves out of the camera field of view. Figure 11.10 summarizes this process. An example of tracking a person with a PTZ camera using zooming functionality is shown in Fig. 11.11.

Kang et al. [278] presented a system performing background modeling and object tracking using a PTZ camera. More recently, Everts et al. [171] presented a statistical framework where multiple PTZ cameras are used to track objects. An application on PTZ cameras can be also found in Chapter 15.

11.3.3 Multi-camera Systems

In the case of multi-camera systems, an important challenge is the association of the objects across the system, in particular across the different cameras. For cameras that have overlapping fields of views, it is possible to use epipolar geometry to fuse the different object locations [423]. A combination of stationary and PTZ cameras with overlapping views is used by Kang et al. [276]. For tracking purposes, the authors used two probabilistic models: An appearance model is used for describing the objects, and a motion model is derived from a Kalman filter.

[2] Camera movements: pan, tilt, zoom.

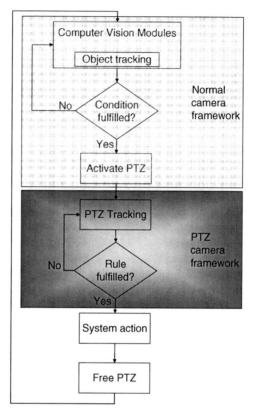

Fig. 11.10 Algorithmic flow for tracking with a PTZ camera

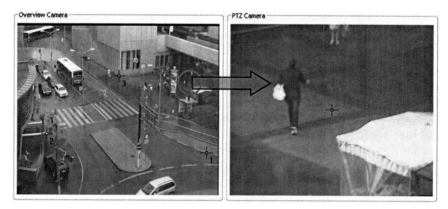

Fig. 11.11 PTZ camera. Zoom view of a tracked person

In many situations large areas are monitored and it is not possible to have overlapping camera views resulting in sparse object observations. In such scenarios, tracking methods have to make some assumptions about the scene's geometry (for example, by using information of entry points and exit points in different camera views [352]), the path followed by the object, or the object's speed [245, 285, 260]. By adding a motion model, Pflugfelder and Bischof successfully tracked one person on cameras, which were positioned up to 2 m apart, with high precision [425]. Javed et al. [262] used an appearance model for tracking people in an open environment. Cevher et al. [102] fused information coming from audio and video sensors, where particle filter tracking is used. Gilbert and Bowden present an approach to track objects across spatially non-overlapping cameras [411]. Their strategy consists of learning the spatial links and the color relationships between the cameras. The tracking accuracy is increased by incremental learning of the object's movement and color variation.

The problem of multi-camera tracking and person handover is also tackled by Siebel et al. [496] within the ADVISOR surveillance system. Following a similar approach, Fleck et al. [178] developed a system comprising of smart cameras which perform people tracking in real time.

Chapters 13 and 17 give details with examples on multi-camera tracking systems.

11.4 Performance Evaluation of Object Tracking

The quality of results obtained by any computer vision algorithm, in particular tracking algorithms, can be assessed by comparing the outcome of related algorithms to manually generated ground truth in terms of common error metrics. Such metrics should be intuitive and have an easy representation, making the interpretation of obtained rates easy. When a tracking algorithm is evaluated, it is interesting to assess the response of the tracker in different situations. Normally, tracking algorithms generate a good response in non-ambiguous situations, for example, when two individuals walk through the same scene without overlapping or superposition of trajectories. But, interesting and challenging cases consist of evaluating the robustness of tracking systems in ambiguous situations such as occlusions between people, scenarios with changing illumination conditions, crowded scenarios, a non-static camera, or resemblance between objects.

In the following, we outline some frameworks which allow the evaluation of either computer vision algorithms in general or tracking algorithms in particular. The metrics defined and used in such frameworks are discussed in Section 11.4.2.

11.4.1 Evaluation Frameworks

One of the most frequently used frameworks for evaluation of computer vision algorithms is the PETS Metrics On-line Evaluation Service.[3] This service, provided by

[3] Performance evaluation of tracking and surveillance on-line evaluation service at the United Kingdom University of Reading in 2005. *http://www.cvg.cs.rdg.ac.uk/cgi-bin/PETSMETRICS/page.cgi?home*.

the University of Reading, permits the evaluation of visual surveillance algorithms based on different data sets and a pre-defined set of metrics in an online manner. Although only metrics for motion segmentation were implemented, it is expected that metrics for object tracking will be available. By using the PETS web site, users submit their results via a user interface and these results are evaluated against the ground truth using the pre-defined metrics. Although the service is particularly geared toward the evaluation of visual surveillance algorithms, especially object detection and object segmentation, it is possible to use it for other application areas. One of the main advantages of this service is that each user submits their own results independently of the used platform. On the other hand, the main disadvantage is that a text file with obtained results is submitted, therefore no computing time is considered.

Another web-based evaluation framework is VIVID [117] which performs analysis on a set of available data sets. Results can be uploaded and the web interface shows the obtained score ranked in relation to previous submissions. Provided data sets cover situations such as differing object resolution, variation in contrast, and the degree of occlusion. The videos were recorded using both normal and thermal IR cameras. The testbed software uses five criteria to rate and rank submitted results.

Smith et al. [503] presented a framework for evaluating tracking results. The authors focused on multiple object tracking and to evaluate their findings, they defined specific performance measures.

The *Video and Analysis Content Extraction* (*Video and analysis content extraction* (VACE)) program was launched to develop novel algorithms and implementations for automatic video content extraction, multi-modal fusion, and event understanding [230]. During the program, performance evaluation of the algorithms was carried out. Again, ground truth data were generated and various performance metrics were defined. An interesting comparison between both frameworks, PETS and VACE, was made by Manohar et al. [355].

The ETISEO project [400] was designed for performance evaluation of video surveillance systems. The project was launched by INRIA and the French government and its objective was to study the dependencies between characteristics of the scenario and algorithms. The participants had to submit their results for an evaluation using pre-defined metrics and these evaluation results were published anonymously. The tracking evaluation used in ETISEO is mainly suited for a multiple object tracking scenario.

Bashir and Porikli [48] presented another methodology to evaluate object tracking systems. To evaluate results of a multiple tracker object, the authors proposed a set of unbiased metrics based on statistical descriptors.

Considering embedded hardware, Van der Wal et al. [546] presented a framework for evaluating real-time vision algorithms running in parallel pipelined architectures. Results using FPGAs and data fusion from five cameras are reported.

More recently, Kasturi et al. [281] developed a framework for evaluating object detection and tracking on video. The developed framework includes many resources

such as ground truth video data, video data itself, evaluation metrics, and a software tool which performs the scoring.

Finally, it is also important to mention the CAVIAR Project [177] because in the course of this project many benchmark data sets were annotated, which are now publicly available. Although no framework evaluation is given, the annotated data sets cover various situations in different environments and the sequences were recorded either using a single camera or a multi-camera system providing a good ground truth for algorithm evaluation. Various forms of occlusion, object disappearance, and object reappearance are typical complexities of annotated scenes.

11.4.2 Metrics

Roughly speaking, evaluation metrics are based on the number of *True Positive* (TP), *False Positive* (FP), *True Negative* (TN), and *False Negative* (FN) in relation to the total number of objects present in the scene or the number of detected objects. These rates are defined as follows:

- A true positive is counted when the algorithm reports a positive result and a real object/event exists in the ground truth.
- A true negative is counted when the algorithm reports a negative result and no object/event is present in the ground truth.
- A false positive is counted when the algorithm reports a positive result and no object/event is present in the ground truth.
- A false negative is counted when the algorithm reports a negative result and a real object/event exists in the ground truth.

Perhaps the most frequently used metrics for evaluating object tracking algorithms are the metrics defined by Black et al. [64]:

- Tracker detection rate: $TRDR = TP_t/(TP_t + FNt)$,
- False alarm rate: $FAR = FP_t/(TP_t + FP_t)$,
- Track detection rate: $TDR = TP_o/(TP_o + FN_o)$, and
- Track fragmentation: $TF = \#$ changes of object id,

where subindex "t" corresponds to tracked objects and subindex "o" corresponds to the total number of objects. The first two metrics, i.e., TRDR and FAR, characterize the performance of the tracker. The completeness of individual ground truth objects is determined by the TDR metric. Finally, the TF metric determines the number of object label changes, which gives an idea as to how well the algorithm maintains consistency along the tracking process. They also used the "path coherence" to measure the consistency along the tracking, the "color coherence" to estimate how coherent the tracking histograms are, and the "shape coherence" which gives an idea of how accurate the tracked object position is in respect to the object ground truth.

Collins et al. [117] concentrated their attention on the stability of the tracker and its accuracy by defining the following metrics:

- Lost track: A track is considered to be lost if the bounding box does not overlap with the ground truth bounding box at all. The first such occurrence terminates the evaluation. This implies that we do not allow the tracker to reacquire the target.
- Tracking stability: Given by the percentage of data set tracked. This is the number of frames in which the algorithm tracked the object before losing it, divided by the total number of frames (i.e., lifetime of the given object).
- Tracking accuracy #1: It is defined as the average (over time) overlap between bounding boxes. The overlap is computed between ground truth and track bounding boxes for the tracked portion of the data set as percentage with respect to the area of the ground truth bounding box. Thus, a 100% accuracy implies a full overlap.
- Tracking accuracy #2: This criterion measures the similarity between the two masks by quantifying the overlap. It is calculated as the average (over time) overlap between binary masks within the overlapping bounding box area. This measure requires a roughly segmented shape of the ground truth and that of the tracked object. The measure is computed as Score = TP/(TP+FP+FN).
- Tracking accuracy #3: In this case, the average (over time) distance transform is computed relative to the ground truth binary mask. The tracked object mask is used to compute the pixel-wise distances from the distance transform map. This computation can be also applied with respect to the tracked object mask. Again in this case, the computation of this measure requires a segmented shape, instead of a bounding box.

Metrics of the framework presented by Smith et al. [503] are as follows:

- *Multiple tracker* (MT): Multiple trackers track the same ground truth.
- *Multiple object* (MO): Two or more ground truth objects are tracked by the same tracker.
- CD: The difference between the number of tracked objects and ground truth tracks normalized by the number of ground truth tracks.
- *Falsely identified tracker* (FIT): In this case, the ID of the ground truth is correct, but the ID of the tracker is not.
- *Falsely identified object* (FIO): This metric measures when the tracker swaps ground truths.

MT, MO, and CD metrics are related to the tracking robustness and tracking consistency, while the last two metrics represent an error of incorrect label distributions. Metrics used in ETISEO [400] are as follows:

- Bounding box overlap: ETISEO defines four bounding box overlap measures, which are quite complicated, with the exception of one measure, which is exactly as defined in VIVID: The overlap is computed as percentage with respect to the area of the ground truth bounding box.

- Lost track: A track is considered to be lost, if the bounding box overlap with the ground truth bounding box is below a user-defined threshold.
- Tracking accuracy #1: ETISEO proposes several measures estimating whether the link between two objects (detected at two consecutive time instants) is correct or not:

 - Precision: # of correct links/total # of links
 - Sensitivity: # of correct links/# of links between ground truth objects
 - F-Score: 2*precision*sensitivity/(precision + sensitivity)

- Tracking time: This measure is identical to the VIVID stability measure and it is computed by counting the frames where the object is tracked with respect to the ground truth lifetime of the object.

But in embedded systems, the computing time is also a critical factor. Concerning execution time, Arth et al. [21] report a rate of 0.346 ms per frame using CIF resolution (352×288 pixels) by running a version of a Kalman filter tracker. Their implementation is an unoptimized version which also uses floating-point values. The authors point out that an improvement might be achieved by using code optimization techniques. Glasl et al. [214] achieve a performance of 25 fps by running a robust variant [473] of the Lucas–Kanade template matching algorithm [338, 41]. Detection rates related to such an implementation using the metrics developed by Black et al. [64] are shown in Table 11.2. The ground truth vehicle count is given by the "GT" column, true positive detections, i.e., correctly detected vehicles, are indicated by the "T+" column. The column named "F+/min" indicates percentage of false positives, i.e., false or "phantom" detections, per minute.

Table 11.2 Object tracking evaluation [214, 326]

Sequence number	GT	T+	F+/min
1	1088	756	0.00
2	731	613	0.14
3	589	508	0.37
4	628	545	0.73

The embedded system presented by Khalegi et al. [286] achieves a performance of 30 fps using QQVGA resolution (160×120 pixels) for the stereo matching tasks. Medeiros et al. [371] report interesting results by employing a parallel implementation of a particle filter algorithm. Considering either 100 particles and a window size of 16×16 pixels or using 60 particles and a window size of 30×30 pixels, they can also reduce the computation time by a factor of 3. Table 11.3 compares execution times of these implementations. On the other hand, DVS vision sensor event-based trackers running on PCs using USB camera interfaces achieve equivalent frame rates of 500–2000 Hz at CPU loads of $< 20\%$ [122, 140].

Table 11.3 Object tracking evaluation on different platforms and applications (D.n.a. refers to "data not available")

Reference	Tracking method	Resolution	Performance (fps)
Fleck et al. [178]	Particle filter	D.n.a.	15
Arth et al. [21]	Kalman filter	352 × 288	25
Schlessman et al. [471]	Lucas–Kanade	D.n.a.	18
Khalegi et al. [286]	Kalman filter	160 × 120	30
Glasl et al. [214]	Robust Lucas–Kanade	352 × 288	25
Medeiros et al. [371]	Particle filter	D.n.a.	25

11.5 Challenges

Although many methods exist, object tracking still faces challenges, especially in case of realistic scenarios. Many methods have been designed for tracking a single object in a controlled environment. This is actually not compatible with real-world applications where usually many objects are present in the scene. In this latter case, a major issue that lessens the tracking performance is the occlusion. Occlusions or interactions between multiple objects, especially in a crowded scenario (refer also to Chapter 6) is till now an unsolved issue for vision-based object tracking.

Another challenge concerns the embedded hardware. Due to the typical limitation of resources in embedded systems, it is always challenging to optimize both the hardware and software architecture to fulfill processing requirements of object tracking. In some approaches matrix operations (multiplications and matrix inversions) are necessary because a robust tracking algorithm involves enormous floating-point operations which can saturate the processing power of embedded hardware platforms. Thus, accuracy and gain in performance are also issues to keep in mind.

In case of using multi-camera systems, the amount of information flow in the system is a key feature. It is necessary to allow multiple cameras tracking the same target using information from other nodes in order to increase the robustness and accuracy of whole system (refer to Chapters 13 and 15 for more details).

11.6 Conclusion and Future Trends

Object tracking is a widely explored topic in computer vision and applications using smart camera systems are rapidly increasing (see, e.g., Chapters 13, 15, and 17).

This chapter presented a description of the state of the art in object tracking, focusing on embedded platforms, where the application of computer vision techniques faces a challenge due to the limitation of available resources. Application areas including signal processing and image processing systems and typical examples are face detection systems, voice recognition, and speech compression, among many others.

Although many algorithms were proposed and developed in recent years, there are still many unresolved issues. Mainly, the resource limitation on embedded plat-

forms and the development of robust multi-camera tracking systems are continuous areas of research. Smart camera applications are characterized by real-time requirements, their computational intensity, and the interaction between different components, both hardware and software. A multiprocessor implementation helps to satisfy execution time constraints.

For certain scenarios, changes in the observed scene are very common. Thus, smart cameras have to adapt their response to such changes. Besides, different types of sensors generate different responses to the same scene. Hence, the integration of different types of sensors, i.e., multi-sensor systems, and the fusion of their data, i.e., multi-data fusion, might be helpful to enhance the output, increasing the tracking detection rate and minimizing the number of false alarms.

Novel vision sensors (e.g., DVS) with focal plane processing and on-chip motion detection proved to be an alternative solution for real-time tracking on embedded hardware. The low data rate (sparse data representation) and the wide dynamic range aspect will allow efficient object tracking in real time without the need to produce a human-readable image.

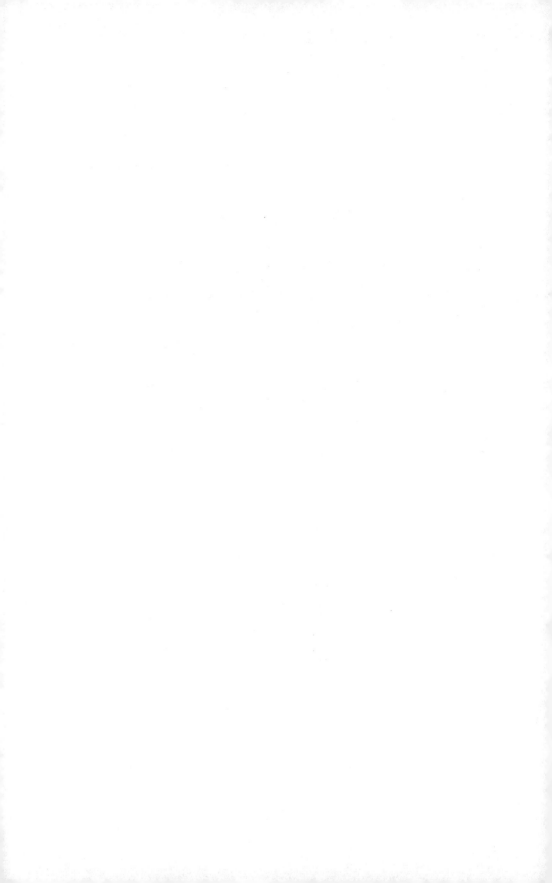

Part V
Distributed Smart Cameras

Chapter 12
Designing a Wireless Smart Camera with a High-Performance Vision System

Richard Kleihorst

12.1 From Ambient Intelligence to Collaborative Smart Camera Networks

Ambient intelligence is arranged by electronic environments that are aware of and responsive to the presence of people. Ambient intelligence is a lively field of research, pushing technology and relevant applications. So far, most applications are focused toward monitoring scenes and persons. As a noninvasive technology, imaging plays an important role in mobile sensing devices. Imaging, backed-up by computer vision, can for instance be used for detecting persons and objects and recognizing behavior such as illness and rioting.

Smart cameras play an important role in both the single and the multi-camera setup [548, 447]. Smart cameras are cameras with embedded vision computing inside the same housing close to the image sensor. The primary reason to use compute engines inside the camera housing instead of doing the computation on a PC or server is cost reduction. From a system perspective, the cost of ownership of smart cameras is far smaller than PC-based solutions. This shows clearly in the recent market developments in surveillance and industrial inspection. Another reason to combine vision processing directly with the sensor is power consumption in the case of low-range wireless setups. This is motivated by shrinking of the ratio of energy consumption for scene analysis (read semantic data compression) versus the energy for broadcasting information. While the first item follows Moore's roadmap, the last item is stuck at the lower boundary of information transmission because of thermal noise.

Contrary to common belief, the (embedded) imaging performance of a smart camera does not have to be far behind the performance of a generic high-level PC, as can be seen from the work of [575, 576]. The simple reason for this is that a

R. Kleihorst (✉)
VITO NV and Ghent University, Boeretang 200, 2400 Mol, Belgium
e-mail: richard@kleihorst.com

The work presented in this chapter has been performed at Philips Research Labs and NXP Research.

A.N. Belbachir (ed.), *Smart Cameras*, DOI 10.1007/978-1-4419-0953-4_12,
© Springer Science+Business Media, LLC 2010

227

smart camera processor can be made dedicated to image processing and thus being more performing and power efficient, while PC-based (or generic processor-based) solutions are not optimized for the typical data flows in a vision task.

During the past decade image sensors have become cheap and available because of the boom in the use of CMOS imagers in mobile phones. Also, IC technology has succeeded in getting high enough performance for limited amounts of energy consumption to make smart cameras possible. Wireless networks are ubiquitous and connection technology has matured over the past 20 years.

Up to now, computer vision is only used in industrial environments. Smart cameras have also been introduced there recently, mainly to lower system costs, avoid network overloads, and to assure ease of use. Now it is time to introduce smart camera networks in the office and consumer domains.

Camera networks are well known in the shape of IP cameras. However, nothing is added to the system except for a transport layer that compresses the video and sends it through a network to a receiving/displaying station. The benefits which arise from the opportunities a network of cameras looking at the same scene can offer are not exploited.

Single-camera vision is basically a difficult task, because it tries to solve the vision challenges from a 2D projection of a 3D scene. While this may work for industrial applications, it poses challenges for scenes where people are involved. Viewing the scene from (enough) more angles solves ambiguities and occlusion problems because a genuine 3D appearance model can be used. Even in simple cases, where multiple cameras are aimed from similar directions, the stereo depth view leads to more robust results.

All camera feeds can be combined (if performance permits) into a single computing engine. As cost of ownership shows, using smart cameras with embedded computers for networks is a better choice. This opens the field for the new domain of collaborative cameras. Using this approach the cameras work together throughout the vision algorithm to solve a certain task. Although the challenges of distributed processing are great, study has shown that achievements of camera networks can be much more intense, reliable, and power efficient.

12.2 Research Goals in This Field

Reasons for academic/engineering research are that the field is proving highly profitable but is not yet mature enough to be deployed yet. "Collaborative smart camera networks" have these properties. Moreover, it is a system not an end product, so many intermediate results will spin out to generate feedback, revenue, and motivation. The research needed to bring the camera networks to a deployable scale has to focus on the following aspects:

1. Real-time computer vision is the major part of the work. The smart cameras allow real-time processing, but the results have to be brought to a robust

enough level to be reliable. This will entail research into vision algorithms and approaches.

2. Collaborative vision is a new domain. Here not only a scene is analyzed from multiple directions, but also the cameras are working jointly to solve the vision task. The network behaves as one system. Some approaches have been presented, but currently there is no transparent, systematic approach. This is needed in order to facilitate future development.

3. Distributed processing is the processing layer of collaborative vision. It shows to users as the software and hardware environment which is used to design tasks that are working together. Key words here are networking, synchronization, quality of service, load balancing, power consumption, etc.

4. Hardware development of the cameras. Smart cameras are on a roadmap to be miniaturized. Technological advances are needed to approach this, including increasing the vision performance and lowering the power consumption and price point.

5. Data fusion with other sensor networks will be needed to improve the reliability of the results and to make the system more applicable in diverse environments. This means investigating how to fuse the vision information with motion, pressure, temperature, sound, and light sensors (networks).

12.3 Why Do Wireless Cameras Have to Be Smart?

As low power consumption and high performance are difficult to achieve for the functionality that the device is intended for — battery-powered video processing – the functionality could be shifted to a mains-powered PC by broadcasting the raw video data. However, this requires in the order of 400 mW for a digital 15 fps gray-level VGA wireless link. It appears that continuously broadcasting live video from cameras to a computing engine like a PC takes more energy from the camera power source than the computation operations for scene analysis would take. Actually, for short distance transmission most of the broadcast energy is dissipated in the DA convertor in the transmitter [453]. This can be seen in Fig. 12.1, where for Bluetooth transmitter electronics 150 nJ per bit is needed and only 1 nJ per bit is needed for the actual transmission.

The technology of these DA converters is very close to their practical lowest power consumption limit, dictated by thermal noise. This becomes clear from the distribution of several modern low-range transmission systems such as Zigbee, Pico-Radio: all are scattered slightly above the straight energy-per-bit line in Fig. 12.2.

For DSP on silicon however, power consumption continues to decrease because of techniques like technology and voltage scaling, lazy computation, and the use of low-energy architectures. This reduction of energy consumption can go magnitudes further before it reaches the intrinsic minimum of silicon [459]. A clear graph to show this is in Fig. 12.3, where silicon performances are rated according to how many million operations per Watt they perform. With the technology nodes on the

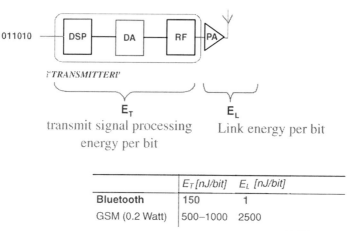

E_T transmit signal processing energy per bit E_L Link energy per bit

	E_T [nJ/bit]	E_L [nJ/bit]
Bluetooth	150	1
GSM (0.2 Watt)	500–1000	2500

Raf Roovers

Fig. 12.1 Energy consumption of short- and medium-range transmission systems. It can be seen from the numbers in the table that most of the energy for the short-range standard (Bluetooth) dissipates into the electronics and not into the air [453]

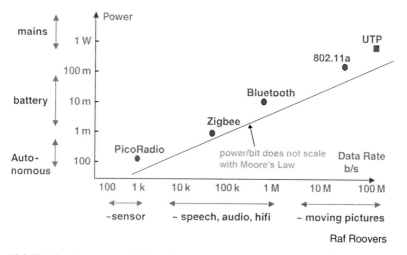

Fig. 12.2 The fixed energy-per-bit line of short-range transmission systems. Note that all modern short-range communication standards are scattered just above the linear line in the curve [453]

X-axis, this graph continues to grow. A clear distinction can also be seen for a general purpose sequential processor (Pentium) and a dedicated parallel processor (Xetal) [294], a derivative of which is used in the presented smart camera.

While wireless transmission is close to its energy efficiency limit, VLSI computation will continue to be more economical. Research into providing more system performance per Watt focuses on developing solutions through the use of strong data-level parallelism and advances in IC technology [3]. This leads to the conclusion that it is a better proposition to invest more into computing at the camera

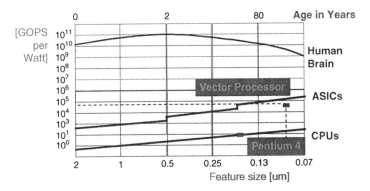

Fig. 12.3 The increasing silicon efficiency in mega operations per second per Watt for different technology nodes. The light-colored curve shows the position of standard (sequential) processors, the darker curve shows the intrinsic performance of dedicated silicon solutions [459]. "Xetal" is a vector SIMD processor and one of the processors used in the camera platform

node itself and sending only event detections to the central host and/or to the other cameras in the connected environment.

12.4 Efficient Image Processing Shows Specific Hardware Kernels

Real-time video processing on (low-cost and low-power) programmable platforms is now becoming possible, thanks to advances in integration techniques [4, 294, 211, 580]. It is important that these platforms are programmable since new vision methods and applications emerge every month. The two types of programmable processors that we propose to be included in smart camera architectures are the SIMD massively parallel processor and (one or more) general-purpose DSPs [267, 268].

The algorithms used for smart cameras can be grouped into three levels: *low-level*, *intermediate-level*, and *high-level* tasks. Figures 12.4 and 12.5 show the task classification and the corresponding data entities, respectively.

The *low-or early-image processing level* is associated with typical kernel operations like convolutions and data-dependent operations using a limited neighborhood of the current pixels. In this part, often a classification or the initial steps toward pixel classification are performed. Because every pixel could be classified in the end as "interesting," the algorithms per pixel are essentially the same. So, if more performance is needed at this level of image processing, with upto a billion pixels per second, it is very fruitful to use this inherent data parallelism by operating on more pixels per clock cycle. The processors exploiting this have an SIMD architecture, where the same instruction is issued on all data items in parallel [268, 223]. From a power consumption point of view, SIMD processors prove to be economical [293]. The parallel architecture reduces the number of memory accesses, clock

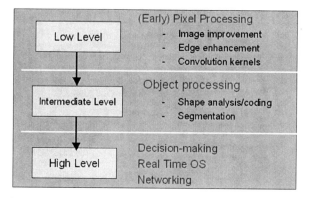

Fig. 12.4 Algorithm classification with respect to the type of operations

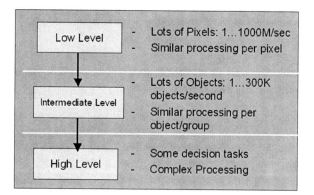

Fig. 12.5 Data entities with processing characteristics and possible ways to increase performance by exploiting parallelism

speed, and instruction decoding, thereby enabling higher arithmetic performance at lower power consumption [4, 294].

In the *high-* and *intermediate-level* part of image processing, decisions are made and forwarded to the user. General-purpose processors are ideal for these tasks because they offer the flexibility to implement complex software tasks and are often capable of running an operating system and doing networking applications.

12.5 Prototype Smart Camera Hardware Platform

At the moment (2008) several prototype smart cameras that can be connected wirelessly are described in literature and shown at conferences. It is expected that some of these and others will be commercially available in the near future. A recent overview can be found in [447] and [107]. Most of the cameras presented are not yet able to work in a collaborative networked way. Also almost none of the cameras adhere to the efficient hardware kernel setup described earlier. Instead, they rely on

either high-power FPGA-based solutions or low-power PDA-like processors that do not have the imaging performance necessary for autonomous smart camera systems.

With earlier-stated considerations in mind, we developed a wireless smart camera system that can operate stand-alone or in a network of cameras. The camera consists of basically four components, one or two VGA color image sensors, an SIMD processor for low-level image processing, a general-purpose processor for intermediate and high-level processing and control, and a communication module. Both processors are coupled using a dual port RAM that enables them to work in a shared workspace at their own processing pace (see Fig. 12.6).

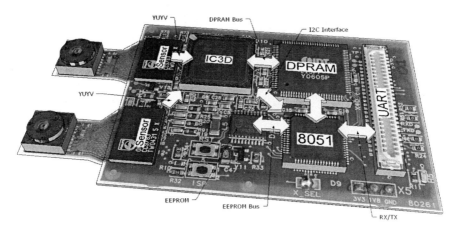

Fig. 12.6 Complete architecture of the WiCa showing all processing and hardware blocks

12.5.1 IC3D SIMD Processor

The IC3D, a member of the Philips' Xetal family of SIMD processors, is composed of five specific internal blocks, see Fig. 12.7. Two of the blocks function as video input and output processors, respectively. They are capable of streaming in and out three digital video signals to the internal memory. The heart of the chip is formed by the linear processor array (LPA) with 320 RISC processors. Each of these processors has simultaneous read and write access within one clock cycle to memory positions in the parallel memory. Both the memory address and the instruction of the processors are shared in SIMD sense. All processors can also read the memory data of their left and right neighbors directly. At the extremes of the linear array, the inputs of the processors are optionally coupled or mirrored. The processors have downloadable instructions ranging from arithmetic and single-cycle multiply-accumulate to compound instructions. In addition to these, there are conditional guarding instructions, enabling data-dependent operations. Data paths are 10-bits wide. Each processor has two word registers and a flag register. The line-memory block stores 64 lines of 3200 bits. Pixels of the image lines are placed in an interlaced way on these memories.

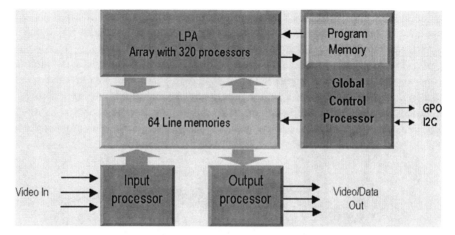

Fig. 12.7 Architecture of the "IC3D" which is a member of the "Xetal" family of SIMD chips

Thus, CIF (320 × 240) images result in 1 pixel per processor, VGA (640 × 480) in 2 pixels per processor, etc. The GCP (global control processor) is a processor dedicated to controlling the IC3D and performing some global DSP operations on the data. It takes care of video synchronization, program flow, and it also communicates with the LPA and the outside world. The peak pixel performance of IC3D is around 50 GOPS. Despite its high pixel performance, the IC3D is an inherently low-power processor as not only instruction decoding is shared between all 320 processors, but also memory access is based on ultra wide memory words that contain complete image lines as opposed to energy consuming access to multiple pixel-wide memory locations. For typical applications, such as feature finding or face detection, the power consumption is well below 100 mW in active processing modes.

12.5.2 Dual Port RAM

The dual port (DP) RAM functions as an asynchronous connection between both processor cores. While the IC3D processor works on streaming (pixel) data, processing the frames at sensor speed, the 8051 host processor (discussed later) will not be working at streaming speed. Moreover, the high-level processing task on the 8051 processor is a non-constant time program which varies in duration depending on the number of objects of interest in the scene.

With that in mind, the IC3D records information from the video, such as feature points or coordinates of objects, or even (parts of) images in the DPRAM. The 8051 can then leisurely read and analyze that information and make decisions regarding the position, scale, or movement direction of objects in the scene.

Transferring information from the 8051 back to the IC3D is also possible via this DPRAM. The memory uses semaphore techniques to avoid corruption of data

if both processors try to record information to the same address at the same time. Also, the memory has banks that can be allocated to a specific process.

The size of the memory is now 128K words of 8 bits, divided into two banks of 64K words each. If the system wants to store in image format, two images of up to 256 × 256 pixels are directly storable. Applications where image format data is stored are for instance dynamic background subtraction and motion estimation.

12.5.3 The Host Controller 8051

To save components and to keep the power consumption low, a top-of-the-range 8051 of ATMEL is used, see Fig. 12.8. This device has all necessary components inside to make a small, yet complete system; it has a large number of usable I/O pins to control the camera and its surroundings. The 8051 has a 16 bit-wide external address bus for memory which fits easily to the dual port memory connected to the IC3D. To indicate special data transfers between the IC3D and 8051, an interrupt line on the 8051 is used that can be triggered by IC3D. The 8051 used has 1792 bytes of internal RAM and 64 kB of Flash to store its program or additional data. The internal 2KB EEPROM is used to store parameters and onboard programs for the IC3D. Communication to the outside world is done via the UART. The UART has its own baud rate generator and as a result all three timers of the 8051 are available for user applications. There are two 8-bit timers and one 16-bit timer. They are now partly used for task switching in a (tiny) operating system.

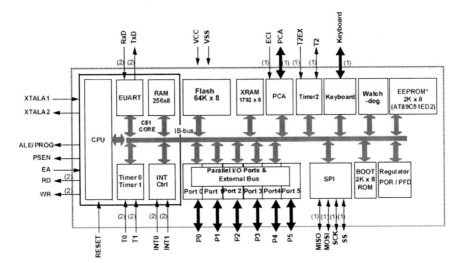

Fig. 12.8 Architecture of the 8051 used on the camera

12.5.4 Aquis Grain ZigBee Module

The Aquis Grain ZigBee module is the transceiver part of the wireless camera. It was developed by Philips Research around ChipCon's CC2420 SOC, see Fig. 12.9 [166]. The radio system implements a MAC layer in IEEE 802.15.4 spec. The software radio system is programmed on an additional 8051 processor and can be modified for special purpose applications. The 802.15.4 standard offers wireless communication within a radius of approximately 5 m. In the communication network the device that starts up first acts as coordinator. The peer-to-peer structure offers direct camera-to-camera communication [332]. It is also quite robust as cameras can be switched on or off (even the coordinator) and the network will remain stable and automatically take action in response to the changes. The communication module is attached to the camera as a wireless UART port of limited capacity. The maximum data rate of around 10 kB/s will only leave room to communicate about details or events in the scene. With a non-real-time rate, images or parts of images can be sent. The network is quite capable, however, of transmitting, for instance, face images of people who are present in the scene to the other cameras or to a host processor. Although the low bit rate seems to pose problems for present-day approaches, it also solves a number of problems and creates new challenges. The low bit rate, for instance, enables a low-power solution as discussed before. Also from a legal and privacy point of view, the cameras will technically not be able to stream live video data, which could make the acceptance rate of cameras in home environments higher. Other wireless standards and modules can be connected to the camera using the UART bus. The low bit rate ZigBee module forces us to do much processing and event description on the camera itself. This corresponds to the earlier elaborated energy efficiency viewpoint of transmission versus computing.

Fig. 12.9 The ZigBee transceiver module used on the camera

12.6 Software System

The camera can be programmed wirelessly or remotely due to "in-system" programmability capabilities of the 8051. New IC3D programs can be uploaded from the 8051 via I^2C in run time. An external I^2C EEPROM can store 16 application programs which can be used for content switching. The 8051 can load a program into the Xetal for a specific task that has to be carried out for a scene.

The software for the wireless camera consists of three components that are developed almost independently. Programs for the IC3D processor are written in extended C++ language with implicit parallel data types. All programs are written in a line-based manner where complete image lines are processed in single clock cycle instructions. By guarding instructions, data-adaptive software structures can be implemented. Typical functions running on this processor are image improvement, motion analysis, object detection, and tracking algorithms. The programs on the 8051 host processor are designed for keeping track of the object data over time. It performs the host function (running the operating system) and can decide to transmit events to a host system.

12.7 Algorithms for Real-Time Vision on This Hardware Platform

Camera sensors in networked systems are now often used for monitoring applications. For this purpose they mainly need to detect objects and persons and report hazardous situations. The detection of (natural) objects in these complex environments is a challenging field of research. The Smart Camera group of Graz University has developed some interesting applications where networks of smart cameras are used for traffic monitoring [76]. Another example is the "eye society" project in MITt's media lab where wirelessly linked PDAs with cameras perform distributed recognition tasks [353]. Furthermore, the general research on distributed processing in smart camera networks for tracking purposes carried out by the embedded systems group of Princeton University is interesting to follow [548].

The techniques reported above are challenged by several aspects regarding the 3D (world) objects in the 2D (image sensors) captured scenes. The objects can occur in many different orientations, rotations, and shapes depending on how they are oriented toward the camera. Objects can be partially occluded in the scene, while detection is still desired. Furthermore, the lighting conditions of the scene are not reliable in non-controlled situations. Colors can be affected by light conditions and intensity by illumination and shadows. These real-world challenges call for 3D, multi-camera techniques and special approaches in the image analysis domain that are robust against viewing angle and illumination changes.

In accordance with the differences in appearance of a similar object from different viewing angles and with the need to be compatible with low-power hardware, feature-based methods are ideal. Feature-based methods exhibit high performance on objects in natural scenes. This is because the features can be made to be scale, rotation, color, and intensity invariant. Using this technology, features are

first detected from the image. These features can be as simple as color combinations, corners, edge pieces or more complex such as responses to Haar filters [266], Gabor filters, or the often used SiFT-based blob features [337]. In Fig. 12.10, an image with detected corners is shown: the colors indicate the position and type of the corners. Note that there is a pipelining delay between the actual corner and the annotation. The corner detection is performed in 31×31 filters. A list with the type of corner and information about the local gradients is enough to recognize this object image from dozens of other images. Corners work well on man-made structures such as buildings, walls, and furniture for finding structures and even for doing gesture analysis. Blob features are shown in Fig. 12.11 (from [329]). Accompanying the location of the feature itself, descriptions are obtained from its surroundings which is matched by a database system trying to recognize the particular feature from a stored set.

Fig. 12.10 Corner feature detection is a simple way to recognize man-made objects, this is a screenshot of a traffic sign recognition program

A major advantage of feature-based techniques is that the algorithm can be clearly divided into a pixel parallel part and a task parallel part. Where the actual feature finding is a pixel parallel part as the same tasks are performed for all pixels, the analysis part can be performed in parallel by dealing with each (unknown) number of feature points that were detected.

In our "mote" the IC3D finds the feature points in the life video feed and writes them into the dual port RAM. The 8051 retrieves them from the RAM at its own pace and compares each feature point with an internal database or even between cameras.

Fig. 12.11 For natural objects blob features are promising. In this image, the size and intensities of the annotated circles indicate the scale where the blob feature was most present

12.8 Application Research on WiCa

At Philips and NXP Research, several projects are carried out that implement applications on the presented wireless smart camera. Among the projects that were tested on this platform are the developments of layered communication protocols that permit the processors on different cameras to contact each other directly [332]. On the imaging side, distributed face detection was mapped, where detection results from different image sensors are fused in order to minimize the false detection rate [264]. Also, first projects for gesture recognition based on hand detection were demonstrated. Our work on camera calibration techniques [499] will enable accurate distributed processing for unsystematically installed cameras. All projects run in real time (video at 24 or 30 fps) on the described wireless smart camera system. An LCD is connected to the camera to show the video path for debugging purposes. The images in this section are taken from this LCD. The typical power consumption of the image processing part is in the order of 50–250 mW, depending on the load of the processor. Some examples of the algorithms that are kernels for applications are described below.

To control the WiCa, a program called WiCaEnv running on a host is used. If connected directly to the WiCa through the UART it emulates an ASCI terminal. If connected to an AquisGrain USB stick, it submits a request to all available WiCas

on the network and builds a list. By selecting one of the WiCas from the list one can establish the wireless terminal to this particular camera. After that, WiCaEnv is used to control the DPRAM, upload programs to IC3D and 8051, set up the sensors and IC3D parameters, and to upload/download content to/from the DPRAM.

Background subtraction is a mechanism to detect all foreground objects for a given frame sequence from a fixed camera. The background image must adapt to gradual and sudden illumination changes, motion changes, camera oscillation, sensor sensitivity, etc. There are different background techniques such as running average, mixture of Gaussians, kernel density estimators, or eigenbackgrounds. All the background techniques with low-to-medium memory requirements can be implemented using the DPRAM as storage area by trading off resolution against the number of backgrounds. In Fig. 12.12, an application of background subtraction is shown. This application does contour detection which is used as one of the inputs for our face detection system based on soft edges [264]. Note the bar indicating where the eyes have been detected. Lately, interesting work has been done on contour and curvature matching for object recognition. Here the multiscale matching process was implemented on the SIMD machine making it possible to do this in real time [491]. To perform real-time screen rotation or transformation, every pixel must be addressed individually. This task is not easy to perform in the SIMD machine, where all operations are similar for the entire video line. The WiCa architecture permits these image-wide operations though, by using the external DPRAM. The address bus of this RAM is connected to the data outputs of IC3D. Any image transformation operation that can be written as SIMD instruction per line on the pixel address can now be implemented very efficiently.

Fig. 12.12 Background subtraction identifies the contours of people appearing in front of the camera, these contours are used as input for an eye detection application as illustrated by the horizontal bar

Figure 12.13 shows a screenshot of an X-axis (tilt) rotation program implementation which is based on the fact that a projective transform is a non-singular linear transformation of homogeneous coordinates. The program shows a tilt between -36 and $+36$ degrees (HW limitation) with the rotation axis placed in the center of the screen. This program is used in lane-detection warning systems and camera calibration for depth estimation from stereo. Figure 12.14 shows a binary image, which resulted from applying edge detection (Robert Cross Operator) to the input image. At the top of the screen the Hough space is displayed for lines with vertical angles. Using the WiCaEnv application it is possible to save the Hough space to DPRAM, scan the Hough space using the 8051, and find three significant lines within the image. This information is then saved to the IC3D which can draw lines (shown in Gray overlay) on the display indicating where the lines have been found. Results and improved methods can be seen as video demos on these links at the footnotes.[1,2] The method itself is described in [232].

Fig. 12.13 By processing address data in SIMD mode, affine transforms on images can be performed at video speed using a few operations

Figure 12.15 is an application based on background subtraction. A background is saved to memory and for the subsequent frames background subtraction is used. A threshold is then applied to the difference image resulting in a binary difference

[1] Xetal Team 2008. Real-time Hough transform. *http://www.youtube.com/watch?v=jpfc1vp5XOQ*.
[2] Xetal Team 2008. Real-time Hough transform, showing gesture control. *http://www.youtube. com/watch?v=6afjN1ranTw*.

Fig. 12.14 At the top of the image the Hough space can be seen, which resulted in the annotation of three significant vertically oriented lines in the image

image. Only the first three lines where a difference occurs are saved to memory. In this way for instance finger tops can be identified in order to generate a human–machine interface. The figure shows how an image can be drawn. The color bar shown at the top of the screen can be used to change the color used for drawing. The desired color is selected by merely pointing. Another example of real-time hand recognition can be seen on video,[3] which shows a method that fuses edge density, motion vector and intensity, and color information to perform real-time hand tracking. The field of robust gesture recognition has improved by introducing more cameras to the situation. Gesture recognition from one camera is suffering from non-robust results [575]. However, by adding more cameras into the process, significant results are achieved. The addition is done in a collaborative manner, whereby each camera does the gesture analysis and 2D results are sent to a central switching Kalman filter for robust 3D results. Papers on this subject include [576, 601]. Video demos can be viewed in the footnotes.[4,5]

[3] Xetal Team 2008. Real-time hand tracking demo. *http://www.youtube.com/watch?v=yc-2fLsU2OM*.

[4] Xetal Team 2008. Collaborative cameras for gesture recognition. *http://www.youtube.com/watch?v=RctO8FdBzQU*.

[5] Xetal Team 2008. Real-time gesture analysis with two wica cameras. *http://www.youtube.com/watch?v=zEl_NmaEd_w*.

Fig. 12.15 This application shows a setup for a user interface. Fingers are recognized and used in this demo for menu selection and drawing. The picture shows a result of the art that can be produced

Principal work, such as depth estimation from stereo, is basically also collaborative camera work. In this approach, however, the sensors are physically close together with a very high internal bandwidth for the collaboration. Results of this research are presented by [209, 210], the latter publication also taking automatic camera calibration into account. Video demos of depth estimation can be viewed in the footnotes.[6,7,8]

12.9 Future Research Directions

As long-term research goal we aim to develop "ubiquitous" smart camera networks. These are networks that are multipurpose, human centered. The same network can be used for gaming, elderly care, domotica, retail and surveillance. The final application is merely a plug-in device to the sensor network, in which the cameras will play an important role in the description of human presence and activity. Currently, ubiquitous smart camera networks do not have an economical value as such. Surveillance, as well as lighting companies are working on their own camera (networks) to

[6] Xetal Team 2008. Depth estimation with a Xetal smart camera. *http://www.youtube.com/watch?v=YVnxYftmTNE*.

[7] Xetal Team 2008. Depth estimation using Xetal smart camera processor. *http://www.youtube.com/watch?v=sLK49e2RNTQ*.

[8] Xetal Team 2008. Wica 1.1 stereo rig. *http://www.youtube.com/watch?v=C-uznmQnC8U*.

enhance their applications. Gaming consoles are adding cameras, and even institutes providing elderly care are experimenting with computer vision.

After a number of years, environments will house more camera networks in parallel for different applications. At that point, the ubiquitous camera networks will become economically viable, simply to reduce the cost of installment. In practice, the camera network will fuse with the other sensor networks being developed and a service provider will maintain a system around the site. A surveillance system can plug into the network and obtain a live update of the tracks of people with an identifier. An elderly care system has a subscription to the network to detect possible falls of selected inhabitants or unusual behavior. A gaming or entertainment system will obtain real-time gesture information from the network.

The skills needed to establish these ubiquitous collaborative camera networks are tremendous and very versatile. One research team will only be able to approach part of the challenge. The entire system has to be mastered in close cooperation with many research institutions, large companies, and high-tech ventures.

12.10 Conclusions

In this publication we presented the wireless smart camera platform that is being used in our research on distributed scene analysis. Smart cameras in a true sense, i.e., cameras with built-in processing, are a key sensor for use in ambient intelligence. The local processing onboard results in a system that only sends key words of information, by air, to a host system. Contrary to earlier belief, the advances in microprocessor architectures and silicon technology have made this more efficient for power consumption than broadcasting live video to an analyzing host PC. We also wish to acknowledge "The Xetal Team" of NXP research, formerly Philips Research, and the many students that visited us, often bringing their own applications.

Chapter 13
Automatic Geo-registration and Inter-sensor Calibration in Large Sensor Networks

Khurram Shafique, Feng Guo, Gaurav Aggarwal, Zeeshan Rasheed, Xiaochun Cao, and Niels Haering

Abstract Modern automated video analysis systems consist of large networks of heterogeneous sensors with different output characteristics, for example, static surveillance cameras, Pan-Tilt-Zoom (PTZ) cameras, infrared cameras, radars, and hyperspectral sensors. These systems must not only perform content extraction on individual sensors but also integrate and fuse the information from different sensors to effectively provide site-wide situational awareness. A critical step to analyzing and fusing data for site-wide scene understanding is to map observations from multiple sensors to a common coordinate system. In this chapter, we present a data-driven approach to automatic and semi-automatic estimation of inter-sensor mapping, relative topology of overlapping cameras, and geo-registration in large visual sensor networks. Data-driven approaches use sensor observations (for example, pairs of simultaneous target detections) over time to infer sensor geometry and network topology. Since these methods use target observation as their primary feature, they not only enable sensor registration in feature-less terrains but are also agnostic to the sensor's output characteristics. In addition, they may also automatically adapt to the changes in sensor geometry. The data-driven approach presented in this chapter exploits domain and model-specific properties to develop efficient sampling-based mechanism for robust model estimation in the presence of outliers.

13.1 Introduction

Modern automated video analysis systems consist of large networks of heterogeneous sensors with different output characteristics, for example, static surveillance cameras, Pan-Tilt-Zoom (PTZ) cameras, infrared cameras, radars, and hyperspectral sensors [119, 167, 485, 131, 519, 441]. Analyzing and fusing data from these sensors to achieve site-wide situational awareness andscene understanding require

K. Shafique (✉)
ObjectVideo Inc, Reston, VA, USA
e-mail: kshafique@objectvideo.com

A.N. Belbachir (ed.), *Smart Cameras*, DOI 10.1007/978-1-4419-0953-4_13,

mapping observations from multiple sensors to a common coordinate system. For example, targets observations from multiple sensors may be mapped to the geodetic coordinate system and displayed on a map-based interface or geo-browser, for example, Google Earth and NASA WorldWind. Availability of such mapping also enables critical operational tasks, such as fusion of multiple target measurements over the network, reasoning about a target's relative or metric size and speed, target handoff across sensors, tasking of PTZ and mobile sensors, and site-wide inference. Due to these benefits, many multi-sensor video analysis systems require geo-registration and/or inter-sensor calibration to be performed at the time of installation [119] (see also Chapter 9). The underlying assumption being that this information does not change over time, which is typically not true. What is needed is an automated and efficient mechanism that can estimate and maintain geo-registration for all sensors.

There is a large body of research that uses image features for supervised and unsupervised sensor registration. In its simplest form, registration for planar scenes and perspective cameras can be performed by manually providing four or more corresponding points in the image and the reference image (or map) [229]. However, feature-based techniques are not feasible in many scenarios (for instance, cameras overlooking water regions or other terrains that do not contain many discriminative or well-localizable features), and even manual registration requires long setup time, specialized tools, and tedious preparation. The shortcomings of feature-based methods and the need for automated methods to estimate and maintain sensor geometry have motivated data-driven approaches that use sensor observations (for example, pairs of simultaneous target detections) over time to infer sensor geometry and network topology [342, 310, 510, 483]. Since these methods use target observation as their primary feature, they not only enable sensor registration in feature-less terrains but are also agnostic to the sensor's output characteristics. In addition, they may also automatically adapt to the changes in sensor geometry. The main challenge that these methods face is to automatically and robustly extract inliers from noisy observations. How they tackle this issue differentiates them from each other. The proposed approach exploits domain-and model-specific properties to constrain the search space for efficient model estimation and noise handling. In particular, the method uses the invariance of collinearity among points under homographic transformation to obtain a reduced search space where the percentage of outliers (in the data) is significantly less than the original search space. Most of the existing data-driven approaches do not take into account the effects of lens distortion on homography estimation. This effect is especially prominent in high-resolution sensors that are now increasingly being used in modern applications. We show that the proposed method can be used to estimate the homography as well as lens distortion parameters in noisy scenarios. We provide both analytical and quantitative results showing that the proposed approach outperforms the existing methods by efficiently and robustly estimating planar homography in very noisy scenarios (with more than 85% outliers) in the presence of lens distortion. We apply the proposed algorithm for multiple applications involving large sensor networks. These include (i) fusing data from targets that broadcast their geo-positioning information, such as

dedicated mobile units (boats, people, vehicles) or targets that broadcast automatic identification system (AIS) information and vehicles and people with RFID tags, for periodic geo-registration of the system; (ii) fusing information from sensors that report the geo-position of targets in their field of view (e.g., RADAR) with the visual sensors for automatic geo-registration and maintenance; and (iii) alignment of multiple visual sensors with overlapping fields of view by fusing the target observations from each sensor. All of these applications can be viewed as special cases of data-driven sensor alignment problem formally defined in Section 13.4. In the following, we collectively refer to these problems as data-driven multi-sensor alignment.

13.2 Problem Definition and Related Research

We assume that the areas of interest in the scene (i.e., areas where targets move) are planar, which is a typical assumption for most surveillance scenarios (see, e.g., Chapter 17). The relationship between the FOV of two sensors, C_i and C_j, in a planar region can be represented in terms of a homography (given by a 3×3 matrix, say \mathbf{H}). If \mathbf{p}_i is the projection of a point on the ground plane in C_i and \mathbf{p}_j is the corresponding point (projection of the same world location as \mathbf{p}_i) in C_j, then $\mathbf{p}_i = \mathbf{H}\mathbf{p}_j$, where both \mathbf{p}_i and \mathbf{p}_j are in homogeneous coordinate system. The homography \mathbf{H} can be obtained by solving a linear system obtained by identifying four or more corresponding points [229] in the two images that lie on the ground plane and do not form degenerate cases, such as co-linearity. Let \mathbf{Z}_i be the set of observations of the sensor C_i, where $\mathbf{Z}_i = \bigcup_t \mathbf{Z}_i(t)$, $\mathbf{Z}_i(t) = \left\{ Z_i^1(t), Z_i^2(t), \ldots, Z_i^{k(t)}(t) \right\}$, and $\mathbf{Z}_i(t)$ the set of $k(t)$ observations in the sensor C_i at time t. The set of all pairs of co-occurring observations between a given sensor pair (C_i, C_j) is defined as $\mathbf{Z}_{ij} = \bigcup_t \mathbf{Z}_i(t) \times \mathbf{Z}_j(t)$. A pair of observations $z_{ij} = \left(Z_i^a(t_k), Z_j^b(t_k) \right) \in \mathbf{Z}_{ij}$ is called an inlier if both observations $Z_i^a(t_k)$ and $Z_j^b(t_k)$ belong to the same target in the world (i.e., satisfy a homographic relationship), z_{ij} is called an outlier otherwise. The multi-sensor alignment problem is to simultaneously identify the mapping (homography) and inliers from the set (C_i, C_j).

Data-driven approaches for multi-sensor registration can be classified as either supervised [285, 287, 439, 261] or unsupervised [310, 510, 352, 507, 528, 483] based on whether or not they require training data or user-supervision. They can be further classified based on the type of model they learn, for example, geometric models [287, 310, 510, 483] and correspondence models [285, 439, 352, 528, 261]. The geometric models explicitly describe the geometric relationship between sensors (or a sensor and a reference) and provide a common coordinate frame for sensor fusion and inter-sensor tracking. Geometric models can be used to fuse sensors with both overlapping and non-overlapping fields of view (the later providing that the geo-registration is available). The correspondence models, however, represent the likelihood of corresponding observations across sensors and are advantageous in

inter-sensor tracking when the fields of view of sensors do not overlap and geo-registration is not available.

The method presented in this chapter estimates the geometric model, i.e., planar homography in an unsupervised fashion and hence is more closely related to [310], [510], and [483]. In [310], an unsupervised data-driven method is presented that uses RANSAC on simultaneously occurring target observation pairs (detections) to obtain planar homography in sensors with overlapping fields of view. Although RANSAC can handle more than 50% of outliers in the data, it is known to become prohibitively expensive as this fraction increases [594] and sometimes without producing a solution even after hundreds and thousands of iterations [510]. Recently, there have been many attempts to improve the efficiency of standard RANSAC for noisy data [361, 393, 533, 402, 554, 594]. Though efficient, most of these methods are limited in their handling of a large number of outliers. For example, [594] describes an algorithm that can handle 70% of outliers for fundamental matrix estimation whereas [554] reports handling of $\approx 85\%$ of outliers on simple line-fitting examples. To account for a large fraction of outliers in the data that are typical in multi-sensor alignment scenarios, the use of tracking information (instead of detections) was proposed in [510]. The method involved assigning a heuristic likelihood to each pair of co-occurring trajectories in two cameras based on the number of objects in the scene, the number of possible pairs at the time, and the matching probability and non-uniformly sampling pairs of trajectories in a RANSAC-based framework. While this method improves over [310], its over-reliance on tracking is a disadvantage in noisy data and scenes with high traffic densities. In [483], a density-based approach is presented that does not rely on tracking data and is able to handle a large fraction of outliers in the data. A joint probability density of co-occurring target locations is estimated by kernel density estimation and the modes are obtained using mean shift. The modes are weighted using Pearson coefficient and are non-uniformly sampled using RANSAC. The use of modes as opposed to original data allows the algorithm to reject most of the outliers before the application of RANSAC and thus the algorithm can work on noisy scenarios. A method to detect and adapt to the changes in topology based on the conformity of modes to the estimated homography was also presented. The density estimation step in [483] assumes availability of long periods of target observations as well as redundancy in the observations. However, there are many practical scenarios where one or both of these assumptions do not hold, for example, obtaining redundant and consistent data is difficult in scenarios where the fields of view span wide areas or drift rather frequently.

The algorithm presented here does not make these assumptions and can handle a large fraction of outliers in small data sets by exploiting the geometric invariant properties to constrain the RANSAC sampling. As opposed to [361, 393, 533, 402, 554, 594] that attempt to improve the RANSAC algorithm for generic model estimation problems, the proposed algorithm utilizes model-specific knowledge that allows it to handle data with more than 95% of outliers. The efficiency of the proposed algorithm as well as minimal data requirement also enables adaptivity to the changes in network topology.

13.3 Using Model-Specific Properties for Efficient Sampling

In this section, we present details of how model-specific properties can be chosen to find efficient sampling in problems involving model estimation in the presence of outliers.

Let \mathbf{Z} be a set of observations and M be the model that we want to estimate from \mathbf{Z}. For each $z \in \mathbf{Z}$, let \mathbf{I}_z be a binary indicator, that is 1 if and only if z is an inlier and let $\mathbf{O}_z = 1 - \mathbf{I}_z$. The RANSAC-based approaches (as in [310]) iteratively generate random samples from the set \mathbf{Z}, estimate a model M (such as homography) from the sample, and evaluate the model over the entire data set until a model is found that fits most of the elements of \mathbf{Z} (defined by the probability of noise) or if a predefined maximum number of iterations is reached.

Using Bayes theorem, the probability of randomly sampling an inlier, s, from the set \mathbf{Z} can be written as

$$P\left(\mathbf{I}_s = 1\right) \propto P\left(\mathbf{I}_s = 1 | s\right) P\left(s\right). \tag{13.1}$$

For example, for a sample drawn from uniform distribution (as in standard RANSAC) , $P\left(\mathbf{I}_s = 1\right) = \sum_{z \in \mathbf{Z}} \mathbf{I}_z / |\mathbf{Z}|$. For simplicity of notation, we will omit the value of binary random variables in the rest of this publication and will assume it to be 1 unless specified otherwise. Given the minimal number of data points (samples), m, needed to estimate the model M and the probability of randomly picking an inlier, $P(\mathbf{I}_s)$, the required number of iterations, J, to obtain an outlier-free set of m samples with a probability ρ is given as $J = \left\lceil \ln\left(1 - \rho\right) / \ln\left(1 - P\left(\mathbf{I}_s\right)^m\right) \right\rceil$ [594]. Note that J serves as a lower bound on the number of iterations and has been found to be quite loose in practice where the required number of iterations to estimate a good model is generally much larger than J [361, 393, 533].

It is easy to see from the above analysis that improving efficiency of a RANSAC-based algorithm in noisy scenarios requires finding a sampling strategy for which $P\left(\mathbf{I}_s\right)$ is better than the uniform sampling. This approach is adapted by [393], [533], and [483], wherein [393] and [533], the prior term in Eq. (13.1) is modified to improve the probability with the former assuming that the inliers are spatially closer to one another than the outliers and the latter using likelihood of matches to define the sampling strategy. On the other hand, [483] assumes redundancy in data to find a smaller subset with improved likelihood term, i.e., $P\left(\mathbf{I}_s | s\right)$. In this publication, we define a sampling strategy that exploits the model-specific properties to improve the likelihood term.

Let \mathbf{Z}^l be the set of all order l subsets of the elements of \mathbf{Z}. For each $z^l \in \mathbf{Z}^l$, let $\mathbf{I}_{z^l} = \prod_{z \in z^l} \mathbf{I}_z$ and $\mathbf{O}_{z^l} = 1 - \mathbf{I}_{z^l}$. Let Q be a property defined on \mathbf{Z}^l and $\mathbf{Q}(z^l)$ be a binary variable that is true if and only if z^l satisfies the property Q. Further let $\mathbf{Z}^l(Q) \subseteq \mathbf{Z}^l$ be the set of all elements z^l of \mathbf{Z}^l that satisfy Q, i.e., $\mathbf{Z}^l(Q) = \left\{z^l \in \mathbf{Z}^l | \mathbf{Q}(z^l) = 1\right\}$. From Eq. (13.1) and by the definition of the set $\mathbf{Z}^l(Q)$, the probability of randomly picking an outlier-free set, s^l, from the set $\mathbf{Z}^l(Q)$ can be written as

$$P\left(\mathbf{I}_{s^l}\right) \propto P\left(\mathbf{I}_{s^l}|\mathbf{Q}(s^l)\right) P\left(s^l\right), \tag{13.2}$$

where

$$P\left(\mathbf{I}_{s^l}|\mathbf{Q}(s^l)\right) = \frac{P\left(\mathbf{I}_{s^l}\right) P\left(\mathbf{Q}(s^l)|\mathbf{I}_{s^l}\right)}{P\left(\mathbf{I}_{s^l}\right) P\left(\mathbf{Q}(s^l)|\mathbf{I}_{s^l}\right) + P\left(\mathbf{O}_{s^l}\right) P\left(\mathbf{Q}(s^l)|\mathbf{O}_{s^l}\right)},$$

$$= \frac{P\left(\mathbf{I}_s\right)^l}{P\left(\mathbf{I}_s\right)^l + \left(1 - P\left(\mathbf{I}_s\right)^l\right) \frac{P\left(\mathbf{Q}(s^l)|\mathbf{O}_{s^l}\right)}{P\left(\mathbf{Q}(s^l)|\mathbf{I}_{s^l}\right)}}.$$

$$\tag{13.3}$$

If m_l is the minimal number of elements of \mathbf{Z}^l, needed to estimate the model M, then the lower bound on the number of iterations to obtain an outlier-free set with the probability ρ is given as $J(l, Q) = \left\lceil \ln(1 - \rho)/\ln\left(1 - P\left(\mathbf{I}_{s^l}\right)^{m_l}\right) \right\rceil$. For a given model, an optimal sampling strategy is one that minimizes $J(l, Q)$ over all l and Q. In practice, any l and Q can be chosen for which $J >> J(l, Q)$, i.e., $m_l \log P\left(\mathbf{I}_{s^l}\right) >> m \log P\left(\mathbf{I}_s\right)$. This observation along with Eq. (13.2) implies that the property Q should be chosen such that $P\left(\mathbf{Q}(s^l)|\mathbf{I}_{s^l}\right) >> P\left(\mathbf{Q}(s^l)|\mathbf{O}_{s^l}\right)$. In the next section, we provide the data-driven homography estimation problem as an example of finding an efficient sampling strategy using model-specific properties.

13.4 Efficient Homography Estimation Using Collinearity Constraint

Recall from Section 13.2, for a given pair of sensors (C_i, C_j), the homography \mathbf{H}_{ij} can be estimated using standard RANSAC by uniformly sampling four pairs at a time from \mathbf{Z}_{ij}. We will refer to this algorithm as RANSAC4 in the rest of this chapter. If v denotes the fraction of inliers in \mathbf{Z}_{ij}, i.e., $P(\mathbf{I}_s) = v$, then the lower bound on the number of iterations needed to find an outlier-free set of samples with probability ρ is given as $J_{RANSAC4} = \left\lceil \ln(1 - \rho)/\ln\left(1 - v^4\right) \right\rceil$.

Consider a set \mathbf{Z}_{ij}^3 of all subsets of order 3 (triplets) of \mathbf{Z}_{ij}. We note that collinearity is invariant under homography transformation, i.e., the corresponding points of collinear points in one sensor are also collinear. Let us call this property (invariance of collinearity) Q_H and define $\mathbf{Z}_{ij}^3(Q_H)$ to be the set of all triplets for which the points in both the sensors are collinear. Note that for each triplet $T \in \mathbf{Z}_{ij}^3$, $P(\mathbf{Q}_H(T)|\mathbf{I}_T) = 1$. Hence, from Eq. (13.2), the probability of uniformly sampling an outlier-free triplet, T, from the set $\mathbf{Z}_{ij}^3(Q_H)$ is given by $P(\mathbf{I}_T) = v^3/\left[v^3 + \left(1 - v^3\right) P(\mathbf{Q}_H(T)|\mathbf{O}_T)\right]$.

The term $P(\mathbf{Q}_H(T)|\mathbf{O}_T)$ in the equation represents the probability of the triplets composed of one or more outliers to be collinear. This can be estimated by finding the probability of three random points being collinear. Note that in practice even three inlier points may not be exactly collinear due to noise or the sensor's lim-

ited resolution. Thus, we define three points to be collinear if the ratio between the shortest height and the longest edge of the triangle formed by the points is less than a suitably defined threshold γ. Assume without loss of any generality that OE represents the largest side of the triangle (Fig. 13.1). Thus, the third point must lie within the region OAE (otherwise OE will not be the largest side of the resulting triangle). Given γ, the shortest height allowed by the model is defined as $h = \gamma|OE|$. Let C be a point on the arc OA such that the distance $d(OE, C) = h$, then the third point must lie within the region $OCTE$. Thus from Fig. 13.1, the probability of three random points being collinear can be estimated as $(\triangle OTE - \triangle OGM + \triangle GFT)/(\triangle OAE - \triangle OAM) \approx \gamma/\left(\pi/3 - \sqrt{3}/4\right)$, where $\triangle X$ represents the area of the region X. Also note that the order of a triplet should remain the same under homography, i.e., the point in the middle must remain in the middle after transformation. Hence, the probability of collinearity of a random triplet is defined by $P\left(\mathbf{Q}_H(T)|\mathbf{O}_T\right) \approx \gamma/\left[3\left(\pi/3 - \sqrt{3}/4\right)\right] = 0.54\gamma$. Thus, $P\left(\mathbf{I}_T\right) = v^3/\left[v^3 + 0.54\gamma\left(1 - v^3\right)\right]$.

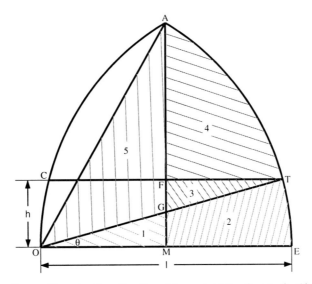

Fig. 13.1 The diagram illustrates the estimation of the probability of a set of uniformly sampled random three points to be collinear. A is the point of intersection of two circles with radius $|OE|$ and centered at O and E, respectively

Note that a homography can be estimated by using only two non-collinear triplets (six pairs of points). Thus the modified RANSAC, called constrained random sample consensus (CONSAC) in the rest of this chapter, uniformly samples two triplets in each iteration from the set $\mathbf{Z}_{ij}(3, Q_H)$ and the lower bound J_{CONSAC} is given as $J_{CONSAC} = \left\lceil ln(1-\rho)/ln\left(1 - P\left(\mathbf{I}_T\right)^2\right)\right\rceil$. It is easy to show that $J_{CONSAC} < J_{RANSAC4}$ for all $P((I)_s) = v > 0.54\gamma$. In our implementation, γ is chosen to be 0.04. For this value of γ, the proposed approach will perform better

as long as $\nu > 0.02$, i.e., there are at least 2% of inliers in the data. The values of J_{CONSAC} and $J_{RANSAC4}$ for different values of ν (with $\rho = 0.999$) are shown in Table 13.1. It can be seen that the theoretical bounds for the triplet-based algorithm are in the order of magnitude better than the standard algorithm. The quantitative results in Section 13.6 show that the practical impact of the proposed method is even more significant.

Table 13.1 Lower bounds on the number of RANSAC iterations

Fraction of inliers ν	2.5%	5%	10%	20%	25%
$J_{RANSAC4}$	17683850	1105237	69074	4313	1764
J_{CONSAC}	13200922	206261	3219	46	9

13.5 Lens Distortion Estimation

So far in this discussion we have not considered the effects of lens distortion on homography estimation, which is a common issue in realistic scenarios and may result in erroneous model estimation if not carefully modeled. These effects are even more pronounced in high-resolution sensors that are increasingly being used in modern systems. To take into account these effects in homography estimation, we use a simple one-parameter distortion model:

$$f(r) = 1 + \kappa r^2, \tag{13.4}$$

where r is the distance of the point under consideration from the distortion center (typically assumed to be the center of the image) and κ is the unknown lens distortion parameter. A brute force method to estimate homography in the presence of lens distortion using such a model is to run the proposed RANSAC-based calibration algorithm for each prospective κ value and select the κ and the corresponding homography that satisfies the largest number of data points. Let us consider one iteration of the proposed CONSAC algorithm under lens distortion. The number of inliers N is a function f of the distortion parameter κ, the threshold τ to determine inliers, and a pair of uniformly sampled triplets $T^{(2)}$ used to compute homography

$$N = f(\kappa, \tau, T^{(2)}). \tag{13.5}$$

Assuming τ to be fixed, the number of inliers can be written as $N = f(\kappa, T^2)$. For multiple iterations of the algorithm with different uniformly sampled triplet pairs, the number of inliers obtained can be written as

$$N = \max_i f(\kappa, T_i^{(2)}), \tag{13.6}$$

and the corresponding homography with the largest number of inliers is the estimated homography. Quite clearly, N increases as additional triplet pairs are added to the set (additional CONSAC iterations). Also, if \cup represents the entire universe of triplet pairs, N is computed using this set as a deterministic continuous function (continuous over integral values as number of inliers can only be an integer).

To keep computational requirements under check, practically one can only hope that the chosen sets of triplet pairs closely approximate the whole universe of triplet pairs. Unless the universe of triplet pairs is small or the fraction of inlier triplets is large, this approximation is often inaccurate. Therefore, choosing κ from a list of candidate distortion parameter values that correspond to the largest number of inliers N obtained using (13.6) will result in a non-robust estimation of the distortion parameter under most realistic scenarios.

To this end, we propose a two-tiered approach that not only provides a robust estimation of distortion parameter but is also efficient. In the first (coarse) stage, the solution space of the probable distortion parameter is coarsely sampled. For each parameter value, the CONSAC algorithm is executed to obtain the inlier counts. The higher the inlier count is, the better the corresponding distortion parameter value fits the data. But as discussed, due to the limited number of CONSAC iterations, this may not provide the robust estimation of the distortion parameter. Therefore, this is followed by a refinement stage.

In the refinement stage, we identify the inlier sets corresponding to a few top-performing distortion parameter candidates in the coarse stage. Instead of a RANSAC-based approach over the triplet pairs, we use these inlier sets (corresponding to κ values with large number of inliers) to recompute homography for a refined sample space of κ values. The main intuition is that the inlier sets corresponding to potentially good κ values should be a good guess to further evaluate the probable κ values instead of randomly sampling pairs of triplets as it is done in the first stage. The number of iterations in the refinement stage is limited by the number of the top-performing inlier sets and the number of candidate distortion parameter values. Typically the total number of iterations at this stage is much smaller than the number of CONSAC iterations for even one candidate κ value in the first stage.

13.6 Results and Applications

In this section, we present quantitative and qualitative results of the proposed algorithm on synthetic data as well as real data from a multi-sensor surveillance and monitoring system that we have developed and deployed at a port in Florida.

13.6.1 Quantitative Evaluation

We use synthetic data with a varying fraction of outliers, variance in spatial noise, and traffic density to evaluate the proposed approach and compare it with standard

RANSAC. The plots in Fig. 13.2 show the comparisons of the execution speed and the estimation error of both algorithms with respect to these parameters. It can be seen from the figure that the proposed algorithm is (i) significantly more efficient than the standard RANSAC (ii) able to handle a large fraction of outliers in the data, and (iii) robust to traffic densities and spatial noise.

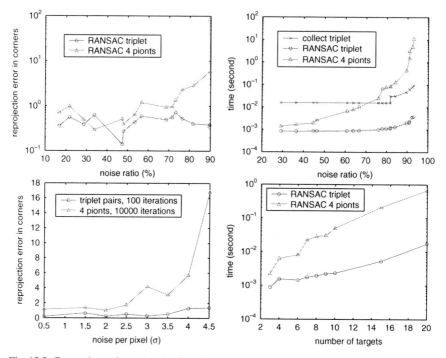

Fig. 13.2 Comparison of speed and estimation error of the proposed algorithm with the standard RANSAC-based approach with respect to the fraction of outliers (*top row*), variance of spatial noise (*bottom left*), and traffic density (*bottom right*)

13.6.2 Semi-supervised Sensor Alignment

In scenarios where the terrain does not have many well-localized and/or discriminative features, even manual sensor alignment or geo-registration is a challenging task. One of the solutions to this problem is the use of dedicated mobile units (people, vehicles, boats, etc.) that report their geo-location while moving in the sensor's field of view. A real-world system utilizing this approach for establishing and maintaining geo-registration in a large visual sensor network is described in [441]. Note that in an uncontrolled environment, neither all targets in the scene transmit geo-positional data nor do all targets transmitting this data have to be visible in one or more sensors. Therefore, one-to-one correspondences between target metadata and

geo-positional data are not available. As a matter of fact, in our experience, accidental correspondences (noise) significantly outnumber the true correspondences (typically noisy data amounts to more than 85% of the total data).

In our experiments, we use a GPS carrier that follows a pre-specified pattern. This provides additional domain-specific constraints (priors) that can be utilized to improve the efficiency of the proposed sampling scheme for matching view detections with the geo-locations of the controlled carrier and estimating geo-registration. Moving direction is one such constraint. When a target moves clockwise around the camera, its corresponding image moves from left to the right in the view and vice versa. To best utilize the moving direction constraint, motion toward or away from the camera should be eliminated. Thus, the GPS carrier should move horizontally across the FOV of the camera. To form a continuous route, it should follow a zigzag curve (Fig. 13.3). Under this condition, half of the outlier viewpoints can be eliminated using the direction of motion constraint. Note that the moving direction constraint is useful even for the traditional four-point RANSAC algorithm. Horizontal motion across the FOV of the camera provides additional benefits for the triplet-based algorithm. As the direction of motion constraint is most effective when the GPS carrier moves horizontally across the FOV of the camera, the traces of the GPS carrier are designed to be horizontal. Therefore, vertical straight lines are drawn to increase the chance of intersecting with them to obtain possible collinear inlier triplets (Fig. 13.4). A vertical line is expected to intersect with the horizontal GPS traces with higher probability than a non-horizontal target trace of any outlier target. Assuming the direction of outlier target traces to be

Fig. 13.3 Semi-supervised sensor alignment: (*left*) a typical GPS track designed to be horizontal for better alignment and (*right*) the fields of view of four cameras obtained using the proposed approach at a port

Fig. 13.4 A snapshot of the camera view with target tracks overlaid with a set of vertical line segments used during matching in the proposed approach

uniformly distributed, the effective mean horizontal projection of the outlier traces is $\left(\int_0^{\pi/2} \cos\theta d\theta \right) / \left(\int_0^{\pi/2} d\theta \right) = 2/\pi$. Therefore, the proposed approach has a $\pi/2$ higher chance of obtaining an inlier triplet point than an outlier triplet point due to the horizontal motion of the GPS carrier. Figure 13.3 shows the result of the proposed approach to geo-register four high-resolution sensors (4000×640) at a port. The estimated fields of view are overlaid on a satellite snapshot of the port. The maximum error is around 15 m at a distance of 1500 m from the cameras. Note that the combined fields of view of the sensors span approximately 4 s km^2. We observe that the geo-registration errors can mostly be attributed to the inaccurate localization of the targets by the tracking algorithm.

13.6.3 Unsupervised Sensor Alignment

We now show the robustness of the proposed approach in unsupervised scenarios in which alignment is done using completely uncontrolled targets. The example of such a scenario includes utilizing ships and boats that broadcast automatic identification system (AIS) information (in some cases mandated by port authorities), RADAR bearing and distance observations of targets at a port, and vehicles and people with RFID tags [441]. Multi-sensor alignment with overlapping fields of view using target observations is another example of unsupervised sensor alignment [483]. For our experiments, we used RADAR information to calibrate high-resolution cameras installed at the port. Figure 13.5 (left) shows the RADAR tracks. The fields of view of cameras estimated using the proposed alignment approach is shown on the right. As with semi-supervised alignment, the maximum error is around 15 m at a distance of 1500 m from the cameras. Figure 13.6 shows an alignment of two visual sensors obtained by the proposed approach based on their target observations during a time span of 5 min. The estimated homography is consistent with the one reported in [483] using target observations from hour-long clips of the same video sequences as well as the manually obtained results by visually matching feature points in both images.

Fig. 13.5 Unsupervised sensor alignment: (*left*) RADAR tracks at a port and (*right*) the fields of view of two high-resolution cameras obtained using the proposed approach

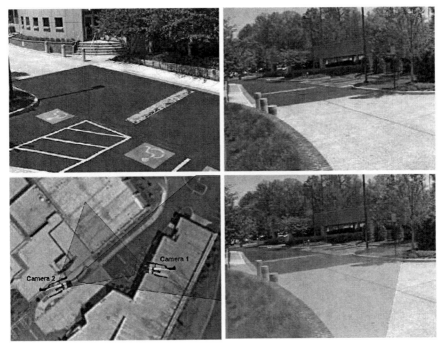

Fig. 13.6 Unsupervised alignment of visual sensors with overlapping fields of view: (*top row*) camera views, (*bottom left*) camera setup, (*bottom right*) warped image using the homography estimated from only 5 min of target observations

13.7 Conclusion

This chapter presents an efficient and robust solution for data-driven multi-sensor alignment. The proposed solution exploits model-specific constraints, in particular, invariance of collinearity under homography transformation to speedup the model estimation in the presence of outliers. The robustness and efficiency of the proposed solution in scenarios involving a large fraction of outliers, spatial noise, and varying traffic densities are shown using both real and synthetic data.

Chapter 14
Application Development and Management of Smart Camera Networks

Wolfgang Beer, Werner Kurschl, Florian Matusek, Bernhard Moser,
Stefan Mitsch, and Stephan Sutor

Abstract This chapter focuses on the management and the application development of distributed smart camera systems by observing the more general point of view of embedded sensor networks. The proposed approach relies on a model-based software engineering concept which allows a more unified and simplified design. Basically, the model-based system development concept provides high-level system functions and facilities for generating platform-specific code. This chapter outlines how this framework allows the integration of models at different levels, e.g., for exploiting low-level sensor data as well as high-level knowledge-based models for detection, classification, and representation of high-level situations in specific use cases. The usefulness of the presented approach shall be demonstrated in a real-world scenario targeting safety and security surveillance in a public airport environment.

14.1 Introduction

Decentralized information processing in sensor networks gained a lot of attention in recent years. Particularly, sensor networks equipped with image sensors pose special challenges to system engineers in terms of processing complex data structures, data fusion, and system design. Due to the recent technical progress, image sensors in combination with compact hardware and information processing facilities for elementary recognition and preprocessing tasks are available in the market. These so-called *smart camera* systems are well-suited for being embedded in sensor networks.

The term *smart camera* or *intelligent camera* refers to a self-contained, stand-alone vision system with a built-in image sensor in the housing of an industrial video camera that contains all necessary communication interfaces and a unit with image processing capabilities. Though limited in terms of processing power and functionality, such systems have reached widespread use in various fields of application

B. Moser (✉)
Software Competence Center Hagenberg GmbH, Austria
e-mail: bernhard.moser@scch.at

A.N. Belbachir (ed.), *Smart Cameras*, DOI 10.1007/978-1-4419-0953-4_14,
© Springer Science+Business Media, LLC 2010

like quality inspection, non-contact measurement, security surveillance, barcode and character reading, or automated pick and place.

Applications with distributed vision are especially well suited for smart cameras where several units operate independently. Inspection problems that require distributed points of observation within assembly machines along production lines or wide-range area applications in sports and security surveillance are examples for such applications. In such networks, also called visual sensor networks, each node extracts local image features which are fused across the network for solving higher level computations. These include camera tampering detection, tracking across multiple fields of views, object recognition, or wide-range stereo vision for extracting 3D information from the observed scenes.

Moreover, for certain applications, e.g., for security and safety surveillance or scouting in sports, smart cameras need to capture images and process these in near real time. The computation results need to be stored in an efficient way, in order to allow high-level queries, e.g., the behavior of certain individuals or objects. In order to avoid unnecessary network traffic and to reduce reaction times, each sensoric node provides a certain amount of individual computational intelligence. Hence, a single smart camera is able to detect tampering but reasoning is done in a global system sense. High-level questions such as "Is this camera tampered with or is it just foggy outside?" or "Which emergency exits are safe and which are blocked by smoke?" can only be inferred this way.

While a smart camera represents a specific sensor node for decentralized analytical processing of visual data, sensor networks represent the general term for all forms of decentralized processing of sensoric data. Sensor networks are often referred to as *Wireless sensor network* (WSN) [452] according to the widespread use of wireless communication protocols, such as Bluetooth or ZigBee between the sensor nodes. Sensor networks are characterized as autonomous and distributed analytical processing units within highly dynamic network environments. Originally developed and first mentioned in the context of prominent military research projects, such as the Smart Dust project [429], nowadays sensor networks are widely spread within environmental monitoring applications.

Today, as processing power and hardware resources are getting cheaper, it is possible to monitor situations in the real world with a multitude of different sensors, which are connected through a network. Each sensor within the network provides preprocessed information about a small aspect of a much wider sensoric picture. This chapter focuses on methodologies to unify and simplify the development of such systems. The presented approach relies on the separation of a system's functional model from low-level implementation details through the use of model-based development.

14.2 Use Case: Airport Public Surveillance

This section illustrates the challenges of system development with respect to the characteristics of a large smart camera and sensor network. The presented use case

focuses on public surveillance and specifically on the estimation of crowd density. The estimation of crowd density is used within the strategic security planning of an airport. The airport is equipped with approximately 700 cameras which are connected to a central control room (CCR) with a fiber optic network. The surveillance system is based on a global model (GM) which defines regions of interest (ROIs) and includes the mapping of smart cameras and sensors within the ROIs. A single camera is responsible for self-calibration (Chapter 9), flow control, and density estimation, as well as for the detection of tampering. As is shown in Fig. 14.1, the output of each camera is a vector field of movement and density information which is mapped on the GM.

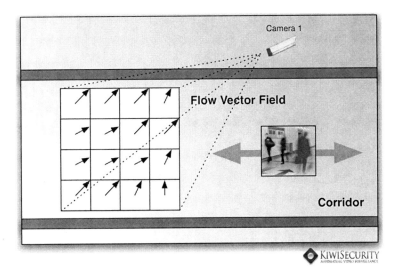

Fig. 14.1 Vector of movement and density of one camera

For this high-security application a local, onboard, and a global tampering detection was employed. The local, onboard tampering detection, which is performed within the smart cameras, detects if a camera is moved or the field of view is obstructed, by, e.g., covering the camera, spraying the camera lens, or fog. This local information is sent to the CCR. The global tampering detection uses the GM for high-level tamper reasoning. Tampering data are fused centrally and higher level reasoning is employed to find correlations between cameras according to their real-world positions. If two neighboring outdoor cameras detect fog, it is probably real fog; if only one camera detects fog, it was probably tampered. The combination of smart cameras within a defined ROI is shown in Fig. 14.2.

According to the systems complexity, as it can be easily identified in Fig. 14.2, global application development mainly depends on the GM and does not directly refer to a single smart camera or sensoric input.

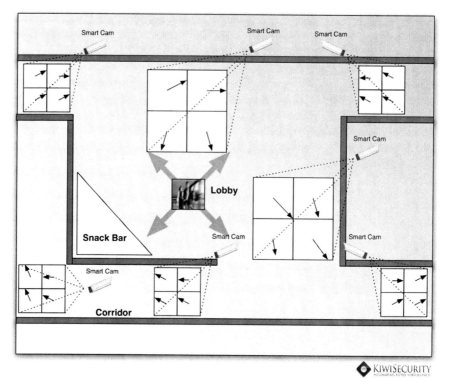

Fig. 14.2 Vector of movement and density of *n* cameras within a ROI

14.3 Related Research

Smart sensor networks are still an active field of ongoing research [516] encompassing aspects like management of the information flow within the network by introducing a generic network protocol [407], efficiently matching features of cameras with overlapping fields of views [362, 217], by representing the field of view in an hierarchical way for efficiently routing queries [128], or designing specific query mechanisms and database models that are able to handle high-level features as compositions of simpler ones [9, 464]. The project by Akdere et al. [9] describes data access and querying in visual sensor networks for 3D sensing. In [9] the primary programming is a special space–time 4D view of the collected or sensed data. Data are accessed via a special query interface over the cube, which provides declarative queries with an SQL-like notation. The queries are translated into an execution plan and then distributed to the nodes, where the plan is executed. The query plan provides optimizing opportunities with respect to energy saving, data distribution, network load, and fault tolerance. In general, the system acts like a distributed database system, comparable to TinyDB, see, e.g., [348], where run times are installed at all nodes providing the necessary hardware abstraction. The Context Recognition Network (CRN) Toolbox describes a C++ framework integrating hardware abstraction, filter algorithms, feature extraction components, and classifiers in

a configurable run-time module to support rapid development of context recognition applications, see, e.g., [44]. Particularly, the CRN Toolbox is designed for deploying such recognition applications to embedded devices that support the POSIX run-time environment.

The systems and approaches mentioned do not rely on a formal meta-model and thus cannot fully benefit from a model-driven system development approach [27]. In particular, a formal meta-model enables the generation of code for various platforms, including the CRN Toolbox, by exchanging the generator templates.

14.4 Model-Driven Development Approach

Today, high-level programming languages like Java or C++ enable the compilation and execution of program code for a multitude of heterogeneous operating systems. These target systems can vary from PCs over mobile devices to embedded controllers. The model-driven development (MDD) approach elaborates the major idea of high-level programming languages to abstract the problem from the implementation details [27]. To solve the challenges of non-standardized software manufacturing, functional models are used to generate code instead of writing individual code for different platforms.

The MDD approach relies on an explicit representation of the functional model of a system and on the generation of platform-specific code. One of the most prominent approaches, following the MDD methodology, is the *model-driven architecture (Model-driven architecture* (MDA)) [26], which was introduced by the OMG (Object Management Group) in 2001.[1] MDA defines the *separation of concerns*, which means the use of separate models for the description of a system's functional, technological, and implementational concerns.

The functional model is referred to as the platform-independent model (PIM) [26], which describes the abstract functional model of the system, while the technological concerns are represented within the platform-specific model (PSM) [26], as illustrated in Fig. 14.3. MDA proposes a software development methodology that allows to develop software by specifying and transforming the abstract functional model (PIM) in combination with the generation of program code, instead of directly writing code for several different platforms. A platform is defined as a specific hardware (e.g., a *NI 1722 Smart Camera, Crossbow Mote*) or a software framework running on the target hardware (e.g., TinyOS or the NI LabView Real-Time Module[2]). A target platform defines the destination where the generated code should be executed.

Figure 14.3 shows the architectural view of a use case which defines a dependency between a camera and a temperature and humidity sensor, in order to perform a tampering check. To create or modify use cases it is necessary to manage

[1] Model-driven architecture of OMG. *http://www.omg.org/mda/*
[2] LabVIEW real-time module of National Instruments. *http://sine.ni.com/nips/cds/view/p/lang/en/nid/13742.*

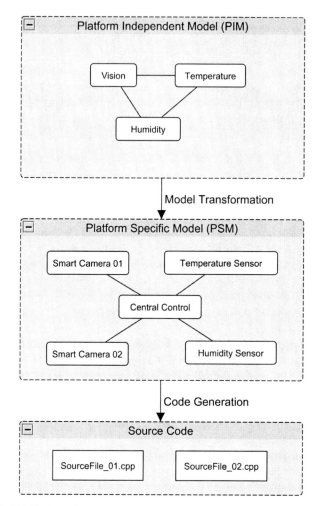

Fig. 14.3 The MDA's three-tier architecture

the dependencies between the different sensors available. Besides the architectural view on use cases, it is necessary to manage the data flow within the system. A hardware-independent model of the data flow shows how a tampering decision is made according to a voting algorithm. Figure 14.4 shows an engineering environment based on Eclipse, which allows the user to define a data flow model for a specific use case. The example in Fig. 14.4 models a use case where the data from five cameras are merged into a voting component which evaluates the incoming data. The voting algorithm decides if the incoming data seem to be a tampering effort. The platform-independent model, based on a MDA approach, allows to easily model complex use cases without worrying about the different camera hardware. Each of the five cameras in Fig. 14.4 can be implemented using completely different hardware.

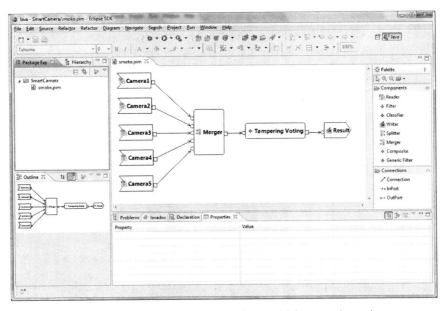

Fig. 14.4 Example for a hardware-independent data flow model for tampering voting

According to the fact that a multitude of different data sources can exist within a complex system, it is necessary to further classify the available data. Here we refer to the research carried out by Baldauf [42] and Strang [512] who propose a uniform context model to classify data sources. References [42] and [512] present surveys on context models ranging from simple key-value pair-based models to complex ontologies.

The *Aspect-scale-context information* (ASC) described in [513] as part of the CoOL ontology and the context atom attributes listed in [42] is a flexible and general basis for building a context model describing low-level context (i.e., raw sensor data), but the model does not facilitate detailed descriptions of system entities (hardware components, individuals, etc.). Every measured sample of data is an instance of a certain *Aspect* (e.g., location, temperature, velocity).

Depending on the selected data source and its hardware capabilities, a data sample is interpreted according to a particular *Scale*. A scale represents the meta-information of a given data sample. It defines the unit and semantic meaning of the sample. Scales additionally offer methods to convert between different scales of one aspect. This is, for example, useful to convert geometric (e.g., WGS-84 coordinates) to symbolic location information (e.g., "Room 123") or to operate with different temperature units (e.g., Celsius and Fahrenheit). Today there are numerous hardware sensors from different vendors that deliver sensoric data in various units, timescale, and formats. Therefore a hardware-independent data flow model offers an approach to handle the growing complexity of the sensoric heterogeneity. The above-outlined PIM describes an application by means of its use cases. By using model transformations the abstract model can be adapted to a certain platform.

The so-called platform-specific model (PSM) is then used to generate platform-specific code. The MDA approach specifies the function of the system within the PIM and platform-dependent input data as well as the sensor hardware (e.g., smart camera) within the PSM. The PIM describes the function of a system and its parts (e.g., constraints, requirements, processing units) as a whole, with all its necessary details, while omitting platform-specific aspects. At the transformation stage, the PSM is used to decide how the parts of the application are distributed across the specific hardware platforms, and which platform-specific code should be generated. The platform-specific code is then deployed and executed on different target platforms within the network. The transformation process toward a platform-specific code allows the adaption of the whole system to platform-specific needs. Hence, the platform-specific code can be optimized to exactly fit the use-case requirements (very much in the same way as custom-written code would be).

This approach stands diametrically opposed to the general-purpose approach of distributed database systems, like TinyDB [348] and the project by Akdere et al. [9], where a special query interface provides declarative queries with an SQL-like notation. The general-purpose approach can for instance, due to its overhead, not always be used in performance and time-critical application scenarios.

It is the goal of this chapter to argue and demonstrate by an illustrative case study that the MDA approach, which relies on the separation of concerns, allows to simplify the development and management of visual sensor networks particularly for complex and time-critical application scenarios.

14.5 Conclusion

While various approaches on designing smart camera networks focus on specific topics like generic network protocols, concepts for matching features of cameras with overlapping fields of view, concepts for routing queries, designing specific query mechanisms and database models or special query interfaces, this chapter concentrates on software design aspects related to reusability, systematics, adaptivity, and flexibility. For this purpose a model-driven software developing paradigm is outlined which requires a formal model of the application. Its usefulness is discussed and illustrated on the basis of a use case for a smart camera network with surveillance facilities for an airport. In particular, it is pointed out that the presented model-driven architecture (MDA) approach is suitable for such distributed visual sensor networks showing the following advantages; (i) a unified and reusable functional model of systems, (ii) flexibility in terms of reusability of subsystems (e.g., tampering check, fog recognition), and (iii) a unified way of system development and deployment on heterogeneous hardware platforms.

Chapter 15
Stereo Vision in a Network of Co-operative Cameras

Sanjeev Kumar, Christian Micheloni, and Gian Luca Foresti

Abstract In this chapter, a smart framework is presented for the object localization on a given ground-plane test map using heterogeneous stereo vision. In particular, the image pairs are captured by using static and *Pan-tilt-zoom* (PTZ) cameras, which are heterogeneous in terms of imaging parameters thus having different focal lengths, image resolutions, intensities, etc. These two cameras are selected in a co-operative manner from a network of static and PTZ cameras and used as a stereo system to localize an object even in the case when it is partially occluded. The various sequences of images captured by these cameras are made homogeneous based on their focal ratio and then by performing zero padding. The pairs of matching points are obtained using scale invariant features (SIFT) matching from stereo images. The rectification transformations are calculated by solving a constrained nonlinear optimization problem. The 3-D position of the object is estimated based on a modified concept of stereo matching in rectified pairs of images. Localization is made using the 3-D position obtained from stereo. Experiments are performed to evaluate the performance of the proposed framework using real sequences of images. The proposed method is useful in stereoscopic as well as in video surveillance applications.

15.1 Introduction

Modern video surveillance systems are more intelligent and smarter than conventional passive video monitoring systems in terms of design and applicability. A number of steps are involved in video surveillance to monitor a wide and complex area such as target detection, localization, and tracking. Localization of moving objects on a given ground-plane map is an important and crucial task in video surveillance systems. In general, it is not practical to cover a wide area with different cameras in addition to the possibility of missing information when there are significant gaps

C. Micheloni (✉)
Department of Mathematics and Computer Science (DIMI), University of Udine, Via delle Scienze 206, 33100 Udine, Italy
e-mail: christian.micheloni@dimi.uniud.it

A.N. Belbachir (ed.), *Smart Cameras*, DOI 10.1007/978-1-4419-0953-4_15,
© Springer Science+Business Media, LLC 2010

in coverage. As a solution, researchers have developed some techniques for video surveillance using dynamic cameras or hybridization of static–dynamic cameras. Generally, these kinds of techniques are based on a 2-D homography between the camera plane and a given ground-plane test map. However, these techniques are not able to perform accurate localization when the object is partially occluded. Smart and adaptive technologies are needed to overcome the above drawback and perform the task of localization as accurately as possible.

Stereo vision has the advantage that it is able to estimate an accurate and detailed 3-D representation of the position of an object with respect to a given co-ordinate system using its two or more perspective images. Generally, a pair of identical cameras is used in classical stereo systems. These cameras are placed along a horizontal line near each other. The 3-D positions of the objects are estimated by solving a geometrical inverse problem, in other words, by using the inverse solution of collinearity equations. These collinearity or perspective projection equations describe the relation between the 3-D position of the objects and their 2-D co-ordinates in the image plane of the camera.

Nowadays, a large number of cameras are used to monitor a wide area. Hence, these cameras can be used as stereo system to achieve effective surveillance. Usually, the distance between these cameras cannot always be kept small as in classical stereo systems. If the two cameras are placed far apart from each other then classical stereo algorithms fail to provide the required 3-D position of the objects. The other main disadvantages are the lack of co-operation between these sensors and heterogeneity in the imaging parameters. These difficulties can be tackled by introducing a smart algorithm. On the other hand, there are many advantages such as more degrees of freedom in terms of *field of view* (*Field of view* (FOV)) and *angle of view* (*Angle of view* (AOV)) by using a stereo unit with heterogeneous cameras (usually a pair of static and PTZ cameras). More accurate results can be obtained by applying these heterogeneous cameras based on stereo systems for localization of objects.

15.1.1 Related Research

In most of the research reported in the literature, a pair of identical cameras is used to build a stereo system [89, 186]. Many real-life problems related to computer vision are solved using these identical camera-based stereo systems only. Generally, these cameras cover fixed fields of view (FOVs). In surveillance applications, one or both identical cameras are replaced by dynamic or PTZ cameras to design a more flexible stereo system [557]. In this way, one can get more degrees of freedom in terms of FOV and AOV. To monitor a large and complex area, a combination of static and PTZ cameras can be used to obtain better results [305].

Recently, research has been carried out by using the hybridization of fixed and PTZ cameras or dual PTZ cameras in stereo vision [305, 557]. Some intelligent approaches related to hybrid-sensors surveillance systems have been proposed in detail [5, 225, 443]. The system proposed in [5] has been successfully applied in

visual security for airports. An intelligent distributed system based on the use of static and dynamic camera networks for the purpose of tracking and detecting suspicious events has been proposed in [375, 458]. In this approach, moving objects have been localized based on a homography between the image plane of the camera and a given test map of the corresponding ground plane. A method for co-ordination between a stationary and dynamic camera to monitor the wide area is presented in [256]. However, these kinds of systems are not able to localize a partially occluded object correctly as its ground position is not visible in this case.

Stereo vision is achieved by extracting 3-D information by processing two or more 2-D images of a given scene. The main steps involved in stereo vision are calibration, rectification, and stereo matching. The procedure to acquire the knowledge of intrinsic and extrinsic calibration parameters of cameras is called camera calibration. Mainly, these calibration parameters are used to rectify the stereo images [205]. If the two cameras are placed side by side on a baseline, having identical intrinsic parameters, then the image pairs acquired by these cameras are known as rectilinear pairs of stereo images. In case of PTZ camera, the main problem is the variation in calibration parameters with respect to different pan, tilt, and zoom settings [520]. One cannot compute these parameters for each position of PTZ camera in real-time applications. Although some advanced techniques have been proposed for automatic calibration of PTZ cameras for surveillance applications [39, 501], these techniques are time consuming and not very effective for real-time applications. More details on self-calibration of various cameras are given in Chapter 9. The alternate way to tackle this problem is to use the techniques which can be applied directly to uncalibrated images [203, 589]. These kinds of techniques contain minimization of a nonlinear function and require some information like a set of matching points from the uncalibrated images.

There are several ways to obtain these pairs of matching points from the pair of images like SIFT matching and daisy descriptors [337, 531]. There are mainly two different approaches to obtain stereo matching between the rectified pair of stereo images, i.e., feature-based [550] and pixel (region)-based methods [440]. Due to the difference in intensities of stereo images captured by heterogeneous sensors, these methods cannot be applied directly to obtain the stereo matching. To overcome this problem, intensities are normalized in stereo images using the intensity information of the pairs of matching points. After normalizing the image pairs, disparities are computed based on some matching criterion. From the disparities, 3-D positions of the objects are estimated [468]. In the disparity estimation, the SSD criterion [521] is used to find the best candidate for matching. Chapter 8 provides a detailed description of stereo matching in an embedded manner.

15.1.2 An Overview of Proposed Works

In the present work, a smart framework is developed for the co-operative stereo localization of the moving objects on a given ground-plane test map. In

particular, the image pairs are captured by using static and PTZ cameras, which are heterogeneous in terms of imaging parameters, thus having different focal lengths, image resolutions, intensities, etc. These two cameras are selected in a co-operative manner from a network of static and PTZ cameras and used as a stereo system to localize an object even in the case when it is partially occluded. The various image sequences captured by these cameras are made homogeneous based on their focal ratio and then by performing zero padding. The pairs of matching points are obtained using SIFT matching from stereo images. The rectification transformations are calculated by solving a constrained nonlinear optimization problem. The 3-D position of the object is estimated based on a modified concept of stereo matching in the rectified pair of images. Localization is made using the 3-D position which is obtained by employing the stereo technique. Experiments are performed to evaluate the performance of the proposed framework using real sequences. In particular, the improvements of the co-operative stereo localization with respect to monocular camera localization will be provided. The proposed method is useful in stereoscopic as well as in video surveillance applications.

The rest of the chapter is organized as follows: an overview of the architecture of our co-operative stereo localization system is given in Section 15.2. Section 15.3 contains a description for some pre-localization steps like compensating the effect of heterogeneous image parameters, SIFT matching, and rectification. A description of stereo matching and the proposed localization scheme are outlined in Section 15.4. In Section 15.5, experimental results using the proposed framework are given and Section 15.6 presents concluding remarks.

15.2 Overview of System Architecture

The system is composed of a network of smart cameras [295]. The camera network contains two kinds of units, static camera units (SCU) and dynamic camera units (DCU), which co-operate with each other. The SCU employs a generic number of static cameras to perform object detection [375], behavior understanding [376], and anomalous event detection [377]. Once an event of interest is detected, the system picks up the closest or the more suitable PTZ camera from the DCU to perform a co-operative stereo localization. The static camera estimates the steering parameters needed to move the PTZ camera in the direction of the selected target. Co-operative stereo localization starts as soon as the selected target is in FOVs of both cameras. Handover between the different static cameras of SCU allows a co-operative tracking of the objects within the monitored environment. Trajectory data are used for the task of switching the different static cameras for a continuous and co-operative tracking. A communication system based on a multicast protocol is used for the co-operation within the cameras' network. This communication system is designed in such a way that it requires a low bandwidth.

In this way, the proposed framework employs a pair of heterogeneous cameras. The first (left) camera is a static camera with a wide and fixed FOV of an outdoor

environment (a parking lot). The static camera is selected from SCU and the PTZ camera is selected from DCU in a co-operative manner. The second (right) camera is an AXIS PTZ camera placed near the static camera. The FOV of this camera depends on the pan, tilt, and zoom settings and it is adjustable according to the requirements [378]. The moving objects or targets are localized on a ground map of the monitored scene. The real-world dimensions of the test map are 40 m in the x-direction and 30 m in the y-direction.

A virtual design of our stereo system is shown in Fig. 15.1, where static and PTZ cameras are represented by C_1 and C_2, respectively. The static camera C_1 has a fixed FOV and the PTZ camera acquires this FOV (partially or fully) using respective pan, tilt, and zoom settings. Once a particular object is detected in static camera view then the pan, tilt, and zoom variables of the PTZ camera are controlled in such a way that the object lies also in the FOV of it.

The properties of the PTZ camera deployment make the stereo vision problem more difficult when compared to classical stereo systems. Therefore, in this framework the captured images from the pair of cameras are heterogeneous in nature, i.e., having different intrinsic parameters. If we perform further operations like rectification on these heterogeneous pairs then it will introduce more errors in the rectified pairs. Thus, it is difficult to compute stereo matching from these erroneously rectified pairs. Not much attention has been paid to this issue in the literature. The effect of these unequal intrinsic parameters must be compensated before rectification. In other words, these heterogeneous pairs of images must be converted into homogeneous pairs before further processing. The proposed approach is based on the focal information of image pairs and can be performed in real time.

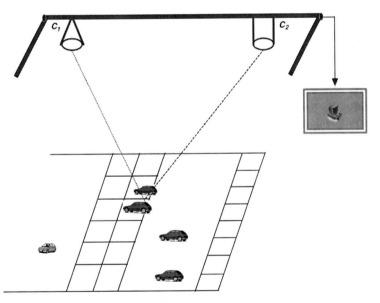

Fig. 15.1 A virtual design of the employed heterogeneous stereo system

15.3 Pre-localization Steps

Some pre-localization steps must be performed before applying the stereo matching in the pairs of stereo images. The first step is to make these pairs homogeneous in terms of internal imaging parameters. The next step is the computation of a set of matching points from homogeneous images using SIFT matching. Figure 15.2 illustrates a flow diagram for these two steps. The last step in this process is the computation of rectification transformations.

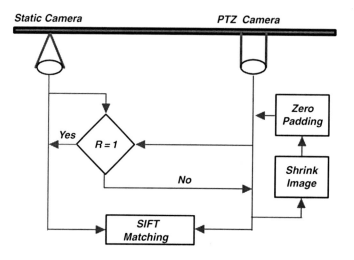

Fig. 15.2 Some pre-localization steps on heterogeneous image pairs

15.3.1 Transforming Pair into Homogeneous Images

The pair of images captured by a pair of heterogeneous cameras has different internal imaging parameters. These make the acquired images heterogeneous mainly due to different zoom settings from both cameras. If we directly performed further operations on these images, the results would be poor resulting in many errors. To overcome this difficulty, the pair of images is made homogeneous before performing other operations.

Let the pair of images I_s and I_d of size $w \times h$ be captured using a pair of static and PTZ cameras, respectively, with arbitrary zoom settings. The task of converting these pairs into homogeneous images is accomplished in the following steps:

1. Calculate the focal ratio $R = f_s / f_d$, where f_s and f_d are the focal lengths of the static and PTZ cameras, respectively.
2. Check whether $R = 1$, if yes, pair of images is homogeneous, otherwise proceed to next step.

3. Resize the image I_d captured by the PTZ camera by a factor of R. Let the size of this image I_d' shrink to $w' \times h'$ from $w \times h$.
4. Perform the zero padding of size $u_1 \times v_1$ on both horizontal sides of image I_d', where u_1 and v_1 can be computed as

$$u_1 = \frac{|w - w'|}{2}, \qquad v_1 = h', \qquad (15.1)$$

now the size of this new image I_d'' is $w \times h'$.
5. Again, perform the zero padding of size $u_2 \times v_2$ on both vertical sides of image I_d'', where u_2 and v_2 can be computed as

$$u_2 = w, \qquad v_2 = \frac{|h - h'|}{2}. \qquad (15.2)$$

6. Repeat step 2.
The modified image has size $w \times h$ as image I_s. This new pair of images is also homogeneous in terms of zoom. The assumption is that the minimum zoom level of the PTZ camera is equivalent to the zoom of the static camera; therefore, zero padding is always performed only on the PTZ camera image in the above process.

15.3.2 SIFT Matching

The process to obtain the matching points from the pair of stereo images is divided into two steps. First, we detect the scale-invariant features in each image separately. In the next step, the matching process of these features is performed between stereo images.

The process of identifying locations in image scale space that are invariant with respect to image translation, scaling, and rotation is based on the localization of a key. This task can be performed in the following steps:

1. Perform the convolution operation on input image I with the Gaussian function with variance $\sigma = \sqrt{2}$. Let the resulted image be I_1.
2. Repeat step 1 on image I_1 to get a new image I_2.
3. Subtract image I_2 from image I_1 to obtain the difference of the Gaussian function as $\sqrt{2}$.
4. Re-sample the image I_2 using bilinear interpolation with a pixel spacing of 1.5 in each direction. A 1.5 spacing means that each new sample will be a constant linear combination of four adjacent pixels. From this we generate a new pyramid level.
5. Determine the maxima and minima of this scale-space function by comparing each pixel in the pyramid to its neighbors.
6. Select key locations at maxima and minima of a difference of Gaussian function applied in scale space.

The SIFT features can be detected from the locations of these keys. These features are detected on the exact key locations as well as locations around it so that reliable matching between different views of an object or scene can be performed. These features are invariant to not only image orientation but also image scale and provide robust matching across a substantial range of affine distortion, change in 3-D viewpoint, addition of noise, and change in illumination. For stereo image matching, SIFT features are extracted from the left image and stored in a database. The right image features are matched by individually comparing each feature to this database and finding candidate matching features based on the Euclidean distance of their feature vectors. We have performed features matching between stereo images using the process given in [337]. The process of rectification is performed based on these pairs of matching points.

The RANSAC algorithm [358] is used to remove the outliers from the pairs of matching points obtained from SIFT. More generally speaking, the basic assumption is that the data consist of inliers, i.e., data points which can be explained by some set of model parameters, and outliers which are data points that do not fit the model. In addition, the data points are subject to noise. An advantage of RANSAC is its ability to robustly estimate the model parameters. It finds reasonable estimates of the parameters even if a high percentage of outliers are present in the data set.

15.3.3 Computation of Rectification Matrices

Image rectification is a process in which stereo images can be wrapped in such a way that the matching points lie on the same horizontal scan line. When the stereo images are not in rectified form, this process can be accomplished by applying 2-D projective transforms, or homographies, to each image. The homography is a linear one to one transformation of the projective plane, which is represented by a 3×3 non-singular matrix.

Once the corresponding points (m_i, m_i') are extracted by exploiting a SIFT matching algorithm, these points are used to compute the rectification transformations H and H' as follows:

In order to estimate the two homographies H and H', the pairs of corresponding points are used as input in the rectification process. Assume that the SIFT matching returns N pairs of corresponding points from the two images, i.e., (m_i, m_i'), $i = 1, 2, \ldots N$. The two homographies can be computed by minimizing the following cost function:

$$E(H, H') = \sum_{i=1}^{N} (m_i'^T H'^T F_\infty H m_i)^2. \tag{15.3}$$

As we know that the first row of F_∞ is a null vector this indicates that Eq. (15.3) involves only the second and third rows of H and H'. Therefore, it is necessary to introduce some constraints in order to determine the first row of H. The minimiza-

tion of the vertical distances between corresponding epipolar lines along a vertical axis is used as this constraint. The nonlinear objective function of the optimization problem together with constraints can be defined as

$$F(H, H') = E(H, H') + \lambda d(H, H'), \qquad (15.4)$$

where $\lambda = [\lambda_1, \lambda_2, \lambda_3]$ is a row vector. The minimization of Eq. (15.4) is a nonlinear minimization problem. To perform this minimization we choose the Levenberg–Marquardt algorithm because of its effectiveness and popularity.

15.4 Stereo Localization

Our aim is to localize an object on the given test map. First, we compute the 3-D position $[X_w, Y_w, Z_w]$ of the object in the fixed camera co-ordinate system using the stereo algorithm. Later, the location $[X_m, Y_m]$ of the object in the given test map can be obtained in the following way:

$$[X_m, Y_m, 1] = H_m^w * [X_w, Y_w, 1], \qquad (15.5)$$

where H_m^w is the homography matrix between the homogeneous co-ordinates of the ground-plane position $[X_w, Y_w]$ of some known points (like corner, mark, poles) and their respective position on the given test map.

There are several ways of computing the homography between two plane views. Some of these techniques are based on direct linear transformation (DLT) or singular value decomposition (SVD) techniques. Here, we have used the IRLS algorithm to compute the required robust homography. This algorithm is less sensitive to outliers when compared to the traditional least square methods and provides a robust homography by minimizing the effect of outliers.

In this publication, localization is performed based on a stereo process. The 3-D position of the object is computed in terms of its co-ordinate $[X_w, Y_w, Z_w]$ in a world reference system. Once the pair of stereo images is rectified, the next step is to compute the disparity between the matching pairs. Our aim is to compute the disparity only for the pixels related to the target. Since the target is detected in the static camera image, we restrict the search for its matching pixels only to the corresponding epipolar lines in the PTZ camera image (see Fig. 15.3). For the target pixels in the static camera image I_s, similarity scores are computed by comparing a fixed, small window of odd dimension centered on the pixel to a window in PTZ camera image (I_d), shifting along the corresponding horizontal scan (epipolar) line. Windows are compared through the normalized SSD measure, which quantifies the difference between the intensity patterns:

$$C = \frac{\sum_{(\xi,\eta)} [I_s(x + \xi, y + \eta) - I_d(x + d + \xi, y + \eta)]}{\sqrt{\sum_{(\xi,\eta)} I_s(x + \xi, y + \eta)^2 \sum_{(\xi,\eta)} I_d(x + \xi, y + \eta)^2}},$$

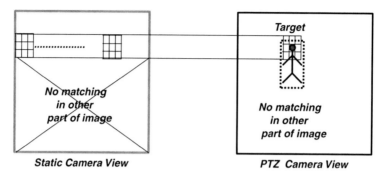

Fig. 15.3 A representation of modified stereo matching

where $\xi \in [-n, n]$ and $\eta \in [-m, m]$. The disparity estimate for pixel (x, y) minimizes the SSD error:

$$d_0(x, y) = \arg \min C(x, y, d).$$

However, we can observe that squared differences need to be computed only once for each disparity, and the sum over the window need not be recomputed from scratch when the window moves by one pixel. Once the disparity d is computed between the position of the target in the left and right images, the distance of the target Z_w from the camera along the optical axis is computed using the following formula:

$$Z_w = f_r \frac{B}{d}, \tag{15.6}$$

where f_r is the focal length for the rectified pair of images and B denotes the baseline distance. Let the position of the target in the static camera image be (x_s, y_s), then the position of the target in the plane normal to the optical axis of the camera is given by

$$X_w = \frac{x_s Z_w}{f_r} \quad , \quad Y_w = \frac{y_s Z_w}{f_r}.$$

Once the 3-D position of the object is estimated, then it is localized in the given test map using Eq. (15.5). In the next section, experimental results are presented for different cases to show the usability of this framework.

15.5 Experimental Results

Several experiments have been conducted to evaluate the performance of the proposed framework to localize moving objects on a given ground-plane map. The real

sequences in a parking lot are acquired by the static and PTZ cameras. A walking person is considered a target and the various cars are considered occlusions. The results have been obtained by considering different cases, i.e., occluded and non-occluded targets, using different zoom settings of PTZ cameras. In this section, we focus our discussion for experimental studies on two different issues. First, we present some results for rectification and localization for the image pairs which are captured on different zoom levels. From these results, we show the accuracy is more in rectification when we rectify the homogeneous image pairs instead of rectifying heterogeneous image pairs directly. Later, the superiority of the proposed framework with respect to standard monocular localization in terms of accuracy is shown.

Figure 15.4 represents the results for rectification and localization using two different frames. The images are captured using different zoom settings of static and PTZ cameras. In the first row, two different heterogeneous pairs of images are shown. The second row contains their homogeneous versions. In the third and fourth rows, rectified-heterogeneous and rectified-homogeneous pairs are given, respectively. The rectification error is calculated using a criterion that is the mean of the vertical distances between epipolar lines in the rectified pairs. The error is reduced from 0.53 to 0.06 pixels in the left pair when it is rectified after making it homogeneous. In the right pair, the error is reduced from 0.79 to 0.07 pixels. The effect of the distortion error is also less when these images are rectified using homogeneous pairs (see Fig. 15.4). The effects of the rectification error with respect to the focal ratio are shown in Table 15.1.

In the second set of experiments, an occluded object is localized in three different frames which are also captured at different pan, tilt, and zoom settings. Figure 15.5 represents the results for the localization of a moving target in three different frames. It is clear from Fig. 15.5 that the proposed algorithm is capable to co-operatively localize the target correctly even in the occluded cases. Moreover, the proposed stereo-vision-based scheme produces a better localization than a monocular camera-based scheme.

A comparison between the proposed framework and standard monocular camera-based technique is shown in Fig. 15.6 using tracked trajectories of a moving target. When the target is occluded, the trajectory which is tracked using a standard monocular camera-based technique is less accurate as compared to the trajectory obtained using the proposed framework. However, both the trajectories are overlapping each other in the case of a non-occluded target. A surface plot is also shown representing the superiority of the proposed framework on the standard monocular camera based on the localization scheme. In this figure, the x-axis represents the height of occlusion and the y-axis represents the distance of the moving object from the static camera along the optical axis. An error criterion is defined based on the distance between the actual location of the object (ground-truth) and its computed location. In case of monocular camera-based scheme, the error is increasing either when the distance of the object from the camera or the height of the occlusion is increasing. In case of the proposed method, the error is almost constant and does not depend on the occlusion's height or the distance of the object from the camera.

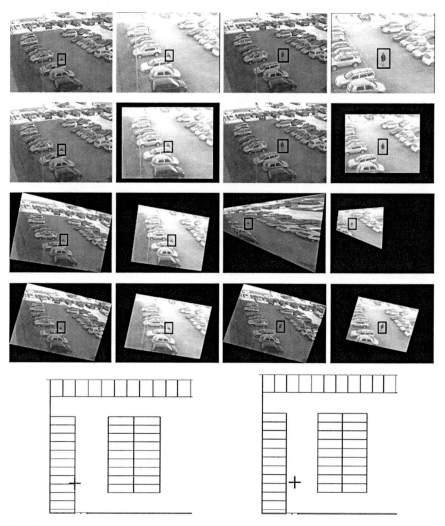

Fig. 15.4 Rectification and localization of an object from two different heterogeneous pairs

Table 15.1 Rectification error with different values of focal ratio in heterogeneous and homogeneous pairs

Focal ratio	Rect. error (heterogeneous)	Rect. error (homogeneous)
1.0	0.06	0.06
0.88	0.53	0.06
0.76	0.67	0.07
0.64	0.93	0.11
0.52	2.67	0.38
0.40	6.45	0.64

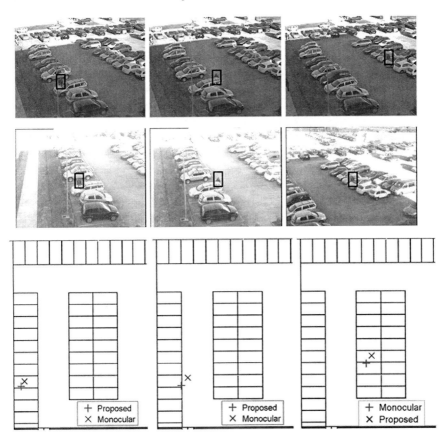

Fig. 15.5 Comparison of proposed and standard monocular localization techniques using three different frames. Static camera frames (*top row*), PTZ camera frames (*middle row*), and localization on given test map (*bottom row*)

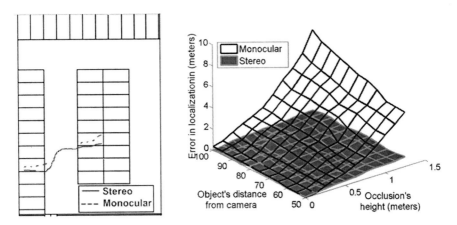

Fig. 15.6 Tracked trajectories of a moving target using the proposed and a monocular camera-based technique (*left*). Errors in the proposed and the monocular localization algorithms corresponding to the occlusion's height and object distance from a static camera (*right*)

15.6 Conclusions

We have presented an approach for the co-operative localization of objects/targets in the ground-plane map using stereo vision. The stereo vision system is configured by taking two heterogeneous sensors (static and PTZ cameras) belonging to a smart camera network. First, the effect of the different imaging parameters has been compensated in an intelligent way using focal ratio and zero padding. Then, the pair of images has been rectified and stereo matching has been performed in a modified concept only for those pixels which are related to the object. The position of the object has been estimated in 3-D space using stereo vision. The object has been localized in the ground-plane map based on the estimated 3-D position. The proposed technique is able to make a more accurate localization when compared to the monocular camera-based localization. The PTZ co-operativeness can be switched among the static cameras following the tracking handover mechanism.

Acknowledgments This publication was partially supported by the Italian Ministry of University and Scientific Research within the framework of the project entitled "Ambient Intelligence: event analysis, sensor reconfiguration and multimodal interfaces." Sanjeev Kumar also extends his gratitude to the Department of Mathematics and Computer Science, University of Udine, for the financial support provided for this publication under the grant MIUR n. 179 dd. 29/01/2007 provided by Italian Ministry of University and Scientific Research.

Part VI
Selected Applications of Smart Cameras

Chapter 16
Smart Cameras for Machine Vision

Yu Shi

Abstract Among many applications of smart cameras, machine vision has been the most successful one. Smart cameras have gained a certain level of maturity in machine vision and have established a solid market share alongside other types of vision systems. Recent market data have shown that smart cameras are enjoying a faster growth rate compared with other vision systems. A great majority of smart cameras for machine vision are stand-alone integrated cameras. In this chapter, we present an overview of smart camera technologies for machine vision. We review their advantages and their applications in industrial machine vision. This is followed by discussions about design methodology and hardware and software systems involved in the development of smart cameras. Later in the chapter, some examples of smart cameras for machine vision are analyzed, followed by speculations about future trends and challenges for smart cameras in machine vision. Some online and other resources for smart cameras and machine vision are given in the last section to conclude the chapter.

16.1 A Brief Introduction to Machine Vision

Computer vision is a research discipline which deals with developing theories and technologies that allow a computer to "see" and understand images from the real world acquired by a camera. Machine vision, or industrial machine vision, is the application of computer vision and other technologies (optical engineering, mechanical engineering, etc.) to industrial automation. Whereas computer vision is more focused on developing new image processing and pattern recognition algorithms to enhance the ability of a computer to see and understand images, machine vision is more concerned with building practical camera systems that can make decisions

Y. Shi (✉)
National ICT Australia
e-mail: yu.david.shi@gmail.com

A.N. Belbachir (ed.), *Smart Cameras*, DOI 10.1007/978-1-4419-0953-4_16,
© Springer Science+Business Media, LLC 2010

or take actions based on that understanding, for the purpose of industrial process automation. In the media, the term "machine vision" is sometimes used to refer to non-industrial applications, whereas in this chapter this term specifically refers to industrial machine vision, including robotic vision.

The earliest machine vision cameras can probably be traced back to the late 1960s when the Massachusetts Institute of Technology (MIT) developed the first real use of image processing in an industrial context with a camera driving a robotic arm [34]. Today, machine vision engineering is a multi-disciplinary effort which involves skills and expertise from computer vision, software engineering, optical engineering, electrical engineering, mechanical engineering, and industrial automation. Compared to human- or manual-based control systems, machine vision systems can greatly enhance the performance of industry automation and control systems and increase productivity. There are plenty of examples of these systems in action in the industrial world which demonstrate their advantages in providing innovative solutions to automatic control with accuracy, reliability, flexibility, consistency, cost effectiveness, improved production competitiveness, and safety for workers. Since the 1990s, machine vision technologies have become increasingly powerful and mature, leading to increasing adoption by and demand from end users.

Cameras are the essential component of any machine vision system. Smart cameras are distinct and integrated vision systems. Since the 1980s, smart cameras have enjoyed high and rapid growth rates in many manufacturing industry segments. Based on this success, machine vision smart cameras have recently extended their applications into non-manufacturing applications such as identifying persons, document processing, traffic engineering, and retail logistics. In fact, these new applications have provided the machine vision industry with a significant share of their total revenue [547]. The growth of smart cameras and the machine vision market is also facilitated by industry efforts to standardize communication interfaces, I/O, and vision software libraries. The standardization has led to tighter integration, improved interoperability, and shortened time-to-market.

In manufacturing, a machine vision system is closely integrated within an automatic control system. Such an integrated system typically includes these components or sub-systems:

- Predominantly, a camera or a vision system that captures and analyzes images of target parts or objects;
- A mechanism to provide continuous supply of parts or objects for inspection or recognition and for post-analysis parts routing (e.g., a conveyor belt);
- A lighting or illumination system that helps the camera to better "see" the objects; and
- Actuators or devices used to perform controls or actions on the analyzed objects based on camera output (e.g., sort or reject defective parts).

The key component of any machine vision system, as with a smart camera, is an *Application-specific information processing* (ASIP) module within the camera or the vision system that is capable of analyzing the incoming images, extracting useful features, making decisions, and generating control actions, all in real time.

For example, to automatically detect and reject faulty parts, the ASIP will segment a part from a captured image; extract a particular feature of the part which can be texture, color or shape; compare it against a template; decide whether the examined part is faulty; and based on a positive outcome, notify the control system to reject it.

16.2 Smart Cameras and Machine Vision

There are two main types of vision systems in machine vision: PC (personal computer)-based systems and smart cameras. In a PC-based system, a general purpose camera can be used to perform image capture. The images are sent to a PC or a PC-hosted embedded system through a communication interface. The common communication interfaces for smart cameras and vision systems are Camera Link, Gigabit Ethernet, GigE Vision (a standard based on Gigabit Ethernet for machine vision industry [32]), Firewire, and USB. In PC-based systems, the ASIP (application-specific information processing) is performed by either the PC or the PC-hosted processing system. PC-based systems can be further divided into two types: one is more tailored to a particular application, the other is more flexible and application-programmable. The former is sometimes referred to as application-specific vision system (ASVS), while the latter is called a configurable vision system (CVS). As its name suggests, the ASVS is a turnkey solution optimized for a particular application, providing best performance but with less flexibility. The CVS, on the other hand, can be more versatile in use due to its re-programmability [547].

Smart cameras are integrated and autonomous vision systems. Compared to standard cameras of which the primary function is to capture images, smart cameras often include a complete computing structure (processor, memory, communications, etc.) inside the camera which performs ASIP beyond simple image capture. In fact, a smart camera integrates image capture, ASIP functionality, communication interfaces, and I/O capabilities all combined in one single camera housing. Some smart cameras are designed to be very compact in physical size, low in power consumption, and optimized for specific inspection tasks. These cameras are sometimes called vision sensors.

One significant advantage of the PC-based systems over smart cameras is their flexibility – they can be programmed or configured to perform a variety of different machine vision tasks. These systems are easier to integrate into automation systems, thanks to the mostly general-purpose parts that can be purchased, replaced, or serviced relatively easily. The ASIP algorithms can generally afford to be more complex due to the availability of large amounts of processing and memory resources. The downside of these systems is their relative complexity in system composition, their physical size which can be as large as to fill a whole room, and the total cost due to higher device or part count. Smart cameras do not require connection to an external processing unit and can perform specific tasks in a stand-alone and autonomous way, only requiring connection to a PC for initial algorithmic setup, camera configuration, and calibration.

The main advantages of smart cameras include

- Simplicity in use;
- Ability to simplify overall machine vision system design and development;
- (Very) low output bandwidth requirement;
- Easiness to maintain data security than with PC-based systems;
- Robustness;
- Compact physical size, which may prove to be very important for or in some industrial application environments;
- Due to their low output bandwidth, smart cameras can operate with connections with virtually unlimited cable length (e.g., Ethernet), whereas transmitting the raw video stream often requires high-performance connections (e.g., Camera Link) with limited cable lengths and high cost. Compressing the raw video stream beforehand (to comply with standard connections' bandwidth) reduces the quality to perform machine vision on the PC.
- Low power consumption; and
- In some cases, lower price due to smaller part count or device count.

On the downside, smart cameras, especially vision sensors, are usually designed and optimized to perform specific tasks and therefore not flexible in terms of adaptability to other non-specified uses. Often, the performance of a smart camera can be limited by the power of its embedded processor(s). Also, there are not as many software programs and libraries available for smart cameras as compared to PC-based systems.

Industrial machine vision is the most active application for smart cameras. It is one of their most successful commercial playgrounds. The first smart cameras for machine vision applications were developed in the 1980s [237]. They went on to experience rapid growth in technologies, application types, and market shares in the 1990s and the 2000s. Recently, machine vision market research has shown that smart cameras are rapidly accounting for a greater share of the machine vision market revenue [248, 30]. In fact, a snapshot of sales of machine vision products of European suppliers between 2005 and 2006 showed that the increase in the combined sales of smart cameras and vision sensors has more than doubled, far beyond the growth of other vision products [475]. The important drivers for this rapid growth include technological progress in new solid state sensor technologies, in embedded computer vision systems development, improving affordability and increasing power of microprocessors, and also due to potential cost saving made possible by integrating image capture, processing, and communication into a single unit. Competition among manufacturers of smart cameras also drove the camera quality up and price down, making them even more popular and thus becoming an established force in the market. There are a huge number of specific applications and tasks that can be effectively completed by smart cameras in machine vision, which led to great involvement of the industry driven by the pursuit for improvement in quality and productivity.

16.3 Applications and Typical Tasks

Industry automation is a technological driver for productivity increase and improving competitiveness. Machine vision is a key enabler of this automation. The end-user industry segments for machine vision and smart cameras include manufacturing, robotics, semiconductor, electronics, pharmaceutical, medical imaging, food, packaging, printing, and paper. Typical tasks performed by these cameras can be divided into three main categories: quality control, object recognition, and process monitoring and control, briefly described below:

- Quality control. Quality control based on flaw detection and inspection is probably the most widely adopted application for smart cameras in machine vision. Typical tasks include parts attributes check, such as shape, color, and texture; surface check; completeness check; physical dimension measurements; position check (e.g., to determine the position and/or orientation of an object so as to guide a robotic arm).
- Code and object recognition. Examples are reading characters and deciphering matrix codes, as well as verifying labels, in 1D or 2D. This is often called OCR (optical character recognition) and OCV (optical character verification).
- Process monitoring and control. The tasks in this category are similar to video surveillance. They include parts counting, parts sorting, and absence/presence detection.

Often these categories and tasks are mixed in real-world applications. Many tasks rely on the same or similar computer vision technologies. For example, object identification based on feature extraction and template matching is an essential technique for many of these tasks.

Figure 16.1 shows a simplified automatic part sorting system equipped with a smart camera. The illustration is inspired from [96]. In this example, the system automatically separates apples based on their size; big or small. The essential components of the system include a smart camera, a lighting system, a robotic arm, and its control sub-system which communicates with the camera, moving the conveyor belt which feeds apples to the camera and robotic arm, and containers for storing the sorted apples. The apples are well illuminated by the lighting system. The smart camera takes a picture of each apple one at a time in synchronization with the speed of the belt. The intelligent image processing algorithm inside the camera segments the apple out from the picture, extracts its contour, and calculates its size. It then compares the size with a pre-defined threshold to determine whether the apple being inspected is of small or big size. Once the size classification is done, an appropriate control signal (which can be as simple as one bit with "1" representing "big size" and "0" representing "small size") is sent to the robotic arm control unit. The control unit can use a simple lookup table to determine the position or the angle of the robotic arm with regard to the belt so that the apple under inspection is deflected by the robotic arm into the appropriate storage container.

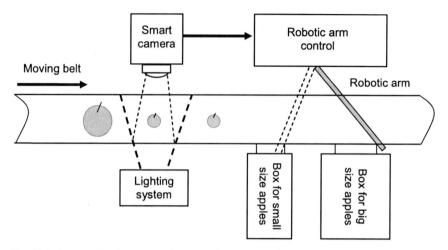

Fig. 16.1 An example of an automatic part sorting system using a smart camera

Recently, we have seen many machine vision systems including smart cameras extend their application areas beyond their traditional niche into other challenging applications such as automobile, surveillance and security, and traffic flow information gathering. This is a sign of the maturity of these cameras.

16.4 Camera Design and Development Methodology

The key to developing a smart camera is the selection of hardware (image sensor, processor, etc.) and software (a library or algorithms) which, when working together, meet application requirements. The design process for smart cameras for industrial machine vision is similar to the design process for other applications. The aspects which receive some more attention are probably the lighting system and mechanical engineering considerations. Generally speaking, design and development of smart cameras for machine vision should start after a project definition stage in which the scope, context, and purpose of the project, especially business considerations, have been laid out clearly. Figure 16.2 shows a diagram illustrating a generic design methodology and process.

16.4.1 Application Requirements and Specification

This stage is essential for the success of any engineering project that involves large investments and/or considerable effort. Clear and accurate requirements specification helps shorten the development cycle and reduce development costs. Typically this stage should provide a clear description about the following aspects:

Fig. 16.2 Generic design and development process

- Application specification. This should provide a detailed description about the target object to be inspected and the features to be analyzed. For example, in surface inspection, what features (color, shape, texture, etc.) are to be used to determine whether a surface is faulty.
- Functionality specification. This is closely related to application specification and should cover the primary task(s) which the camera should perform. Any secondary desired functionality can also be mentioned.
- Technical specification. This should cover key parameters and tolerances for the primary tasks, for example, image sensor resolution, the distance between camera and objects to be inspected, total allowable processing time for the inspection of one object, before the next comes into camera view. Physical dimension and weight of the camera may also be specified.
- Environment specification. This should cover physical and mechanical aspects of the setting of the camera system. The physical positioning of the camera relative to the parts needs to correspond to the lighting conditions and the camera lens. Protection against vibration and excessive heat should also be considered.
- Constraints specification. This should cover issues such as project time frame, total cost, risk management.

16.4.2 System Architecture Design

The architecture design should ensure that the application requirements and specifications are met, within the allowed constraint boundaries. It should provide at least these outputs:

- Hardware architecture. This should specify the overall camera hardware parts and inter-connections, including optical components. Importantly, the choice of an image and video processing sub-system is critical to the camera performance.
- Software architecture. This should go closely with the hardware architecture proposition. Mapping software modules to hardware resources is a challenging research topic and a critical factor affecting the overall performance and cost

of the camera. Using a commercially available machine vision library which is compatible with hardware architecture can simplify software architecture design. The selection of a real-time operating system for the camera is also closely related to the hardware architecture. User and control interface should be part of the software architecture specification.

- At the heart of a smart camera are its application-specific image processing and pattern recognition (IPPR) algorithms. To develop smart camera software from scratch, the availability and selection of these algorithms are indispensable to the realization of the purpose of the camera. This can be helped by using commercially available IPPR libraries or IP (Intellectual Property) inventories. Some may need customization to the source to be usable.

- Possibility of using a smart camera development platform. Using a commercial or well-established smart camera development platform can reduce risks in architecture design and potentially reduce design and development cost, but unfortunately to date there are not many such platforms available on the market yet. Notably, Sony has recently released two smart camera development systems, XCI-SX1 and XCI-V3. The XCI-SX1 integrates an SXGA CCD image sensor and an AMD GeodeGX533 400 MHz processor running MontaVista Linux operating system.[1] The camera platform is designed to provide OEMs (Original Equipment Manufacturers), systems integrators and vision tool manufacturers, a rugged, robust component, combining the imager, intelligence, and interface, in a single plug-in module that is easy to set up and to integrate.

- Optical system. The optical sub-system design is also critical for the overall performance of a smart camera or any camera. Even with ideal lighting or illumination, the correct choice of a lens or optical settings can help acquire sharp and aberration-free images.

- Lighting system. While the lighting system is not part of a camera system, the importance of correct lighting to a robust machine vision solution should not be underestimated. A well-calibrated lighting system is critical to ensure that a camera recognizes/identifies a part or features of the part (e.g., color) with good contrast and with consistency in brightness. The parameters to be considered when selecting the right illumination type include wavelength, brightness, and homogeneity, which in many cases should be correlated with the requirements of the image processing software.

- Calibration mechanism. Calibration ensures that a camera will work under consistent conditions, which is important to the robustness and performance of the camera. Calibration becomes even more important when more than one camera is involved in the vision system and they operate jointly.

[1] Sony First Generation Smart cameras. *Information published at the Sony web site and accessed in January 2009.*

16.4.3 Proof-of-Concept

This may be an optional stage. Assuming IPPR algorithms are already selected, the objective of this stage is to help test and validate algorithmic and performance hypotheses using another computing platform, such as on a PC connected to a general-purpose industry camera, or using appropriate simulation tools. The results of this stage may provide useful feedback to the architecture design stage. This stage may, in some cases, also involve research to create new algorithms to meet particular functionality requirements.

16.4.4 Development, Implementation, and Integration

This stage is probably the most time-consuming phase of the project and should deliver an engineering prototype of the camera when completed. A crucial task at this stage could be converting IPPR algorithms which may be originally written in a high-level programming language to a more hardware-friendly language such as assembler or VHDL (VHSIC Hardware Description Language, with VHSIC standing for Very High Speed Integrated Circuits), depending on the chosen embedded processors.

16.4.5 Test and Evaluation

This includes field test and performance evaluation under realistic use scenarios and physical environments to ensure that the camera meets application requirements, to test mechanical and electrical interfaces, to identify potential problems and possible improvements, and to benchmark camera performance against most if not all technical specifications. The results may serve as feedback to any of the above stages for adjustments or improvements. Other output produced at this stage may also include a calibration scheme, documentation, a maintenance manual.

16.5 Camera Systems for Machine Vision

Generally speaking a camera system consists of a lens, an image capture device, an image processor with associated memory and data buses, and communication channels. This section takes a close look at these aspects in terms of considerations that need to be taken into account when completing camera system architecture design. We also take a look at some real-time operating systems that are used by smart cameras for machine vision applications.

16.5.1 Optics

Together with the lighting system, the optics of the camera system helps the camera to identify the focused object with good contrast, sharpness, high signal-to-noise ratio, and with minimum distortion. Understanding the principles of the optics is the basis for the selection of good and matching lenses for the camera system. Important parameters include object–camera distance, focal length, required depth of field-of-view, aperture [237]. Reference [237] provides comprehensive coverage of issues related to both lighting and optical systems for machine vision.

16.5.2 Image Capture

Image capture is where a camera "sees" things. The main component of the image capture unit or camera front end is essentially a solid state image sensor. The image sensor is the eyes of the smart camera, or any camera. Nowadays, there are mainly two solid state image sensors to choose from, CCD and CMOS. The main technical parameters of an image sensor include resolution, frame rate, scan type, light sensitivity, and noise level. CCD is still the dominant sensor type for machine vision cameras, including smart cameras, but the uptake of CMOS image sensors is growing. At the moment CMOS sensors are used in applications or context where image quality and light sensitivity requirements are not very high, for example, tasks such as performing simple absence/presence inspection.

The main advantages of CCD sensors include high sensitivity, very low noise, mature, and standardized support circuitry. Compared to CCD, CMOS imaging is a relatively new technology but with faster growth in market share. The advent of CMOS image sensors is arguably the most significant single factor that has contributed to the popularity and proliferation of smart cameras across many application areas, including machine vision. The main advantages of CMOS sensors, compared to CCD, include smaller size, cheaper manufacturing cost, lower power consumption, the ability to build a camera-on-a-chip, the ability to integrate intelligent processing circuits onto the sensor chip, and significantly simplified camera system design. The ability of integrating on-chip image processing logic and circuitry makes it possible to create single-chip smart cameras or smart sensors. These very small form factor cameras can be very useful where physical space or power consumption is very restricted. CMOS image sensors with logarithmic characteristics provide a higher dynamic range than standard sensors do, which enables them to be excellent candidates for high dynamic range applications.

16.5.3 Embedded Processors

Embedded image processors are the brains of the smart cameras. Early smart cameras used very primitive microcontrollers such as Z80 operating at 8 MHz (in the

1980s), today smart cameras use powerful microprocessors such as TI's (Texas Instruments) 'C6x DSP (Digital Signal Processor) running at 1 GHz and beyond [237]. There are essentially four types of processors which are used in most of the smart cameras for machine vision:

- General-purpose desktop or embedded microprocessors. Examples are Intel Pentium, Celeron, AMD Geode processors, PowerPC, and MIPS. They are relatively cheap and flexible in use. However, these processors, being general purpose, are not ideal for real-time image processing tasks, especially for processing image output from high-resolution and/or high frame rate image sensors.
- Digital signal processors. They generally provide higher performance for image processing algorithms. Typical examples are TI's DSPs.
- Media processors. Media processors can be thought of as a special class of DSPs. They provide a good trade-off between flexibility and cost-effectiveness. They typically have a high-end DSP core employing SIMD (Single Instruction Multiple Data) and VLSI (Very Large Scale Integration) architectures, married on-chip with some typical multimedia peripherals such as video ports, networking support, and other fast data ports [289]. Examples of media processors are Philips TriMedia and TI's DM64x.
- FPGA (Field Programmable Gate Array) with embedded processors. The FPGA has recently emerged as a very good hardware platform candidate for embedded vision systems such as smart cameras, especially in academia and the research environment. One of the most important advantages of the FPGA is the ability to exploit the inherently parallel nature of many vision algorithms. Many FPGA manufacturers embed microprocessors into FPGA, making them more versatile and powerful. For example, Xilinx embedded PowerPC into their high-end Virtex FPGAs, while Altera offered Nios II in their Stratix FPGAs.

When choosing embedded processors, the choice of an operating system and the complexity of image processing and pattern recognition (IPPR) algorithms have to be considered jointly. Mapping IPPR algorithms to embedded processing architecture is a challenging research topic.

16.5.4 Operating Systems

The use of operating systems (OSes), especially embedded and real-time OSes, running on the embedded processors brings many benefits to the development and run-time performance of smart cameras. These include support for memory management, networking, inter-process communication, real-time computing, and high-level design languages such as C and C++. Apart from proprietary OSes provided by camera manufacturers, popular general-purpose OSes include [567]

- Desktop OSes. Examples are Windows, Linux, and MS-DOS.
- Embedded OSes. An embedded operating system is an operating system for embedded systems. Examples include Windows CE, Windows XP embedded,

and embedded Linux. Some embedded OSes such as Windows XP Embedded, are not inherently real-time operating systems, but it is possible to add real-time capabilities and optimize them to meet real-time requirements.

- Real-time OSes or RTOSes. Examples are RTLinux, pSOS, and QNX RTOS.

Software development tool compatibility is an issue that should be considered when selecting an operating system for smart camera development.

16.5.5 IO and Communication Protocols

Popular communication protocols include Camera Link, Gigabit Ethernet or GigE Vision, Firewire (IEEE 1394), USB 2, RS232. Camera Link and to a lesser extent Gigabit Ethernet are suitable for high bandwidth systems, while Firewire and USB are probably sufficient for low bandwidth applications. Camera I/O can be either analog or digital. They provide support for external event trigger input, synchronization among cameras and vision system components, and control external devices such as programmable logic controllers.

16.6 Smart Camera Algorithms for Machine Vision

16.6.1 Application Characteristics

The reason why a smart camera is smart lies in the fact that the camera cannot only see but also think and make decisions, thanks to the image processing and pattern recognition (IPPR) algorithms that run inside the camera. One significant reason why smart cameras have been notably more successful in industrial machine vision than in video surveillance and other applications, is that these IPPR algorithms generally work better in the machine vision environment and conditions. In other words, the application requirements for machine vision cameras are less restrictive compared with those for video surveillance cameras which face more uncertainties in terms of weather and lighting conditions, movement of different objects, occlusion, etc. Thus, in machine vision the IPPR algorithms have a better chance to achieve robustness and reliability, key factors necessary for real-world applications and viable commercial products. Compared to video surveillance, machine vision has the following advantages:

- The object(s) to be analyzed are generally not humans or unknown objects, and tend to have fixed or rather predictable sizes, shapes, colors, and other features. If moving, the object(s) usually move along a known trajectory.
- Indoor use, thus good and consistent lighting conditions can be actively controlled in a more easier way;
- Selection of dedicated and matching illumination source(s) helps achieve optimal contrast;

- Minimum problems of occlusion, if any;
- Static and known background, thus background modeling is simple;
- There are only limited object patterns to be recognized;
- No human movement tracking and behavior recognition is necessary.

On the other hand, many application requirements for machine vision cameras are arguably more demanding than for other cameras, for example, high-speed analysis, high precision, low false rejection rate. These are the factors directly impacting on productivity and are essential for the cameras.

16.6.2 General Processing Chain

The general IPPR processing chain for smart cameras in machine vision is similar to that in video surveillance, even though in the case of machine vision, there is less emphasis on motion analysis and/or video processing. Figure 16.3 shows a high – level processing flow diagram. As shown in the illustration, the flow can be divided into three phases: signal/image level processing, feature/object level processing, and semantic/decision level processing.

The objective of signal or image level processing is to perform image enhancement and linear transformation when necessary. This is because despite trying hard to use and appropriately select camera front end, lenses, illumination, and lighting arrangement, sometimes the image quality is still not sufficient or can be improved. There are many techniques for image enhancement, such as image smoothing via low-pass filtering. Transformation techniques include gray value transformation, radiometric calibration, affine transformation, projective transformation [237]. The purpose of linear transformation is to ensure that the object(s) of interest in the image are in consistent position and/or orientation to make the subsequent processing stages simpler.

At the core of the smart camera, the objective of feature or object level processing is to perform feature extraction and object recognition/identification. This consists of calculating pre-defined features from the images so that they (the features) can be used to identify objects of interest. The transformation from an image to a set of feature vectors greatly reduce the amount of data to be processed further. The feature

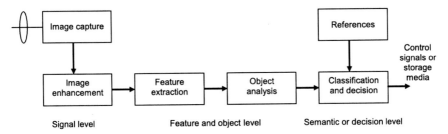

Fig. 16.3 Generic IPPR processing chain for smart cameras for machine vision

vectors are usually more noise robust than the images themselves. Image segmentation, or the identification of the regions of interest, is usually the first stage of feature extraction or can sometimes be all that is needed for feature extraction. Common features include shapes, contours, colors, texture, and sizes. Edge detection and extraction is one of most used segmentation techniques. Morphological operations and geometric fitting can be used to improve segmentation results. Pattern recognition techniques can be used to identify objects of interest based on features. One of the most popular techniques is template matching. Recently we have seen neural network-based object recognition algorithms embedded into machine vision smart cameras [567, 566, 538].

The objective of semantic or decision level processing is what a smart camera is all about. Features or objects generated from the previous stage of processing can be compared against pre-defined test criteria, reference features, or reference objects, so that a decision is made as to whether the object in question is "normal" or not (e.g., a faulty part). If "normal," no action will be taken apart from gathering some data for the purpose of statistical analysis; if not, control signals can be sent to actuators or devices so that the faulty part be taken care of (e.g., placed into a bin or attached with a marker).

16.6.3 Software and Libraries

Building on some of the IPPR techniques, software developer houses provide libraries for machine vision applications such as those described in Section 16.3. According to [602], machine vision software can be divided into three types:

- "Library-based software." This is the typical solution for PC-based vision systems. Developers can call on low-level IPPR algorithms from the library and focus on functionality and/or application development.
- "Closed systems." This refers to installable software executables that target particular hardware architecture and support users for customization of specific functionality rather than the development of the functionality. Users do not have to be skilled in machine vision programming. However, this type of software lacks flexibility as opposed to the library-based type.
- "Component-based systems." These are likely to be based on Microsoft's COM (component object model) architecture and encapsulate task-oriented machine vision functionality [602].

MVTec's Halcon library [33] is a library-based system. The Halcon library provides algorithms that include shape-based matching to find objects based on ROI (region of interest) modeling, blob analysis, metrology (both 1D and 3D), edge detection, edge and line extraction, contour processing, template matching, and color processing. Recently, Texas Instruments (TI) has released royalty-free VLIB

software library for developers of vision systems and smart cameras.[2] The VLIB, optimized for TI's TMS320C64x processors, contains over 40 software packages for a wide range of applications in machine vision, video surveillance, and so on. Another popular open source library for computer vision is Intel's OpenCV Library. For example, Vision Components, a German manufacturer of smart cameras, has adapted OpenCV to its proprietary real-time operating system, implementing it on all their smart cameras [249].

16.7 Examples of Smart Cameras for Machine Vision

In this section, we take a look at some smart cameras that have been available on the machine vision market in recent years. Table 16.1, which is largely based on the "Sampling of Smart Cameras on the Market" by Andrew Wilson in 2006 [567], shows a selection of smart cameras from some major manufacturers and suppliers, focusing on their key architectural and software, characteristics, such as image sensor types and resolutions, embedded processors, operating systems (OS), embedded software and development tools. The original table also shows the I/O and communication interfaces of many of the selected cameras, with Ethernet, USB, and RS232 being among the popular interfaces.

16.8 Future of Smart Cameras for Machine Vision

The future of smart cameras in machine vision is bright and machine vision will continue to be the main real-world application for smart cameras for years to come. Automation has yet to be applied to many suitable applications in manufacturing industries worldwide. The scope for growth for machine vision and smart cameras is therefore still very large. Technology progress and business imperatives (pursuit for increased productivity) will continue to drive the growth. More industry support for standards and product development will also assist the growth. Looking to the future, we could discern the following trends or challenges for smart cameras in machine vision.

General trends and applications:

- Level of integration and flexibility in functionality of smart cameras will continue to improve. This is facilitated by increasing capability and performance of embedded hardware and software and by experiences.
- Machine vision smart cameras will likely make further foray into non-manufacturing applications, such as in video surveillance, automobile, and traffic surveillance.

[2] VLIB Software Library of More Than 40 Royalty-Free Kernels. *Information published in December 2008 at the web site of Texas Instruments and accessed in January 2009.*

Table 16.1 A sampling of smart cameras on the market [567]. n/a: data not available

Company	Camera	Sensor	Processor	OS	Software
Analogic	Bi-I V301	CMOS 1280 × 1024	TI DSP	Windows/Linux	Halcon, InstantVision
Basler	exA1600-14m/-14c	CCD 1624 × 1236	MIPS	Linux	Halcon
Cognex	DVT 552C	CCD 640 × 480	TI DSP	DSP/BIOS	DVT Intellect s/w
JAI	TS-2030EN	CCD 1920 × 512	PowerPC	Linux	n/a
Matrox Imaging	Iris P700	CCD 1024 × 768	Intel ULP Celeron	Windows CE .NET 4.2	Matrox Imaging Library
National Instruments	NI 1700 series	CCD 1280 × 1024	TI DSP, PowerPC	Real-time OS	Vision Builder for Automated Inspection, LabVIEW
Neuricam	NC-5300 PCCam	CMOS 640 × 480	NS Geode	Linux	PC s/w development tools
Philips	Inca 320	CMOS 1280 × 1024	Philips TriMedia	pSos	Rhapsody C/C++ or Clicks GUI
Sony	XCI-SX1	CCD 1280 × 1024	AMD Geode	Linux/Windows XPe	Halcon, Euresys' e-Vision, FDS imaging s/w
Vision Components	VC4458	CCD 640 × 480	TI DSP	RTOS	VC Lib Image Processing Library
Elphel	353/363	CMOS up to 5MegaPixel	FPGA	Linux	n/a
Fast Vision	FastCamera40	CMOS 2352 × 1728	FPGA, PowerPC		n/a
Sony	XCI-V100	CCD 640 × 480	FPGA, x86 compatible	Windows XPe	n/a
Tattile	M1A	CCD 1024 × 768	FPGA, XScale	RTLinux	n/a
Wintriss	OPSIS 5150/7500	CCD linescan	FPGA, PowerPC	Embedded VxWorks real-time operating system	ActiveX controls library

- Standardization and integration support are needed to facilitate the deployment of smart cameras into the well-established industry automation and control systems, especially in the manufacturing industry. This integration can happen at several levels, such as mechanical, electrical, calibration, synchronization, and data communication. These types of integration will allow smooth introduction of smart cameras and allow benefits of smart cameras to show more quickly [237].

Hardware and camera system:

- CMOS image sensors are likely to continue to increase their market share from their CCD counterparts. Image sensor resolutions will continue to increase while prices will decrease. Higher resolution cameras can generally improve quality of applications.
- As 64-bit processing is gaining pace in desktop computing, this is likely to be reflected in vision systems and in at least some smart cameras, increasing processor real-time performance and capability.
- The embedded processing architecture is likely to move from single processor architecture to multi-processor architecture. The multiple processors may involve processors of a heterogeneous nature, such as an FPGA in front of a DSP in the processing chain, so as to exploit benefits of different types of processors.
- Stereo vision and 3D vision will become more mature.
- Cameras operating in a non-visible spectrum such as X-ray, ultraviolet, and infrared will become more popular and more widespread. In particular, infrared cameras are likely to find more machine vision applications as thermal and infrared artifacts are recognized as key parameters for process diagnostics in process intensive industries [603].
- We may see more applications of wireless smart cameras and smart camera network in machine vision. Wireless cameras allow very flexible physical deployment of the cameras. Smart camera network is an enabler for stereo vision and 3D vision.
- Use of FPGAs in smart cameras is likely to become easier, providing more flexibility and re-programmability for smart cameras.

Software and intelligence:

- Embeddable machine learning and artificial intelligence techniques can offer unprecedented performance and flexibility to machine vision systems. They can enable new application and new performance levels for smart cameras.
- Neural network and fuzzy-logic techniques seem to become a key intelligence paradigm in machine vision in view of a streamlined decision-making process of smart cameras. For example, to provide the ability to better match the performance of human inspectors in applications entailing decisions based on subjective scene analysis [603].
- Software will likely become more portable, making software increasingly unbundled from underlying hardware used to run such software, because of the cost/performance ratio [602].

- Recently, there seems to be an emergence of adaptive machine vision algorithms which maintain good performance even when the scene environment changes, such as in terms of lighting conditions. These smart algorithms could contribute to the simplification and cost reduction of future machine vision systems.

Communications and I/O:

- Gigabit Ethernet and Camera Link will likely dominate high-speed and high-bandwidth systems.
- Fiber channel interfaces may become more important for multiple camera systems and long distance (between cameras and control systems) applications [603].
- Gigabit Ethernet smart cameras with Power-over-Ethernet (PoE), which allows provision of Power-over-Ethernet cable (at distances of up to 100 m) and eliminates the need for a separate power cable, may become popular.

Standards and development support:

- There is likely to be a push for more standardization to facilitate stability, interoperability, communication and integration of components, software modules, IP immersion, and services. Standardization is likely to encourage more small players to come into camera development which is currently dominated by big companies who offer end-to-end solutions.
- GenICam [31], a standard promoted by the EMVA (European Machine Vision Association), may provide integration support for future smart cameras. The goal of GenICam is to provide a generic programming interface for all kinds of cameras. No matter what interface technology (GigE Vision, Camera Link, 1394 DCAM (1394-based Digital CAMera specification), USB, etc.) they are using or what features they are implementing, the application programming interface (API) should remain the same.
- More generic smart camera development platforms and more proven design methodologies may emerge to assist developers and shorten time-to-market of new products or new applications.

16.9 Machine Vision Resources

In this section, we provide readers with some online and other resources related to smart cameras and machine vision. All web sites and web pages listed in this section have been accessed and verified as of April 2009.

Camera manufacturers and suppliers:

There are many manufacturers and suppliers of smart cameras for machine vision in the world, mostly in West European countries especially Germany, in North America, and in Japan. Below is a non-exhaustive list of these companies, together with country of origin, main products, and company or product web pages.

- AIT Goehner. Germany. Smart cameras, vision sensors.
 http://www.optischepruefsysteme.de/
- Allied Vision technologies. Germany. Smart cameras.
 http://www.alliedvisiontec.com/avt-products/cameras.html
- Asentics. Germany. Smart cameras.
 http://www.asentics.de/english/index.htm
- Basler. Germany. Smart cameras.
 http://www.baslerweb.com/
- Baumer. Germany. Vision sensors.
 http://www.baumerinspection.com/products1.html?&L=1
- Camsensor. New Zealand. Smart cameras.
 http://www.camsensor.com/smartcamera.htm
- Cognex Vision Systems. USA. Smart cameras, micro vision systems.
 http://www.cognex.com/ProductsServices/VisionSystems/DVT.aspx?id=166
- Datasensor. Italy. Smart cameras, vision sensors.
 http://www.vision-sensors-illuminators.com/#
- EVT Eye Vision Technology. Germany. Smart cameras, vision sensors.
 http://www.evt-web.com/en/home/
- Imaging Solutions Group. USA. Area and line scan smart cameras.
 http://www.isgchips.com/Templates/t_camera.htm
- JAI. Denmark. Smart cameras, including infrared, ultraviolet.
 http://www.jai.com/EN/CameraSolutions/Pages/Home.aspx
- ISRA Vision. Germany. Smart cameras, vision sensors.
 http://www.isravision.com/
- Matrix Vision. Germany. Smart cameras, vision sensors.
 http://www.matrix-vision.com/products.php?lang=en
- Matrox Eletronic Systems. Canada. Immersion-resistant and extremely rugged smart cameras.
 http://www.matrox.com/imaging/products/smart_cameras.cfm
- Microscan. USA. Smart cameras, PCI-based solutions.
 http://microscan.com/en-us/Products/ProductCategory.aspx?id=263
- National Instruments. USA. Smart cameras, compact smart vision systems supporting multiple cameras.
 http://sine.ni.com/nips/cds/view/p/lang/en/nid/204077
- Neuricam. Italy. Smart cameras for non-manufacturing applications.
 http://www.neuricam.com/main/catalog.asp
- Omron Electronics. Germany. Smart cameras, vision sensors.
 http://www.omron.com/products/indu.html
- PPT Vision. USA. Smart cameras.
 http://www.pptvision.com/
- Sony. Japan. Smart cameras and development platforms.
 http://pro.sony.com/bbsc/ssr/cat-industrialcameras/resource.solutions.bbsccms-assets-mkt-indauto-Solutions-smartcameras.shtml
- Tattile. Italy. FPGA-based smart cameras.
 http://www.tattileusa.com/alpha/

- Vision Components. Germany. Smart cameras, vision sensors.
 http://www.vision-components.de/
- Wintriss Engineering. USA. Smart line scan cameras for web inspection.
 http://www.weco.com/

Online resources:

- Smart camera – links to smart camera manufacturers.
 http://www.smartcamera.it/links.htm
- Machine Vision Online. An online information service provided by the Automated Imaging Association (AIA, Michigan, USA).
 http://www.machinevisiononline.org/
- Machine Vision Resources.
 http://elm.eeng.dcu.ie/ whelanp/resources/resources.html.
- Axtel Machine Vision Resources.
 http://www.axtel.com/machine-vision.html
- Vision Systems Design.
 http://www.vision-systems.com/topics/smart-cameras.html
- Introduction to Machine Vision.
 http://www.machinevision.co.uk/
- Computer Vision Online.
 http://www.computervisiononline.com/
- Imaging and Machine Vision Europe.
 http://www.imveurope.com/
- The web portal of the UK Industrial Vision Association.
 http://www.ukiva.org/
- The European Machine Vision Association.
 http://www.emva.org/
- Machine Vision Germany.
 http://www.vdma.org/visionfinder
- German Machine Vision Companies and Research Groups.
 http://kogs-www.informatik.uni-hamburg.de/koethe/german_vision.html
- German Machine Vision Portal.
 http://www.machine-vision.de/

Recent books:

- *Handbook of Machine Vision.* By A. Hornberg. Published by Wiley-VCH, Weinheim. Edition 2006. ISBN: 978-3527405848.
- *Embedded Computer Vision.* By B. Kisacanin, S.S. Bhattacharyya, S. Chai. Published by Springer-Verlag. Edition 2008. ISBN: 978-1-84800-303-3.
- *Machine Vision Algorithms and Applications.* By C. Steger, M. Ulrich, C. Wiedemann. Published by Wiley-VCH, Weinheim. Edition 2007. ISBN: 978-3-527-40734-7.
- *Image Processing, Analysis, and Machine Vision.* By M. Sonka, V. Hlavac, R. Boyle. Published by CL-Engineering. Edition 2007. ISBN: 978-0495082521.

- *Machine Vision : Theory, Algorithms, Practicalities*. By E. R. Davies. Published by Morgan Kaufmann. Edition 2004. ISBN: 978-0122060939.

Conferences, workshops and trade shows on machine vision and computer vision:

- The annual British Machine Vision Conference. Organized by the British Machine Vision Association.
 http://www.bmva.ac.uk/
- The International Robots, Vision & Motion Control Show. Held every 2 years and organized by the Robotic Industries Association (Michigan, USA), the AIA and the Motion Control Association (Michigan, USA).
 http://www.robots-vision-show.info/robots_vision_show_info.html
- Computer Vision Conferences Listings.
 http://iris.usc.edu/Information/Iris-Conferences.html;
 http://www.wikicfp.com/cfp/servlet/tool.search?q=vision
- The IAPR (International Association for Pattern Recognition) Conference on Machine Vision Applications (MVA). Organized by Japanese academia and industries.
 http://www.mva-org.jp/
- The International Conference on Machine Vision, Image Processing, and Pattern Analysis (MVIPPA). Organized by the World Academy of Science, Engineering and Technology (WASET).
 http://www.waset.org/
- The European Machine Vision Business Conference. Organized by the EMVA.
 http://www.emva.org/emva_events_and_conferences
- The ACM/IEEE International Conference on Distributed Smart Cameras (ICDSC).
 http://www.icdsc.org/
- Machine Vision China.
 http://www.mvchina.org/

Journals:

- *The Journal of Machine Vision and Applications*. Published by Springer Berlin / Heidelberg.
 http://www.springerlink.com/content/0932-8092
- *The IEEE Transactions on Pattern Analysis and Machine Intelligence*. Published by IEEE.
 http://www.computer.org/tpami/
- *The Advanced Imaging*. Published by Cygnus Business Media.
 http://www.advancedimagingpro.com/

Chapter 17
Smart Cameras for Visual Surveillance

Khurram Shafique and Omar Javed

Abstract Automated visual surveillance systems must retrieve and integrate relevant information from a large number of sensors and present it in a user-friendly manner. These systems rely on smart cameras that extract target meta-information from content-rich video data by detecting and classifying the targets of interest in their respective fields of view and tracking them over time. The smart cameras thus provide an ideal platform for data collection and low/mid-level video analysis. However, high-level scene understanding and context-sensitive reasoning require learning of environment parameters and their spatiotemporal variation. Such learning and reasoning is an important characteristic ability of all cognitive systems that increase the adaptability and thus the utility of such systems. In this chapter, we show how smart cameras can mimic this intelligent behavior by learning models from past observations and exploiting them to enable robust target detection and classification, persistent target tracking, anomalous behavior detection, inter-sensor calibration, and geo-registration.

17.1 Introduction

Automated surveillance systems have made great strides in recent years. What used to be single camera systems with limited capabilities (of detecting and tracking targets) [574, 225, 509] have evolved into large multi-sensor networks for wide area video analysis [119, 167, 485, 131, 518]. These systems aim to provide site-wide situational awareness by (i) extracting useful metadata from videos that describes the scene including the static and moving objects, their interactions, and behaviors; (ii) fusing the extracted information from multiple sensors; and (iii) presenting them in a user-friendly manner. Until recently, most systems treated common problems, such as target detection, persistent tracking, target classification, and data fusion, independently and tried to infer properties of individual elements in the scene without regard for interaction among these elements, scene context, and previous

K. Shafique (✉)
ObjectVideo Inc, Reston, VA, USA
e-mail: kshafique@objectvideo.com

A.N. Belbachir (ed.), *Smart Cameras*, DOI 10.1007/978-1-4419-0953-4_17,
© Springer Science+Business Media, LLC 2010

observations. Due to their memoryless behavior, these systems lacked the capability of learning the environment parameters and intelligent reasoning based on these parameters.

A number of studies have provided strong psychophysical evidence of the importance of context for scene understanding in humans, such as handling long-term occlusions, detection of anomalous behavior, and even improving the existing low-level vision tasks of object detection and tracking [61, 534]. We argue that over the period of its operation, a smart camera should be able to model the scene from its observables and be able to improve its performance based on this model. The high-level knowledge that is necessary to make such inferences derives from domain knowledge, past experiences, temporal consistency, as well as scene geometry, for example, identified pathways, roads, entry and exit points in the scene, learned causal relationships between sub-events, learned traffic and target behavior patterns in the area. Consider a scene that contains bushes that only allow partial or no observation while the targets pass behind them. Most existing systems only detect the target when it comes out of the bushes and are unable to link the observations of the target before and after the long-term occlusion. Given that this behavior of targets disappearing and appearing after a certain interval at a certain place is consistently observed, an intelligent system should be able to infer the correlation between these observations and to use it to correctly identify the targets at reappearance. We believe that identification, modeling, and analysis of these processes and their associated parameters are the key to achieving autonomous intelligent decision-making capabilities. In this chapter, we show through examples how scene context, domain-specific knowledge, and learned priors can be used to enable adaptable and practical visual surveillance systems and solve typical visual surveillance problems that include sensor calibration, geo-registration, behavior prediction, detection of anomalous patterns in the scene, improvement of foreground detection, target classification, and persistent tracking.

17.2 Related Work

Trajectory and path modeling is an important step in various applications, many of which are crucial to surveillance and monitoring systems. Such models can be used to filter tracking algorithms, generate likely paths, find locations of sources and sinks in the scene, and detect anomalous tracks. This kind of modeling can be directly used as a feedback to the initial stages of the tracking algorithm and applied to solve short-and long-term occlusions. In recent years, a number of different methods and features for trajectory and path modeling of traffic in the scene have been proposed. These methods differ by their choice of features, models, learning algorithms, applications, and training data. See [91] for a detailed review of these models.

In [246, 412, 265], neural network-based approaches for learning of typical paths and trajectory modeling are proposed. Other than the computational complexity and lack of adaptability of neural networks, a major disadvantage of these methods is

their inability to handle incomplete and partial trajectories. Fernyhough et al. [175] use the spatial model presented in [241] as a basis for a learning algorithm that can automatically learn object paths by accumulating the traces of targets. Koller-Meier et al. [298] use a node-based model to represent the average of trajectory clusters. A similar technique is suggested by Lou et al. [336]. Although both methods successfully identify the mean of common trajectory patterns, no explicit information is derived regarding the distribution of trajectories around the mean. A hierarchical clustering of trajectories is proposed in [218, 509], where trajectories are represented as a sequence of states in a quantized 6D space for trajectory classification and the method is based on a co-occurrence matrix that assumes that all trajectory sequences are equally long. However, this assumption is usually not true in real sequences.

Javed et al. [261] present a non-parametric motion model to describe the relationship between spatiotemporal features of observations between two cameras. The model is learned based on the sparse observation during supervised training. In [508], a hidden Markov model-based scheme of learning sources and sinks is presented, where all sequences are two-state long. The knowledge of sources and sinks is used to correct and stitch tracks in a closed-loop manner. HMM-based approaches are also presented in [445, 553], where trajectories are modeled as transitions between states representing Gaussian distributions on the 2D image plane. Galata et al. [207] propose a mechanism that automatically acquires stochastic models of any behavior. Unlike HMMs, the proposed variable length Markov model can capture dependencies that may have a variable timescale.

Hoiem et. al. [235] take a step forward in image and scene understanding and propose improvement in object recognition by modeling the correlation between objects, surface geometry, and camera viewpoints. Rosales et al. [454] estimate motion trajectories using an extended Kalman filter to enable improved tracking before, during, and after occlusions. Kaucic et al. [282] present a modular framework that handles tracking through occlusions and the blind regions between cameras by the initialization, tracking, and linking of high-confidence smaller track sections. Wang et al. [555] propose measures for similarity between tracks that take into account spatial distribution, velocity, and object size. The trajectories are then clustered based on object type and its spatial and velocity distributions. Perera et al. [418] present a method to reliably link track segments during the linking stage. Splitting and merging of tracks is handled to achieve multi-object tracking through occlusion. Recently, Hu et al. [244] have presented an algorithm for learning motion patterns where foreground pixels are first clustered using fuzzy K-means algorithm and trajectories are then hierarchically clustered based on the results of the previous step. Trajectory clustering is performed in two layers for spatial and temporal clustering. Each pattern of clustered trajectories is then assumed to be a link in a chain of Gaussian distributions, the parameters for which are estimated using features of each clustered trajectory. Results of experiments on anomaly detection and behavior prediction are reported.

In this chapter, we show how models encoding a priori knowledge, such as scene transition models, target occurrence models, and co-occurrence models (in single or

multiple sensors), can be learned from sensor observations and utilized to improve target detection, target tracking, target classification, inter-sensor calibration/geo-registration (refer also to Chapter 13), and target behavior analysis.

17.3 Smart Cameras for Target Detection

The difference in the appearance of objects from the background has been a widely used criterion for object detection. In addition to object appearance, history of activity in the scene as well as domain-specific knowledge also provide important cues that can be used to improve target detection. For example, at any given time, the regions in the scene that are typically seen vacant are less likely to show a foreground object than the regions that exhibit higher activity. Similarly, temporal persistence is also an intrinsic property of the foreground objects that can be used to determine if a given region is a foreground. Temporal persistence of an object implies that unless an object exits from the scene or becomes occluded, it has to either stay in the same place or move to a location within the spatial vicinity of the current observation. Given that a smart camera learns a model of observed scene activity as well as a model of the transition of observed objects from one scene location to another (e.g., joint probability density of starting and ending point of moving objects in the scene and the transition times), it can improve its detection performance over time using the learned behavior.

Formally, a typical background subtraction solution seeks to find the likelihood of a pixel u belonging to the foreground at time instant t. Let \mathbf{u} be a random variable which is true if and only if the pixel u is a foreground pixel. Also, let Λ be the appearance feature set used to model the background (for example, color/grayscale in appearance-based model) and $\Phi = \{\phi_1, \phi_2, \ldots, \phi_Q\}$ be the set of pixels detected as foreground at time instant $t - 1$, where Q is the total number of the foreground pixels in the previous frame. Then according to Bayes rule,

$$P(\mathbf{u} = true | \Lambda, \Phi) \propto P(\Lambda, \Phi | \mathbf{u} = true) P(\mathbf{u} = true). \qquad (17.1)$$

Assuming independence of appearance Λ and the foreground history Φ, we may write

$$P(\mathbf{u} = true | \Lambda, \Phi) \propto P(\Lambda | \mathbf{u} = true) P(\Phi | \mathbf{u} = true) P(\mathbf{u} = true). \qquad (17.2)$$

Typical background subtraction algorithms [485, 509] model appearance-based likelihood $P(\Lambda | \mathbf{u} = true)$ but ignore the foreground history term $P(\Phi | \mathbf{u} = true)$ as well as the prior $P(\mathbf{u} = true)$. Given that a scene transition model is learned from the scene observations, it can be used to extract these terms and improve the detection performance [463]. Figure 17.1 compares the detection performance with and without the use of a learned scene model. It can be seen that the use of a learned scene model decreases the number of false positives and results in true silhouettes

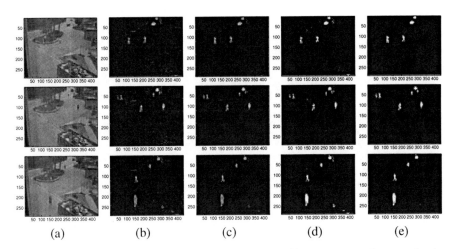

Fig. 17.1 Foreground modeling: each row shows an example of improvement on foreground probability estimation. (**a**) Original image, (**b**) probability map using only the mixture of the Gaussian's method, and (**c**) foreground probability map using the learned transition model in conjunction with the mixture of the Gaussian's model. Columns (**d**) and (**e**) show foreground masks obtained using the maps in (**b**) and (**c**), respectively. Columns (**b**) and (**c**) show an improvement of foreground probability modeling while (**d**) and (**e**) show a reduction in the number of false positives

that are much more pronounced. Such a scheme provides a simple and effective way of reducing errors and improving background subtraction and can tackle commonly encountered detection issues, for example, false alarms resulting from the motion of background objects.

17.4 Smart Cameras for Behavior Analysis

Scene models learned over sufficiently large periods of time, such as scene transition models [463] and target property models (Fig. 17.2) [441], encode the expected behavior (or normalcy) of the targets in the scene. Hence, these models can also be used to detect abnormal behavior or anomalies in the scene, which is a desirable feature for any visual surveillance system. Given a generative scene model, the anomaly detection algorithm may generate its own predictions for future states by sampling the model without using the current observation of the tracker [463]. The predicted tracks are then compared with the actual measurements of objects and a difference measure between them is computed. For example, let the set of predicted states of an object be $\Theta = \{\theta_1, \theta_2, \ldots, \theta_{i+1}\}$ and the actual measurements as observed by the tracking algorithm be $\Omega = \{\omega_1, \omega_2, \ldots, \omega_i\}$. Then the observed track described by Ω can be labeled as anomalous if $d_i > d_{th}$, where

$$d_i = \frac{1}{n+1} \sum_{j=i-n}^{i} \left((\omega_j - \theta_j)^T \Sigma_\Theta^{-1} (\omega_j - \theta_j) \right)^{\frac{1}{2}}, \qquad (17.3)$$

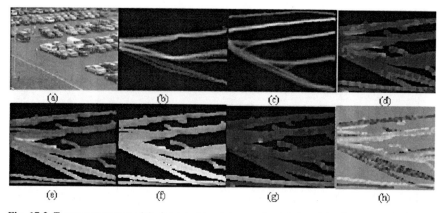

Fig. 17.2 Target property models for a parking lot scenario: (**a**) A parking lot scene, (**b**) human sightings model, (**c**) vehicle sightings model, (**d**) human width model, (e) human height model, (**f**) human size model, (**g**) human speed model, and (**h**) human direction model. *Blue* represents smaller values and *red* represents higher values

and Σ_{Θ} is the covariance matrix of x-and y-coordinates of all the potential (candidate) next states, n is the number of previous states included in the calculation of the Mahalanobis distance, and d_{th} is a predefined maximum difference between observed and predicted tracks. Such an approach is sufficient to find a sequence of transitions significantly different than the predictions from the state transition distribution and can easily identify an anomalous event in terms of motion patterns. Using this formulation trajectories that are *spatially* incoherent or *temporally* inconsistent with normal behavior can be identified, e.g., the presence of objects in unusual areas or significant speed variation, respectively. Increasing the value of n (Eq. 17.3) helps to detect suspicious behavior where activity is not necessarily unusual in either spatial or temporal domains but the object has been in view for a long time and error (distance between actual and predicted paths) has accumulated and crossed the d_{th} barrier. Hence the approach used for anomaly detection is able to identify several different kinds of anomalous behavior.

Figure 17.3 shows the results of the anomaly detection algorithm described above. In the top row of Fig. 17.3(a), a person walks through the paved region and then onto the grass. The algorithm separates this trajectory into typical and atypical parts. The light gray track shown in the figure is the track of concern, the dark gray track is the area where the prediction follows observations while dotted black shows the prediction once an anomaly is detected. Notice how the light gray track is closely followed by the dark gray one as long as it is a typical behavior. At the time of model learning, the dump trailer was at a different position resulting in classification of the track observed in the middle row of Fig. 17.3(a) as anomalous. The bottom row of Fig. 17.3(a) shows another *spatially* incoherent track through an area where no motion is usually observed.

The top row of Fig. 17.3(b) shows anomaly due to the unusual speed of a person riding a bicycle in an area where people usually only walk. The middle row of

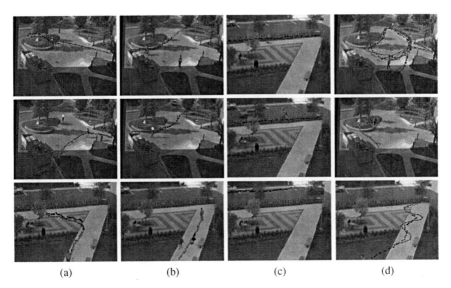

(a)　　　　　　(b)　　　　　　(c)　　　　　　(d)

Fig. 17.3 Results of anomaly detection: (**a**) Spatially anomalous, (**b**) and (**c**) temporally anomalous, and (**d**) suspicious behavior due to the presence over large distances or an extended period. *Light gray* track represents the actual (observed) track. *Dark gray* and *black* tracks correspond to typical and atypical (anomalous) *predicted* paths, respectively

Fig. 17.3(b) shows the results of the algorithm in another example where a person is running in the same paved area. Again, this behavior has not been observed in the tracks used for training purposes because people usually do not run around in this area. The bottom row of Fig. 17.3(b) shows a stopping action where a person sits down to tie their shoelaces. Three more examples of the second type of anomaly (temporal inconsistency) are shown in Fig. 17.3(c). The top and middle rows in the third column show two persons skating and riding a bicycle, respectively, while the bottom row shows a person walking on the road where usually only cars are observed. Since the speed of objects in Fig. 17.3(b) and (c) differs significantly from the average speed of objects during training, the prediction either lags behind as compared to the actual measurements from the tracker or hurries ahead resulting in the observed trajectory being labeled as anomalous. Three examples of the third type of anomalies are shown in Fig. 17.3(d). In the top row of Fig. 17.3(d) a person is walking slowly in a circular path for a few minutes. The motion pattern itself is not anomalous to the learned distribution, but the presence of the object in the scene for a much longer period of time results in an accumulation of *error* calculated as d_i using larger values of n in Eq. (17.3) and eventually becomes greater than d_{th} resulting in the classification of the sequence as an anomaly. The middle row of Fig. 17.3(d) shows a person jumping over an area which people usually only sit on. Even though the person is not present in the scene for very long, the error d_i quickly becomes significant due to the incoherence of his actions relative to the training examples. The bottom row shows a zigzag pattern of walking, a motion that has not been observed before, resulting in the classification of the trajectory as anomalous.

17.5 Smart Cameras for Persistent Tracking

One of the critical requirements for a smart camera-based surveillance system is the ability to track objects through long-term and short-term occlusions. Traditionally, parametric motion models, such as constant velocity or constant acceleration, are used in conjunction with appearance models to resolve the ambiguities between possible correspondences. However, appearance models and motion models tend to drift significantly as the duration of occlusion increases. In addition, parametric motion models usually fail when objects adapt arbitrary paths or when the actual motion is altered during occlusion by the physical constraints, such as physical path, doors, traffic lights. However, given enough observations of objects moving through a given scene region, these traffic patterns and behaviors can be learned by a state transition model $p(X, Y, \tau)$ [463] that encodes the joint probability of the object's initial and final state (X and Y, respectively) and the transition time τ. Such a model of traffic patterns is able to handle shortcomings of traditional methods even when occlusions are not permanently present in the scene, e.g., person to person occlusions, large objects like vehicles that hide smaller moving objects from view.

The goal of a persistent tracker is to find correspondences between successive instances of objects at any given time. This task proves to be very difficult when the color and shape distributions of objects are very similar or when the objects are in very close proximity of each other. However, given the learned state transition model $p(X, Y, \tau)$, a hierarchical use of transition density can be used to assign larger weights to more likely paths. Assume now that the observed measurements of m objects at time instant i are given by $\Omega = \{\omega_i^1, \omega_i^2, \ldots, \omega_i^m\}$ and the predicted states of previously observed s objects are $\Theta = \{\theta_i^1, \theta_i^2, \ldots, \theta_i^s\}$, respectively. We must find the mapping function from the set $\{\Omega_i^k\}$, $1 \leq k \leq m$, to the set $\{\Theta_i^l\}$, $1 \leq l \leq s$. To establish this mapping function, we use the graph-based algorithm proposed in [484], where the weights of the edges corresponding to the mapping Θ_i^l and Ω_i^k are given by the Mahalanobis distance between the estimated position θ_i^l and the observed position ω_i^k for each l and k.

In absence of measurements, the algorithm propagates the track based on samples from the distribution. Figure 17.4 shows two examples of tracks that have undergone erroneous labeling by a tracking algorithm using parametric motion model because both of them had considerable missing portions due to total occlusion. In the top row of Fig. 17.4, the tracker assumes that two objects walked toward the golf car and then returned to their original locations, which is not correct. Each of these tracks are propagated through predicted locations using the learned model to join the correct track. The result of propagation based on weighted mean of these samples is shown in top row of Fig. 17.4(b) and (c), where both tracks are separately shown for clarity. Dark gray and light gray intensities show two different tracks and the black color indicates the part where the trajectory has been stitched. The bottom row of Fig. 17.4 illustrates a similar example where a truck is obstructing the camera's view. Here again the objects had undergone total occlusion due to the truck obstructing the camera's view. Once again, the occlusion is successfully resolved using the learned model.

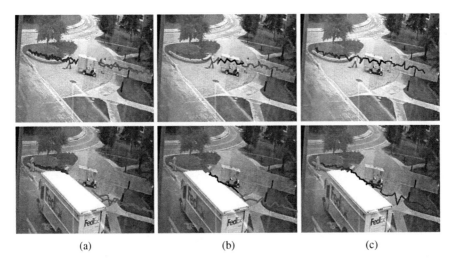

(a) (b) (c)

Fig. 17.4 For each row, (**a**) shows the observed tracks in *light gray* and *dark gray* that have been labeled wrong and (**b**) and (**c**) show the stitched part of tracks in *black* and the actual tracks in *light gray* and *dark gray*, respectively

17.6 Smart Cameras for Target Classification

Surveillance cameras need to classify the type of objects moving in the scene for monitoring activity and understanding threats. In urban monitoring systems, this task can be the categorizing of the detected object as a person, a group of persons, a vehicle, an animal, a bicycle, etc. In maritime scenarios, the classification task entails categorizing watercraft, such as small recreational watercraft (e.g., sailboats, dinghies, speed boats), commercial vessels (e.g., cargo ships, tankers, barges, tug boats, and cruise ships), and naval vessels (e.g., cutters and coastal patrol ships). In this section, we show how domain-specific prior knowledge and additional sources of information can be used to improve classification performance for maritime surveillance (Fig. 17.5).[1] In addition to imagery, a supplementary source of classification information for watercraft is provided by the *Automated identification system* (AIS). All vessels with 300 or more gross tonnage are required to provide AIS information. AIS information is readily available via an AIS receiver and can be used to learn both short-and long-term trends in terms of the number and type of watercraft moving in the area. The number of ship occurrences for each watercraft category, extracted from the AIS information collected for more than 6 months at a port in Florida, is shown in Fig. 17.6. It is clear that freight ships are the most frequent visitors to the port, while there are no instances of passenger cruise ships. The priors for occurrence as well as the mensuration features contained in the AIS

[1] The watercraft classification research presented here was funded by Office of Naval Research (ONR) SBIR funding, Contract No. N00014-08-C-0110. The sources of watercraft images include online ship databases and the watercraft imagery database provided by ONR

Barge Tugboat Cruise Ship Freighter

Fig. 17.5 Examples of the commercial watercraft categories

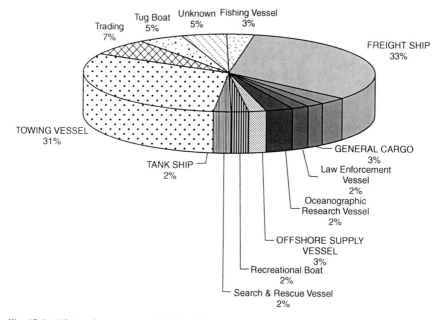

Fig. 17.6 AIS data from a port in Florida. Ships' occurrences vs. ship categories. Freight ships and towing vessels are the most common watercraft in the port. This information is plugged into the image-based watercraft classifier for performance enhancement

information are important cues that can be used to improve the accuracy of a visual watercraft classification.

To model watercraft appearance, we used a new set of biologically inspired features called "C2 features" [482] that exhibit a better trade-off between complexity and discriminative ability than commonly used Haar-based or histogram-based features. Each element of this set is a feature obtained by combining the response of local edge detectors that are slightly position- and scale-tolerant of neighboring positions and multiple orientations, i.e., emulating complex cells in the primary visual cortex. The C2 features are extracted by first computing a set of features learned from the positive training set. Then, a multi-class boosted classifier [191] is learned on the vector of features obtained from the input image. In addition to the C2 features we also evaluated the use of 3D mensuration data (height, width,

Category	No. of positive training examples	Precision	Recall
Cruise Ship	200	62.75	66.67
Freighter	200	70.00	81.16
Barge	60	51.43	85.71
Hovercraft	60	70.59	50.00
Coast Guard Cutter	100	62.50	52.94
Oil Tanker	60	42.19	45.45
Speed Boat	80	47.62	76.92
Recreational Boat	60	27.27	45.45
Canoe	60	11.54	7.69
Sail Boat	80	19.35	12.50
Pontoon	60	21.05	26.67
Tug Boat	60	70.83	73.91
Jet Ski	60	38.89	33.33

Fig. 17.7 Classification results for recreational and commercial watercraft categories using the multi-class boosted classifier. Only appearance features were used for classification

and length) of watercraft extracted from AIS data as features for classification. The classification results of the multi-class boosted classifier using C2 features only are given in Fig. 17.7. The first six classes belong to ships whereas the remaining seven classes belong to boats. Note that the classification was done based only on appearance information (C2 features) and AIS-based priors were not used in the analysis. The classification analysis for ships (watercraft of length/weight 40+ feet/tons) and recreational boats indicates that without mensuration information

- Freighters are easily distinguishable from the rest of the ships.
- Cruise ships are sometimes mislabeled as freighters or barges.

Category	Training Samples	Testing Samples	Appearance Only		Mensuration Only		Appearance + Mensuration	
			Prec.	Recall	Prec.	Recall	Prec.	Recall
Cruise Ship	320	77	61.63	74.65	57.58	74.03	87.80	97.30
Freighter	300	97	61.24	83.16	85.42	84.54	96.94	97.94
Barge	90	26	42.11	53.33	53.33	61.54	92.31	100.00
Hovercraft	66	30	42.86	18.75	72.22	44.83	93.10	93.10
Coast Guard Cutter	125	33	25.00	47.62	44.44	55.17	74.19	79.31
Oil Tanker	72	27	71.43	50.00	40.00	07.69	88.89	61.54
Sail Boat	130	38	43.48	60.61	24.44	28.95	55.32	76.47
Speed Boat	105	33	43.24	72.73	31.58	36.36	54.29	63.33
Tug Boat	130	39	55.77	78.38	65.71	58.97	76.19	86.49
Recreational Boat	80	27	25.00	25.00	23.08	22.22	80.00	48.00
Jet Ski	67	27	46.15	24.00	40.00	22.22	64.00	64.00
Pontoon	67	20	40.91	56.25	31.58	30.00	70.00	73.68
Canoe	90	26	22.73	21.74	18.75	23.08	51.85	56.00
Overall	**1642**	**500**	**44.73**	**51.24**	**45.24**	**42.27**	**75.76**	**76.70**

Fig. 17.8 Classification results for recreational and commercial watercraft categories using the multi-class boosted classifier. The overall precision slightly improves for mensuration-only features but the overall recall drops compared to the appearance-only features. By utilizing both appearance- and mensuration-based priors, the classification precision and recall improves significantly for all the watercraft classes

- Barges are often mislabeled as freighters, coast guard cutters, oil tankers, or cruise ships.
- Hovercraft are mostly mislabeled as cruise ships, freighters, or coast guard cutters.
- Coast Guard cutters are often mislabeled as cruise ships or freighters.
- Tankers are not easily distinguishable from the rest of the ships.
- Tug boats are easily distinguishable from the rest of the boats.
- Speed boats are sometimes mislabeled as recreational boats or canoes.
- Recreational boats are mostly mislabeled as speed boats or pontoons.
- Jet skis are mostly mislabeled as pontoons or canoes.
- Sail boats, pontoons, and canoes are not distinguishable from the rest of the boats.

Further experimentation was conducted using prior knowledge about 3D mensuration derived from AIS information. The classification results of the multi-class boosted classifier with prior information are shown in Fig. 17.8. It can be seen that prior domain knowledge significantly improves the classification performance compared to classifiers that only use image-based features.

17.7 Self-Calibrating Smart Camera Networks

Surveillance and monitoring of wide areas requires a network of cameras. These cameras may come from heterogeneous sources, such as Pan–Tilt–Zoom (PTZ) cameras, static surveillance cameras, and radars. In addition, the sensors may differ in their output characteristics, for example, visual, infrared (IR), hyperspectral. Analyzing this multi-modal data to achieve complete situational awareness and a global scene understanding requires sensor calibration, which provides the information about the arrangement of cameras in space and the interaction between the outputs of these heterogeneous sensors. Calibrating camera networks (refer also to Chapter 9) is important as it enables critical operational tasks, such as geo-registration, data fusion, and target handoff from one sensor to another. It also provides metric information, such as position, size, speed, and heading of the detected objects for high-level inference. It is therefore desirable to have an automated and efficient mechanism that can estimate topology of a given camera network, detect changes in the topology over time, and adapt to these changes accordingly.

There is a large body of work in the area of multi-camera tracking [261, 245, 285] that deals with the use of learned traffic models to estimate topology of a camera network. These approaches can be classified as either supervised [261, 285, 287, 439] or unsupervised [508, 310, 507, 352] based on whether or not they require training data or user supervision. Here, we use an unsupervised method to show how smart cameras can use scene models learned from observations to automatically determine and maintain their network topology [483].

Assuming that the area where targets move in the scene is planar (a fair assumption for most surveillance scenarios), the relationship between observations \mathbf{p} and \mathbf{q} of an object in two different sensors can be represented in terms of a homography

(given by a 3×3 matrix, say **H**), i.e., $\mathbf{p} = \mathbf{Hq}$. For a given pair of sensors, the simultaneous target observations in the sensors provide two complementary hypotheses, i.e., the observations either result from the same object in real world or are accidentally aligned. Multiple observations at the same (or nearby) locations of both sensors bolster the first hypothesis (note that they may also be a consequence of frequent accidental alignments), whereas the second hypothesis is strengthened if further observations in one sensor (at that particular location) do not coincide with observations in the other sensor (at the corresponding location). Thus, if a joint density of the target observations in a pair of sensors is learned, then the modes in the density represent the pairs of points in the fields of view of both sensors that most likely observe the same region in the scene [483]. These modes can be detected by using a mean-shift-based approach and weighted based on a measure of dependence between the two observations (for example, Pearson correlation coefficient) to handle cases where frequent accidental alignments of observations result in high probability of co-occurrence. Figure 17.9 shows two sensor views and the marginal probability densities (negative log of densities is shown for better visualization) with respect to each view. It can be seen that the densities capture the common area of activities very well. The top weighted and the lowest weighted modes from Fig. 17.9 are shown in Fig. 17.10(a) and (b). It can be seen from the figure that the top weighted modes coincide well with the true correspondences in the scene whereas the lowest weighted modes are misaligned. Once the most likely correspondences are identified, a homography between the two sensors can be esti-

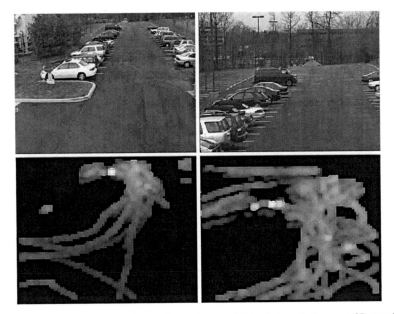

Fig. 17.9 *Top row*: Two camera views with overlapping fields of view, *Bottom row*: 2D marginals of the 4D co-occurrence densities with respect to x-and y-coordinates of each view

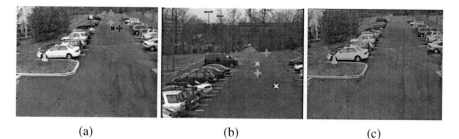

(a) (b) (c)

Fig. 17.10 (**a–b**) The top weighted (+) and lowest weighted (x) modes are shown as same grayscale corresponding points, (**c**) estimated view registration

mated using RANSAC-based methods. Figure 17.10(c) shows the aligned views of Fig. 17.9 using the estimated homography. Note that the proposed algorithm does not impose any constraint on the sensor type or modality and can be applied in a similar fashion with additional sources of information, for example, GPS/AIS data receivers, where the geo-coordinates provided by GPS/AIS data can be used to geo-register the cameras in the network [441].

17.8 Conclusion

In conclusion, we have shown the effectiveness of the use of priors derived from past observations and domain-specific knowledge to improve the performance of low/mid-level vision tasks. In particular, we showed how non-parametric models of transitions of objects in the scene as well as co-occurrences of observations across multiple sensors can be learned and exploited to enable smart visual surveillance systems. Examples of various applications, such as target detection and classification, persistent tracking, anomalous behavior detection, inter-sensor calibration, and geo-registration, are presented along with the experiments and results based on real data to validate the above claims.

Chapter 18
Camera-Based Automotive Systems

Massimo Bertozzi, Luca Bombini, Alberto Broggi, Paolo Grisleri, and Pier Paolo Porta

Abstract This chapter addresses the most important issues involved in the selection, installation, and calibration of a camera system onboard a vehicle, taking into consideration all the specific characteristics of the automotive environment and the requirements of the various applications.

18.1 Introduction

An extremely challenging application of artificial vision and smart cameras is visual perception onboard vehicles. The ability to perceive and understand the surrounding environment is of paramount importance for advanced driver assistance systems (ADAS), be they just warning systems to alert the human driver or autonomous systems directly controlling vehicle motion.

Environmental perception can be carried out, thanks to a great variety of different sensors and technologies (including cameras, laser, radar, sonar) but the processing of a picture can deliver an extremely rich quantity of information, much more articulated than with other sensors.

The integration of cameras on vehicles is indeed a topic that has been addressed for a long time; the first vehicle prototypes with cameras onboard were demonstrated in the late 1980s. At that time the main impeding factor was the limited processing power available for real-time image analysis. Other problems were indeed present, but computational resources kept researchers focused on the processing architecture rather than the sensor itself. In the last few years, on the other hand, computational constraints have been eased by the availability of sufficiently powerful and low-cost processing engines and a considerable effort has been put into the design of smart cameras that fit on vehicles.

A. Broggi (✉)
VisLab, Via G.P. Usberti 181/A, 43100 Parma, Italy
e-mail: broggi@ce.unipr.it

A.N. Belbachir (ed.), *Smart Cameras*, DOI 10.1007/978-1-4419-0953-4_18,
© Springer Science+Business Media, LLC 2010

An ever increasing number of vehicles have been equipped with cameras for environmental sensing within different research projects; on the industrial side, however, car manufacturers started with the integration of other technologies first, such as radars or sonars. The use of a camera on series vehicles is still currently limited to very basic applications, such as parking monitoring or night vision enhancement, in which no processing is performed: no automatic recognition is done, focusing only on image display.

As mentioned, on the contrary, research projects are actively pursuing the benefit of imaging, although the processing is definitely more complex and additional issues must be considered.

Functions such as detecting the driving lane or obstacles on the path, recognizing traffic signs, or localizing pedestrians need cameras installed on the frontal part of the vehicle looking forward, but each function has specific requirements on orientation, field of view, and sensitivity that must be carefully addressed and that are part of the camera selection and design process. Other applications such as parking assistance, blind stop monitoring, or junction management require cameras oriented differently, and – again – also specific considerations regarding the previously mentioned parameters.

Nonetheless, a primary constraint that is generally overlooked is the appearance and integration of the sensor in the vehicle. The sensor position must be carefully localized according to both functionality and style: Besides its obvious need to perform a given function, the integration of a new sensor must not be invasive, must not occlude the driver visibility, and must not alter the vehicle aesthetic aspect, yet providing enough evidence for the sensor to be perceived as a real value.

This chapter outlines all the technological issues, the setup constraints, and the calibration problems that must be considered when using applications involving the use of a camera onboard a moving vehicle. Additional problems, specific to the automotive environment such as vehicle dynamics, system temperature, environmental illumination, and camera vibrations, are also discussed and possible solutions highlighted.

18.2 Technology

This section gives an overview of the main technologies used in automotive applications to capture road images and feed the processing stage with relevant information. Camera selection – the first important degree of freedom when designing a vision system – usually requires to slightly change the parameters obtained from theoretical considerations to match the available models on the market. It is hard to evaluate theoretically how the performance of the final system is impacted by this choice. Mechanical constraints and price are other important constraints that have to be carefully considered when choosing a camera to develop an application for the mass market.

Common advanced driving assistant systems with typical camera features are summarized in Table 18.1.

Table 18.1 Common automotive applications with typical camera features

Application	Pedestrian detection	Lane detection	Obstacle detection	Traffic-signs recognition	Parking	Blind spot	Automatic headlight control
Sensor/camera (global shutter)	Thermal	Visible/NIR	Visible/NIR	Visible/NIR	Visible/NIR	Visible/NIR	NIR
Pixel resolution	320×240	VGA or greater	VGA or greater	VGA or greater	VGA or greater	VGA or greater	VGA or greater
Dynamic range	Thermal	Highest	Highest	Highest	Highest	Highest	Highest
Temporal resolution	At least 10 Hz	At least 10 Hz	At least 10 Hz	At least 10 Hz	At least 10 Hz	At least 10 Hz	At least 10 Hz
Technology	Micro-bolometer	CCD	CCD/CMOS	CCD	CMOS	CCD/CMOS	CMOS
Advantages	Day/night, no texture on targets	High S/N ratio	Low cost	Low cost	Low cost	Low cost	No smear
Limitations	Expensive, hot backgrounds	Night: smear	Smear or noise	Dynamic range	Ego-motion detection	Dynamic range	Dynamic range
Heads	Mono or stereo	Mono or stereo	Mono or stereo	Mono	Mono	Mono	Mono or stereo

18.2.1 NIR and FIR Sensors

Automotive cameras suitable for ADAS are designed to make processing system recognition tasks easier and more robust. This includes the use of special sensors able to capture radiations with wavelengths outside the perception range of the human eye. There are two main interesting ranges of frequencies used in automotive applications: near infrared (NIR) and far infrared (FIR).

NIR is the acronym used to indicate the electromagnetic waves with wavelength between 700 and 3000 nm. This radiation cannot be perceived by the human eye but is full of important information, especially during the night. Moreover, when the scene is illuminated with high beams emitting in the NIR range, humans in other cars do not perceive the dazzling[1] by the lighting system while vision systems can perform its detection on a fully illuminated scene. The NIR light is valuable, thanks to the different reflectivity of objects in this range. Scenes looking poorly illuminated in the visible domain have a good amount of information still available in the NIR domain. Thus, capturing and performing detections on these kinds of images usually lead to better results than using visible images.

Thanks to the physical silicon characteristics, most of the commercial/industrial devices already capture the NIR radiation and a filtering glass is inserted between the lens and the sensor to filter out the intensity content in this range in order to obtain images with more realistic colors.

Special fabrication processes may improve the sensitivity in the NIR domain. In these cases the visible contribution can be filtered out obtaining pure NIR images. Due to the visible cutoff filter, the amount of light reaching the sensor is strongly reduced, thus longer shutters and/or higher gains must be used to obtain a correct exposure. Images taken in the NIR domain are suitable for lane detection and pedestrian detection. Not all materials have a good NIR reflectivity. Some PVC (polyvinyl chloride) clothes adsorb this kind of light which makes the recognition task more difficult. This is a strong limiting factor to the use of this kind of images for pedestrian detection.

Far infrared is conventionally intended to be the spectrum of the electromagnetic waves with wavelength between 3 and 25–40 μm. Measuring the intensity of this type of radiation emitted by a body allows to measure its temperature. Range from 3 to 5 μm is sometimes also referred to as MWIR (medium wavelength infrared) while from 5 to 14 μm is named LWIR (long wavelength infrared).

Sensors able to produce a thermal image of the framed scene are used in aftermarket products for night vision driving assistants [322]. In a thermal image each pixel value is related to the temperature of the surface covered by the pixel projection through the lenses via a typical transfer function.

One of the interesting points about FIR in the automotive industry is related to the high air transparency of these wavelengths. Figure 18.1 describes how the air transmittance changes with the radiation wavelength. This function looks like a

[1] This solution can be unsafe for the human eye in proximity (0–10 m) of the car.

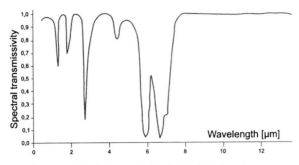

Fig. 18.1 The transmittance of the air has a window in the far-infrared range

sequence of high-attenuation and high-transmittance ranges. These ranges are called *atmospheric windows*. The transmittance in the LWIR range is high thus the radiation is not attenuated over a long distance. On the other hand, in the MWIR range a sensible attenuation occurs and makes air opaque for this radiation at distances of some tens of meters.

FIR images are used in automotive systems to detect pedestrians and animals, thanks to the different temperature of their body with respect to the background (see Fig. 18.2(a). However, limitations of this approach can be due to heavy clothes worn in winter – masking the human emissivity – and hot backgrounds during summer – where the background may be hotter than the subjects – as shown in Fig. 18.2(b).

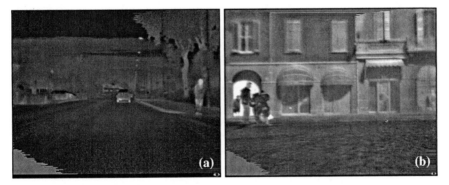

Fig. 18.2 FIR images allow an easy detection for pedestrians and vehicles in winter (**a**). In the summer scene (**b**) the pedestrian at left in the *right* image is cooler than the background gate

Although these systems are really effective for human detection at medium-low temperatures only, they are not widespread due to the sensor cost.

18.2.2 Color Sensors

The color information is important for the detection of structured elements such as vehicles, lanes, road markings, pedestrian crossings, traffic lights, and traffic signs.

A cheap way to obtain color using a single imager is to install on the top of each pixel a color filter. This way each pixel is exposed to a specific wavelength range depending on the color filter.

The most common solution is to use a Bayer pattern. Referring to a 2×2 pixel cell, four possible combinations of R, G, and B wavelengths are commonly used. Usually two pixels are dedicated to the green radiation since the human eye is more sensitive to this color; the other two are used to filter the red and blue components.

The color image can be reconstructed using different algorithms. These can be fast or accurate, depending on the needed accuracy and on the available computational power. The best reconstruction can be obtained by sub-sampling: each RGB pixel of the final color image is obtained directly from a 2×2 pixel in the raw image. Other techniques may show artifacts due to the spread of the color info over several adjacent pixels. A Bayer image uses one-third of a RGB image size; this is beneficial to reduce bandwidth during transmission. Software libraries can be deployed to perform transformations and detection directly on the Bayer image.

18.2.3 Global and Rolling Shutter

A sensor with a global shutter exposes all pixels at the same time. Each pixel integrates an amount of light coming from different portions of the framed scene at the same time. If the shutter is too slow, when the sensor is mounted on a fast moving vehicle, motion blur can occur. While in some situations like lane detection this can lead to a more uniform and easier image to work with, in other situations like obstacle detection it can lead to blurred and unusable images. A global shutter can be expensive since it requires high-speed electronics. A global shutter is typical for CCD technology.

On the other hand, a simpler alternative for CMOS sensors is a rolling shutter. Different areas of the image (often each line) are electronically exposed at different times. This can lead to image artifacts like skew for still images or wobbling for image sequences. These artifacts occur when the camera is moving or the framed scene contains moving objects. The results are as annoying for camcorder and consumer camera users, as they are unacceptable for image analysis, especially in automotive systems, since the constraint that the source image is taken at the same time is violated.

18.2.4 Multi-imager Sensors

Vision systems may use one or more sensors. A system with two imagers connected or integrated onto the same board and specifically oriented to frame the same scene but from two different angles is called stereoscopic. Such a system has an additional feature to be considered in the design phase: the baseline, i.e., the distance between the two imagers. Depending on the baseline width, the stereo head will be

tailored to detect objects at different distances: with a large baseline far objects are better detected while with a short baseline close 3D reconstruction is possible. If the sensors are mounted on the same, rigid mechanical bar a factory calibration can be performed to adjust the relative orientation. If the sensors are separated (such as in case of two separate cameras) inter-calibration problems may occur if one of the sensors loses its orientation.

Simple detection or recognition systems use one (monocular) single camera to capture the image stream that will be analyzed. This kind of system relies on the knowledge of camera orientation with respect to the world reference system to provide an accurate distance estimation of the detected objects. If the camera is mounted on a moving vehicle, its orientation changes continuously, depending on many variables like bumpers response, vehicle speed, or road roughness. An accurate stabilization system, which may be obtained by analyzing the acquired images or using other sensors such as inertial measurement units (IMU), can help make the system more robust to many of these changes. However, this is true only on flat grounds. The estimation of road slope is possible for monocular systems only if additional assumptions are made, such as constant road width or specific lane markings structure. Stereo systems, on the other hand, can provide distance estimation even on non-flat terrains. Other features like road slope and instantaneous pitch can be detected from the processing of a stereo pair. The drawback of this technique is the high cost involved in duplicating the sensor, keeping it calibrated, and providing additional computing power. Systems with more than two heads have also been designed for very specific applications [82].

18.2.5 High Dynamic Range

The brightness of an automotive scene can range from 0.1 to $50000\,cd/m^2$. With current sensors it is not possible to capture this dynamic range[2] in a single shot. An alternative, and cheaper, way to work with high dynamic range (HDR) images is to take different shots, two for instance, with different shutter values, one underexposed and one overexposed, and then use an algorithm to merge them together in a unique image with an extended dynamic range.

The shots can be taken using different sensors or the same sensor. When using different sensors, the images must be taken at the same time, so that moving objects are in the same position in both images. Unfortunately, this technique is expensive since it requires two sensors with exactly the same orientation. Moreover since the two sensors are not in the same position but skewed at least along one axis, some artifacts will appear in the final image. For these reasons the other technique is preferred, i.e., taking the images from the same sensor but at different times; this is commonly done to take HDR pictures of still scenes. In the case of automotive

[2] Dynamic range is intended to be the ratio between the greatest amount of light to produce the brightest pixel and the least amount of light to produce the darkest pixel within the same frame.

applications the movement of the camera is an even worse source of artifacts, since two consecutive images will indeed frame the world from two different points of view regardless of moving or still objects. In the next few years the market will see the introduction of new CMOS sensors where the pixel response can be different in different areas of the image, which is useful especially in challenging illumination conditions such as entering or exiting tunnels and with strong shadows.

18.2.6 Frame Rate and Processing Rate

Automotive systems need to respond in the shortest amount of time possible to the situations they are designed to recognize giving the driver or to the actuation system the longest time possible to actuate the proper countermeasures. This requires to sample the world at a sufficiently high frequency. Obviously there is not a unique rule to compute this frequency, and the solution is a trade-off between different constraints, one of the most important being the cost. Vehicle speed and motion type – such as rectilinear, curve, or abrupt maneuver – can strongly influence the requirement of more samples per second. On the other hand, the processing system should have enough computational power to run the algorithm fast enough to utilize the amount of data produced by the sensors. This, especially for images and depending on the resolution, creates the need for a new generation of processing units able to supply the proper processing rate. A specific generation of embedded processing chips is needed to match the difficult constraints of the ADAS market: high computational power, minimum need of external components, low power consumption, large temperature range, large shock resistance, and finally small size to be directly integrated into the smart camera.

18.2.7 Optics

Besides the sensor, optics are primarily responsible for image quality. Depending on the focal length, the optic will introduce some geometric distortion in the image. This distortion can be removed using a lookup table obtained from accurate theoretical models or from experimental measurements. The experimental solution is preferable since it delivers more accurate results for the whole system.

The amount of light captured by the lens is important in night applications. Also NIR-only systems should use bright lenses to compensate for the visible filter attenuation. When choosing lenses, size, cost, and the amount of light (f number) should be carefully considered.

High-definition sensors with a large size (1/2" or more) require finding an appropriate lens which is able to cover the entire sensor area, as otherwise vignetting[3] phenomena might occur.

[3] Vignetting is a noticeable gradient within the image brightness. The image has a high brightness near its center which decreases in the peripheral areas.

Depending on the glass quality, lenses have an optical resolution. Resolution is the capability of an optical system to distinguish between two adjacent points. The lens quality must be selected appropriately according to the sensor. High-definition lenses help to resolve details which are needed for the detection of far features (such as traffic signs or pedestrians).

Optics usually have a few regulation gears for focus or iris aperture. In automotive environments, locking screws for these gears are useful to contrast unwanted movements due to vibrations. Any change in focus or iris causes a variation of the aperture angle and likely a movement of the optical center over the sensor. To avoid calibration problems, in extremely harsh environments or for series production, fixed focus and fixed iris are preferable. Adjustable optics are useful in prototyping phases.

18.3 Setup

This section gives an overview of the main problems and constraints in the system setup for automotive applications.

Typical problems of artificial vision systems, such as background noise, camera movements, illumination conditions, and characteristics of the target to detect, are amplified in the automotive field. Unlike industrial applications or video surveillance systems, the scenario changes continuously, the camera is on the move, the vehicle is subject to vibrations and oscillations due to road coarseness, some targets like pedestrians can only be defined in a statistical and non-exhaustive way. Moreover the area for system wiring and sensors positioning is very limited and usually a camera-based system must be connected to other vehicle sensors or devices.

For these reasons, the setup design is one of the most complex challenges in the implementation of a complete system. System designers have to consider the constraints discussed in the following section.

18.3.1 Functionality

A wide range of ADAS are currently available on the market and others will come out shortly [404]: adaptive cruise control, all-round-view, collision warning and auto break, pre-crash safety, lane departure warning, lane keeping assistant, stop-and-go assistant, blind spot detection, lane change assistant, and night vision.

The hardware setup strongly depends on the specific functionality. Some of these systems like Lane Departure Warning or Blind Spot Detection require a simple hardware setup: one smart camera connected to an integrated display on the vehicle. Other systems like Stop-and-Go or Collision Warning and Auto Break require a more complex setup: a stereo system or a sensor fusion with other devices.

ADAS providing complex pre-crash features, such as pedestrian detectors, require a more complex design since they need to process data from several sensors which

might already be used for other purposes – such as a single wheel speed detector for ESP (electronic stability program) – to perform their task.

For multi-sensor systems synchronization must be ensured to avoid artificial data re-alignment inside the ECU (electronic control unit). Synchronization must be supported by sensors and is usually distributed as a square wave triggering the sampling instant. If sensors only supply a strobe signal, a robust time stamping inside the ECU is required in order to allow real-time data alignment. Data alignment can be problematic from some sensors like forward-looking cameras.

18.3.2 Technical Feasibility of Device Positioning

In the prototyping phase, the sensors installation must follow a feasibility analysis. During this phase, constraints like installation cost and system performance must be considered together with aesthetics or ergonomics. The perception system components can be placed all around the vehicle depending on the application without limiting the visibility for the driver and can be placed both inside or outside the cabin.

These choices are driven by both the target application and technological issues. Inside the cabin the camera is protected from rain, snow, and dust but has to follow some aesthetic and ergonomic constraints. Moreover, modern heat-treated windshields filter the near-infrared wavelength causing loss of information if the system use an infrared camera sensor. This problem can be solved in different ways such as replacing the windscreen or changing the camera position outside the cabin.

Far-infrared cameras cannot be placed inside the cabin since glass is opaque to these wavelengths. Figure 18.3(a) shows an example of FIR camera integration. However, an outdoor installation has to cope with environment-related problems such as cleaning the device, waterproof resistance, and in some cases shock resistance. Devices mounted in peripheral positions – such as behind the bumper – need a protection system from shocks. Figure 18.3(b) shows a possible solution for the camera setup in a Start-Inhibit system on a truck [84].

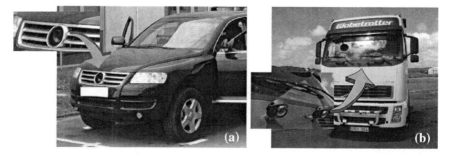

Fig. 18.3 Example of integrating of a FIR vision system: an infrared camera is mounted in a central position in the front of the vehicle (**a**). Integration of a stereo vision system on a truck (**b**)

18.3.3 Wiring and Positioning

Device positioning and wiring have to be carefully considered if needed. As discussed in previous sections, ADAS systems require extremely small cameras that are suitable for integration with low impact inside the car and reasonable processing power to perform recognition task. For these reasons, industrial smart cameras including sensor and processing unit in one enclosure are still not sufficient for ADAS applications. A good solution is to keep the vision sensor and a compact processing unit separated and connected by some robust interface, such as Ethernet, firewire, or USB cables. Is this way the embedded processing unit of appropriate power can be placed more freely on the vehicle where there is space available. Some systems may have the ECU placed in proximity of the sensor and produce the results – such as driver warnings – directly there. However, if sensors are placed outside the cabin, connection cables between the sensor and the ECU must be placed taking into account problems such as temperature range, electromagnetic interferences generated by the engine, and thermal noise, all of which cause signal degradation. These problems are critical if the signal has a high frequency, such as for high-resolution or high frame rate cameras. Differential buses such as CAN (controller area network), firewire, or LVDS (low-voltage differential signal) provide the necessary robustness for communication.

18.3.4 Lighting Control

During day, scene illumination is determined by weather conditions. When the camera is placed inside the cabin, internal illumination can cause reflections on the glass (see Fig. 18.4(a)); to avoid this effect a small black chamber can be installed around the camera (like the one in Fig. 18.4(b)).

Fig. 18.4 Color image acquired by an onboard camera with reflections in the bottom (a). A possible solution to protect the camera sensor from reflections (b)

At night, on the other hand, illumination is poor even with a NIR camera and the system requires a proper illuminating hardware (with respect to the camera

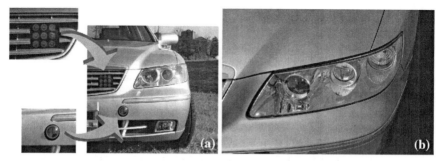

Fig. 18.5 Two different types of near-infrared lamps installed on an experimental vehicle (**a**). Night vision lighting system composed by low/high beam light to the *left*, NIR lamp in the *middle*, and parking light to the *right* (**b**)

sensitivity spectrum). In Fig. 18.5(a), the setup with two different NIR lamps is shown. In Fig. 18.5(b) the NIR illuminator has been integrated within the head lamp assembly.

18.4 Calibration

Camera calibration is one of the main issues in machine vision applications. In general calibration provides a correspondence between the results of an algorithm and the real world. It is a hard link between the software and its application.

The calibration process consists in finding the extrinsic and intrinsic parameters of a camera; the former being the camera position and orientation, the latter being the internal parameters, i.e., focal length, optical center, etc.

In the literature many algorithms for camera calibration have been proposed for monocular systems [537, 559, 593], stereo systems [599, 306], etc., but many of them are linked to some particular hypotheses that ease the calibration step; usually these hypotheses are not verified in automotive environments, for example, short distance perception, still scenarios, or still camera.

Calibration assumes a particular importance in stereo systems, or in general in systems that involve more sensors; in fact, when a monocular system is affected by a miscalibration, its results are projected in wrong real-world coordinates; therefore, the last step of the processing is degraded. On the other hand, when a multi-sensor system (such as a stereo system for example) is affected by miscalibration, the correctness of the whole processing is compromised since it gets deeply degraded by wrong information matching between the sensors.

The most common way to perform calibration in an automotive system is to use a large calibration grid as, for example, the one shown in Fig. 18.6. Through a calibration tool it is possible to pinpoint all the known 3D world points in the image thus performing an association; then the calibration parameters can be extracted. Figure 18.7 shows one of these tools: the acquired image is shown on the left-hand side while its corresponding view of the world coordinates is shown on the right.

Fig. 18.6 On the *left*, example of an automotive calibration grid available at VisLab (http://www.vislab.it). Each grid point is indicated by two nails: a *yellow* plastic one, used for visible cameras, and a metal, light reflecting one, to calibrate FIR cameras and visible cameras at night. On the *right*, chessboard used for calibration for indoor applications

Fig. 18.7 A handy camera calibration tool developed by VisLab

18.4.1 Mechanical Issues

During the prototyping phase cameras have to be placed with many degrees of control. It is important to choose a good trade-off between comfort during camera adjustment and robustness of the system itself. To perform camera orientation in the best way, the choice of an appropriate camera mount is fundamental. In many applications it is useful to have all three axes available. On the other hand, the more degrees of freedom are available, the more the camera can be moved by vibrations or other mechanical causes. However in the final configuration, cameras will be fixed into a rigid camera mounts to improve robustness and stillness. The first step with adjustable camera mounts is useful because for some applications a particular orientation relates the system to under specific hypotheses that can be used to simplify the algorithm and speed up the computation process [83].

Once calibration is achieved, it must be kept throughout the whole product lifetime. Otherwise, either an automatic or manual procedure mustbe made to

compensate for drifts. In case of an automatic procedure, the system periodically checks the system calibration and runs a recalibration algorithm if needed. In case of a manual procedure, the system, once a miscalibration has been detected, can either offer a simple recalibration procedure to the end customer (e.g., drive on a straight road) or suggest to approach an authorized garage for a recalibration by means, for example, of a grid.

There are some mechanical issues affecting calibration that have to be considered: vibrations, for example, are very critical in automotive applications, especially with trucks. The choice of the optics is critical as well, since the optical center is different from the image center. The optical center is one of the intrinsic parameters that has to be extracted with the calibration procedure. In particular, if a focus adjustment is needed after recalibration, this will result in a change of the intrinsic parameters: focal length and also optical center position can change. The former is a direct consequence of focus adjustment while the latter is a result of imprecisely mounted optics on the sensor. In fact, if the lens axis is not perfectly perpendicular to the sensor plane, then the rotation movement can cause a movement of the optic center.

18.5 Specific Automotive Issues

Camera-based automotive systems have to face issues specific to the automotive domain. The main issue is due to the fact that cameras are installed on moving vehicles and therefore the vision system and its related processing steps must be robust with respect to vehicle movements. In most cases, the vehicle's ego-motion must be taken into account. Besides ego-motion, also other kinds of movements like vibrations or oscillations represent a source of noise for vision-based systems.

Other issues are related to specific environmental conditions in outdoor environments. In fact, temperature and illumination conditions can vary and can be barely controlled. Especially for illumination, extreme situations like direct sunlight or strong reflections must be taken into account. In addition, other light sources, such as car headlights or reflectors, might be present in a typical automotive scene.

Specific camera issues related to the automotive environment are summarized in Table 18.2.

Table 18.2 Common automotive applications with typical camera features

Issue	Ego-motion	Oscillations and vibrations	Illumination conditions
Properties	Moving background, perspective changes	Noise overlapped to ego-motion	Object texture changes, bad reflections
Impact	Motion blur, object changes	Tracking problems	Camera dazzling, bad recognition
Workaround	Faster shutters, better processing	Better ego-motion detection	Better processing, higher dynamic range

18.5.1 Vehicle Ego-Motion

When the vision system is installed onboard a vehicle, it has to be robust with respect to vehicle movements. This design issue can be examined at two different levels: vision devices (i.e., cameras configuration) and processing (algorithms).

Concerning the cameras, some technologies are not robust to motion artifacts and moving objects are blurred in acquired images. This effect is particularly evident when the vehicle makes a sharp turn and the whole background begins to move. Figure 18.8 shows the effect for a FIR camera.

Fig. 18.8 An example of motion blur in FIR images acquired by an onboard vision system: the *left* image was captured when the vehicle was still, while the *right* photograph was taken only a few seconds later – when the vehicle turned *left*– and shows a heavy horizontal motion blur effect

While blurring can even help in some scenarios and for specific vehicle movements by hiding unnecessary details, generally it has to be avoided. Therefore, a careful camera selection is a mandatory step in designing the setup. Specifically, old CMOS-based cameras more likely feature a slow sensor and, thus, can be affected by this problem. Conversely, the effect is not appreciable for CCD-based cameras and, generally, in recent CMOS models.

Vehicle movements, namely ego-motion, must be considered as input for many image processing algorithms. The computation of ego-motion for a vision system can be performed using machine vision techniques like the analysis of background movements or visual odometry [146]; however, these techniques require additional computing and are not always applicable, in such cases added (and often expensive) sensors like gyroscopes, odometers, or inertial devices are generally used.

18.5.2 Oscillations and Vibrations

Oscillation and vibrations have been already discussed from a mechanical point of view for calibration; in this section, specific issues for processing in automotive applications are covered.

Besides tracking, other vision-based applications are affected by vehicle movements as well. In fact, many systems rely on calibration to recover 3D information or to detect objects. Unfortunately, vibrations or oscillations, induced by normal vehicle functioning, affect calibration and may lead to incorrect results.

Therefore, image stabilization techniques are widely used to cope with this problem. In some cases, this can be done during the acquisition step, since some cameras feature image stabilization at sensor level. Another hardware-based solution is the use of electromechanical stabilization platforms [469] or lenses-based mechanisms [93]. These approaches are generally effective for suppressing really abrupt movements but are less suited for removing the specific range of movements due to oscillations or vibrations typical of the automotive field [68].

In most situations, a specific processing phase devoted to removing this source of noise has to be developed. This is a difficult task, since only unwanted vision system motions have to be removed, while the motion components due to vehicle ego-motion have to be preserved.

Vibrations and oscillations are considered the *high-frequency* component of global motion and therefore image stabilization can be applied in an attempt to smooth inter-frame motions. In specific situations, this task can be simplified in order to remove critical noise components only; in fact, the definition of *unwanted motions* can depend on the specific application; as an example, pitch variations can highly affect distance estimation for monocular systems which often relies on the vertical features positioning in the acquired images to estimate distance; in such a specific case only pitch deviations should be removed to avoid wrong distance estimation [68]. Conversely, in a stereo system, distance can be computed exploiting 3D triangulations but, at the same time, a large number of stereo vision-based systems are based on the assumption of a null roll. In such cases, pitch oscillations barely affect the processing while roll variations have to be compensated.

An image stabilization process is generally divided into two different steps: inter-frame motion detection and motion compensation.

In the first step, most systems exploit feature detection and tracking to recover motion. Again, the nature of the features to extract highly depends on the stabilization requirements: for simple stabilization techniques or when real-time constraints apply, simple features are generally extracted like edges [68]. More complex features, like lane markings, are used when a more precise stabilization process is required [315].

A different approach for motion detection is based on the use of dense matching techniques like image disparity or optical flow computation.

The motion compensation stage is used to compute the roto-translation which is applied to consecutive frames to minimize noise introduced by vibrations and oscillations. In simple cases, it is based on a low-pass filter to remove high-frequency components of movements, but also more complex approaches that exploit supplementary information on the scenario, like object or background position, are widely used.

18.5.3 Illumination Conditions

In the automotive environment, illumination can be barely controlled and therefore represents a major issue.

In fact, weather conditions, the different sun positions, and artificial light sources such as headlights or street lamps highly affect scene illumination. This is true for daylight or near-infrared cameras, while in the case of far-infrared cameras the problem arises only in extreme situations like direct sun framing or when light sources also produce thermal effects. Shadows represent a critical issue for image acquisition and processing; in fact, the simultaneous presence of shady and fully illuminated areas in the scene may lead to acquiring images in which shady areas are too dark or illuminated objects are too bright. Moreover, shadows represent a pattern that can interfere with the image processing systems based on pattern matching techniques. One case, in which shadow's presence indirectly impacts on FIR domain as well, is due to thermal effect that light can have. In fact, sun or even artificial lights increase the temperature of objects exposed to lights creating *thermal shadows*; Figure 18.2(b) showed this effect on the wall below the tents, which is colder than the other portions of the wall that are heated by the sun.

In addition, vehicle movements can lead to abrupt changes in illumination conditions. The worst situation happens when the sun is suddenly framed or exiting/entering a tunnel, making the entire image completely dark or white.

In such cases, cameras that have a fast automatic exposure control (AEC) are recommended. AEC acts on both camera gain and control to compensate global illumination changes. Since a large gain value introduces noise at camera sensor level, it would be better to have a system that primarily acts on the shutter trying to maintain a low gain value; in addition, such a system can avoid to monitor the whole image reducing the area used for exposure control to the one actually processed. Figure 18.9 shows the result of an evolute exposure control algorithm that has been conceived to compute the most suitable exposure for the lower portion of the image, since the area of interest is the road and not the sky. In this case, the pedestrian can be recognized, while the computation of the exposure using also the upper portion of the image would have left the road completely dark. This requires a camera that features inputs for controlling gain and shutter like most IEEE1394 or IP-based cameras or a smart camera with some processing inside.

18.5.3.1 Smear Effect

The *smear effect* is another artifact degrading image quality for cameras in the visible domain: a strong light that directly hits the sensor in low illumination conditions produces bright artifacts, especially vertical bright lines (see Fig. 18.10(a)). This effect is typical for visible cameras and, in the automotive environment, can be easily caused by reflectors or other vehicles' headlights at night or inside tunnels. This effect represents a source of noise for image processing leading to wrong results, i.e., a lane markings detection system, that is typically based on the detection of

Fig. 18.9 Example of automatic exposure control obtained by defining a specific area (matched with the application) in which the contrast and brightness should assume optimal values

Fig. 18.10 Smear effect in (**a**) visible cameras and (**b**) NIR devices

bright lines on the road surface, can be fooled to interpret smear effects as lane markings.

Smear effect is caused by internal reflections inside the camera and lens system and is lower at the infrared wavelength. Therefore, near infrared cameras are less affected by this problem (see Fig. 18.10(b)) and can be evaluated as a replacement for standard daylight cameras in many situations.

18.5.3.2 Reflections and Glares

Reflection represents another source of problems for onboard systems.

The worst case is due to strong light reflections that dazzle the camera and lead to saturated images, but also weak reflections can create artifacts in acquired images. As an example, Fig. 18.11 shows how a wet asphalt road behaves as a mirror in

Fig. 18.11 Reflection of a wet surface for far-infrared radiations

the FIR domain and produces ghost pedestrians in the acquired image. In order to reduce reflections, a polarized lens can be used for cameras.

18.6 Concluding Remarks

Indeed the use of cameras onboard vehicles opens a great deal of opportunities to provide the vehicle itself with full awareness about the surrounding environment. Cameras have the capability to record many details – even small ones – of the environment and are based on the same technology used by humans when driving. Unfortunately, although cameras may achieve a resolution and sharpness higher than the human eyes, there are still issues to be solved: mimicking the driver requires not only the ability to process iconic data like images at a high frame rate but also the capability to select the important parts of the scene, which – in turn – may require moving/rotating the head as well. In the case of the electronic driver, this might lead to either move the camera or fuse the information coming from different cameras around the vehicle, pointing at different directions.

The issues discussed in this chapter also clearly show that developing a smart camera for the ADAS market is a difficult endeavor. In fact, it is mandatory to match specific constraints and, in particular size, processing power, and reliability that the current technology can provide have to be still improved for an effective deployment for smart cameras in the automotive scenario.

Cameras have the great advantage over other sensors, such as laserscanners, that nothing is moving inside the box, and adding mechanical parts to move the box would translate into degrading their applicability for harsh environments. Besides requiring additional hardware, power, and connections, changes in camera orientation may result in losing the sensor calibration in case the mechanics are not precise enough; therefore, the cost of a robust gazing system might be comparable – if not higher – than a solution based on multiple cameras.

The last solution, based on the integration of multiple cameras, is indeed preferred in off-road applications where vehicles are subject to heavy and strong vibrations, therefore, requiring a much stronger and ruggedized – and hence expensive – gazing mechanics.

Another great advantage of cameras is that they are based on a passive sensing technology and are therefore specifically preferred for military purposes.

Much like the other sensors, cameras require a calibration before being able to deliver information that can be registered with the environmental reference system. Other sensors like laserscanners require proper positioning and orientation since all their measurements are used for environmental reconstruction (due to the limited number of samples of the 3D scene). On the other hand, thanks to the high resolution of imaging devices, even if the camera is not perfectly aligned, data can be manipulated (the image is rototranslated), compensating for small orientation errors. In other words, a laserscanner oriented toward the ground will always yield unusable data, while a camera might still be able to provide images that – after a specific preprocessing – can contain meaningful data.

This preprocessing step, aimed at compensating for small errors in camera orientation, is performed on each image acquired by the camera, with parameters defined after installation. However, some vision systems are able to recalibrate themselves on the fly, recomputing the preprocessing parameters in order to compensate also for drifts in the orientation due – for example – to strong vibrations or accidental camera movements.

Finally, camera installation has another great advantage over other sensors: radars or laserscanners need to be positioned in front of the vehicle, typically in or near the bumper; this forefront position allows to acquire data without any occlusion caused by vehicle parts. However, unintentional small bumps against obstacles or other vehicles during parking maneuvers or dirt and rocks thrown by the preceding vehicle while driving at high speeds may damage the sensor. Cameras, on the other hand, are generally installed inside the cabin, behind the windshield, thus, besides being automatically protected against bumps, rocks, or dirt, they are also kept at an ideal operative temperature. Moreover, in some installations the wiper keeps the glass in front of the cameras clean when it rains.

Unfortunately cameras suffer from the main problem that affects human drivers and which is usually one of the causes of accidents: bad visibility. During fog or heavy rain – and also in particularly bad illumination conditions such as the sun low on the horizon and in front of the sensor – the cameras cannot deliver meaningful data. Some wavelengths, such as far infrared, are able to penetrate fog and light rain, but generic daylight or near-infrared sensors cannot.

As concluding remark it is important to note that due to their potentialities, low cost, and high range of applications cameras offer very promising possibilities; nevertheless cameras alone may not be able to disambiguate and correctly perceive every situation. For example, a textureless wall in front of the vehicle is barely perceivable, just like a gray obstacle on a gray background. To be sure to successfully handle every single situation, data fusion with other sensors based on different perceiving technologies is mandatory.

Part VII
Smart Camera Markets

Chapter 19
Market Demands and Analysis

Bernhard Kohn and Raffael Binder

This chapter gives an overview of the current market of smart cameras and future demands. Most of the information is based on two market studies and a survey conducted among smart camera producers and distributors. The chapter is separated into five sections: Section 19.1 starts with a short review of recent developments in the vision and smart camera market. The following section discusses the smart camera types, develops a classification system, and provides typical examples of these models. An analysis of the vision market of today in general, as well as the smart camera market in particular, will be shown in Section 19.3. Typical fields of application will be described in Section 19.4. Finally, Section 19.5 discusses the demands of smart cameras used nowadays and special economic demands connected with business in these areas.

19.1 Introduction

To visualize the current situation of the smart camera market and the technological status quo and its near future it is necessary to take a look at the development of the overall machine vision market. These data will give a first impression of the growth of the smart camera market and its applications.

The *European machine vision association* (EMVA) has been creating annual reports of the European vision technology market since 2005. Figure 19.1 shows the German vision market development from 1998 to 2008. Germany is the leading supplier in Europe (35% of the total sales of all European companies in 2007 [170]) and hence a representative country to illustrate the overall market development. The industry had its maximum turnover growth in 2000 with a rate of 28% and an average market growth of 13%.

This development shows the ongoing growth of the machine vision market for the past 10 years. The weak result in 2007 ($\sim 3.5\%$) can be explained by the worldwide

B. Kohn (✉)
AIT Austrian Institute of Technology, Austria
e-mail: bernhard.kohn@ait.ac.at

A.N. Belbachir (ed.), *Smart Cameras*, DOI 10.1007/978-1-4419-0953-4_19, 341
© Springer Science+Business Media, LLC 2010

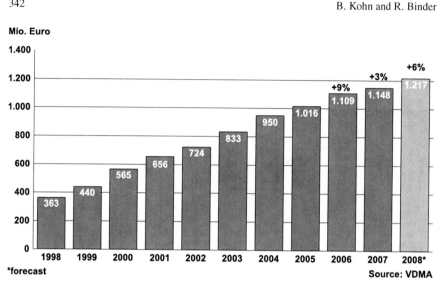

Fig. 19.1 Industrial vision Germany, total turnover (home + abroad) from 1998 to 2008 [170]

economic crisis. The EMVA study [170] also reveals some changes in the use of machine vision. A trend goes "... towards simple standard systems such as vision sensors or smart cameras ..." [170]. Despite a weak turnover growth of 3.5% the "... units sold by the European suppliers increased at 19% in total ..." [170].

The Annual Machine Vision Market Study 2008 [29] conducted by the AIA supports the findings of the European data even for smart cameras. "Smart cameras are the newest and fastest growing market in *Machine vision* (MV)" [29]. The North American market shows an increase of turnover for smart cameras from $58.6 million (USD) in 2003 to $116.6 million in 2007 [29]. The relative turnover growth decreases from 43.3% in 2003 to 2.1% in 2007 for the smart cameras market and an average turnover growth of 24.6% in the past 5 years.

This leads to the conclusion that the average growth rate of the smart camera market is better compared to the overall machine vision market. But it is also dramatically influenced by the current economical situation.

19.2 Overview of Smart Camera Models

19.2.1 Classification

To be able to give an overview of the smart camera models it seems to be important to establish a smart camera classification system. There are different ways of defining a smart camera and classifying the different models.

Yu Shi [488] makes a distinction between "stand-alone smart cameras," "non-stand-alone smart cameras," and "networked smart cameras." See also Chapter 2 for a more detailed look at the topic of smart camera classification. The AIA on the other hand defines the smart camera market in terms of three types of products: smart cameras (a.k.a. intelligent cameras), vision sensors, and embedded vision processors (a.k.a. embedded vision computers and compact vision systems) [29]. The term "vision sensors" is mainly used in the machine vision area and refers in this context mostly to lower-end smart cameras. EMVA defines smart cameras as follows: "A smart camera with embedded intelligence, such as a microprocessor, DSP or FPGA, which can be programmed to make the camera behave like a configurable frame grabber-based PC-system. It includes the compute functionality required to execute vision algorithms within the camera body itself" [170]. The EMVA study also distinguishes between smart cameras and vision sensors as it is done in the AIA study, although there are subtle differences between both definitions.

At the trade fair Vision 2008[1] in Stuttgart, Germany, a survey was conducted by the authors among smart camera producers and distributors. A very astonishing result was that there is no common definition for the term "smart camera" in the producers'/distributors' vocabulary. Typical labels were "vision sensor" and "intelligent camera," but sometimes used for very similar products. In some countries, such as Japan, it is also common to call a smart vision box connected to standard cameras a "smart camera," as Dietmar Buxbaum, CEO of Buxbaum Automation, points out.

So it is obviously difficult to categorize the smart camera models on the market in such terms. Another possibility to categorize smart cameras could be based on the internal architecture. But as the development of embedded systems is rather fast-paced no lasting characterization would be possible on this base. After analyzing the survey administered at the trade fair, there seem to be four main questions an end user may ask himself/herself (independent of the image processing problem he/she has to solve):

- Can I connect directly special input/output devices for fast setup (e.g., touchscreen, keyboard, monitor, mouse)?
- Do I need a personal computer for configuration?
- Do I need to develop special image processing algorithms?
- Can I connect special input/output devices for communication and programming (e.g., touchscreen, keyboard, monitor, mouse)?

These questions can be mapped to a space of two dimensions. The space differs in one dimension between configurable systems versus programmable systems and on the other dimension between embedded and PC-like systems. "Embedded" stands for a smart camera, which needs an additional PC for configuration purposes. "PC-like" systems are a kind of stand-alone smart camera, equipped with a touchscreen or keyboard/monitor for communication/configuration purposes, that means no additional PC is needed for configuration purposes. Of course, the PC-like sys-

[1] Also called Vision Expo 2008. http://cms.messe-stuttgart.de/.

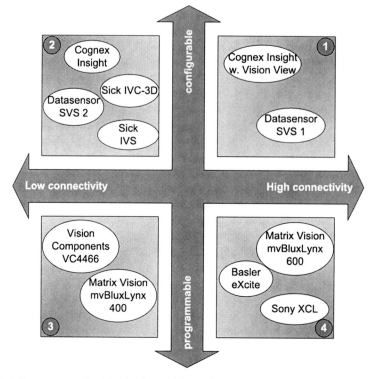

Fig. 19.2 Smart camera classification for model overview

tems are also embedded systems and should not be confused with PC-based systems ("PC-based" stands for a standard camera connected to a personal computer, where the image processing will be carried out on the personal computer).

Figure 19.2 shows the classification space with typical smart camera models plotted in. Information on the chosen models can be found in Fig. 19.3. The choice of models does not imply any kind of rating of smart cameras: there exist many other smart cameras from the same or other manufacturers which are not mentioned here. Although there are smooth transitions between the models, four main categories (each quadrants of the plot) could be described as

- PC-like/configurable (1)

 This type of smart camera is a stand-alone device, which could be easily configured with add-on peripherals, e.g., special panel or touchscreen. Typical applications are inspection, position estimation, barcode reading, etc. There is no standard processing unit used. The application software is provided by the producer and offers standard functionality. These systems are very easy to use. Especially in production environments the possibility to directly interact during an inspection task could be a plus.

- Embedded/configurable (2)

 For this type of smart camera there is a need for an external personal computer for configuration of the device. This could be useful, if there are several smart cam-

type	distributor	manufacturer	model	processing unit	resolution	memory	FPGA for application	inspection	measurement	code reading	object location
pc-like/ configurable	Buxbaum/ Stemmer - Imaging	Cognex	In-Sight Micro 1020 with Vision View	Texas Instrument	640x480	64 MB	-	x	x	-	x
	Datasensor	Datasensor	Smart Vision Sensor 1	Blackfin-DSP	640x480	not known	-	x	x	x	x
embedded/ configurable	Datasensor	Datasensor	Smart Vision Sensor 2	Blackfin-DSP	640x480	not known	-	x	x	x	x
	Microscan	Microscan	Hawkeye 1600TS	RISC Processor	648x494	64 MB	-	x	x	x	x
			Hawkeye 1600TH	RISC Processor	1024x768	64 MB	-	x	x	x	x
	Sick	Sick	Inspector Vision Sensor	800 MHz	384x384	not known	-	x	x	-	x
			IVC-3D	800 MHz	2048x1	not known	x	-	-	-	-
	Buxbaum/ Stemmer - Imaging	Cognex	Insight 5600	Texas Instrument	640x480	64 MB	-	x	x	x	x
			Insight 5604	Texas Instrument	1024x1	64 MB	-	x	x	x	x
embedded/ programmable	Matrix Vision	Matrix Vision	mvBlueLynx 400	power pc 200 MHz	640x480 .. 1600x1200	32 MB	x	x	x	x	x
	Vision Components	Vision Components	VC4466	Texas Instrument 1GHz	1024x768	64 MB	-	x	x	x	x
pc-like/ programmable	Basler	Basler	eXcite exA1390 eXcite exA1600	RM 9000 1.0 GHz	1392x1040 1624x1236	128 MB	-	x	x	x	x
	Matrix Vision	Matrix Vision	mvBlueLynx 600	power pc 400 MHz	640x480 .. 1600x1200	64 MB	x	x	x	x	x
	Maxx Vision	Sony	XCI - V100/V100C	VIA Eden, 1GHz	640x480	512 MB	x	x	x	x	x
			XCI - SX100/SX100C	VIA Eden, 1GHz	1280x1040	512 MB	x	x	x	x	x

Fig. 19.3 Typical manufacturer and smart camera models of the categories embedded and configurable

eras reachable over Ethernet, so the configuration can take place on a personal or portable computer. There is no standard processing unit used and no possibility for loading self-developed applications. There are systems which offer the possibility to adjust parameters for the inspection task only, similar to the PC-like/configurable models. Advanced systems offer the possibility of scripting, which means the user can combine predefined image processing algorithms to implement more sophisticated inspection tasks. After uploading user-specific configurations or scripts, the smart camera works autonomously without further user interaction.

- Embedded/programmable (3)

 The embedded/programmable smart cameras are advanced systems. They are used for special image processing tasks for specific customer solutions. The typical customer is the system integrator, not the end user. A *Software Development Kit* (SDK) for the system will be provided by the manufacturer and additionally a library for image processing. Matrix Vision provides for their model mvBlueL-YNX, an image processing library (named mvImpact), with comprehensive functionality. The application for the camera is typically developed on a personal computer and then transferred to the camera. Generally, the system is based on an operating system (often special versions of uClinux or Linux), which provides basic system access functionality. Embedded/programmable type of smart cameras do not support devices like touchscreen/keyboard/mouse, so that the system cannot be configured without a personal computer.

- PC-like/programmable (4)

 This type of smart camera can be described as a very small personal computer with integrated vision sensor. The user can directly connect a monitor, key-

board, and mouse and use an embedded operating system like Linux or windows embedded. The hardware is separated very well from the software, which enables the user to use not only software libraries provided by the manufacturer but also libraries from third parties. As CEO Sayed Soliman from MaxxVision states, this type of smart camera will be the future of this technology, as developed applications can be reused whenever a new smart camera model with improved performance is released. The software development can be done directly on the smart camera but also on a personal computer with standard development environments. The user can choose between different operating systems like Linux or embedded Windows®.

19.3 Market Description

19.3.1 Overview of the Vision Market

To accurately highlight the smart camera market, it is best to look first at the total machine vision market. This overview uses results from surveys conducted by EMVA (Europe) and AIA (US). Hence, the focus will be on the results of European companies and the situation of the North American market – two representative economies.

The European machine vision market (based on participating companies) achieved a turnover of €769 million (EUR) in 2007 [170]. This is an increase of 4% and indicates a change in the use of machine vision as mentioned in Section 19.1.

Figure 19.4 gives an overview of total sales by products in Europe. Application-specific vision systems and cameras are still the top selling products. Smart cameras do not achieve comparable sales values. Vision sensors, in the AIA study also part of the smart cameras market, achieve weak results too. This can be explained by the early status of the product life cycle of smart cameras as shown in Fig. 19.5.

Figure 19.6 presents the segmentation of European turnover by region. Two-thirds are generated in Europe while America and Asia are responsible for the rest of the turnover.

In North America the machine vision industry achieved a total turnover of $1,555.5 million (USD) which is equivalent to €1,175.5 million (EUR) in 2007 [29].

19.3.2 Smart Camera Market

Figure 19.4 shows weak sales results for smart cameras and vision sensors compared to the total revenue of vision products. The strength of these components can be seen in the relative increase as shown in Fig. 19.7. Smart cameras show a sales increase of 5%, whereas vision sensors sales increased by a remarkable 58% from 2006 to 2007.

Although there is an increase in the sales value of smart cameras, the development of sold units is decreasing by 16% from 2006 to 2007. Conversely the amount

Value of total sales of European vision companies*
by products 2006 and 2007

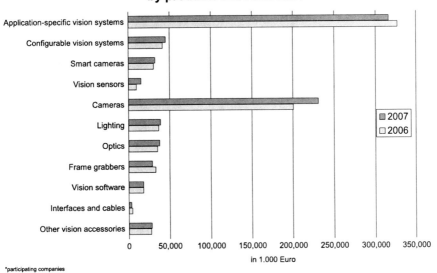

*participating companies

Fig. 19.4 Value of total sales of European vision companies by products 2006 and 2007 [170]

Fig. 19.5 Sales revenue by PLC stage [29]

of sold vision sensors increased by 179.9%. This underlines the trend reflected by the sales figures.

The North American market as shown in Fig. 19.8 looks slightly different at first glance. Sales revenue (+ 2.1%) as well as sold units (+ 6.1%) increased in 2007 compared to 2006. But it has to be considered that in the AIA study smart cameras include vision sensors as opposed to the EMVA results. An accumulated result of smart cameras and vision sensors of the EMVA data would result in a sales increase of +17.9% and a rise in sold units by 30.8%. After taking into account all problems by comparing the two data sources EMVA and AIA, it is obvious that the smart

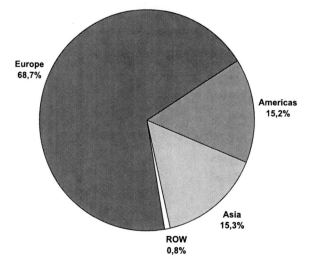

Fig. 19.6 Total turnover of vision products (in %) by European suppliers in 2007 clustered by regions [170]

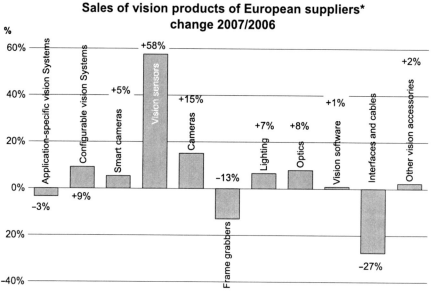

Fig. 19.7 Sales of vision products by European suppliers change 2007/2006 [170]

camera market was revived by vision sensors. The AIA explains the weak results for 2007 as follows: "These 2007 results betray uncharacteristically weak growth for smart cameras, reflecting a slowdown in the economy and not a deviation from the product life cycle of smart cameras" [29].

	Actual	Actual	Actual	Actual	Actual	
	2003	2004	2005	2006	2007	CAGR
Revenue ($M)	$58.6	$86.7	$99.2	$114.2	$116.6	-
%	43.3%	48.0%	14.4%	15.2%	2.1%	10.4%
Units	18,296	19,695	23,448	27,091	28,750	-
%	27.9%	7.60%	19.1%	15.5%	6.1%	13.4%
Average Price	$3,203	$4,402	$4,230	$4,217	$4,055	-

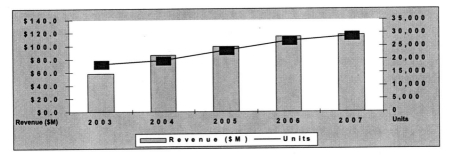

Fig. 19.8 Smart camera sales revenue in million USD and units: 2003–2007 [29]

19.3.3 Smart Camera Versus PC

To understand the development of the smart camera market there is one question that has to be considered. Will smart cameras ever substitute PC-based systems? Although there are different suggested definitions of smart cameras the answers to this question are very similar by all participating companies. Some interesting pros and cons of PC-based systems and smart cameras could be identified from the conducted interviews.

First of all, one overall statement: PC-based systems will never die out. They will get smaller and more compact and perhaps they will eventually become smart cameras. This theory is supported by the fact that lower cost and more powerful PC-based systems have been introduced in response to the compact and cheaper smart cameras as mentioned in the AIA study.

Some arguments for PC-based systems: "new developments are made with," "higher performance," "provide more complex solutions," "enable multiple camera solutions." And some arguments against them: "need much consulting and integration know-how," "more complex to sell, support, and teach," "data transfer is bottleneck."

And here are some arguments for smart cameras from a producers'/suppliers' point of view: "enable application-specific development by the user," "less performance but enough for customer," "cams become smaller," "increasing range of possible applications," and "easy to use."

To sum it up, all interview partners mentioned that PC-based systems will always be used for new, complex, and niche applications. The developments based on PC-based systems will be transferred into compact small cameras if the market is

interested and if they are profitable enough. A co-existence of both approaches is forecast.

19.4 Typical Fields of Application

It would have been very interesting to differentiate the sales figures shown in Section 19.3 by typical fields of applications and/or end-user industries. Because of a lack of data on the one hand and reluctance to provide information on the other hand this break down is not possible. Instead this section provides some interesting data from the AIA study and will take a look at the versatile fields of application and possibilities that smart cameras provide.

19.4.1 Sales by Industry/Application

As shown in Fig. 19.9 the AIA study identifies applications in the field of mechanical and electronics assembly verification (27.9% units (+ 7.8), 35.9% revenue (+ 14.2)) as the most common ones, followed by part (12.7% units, 10.0% revenue) and character recognition (12.6% units, 13.6% revenue).

	2005 Units	2006 Units	2007 Units	2005 Revenue	2006 Revenue	2007 Revenue
2D, 3D Metrology	9.7%	8.4%	9.4%	5.1%	4.0%	4.7%
Surface Flaw/Cosmetic Analysis	18.1%	12.2%	11.4%	22.7%	20.4%	18.0%
Mechanical/Electronic Assembly Verification	18.9%	20.1%	27.9%	22.0%	21.7%	35.9%
Visual Servoing (2D and 3D)	0.0%	0.0%	0.0%	0.0%	0.0%	0.0%
Location Analysis - Robot Guidance	5.6%	3.6%	1.8%	4.0%	3.9%	1.7%
Location Analysis - Search	3.6%	9.4%	11.7%	4.5%	5.2%	7.0%
Character Recognition	12.3%	15.6%	12.6%	11.3%	17.9%	13.6%
Part Recognition	15.2%	13.9%	12.7%	13.1%	12.2%	10.0%
2D Symbol Reading	12.3%	12.9%	7.6%	9.9%	11.4%	4.8%
Other	4.3%	4.0%	4.9%	7.4%	3.3%	4.3%
Total	100.0%	100.0%	100.0%	100.0%	100.0%	100.0%

Fig. 19.9 Smart camera sales – Percent distribution by application [29]

The AIA also provides numbers for end-user industries. The semiconductor manufacturing industry (27.5% units, 4.8% revenue) consumes one-third of all smart cameras sold in the North American market, followed by electronics/electronical (12.4% units, 18.6% revenue) and automotive manufacturers (10.2% units, 13.2%). In the non-manufacturing industries medical and biotechnology applications lead with 8% of the total units sold, while generating weak revenue – only 0.1%. The products in the area of intelligent transportation systems (ITS) amount to only 1.7% of all sold units, however, with a revenue of 2.5%.

These numbers provided by the AIA as well as the statements by experts, producers, and providers show one result: "smart cameras are used for a wide variety of applications, attesting to their great versatility in machine vision" [29].

For Andrew Wilson, editor of the established journal *Vision Systems Design*, the main fields of application are machine vision, image processing, remote sensing, agricultural inspection, food inspection, biomedical analysis, and robot vision. The survey among smart camera manufacturers identified the application fields of automation, traffic control, security, medical technology, marketing, entertainment, recycling, and the automotive sector (in-car). All the mentioned applications can be aggregated into four general topics:

- Machine vision/automation
- Traffic control/security
- Automotive (in-car)
- Others

Independent of a specific application the survey results in some common findings regarding the current usage of smart cameras. As Andrew Wilson mentions, smart cameras were "originally appearing about ten years ago with limited on-board processing capability." Ongoing technological developments and experience in user-friendly interfaces raised the acceptance over the last few years. This process still continues. Today customer training is still necessary. Successful smart camera distributors and producers provide such courses. Another indicator for the current success of smart cameras is the still growing number of smart camera providers.

In contrast to these encouraging developments there are also arguments against smart cameras. One often-mentioned problem is encountered in the area of multiple camera systems. These systems, especially used in the security and traffic sector, are much more expensive with smart cameras. But regarding the demand for data reduction in multiple camera systems it seems only a matter of price.

As an early assessment of the current market Mr. Uwe Furtner, General Manager of Standard Products at Matrix Vision, says, "You need staying power and financial background to establish innovative products like smart cameras on an established market." This is especially interesting in light of the current economic crisis.

19.4.2 Machine Vision/Automation

As shown in the AIA figures and confirmed by the interviews, the field of manufacturing and automation is currently the biggest market for smart cameras. Applications like factory automation, automotive production, packaging, and robotic systems are the main drivers in this sector. Especially robotic applications are seen as a huge market. The classic machine vision market can also be seen as the playground for smart cameras which explains this leadership role.

Actually this situation can change in the next few years. Mr. Werner Borchert, Product Manager Components at Basler, says that from his point of view a combination of embedded PC with Gigabit Ethernet cameras will play a major role in machine vision market over the next years.

19.4.3 Traffic Control/Security

In the field of traffic control, special environmental circumstances have to be mentioned. Flexible interfaces like GigE seem to be a kind of door opener. Currently, applications like Section Control and wrong-way driver detection at on-ramps are also available along with more unconventional solutions to count boats at rivers for security reasons. The processing power inside the camera enables different kinds of intelligence. An automated selection of the interesting object in connection with self-calibration of the camera is also an outcome of today's smart camera approaches.

As shown in Fig. 19.10 for the world market for *video content analysis* (*Video content analysis* (VCA)), an important component in traffic control and security systems (ITS), embedded systems outperformed PC-based systems in this field. This underlines the growing usage of smart cameras.

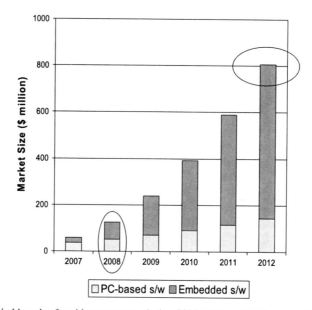

Fig. 19.10 World market for video content analysis – 2008 Edition, IMS Research; Analyst – Niall Jenkins

The applications in the security sector are also very widespread. Current systems are smart cameras with Ethernet connection, intelligent networks, entrance control at airports, and face control. Furthermore, established smart camera producers think that the ITS sector will be a driving sector in future and will expand to a mass market.

19.4.4 Automotive (In-Car)

The usage of smart cameras to enable driving assistance systems is a very special field of application. For most smart camera producers established in the machine vision market, this market seems to be unconquerable. Special demands for size/dimensions and low costs in combination with the difficult environments the cameras should work in are huge barriers for doing business in the automotive industry.

To get some insight, the renowned company BMW Group agreed to provide some information. The following paragraph is the result of a written questionnaire.

The company defines smart cameras as "small and cheap cameras for miscellaneous applications." In their point of view smart cameras "offer the possibility to introduce new customer functionality and make [their] products more attractive." Only the benefits of smart cameras like price and size offer this possibility. These benefits coincide with the advantages mentioned in other industries.

Smart cameras used by BMW are based on CMOS sensors and are equipped with *high dynamic range (High dynamic range* (HDR)) capabilities. Therefore, they use "standard cameras available on the market with slight modifications." It is assumed that they use OEM camera boards.

Currently, smart cameras are installed in the following car series: BMW 5 series; BMW 6 series; and the new BMW 7 series; BMW X5 and X6. "Applications will be extended to further models, but currently we cannot name specific models." Although it is not possible to give exact figures about how many smart cameras BMW is applying every year because the number depends on customers' orders the trend is obvious: "the numbers are rising."

For BMW Group, the four most important fields of requirements are resolution, improved HDR capabilities, flexible read out mechanism, and pricing. Resolution is currently VGA but has to be doubled for future applications. The HDR capabilities have to be improved for usage of the smart camera in dark as well as in very bright situations as much as possible. The price demand "as low as possible but in high quality."

These are the current applications realized by smart cameras: Lane Departure Warning, High Beam Assist, Speed Limit Information, Side View, and Backup camera. Future developments include advanced object detection for miscellaneous applications, e.g., in driver assistance systems.

Because of competitive reasons BMW Group does not publish detailed sales figures components.

19.4.5 Others

In this field of application, the medical and biotechnology industry is currently the most interesting sector. This is also reflected by the AIA figures. From cell analysis to measuring eyeglasses only this market offers a large variety of applications. High processing power but at the same time small dimensions are the reason for the usage of smart cameras (not only) in this field.

Other applications can be found in the fields of entertainment (e.g., new interactive games in fun parks, movement analysis in sports, special multiple camera systems for the film industry), marketing (e.g., people counting for customer stream analysis in shopping malls), or recycling (e.g., bottle retail machines).

19.5 Market Demands

The following statement by John Agapakis, Director of Business Development at Microscan, is a good starting point to assess customer demands: "easier, faster, smaller and cheaper." These are the generalized requirements for smart cameras. But in detail, the demands depend on the point of view and the actual application. Figure 19.5 shows the product life cycle of a smart camera and the current position in time as proposed by the AIA Annual Machine Vision Market Study [29]. "This growth and the relative newness of this type of product indicate that smart cameras find themselves in the so-called growth stage of their product life cycle" [29]. This means that there is much potential for improvements in the next few years, especially as Steve Geraghty, Director of Operations at Dalsa remarks "factory automation will not raise its demands as fast as technologically possible."

In the machine vision market the demands differ between system integrator and end user. For configurable/PC-like smart cameras simple installation and configuration is the primary demand. "Not more than three steps should a GUI need for configurating the system" claims Thomas Bauer, Product Manager at Datasensor. But also component size and price are important. As Dr. Mats Gökstorp, member of the management board of Sick, states, "integration costs have to be lowered significantly." These cameras are almost solely used by the end user.

Configurable/embedded smart cameras should also be characterized by easy installation. The configuration could be more challenging, as advanced features like scripting for more complex image processing are used. The performance and robustness of algorithm are very important. These smart cameras are mainly used by the more demanding end customer, but for solutions, where it is "not affordable to consult a system integrator" states Peter Keppler, Vision Solutions Sales Manager of Stemmer Imaging.

High-end smart cameras, embedded/programmable camera types, convince first and foremost with better performance. The main customers are system integrators with the demand of solving highly sophisticated image processing tasks. It is expected that experts are installing and using these systems, so that a comfortable development environment will be very important. Also special software libraries for image processing are needed (e.g., Matrix Visions mvBlueLynx provides a special library called mvIMPACT). Typically, the customer can choose from a range of different models to match the needed performance of the application (e.g., different resolutions 640×480–1600×1200, 32 MB–512 MB RAM, processor speed 500 MHz–1 GHz).

The last step in the evolution of the smart camera is the PC-like/programmable smart camera, like Sony's new XCL series (V100/SX100) or Basler's eXcite Series.

The eXcite Series is up to now supported by the well-known Halcon library. For Sony's XCL series a broad range of image processing libraries are available like Cognex VisionPro®, Dalsa Sapera™ Processing, and Sherlock™ Software.[2] It is possible to connect keyboard, mouse, and monitor to the system. This is almost a PC-based system, but simply put in a small housing and combined with an imager. There is a high level of decoupling of hardware and software of the smart camera, which will be the future of the advanced systems.

Acknowledgments The authors would like to thank the following organizations for allowing us to reprint data from their detailed market studies.

- Automated Imaging Association (AIA) www.machinevisiononline.org
 Paul Kellett, Director Market Analysis
- European Machine Vision Association (EMVA) www.emva.org
 Patrick Schwarzkopf, General Secretary
- IMS Research www.imsresearch.com
 Niall Jenkins Market Research Analyst

Furthermore, the authors would like to thank the following companies and individuals for taking part in the survey (carried out at the trade fair Vision 2008, Stuttgart, Germany).

- Basler www.basler-vc.com
 Dipl.-Ing. Werner Borchert, Product Manager - Components
- Buxbaum www.myAutomation.at
 Ing. Dietmar Buxbaum, CEO
- Dalsa www.dalsa.com
 Steve Geraghty, Director of Operations
- Datasensor www.datasensor.com
 Michele Leoni, Product Manager – Inspection
 Thomas Bauer, Product Manager – Central Europe
- Matrix Vision www.matrix-vision.de
 Dipl. Ing. Uwe Furtner, General Manager Standard Products
- MaxxVision www.maxxvision.com
 Sayed Soliman, CEO
- Microscan www.microscan.com
 John Agapakis, Director – Business Development
- Sick AG – www.sick.com
 Dr. Mats Gökstorp, Management Board – Division Advanced Industrial Sensors
- Stemmer Imaging www.stemmer-imaging.de
 Dipl.-Ing. (FH) Peter Keppler, Vision Solutions Sales Manager
 Dipl.-Ing. Peter Stiefenhöfer, Marketing & Public Relations Manager

And last but not least, we would like to thank the following companies for sharing information by e-mail on the topic of smart cameras.

- BMW Group – www.bmw.de
 Katharina Bölsterl, Konzernkommunikation und Politik, Technologiekommunikation
- Vision Systems Design www.vision-systems.com
 Andrew Wilson, Editor

[2] http://www.sony.com.

Part VIII
The Future of Smart Cameras

Chapter 20
Future Directions of Smart Cameras

Ahmed Nabil Belbachir

Abstract Forecasting the future trends of smart cameras is a real challenge due to the rapid evolution of technologies, applications, and user needs. This chapter attempts to provide perspectives of smart cameras based on the analysis of actual evidences and indicators. This chapter summarizes future directions and prospects of smart cameras in three underlying dimensions: the scientific interest and trends; application needs and expansions; and the market evolution, impulses, and trends. The key characteristics and advantages of smart cameras are integration and intelligence. The key enablers of integration and intelligence are the power behind embedded processors, ensuring reliability of vision algorithms working under real-world conditions. The 64-bit processing and multi-core processors [541] will find their ways into smart camera systems and significantly improve the system capabilities. The increase in processing power, together with functional re-programmability, will help overcome a key perceived disadvantage of smart cameras – flexibility. The future directions of smart cameras under the above-listed three aspects are analyzed in detail in this chapter.

20.1 Scientific Interest

The scientific interest related to smart cameras is mainly driven by open research questions, unsolved scientific issues, and the new challenging research directions. The research trends are mainly related to the areas of electronic engineering (future imaging technologies), computer engineering (future embedded systems), and computer vision (future computer vision). Based on actual research highlights, the following topics can contribute to the future of smart cameras.

- **Systems on-Chip (SoC)**

 The performance and efficiency of electronic technologies and systems is growing and will continue to grow over the next decades. One of the main interests of

A.N. Belbachir (✉)
Neuroinformatics, Safety & Security Department, AIT Austrian Institute of Technology, Vienna, Austria
e-mail: nabil.belbachir@ait.ac.at

A.N. Belbachir (ed.), *Smart Cameras*, DOI 10.1007/978-1-4419-0953-4_20, 359

the microelectronics community is the integration of computational intelligence on-chip to improve capabilities of systems. A vision sensor chip will not only be responsible for capturing an image but will also include computer vision algorithms as analog or digital circuits with onboard computation capabilities and without the need for a PC or embedded computing. The whole chip will probably be so compact that it will be smaller than one US cent. Exploiting these SoC capabilities [566], smart cameras will become increasingly cheaper, consume less power, and probably integrate wireless technologies.

- **Computer Vision and Image Understanding**

Computer vision aims to duplicate human vision in computer algorithms to achieve tasks like recognition, understanding, and perception. Although a large scientific community is involved in this field, there are still a large number of open research questions, which have not yet been resolved due to the complexity of the above-listed tasks for a computer. For example, video surveillance is affected by the non-maturity of vision systems for many surveillance applications, despite the efforts invested in the past three decades. Several questions like object recognition, identification, segmentation, scene perception, and understanding are far from being mature in automated operations and/or used in applications in an unsupervised approach. The complexity of this area is contributing to the growing size of the research community and the number of researchers such that future smart cameras will benefit in a straightforward way from the groundbreaking results expected in this area.

- **Biologically inspired Vision**

Biologically inspired vision involves neuroscientists, electronic scientists, and computer scientists to understand and mimic the human vision system. In this area scientists are concerned with understanding the human vision mechanism (eye, brain, and neural communication) and building computational algorithms and/or vision systems that exactly duplicate the biology. As an example, David Marr, one of the founders of the discipline *Neuroinformatics* and the pioneer in the study of computer/human vision, aimed in an early sketch [357] to capture the significant intensity changes in an image, in an attempt to duplicate one effect of human vision. Carver Mead [369] founded the discipline of *Neuromorphic Engineering* to mimic biological theories in VLSI systems. These contributions raise interest of a large community of mainly electronic and computer scientists to explore new biologically inspired vision technologies [56, 55].

Smart cameras will certainly exploit these future technologies toward *smart eyes*[1] and/or *seeing computers*.

[1] Eg. http://www.ait.ac.at/safety_security/safety_security_ni_en.html

- **Networked Cameras**

 Cameras are getting more compact, low cost, emerging for a wide range of applications such that the number of cameras installed and operated is increasing very fast. On the other hand, the capacity of memory devices is increasing rapidly at low-cost prices. As a consequence, there are and will be a huge number of cameras (in the order of billions) operating and delivering zettabytes or yottabytes of data for the next five decades. This practical aspect has already called attention of the community dealing with embedded systems to open research fields like ubiquitous, distributed, and pervasive computing. A number of scientists are investigating systems and tools for managing large-scale networks of cameras in centralized, decentralized, and hybrid manners. Other research communities are investigating, information archiving, and retrieval for large-size databases. Smart cameras will improve intelligence and performance by exploiting the outcomes of those fields of research in the future decades.

- **Sensor Fusion**

 Sensor fusion seeks to analyze an object or an environment by using joint information provided by more than one sensor of the same type (homogeneous network) or of different types (heterogeneous network). Typically, vision sensors will be one of the sensor types as they often provide "superior" kind of information about an object or an environment. Other sensor types for fusion with vision sensing include acoustic, ultrasonic, or infrared sensors. Sensor fusion is a powerful and challenging idea because it can use the advantage of one sensor type to compensate the disadvantage of other sensors, or to improve object recognition rate, so as to improve reliability and usability of the joint sensing system. Advances in sensor fusion research will undoubtedly enable new applications for smart cameras for applications such as surveillance, security, machine vision, and health care.

20.2 Application Trends

Many research contributions are driven by application needs and requirements. Several scientists are motivated to merge their findings to solve practical issues for certain applications. In general, many scientists are funded by applications stakeholders to pursue their research. We believe that those applications will host future smart cameras.

- **Multimedia**

 Future cameras for consumer electronics will not only be dedicated to acquiring images but also host specific capabilities like biometric identification, person identification, tracking, and security. Examples of such applications for the future smart cameras are mobile phones cameras, laptop/PC cameras (e.g., chat and videophony). Other applications such as object recognition, retrieval, and archiving will also involve future smart cameras. In particular, camera phones

are likely to become an important future playground for smart cameras [433]. At the moment, most cameras on mobile phones are designed for taking pictures. Sooner or later people will want to make use of the cameras for purposes beyond just taking pictures [522]. Some camera phones can already scan product labels/codes at the supermarket and connect the phone to the web sites of producers or manufacturers [591]. Other mobile phones [253] embed a crosswatch system for orienting visually impaired pedestrians. Other future applications, for example, ambient assisted living [105] , and entertainments, will include extracting information from the user's environment and adding to the practical value and fun factor of mobile platforms.

- **Machine Vision**

 Due to the increasing requirements of industrial vision, smart camera applications will improve performance (in speed and accuracy) for machine vision applications like quality control, inspection, and other machine vision tasks. Machine vision is likely to continue to be the main commercial market for smart cameras in the near future. Building on their experiences and technical success in machine vision, many manufacturers of smart cameras have recently extended applications into the non-machine vision market, for example, in access control, document processing, traffic engineering, and retail logistics. This trend is good news for the commercial development and growth of smart cameras in the market as a whole. As the performance of embedded processors continues to improve, 3D vision and stereo vision will improve the quality of some machine vision and robotic applications and enable new applications.

- **Surveillance and Security**

 Surveillance and security include challenging tasks for smart cameras, whenever autonomy is required. Autonomous surveillance systems for public spaces, restricted spaces, private spaces, and industrial areas will be one of the major applications for future smart cameras. *Intelligent transportation systems* (ITS) have been an active application area for smart cameras. One example is *Automatic number plate recognition* (ANPR). ANPR is an enabling technology for congestion charge. As road/lane tolling and congestion charge are likely to become more accepted in the world's congested cities, ANPR using smart cameras will be likely to become more widely used in the near future. Other likely applications include automatic traffic incident detection, pedestrian safety, and road enforcement.

- **Space and Robotics**

 Future space missions need smart cameras [54] and autonomous systems for the exploration of the far Universe and the approaching planets. This application concerns not only computer vision but also microelectronics as space technologies are usually expensive and lowering the price of space cameras will be one of the major objectives.

- **Automotive**

 Automotive applications are among the most interesting applications for smart cameras, because smart cameras can help vehicles to "see" the driving environment widely and quickly. Low power, small size, and autonomy of smart cameras are also important features for automotive applications. However, automotive is also among the most challenging applications for smart cameras. In machine vision, cameras are usually still, objects under inspection are relatively simple to detect and recognize. In surveillance and security applications, the target objects can be moving and recognition can become difficult. In automotive applications, cameras are usually moving with the vehicles and the objects (other vehicles, pedestrians, etc.) can be in motion as well. This makes automotive applications for smart cameras very challenging. Nevertheless, some applications involving smart cameras have already entered into the automotive market. One such example was cited by [180] about a smart camera performing lane-departure monitoring and detection, which has been deployed in some car models in the automotive industry. With the continuing advances of smart camera technologies, we will like to see more deployment of smart cameras in automotive applications, for example, for adaptive cruise control, monitoring of blind spots, parking assistance, and pre-crash warning (side effects).

20.3 Market Evolution

Smart cameras have not only raised the interest of scientists and practitioners but the name itself is also used by several manufacturers and industries as a marketing tool for attracting and motivating for new products. Smart camera industries had an average market growth of 13% in the last decade with a maximum turnover growth in 2000 with a rate of 28% (refer to Chapter 19 for more details). The future market of smart cameras will very likely multiply, especially if the above-listed research issues are resolved and the scientific findings are validated within one of the above-listed applications. Typical markets will be the automotive and the production industry, security applications, and the military. Other emerging markets will likely include multimodal human–computer interaction, toys, video games, edutainment, medicare, health care, and ambient assisted living.

20.4 Outlook and Perspective

This chapter intends to involve the readers in contributing to the future of smart cameras. All other chapters are dedicated to presenting the status of research and achievements regarding smart cameras as well as current investigations. Those chapters are important to provide an overview of the topic with a certain level of detail. In this chapter, we find it necessary to highlight opportunities for future investigations by listing the existing potential from research, applications, and market

point of views. I aimed to present few ideas, unsolved research questions, potential applications, and market future orientations. I hope to have supported ambitious scientists and practitioners in finding attractive topics for contribution toward developing future smart cameras.

References

1. T. Aach and A. Kaup, in *Signal Processing: Image Communication*. Bayesian Algorithms for Change Detection in Image Sequences Using Markov Random Fields, vol. 7, no. 2, pp. 147–160, (1995)
2. T. Aach, A. Kaup and R. Mester, in *Signal Processing*. Statistical Model-Based Change Detection in Moving Video, vol. 31, pp. 165–180, (1993)
3. A. Abbo, R. Kleihorst, V. Choudhary and L. Sevat, in *Lecture Notes in Computer Science, Springer. PATMOS2004, Santorini, Greece*. Power Consumption of Performance-Scaled SIMD Processors, pp. 532–540, (2004)
4. A. Abbo and R. Kleihorst, in *ACIVS2002*, Gent, Belgium. A Programmable Smart Camera Architecture, (2002)
5. B. Abidi, A. Koschan, S. Kang, M. Mitckes and M. Abidi, in *Multisensors Surveillance Systems: The Fusion Perspective*. Automatic Target Acquisition and Tracking with Cooperative Static and PTZ Video Cameras, pp. 43–59, (2003)
6. L. Agapito, E. Hayman and I. Reid, in *International Journal of Computer Vision*. Self-calibration of Rotating and Zooming Cameras, vol. 45, no. 2, pp. 1573–1405, (2001)
7. M. Ahmed and A. Farag, in *IEEE Transactions on Image Processing*. Nonmetric Calibration of Camera Lens Distortion: Differential Methods and Robust Estimation, vol. 14, no. 8, pp. 1215–1230, (2005)
8. K. Aizawa, H. Ohno, T. Hamamoto, M. Hatori and J. Yamazaki, in *Proceedings of International Conference on Image Processing*. A Novel Image Sensor for Video Compression, vol. 3, pp. 591–595, (1994)
9. M. Akdere, U. Centintemel, D. Crispell, J. Jannotti, J. Mao and G. Taubin, in *Lecture Notes in Computer Science, Springer. Proc. 2nd Intl. Conf. on Geosensor Networks, Boston, USA*. Data-Centric Visual Sensor Networks for 3D Sensing, pp. 131–150, (2006)
10. L. Albani, P. Chiesa, D. Covi, G. Pedegani, A. Sartori and M. Vatteroni, in *Proceedings of the 28th European Solid-State Circuits Conference*. VISoc: A Smart Camera SoC, pp. 367–370, (2002)
11. Y. Aloimonos, I. Weiss and A. Bandyopadhyay, in *Proceedings of the First International Conference on Computer Vision (ICCV)*. Active Vision, pp. 35–54, (1987)
12. Altera Corporation, in *Datasheet SII5v1-3.1, SII5v2-3.1*. Stratix II Device Handbook, (2007)
13. Altera Corporation, in *Datasheet*. Nios II Processor Reference Handbook, (2009)
14. K. Ambrosch, W. Kubinger, M. Humenberger and A. Steininger, in *EURASIP Journal on Embedded Systems*. Flexible Hardware-Based Stereo Matching, Article ID 386059, 12 pp. (2009)
15. American Society of Photogrammetry in J.C. McGlone (ed.), *ASPRS*. Manual of Photogrammetry, (2004)
16. F. Andoh, H. Shimamoto and Y. Fujita, in *IEEE Transactions on Electron Devices*. A Digital Pixel Image Sensor for Real-time Readout, vol. 47, no. 11, pp. 2123–2127, (2000)

17. F. Andoh, K. Taketoshi, J. Yamazaki, M. Sugawara, Y. Fujita, K. Mitani, Y. Matuzawa, K. Miyata and S. Araki, in *37th ISSCC IEEE International Solid-State Circuits Conference, 1990. Digest of Technical Papers*. .. A 250000-pixel Image Sensor with FET Amplification at Each Pixel for High-speed Television Cameras, pp. 212–213, (1990)

18. A. Andreou and K. Boahen, in Chapter 8 in M. Ismail et al. *Analog VLSI Signal and Information Processing*, Mc Graw-Hill, Neural Information Processing II, pp. 358–413, (1994)

19. M. E. Antone and S. Teller, in *Proceedings of the International Conference on Computer Vision and Pattern Recognition (CVPR), Hilton Head Island, SC, USA*. Automatic Recovery of Relative Camera Rotations for Urban Scenes, vol. 2, pp. 282–289, (2000)

20. S. Apewokin, B. Valentine, R. Bales, L. Wills and S. Wills, in *Proceedings of 2nd IEEE Workshop on Embedded Computer Vision (ECVW), CVPR 2008, Fort Collins, CO, USA*. Tracking Multiple Pedestrians in Real-time Using Kinematics, pp. 1–6, (2008)

21. C. Arth, H. Bischof and C. Leistner, in *Proceedings IEEE Conference on Computer Vision and Pattern Recognition (CVPR), IEEE Workshop on Embedded Computer Vision (ECVW), New York, USA*. TRICam – an Embedded Platform for Remote Traffic Surveillance, P. 125, (2006)

22. C. Arth, C. Leistner and H. Bischof, in *First ACM/IEEE International Conference on Distributed Smart Cameras*. Object Reacquisition and Tracking in Large-scale Smart Camera Networks, pp. 156–163, (2007)

23. C. Arth, F. Limberger and H. Bischof, in *IEEE International Conference on Computer Vision and Pattern Recognition (CVPR '07)*. Real-time License Plate Recognition on an Embedded DSP-platform, pp. 1–8, (2007)

24. M. Arulampalm and S. Maskell and N. Gordon and T. ClaPages, in *IEEE Transactions on Signal Processing*. A Tutorial on Particle Filters for Online Nonlinear Non-Gaussian Bayesian Tracking, vol. 50, no. 2, pp. 174–188, (2002)

25. Asentics GmbH & Co KG in *Datasheet*. Datenblatt Intelligenter Zeilensensor, (2003)

26. U. ASSmann, M. Aksit and A. Rensink, in *Springer Lecture Notes in Computer Science*. Model Driven Architecture: European MDA Workshops – Foundations and Applications, (2005)

27. C. Atkinson and T. Kuhne, in *IEEE Software*. Model-Driven Development: A Metamodeling Foundation, vol. 20, no. 5 pp. 36–41, (2003)

28. D. Aubert, in *Proceeding of 10th International Conference on Image Analysis and Processing, Venice, Italy*. Passengers Queue Measurement, pp. 1132–1135, (1999)

29. Automated Imaging Association, in *2008 AIA Annual Machine Vision Market Study. Ann Arbor MI, USA*. AIA Annual Machine Vision Market Study, (2008)

30. Automated Imaging Association. *Article published in April 2008 at the Website of Process and Control Today. Information Accessed in January 2009*. New Machine Vision Market Study and Forecasts for 2007 Through 2012, (2008)

31. Automated Imaging Association. *Information Published at the Website of GenICam and accessed in January 2009*. The EMVA GenICam standard, (2009)

32. Automated Imaging Association. *Information Published at the Website of the Machine Vision Online and accessed in January 2009*. GigE Vision Standard, (2009)

33. Automated Imaging Association. *Information Published at the Website of MVTec and accessed in January 2009*. Halcon: The Power of Machine Vision, (2009)

34. Automated Imaging Association. *Information Published at the Website of Machine Vision of UK and Accessed in January 2009*. A Brief History of and An Introduction to Machine Vision, (2009)

35. S. Avidan, in *IEEE Transactions on Pattern Analysis and Machine Intelligence, PAMI*. Support Vector Tracking, vol. 26, no. 8, pp. 1064–1072, (2004)

36. M. Azadmehr, J.P. Abrahamsen and P. Hafliger, in *IEEE International Symposium on Circuits and Systems, ISCAS (2005)*. A Foveated AER Imager Chip [Address Event Representation], vol. 3, pp. 2751–2754, (2005)

37. P. Babenko and M. Shah, in *Journal of Real-Time Image Processing*. MinGPU: A Minimum GPU Library for Computer Vision, vol. 3, no. 4, pp. 255–268, (2008)

38. N. I. Badler, in *Proceedings of the 2nd International Joint Conference on Pattern Recognition*. Three Dimensional Motion from Two-dimensional Picture Sequences, pp. 157–161,(1974)

39. J. Badri, C. Tilmant, J. M. Lavest, Q. C. Phan and P. Sayd, in *Proceedings of SCIA 2007, LNCS 4522*. Camera to Camera Mapping for Hybrid Pan-Tilt-Zoom Sensors Calibration, pp. 132–141, (2007)

40. R. Bajcsy, in *Proceedings of the IEEE Special no. on Computer Vision*. Active Perception, vol. 76 no. 8, pp. 996–1005, (1988)

41. S. Baker, R. Gross, T. Ishikawa, I. Matthews and R. Baker, in *Proceedings of International Joint Conference on Artificial Intelligence*. Lucas-Kanade 20 Years on: a Unifying Framework: Part 2, (2003)

42. M. Baldauf, S. Dustdar and F. Rosenberg, in *International Journal of Ad Hoc and Ubiquitous Computing*. A Survey on Context-Aware systems, vol. 2, no. 4, pp. 263–277 (2004)

43. D.H. Ballard, in *Artificial Intelligence Journal*. Animate Vision, vol. 48, pp. 57–86, (1991)

44. D. Bannach, O. Amft and P. Lukowicz, in *IEEE Pervasive Computing*. Rapid Prototyping of Activity Recognition Applications, vol. 7, no. 2, pp. 22–31, (2008)

45. Y. Bar Shalom and T. Fortmann, in *Academic Press*, San Diego, California, *USA*. Tracking and Data Association, (1988)

46. S. T. Barnard, in *Artificial Intelligence Elsevier Science B. V.*. Interpreting Perspective Images, vol. 21, no. 4, pp. 435–462, (1983)

47. M. Barth and C. Barrows, in *IEEE International Conference on Intelligent Robots and Systems*. Fast Panoramic Imaging System and Intelligent Imaging Technique for Mobile Robots, vol. 2, pp. 626–633, (1996)

48. F. Bashir and F. Porikli, in *Proceedings IEEE Conference on Computer Vision and Pattern Recognition (CVPR), Workshop on Performance Evaluation of Tracking and Surveillance (PETS)*, New York, USA. Performance Evaluation of Object Detection and Tracking Systems, (2006)

49. Basler AG, in *User Manual*. Basler Sprint User's Manual for Color Cameras, (2008)

50. D. Bauer, A.N. Belbachir, N. Donath, G. Gritsch, B. Kohn, M. Litzenberger, C. Posch, P. Schön and S. Schraml, in *EURASIP Journal on Embedded Systems, doi:10.1155/2007/82174*. Embedded Vehicle Speed Estimation System Using an Asynchronous Temporal Contrast Vision Sensor, Article ID 82174, 12 pp., (2007)

51. B.E. Bayer, *US Patent 3971065*. Color Imaging Array, (1976)

52. S. Becker and M.V. Bove, in *SPIE Symposium on Electronic Imaging. San Jose, USA*. Semi-automatic 3-D Model Extraction from Uncalibrated 2-D Camera Views, pp. 447–461, (1995)

53. M. Beising, in *Presentation at Industrial Vision Days, Vision Trade Fair*. Web-Inspection mit dem Smart Camera System, (2007)

54. A.N. Belbachir, in *Vdm Verlag Dr. Müller*. On-Board Processing for Infrared Observatories: Theory and Application, (2008)

55. A.N. Belbachir, M. Hofstätter, M. Litzenberger and P. Schön, in *Journal of Measurement Science and Technology*. High-precision Shape Representation Using a Neuromorphic Imaging Sensor with Synchronous Address-event Communication Interface, (2009)

56. A.N. Belbachir, M. Litzenberger, C. Posch and P. Schön, in *Proceedings of the IEEE International Symposium on Industrial Electronics, ISIE2007*. Real-Time Vision Using a Smart Sensor System, pp. 1968–1973, (2007)

57. S. Bell, B. Edwards, J. Amann et al., in *Digest of Technical Papers Solid-state circuits conference, ISSCC (2008)*. TILE64™ Processor: A 64-core SoC with Mesh Interconnect, pp. 88–598, (2008)

58. A. Bermak, in *IEEE International Symposium on Circuits and Systems, ISCAS (2002)*. A CMOS Imager with PFM/PWM Based Analog-to-digital Converter, vol. 4, pp. 53–56, (2002)

59. A. Bermak, in *Proceedings of the IEEE 2005 Custom Integrated Circuits Conference*. An 8/4-bit Reconfigurable Digital Pixel Array with On-chip Non-Uniform Quantizer, pp. 223–226, (2005)

60. T.M. Bernard, B.Y. Zavidovique and F.J. Devos, in *IEEE Journal of Solid-State Circuits*. A Programmable Artificial Retina, vol. 28, no. 7, pp. 789–798, (1993)

61. I. Biederman, in *Perceptual Organization, Hillsdale, NJ: Lawrence Erlbaum Associates*. On the semantics of a Glance at a Scene, pp. 213–253, (1981)

62. M. Bigas, E. Cabruja, J. Forest and J. Salvi, in *Microelectronics Journal, Elsevier 2006*. Review of CMOS Image Sensors, vol. 37, pp. 433–451, (2006)

63. S. Birchfield and C. Tomasi, in *International Journal of Computer Vision*. Depth Discontinuities by Pixel-to-Pixel Stereo, vol. 35, no. 3, pp. 269–293, (1996)

64. J. Black and T. Ellis and P. Rosin, in *Joint IEEE Int. Workshop on Visual Surveillance and Performance Evaluation of Tracking and Surveillance (VS-PETS)*. A Novel Method for Video Tracking Performance Evaluation, pp. 125–132, (2003)

65. K.A. Boahen, in *IEEE Transactions on Circuits and Systems II: Analog and Digital Signal Processing*. Point-to-point Connectivity Between Neuromorphic Chips Using Address Events, vol. 47, no. 5, pp. 416–434, (2000)

66. K.A. Boahen, in *IEEE Transactions on Circuits and Systems I: Regular Papers*. A Burst-mode Word-serial Address-event Link-i: Transmitter Design, vol. 51, no. 7, pp. 1269–1280, (2004)

67. E. Bodenstorfer, J. Fürtler, J. Brodersen, K.J. Mayer, C. Eckel, K. Gravogl and H. Nachtnebel, in *Proceedings of the Society of Photo-Optical Instrumentation Engineers (SPIE)*, N. Kehtarnavaz and M.F. Carlsohn (eds.) *Real-Time Image Processing 2007*. High-speed Line-scan Camera with Digital Time Delay Integration, vol. 6496, pp. I–4960, (2007)

68. L. Bombini, P. Cerri, P. Grisleri, S. Scaffardi and P. Zani, in *Proc. IEEE Intl. Conf. on Intelligent Transportation Systems 2006, Toronto, Canada*. An Evaluation of Monocular Image Stabilization Algorithms for Automotive Applications, pp. 1562–1567, (2006)

69. B. Bose and E. Grimson, in *Proceedings of the Joint IEEE International Workshop on Visual Surveillance and Performance Evaluation of Tracking and Surveillance (VS-PETS)*. Ground Plane Rectification by Tracking Moving Objects, (2003)

70. F. Boussaid, A. Bermak and A. Bouzerdoum, in *Transactions on Consumer Electronics, IEEE*. An Ultra-low Power Operating Technique for Mega-pixels Current-mediated CMOS Imagers, vol. 50, no. 1, pp. 46–53, (2004)

71. F. Boussaid, C. Shoushun and A. Bermak, in *International Conference on Design and Test of Integrated Systems in Nanoscale Technology DTIS(2006)*. A Novel Scalable Spiking Pixel Architecture for Deep Submicron CMOS Technologies, pp. 131–135, (2006)

72. A. Bouzerdoum, A. Moini, A. Yokovleff and X.T. Nguyen, in *IEEE International Conference on Systems, Man, and Cybernetics, 1994*. A Smart Visual Micro-sensor, vol. 1, pp. 276–279, (1994)

73. Y. Boykov, O. Veksler and R. Zabih, in *IEEE Transactions on Pattern Analysis and Machine Intelligence*. Fast Approximate Energy Minimization via Graph Cuts, vol. 23, pp. 1222–1239, (2001)

74. G. Bradski and A. Kaehler, in *O'Reilly Media*. Learning OpenCV: Computer Vision with the OpenCV Library, (2008)

75. V. Brajovic and T. Kanade, in *IEEE Transactions on Robotics and Automation*, A VLSI Sorting Image Sensor: Global Massively Parallel Intensity-to-Time Processing for Low-latency Adaptive Vision, vol. 15, issue 1, pp. 67–75, (1999)

76. M. Bramberger, *PhD Thesis at Graz University, Austria*. Distributed Task Allocation in Clusters of Embedded Smart Cameras, (2005)

77. M. Bramberger, J. Brunner, B. Rinner and H. Schwabach, in *Proceedings of the 10th IEEE Real-Time and Embedded Technology and Applications Symposium (RTAS)*. Real-time Video Analysis on an Embedded Smart Camera for Traffic Surveillance, pp. 174–181, (2004)

78. M. Bramberger, A. Doblander, A. Maier, B. Rinner and H. Schwabach, in *IEEE Computer. Distributed Embedded Smart Cameras for Surveillance Applications*, vol. 39, no. 2, pp. 68–75, (2006)

79. C. Bräuer-Burchardt, in *Proceedings of the 24th Pattern Recognition Symposium (DAGM). A Simple New Method for Precise Lens Distortion Correction of Low Cost Camera Systems*, pp. 570–577, (2004)

80. B. Brillault-O'Mahony, in *Journal of Computer Vision, Graphics and Image Processing. New Method for Vanishing Point Detection*, vol. 54, no. 2, pp. 289–300, (1991)

81. G. Brodin et al., in *Proceedings of the Workshop for pattern recognition in practice 1980. Computer Vision Systems: a Practical Approach*, pp. 289–298, (1980)

82. A. Broggi, A. Cappalunga, C. Caraffi, S. Cattani, S. Ghidoni, P. Grisleri, P.P. Porta, M. Posterli and P. Zani, in *IEEE Trans. on Intelligent Transportation Systems. TerraMax Vision at the Urban Challenge 2007*, (2008)

83. A. Broggi, C. Caraffi, P.P. Porta and P. Zani, in *Proc. IEEE Intl. Conf. on Intelligent Transportation Systems 2006, Toronto, Canada. The Single Frame Stereo Vision System for Reliable Obstacle Detection used during the 2005 Darpa Grand Challenge on TerraMax*, pp. 745–752, (2006)

84. A. Broggi, P. Medici and P.P. Porta, in *EURASIP Journal on Embedded Systems – Special no. on Embedded Systems for Intelligent Vehicles. StereoBox: a Robust and Efficient Solution for Automotive Short Range Obstacle Detection*, ISSN 1687-3955, (2007)

85. T. Broida, S. Chandrashekhar and R. Chellapa, in *IEEE Transactions on Aerospacial Electronic Systems. Recursive Techniques for the Estimation of 3-D Translation and Rotation Parameters from Noisy Image Sequences*, vol. 26, pp. 639–656, (1990)

86. T. Broida and R. Chellapa, in *IEEE Transactions on Pattern Analysis and Machine Intelligence. Estimation of Object Motion Parameters from Noisy Images*, vol. 8, no. 1, pp. 90–99, (1986)

87. G.J. Brostow and R. Cipolla, in *Proceedings of the IEEE Conference on Computer Vision and Pattern Recognition (CVPR2006). Unsupervised Bayesian Detection of Independent Motion in Crowds*, vol. 1, pp. 594–601, (2006)

88. D.C. Brown, in *Proceedings of the Symposium on Close-Range Photogrammetry, Urbana, Illinois, USA. Close-range Camera Calibration*, pp. 855–866, (1971)

89. M.Z. Brown, Burschka and G.D. Hager, in *IEEE Transactions on Pattern Analysis and Machine Intelligence. Advances in Computational Stereo*, vol. 25, no. 8, pp. 993–1008, (2003)

90. F. Buechli, E. Heeb and K. Knop, in *Proceedings of SPIE – The International Society for Optical Engineering, 1985. Low Cost Smart Camera*, pp. 278–283, (1985)

91. H. Buxton, in *Generative Model Based Vision Workshop. Generative Models for Learning and Understanding Dynamic Scene Activity*, pp. 71–81, (2002)

92. J. Canny, in *IEEE Transactions on Pattern Analysis and Machine Intelligence (PAMI). A Computational Approach to Edge Detection*, vol .8, no. 6, pp. 679–698, (1986)

93. B. Cardani, in *IEEE Control System Magazine. Optical Image Stabilization for Digital Cameras*, vol. 26, no. 2, pp. 21–22, (2006)

94. R. Carmona, F. Jimenez-Garrido, R. Domfnguez-Castro, S. Espejo and A. Rodriguez-Vazquez, in *Proceedings on Design, Automation and Test in Europe Conference and Exhibition (2002). Bio-inspired Analog VLSI Design Realizes Programmable Complex Spatio-temporal Dynamics on a Single Chip*, pp. 362–366, (2002)

95. B. Caprile and V. Torre, in *International Journal of Computer Vision (IJCV). Using Vanishing Points for Camera Calibration*, vol. 4, pp. 127–140, (1990)

96. K.R. Castleman, in *Prentice-Hall Inc. Digital Image Processing*, (1996)

97. A. Cavallaro and T. Ebrahimi, in *EURASIP Journal on Applied Signal Processing. Interaction Between High-Level and Low-Level Image Analysis for Semantic Video Object Extraction*, vol. 6, pp. 786–797, (2004)

98. A. Cavallaro and T. Ebrahimi, in *Proceedings of IEEE International Symposium on Circuits and Systems (ISCAS) Sydney, Australia.* Change Detection Based on Color Edges, vol. 2, pp. 141–144, (2001)

99. A. Cavallaro and T. Ebrahimi, in *Proceedings of SPIE Electronic Imaging - Visual Communications and Image Processing, San Jose, California, USA.* Video Object Extraction Based on Adaptive Background and Statistical Change Detection, pp. 465–475, (2001)

100. A. Cavallaro and F. Ziliani, in *Multimedia Video-Based Surveillance Systems, Kluwer Academic Publishers, Boston, USA.* Image Analysis for Advanced Video Surveillance, pp. 57–67, (2000)

101. G.L. Cembrano, A. Rodriguez-Vazquez, R.C. Galan, F. Jimenez-Garrido, S. Espejo and R. Dominguez-Castro, in *IEEE Journal of Solid-State Circuits.* A 1000 fps at 128×128 Vision Processor with 8-bit Digitized I/O, vol. 39, issue 7, pp. 1044–1055, (2004)

102. V. Cevher, A. Sankaranarayanan, J. McClellan and R. Chellapa, in *IEEE Transactions on Multimedia.* Target Tracking Using a Joint Acoustic Video System, vol. 9, pp. 715–727, (2007)

103. P. Chalimbaud and F. Berry, in *EURASIP Journal on Embedded Systems.* Embedded Active Vision System Based on a FPGA Architecture. Article ID 35010, 12 pp. doi:10.1155/2007/35010, (2007)

104. P. Chalimbaud, F. Marmoiton and F. Berry, in *International Journal of Robotics Research.* Towards an Embedded Visuo-Inertial Smart Sensor, vol. 26, no. 6, pp. 537–546, (2007)

105. M. Chan, D. Estève, C. Escriba and E. Campo, in *Journal of Computer Programs in Biomedicine.* A Review of Smart Homes: Present State and Future Challenges, vol. 91, pp. 55–81, (2008)

106. A.B. Chan, Z.J. Liang and N. Vaconcelos, in *Proceedings of the IEEE Conference on Computer Vision and Pattern Recognition (CVPR2008), Anchorage, AK, USA.* Privacy Preserving Crowd Monitoring: Counting People without People Models or Tracking, pp. 1–7, (2008)

107. P.W. Chen, P. Ahammad, C. Boyer, S. Huang, L. Lin, E.J. Lobaton, M.L. Meingast, S. Oh, S. Wang, P. Yan, A. Yang, C. Yeo, L. Chang, J. D. Tygar and S.S. Sastry, in *Third ACM/IEEE International Conference on Distributed Smart Cameras (ICDSC).* CITRIC: A Low-bandwidth Wireless Camera Network Platform, pp. 1–10, (2008)

108. Y. Chen, Y. Rui and T. Huang, in *Proceedings of IEEE Conference on Computer Vision and Pattern Recognition (CVPR) 2000, Hilton Head, SC, USA.* JPDAF Based HMM for Real-time Contour Tracking, pp. 543–550, (2000)

109. M. Chiu, R. Depommier and T. Spindler, in *Proceedings of International Conference on Pattern Recognition, Cambridge, UK.* An Embedded Real-time Vision System for 24-Hour Indoor/Outdoor Car Counting Applications, pp. 338–341, (2004)

110. M. Clapp and R. Etienne Cummings, in *IEEE Sensors Journal.* Dual Pixel Array for Imaging, Motion Detection and Centroid Tracking, vol. 2, no. 6, pp. 529–548, (2002)

111. T.Y.W. Choi, B.E. Shi and K.A. Boahen, in *IEEE Transactions on Circuits and Systems I: Regular Papers.* An ON-OFF Orientation Selective Address Event Representation Image Transceiver Chip, vol. 51, no. 2, pp. 342–353, (2004)

112. B. Choubey, S. Aoyoma, S. Otim, D. Joseph and S. Collins, in *IEEE Sensors Journal.* An Electronic Calibration Scheme for Logarithmic CMOS Pixels, vol. 6, no. 4, pp. 950–956, (2006)

113. Chromasens GmbH, in *Chromasens GmbH Press.* Aleos Modular Camera System User Manual, (2007)

114. R. Cipolla and E. Boyer, in *Proceedings of the APR Workshop on Machine Vision Applications, Chiba, Japan.* 3D Model Acquisition from Uncalibrated Images, pp. 559–568, (1998)

115. T.A. Clarke and J.G. Fryer, in *Photogrammetric Record.* The Development of Camera Calibration Methods and Models, vol. 16, no. 91, pp. 51–66, (1998)

116. Cognex Corporation, in *Cognex Corporation Press.* Installation and User Guide for DVT Vision Sensors, (2006)

117. R. Collins, X. Zhou and S.K. Teh, in *IEEE International Workshop on Performance Evaluation of Tracking and Surveillance (PETS 2005), Beijing, China*. An Open Source Tracking Testbed and Evaluation Website, (2005)

118. R.T. Collins and R. S.Weiss, in *Proceedings of the 3rd International conference on Computer Vision (ICCV)*. Vanishing Point Calculation as Statistical Inference on the Unit Sphere, pp. 400–403, (1990)

119. R. Collins, A. Lipton, H. Fujiyoshi and T. Kanade, in *Proceedings of the IEEE*. Algorithms for Cooperative Multisensor Surveillance, vol. 89, issue 10, pp. 1456–1477, (2001)

120. D. Comaniciu, V. Ramesh and P. Meer, in *IEEE Transactions on Pattern Analysis and Machine Intelligence*. Kernel-based Object Tracking, vol. 25, pp. 564–575, (2003)

121. Commission Internationale de L'Eclairage, in *CIE*. CIE 1988 2 Degree Spectral Luminous Efficiency Function for Photopic Vision, (1990)

122. J. Conradt, P. Lichtsteiner, R. Berner, T. Delbruck, RJ. Douglas and M. Cook, in *Live Demonstration Session at Neural Information Processing Systems*. A Pencil Balancing Robot Using Only Spike-based Visual Input, (2008)

123. T. Cootes, C. Taylor, D. Cooper and J. Graham, in *Computer Vision and Image Understanding*. Active Shape Models - Their Training and Application, vol. 61, no. 1, pp. 38–59, (1995)

124. K. Cornelis, M. Pollefeys and L. Van Gool, in *A. Heyden (ed.) Proceedings of the 7th European Conference on Computer Vision (ECCV), vol. Springer LNCS 2351*. Lens Distortion Recovery for Accurate Sequential Structure and Motion Recovery, pp. 186–200, (2002)

125. R. Costantini, G. Ramponi, J. Bracamonte, B. Piller, M. Ansorge and F. Pellandini, in *Proceedings of SPIE, the International Society for Optical Engineering, Electronic Imaging Conference*, San Jose, CA, USA. Countering Illumination Variations in a Video Surveillance Environment, pp. 85–97, (2001)

126. J. Costas-Santos, T. Serrano-Gotarredona, R. Serrano-Gotarredona and B. Linares-Barranco, in *IEEE Transactions on Circuits and Systems I: Regular Papers*. A Spatial Contrast Retina with On-chip Calibration for Neuromorphic Spike-based AER Vision Systems, vol. 54, no. 7, pp. 1444–1458, (2007)

127. A. Criminisi, I. Reid and A. Zisserman, in *International Journal of Computer Vision*. Single View Metrology, vol. 40, no. 2, pp. 123–148, (2000)

128. D. Crispell, G. Taubin and J. Jannotti, in *Proc. 6th Workshop on Omnidirectional Vision, Camera Networks, and Non-classical Cameras (OMNIVIS 2005)*. Image Based Routing for Image Based Rendering, (2005)

129. C. Cristianini and J. Shawe-Taylor, in *Cambridge University Press*. An Introduction to Support Vector Machines and Other Kernel-based Learning Methods, (2000)

130. C. Cuadrado, A. Zuloaga, J.L. Martin, J. Laizaro and J. Jimenez, in *Proceedings of the IEEE 32nd Annual Conference on Industrial Electronics*. Real-Time Stereo Vision Processing System in a FPGA, pp. 3455–3460, (2006)

131. R. Cucchiara, A. Prati, R. Vezzani, L. Benini, E. Farella and P. Zappi, in *Journal of Ubiquitous Computing and Intelligence*. Using a Wireless Sensor Network to Enhance Video Surveillance, vol. 1, pp. 1–11, (2006)

132. E. Culurciello and A.G. Andreou, in *Electronics Letters*. 16x16 Pixel Silicon on Sapphire CMOS Digital Pixel Photosensor Array, vol. 40, no. 1, pp. 66–68, (2004)

133. E. Culurciello, R. Etienne-Cummings and K.A. Boahen, in *IEEE Journal of Solid-State Circuits*. A Biomorphic Digital Image Sensor, vol. 38, no. 2, pp. 281–294, (2003)

134. N. Dalal and B. Triggs, in *Conference on Computer Vision and Pattern Recognition (CVPR)*. Histograms of Oriented Gradients for Human Detection, pp. 886–893, (2005)

135. Dalsa Corporation. *User Manual*. Piranha Color Trilinear Camera User Manual, (2007)

136. Dalsa Corporation. *User Manual*. Eclipse EC-11-xxx40 Advanced Line Scan Cameras User's Manual, (2002)

137. E. R. Davies, in *Morgan Kaufmann Publishers Inc.*. Machine vision: Theory, Algorithms, Practicalities, (2004)

138. T. Delbruck, in *IEEE Transactions on Neural Networks*, Silicon Retina with Correlation-based, Velocity-tuned Pixels, pp. 529–541, (1993)

139. T. Delbruck, in *Proceedings of Intl. Symposium on Secure-Life Electronics, Advanced Electronics for Quality Life and Society*, University of Tokyo, Tokyo, Japan. Frame-free Dynamic Digital Vision, pp. 21–26, (2008)

140. T. Delbruck and P. Lichtsteiner, in *IEEE International Symposium on Circuits and Systems, ISCAS2007*, New Orleans, USA. Fast Sensory Motor Control Based on Event-based Hybrid Neuromorphic Procedural System, pp. 845–848, (2007)

141. F. Devernay and O. Faugeras, in *Machine Vision and Applications*. Straight Lines have to be Straight, vol. 13, no. 1, pp. 14–24, (2001)

142. A. K. Dey, D. Salber and G. D. Abowd. in *Human-Computer Interaction (HCI) Journal*. A Conceptual Framework and a Toolkit for Supporting the Rapid Prototyping of Context-Aware Applications, vol. 16, no. 2–4, pp. 97–166, (2001)

143. F. Dias Real, P. Chalimbaud, F. Berry, F. Marmoiton and J. Serot, in *Cognitive Systems with Interactive Sensors (COGIS)*. Embedded Early Vision Systems: Implementation Proposal and Hardware Architecture, (2006)

144. F. Dias Real, F. Berry, F. Marmoiton and J. Serot, in *International Conference on Distributed Smart Cameras (ICDSC)*. Hardware, Design and Implementation Issues on a FPGA Based Smart Camera, (2007)

145. A. Dickinson, B. Ackland, E.S. Eid, D. Inglis and E.R. Fossum, in *42nd IEEE International Solid-State Circuits Conference (ISSCC 1995) Digest of Technical Papers*. A 256x256 CMOS Active Pixel Image Sensor with Motion Detection, pp. 226–227, (1995)

146. E.D. Dickmans and B.D. Mysliwetz, in *IEEE Trans. on Pattern Analysis and Machine Intelligence*. Recursive 3-D Road and Relative Ego-State Recognition, vol. 14, pp. 199–213, (1992)

147. J. Doge, G. Schonfelder, G.T. Streil and A. Konig, in *IEEE Transactions on Circuits and Systems II: Analog and Digital Signal Processing*. An HDR CMOS Image Sensor with Spiking Pixels, Pixel-level ADC, and Linear Characteristics, vol. 49, no. 2, pp. 155–158, (2002)

148. R. Dominguez Castro, S. Espejo, A. Rodriguez-Vazquez, R.A. Carmona, P. Foldesy, A. Zarandy, P. Szolgay, T. Sziranyi and T. Roska, in *IEEE Journal of Solid-State Circuits*. A 0.8-um CMOS Two-dimensional Programmable Mixed-signal Focal-plane Array Processor with On-chip Binary Imaging and Instructions Storage, vol. 32, no. 7, pp. 1013–1026, (1997)

149. A. Doucet, N. Freitas and N. Gordon, in *Sequential Monte Carlo Methods in Practice*, New York, Springer-Verlag. (2001)

150. M. Drobics, in *Proceedings of the 2003 Mathematica Developer Conf., Champaign, IL, USA, Wolfram Research Inc.*. Machine Learning Framework for Mathematica: Creating Understandable Computational Models from Data, (2003)

151. P. Dudek and P.J. Hicks, in *The 2001 IEEE International Symposium on Circuits and Systems (2001) ISCAS*. An Analogue SIMD Focal-plane Processor Array, vol. 4, pp. 490–493, (2001)

152. P. Dudek and P.J. Hicks, in *IEEE Transactions on Circuits and Systems I: Regular Papers*. A General-purpose Processor-per-pixel Analog SIMD Vision Chip, vol. 52, no. 1, pp. 13–20, (2005)

153. E. Durucan and T. Ebrahimi, in *Proceedings of X European Signal Processing Conference, Tampere, Finland*. Robust and Illumination Invariant Change Detection Based on Linear Dependence for Surveillance Applications, pp. 1041–1044, (2000)

154. R.H. Dyck and G.P. Weckler, in *IEEE Transactions on Electron Devices 1968*. Integrated Arrays of Silicon Photodetectors for Image Sensing, vol. 15, no. 4, pp. 196–201, (1968)

155. R. A. Easton, in *Wescon Conference Record, 1996*. Smart Digital Cameras for Product Quality Inspection, pp. 402–404, (1996)

156. C. Eckel, E. Bodenstorfer, H. Nachtnebel, P. Rössler and K.J. Mayer, in *Proceedings of the Austrochip 2006*. Hochgeschindigkeits-Farbzeilenkamera Mit Intelligenter Datenvorverar-Beitung, pp. 103–108, (2006)

157. G. Edwards, C. Taylor and T. Cootes, in *Proceedings of International Conference on Face and Gesture Recognition*, Nara, Japan. Interpreting Face Images Using Active Appearance Models, pp. 300–305, (1998)
158. J. E. Eklund, C. Svensson and A. Astrom, in *IEEE Transactions on Very Large Scale Integration (VLSI) Systems*. VLSI Implementation of a Focal Plane Image Processor: a Realization of the Near-sensor Image Processing Concept, vol. 4, no. 3, pp. 322–335, (1996)
159. A. El Gamal, D.X. Yang and B.A. Fowler, in *Proceedings SPIE Vol. 3650*. Pixel-level Processing: Why, What, and How?, vol. 3650, pp. 2–13, (1999)
160. R. Lorch, "Ibn-al-Haytham," Encyclopedia Britannica, 06. Aug. 2008
161. R. Eshel and Y. Moses, in *IEEE International Conference on Computer Vision and Pattern Recognition (CVPR)*. Homography Based Multiple Camera Detection and Tracking of People in a Dense Crowd, pp. 1–8, (2008)
162. J. Espedal, in *IEEE Proceedings of the National Aerospace and Electronics Conference, 1985*. MICRONEYE, pp. 1457–1462, (1985)
163. S. Espejo, R. Carmona, R. Dominguez-Castro and A. Rodriguez-Vazquez, in *International Journal of Circuit Theory and Applications*. CNN Universal Chip in CMOS Technology, vol. 24, pp. 93–111, (1996)
164. S. Espejo, R. Dominguez-Castro, G. Linan and A. Rodriguez-Vazquez, in *IEEE International Conference on Electronics, Circuits and Systems*. A 64 × 64 CNN Universal Chip with Analog and Digital I/O, vol. 1, pp. 203–206, (1998)
165. S. Espejo, A. Rodriguez-Vazquez, R. Dominguez-Castro, J.L. Huertas and E. Sanchez-Sinencio, in *IEEE Journal of Solid-State Circuits*. Smart-pixel Cellular Neural Networks in Analog Current-mode CMOS Technology, vol. 29, no. 8, pp. 895–905, (1994)
166. J. Espina, T. Falck and O. Mülhens, in *Body Sensor Networks*, G.Z. Yang (ed.), Springer. Network Topologies, Communication Protocols and Standards, pp. 145–182, (2006)
167. M. Espina and S. Velastin, in *IEE Proceedings - Vision, Image, and Signal Processing*. Intelligent Distributed Surveillance Systems: A Review, vol. 152, no. 2, pp. 192–204, (2005)
168. R. Etienne-Cummings and J. Van der Spiegel, P. Mueller, in *IEEE. Transactions on Circuits and Systems I: Fundamental Theory and Applications*, A Focal Plane Visual Motion Measurement Sensor, pp. 55–66, (1997)
169. R. Etienne-Cummings, Z.K. Kalayjian and Donghui Cai, in *IEEE Journal of Solid-State Circuits*. A Programmable Focal-plane MIMD Image Processor Chip, vol. 36, no. 1, pp. 64–73, (2001)
170. European Machine Vision Association. *European Vision Technology Market Statistics (2008) Frankfurt/Main, Germany*, (2008)
171. I. Everts, N. Sebe and G. Jones, in *Proceedings of the 14th International Conference on Image Analysis and Processing*. Cooperative Object Tracking with Multiple PTZ Cameras, pp. 323–330, (2007)
172. O. Faugeras, in *The MIT Press, 4th Edition*. Three-Dimensional Computer Vision, A Geometric Viewpoint, (2001)
173. O. Faugeras and Q.T. Luong, in *The Geometry of Multiple Images*, MIT Press Cambridge (2001)
174. O.D. Faugeras, Q.T. Luong and S.J. Maybank, in *Proceedings of the European Conference on Computer Vision*. Camera Self-calibration: Theory and Experiments, pp. 321–334, (1992)
175. J. Fernyhough, A. Cohn and D. Hogg, in *Lecture Notes in Computer Science Springer*. Generation of Semantic Regions from Image Sequences, pp. 475–484, (1996)
176. P. Fieguth and D. Terzopoulos, in *Proceedings of IEEE Conference on Computer Vision and Pattern Recognition, San Juan, Puerto Rico*. Color-based Tracking of Heads and Other Mobile Objects at Video Frame Rates , pp. 21–27, (1997)
177. R. Fisher, in *Proceedings Sixth IEEE International Workshop on Performance Evaluation of Tracking and Surveillance (PETS04), Prague, Czech Republic*. Surveillance Ground Truth Data Set, pp. 1–5, (2004)

178. S. Fleck, F. Busch, P. Biber and W. StraSSer, in *Proceedings IEEE Conference on Computer Vision and Pattern Recognition (CVPR), IEEE Workshop on Embedded Computer Vision (ECVW)*, New York, USA. 3D Surveillance – A Distributed Network of Smart Cameras for Real-Time Tracking and its Visualization in 3D, pp. 83–90, (2006)

179. F. Fleuret, J. Berclaz, R. Lengagne and P. Fua, in *6th International Workshop on Visual Surveillance*. Multiple-People Tracking through Global Optimization, (2006)

180. B. Flinchbaugh, in *B. Kisacanin and V. Pavlovic and T.S. Huang. (Editors of) Real-Time Vision for Human-Computer Interaction. Springer US*. Smart Cameras Systems Technology Roadmap, pp. 285–297, (2005)

181. W. Förstner and S. Ruwiedel, in *Herbert Wichmann Verlag*. Robust Computer Vision – Quality of Vision Algorithms, (1992)

182. R. Forchheimer, K. Chen, C. Svensson and A. Odmark, in *Journal of VLSI Signal Processing, 1993*. Single-chip Image Sensors with a Digital Processor Array, Natural and Artificial Low-Level Seeing Systems, vol. 5, no. 2-3, pp. 121–131, (1993)

183. R. Forchheimer and A. Odmark, in *Proceedings of SPIE Applications of Digital Image Processing*. A Single Chip Linear Array Processor, vol. 397, pp. 425–430, (1983)

184. G.L. Foresti, C. Micheloni, L. Snidaro, P. Remagnino and T. Ellis, in *IEEE Signal Processing Magazine*. Active Video-based Surveillance System: The Low-level Image and Video Processing Techniques Needed for Implementation, vol. 22, no. 2, pp. 25–37, (2005)

185. S. Forstmann, Y. Kanou, J. Ohya, S. Thuering and A. Schmitt, in *IEEE Conference on Computer Vision and Pattern Recognition Workshop*. Real-Time Stereo by Using Dynamic Programming, vol. 3, pp. 29–36, (2004)

186. D. Forsyth and J. Ponce, in *Prentice Hall*. Computer Vision: A Modern Approach, (2003)

187. E.R. Fossum, in *IEEE Transactions on Electron Devices*. CMOS Image Sensors: Electronic Camera on a Chip, vol. 44, no. 10, pp. 1689–1698, (1997)

188. B. Fowler, A. El Gamal and D.X.D. Yang, in *IEEE Conference on Solid State Circuits, Digest of Technical Papers*. A CMOS Area Image Sensor with Multiplexed Pixel Level A/D Conversion, pp. 226–227, (1994)

189. N. Franceschini, J.M. Pichon, C. Blanes and J.M. Brady, in *Philosophical Transactions: Biological Sciences, 1992*. From Insect Vision to Robot Vision, vol. 337, no. 1281, Natural and Artificial Low-Level Seeing Systems, pp. 283–294, (1992)

190. J.G. Freyer and D.C. Brown, in *Photogrammetric Engineering and Remote Sensing*. Lens Distortion for Close-range Photogrammetry, vol. 52, no. 1, pp. 51–58, (1986)

191. J. Friedman, T. Hastie and R. Tibshirani, in *The Annuals of Statistics*. Additive Logistic Regression: A Statistical View of Boosting, vol. 28, pp. 337–407, (2000)

192. K.P. Frohmader, in *IEEE Journal of Solid-State Circuits*. A Novel MOS Compatible Light Intensity-to-frequency Converter Suited for Monolithic Integration, vol. 17, no. 3, pp. 588–591, (1982)

193. P.W. Fry, P.J.W. Noble and R.J. Rycroft, in *IEEE Journal of Solid-State Circuits 1970*. Fixed-pattern Noise in Photomatrices, vol. 5, no. 5, pp. 250–254, (1970)

194. J. Fürtler, J. Brodersen, P. Rössler, K.J. Mayer, G. Cadek, C. Eckel and H. Nachtnebel, in *Proceedings of the Society of Photo-Optical Instrumentation Engineers (SPIE)*, N. Kehtarnavaz, P.A. Laplante (eds.) Real-Time Image Processing 2006. Architecture for Hardware Driven Image Inspection Based on FPGAs, vol. 6063, pp. 105–113, (2006)

195. J. Fürtler, E. Bodenstorfer, K.J. Mayer, J. Brodersen, D. Heiss, H. Penz, C. Eckel, K. Gravogl and H. Nachtnebel, in *Proceedings of the Society of Photo-Optical Instrumentation Engineers (SPIE)*, F. Meriaudeau and K.S. Niel (eds.) *Machine Vision Applications in Industrial Inspection XV*. High-performance Camera Module for Fast Quality Inspection in Industrial Printing Applications, vol. 6503, (2007)

196. J. Fürtler, W. Krattenthaler, K.J. Mayer, H. Penz and A. Vrabl, in *Computers in Industry*. SIS-stamp: An Integrated Inspection System for Sheet Prints in Stamp Printing Application, vol. 56, no. 8-9, pp. 958–974, (2005)

197. J. Fürtler, K.J. Mayer, M. Rubik, H. Penz, J. Brodersen, G. Christian, C. Eckel and H. Nachtnebel, in , *Real-Time Image Processing 2008 Proceedings of SPIE-IS&T Electronic Imaging*, N. Kehtarnavaz and M.F. Carlsohn (eds.). Streaming Warper with Cubic Spline Interpolation for Rectification of Distorted Images on FPGAs, vol. 6811, pp. 137–146, (2008)

198. J. Fürtler, K.J. Mayer, C. Eckel, J. Brodersen, H. Nachtnebel and G. Cadek, in *EURASIP Journal on Embedded Systems*. Geometry Unit for Analysis of Warped Image Features on Programmable Chips, (2007)

199. J. Fürtler, P. Rössler, H. Nachtnebel, K.J. Mayer, G. Cadek and C. Eckel, in *EURASIP Journal on Embedded Systems*. Design Considerations for Scalable High-performance Vision Systems Embedded in Industrial Print Inspection Machines, (2007)

200. K. Fukushima, Y. Yamaguchi, M. Yasuda and S. Nagata, in *IEEE Proceedings*. An Electronic Model of the Retina, vol. 58, no. 12, pp. 1950–1951, (1970)

201. E. Funatsu, K. Hara, T. Toyoda, Y. Miyake, J. Ohta, S. Tai and K. Kyuma, in *IEEE Photonics Technology Letters*. An Artificial Retina Chip Made of a 128*128 pn-np Variable-sensitivity Photodetector Array, vol. 7, no. 2, pp. 188–190, (1995)

202. E. Funatsu, Y. Nitta, Y. Miyake, T. Toyoda, J. Ohta and K. Kyuma, in *IEEE Transactions on Electron Devices*. An Artificial Retina Chip with Current Mode Focal Plane Image Processing Functions, vol. 44, no. 10, pp. 1777–1782, (1997)

203. A. Fusiello and L. Irsara. *Research Report RR 43/2006, Department of Computer Science, University of Verona, Italy*. Quasi-euclidean Uncalibrated Epipolar Rectification, (2006)

204. A. Fusiello, E. Trucco and A. Verri, in *Proceedings of the British Machine Vision Conference*, BMVA Press. Rectification with Unconstrained Stereo Geometry, pp. 400–409, (1997)

205. A. Fusiello, E. Trucco and R. Verri, in *Machine Vision and Applications*. A Compact Algorithm for Rectification of Stereo pairs, vol. 12, pp. 16–22, (2000)

206. R.C. Galan, F. Jimenez-Garrido, R. Dominguez-Castro, S. Espejo, T. Roska, C. Rekeczky, I. Petras and A. Rodriguez-Vazquez, in *IEEE Transactions on Neural Networks*. A Bio-inspired Two-layer Mixed-signal Flexible Programmable Chip for Early Vision, vol. 14, no. 5, pp. 1313–1336, (2003)

207. A. Galata, N. Johnson and D. Hogg, in *Computer Vision and Image Understanding: CVIU*. Learning Variable Length Markov Models of Behaviour, vol. 81, pp. 398–413, (2001)

208. A. C. Gallagher, in *Pattern Recognition*. A Groundtruth Based Vanishing Point Detection Algorithm, vol. 35, pp. 1527–1543, (2002)

209. X. Gao, R. Kleihorst and B. Schueler, in *Proceedings ECV/CVPR 2008, Anchorage, USA*. Stereo Vision in a Smart Camera System, (2008)

210. X. Gao, R. Kleihorst, P. Meijer and B. Schueler, in *International Conference on Distributed Smart Cameras, Stanford, Ca, USA*. Self-rectification and Depth Estimation of Stereo Video in a Real-time Smart Camera System, pp. 1–8, (2008)

211. J. Gealow and C. Sodini, in *IEEE Journal of Solid-State Circuits*. A Pixel-parallel Image Processor Using Logic Pitch-matched to Dynamic Memory, vol. 34, no. 6, pp. 831–839, (1999)

212. P. Giacon, S. Saggin, G. Tommasi and M. Busti, in *Xcell Journal*. Implementing DSP Algorithms Using Spartan-3 FPGAs, vol. 53, pp. 22–25, (2005)

213. A. Gil, O. Reinoso, C. Fernandez and M.A. Vicente, in *Proceedings of 3rd International conference on Informatics in Control and Automation in Robotics, Lisbon, Portugal*. Simultaneous Localization and Mapping in Unmodified Environments Using Stereo Vision, pp. 482–488, (2006)

214. H. Glasl, D. Schreiber, N. Viertl, S. Veigl and Gustavo Fernández, in *11th International IEEE Conference on Intelligent Transportation Systems, Beijing, China*. Video Based Traffic Congestion Prediction on an Embedded System, pp. 950–955, (2008)

215. R.C. Gonzalez, J.A. Cancelas, J. C. Alvarez, J.A. Fernandez and J.M. Enguita, in *IEEE Conference on Emerging Technologies and Factory Automation*. Fast Stereo Vision Algorithm for Robotic Applications, vol. 1, pp. 97–104, (1999)

216. L. Grammatikopoulos, G. Karras and E. Petsa, in *Proceedings of the XIX CIPA International Symposium*, Antalya, Turkey. Camera Calibration Approaches Using Single Images of Manmade Objects, pp. 328–332, (2003)

217. K. Grauman and T. Darrell, in *Proceedings IEEE Conference on Computer Vision and Pattern Recognition (CVPR)*, San Diego, CA, USA. Efficient Image Matching with Distributions of Local Invariant Features, vol. 2, pp. 627–637, (2005)

218. W. Grimson, C. Stauffer, R. Romano and L. Lee, in *Proceedings of the International Conference on Computer Vision and Pattern Recognition, CVPR98*. Using Adaptive Tracking to Classify and Monitor Activities in a Site, pp. 22–29,(1998)

219. V. Gruev and R. Etienne-Cummings, in *IEEE Transactions on Circuits and Systems II: Analog and Digital Signal Processing*. Implementation of Steerable Spatiotemporal Image Filters on the Focal Plane, vol. 49, no. 4, pp. 233–244, (2002)

220. V. Gruev, Z. Yang, J.V. der Spiegel and R. Etienne-Cummings, in *IEEE International Symposium on Circuits and Systems (2007) ISCAS*. Two Transistor Current Mode Active Pixel Sensor, pp. 2846–2849, (2007)

221. X. Guo, X. Qi and J.G. Harris, in *IEEE Sensors Journal*. A Time-to-First-Spike CMOS Image Sensor, vol. 7, no. 8, pp. 1165–1175, (2007)

222. A.M. Haas, S.L. Williams, M.H. Cohen and P.A. Abshire, in *48th Midwest Symposium on Circuits and Systems (2005)*. Dark Address Event Representation Imager, vol. 1, pp. 388–391, (2005)

223. D.W. Hammerstrom and D.P. Lulich, in *Proceedings of the IEEE*. Image Processing Using One-dimensional Processor Arrays, vol. 84, pp. 1005–1018, (1996)

224. A. Hampapur, L. Brown, J. Connell, S. Pankanti, A. Senior and Y. Tian, in *IEEE Pacific-Rim Conference On Multimedia*. Smart Surveillance: Applications, Technologies and Implications, vol. 2, pp. 1133–1138, (2003)

225. S. Haritaoglu, D. Harwood and L. Davis, in *IEEE Transactions on Pattern Analysis and Machine Intelligence*. w^4: Real-Time Surveillance of People and their Activities, vol. 22, no. 8, pp. 809–830, (2000)

226. I. Haritaoglu, D. Harwood and L. Davis, in *Proceedings of 2nd IEEE Workshop on Visual Surveillance*, Fort Collins, CO, USA. Hydra: Multiple People Detection and Tracking Using Silhouettes, pp. 6–13, (1999)

227. R. Hartley, in *International Journal of Computer Vision*. Theory and Practice of Projective Rectification, vol. 35, pp. 115–127, (1999)

228. R. Hartley and S.B. Kang, in *Tech. Rep. MSR-TR-2005-42, Microsoft Research*. Parameter-free Radial Distortion Correction with Centre of Distortion Estimation, (2005)

229. R. Hartley and A. Zisserman, in *Cambridge University Press*. Multiple View Geometry in Computer Vision, (2004)

230. A. Hauptmann, in *Lecture Notes in Computer Science*, Springer. Lessons for the Future from a Decade of Informedia Video Analysis Research, vol. 3568, pp. 1–10, (2005)

231. N. Hayashi, H. Nittaya, K. Masahiro and M. Kato, in *Proceedings of the 1992 International Conference on Industrial Electronics, Control, Instrumentation, and Automation*. New Approach to and Implementation of an LSI for High-speed Image Labeling, vol. 2, pp. 767–771,(1992)

232. Y. He, Z. Zivkovic, R. Kleihorst, A. Danilin and H. Corporaal, in *International Conference on Distributed Smart Cameras*, Stanford, Ca, USA. Real-time Implementations of Hough Transform on SIMD Architecture, (2008)

233. S. Hengstler, D. Prashanth, S. Fong and H. Aghajan, in *International Symposium on Information Processing in Sensor Networks (IPSN)*. MeshEye: A Hybrid-resolution Smart Camera Mote for Applications in Distributed Intelligent Surveillance, pp. 360–369, (2007)

234. I. Hermanto, R.E. Gagnon and P. Heam, in *IEEE Canadian Conference on Electrical and Computer Engineering, 1997*. Machine Vision For Ice Layer Thickness Measurements, vol. 2, pp. 819–822, (1997)

235. D. Hoiem, A. Efros and M. Hebert, in *Proceedings of the International Conference on Computer Vision and Pattern Recognition, CVPR06*. Putting Objects in Perspective, vol. 2, pp. 2137–2144, (2006)

236. G.R. Hopkinson, T.M. Goodman and S.R. Prince, in *A Guide to the Use and Calibration of Detector Array Equipment*, SPIE-Press, Bellingham, WA, USA. (2004)

237. A. Hornberg, in *Wiley-VCH 2006 Edition*. Handbook of Machine Vision, (2006)

238. T. Horprasert, D. Harwood and L. Davis, in *Proceedings of Int. Conf. on Computer Vision, Frame Rate Workshop*. A Statistical Approach for Real-time Robust Background Subtraction and Shadow Detection, pp. 436–439, (1999)

239. J. Horton, R. Mazza and H. Dym, in *Proceedings of the IEEE*. The Scanistor – a Solid State Image Scanner, vol. 52, pp. 1513–1528, (1964)

240. M. Hotter, R. Mester and F. Muller, in *Signal Processing: Image Communication*. Detection and Description of Moving Objects by Stochastic Modelling and Analysis of Complex Scenes, vol. 8, pp. 281–293, (1996)

241. R. Howard and H. Buxton, in *10th European Conference On Artificial Intelligence*. Analogical Representation of Spatial Events, for Understanding Traffic Behaviour, pp. 785–789, (1992)

242. Y. Hsu, H. Nagel and G.Rekers, in *Computer Vision, Graphics and Image Processing*. New Likelihood Test Methods for Change Detection in Image Sequences, vol. 26, pp. 73–106, (1984)

243. W. Hu, T. Tan, L. Wang and S. Maybank, in *IEEE Trans. on Systems, Man and Cybernetics, Part C: Applications and Reviews*. A Survey on Visual Surveillance Object Motion and Behaviors, vol. 34, no. 3, pp. 334–352, (2004)

244. W. Hu, X. Xiao, Z. Fu, D. Xie, T. Tan, and S. Maybank, in *IEEE Transactions on Pattern Analysis and Machine Intelligence*. A System for Learning Statistical Motion Patterns, vol. 28 pp. 1450–1464, (2006)

245. T. Huang and S. Russell, in *Proceedings of 15th International Joint Conference on Artificial Intelligence*, Nagoya, Japan. Object Identification in a Bayesian Context, pp. 1276–1283, (1997)

246. A. Hunter, J. Owens and M. Carpenter, in *IEE Intelligent Distributed Surveillance Systems*. A Neural System for Automated CCTV Surveillance, pp. 14/1–14/5, (2003)

247. A. Ilie and G. Welch, in *ICCV '05: Proceedings of the Tenth IEEE International Conference on Computer Vision*. Ensuring Color Consistency Across Multiple Cameras, vol. 2, pp. 1268–1275, (2005)

248. IMS Research. *Article Published in September 2005 at the Website of IMS Research. Information Accessed in January 2009*. Smart Cameras Drive Machine Vision Market Growth, (2005)

249. IMV Europe. *Information Published in October 2008 at the Website of the IMV Europe and Accessed in January 2009*. OpenCV – Vision Components, (2008)

250. G. Indiveri, P. Oswald and J. Kramer, in *IEEE International Symposium on Circuits and Systems, ISCAS (2002)*. An Adaptive Visual Tracking Sensor with a Hysteretic Winner-Take-all Network, vol. 2, pp. II-324–II-327, (2002)

251. M. Isard and A. Blake, in *Proceedings European Conference on Computer Vision*. Icondensation: Unifying Low-level and High-level Tracking in a Stochastic Framework, vol. 1, pp. 767–781, (1998)

252. M. Ishikawa, K. Ogawa, T. Komuro and I. Ishii, in *IEEE International Conference on Solid-State Circuits, ISSCC, Digest of Technical Papers*. A CMOS Vision Chip with SIMD Processing Element Array for 1 ms Image Processing, pp. 206–207, (1999)

253. V. Ivanchenko, J. Coughlan and H. Shen, in *IEEE Computer Society Conference on Computer Vision and Pattern Recognition Workshops, 2008*. Detecting and Locating Crosswalks using a Camera Phone, pp. 1–8, (2008)

254. A. Iwata, M. Nagata, N. Takeda, M. Homma and T. Norie, in *The IEEE International Symposium on Circuits and Systems, Proceedings ISCAS 2000*. Pulse Modulation Circuit Architecture and its Application to Functional Image Sensors, vol. 2, pp. 301–304, (2000)

255. B. Jähne, in *Digital Image Processing*, Springer-Verlag, Berlin. (2002)

256. A. Jain, D. Kopell, K. Kakligian and Y. F. Wang, in *Proceedings of IEEE Conference on Computer Vision and Pattern Recognition*, New York, USA. Using Stationary-Dynamic

Camera Assemblies for Wide-area Video Surveillance and Selective Attention, vol. 1, pp. 537–544, (2006)

257. R. Jain and H. Nagel, in *IEEE Transactions on Pattern Analysis and Machine Intelligence*. On the Analysis of Accumulative Difference Pictures from Image Sequences of Real World Scenes, vol. 1, pp. 206–214, (1979)

258. J.R. Janesick, in *Scientific Charge Coupled Devices*, SPIE-Press. (2001)

259. J. Janesick, in *oeMagazine*. Duelling Detectors, pp. 30–33, (2002)

260. O. Javed, Z. Rasheed, K. Shafique and M. Shah, in *Proceedings of IEEE International Conference on Computer Vision (ICCV), Nice, France*. Tracking Across Multiple Cameras Disjoint Views, pp. 952–957, (2003)

261. O. Javed, K. Shafique, Z. Rasheed and M. Shah, in *Computer Vision and Image Understanding Journal*. Modeling Inter-camera Space-time and Appearance Relationships for Tracking Across Non-overlapping Views, vol. 109, no. 2, pp. 146–162, (2008)

262. O. Javed, K. Shafique and M. Shah, in *Proceedings of IEEE Conference on Computer Vision and Pattern Recognition 2005, San Diego, California, USA*. Appearance Modeling for Tracking in Multiple Non-overlapping Cameras, vol. 2, pp. 26–33, (2005)

263. O. Javed and M. Shah, in *Automated Multi-Camera Surveillance: Algorithms and Practice*, Springer Verlag. (2008)

264. V. Jeanne, F.X. Jegaden, R. Kleihorst, A. Danilin and B. Schueler, in *DSC'06, Boulder, USA*. Real-time Face Detection on a Dual-Sensor Smart Camera Using Smooth-edges Technique, (2006)

265. N. Johnson and D. Hogg, in *Image and Vision Computing*. Learning the Distribution of Object Trajectories for Event Recognition, vol. 14 pp. 609–615, (1996)

266. M. Jones and P. Viola, in *Proceedings IEEE Conference on Computer Vision and Pattern Recognition (CVPR)*. Fast Multi-view Face Detection, (2003)

267. P. Jonker, in *Kluwer*. Morphological Image Processing: Architecture and VLSI Design, (1992)

268. P. Jonker, in *Proceedings 12th IAPR Conf. on Pattern Recognition, Jerusalem, Israel*. Why Linear Arrays are Better Image Processors, pp. 334–338, (1994)

269. I. Junejo and H. Foroosh, in *Proceedings of the IEEE International Conference on Video and Signal Based Surveillance (AVSS'06)*. Robust Auto-calibration from Pedestrians, (2006)

270. S. Kagami, T. Komuro and M. Ishikawa, in *The 8th IEEE International Workshop on Advanced Motion Control, AMC '04*. A High-speed Vision System with In-pixel Programmable ADCs and PEs for Real-time Visual Sensing, pp. 439–443, (2004)

271. K. Kagawa, K. Isakari, T. Furumiya, A. Uehara, T. Tokuda, J. Ohta and M. Nunoshita, in *Electronics Letters*. Pixel Design of Pulsed CMOS Image Sensor for Retinal Prosthesis with Digital Photosensitivity Control, vol. 39, no. 5, pp. 419–421, (2003)

272. K. Kagawa, K. Yasuoka, D.C. Ng, T. Furumiya, T. Tokuda, J. Ohta and M. Nunoshita, in *IEEE Journal of Selected Topics in Quantum Electronics*. Pulse-domain Digital Image Processing for Vision Chips Employing Low-voltage Operation in Deep-Submicrometer Technologies, vol. 10, no. 4, pp. 816–828, (2004)

273. K. Kagawa, S. Shishido, T. Sasaki, I. Nagahata, M. Nunoshita and J. Ohta, in *IEICE Electronics Express*. A Low-Voltage PWM CMOS Imager with Small Pixel Size Using an In-pixel Gate-common Comparator, vol. 34, no. 8, pp. 271–276, (2007)

274. R. Kalman, in *Transactions of the ASME Journal of Basic Engineering*. A New Approach to Linear Filtering and Prediction Problems, pp. 35–45, (1960)

275. K. Kanatani, in *Elsevier*. Statistical Optimization for Geometric Computation, (1996)

276. J. Kang, I. Cohen and G. Medioni, in *Proceedings of IEEE Conference on Computer Vision and Pattern Recognition (CVPR), Madison, Wisconsin, USA*. Continuous Tracking Within and Across Cameras Streams, pp. 267–272, (2003)

277. J. Kang, I. Cohen and G. Medioni, in *Proceedings of 17th IEEE Conference on Pattern Recognition (ICPR), Cambridge, UK*. Object Reacquisition using Geometric Invariant Appearance, pp. 759–762, (2003)

278. S. Kang, J. Paik, A. Koschan, B. Abidi and M. Abidi, in *Proceedings of SPIE 6th International Conference on Quality Control by Artificial Vision, Tennessee, USA*. Real-time Video Tracking Using PTZ Cameras, vol. 5132, pp. 103–111, (2003)

279. N. Karlsson, E. Benardo, J. Ostrowski, L. Gonclaves, P. Pirjanian and M. E. Munich, in *International Conference on Robotics and Automation (ICRA)*, Barcelona, Spain. The vSLAM Algorithm for Robust Localization and Mapping, (2005)

280. R. Kasturi, in *Computer Science & Engineering University of South Florida, Tampa, USA*. Performance Evaluation Protocol for Face, Person and Vehicle Detection & Tracking in Video Analysis and Content Extraction (VACE-II), (2006)

281. R. Kasturi, D. Goldgof, P. Soundararajan, V. Manohar, M. Boonstra, V. Korzhova, J. Zhang, R. Bowers and J. Garofolo, in *IEEE Transactions on Pattern Analysis and Machine Intelligence*. Framework for Performance Evaluation of Face, Text, and Vehicle Detection and Tracking in Video: Data, Metrics, and Protocol, vol. 31, no. 2, pp. 319–336, (2008)

282. R. Kaucic, A. Perera, G. Brooksby, J. Kaufhold and A. Hoogs, in *Proceedings IEEE Conference on Computer Vision and Pattern Recognition (CVPR)*. A Unified Framework for Tracking Through Occlusions and Across Sensor Gaps, vol. 1, pp. 990–997, (2005)

283. S. Kavadias, B. Dierickx, D. Scheffer, A. Alaerts, D. Uwaerts and J. Bogaerts, in *IEEE Journal of Solid-State Circuits*. A Logarithmic Response CMOS Image Sensor with On-chip Calibration, vol. 35, no. 8, pp. 1146–1152, (2000)

284. M. Kemp, in *The Science of Art: Optical Themes in Western Art from Brunelleschi to Seurat*, Yale University Press New York (1992)

285. V. Kettnaker and R. Zabith, in *Proceedings of IEEE Conference on Computer Vision and Pattern Recognition (CVPR), 1999*, Fort Collins, Colorado, USA. Bayesian Multi- Camera Surveillance, vol. 2, pp. 117–123, (1999)

286. B. Khaleghi, S. Ahuja and Q. Wu, in *Proceedings of 2nd IEEE Workshop on Embedded Computer Vision (ECVW), CVPR 2008*. An Improved Real-time Miniaturized Embedded Stereo Vision System (MESVS-II), pp. 1–8, (2008)

287. S. Khan, O. Javed, Z. Rasheed and M. Shah, in *IEEE International Conference on Computer Vision*. Human Tracking in Multiple Cameras, vol. 1. pp. 331–336, (2001)

288. S. Khawam, I. Nousias, M. Milward, Y. Yi, M. Muir and T. Arslan, in *IEEE Transactions on Very Large Scale Integration (VLSI) Systems*. The Reconfigurable Instruction Cell Array, vol. 16, no. 1, pp. 75–85, (2008)

289. B. Kisacanin, in *Proceedings of the 2005 IEEE Computer Society Conference on Computer Vision and Pattern Recognition*. Examples of Low-Level Computer Vision on Media Processors, P. 135, (2005)

290. B. Kisacanin, S.S. Bhattacharyya and S. Chai. in *Embedded Computer Vision*, Springer, New York (2007)

291. A. Kitchen, A. Bermak and A. Bouzerdoum, in *IEEE Electron Device Letters*. PWM Digital Pixel Sensor Based on Asynchronous Self-resetting Scheme, vol. 25, no. 7, pp. 471–473, (2004)

292. A. Kitchen and A. Bermak and A. Bouzerdoum, in *IEEE Transactions on Electron Devices*. A Digital Pixel Sensor Array with Programmable Dynamic Range, vol. 52, no. 12, pp. 2591–2601, (2005)

293. R. Kleihorst, in *Abstracts of the SAFE & ProRISC/IEEE Workshops on Semiconductors, Circuits and Systems and Signal Processing, Veldhoven, The Netherlands*. A SIMD Smart Camera Architecture for Real-time Face Recognition, (2003)

294. R. Kleihorst, A. Abbo, A. van der Avoird, M.O. de Beeck, L. Sevat, P. Wielage, R. van Veen and H. van Herten, in *ISCAS 2001, Sydney, Australia*. Xetal: A Low-power High-performance Smart Camera Processor, vol. 5, pp. 215–218, (2001)

295. R. Kleihorst, B. Schueler and A. Danilin, in *Proceedings of IEEE International Conference on Acoustics, Speech and Signal Processing, 2007*. Architecture and Applications of Wireless Smart Cameras (Networks), vol. 4, Pages:IV-1373–IV-1376, (2007)

296. R. Kleihorst, B. Schueler, A. Danilin and M. Heijligers, in *Workshop on Distributed Smart Cameras (DSC)*. Smart Camera Mote with High Performance Vision System, (2006)

297. S. Kleinfelder, S. Lim, X. Liu and A. El Gamal, in *IEEE Journal of Solid-State Circuits*. A 10000 Frames/s CMOS Digital Pixel Sensor, vol. 36, no. 12, pp. 2049–2059, (2001)

298. E. Koller-meier and L.V. Gool, in *2nd European Workshop on Advanced Video-Based Surveillance Systems*. Modeling and Recognition of Human Actions Using a Stochastic Approach, pp. 17–28, (2001)

299. V. Kolmogorov and R. Zabih, in *IEEE Conference on Computer Vision*. Computing Visual Correspondence with Occlusions using Graph Cuts, pp. 508–515, (2001)

300. T. Komuro, I. Ishii, M. Ishikawa and A. Yoshida, in *Electron Devices, IEEE Transactions on*. A Digital Vision Chip Specialized for High-speed Target Tracking, vol. 50, no. 1, pp. 191–199, (2003)

301. T. Komuro, S. Kagami and M. Ishikawa, in *IEEE Journal of Solid-State Circuits*. A Dynamically Reconfigurable SIMD Processor for a Vision Chip, vol. 39, no. 1, pp. 265–268, (2004)

302. J. Kosecka and W. Zhang, in *Proceedings of the 7th European Conference on Computer Vision (ECCV), Springer-Verlag*. Video Compass, vol. 2353, pp. 476–490, (2002)

303. N. Krahnstoever and P. Mendoca, in *Proceedings of the 5th International conference on Computer Vision (ICCV)*. Bayesian Autocalibration for Surveillance, vol. 2, pp. 1858–1865, (2005)

304. J. Kramer, in *IEEE International Symposium on Circuits and Systems, ISCAS (2002)*. An ON/OFF Transient Imager with Event-Driven, Asynchronous Read-Out, vol. 2, pp. 165–168, (2002)

305. S. Kumar and C. Piciarelli, in *VISSAP-09, Lisbon, Portugal*. Stereo Vision Using Heterogeneous Sensors for Complex Scene Monitoring, (2009)

306. H. Kwon, J. Park and A. Kak, in *IEEE International Conference on Robotics and Automation*. A New Approach for Active Stereo Camera Calibration, pp. 3180–3185, (2007)

307. E.F. Lally, in *Space Flight Report to the Nation, American Rocket Society*. Mosaic Guidance for Interplanetary Travel, pp. 2249–2261, (1961)

308. E. Lange, E. Funatsu, K. Hara and K. Kyuma, in *Proceedings of 1993 International Joint Conference on Neural Networks*. Artificial Retina Devices – Fast Front Ends for Neural Image Processing Systems, vol. 1, pp. 801–804, (1993)

309. J.P. Lazzaro, J. Wawrzynek, M. Mahowald, M. Sivilotti and D. Gillespie, in *IEEE Transactions on Neural Networks*. Silicon Auditory Processors as Computer Peripherals, vol. 4, no. 3, pp. 523–528, (1993)

310. L. Lee, R. Romano and G. Stein, in *IEEE Trans. on Pattern Recognition and Machine Intelligence*. Monitoring Activities from Multiple Video Streams: Establishing a Common Coordinate Frame, vol. 22 pp. 758–768, (2000)

311. K.F. Lee and B. Tang, in *IEEE Intelligent Vehicles Symposium*. Image Processing for In-vehicle Smart Cameras, (2006)

312. B. Leibe, K. Schindler, N. Cornelis and L.V. Gool, in *IEEE Transactions on Pattern Analysis and Machine Intelligence*. Coupled Object Detection and Tracking from Static Cameras and Moving Vehicles, vol. 30, no. 10, pp. 1683–1698, (2008)

313. G. Lepage, D. Dantès and W. Diels, in M.M. Blouke (ed.) *Society of Photo-Optical Instrumentation Engineers (SPIE) Conference Series, Society of Photo-Optical Instrumentation Engineers (SPIE) Conference Series*. CMOS Long Linear Array for Space Application, vol. 6068, pp. 61–68, (2006)

314. H. Li and R. Hartley, in *Proceedings of the 6th Workshop on Omnidirectional Vision, Camera Networks and Non-classical Cameras*. A Non-iterative Method for Correcting Lens Distortion from Nine Point Correspondences, (2005)

315. Y.M. Liang, H.R. Tyan, H.Y.M. Liao and S.W. Chen, in *Proceedings of IEEE Intl. Conf. on Intelligent Transportation Systems, Shangai, China*. Stabilizing Image Sequences Taken by the Camcorder Mounted on a Moving Vehicle, pp. 90–95, (2003)

316. P. Lichtsteiner and T. Delbruck, in *Research in Microelectronics and Electronics, 2005 PhD.* A 64x64 AER Logarithmic Temporal Derivative Silicon Retina, vol. 2, pp. 202–205, (2005)

317. P. Lichtsteiner, C. Posch and T. Delbruck, in *IEEE Journal of Solid-State Circuits.* A 128 × 128 120 dB 15 us Latency Asynchronous Temporal Contrast Vision Sensor, vol. 43, no. 2, pp. 566–576, (2008)

318. D. Liebowitz, in *Ph.D. thesis, University of Oxford, Department of. Engineering Science.* Camera Calibration and Reconstruction of Geometry from Images, (2001).

319. D. Liebowitz and A. Zisserman, in *Proceedings of the Conference on Computer Vision and Pattern Recognition, IEEE, Santa Barbara, CA, USA.* Metric Rectification for Perspective Images of Planes, pp. 482–488, (1998)

320. D. Liebowitz and A. Zisserman, in *Proceedings of the IEEE International Conference on Pattern Recognition (ICCV).* Combining Scene and Auto-calibration Constraints, vol. 1, pp. 293–300, (1999)

321. R. Lillestrand, in *IEEE Transactions on Computers.* Techniques for Change Detection, vol. 21, no. 7, pp. 654–659, (1972)

322. Q. Lin et al., in *Proceedings of VISION 2008 Intl. Conference, Versailles-Satory, France.* A Far-Infrared based Night-Vision System with Detection, (2008)

323. G. Linan, R. Dominguez-Castro, S. Espejo and A. Rodriguez-Vazquez, in *Proceedings of the 27th European Conference on Solid-State Circuits, ESSCIRC.* ACE16K: An Advanced Focal-plane Analog Programmable Array Processor, pp. 201–204, (2001)

324. D. Litwiller, in *Photonics Spectra.* CCD vs CMOS: Facts and Fiction, vol. 3, pp. 154–158, (2001)

325. D. Litwiller, in *Photonics Spectra.* CMOS vs. CCD, (2005)

326. M. Litzenberger, H. Glasl, B. Kohn, B. Schalko, and G. Fernández, in *Proceedings of the 11th International IEEE Conference on Intelligent Transportation Systems, Beijing, China.* Sensor Fusion on an Embedded System for Traffic Data Analysis – ETRADA-V System, pp. 894–899, (2008)

327. M. Litzenberger, A.N. Belbachir, P. Schon and C. Posch, in *First ACM/IEEE International Conference on Distributed Smart Cameras, 2007.* Embedded Smart Camera for High Speed Vision, pp. 81–86, (2007)

328. M. Litzenberger, C. Posch, D. Bauer, A.N. Belbachir, P. Schon, B. Kohn and H. Garn, in *Proceedings of the 4th Digital Signal Processing Workshop, 12th – Signal Processing Education Workshop.* Embedded Vision System for Real-time Object Tracking Using an Asynchronous Transient Vision Sensor, pp. 173–178, (2006)

329. H. Liu, in *Philips Apptech.* Personal Communication, (2004)

330. S.C. Liu, C.W. Fu and S. Chang, in *IEEE Transactions on Image Processing.* Statistical Change Detection with Moments under Time-Varying Illumination, vol. 7, no. 9, pp. 1258–1268, (1993)

331. S.C. Liu, J. Kramer, G. Indiveri, T. Delbruck and R. Douglas, in *Analog VLSI: Circuits and Principles*, The MIT Press, Cambridge (2004)

332. E. Ljung, E. Simmons, A. Danilin, R. Kleihorst and B. Schueler, in *DSC'06, Boulder, USA.* 802.15.4 Powered Wireless Smart Cameras Network, (2006)

333. M. Loose, K. Meier and J. Schemmel, in *IEEE Journal of Solid-State Circuits.* A Self-calibrating Single-chip CMOS Camera with Logarithmic Response, vol. 36, no. 4, pp. 586–596, (2001)

334. A. Lopich and P. Dudek, in *Proceedings of IEEE International Symposium on Circuits and Systems, ISCAS (2006).* Architecture of a VLSI Cellular Processor Array for Synchronous/Asynchronous Image Processing, pp. 3618–3621, (2006)

335. A. Lopich and P. Dudek, in *IEEE International Symposium on Circuits and Systems, ISCAS (2008).* ASPA: Focal Plane Digital Processor Array with Asynchronous Processing Capabilities, pp. 1592–1595, (2008)

336. J. Lou, Q. Liu, T. Tan and W. Hu, in *Proceedings of the IEEE International Conference on Pattern Recognition, ICPR2002*. Semantic Interpretation of Object Activities in a Surveillance System, vol. 3, pp. 777–780, (2002)

337. D.G. Lowe, in *International Journal of Computer Vision*. Distinctive Image Features from Scale-invariant Keypoints, vol. 60, no. 2, pp. 91–110, (2004)

338. B. Lucas and T. Kanade, in *Proceedings of International Joint Conference on Artificial Intelligence*. An Iterative Image Registration Technique with an Application to Stereo Vision, pp. 674–679, (1981)

339. T. Lule, S. Benthien, H. Keller, F. Mutze, P. Rieve, K. Seibel, M. Sommer and M. Bohm, in *Electron Devices, IEEE Transactions on*. Sensitivity of CMOS Based Imagers and Scaling Perspectives, vol. 47, no. 11, pp. 2110–2122, (2000)

340. Q. Luo and J.G. Harris, in *Proceedings of the 2004 International Symposium on Circuits and Systems*. A Time-based CMOS Image Sensor, vol. 4, pp. IV–840–3, (2004)

341. E. Lutton, H. Maitre and J. Lopez-Krahe, in *IEEE Transactions on Pattern Analysis and Machine Intelligence (PAMI)*. Contribution to the Determination of Vanishing Points Using Hough Transform, vol. 4, no. 16, pp. 430–438, (1994)

342. F. Lv, T. Zhao and R. Nevatia, in *International Conference on Pattern Recognition*. Self-calibration of a Camera from Video of a Walking Human, vol. 1, pp. 562–567, (2002)

343. R.F. Lyon, in *SPIE 2006 for an Invited Paper*. A Brief History of 'Pixel', (2006)

344. R.F. Lyon, in *Computer Science Press. Invited Paper, CMU Conference on VLSI Structures and Computations, Pittsburgh*, H.T.Kung, B.Sproull, and G.Steele, (eds.). The Optical Mouse, and an Architectural Methodology for Smart Digital Sensors, (1981)

345. R.F. Lyon. *European Patent*. Apparatus for Controlling Movement of a Curser in a Computer Display System, (1983)

346. Y. Ma, S. Soatto, J. Kosecka and S.S. Sastry, in *Springer*. An Invitation to 3-D Vision, (2004)

347. J. Mac Cormick and A. Blake, in *International Journal on Computer Vision*. Probabilistic Exclusion and Partitioned Sampling for Multiple Object Tracking, vol. 39, no. 1, pp. 57–71, (2000)

348. S.R. Madden, M.J. Franklin, J.M. Hellerstein and W. Hong, in *SIGMOD*. The Design of an Acquisitional Query Processor for Sensor Networks, (2003)

349. M.J. Magee and J.K. Aggarwal, in *Journal of Computer Vision, Graphics and Image Processing*. Determining Vanishing Points from Perspective Images, vol. 26, no. 2, pp. 256–267, (1984)

350. M. Mahowald and C.A. Mead, in *C. A. Mead, Analog VLSI and Neural Systems, Addison-Wesley*. Silicon Retina, pp. 257–278, (1989)

351. A. Makarov, J. Vesin and F. Reymond, in *Proceedings of SPIE Electronic Imaging – Real Time Imaging, San José, USA*. Intrusion Detection Robust to Slow and Abrupt Lighting Changes, pp. 44–54, (1996)

352. D. Makris, T. Ellis and J. Black, in *Proceedings of the International Conference on Computer Vision and Pattern Recognition*. Bridging the Gaps Between Cameras, vol. 2, pp. II-205–II-210, (2004)

353. J. Mallet and V.M. Bove, in *ICME2003, Baltimore, MD, USA*. Eye Society, (2003)

354. H.S. Malvar, L.W. He and R. Cutler, in *Proceedings of International Conference on Acoustics, Speech, and Signal Processing*. High Quality Linear Interpolation for Demosaicing of Bayer-Patterned Color Images, vol. 3, pp. III–485–8, (2004)

355. V. Manohar, M. Boonstra, V. Korzhova, P. Soundararajan, D. Goldgof, R. Kasturi, S. Prasad, H. Raju, R. Bowers and J. Garofolo, in *Proceedings IEEE Conference on Computer Vision and Pattern Recognition (CVPR), Ninth IEEE International Workshop on Performance Evaluation of Tracking and Surveillance (PETS), New York, USA*. PETS vs. VACE Evaluation Programs: a Comparative Study, pp. 1–6, (2006)

356. L. Marcenaro, G. Gera and C. Regazzoni, in *Proceedings of European Signal Processing Conference (EUSIPCO), Tampere, Finland*. Adaptive Change Detection Approach for Object Detection in Outdoor Scenes under Variable Speed Illumination Changes, (2000)

357. D. Marr, in *W.H. Freeman*. Vision: A Computational Investigation into the Human Representation and Processing of Visual Information, (1983)
358. A.F. Martin and R.C. Bolles, in *Comm. of the ACM*. Random Sample Consensus: A Paradigm for Model Fitting with Applications to Image Analysis and Automated Cartography, vol. 24, pp. 381–395, (1981)
359. N. Massari, M. Gottardi, L. Gonzo, D. Stoppa and A. Simoni, in *IEEE Transactions on Neural Networks*. A CMOS Image Sensor with Programmable Pixel-Level Analog Processing, vol. 16, no. 6, pp. 1673–1684, (2005)
360. N. Massari, M. Gottardi and A. Simoni, in *Proceedings of IEEE Sensors*. A CMOS Optical Sensor with on Focal Plane Programmable Spatio-Temporal Filters, vol. 3, pp. 1281–1284, (2004)
361. J. Matas and O. Chum, in *Proceedings of the British Machine Vision Conference*. Randomized Ransac with t(d,d) Test, (2002)
362. J. Matas, O. Chum, M. Urban and T. Pajdla, in *Proceedings of the British machine vision conference. Stephens & George Print Group, London, UK*. Robust Wide Baseline Stereo from Maximally Stable Extremal Regions, vol. 1, pp. 384–393, (2002)
363. D. Matolin, C. Posch, R. Wohlgenannt and T. Maier, in *IEEE International Symposium on Circuits and Systems, ISCAS (2008)*. A 64x64 Pixel Temporal Contrast Microbolometer Infrared Sensor, pp. 1644–1647, (2008)
364. K.J. Mayer. *Austrian patent AT 501.761*. Farbzeilenkamera, (2006)
365. K.J. Mayer. *Austrian patent pending AT 504.626*. Verfahren und Einrichtung zur Aufnahme, Prüfung und Auswertung von Bildern eines Gegenstandes, (2006)
366. K.J. Mayer, W. Krattenthaler, A. Vrabl and D. Heiss. *Austrian patent AT 502.069*. Verfahren und Einrichtung zur Prüfung von Gegenständen, (2006)
367. L.G. McIlrath, in *IEEE Journal of Solid-State Circuits*. A Low-power Low-noise Ultrawide-dynamic-range CMOS Imager with Pixel-parallel A/D Conversion, vol. 36, no. 5, pp. 846–853, (2001)
368. L.G. McIlrath, V.S. Clark, P.K. Duane, R.D. McGrath and W.D. Waskurak, in *IEEE Transactions on Electron Devices*. Design and Analysis of a 512x768 Current-mediated Active Pixel Array Image Sensor, vol. 44, no 10, pp. 1706–1715, (1997)
369. C. Mead, in *Analog VLSI and Neural Systems*, Addison-Wesley, New york (1989)
370. R. Mech and M. Wollborn, in *Signal Processing*. A Noise Robust Method for 2D Shape Estimation of Moving Objects in Video Sequences Considering a Moving Camera, vol. 66, no. 2, pp. 203–217, (1998)
371. H. Medeiros, J. Park, and A. Kak, in *Proceedings of 2nd IEEE Workshop on Embedded Computer Vision (ECVW), CVPR 2008*. A Parallel Color-based Particle Filter for Object Tracking, pp. 1–8, (2008)
372. S. Mendis, S.E. Kemeny and E.R. Fossum, in *IEEE Transactions on Electron Devices*. CMOS Active Pixel Image Sensor, vol. 41, no. 3, pp. 452–453, (1994)
373. S.K. Mendis, S.E. Kemeny and E.R. Fossum, in *International Electron Devices Meeting, 1993. IEDM '93. Technical Digest*. A 128x128 CMOS Active Pixel Image Sensor for Highly Integrated Imaging Systems, pp. 583–586, (1993)
374. S.K. Mendis, S.E. Kemeny, R.C. Gee, B. Pain, C.O. Staller, Q. Kim and E.R. Fossum, in *IEEE Journal of Solid-State Circuits*. CMOS Active Pixel Image Sensors for Highly Integrated Imaging Systems, vol. 32, no. 2, pp. 187–197, (1997)
375. C. Micheloni, G.L. Foresti and L. Snidaro, in *IEE-proc. Vis. Image Signal Processing*. A Network of Co-operative Cameras for Visual Surveillance, vol. 152, no. 2, pp. 205–212, (2005)
376. C. Micheloni, C. Piciarelli and G.L. Foresti, in *Behaviours Research Methods*. How a Visual Surveillance System Hypothesizes How You Behave, vol. 38, pp. 447–455, (2006)
377. C. Micheloni, C. Piciarelli and G. L. Foresti, in *IEEE Transactions on Circuits and Systems for Video Technology*. Trajectory-based Anomalous Event Detection, vol. 18, no. 11, pp. 1544–1554, (2008)

378. C. Micheloni and G.L. Foresti, in *IEEE International Conference on Pattern Recognition, Honk Kong*. Focusing on Target's Features while Tracking, pp. 836–839, (2006)

379. Micron, Inc., in *Datasheet*. 1.3-megapixel CMOS Active-Pixel Digital Image Sensor, (2004)

380. B. Mičušík, H. Wildenauer and J. Košecká, in *Proceedings of IEEE Conference on Computer Vision and Pattern Recognition (CVPR)*. Detection and Matching of Rectilinear Structures, pp. 1–7, (2008)

381. B. Mičušík, H. Wildenauer and M. Vincze, in *Proceedings of IEEE International Conference on Robotics and Automation (ICRA)*. Towards Detection of Orthogonal Planes in Monocular Images of Indoor Environments, pp. 999–1004, (2008)

382. I. Mikic, P. Cosman, G. Kogut and M. Trivedi, in *Proc. Int. Conf. on Pattern Recognition (ICPR), Barcelona, Spain*. Moving Shadow and Object Detection in Traffic Scenes, vol. 1, pp. 321–324, (2000)

383. A. Minagawa, N. Tagawa, T. Moriya and T. Gotoh, in *Proceedings of the International Conference on Image Analysis and Processing*. Line Clustering with Vanishing Point and Vanishing Line, pp. 388–393, (1999)

384. A. Mohan, C. Papageorgiou and T. Poggio, in *IEEE Transactions on Pattern Analysis and Machine Intelligence*. Example-based Object Detection in Images by Components, vol. 23, Nr. 4, pp. 349–361, (2001)

385. A. Moini, in *Vision Chips*, Kluwer Academic Publishers, Norwell, MH, USA (1999)

386. H. Moravec. *PhD Thesis at Stanford University, USA*. Obstacle Avoidance and Navigation in the Real World by a Seeing Robot Rover, (1980)

387. S.R. Morrison, in *Solid-State Electron 1963*. A New Type of Photosensitive Junction Device, vol. 5, pp. 485–494, (1963)

388. R. Mosqueron, J. Dubois, M. Mattavelli and D. Mauvilet, in *EURASIP Journal on Embedded Systems*. Smart Camera Based on Embedded HW/SW Co-processor, Article ID597872, Volume 2008, doi:10.1155/2008/597872, (2008)

389. R. Mosqueron, J. Dubois and M. Paindavoine, in *EURASIP Journal on Embedded Systems*. High-Speed Smart Camera with High Resolution, Article ID 24163, 16 pp. doi:10.1155/2007/24163, (2007)

390. I.T. Muirhead, in *IEE Colloquium on Integrated Imaging Sensors and Processing 1994*. Developments in CMOS Camera Technology, pp. 5/1–5/4, (1994)

391. Y. Muramatsu, S. Kurosawa, M. Furumiya, H. Ohkubo and Y. Nakashiba, in *IEEE Journal of Solid-State Circuits*. A Signal-processing CMOS Image Sensor Using a Simple Analog Operation, vol. 38, no. 1, pp. 101–106, (2003)

392. Y.M. Mustafah, A. Bigdeli, A.W. Azman and B.C. Lovell, in *Recent Advances in Security Technology (RNSA)*. Smart Cameras Enabling Automated Face Recognition in the Crowd for Intelligent Surveillance System, (2007)

393. D. Myatt, P. Torr, S. Nasuto and R. Craddock, in *British Machine Vision Conference*. Napsac: High Noise, High Dimensional Robust Estimation – Its in the Bag, (2002)

394. M. Nagata, J. Funakoshi and A. Iwata, in *IEEE Journal of Solid-State Circuits*. A PWM Signal Processing Core Circuit Based on a Switched Current Integration Technique, vol. 33, no. 1, pp. 53–60, (1998)

395. J. Nakamura, B. Pain, T. Nomoto, T. Nakamura and E.R. Fossum, in *IEEE Transactions on Electron Devices*. On-Focal-Plane Signal Processing for Current-Mode Active Pixel Sensors, vol. 44, no. 10, pp. 1747–1758, (1997)

396. M. Narayana and D. Haverkamp, in *Proceedings of 4th IEEE CVPR Workshop - Workshop on Object Tracking and Classification Beyond the Visible Spectrum (OTCBVS'07), Minneapolis, Minnesota, USA*. A Bayesian Algorithm for Tracking Multiple Moving Objects in Outdoor Surveillance Video, (2007)

397. T. Natschläger, F. Kossak and M. Drobics, in *Proceedings 13th IEEE Int. Conf. on Fuzzy Systems, Budapest, Hungary*. Extracting Knowledge and Computable Models from Data — Needs, Expectations, and Experience, pp. 493–498, (2004)

398. A. Neri, S. Colonnese, G. Russo and P. Talone, in *Signal Processing*. Automatic Moving Object and Background Separation, vol. 66, no. 2, pp. 219–232, (1998)

399. D.C. Ng, T. Furumiya, K. Yasuoka, A. Uehara, K. Kagawa, T. Tokuda, M. Nunoshita and Jun Ohta, in *IEEE Transactions on Circuits and Systems II: Express Briefs*. Pulse Frequency Modulation Based CMOS Image Sensor for Subretinal Stimulation, vol. 53, no. 6, pp. 487–491, (2006)

400. A. Nghiem, F. Bremond, M. Thonnat and V. Valentin, in *Proceedings of AVSS 2007, September, 2007, London, UK*. ETISEO, Performance Evaluation for Video Surveillance Systems, (2007)

401. Y. Ni, F. Devos, M. Boujrad and J.H. Guan, in *IEEE Journal of Solid-State Circuits*. Histogram-equalization-based Adaptive Image Sensor for Real-time Vision, vol. 32, no. 7, pp. 1027–1036, (1997)

402. D. Nister, in *International Conference on Computer Vision*. Preemptive RANSAC for Live Structure and Motion Estimation, (2003)

403. P.J.W. Noble, in *IEEE Transactions on Electron Devices*. Self-scanned Silicon Image Detector Arrays, vol. 15, no. 4, pp. 202–209, (1968)

404. J. Norén, *Thesis Dissertation at the University of Linkoping*. Warning Systems Design in a Glass Cockpit Environment, (2008)

405. E. Norouznezhad, A. Bigdeli, A. Postula and B.C. Lovell, in *Second ACM/IEEE International Conference on Distributed Smart Cameras*. A High Resolution Smart Camera with GigE Vision Extension for Surveillance Applications, (2008)

406. K. Nummiaro, E. Koller Meier and L.V. Gool, in *Proceedings of First International Workshop on Generative Model Based Vision*. A Color -Based Particle Filter, (2002)

407. K. Obraczka, R. Manduchi and J.J. Garcia Luna Aveces, in *Proceedings 5th Intl. Symposium on Wireless Personal Multimedia Communications 3*. Managing the Information Flow in Visual Sensor Networks, pp. 1177–1181, (2002)

408. J. Ohta, in *First Edition. Smart CMOS Image Sensors and Applications*, CRC Press, USA (2008)

409. Y. Ohta and T. Kanade, in *IEEE Transactions on Pattern Analysis and Machine Intelligence*. Stereo by Intra- and Inter-Scanline Search Using Dynamic Programming, vol. 7, pp. 139–154, (1985)

410. K. Okuma, A. Taleghani, N. de Freitas, J. Little and D. Lowe, in *Proceedings of 8th European Conference on Computer Vision (ECCV) 2004, Prague, Czech Republic, LNCS*. A Boosted Particle Filter: Multitarget Detection and Tracking, vol. 3021, pp. 28–39, (2004)

411. K. Okuma, A. Taleghani, N. de Freitas, J. Little and D. Lowe, in *Proceedings of 9th European Conference on Computer Vision (ECCV) 2006, Graz, Austria, LNCS, Springer Verlag*. Tracking Across Cameras by Incrementally Inter-camera Colour Calibration and Pattern of Activity, vol. 3952 II, pp. 125–136, (2006)

412. J. Owens and A. Hunter, in *3rd IEEE International Workshop on Visual Surveillance*. Application of the Self-organising Map to Trajectory Classification, (2000)

413. F. Paillet, D. Mercier and T.M. Bernard, in *Proceedings of Twelfth Annual IEEE International ASIC/SOC Conference*. Second Generation Programmable Artificial Retina, pp. 304–309, (1999)

414. F. Pardo, J.A. Boluda, J.J Perez, B. Dierickx and D. Scheffer, in *Proceedings of SPIE, Advanced Focal Plane Processing and Electronic Cameras*. Design Issues on CMOS Space-variant Image Sensors, vol. 2950, pp. 98–107, (1996)

415. J.H. Park, S. Kawahito and Y. Wakamori, in *IEICE Electronics Express*. A New Active Pixel Structure with a Pinned Photodiode for Wide Dynamic Range Image Sensors, vol. 2, no. 18, pp. 482–487, (2005)

416. E. Pece, in *Proceedings of First IEEE International Workshop on Performance Evaluation of Tracking and Surveillance, PETS, Grenoble, France*. Tracking by Cluster Analysis of Image Differences, pp. 295–303, (2000)

417. H. Penz, I. Bajla, K.J. Mayer and W. Krattenthaler, in *Proceedings of the Conference on Diagnostic Imaging Technologies and Industrial Applications*. High-speed Template Matching with Point Correlation in Image Pyramids, vol. 3827, pp. 85–94, (1999)

418. A. Perera, C. Srinivas, A. Hoogs, G. Brooksby and W. Hu, in *IEEE Conf. on Computer Vision and Pattern Recognition*. Multi-object Tracking Through Simultaneous Long Occlusions and Split-merge Conditions, pp. 666–673, (2006)

419. M.R. Peres, in *Focal Press, 4th edition*. The Focal Encyclopedia of Photography, (2007)

420. S. Perri, D. Colonna, P. Zicari and P. Corsonello, in *Proceedings of the 13th IEEE International Conference on Electronics, Circuits and Systems*. SAD-Based Stereo Matching Circuit for FPGAs, (2006)

421. R. Pflugfelder. *PhD Thesis at Graz University of Technology*, Austria. Self-calibrating Cameras in Video Surveillance, (2008)

422. R. Pflugfelder and H. Bischof, in W. Burger and J. Scharinger (eds.) *Digital Imaging in Media and Education, Proceedings of the 28th AAPR Workshop, AAPR/ÖAGM — Österreichische Arbeitsgemeinschaft Mustererkennung, Österreichische Computer Gesellschaft*. Vanishing Points and Lorries, vol. 179, pp. 205–212, (2003)

423. R. Pflugfelder and H. Bischof, in *Proceedings of the IEEE International Conference on Advanced Video and Signal based Surveillance. London, UK*. People Tracking Across Two Distant Self-calibrated Cameras, (2007)

424. R. Pflugfelder, H. Bischof, G. Fernandez, M. Nölle and H. Schwabach, in *Proceedings of the 8th IEEE International Conference on Intelligent Transportation Systems (ITSC)*. Influence of Camera Properties on Image Analysis in Visual Tunnel Surveillance, (2005)

425. R. Pflugfelder and H. Bischof, in *Proceedings of 19th International Conference on Pattern Recognition, Miami, Florida, USA*. Tracking Across Non-overlapping Views via Geometry, (2008)

426. R. Philipp and R. Etienne-Cummings, in *Analog Integrated Circuits and Signal Processing Journal*, A Single Chip Stereo Vision System, pp. 703–712, (2004)

427. R.M. Philipp, D. Orr, V. Gruev, J. Van der Spiegel and R. Etienne-Cummings, in *IEEE Journal of Solid-State Circuits*. Linear Current-mode Active Pixel Sensor, vol. 42, no. 11, pp. 2482–2491, (2007)

428. B.T. Phong, in *Commun. ACM*. Illumination for Computer Generated Pictures, vol. 18, no. 6, pp. 311–317, (1975)

429. K.S.J. Pister, J.M. Kahn, and B.E. Boser, in *Highlight Article, Electronics Research Laboratory Research Summary*. Smart Dust: Wireless Networks of Millimeter-Scale Sensor Nodes, (1999)

430. E. Polat, M. Yeasin, and R. Sharma, in *Proceedings of the IEEE Workshop on Multi-Object Tracking (WOMOT'01)*. Tracking Body Parts of Multiple People: A New Approach, pp. 35–41, (2001)

431. C. Posch, M. Hofstätter, D. Matolin, G. Vanstraelen, P. Schon, N. Donath and M. Litzenberger, in *IEEE International Conference on Solid-State Circuits, ISSCC (2007) Digest of Technical Papers*. A Dual-line Optical Transient Sensor with On-chip Precision Time-stamp Generation, pp. 500–618, (2007)

432. C. Posch, D. Matolin and R. Wohlgenannt, in *IEEE International Symposium on Circuits and Systems, ISCAS (2008)*. An Asynchronous Time-based Image Sensor, pp. 2130–2133, (2008)

433. K. Pulli, T. Aarnio, V. Miettinen, K. Roimela and J. Vaarala, in *Morgan Kaufmann*. Mobile 3D Graphics, (2008)

434. PULNiX Inc., in *Specification of the Camera Link Interface Standard for Digital Cameras and Frame Grabbers*, PULNiX Press, USA (2000)

435. X. Qi, X. Guo and J.G. Harris, in *Proceedings of the IEEE Conference on Circuits and Systems, ISCAS2004*. A Time-to-First Spike CMOS Imager, vol. 4, pp. IV–824–7, (2004)

436. L. Quan and R. Mohr, in *Pattern Recognition Letters*. Determining Perspective Structures Using Hierarchical Hough Transform, vol. 9, pp. 279–286, (1989)

437. V. Rabaud and S. Belongie, in *Proceedings of the IEEE Conference on Computer Vision and Pattern Recognition (CVPR2006)*, New York, USA. Counting Crowded Moving Objects, (2006)

438. R. J. Radke, S. Andra, O. Al-kofahi and B. Roysam, in *IEEE Transactions on Image Processing*. Image Change Detection Algorithms: A Systematic Survey, vol. 14, pp. 294–307, (2005)

439. A. Rahimi, B. Dunagan and T. Darrell, in *Proceedings of the IEEE Conference on Computer Vision and Pattern Recognition*. Simultaneous Calibration and Tracking with a Network of Non-overlapping Sensors, vol. 1, pp. I-187–I-194, (2004)

440. S. Randriamasy and A. Gagalowicz, in *Proceedings of Computer Vision and Pattern Recognition*. Region Based Stereo Matching Oriented Image Processing, pp. 736–737, (1991)

441. Z. Rasheed, X. Cao, K. Shafique, H. Liu, L. Yu, M. Lee, K. Ramnath, T. Choe, O. Javed and N. Haering, in *ACM/IEEE International Conference on Distributed Smart Cameras*. Automated Visual Analysis in Large Scale Sensor Networks, pp. 1–10, (2008)

442. C. Rasmussen and G. Hager, in *IEEE Transactions on Pattern Analysis and Machine Intelligence*. Probabilistic Data Association Methods for Tracking Complex Visual Objects Probabilistic Data Association Methods for Tracking Complex Visual Objects, vol. 23, no. 6, pp. 560–576, (2001)

443. C. Regazzoni, V. Ramesh and G.L. Foresti, in *Proceedings of the IEEE*. Special no. on Video Communications, Processing, and Understanding for Third Generation Surveillance Systems, vol. 89, no. 10, pp. 1355–1539, (2001)

444. D.B. Reid, in *IEEE Transactions on Automatic Control*. An Algorithm for Tracking Multiple Targets, vol. 24, no. 6, pp. 843–854, (1979)

445. P. Remagnino and G. Jones, in *Proceedings of British Machine Vision Conference*. Classifying Surveillance Events from Attributes and Behaviour, (2001)

446. B. Rinner, M. Jovanovic and M. Quaritsch, in *Proceedings of the IEEE International Conference on Acoustics, Speech, and Signal Processing (ICASSP)*. Embedded Middleware on Distributed Smart Cameras, pp. 1381–1384, (2007)

447. B. Rinner, T. Winkler, W. Schriebl, M. Quaritsch and W. Wolf, in *Proceedings of the Second ACM/IEEE International Conference on Distributed Smart Cameras*. The Evolution from Single to Pervasive Smart Cameras, pp. 1–10, (2008)

448. B. Rinner and W. Wolf, in *Proceedings of the IEEE*. An Introduction to Distributed Smart Cameras, vol. 96, no. 10, pp. 1565–1575, (2008)

449. J. Rittscher, P. Tu and N. Krahnstoever, in *Proceedings of Computer Vision and Pattern Recognition*, San Diego, USA. Simultaneous Estimation of Segmentation and Shape, (2005)

450. A. Rodriguez Vazquez, S. Espejo, R. Dominguez-Castron, J.L. Huertas and E. Sanchez-Sinencio, in *IEEE Transactions on Circuits and Systems II: Analog and Digital Signal Processing*. Current-mode Techniques for the Implementation of Continuous- and Discrete-time Cellular Neural Networks, vol. 40, no. 3, pp. 132–146, (1993)

451. A. Rodriguez Vazquez, G. Linan-Cembrano, L. Carranza, E. Roca-Moreno, R. Carmona-Galan, F. Jimenez-Garrido, R. Dominguez-Castro and S.E. Meana., in *IEEE Transactions on Circuits and Systems I: Regular Papers*. ACE16k: The Third Generation of Mixed-signal SIMD-CNN ACE Chips Toward VSoCs, vol. 51, no. 5, pp. 851–863, (2004)

452. K. Römer and F. Mattern, in *IEEE Wireless Communications*. The Design Space of Wireless Sensor Networks, Vol. 11, no. 6, pp. 54–61, (2004)

453. R. Roovers, in *Philips Research Laboratories*. Personal Communication, (2005)

454. R. Rosales and S. Sclaroff, in *CVPR Workshop on the Interpretation of Visual Motion*. Improved Tracking of Multiple Humans with Trajectory Prediction and Occlusion Modeling, (1998)

455. C.A. Rosen, N.J. Nilsson and M.B. Adams, in *Proposal ESU 65-1 Technical, See proposal ESU 65-117 and Project 5953, Stanford University*, A Research and Development Program in Applications of Intelligent Automata to Reconnaissance-Phase, (1965)

456. C. Rother. *PhD Thesis, Royal Institute of Technology, Stockholm, Sweden*. Multi-View Reconstruction and Camera Recovery Using a Real and Virtual Reference Plane, (2003)

457. A. Rowe, A. Goode, D. Goel and I. Nourbakhsh, in *Carnegie Mellon Robotics Institute Technical Report*. CMUcam3: An Open Programmable Embedded Vision Sensor, RI-TR-07-13, (2007)

458. E. Royer, M. Lhuillier, M. Dhome and T. Chateau, in *IEEE Conference on Computer Vision and Pattern Recognition (CVPR 2005)*, San Diego, CA, USA. Localization in Urban Environments: Monocular Vision Compared to a Differential GPS Sensor, vol. 2, pp. 114–121, (2005)

459. E. Roza, in *Philips Research Laboratories*. Personal Communication, (2003)

460. P.F. Ruedi, P. Heim, F. Kaess, E. Grenet, F. Heitger, P.Y. Burgi, S. Gyger and P. Nussbaum, in *IEEE Journal of Solid-State Circuits*. A 128 × 128 Pixel 120-dB Dynamic-range Vision-sensor Chip for Image Contrast and Orientation Extraction, vol. 38, no. 12, pp. 2325–2333, (2003)

461. R.G. Runge, M. Uemura and S.S. Viglione, in *Cybernetic Problems in Bionics*. Electronic Synthesis of the Neural Networks in the Pigeon Retina, pp. 791–800, (1968)

462. J. C. Russ, in *The Image Processing Handbook*, CRC Press, Inc., Third Edn. Boca Raton, FL, USA. (1998)

463. I. Saleemi, K. Shafique and M. Shah, in *IEEE Transactions on Pattern Analysis and Machine Intelligence*. Probabilistic Modeling of Scene Dynamics for Applications in Visual Surveillance, (2009)

464. E. Saykol, U. Gudukbay and O. Ulusoy, in *Lecture Notes in Computer Science*. A Database Model for Querying Visual Surveillance by Integrating Semantic and Low-Level Features, vol. 3665, pp. 163–176, (2005)

465. F. Schaffalitzky and A. Zisserman, in *Image and Vision Computing*. Planar grouping for Automatic Detection of Vanishing Lines and Points, vol. 18, pp. 647–658, (2000)

466. M. Schanz, C. Nitta, A. Bussmann, B.J. Hosticka and R.K. Wertheimer, in *IEEE Journal of Solid-State Circuits*. A High-Dynamic-Range CMOS Image Sensor for Automotive Applications, vol. 35, no. 7, pp. 932–938, (2000)

467. D. Scharstein and R. Szeleski, in *IEEE Computer Society Conference on Computer Vision and Pattern Recognition*. High Accuracy Stereo Depth Maps Using Structured Light, pp. 195–202, (2003)

468. D. Scharstein and R. Szeliski, in *Int. Journal of Computer Vision*. A Taxonomy and Evaluation of Dense Two-frame Stereo Correspondence Algorithms, vol. 47, no. 1–3, pp. 7–42, (2002)

469. J. Schiehlen and E. Dickmanns, in *Procs. IEEE/RSJ Intl. Conf. on Intelligent Robots and Systems*. Design and Control of a Camera Platform for Machine Vision, pp. 2058–2063, (1994)

470. G. Schindler and F. Dellaert, in *Proceedings of the Conference on Computer Vision and Pattern Recognition*. Atlanta World: An Expectation Maximization Framework for Simultaneous Low-level Edge Grouping and Camera Calibration in Complex Man-made Environments, pp. 203–209, (2004)

471. J. Schlessman, C. Chen, W. Wolf, B. Ozer, K. Fujino and K. Itoh, in *Proceedings of the 2006 Conference on Computer Vision and Pattern Recognition Workshop*, Washington, DC, USA. Hardware/Software Co-Design of an FPGA-Based Embedded Tracking System, pp. 123–130, (2006)

472. R. Schneidermann, in *Electronics*. Smart Cameras Clicking with Electronic Functions, vol. 48, no. 17, pp. 74–81, (1975)

473. D. Schreiber, in *Pattern Recognition Letters*. Robust Template Tracking with Drift Correction, vol. 28, pp. 1483–1491, (2007)

474. M.A. Schuster and G. Strull, in *IEEE Transactions on Electron Devices 1966*. A Monolithic Mosaic of Photon Sensors for Solid-state Imaging Applications, vol. 13, pp. 907–912, (1966)

475. P. Schwarzkopf. *Information Published at the Website of the EMVA and Accessed in January 2009*. The European Machine Vision Market, (2007)

476. H. Schweitzer, J. Bell and F. Wu, in *Proceedings of 7th European Conference on Computer Vision (ECCV) 2002, Copenhagen, Denmark*. Very Fast Template Matching, pp. 358–372, (2002)

477. I. Sekita, in *Proceedings on CVVC*. On Fitting Several Lines Using the EM Algorithm, pp. 107–109, (1994)

478. L. Seiler et. al., in *Proceedings of ACM SIGGRAPH*. Larrabee: A Many Core $\times 86$ Architecture for Visual Computing, vol. 27, (2008)

479. J.G. Semple and G.T. Kneebone, in Oxford *Algebraic Projective Geometry*, Oxford Press. (1998)

480. M. Sen, I. Corretjer, F.H.S. Saha, J. Schlessman, S.S. Bhattacharyya and W. Wolf, in *Proceedings of IEEE Workshop on Embedded Computer Vision (ECVW), CVPR, San Diego, CA, USA*. Computer Vision on FPGAs: Design Methodology and its Application to Gesture Recognition, pp. 133–141, (2005)

481. K.S. Seo, J.H. Lee and H.M. Choi, in *Pattern Recognition Letters*. An Efficient Detection of Vanishing Points Using Inverted Coordinates Image Space, vol. 27, pp. 102–108, (2006)

482. T. Serre, L. Wolf, S. Bileschi, M. Riesenhuber and T. Poggio, in *IEEE Transactions on Pattern Analysis and Machine Intelligence*. Robust Object Recognition with Cortex-Like Mechanisms, vol. 29, pp. 411–426, (2007)

483. K. Shafique, A. Hakeem, O. Javed, and N. Haering, in *IEEE Workshop on Applications of Computer Vision*. Self Calibrating Visual Sensor Networks, pp. 1–6, (2008)

484. K. Shafique and M. Shah, in *IEEE Transactions on Pattern Analysis and Machine Intelligence*. A Non-iterative Greedy Algorithm for Multi-frame Point Correspondence, vol. 27, pp. 51–65, (2005)

485. M. Shah, O. Javed and K. Shafique, in *IEEE Multimedia*. Automated Visual Surveillance in Realistic Scenarios, vol. 14, pp. 30–39, (2007)

486. L. Shapiro, in *Sensor Review, 1996*. Intelligent Cameras, vol. 16, no. 3, pp. 4–5, (1996)

487. A. Shashua, Y. Gdalyahu and G. Hayun, in *Proceedings of the IEEE Intelligent Vehicles Symposium, Parma, Italy*. Pedestrian Detection for Driving Assistance Systems: Single-Frame Classification and System Level Performance, pp. 1–6, (2004)

488. Y. Shi and S. Lichman, in *CCTV Focus*. Smart Cameras: A Review, no. 36, pp. 34–43 2006, and no. 37, pp. 38–45, (2006)

489. J. Shi and C. Tomasi, in *Proceedings of IEEE Conference on Computer Vision and Pattern Recognition, Seattle, WA, USA*. Good Features to Track, pp. 593–600, (1994)

490. Y. Shi and T. Tsui, in *Proceedings 8th Asian Conference on Computer Vision*. An FPGA-based Smart Camera for Gesture Recognition in HCI Applications, (2007)

491. P. Shin, X. Gao, R. Kleihorst, J. Park and A. Kak, in *International Conference on Distributed Smart Cameras, Stanford, CA, USA*. An Efficient Algorithm for the Extraction of Contours and Curvature Scale Space on SIMD-Powered Smart Cameras, (2008)

492. C. Shoushun and A. Bermak, in *Proceedings. of the IEEE International Symposium on Circuits and Systems, ISCAS2005*. A Low Power CMOS Imager Based on Time-to-First-Spike Encoding and Fair AER, vol. 5, pp. 5306–5309, (2005)

493. C. Shoushun, F. Boussaid and A. Bermak, in *IEEE Sensors Journal*. Robust Intermediate Read-out for Deep Submicron Technology CMOS Image Sensors, vol. 8, no. 3, pp. 286–294, (2008)

494. J.A. Shufelt, in *IEEE Transactions on Pattern Analysis and Machine Intelligence*. Performance Evaluation and Analysis of Vanishing Point Detection Techniques, vol. 21, no. 3, pp. 282–288, (1999)

495. O. Sidla, Y. Lypetskyy, N. Brändle and S. Seer, in *IEEE International Conference on Advanced Video and Signal Based Surveillance*. Pedestrian Detection and Tracking for Counting Applications in Crowded Situations, (2006)

496. N. Siebel and S. Maybank, in *Proceedings of IEEE Workshop on Applications on Computer Vision (ACV), CVPR 2004,* Washington, DC, USA. The Advisor Visual Surveillance System, (2004)

497. R. Sim and J.J. Little, in *Proceedings of the 2006 IEEE/RSJ International Conference on Intelligent Robots and Systems.* Autonomous Vision-Based Exploration and Mapping Using Hybrid Maps and Rao-Blackwellised Particle Filters, (2004)

498. H. Simon, in *Harper and Row,* The shape of Automation: For Men and Management, (1965)

499. E. Simmons, E. Ljung and R. Kleihorst, in *DSC'06,* Boulder, USA. Distributed Vision with Multiple Uncalibrated Smart Cameras, (2006)

500. J. Singh, in New york *Optoelectronics: An Introduction to Materials and Devices,* McGraw-Hill (1996)

501. S.N. Sinha and M. Pollefeys, in *Workshop on Omnidirectional Vision and Camera Networks at ECCV-04, Prague, Czech Republic.* Towards Calibrating a Pan-Tilt-Zoom Camera Network, (2004)

502. K. Skifstad and R. Jain, in *Computer Vision, Graphics, and Image Processing.* Illumination Independent Change Detection for Real World Image Sequences, vol. 46, pp. 387–399, (1989)

503. K. Smith, S. Ba, J. Odobez and D. Gatica Perez, in *Proceedings IEEE Conference on Computer Vision and Pattern Recognition, Workshop on Empirical Evaluation Methods in Computer Vision (CVPR-EEMCV),* San Diego, CA, USA. Evaluating Multi-Object Tracking, (2005)

504. M. Sonka, V. Hlavac and R. Boyle, in *Thomson-Engineering.* 2nd Edition. Image Processing, Analysis, and Machine Vision, (1998)

505. J.D. Spinhirne, V.S. Scott, J.F. Cavanaugh, S. Palm, K. Manizade, J.W. Hoffman and R.C. Grush, in E.L. Dereniak, R.E. Sampson (eds.) Society of Photo-Optical Instrumentation Engineers (SPIE) Conference Series, Infrared Detectors and Focal Plane Arrays V. Preliminary Spaceflight Results from the Uncooled Infrared Spectral Imaging Radiometer (ISIR) on Shuttle Mission sts-85, vol. 3379, pp. 14–21, (1998)

506. J. Stauder, R. Melch and J. Ostermann, in *IEEE Transactions on Multimedia.* Detection of Moving Cast Shadows for Object Segmentation, vol. 1, no. 1, pp. 65–77, (1999)

507. C. Stauffer, in *Proceedings of the IEEE Workshop on Motion and Video Computing.* Learning to Track Objects Through Unobserved Regions, vol. 2, pp. 96–102, (2005)

508. C. Stauffer, in *Proceedings of the Second IEEE Event Mining Workshop at CVPR2003.* Estimating Tracking Sources and Sinks, vol. 4, pp. 35, (2003)

509. C. Stauffer and W. Grimson, in *IEEE Transactions on Pattern Analysis and Machine Intelligence.* Learning Patterns of Activity Using Real Time Tracking, vol. 22, no. 8, pp. 747–757, (2000)

510. C. Stauffer and K. Tieu, in *Proceedings of the IEEE Computer Vision and Pattern Recognition Conference CVPR2003.* Automated Multi-camera Planar Tracking Correspondence Modeling, vol. 1, pp. I-259–I-266, (2003)

511. C. Stauffer, K. Tieu and L. Lee, in *Proceedings of the Joint IEEE International Workshop on Visual Surveillance and Performance Evaluation of Tracking and Surveillance.* Robust Automated Planar Normalization of Tracking Data, pp. 1–8, (2003)

512. T. Strang and C. Linnhof-Popien, in *First International Workshop on Advanced Context Modelling, Reasoning And Management at UbiComp 2004, Nottingham, England.* A Context Modeling Survey, (2004)

513. T. Strang, C. Linnhof-Popien, and K. Frank, in J.B. Stefani, I. Dameure, and D. Hagimont (ed.), LNCS 2893: Proceedings of 4th IFIP WG 6.1 International Conference on Distributed Applications and Interoperable Systems (DAIS2003), Paris, France, volume 2893 of Lecture Notes in Computer Science (LNCS), Springer Verlag. CoOL: A Context Ontology Language to Enable Contextual Interoperability, pp. 236–247, (2003)

514. P. Sturm and S.J. Maybank, in *Proceedings of the British Machine Vision Conference.* A Method for Interactive 3D Reconstruction of Piecewise Planar Objects from Single Images, pp. 265–274, (1999)

515. J. Sun, N.N. Zheng and H.Y. Shum, in *IEEE Transactions on Pattern Analysis and Machine Intelligence*. Stereo Matching Using Belief Propagation, vol. 25, pp. 787–800, (2003)

516. S. Sutor, F. Matusek and R. Reda, in *Proceedings of the Fourth Advanced International Conference on Telecommunications, Athens*. WSSU: High Performance Wireless Self-Contained, Surveillance Unit; an Ad Hoc Video Surveillance System, (2008)

517. S.M. Sze and K.K. Ng, in *Physics of Semiconductor* Devices, Third Edition John Wiley and Sons, New york (2007)

518. M. Taj and A. Cavallaro, in *IEEE International Conference on Image Processing*. Multi-camera Scene Analysis Using an Object-centric Continuous Distribution Hidden Markov Model, (2007)

519. M. Taj, E. Maggio and A. Cavallaro, in *Proceedings of Classification of Events, Activities and Relationships (CLEAR) Workshop*, Baltimore, Maryland (USA). Person and Vehicle Detection and Tracking: Experiments on the CLEAR Dataset, (2007)

520. M. Tajkovic, in *Proceedings of the 5th Asian Conference on Computer Vision (ACCV)*, Melbourne, Australia. Interactive Calibration of a PTZ Camera for Surveillance Applications, (2002)

521. H. Tao, H.S. Sawhney and R. Kumar, in *Proceedings of the Int. IEEE Conference on Computer Vision, Vancouver, British Columbia, Canada*. A Global Matching Framework for Stereo Computation, pp. 532–539, (2001)

522. G. Takacs et al., in *Proceedings of the ACM International Conference on Multimedia Information Retrieval, 2008*. Outdoors Augmented Reality on Mobile Phone Using Loxel-based Visual Feature Organization, pp. 427–434, (2008)

523. N. Takeda, M. Homma, M. Nagata, T. Morie and A. Iwata, in *Proceedings of the ASP-DAC (2000) Asia and South Pacific Design Automation Conference*. A Smart Imager for the Vision Processing Front-end, pp. 19–20, (2000)

524. K.P. Tanaka, F. Ando, K. Taketoshi, I. Ohishi and G. Asari, in *Japanese Journal of Applied Physics*. Novel Digital Photosensor Cell in GaAs IC Using Conversion of Light Intensity to Pulse Frequency, vol. 32, no. 11A, pp. 5002–5007, (1993)

525. J. Tanner and C. Mead, in *IEEE VLSI Signal Processing II*. An Integrated Analog Optical Motion Sensor, pp. 59–87, (1988)

526. G.R. Taylor, A.J. Chosak and P.C. Brewer, in *Proceedings of IEEE International Conference on Computer Vision and Pattern Recognition*. OVVV: Using Virtual Worlds to Design and Evaluate Surveillance Systems, pp. 1–8, (2007)

527. J. Tierno and C. Campo, in *IEEE Pervasive Computing*. Smart Camera Phones: Limits and Applications, (2005)

528. K. Tieu, G. Dalley and W. Grimson, in *Proceedings of the Int. IEEE Conference on Computer Vision*. Inference of Non-overlapping Camera Network Topology by Measuring Statistical Dependence, (2005)

529. G. Timar and C. Rekeczky, in *IEEE Transactions on Circuits and Systems I: Regular Papers*. A Real-Time Multitarget Tracking System with Robust Multichannel CNN-UM Algorithms, vol. 52, no. 7, pp. 1358–1371, (2005)

530. T. Tokuda, D.C. Ng, H. Okamoto, K. Kagawa, J. Ohta and M. Nunoshita, in *Proceedings of IEEE Sensors*. Wide Dynamic Range Pulse Modulation Image Sensor for On-chip Bioimaging Applications, vol. 2, pp. 818–821, (2004)

531. E. Tola, V. Lepetit and P. Fua, in *IEEE International Conference on Computer Vision and Pattern Recognition*, Anchorage, Alaska, USA. A Fast Local Descriptor for Dense Matching, pp. 1–8, (2008)

532. C. Tomasi and T. Kanade, in *Carnegie Mellon University Technical Report CMU-CS-91-132*. Detection and Tracking of Point Features, (1991)

533. B. Tordoff and D. Murray, in *European Conference on Computer vision*. Guided Sampling and Consensus for Motion Estimation, (2002)

534. A. Torralba, in *Contextual Influences on Saliency, Neurobiology of Attention*, Academic Press Inc, London. (2005)

535. D. Toth, T. Aach and V. Metzler, in *Proceedings of European Conference on Signal Processing (EUSIPCO)*, Tampere, Finland. Bayesian Spatio-temporal Motion Detection under Varying Illumination, pp. 2081–2084, (2000)

536. E. Trucco and K. Plakas, in *IEEE Journal of Oceanic Engineering*. Video Tracking: a Concise Survey, vol. 31, no. 2, pp. 520–529, (2006)

537. R.Y. Tsai, in *IEEE Journal of Robotics and Automation*. A Versatile Camera Calibration Technique for High-Accuracy 3D Machine Vision Metrology Using Off-the-Shelf TV Cameras and Lenses, vol. RA-3, no. 4, pp. 323–344, (1987)

538. F.D. Turek. *Information Published in March 2007 at the Website of the Vision Systems and Accessed in January 2009*. Introduction to Neural Net Machine Vision, (2007)

539. Tuytelaars, in *Proceedings of the International Conference on Computer Vision (ICCV)*. The Cascaded Hough Transform as an Aid, (1998)

540. M. Ulstad, in *Pattern Recognition*. An Algorithm for Estimating Small Scale Differences Between Two Digital Images, vol. 5, pp. 323–333, (1973)

541. T. Ungerer et al. *Technical Report of VDE, Germany*. Grand Challenges der Technischen Informatik, 2008

542. J. Vaganay and B. Jouvencel, in *IEEE OCEANS1996*. Motion Estimation for ROV Stabilization with a Light-Stripe Sensor, vol. 3, pp. 1088–1093, (1996)

543. F.A. Van den Heuvel, in *International Archives of Photogrammetry and Remote Sensing*. Vanishing Point Detection for Architectural Photogrammetry, vol. 32, no. 5, pp. 652–659, (1998)

544. F.A. Van den Heuvel, in *International Archives of Photogrammetry and Remote Sensing*. Estimation of Interior Orientation Parameters from Constraints on Line Measurements in a Single Image, vol. 32, pp. 81–88, (1999)

545. J. Van der Spiegel, G. Kreider, C. Claeys, I. Debusschere, G. Sandini, P. Dario, F. Fantini, P. Belluti and G. Soncini, in *Proceedings of the Workshop on Analog Integrated Neural Systems*. In C. Mead and M. Ismail, (eds.), *Analog VLSI Implementation of Neural Systems*. Kluwer Academic Publishers, Boston. A Foveated Retina-like Sensor Using CCD Technology, chapter 8, pp. 189–212, (1989)

546. G. Van der Wal, F. Brehm, M. Piacentino, J. Marakowitz, E. Gudis, A. Sufi and J. Montante, in *Proceedings of Embedded Computer Vision Workshop, International Conference on Computer Vision and Pattern Recognition*. An FPGA-based Verification Framework for Real-Time Vision Systems, (2006)

547. VDMA. *Information Published at the VDMA Website and Accessed in January 2009*. Machine Vision 2009/2010, Applications – Products – Suppliers, (2009)

548. S. Velipasalar and W. Wolf, in *Proceedings of Int. Conf. Image Proc. (ICIP'05)*, Genova, Italy. Multiple Object Tracking and Occlusion Handling by Information Exchange Between Uncalibrated Cameras, (2005)

549. P. Venier, O. Landolt, P. Debergh and X. Arreguit, in *IEEE International Solid-State Circuits Conference, 1996. Digest of Technical Papers*. Analog CMOS Photosensitive Array for Solar Illumination Monitoring, pp. 96–97, (1996)

550. V. Venkateswar and R. Chellappa, in *International Journal of Computer Vision*. Hierarchical Stereo and Motion Correspondence Using Feature Groupings, vol. 15, pp. 245–269, (1995)

551. P. Villegas, X. Marichal and A. Salcedo in *Proceedings of the International Workshop on Image Analysis for Multimedia Interactive Services (WIAMIS99)*. Objective Evaluation of Segmentation Masks in Video Sequences, pp. 85–88, (1999)

552. P. Viola and M. Jones, in *Conference on Computer Vision and Pattern Recognition*. Rapid Object Detection using a Boosted Cascade of Simple Features, (2001)

553. M. Walter, A. Psarrou and S. Gong, in *Proceedings of British Machine Vision Conference*. Learning Prior and Observation Augmented Density Models for Behaviour Recognition, (1999)

554. H. Wang and D. Suter, in *IIEEE Transactions on Pattern Analysis and Machine Intelligence.* Robust Adaptive-scale Parametric Model Estimation for Computer Vision, vol. 26, no. 11, pp. 1459–1474, (2004)
555. X. Wang, K. Tieu and E. Grimson, in *Proceedings of the European Conf. on Computer Vicion.* Learning Semantic Scene Models by Trajectory Analysis, (2006)
556. X. Wang, W. Wong and R. Hornsey, in *IEEE Transactions on Electron Devices.* A High Dynamic Range CMOS Image Sensor with In-pixel Light-to-frequency Conversion, vol. 53, no. 12, pp. 2988–2992, (2006)
557. D. Wan and J. Zhaou, in *Computer Vision and Image Understanding.* Stereo Vision Using two PTZ Cameras, vol. 112, issue 2, pp. 184–194, (2008)
558. G.P. Weckler, in *IEEE Journal of Solid-State Circuits.* Operation of p-n Junction Photodetectors in a Photon Flux Integrating Mode, vol. 2, no. 3, pp. 65–73, (1967)
559. G.Q. Wei and S.D. Ma, in *IEEE Transactions on Pattern Analysis and Machine Intelligence.* Implicit and Explicit Camera Calibration: Theory and Experiments, vol. 16, no. 5, pp. 469–480, (1994)
560. B.N. Wei, Y. Shi, G. Ye and J. Xu, in *Proceedings of IEEE 10th Workshop on Multimedia Signal Processing.* Developing a Smart Camera for Road Traffic Surveillance, (2008)
561. P.K. Weimer, G. Sadasiv, J.E. Meyer, L. Meray-Horvath and W.S. Pike, in *Proceedings of the IEEE.* A Self-scanned Solid-state Image Sensor, vol. 55, no. 9, pp. 1591–1602, (1968)
562. J. Wild et al., in *Women in Photography International,* Digital Photography Milestones from Kodak, (2007)
563. A. Wilson, in *Vision Systems Design, July 2008.* Smart Camera Monitors Traffic, vol. 13, no. 7, (2008)
564. A. Wilson in *Vision Systems Design, January 2009.* CMOS Sensors Target Multiple Applications, vol. 14, no. 1, pp. 19–20, (2009)
565. A. Wilson, in *Vision Systems Design, January 2009.* Extendable Standards, vol. 14, no. 1, pp. 41–45, (2009)
566. A. Wilson, in *Vision Systems Design, February 2009.* High-Res Cameras Use Fiber Interfaces, vol. 14, no. 2, pp. 17–18, (2009)
567. A. Wilson. *Information Published in September 2006 at the Website of the Vision Systems and Accessed in January 2009.* Smart Cameras Look for Smarter Uses, vol. 11, no. 9, (2006)
568. Wintriss Engineering Corporation, in *Product Specification Press.* Opsis 5150/7500 Smart Camera System Product Specifications, (2005)
569. R. Wodnicki, G. W. Roberts and M.D. Levine, in *IEEE Journal of Solid-State Circuits.* A Log-Polar Image Sensor Fabricated in a Standard 1.2-μ m ASIC CMOS Process, vol. 32, no. 8, pp. 1274–1277, (August 1997)
570. W. Wolf, in L.T. Yang et al. (eds.) EUC 2004, Springer LNCS 3207. Cameras and Pervasive Information Systems, pp. 1107–1108, (2004).
571. W. Wolf, B. Ozer and T. Lu, in *IEEE Computer.* Smart Cameras as Embedded Systems, vol. 35, no. 9, pp. 48–53, (2002)
572. W. Wolf and P. Cook, in *NSF Workshop on Cyber-Physical Systems.* Smart Cameras and Microphones, (2006)
573. J.I. Woodfill, G. Gordon and R. Buck, in *Proceedings of the 2004 Conference on Comput. Vision and Pattern Recognition Workshops.* The Tyzx DeepSea High Speed Stereo Vision System, (2004)
574. C. Wren, A. Azarbayejani, T. Darrel and A. Pentland, in *IEEE Transactions on Pattern Analysis and Machine Intelligence.* Pfinder, Real time Tracking of the Human Body, vol. 19, pp. 780–785, (1997)
575. C. Wu, H. Aghajan and R. Kleihorst, in *International Conference on Distributed Smart Cameras,* Vienna, Austria. Mapping Vision Algorithms on SIMD Architecture Smart Cameras, (2007)
576. C. Wu, R. Kleihorst and H. Aghajan, in *International Conference on Information Processing in Sensor Networks (ISPN),* St. Louis, USA. Real-time Human Posture Reconstruction in Wireless Smart Camera Networks, (2008)

577. C. Xu, W. Zhang, W.H. Ki and M. Chan, in *IEEE Journal of Solid-State Circuits*. A 1.0-v VDD CMOS Active-pixel Sensor with Complementary Pixel Architecture and Pulse Width Modulation Fabricated with a 0.25-um CMOS Process, vol. 37, no. 12, pp. 1853–1859, (2002)

578. O. Yadid-Pecht and R. Etienne-Cummings, in *CMOS Imagers – From Phototransduction to Image Processing* First Edition Kluwer Academic Publishers, (2004)

579. O. Yadid-Pecht, R. Ginosar and Y. Shacham-Diamand, in *IEEE Transactions on Electron Devices*. A Random Access Photodiode Array for Intelligent Image Capture, vol. 38, no. 8, pp. 1772–1780, (1991)

580. H. Yamashila and C. Sodini, in *ISSCC2001 Digest of technical papers*. A 128 × 128 CMOS Imager with 4 × 128 Bit-serial Column-parallel PE Array, (2001)

581. D.X.D. Yang, B. Fowler and A. El Gamal, in *Proceedings of the IEEE 1996 Custom Integrated Circuits Conference*. A 128x128 Pixel CMOS Area Image Sensor with Multiplexed Pixel Level A/D Conversion, pp. 303–306, (1996)

582. D.X.D. Yang, B. Fowler and A. El Gamal, in *Proceedings of the IEEE 1998 Custom Integrated Circuits Conference)*. A Nyquist Rate Pixel Level ADC for CMOS Image Sensors, pp. 237–240, (1998)

583. D.X.D. Yang, A. El Gamal, B. Fowler and H. Tian, in *IEEE Journal of Solid-State Circuits*. A 640x512 CMOS Image Sensor with Ultrawide Dynamic Range Floating-point Pixel-Level ADC, vol. 34, no. 12, pp. 1821–1834, (1999)

584. W. Yang, in *Proceedings of IEEE International Solid-State Circuits Conference, 1994. Digest of Technical Papers*. A Wide-dynamic-range, Low-power Photosensor Array, pp. 230–231, (1994)

585. Z. Yang, V. Gruev and J. Van der Spiegel, in *Proceedings 2006 IEEE International Symposium on Circuits and Systems, ISCAS2006*. A CMOS Linear Voltage/Current Dual-Mode Imager, (2006)

586. Z. Yang, V. Gruev and J. Van der Spiegel, in *IEEE International Symposium on Circuits and Systems, ISCAS2008*. Current-Mode Image Sensor with 1.5 Transistors per Pixel and Improved Dynamic Range, pp. 1850–1853, (2008)

587. A. Yilmaz, O. Javed and M. Shah, in *ACM Computing Surveys*. Object Tracking: A Survey, vol. 38, no. 4, (2006)

588. R. Zabih and J. Woodfill, in *European Conference on Computer Vision, Springer, New York, USA*. Non-parametric Local Transforms for Computing Visual Correspondence, pp. 151–158, (1994)

589. A. Zahrani, S. Ipson and J. Haigh, in *Information Sciences*. Application of a Direct Algorithm for the Rectification of Uncalibrated Images, pp. 53–71, (2004)

590. A. Zarandy and C. Rekeczky, in *IEEE Circuits and Systems Magazine*. Bi-i: a Standalone Ultra High Speed Cellular Vision System, vol. 5, no. 2, pp. 36–45, (2005)

591. E.Y. Zeng, D.C. Yen, H.G. Hwang and S.M. Huang, in *International Journal of Services Technology and Management*. Mobile Commerce: The Convergence of E-commerce and Wireless Technology, vol. 4, pp. 302–322, (2003)

592. Z. Zhang, in *Proceedings of International IEEE Conference on Computer Vision*. Flexible Camera Calibration by Viewing a Plane from Unknown Orientations, pp. 666, (1999)

593. Z. Zhang, in *IEEE Transactions on Pattern Analysis and Machine Intelligence*. A Flexible New Technique for Camera Calibration, vol. 22, no. 11, pp. 1330–1334, (2000)

594. W. Zhang and J. Kosecka, in *Robotics: Science and Systems Conference*. A New Inlier Identification Procedure for Robust Estimation Problems, (2006)

595. S. Zhou, R. Chellapa and B. Moghaddam, in *IEEE Transactions on Image Processing*. Visual Tracking and Recognition Using Appearance Adaptive Models in Particle Filters, vol. 11, pp. 1434–1456, (2004)

596. H. Zhou, M. Taj and A. Cavallaro, in *International Conference on Distributed Smart Cameras (ICDSC)*. Audiovisual Tracking using STAC Sensors, (2007)

597. H. Zimmermann, in *Springer*. Integrated Silicon Optoelectronics, (2000)
598. C. Zinner, M. Humenberger, K. Ambrosch and W. Kubinger, in *Lecture Notes in Computer Science 5358*. An Optimized Software-based Implementation of a Census-Based Stereo Matching Algorithm, pp. 216–227, (2008)
599. N. Ziraknejad, S. Tafazoli and P. Lawrence, in *Proceedings of IEEE Workshop on Machine Learning for Signal Processing*. Autonomous Stereo Camera Parameter Estimation for Outdoor Visual Servoing, pp. 157–162, (2007)
600. B. Zitova and J. Flusser, in *Image and Vision Computing*. Image Registration Methods: A Survey, vol. 21, no. 11, pp. 977–1000, (2003)
601. Z. Zivkovic, R. Kleihorst, A. Danilin, B. Schueler, C. Chan, H. Aghajan, G. Arturi and V. Kliger, in *Proceedings ECV/CVPR 2008*, Anchorage, USA. Towards Low Latency Gesture Control Using Smart Camera Network, (2008)
602. N. Zuech. *Information Published in November 2005 at the Website of the Machine Vision Online and Accessed in January 2009*. Machine Vision Software, (2005)
603. N. Zuech. *Information Published in January 2006 at the Website of the Machine Vision Online and Accessed in January 2009*. Machine Vision Trends, (2006)
604. R. Pflugfelder, H. Bischof, *in IEEE Transactions on Pattern Analysis and Machine Intelligence. Localization and Trajectory Reconstruction in Surveillance Cameras with Non-overlapping Views. IEEE computer Society Digital Library*. IEEE Computer Society, (2009)

Index

35mm film camera, 7
3D, 154
 Vision, 299

A
Absolute conic, 164
Active
 Pixel sensing, 23
 Pixel sensor, see also APS pixel, 66
 Shape model, 113–116
 Vision, 26, 37
AdaBoost algorithm, 204
Adaptive algorithms, 300
Address event, 152–156
 Representation, 77, 79
ADSP2181, 100
Advanced driver assistance systems, 319, 327
AE tracking, 205, 206
Al Kindi, vi
Alhacen, v, 6
Ambient assisted living, 362
Analog Devices, 153
Analog technology, 8
Ancient Greek, 4
Anomaly detection, 310
Aphrodite, 4
Application trends, 361
Application-specific information processing,
 22–25, 28–33, 284
Application-specific vision system, 285
APS pixel, 64
Areascan camera, 125, 129
Aristotle, v, 4
Array read-out, 93
Artificial retinas, 28, 32
ASIC, 41
Asynchronous address-event representation, 94
Atmospheric windows, 323
Automated identification system, 313

Automated imaging association, AIA, 342,
 343, 346, 347, 349–351, 353, 354
Automated surveillance systems, 305
Automatic
 Calibration, 332
 Exposure control, 335
Automotive, 332, 363
 Applications, 48
 In-car, 353
Averroes, vi, 6
Avian retina model, 11

B
Background
 Model, 113
 Subtraction, 203, 204, 308
Bandgap energy, 55, 58
Bayer filter
 De-mosaicing, 128, 129
 Matrix, 127
Bayer pattern, 89, 324
Beam splitting, 125
Behavior Analysis, 309
Binary
 Image, 195
 Map, 193
 Mask, 195, 196
Bing Crosby, 8
Biologically-inspired
 Features, 314
 Stereo, 152, 153
 Vision, 360
 Vision sensor, 137, 151
Biometry, 120
Blob labeling, 131, 134
Blob-based detection, 201, 204, 205
Block matching, 155
Brightness, 55

C
Calibration, 290
 Issues, 331
 Matrix, 169
Calotype, vi, 7
Camera
 As an automotive sensor, 337
 Calibration for vehicles, 330
 Design, 288
 Lens, 125, 129, 134
 Link, 121, 132, 133, 135, 285, 294
 Lucida, 7
 Manufacturers, 300
 Obscura, vi, 6
 On vehicles, 319
 Positioning inside vehicles, 328, 329, 338
 Problems, 338
Carl Friedrich Gauss, 7
Carrier mobility, 59
Cart, vi, 9
Carver Mead, 360
CAVIAR Project, 219
CCD, 63, 90
 Image sensors, 23, 292
 Sensor, 39
Census transform, 140
Change detection, 181, 183
Charge carrier, 58
Circular points, 164
Classification, 134, 192
 Schemes, 4
 Smart cameras, 27, 29
 Vision systems, 28
CMOS, 92
 Image sensors, 23, 65, 292, 299
 Sensor, 39, 45
Co-operative stereo, 270
Code generation, 266
Cognex, 16
Coherent detector, 57
Collodion process, 7
Color, 55
Color correction, 129
Communication
 Interface, 22, 24, 29, 33, 38, 42, 285
 Protocol, 42, 294
Compact
 System smart cameras, 30, 31, 33
 Vision systems, 29
Computational
 Power, 326
 Vision sensor, 72
Computer

Vision, 20, 199–201, 203, 205, 213, 214, 217, 222, 283
 Vision and image understanding, 360
Conduction band, 58
Conductivity, 59
Configurable vision system, 285
Conic, 163
Consistency check, 144, 155
Consumer electronics, 120
Context model, 265
Controller area network, 329
Conversion gain, 67
Convolution, 101, 107
Current mode pixel, 72, 73

D
Daguerreotype, vi, 7
Data
 Acquisition, 38
 Association, 203, 204
 Driven approach, 247
 Fusion, 218
 Processing, 38, 40
 Rate, 120, 123, 127, 132, 135
 Transfer bottleneck, 123, 132, 134
David Marr, 360
Decision level processing, 296
Detectivity, 59
Development methodology, 288
Digital
 Camera, 9
 Image processing, 9
 Pixel sensor, 76
 Signal processor, see also DSP, 22, 25, 293
 Technology, 8
Disparity, 137, 152, 153, 155
 Map, 137, 139, 140, 143, 145, 151, 155, 156
Distributed
 Cameras, 204, 205
 Smart cameras, 30, 31, 33
Doping semiconductor, 59
DSP, 37, 42, 45, 46, 151, 152
DVS, 201, 205, 221
Dynamic range, 65–67, 72, 75

E
Early vision, 37
Edwin Herbert Land, 7
Electromagnetic radiation, 54
Electronic control units, 329
Embedded
 Computer, 100
 Computer vision, 23

Hardware, 199–201, 203, 205, 207, 209, 211, 213, 215, 217–219, 221–223
Platforms, 199, 200, 213, 222
Processing, 40
Processor, 42, 45, 292
Smart cameras, 30–32
Systems, 20
Vision processor, 4
Vision systems, 28
Emission theory, vi
Empedocles of Acragas, 4
Energy band, 58
Epipolar, 275
Lines, 154, 155
Error map, 131
Ethernet
1 Gbit, 132, 135
10 Gbit, 132, 135
ETISEO evaluation project, 218
Euclid, vi, 4
Eugene F. Lally, vi, 8
European machine vision association, EMVA, 341–343, 346, 347
Event-based vision, 75, 77
Examination, 134
Exposure
Control, 126
Time, 125
Extrinsic camera parameters, 162
Extrinsic semiconductor, 59

F
F-number, 6
Fairchild Semiconductor, 9
Far infrared, 322
Feature
Analysis, 186
Extraction, 33, 134, 183, 287, 296
FESTO SBOC-M-R1B, 101
Fiberoptic, *see* Ethernet
Fill factor, 65
Filmless camera, 9
Firewire, 285, 294
First
Electronic person, 12
Magnetic video tape, 8
Megapixel sensor, 9
Mobile robot, 10
Naming of smart camera, vii, 13
Permanent photo paper, 7
Spatial vision chip, 14
Usable camera tube, 7
Fixed pattern noise, 9

Fixed-point arithmetic, 102, 107, 109–111, 113, 116
Flat field correction, 129
Float data type, 101, 102, 107–111, 116
Focal plane processing, 72
Focus plane, 3
Foveated image sensor, 14, 86
FPGA, 22, 36, 41, 45, 218, 293
Platform, 213
Frame storage, 16
Frederick Scott Archer, 7
Future
Directions, 359
Smart camera, 360–362, 364
Trends, 359

G
Gaussian filter, 129
Gemma Frisius, 6
Geo-registration, 246
Geometric distortion
Correction of, 129
George Eastman, 7
Gigabit ethernet, 285, 294
GigE vision, 132, 285, 294
Giovani Battista della Porta, 6
Giovanni Battista Amici, 7
Global shutter, 128, 324
GPS, 255
Gradient image, 129

H
Hans Moravec, vi, 9
Hardware, 35, 38
Architecture, 289
Hausdorff distance, 204
HDR
Images, 325
Herbert Simon, 10
Heterogeneous
Architecture, 40, 45
Stereo vision, 267, 271
High-performance smart camera, 122
High-speed camera, 45
Histogram of oriented gradients, 102, 113–116
Holes, 58
Homography, 167, 269, 274
Human-computer interaction, 49

I
Iconoscope, 7
Illuminance, 56
Illumination, 125
Illumination invariant features, 184

Image
 Capture, 22, 292
 Conditioning, 134
 Enhancement, 295
 Industries, 16
 Level processing, 295
 Processing, 21
 Processing and pattern recognition, 290,
 291, 293–296
 Processing pipeline, 121, 126, 127, 134
 Processing system, 132
 Pyramids, 130
 Segmentation, 296
 Sensor, 38
 Stabilization on vehicles, 325, 334
Image of absolute conic, 168
Imager
 Areascan, 121, 126–128, 134
 Interface, 95
 Linescan, 135
Imputer3, 15
Inertial sensing, 39, 45
Infinite homography, 168
Infrared
 Cameras, 299
 Radiation, 54, 58
 Sensors, 13
Insect vision, 15
Integrated smart cameras, 30
Intelligent
 Approach, 268
 Camera, 21
Inter-sensor
 Calibration, 246
 Tracking, 247
International lighting commission, 57
Interpixel processing, 71, 72
Intrapixel processing, 71
Intrinsic
 Calibration, 168
 Camera parameters, 162
 Semiconductor, 59
Intromission theory, vi
Irradiance, 56

J
Jan Van der Spiegel, 14
Johannes Kepler, vi, 7
John T. Jack Mullin, 8
Joseph Nicephore Niepce, 7

K
Kalman filter, 113, 203, 204, 215
Kinescope, 7

KLT
 Point tracking, 102, 107, 108, 110, 112,
 114–116

L
Lens, 327
 Distortion, 165
 Distortion estimation, 252
Leonardo da Vinci, 6
Libraries, 296
Light
 Room, 7
 Sensitivity, 126
 Strip sensor, 16
Lighting system, 284, 290
Line trigger, 125, 133
Line-at-infinity, 163
Linear-polar sensor, 86
Linescan camera, 121–127, 132, 134, 135
Linux, 100, 101, 103
Log-polar sensor, 87
Logarithmic PD APS, 68
Look-up tables, 326
Lord Rayleigh, 4
Louis Daguerre, 7
Low level processing, 36
Lucas-Kanade algorithm, 204, 221
Luminous efficiency function, 56
Luminous flux, 56

M
Machine vision, 20, 22, 23, 25, 29, 31, 32, 120,
 124, 134, 283, 351, 362
Majority carrier, 59
Many-core, 135
Map building, 149, 150
Market
 Demands, 354
 Description, 346
 Evolution, 363
 Study, 120
Markov Chain Monte Carlo, 205
Mars missions, vi, 9
Mavica electronic still camera, 9
Mean shift tracking, 205
Mechanical adjustment, 134
Mediaprocessor, 37, 42, 293
Memory allocation, 104, 105
Micius, 4
Microcontroller, 42, 45
Microlenses, 87
Minority carrier, 59
Mobile devices, 50
Model

Aspect-scale-context information, 265
Based software engineering, 259
Driven approach, 263
Driven architecture, 263
Platform-independent , 263
Platform-specific, 263, 266
Monochromatic, 55
Morphological operations, 296
Morrison, 8
Mosaic
 Guidance, 9
 Photosensor, 8
Mosaic filter, 125
Motion picture camera, 7
Mozi, see also Micius, v
Multi-camera, 199, 201, 215, 217, 219, 222,
 223
Multi-sensor registration, 247
Multi-target tracking, 203–205
Multi-view geometry, 174
Multimedia, 361
Multiprocessor architecture, 40, 46

N
Near infrared, 322
Network
 Heterogeneous sensors, 245
Network-based vision systems, 29
Networked camera, 361
Neural network, 296, 299
Neuromorphic engineering, 14
Noise, 126, 129
 kTC, 67
Noise-equivalent power, 59
Non-overlapping, 174
NRE, 40
NSAD, 155

O
Object
 Level processing, 295
 Localization, 267, 275
 Recognition, 287
 Tracking, 199–201, 203–205, 207, 209,
 211, 213, 215, 217–219, 221–223, 312
Obstacle avoidance, 9, 149
Omega shape, 113
OpenCV, 23, 101, 103, 104, 106, 107, 297
Operating systems, 293
Optical character recognition, 134
Optical flow, 203, 213
Optical mouse, vii, 13
Optical system, 290
Optics, 292

Oscillations and vibrations, 333
Oskar Barnack, 7

P
Packaging, 120
Panoramic images, 16
Parallel
 Computation, 214
 Processing, 36, 38, 41
Particle filter, 203–205, 214, 217, 221
Passive pixel sensor, 65, 66
Pattern recognition, 296
PC-based
 Systems, 285, 344
 Vision system, 29
PC-hosted smart cameras, 33
PCA-SIFT features, 204
Pedestrian
 Detection, 323
 Tracking, 99, 103, 108, 112, 113, 115–117
Persistent tracking, 312
Perspective projection, 165
PETS Metrics, 217
Petzval, 4
Photo
 CD standard, 15
 Conductor, 60
 Detector, 59
 Diode, 61
 Diode APS, 66
 Gate, 63
 Receptor, 63–65
 Transistor, 63
Photogate APS, 68
Photometric, 56
Photon, 55, 59
Photon energy, 55
Photopic vision, 56
Pigeon's retina, 10
Pinhole, v, 3
 Principle, 7
 SPECT, 6
Pinned photodiode APS, 67
Pixar labs, 9
Pixel, 9
 Array, 9
 Blooming, 126
Pixel-level
 ADC, 76
 Digital processing, 76
 Processing, 71, 72
Planck's constant, 55
Plumb-line method, 166

Point correlation, 130
Polaroid process, 7
Power consumption, 40, 43
Power-over-Ethernet, 300
Print
 Defects, 131
 Flaw classes, 122, 127
 Flaw detection, 123, 126, 129
 Inspection, 120–122, 125, 127, 132, 134
 Inspection system, 121, 123
 Quality, 120, 121, 124, 127, 134
Printing machine, 130
Process control, 287
Processing
 Chain, 295
 Issues in vehicle, 332
Programmability, 40
Projective space, 162
Prototype board, 132
Ptolemy, vi
PTZ
 Camera, 215, 245, 267–273, 277
Pulse-frequency modulation, 74–76
Pulse-modulation imaging, 74
Pulse-width modulation, 74–76

Q
Quality control, 287
Quantum
 Detector, 57
 Efficiency, 59

R
Radiant flux, 56
Radiometric, 56
Random Access, 95
RANSAC, 249
Real-time, 120, 199, 205, 210, 217, 218
 Operating system, 24, 290, 293, 294, 297
 Tracking, 206
Rectangular structures, 178
Rectification, 138, 152, 153, 269, 271, 274
Reference frame, 187
Reflections and glares, 336
Registration, 130
Relative motion estimation, 16
Research project, 44, 47
Responsivity, 59
Reticon Inc., 9
Richard Leach Maddox, 7
Richard Lyon, vii, 13
Road enforcement, 362
Robot navigation, 149
Rolling shutter, 128, 324

Ron Schneidermann, vii, 13
RS232, 294

S
Scanistor, 9
Scanning, 93
Scientific interest, 359
Security printings, 120
Segmentation, 131, 181
Self-calibrating
 Smart camera networks, 316
Self-calibration, 162
Self-scanning silicon image detector
 arrays, 9
Semiconductor, 59
 Photodetector, 58
Sensing devices, 39
Sensor
 Alignment, 254
 Fusion, 361
 Networks, 260
Separation of concerns, 263
Setup for automotive applications, 327
Shaft encoder, 125
Shen K'uo, 6
SIFT matching, 269, 272, 273
Signal to noise ratio, 60, 66, 67, 72, 126
Silver bromide process, 7
SIMD, 36, 44, 110, 111, 205, 213, 214, 231,
 233, 240
Similarity metric, 155
Single-chip smart cameras, 30–32
Smart camera, 4, 21, 29, 119–121, 124, 131,
 134, 135
 Algorithms, 294
 Applications, 47
 Definition, 21
 Design, 35, 38
 Development platform, 290
 Examples, 44
 Market, 341, 343, 346, 349
 Models, 342–344
 Systems, 12
Smart eye, 360
Smart sensors, 32
Smear effect on vehicles, 335
Smearing, 126
Sobel filter, 129
Software architecture, 289
Solid state
 CCD image sensor, 9
 Imaging, 8
Space, 362

Sparse
 Census transform, 146
 Depth map, 151, 155, 156
Spatio-temporal vision chips, 14
Specifications, 288
Spectrum of electromagnetic radiation, 54
Speed of light, 55
Stand-alone smart cameras, 30–32
Standards, 299, 300
Stereo, 151–156
 Camera calibration, 330
 Cameras, 324
 Matching, 140, 145
 Smart camera, 151
 Vision, 137, 153, 268, 269, 271, 277, 280,
 299
Steve Kirsch, 13
Steven Sasson, 9
Still photos, 8
Sum of absolute differences, 140
Support vector machine, 102, 103, 113
Surveillance, 362
Surveillance and monitoring, 316
Synchronous address-event representation, 93
System architecture, 40, 289

T
Tampering detection, 260, 261
Target
 Classification, 313
 Detection, 308
Template matching, 287, 296
Tesselation, 84
Theory of lenses, 7
Thermal detector, 57
Thin-film-transistors, 9
Thomas Alva Edison, 7
Thresholding, 101
Time-based pixel, 74
Timeline of smart cameras, 5
TMS320C644x DSP, 101, 102, 108
Trackball mouse, 13
Tracking
 Evaluation framework, 199, 201, 217, 218
 Performance evaluation, 199, 201, 217, 218
 VIVID evaluation framework, 218
Traffic, 362
Traffic control, 352
Transformation techniques, 295
Transient vision sensor, see also DVS, 151,
 152, 156
Transportation, 120
Transputer network, 16

Tri-linear sensor, 125

U
Ultraviolet radiation, 54, 58
USB, 285, 294

V
VACE evaluation program, 218
Valence band, 58
Vanishing
 Lines, 171
 Points, 162
VC11, 100
VC4465, 103, 106, 108, 111, 116
Vehicle
 Detection and tracking, 204
 Ego-motion, 333
Very compact smart camera, 15
Video
 Analysis, 245, 305
 Analytics, 22
 Surveillance, 120, 161, 181
 Surveillance system, 48
Vidicon, 8
Visible light, 55
Vision
 Chips, vii, 14
 Sensor, 4
 Sensors, 285, 286
 System, 21, 28, 119, 284
 System-on-chip, 73, 96, 359
Vision Components, 99–101, 106, 108, 115,
 116
Visual
 Surveillance, 306
Vladimir Kosma Zworykin, 7
Vocabulary tree, 204

W
Warping unit, 130
Wavelength, 54, 55
Weckler, 9
WiCa, 239, 240
WiCaEnv, 239–241
Wide baseline stereo, 268
William Hyde Wollaston, 7
Windowing, 95
Winner Takes All, 143
Wireless
 Cameras, 25, 229, 299
 Communication, 43
 Sensor network, 260
 Smart camera, 16, 44

X

Xetal, 231, 233
XScale PXA255, 101

Z

Zeiss formula, 6
Zigbee, 229, 236
Zoom, 272

Breinigsville, PA USA
11 March 2010
233999BV00010B/34/P